'Pleasurable and stimulating to read. The book is very well-researched; the author has mastered the most recent bibliography of what constitutes queenship studies, and constructs a vivid and believable portrayal of its evolution. It has the potential to be adopted in different types of courses – including medieval European history survey classes and history seminars focusing on political power, gender, etc.' – **Núria Silleras-Fernández**, *University of Colorado at Boulder, USA*

Medieval queens led richly complex lives and were highly visible women active in a man's world. Linked to kings by marriage, family and property, queens were vital to the institution of monarchy.

In this comprehensive and accessible introduction to the study of queenship, Theresa Earenfight documents the lives and works of queens and empresses across Europe, Byzantium and the Mediterranean in the Middle Ages. The book:

- introduces pivotal research and sources in queenship studies, and includes exciting and innovative new archival research
- highlights four crucial moments – c.300, c.700, c.1100 and c.1350 – across the full span of the Middle Ages when Christianity, education, lineage and marriage law fundamentally altered the practice of queenship
- examines theories and practices of queenship in the context of wider issues of gender, authority and power.

This is an invaluable and illuminating text for students, scholars and other readers interested in the role of royal women in medieval society.

Theresa Earenfight is Professor of History at Seattle University, USA. She is author of *The King's Other Body: María of Castile and the Crown of Aragon* and editor of *Queenship and Political Power in Medieval and Early Modern Spain* and *Women and Wealth in Late Medieval Europe*.

QUEENSHIP AND POWER

Series Editors: Carole Levin and Charles Beem

This series brings together monographs, edited volumes and textbooks from scholars specializing in gender analysis, women's studies, literary interpretation, and cultural, political, constitutional, and diplomatic history. It aims to broaden our understanding of the strategies that queens – both consorts and regnants, as well as female regents – pursued in order to wield political power within the structures of male-dominant societies. In addition to works describing European queenship, it also includes books on queenship as it appeared in other parts of the world, such as East Asia, Sub-Saharan Africa, and Islamic civilization.

Editorial Board

Linda Darling, University of Arizona (Ottoman Empire)
Theresa Earenfight, Seattle University (Spain)
Dorothy Ko, Barnard College (China)
Nancy Kollman, Stanford University (Russia)
John Thornton, Boston University (Africa and the Atlantic World)
John Watkins (France and Italy)

Textbooks in the Queenship and Power series

Queenship in Medieval Europe
Theresa Earenfight

Forthcoming
Queenship in Early Modern Europe
Charles Beem

OTHER BOOKS BY THERESA EARENFIGHT

The King's Other Body: María of Castile and the Crown of Aragon

Queenship and Political Power in Medieval and Early Modern Spain (Editor)

Women and Wealth in Late Medieval Europe (Editor)

QUEENSHIP IN MEDIEVAL EUROPE

THERESA EARENFIGHT

© Theresa Earenfight 2013

All rights reserved. No reproduction, copy or transmission of this publication may be made without written permission.

No portion of this publication may be reproduced, copied or transmitted save with written permission or in accordance with the provisions of the Copyright, Designs and Patents Act 1988, or under the terms of any licence permitting limited copying issued by the Copyright Licensing Agency, Saffron House, 6-10 Kirby Street, London EC1N 8TS.

Any person who does any unauthorized act in relation to this publication may be liable to criminal prosecution and civil claims for damages.

The author has asserted her right to be identified as the author of this work in accordance with the Copyright, Designs and Patents Act 1988.

First published 2013 by
PALGRAVE MACMILLAN

Palgrave Macmillan in the UK is an imprint of Macmillan Publishers Limited, registered in England, company number 785998, of Houndmills, Basingstoke, Hampshire RG21 6XS.

Palgrave Macmillan in the US is a division of St Martin's Press LLC, 175 Fifth Avenue, New York, NY 10010.

Palgrave Macmillan is the global academic imprint of the above companies and has companies and representatives throughout the world.

Palgrave® and Macmillan® are registered trademarks in the United States, the United Kingdom, Europe and other countries

ISBN 978-0-230-27645-1 hardback
ISBN 978-0-230-27646-8 paperback

This book is printed on paper suitable for recycling and made from fully managed and sustained forest sources. Logging, pulping and manufacturing processes are expected to conform to the environmental regulations of the country of origin.

A catalogue record for this book is available from the British Library.

A catalog record for this book is available from the Library of Congress.

10 9 8 7 6 5 4 3 2 1
22 21 20 19 18 17 16 15 14 13

Printed in China

Contents

List of Illustrative Material vii
Acknowledgments ix

**Introduction: Not Partial, Prejudiced or Ignorant:
The Study of Queens and Queenship in Medieval Europe** 1

 The geographic contours of European queenship 13
 The temporal boundaries of medieval queenship 15
 Sources and methods 20
 Theoretical frameworks 24
 Organization of the book 28
 A note on place names, translations and proper names 28

**1 Theme and Variations: Roman, Barbarian and Christian
Societies in the Fashioning of Medieval Queenship,
c. 300–700** 31

 Eastern Roman Empire and early Byzantine Empire 39
 Frankish and Merovingian realms 53
 Early medieval Britain and Ireland 64
 The Iberian Peninsula and Italy 70
 Conclusions 73
 For further research 75

**2 Legitimizing the King's Wife and Bed-Companion,
c. 700–1100** 79

 The Byzantine Empire 86
 The Carolingian Empire 91
 Saxon and Ottonian empresses 98

Early Capetian France	100
England, Scotland and Wales	103
Christian Iberia	115
Eastern Europe, Scandinavia and Kievan Rus'	117
Conclusions	119
For further research	121

3 **'The Link of Conjugal Troth': Queenship as Family Practice, c. 1100–1350** — 123

England and Scotland	131
France	150
The Iberian Kingdoms: León, Castile, the Crown of Aragon and Portugal	160
The Mediterranean: the Byzantine Empire, Latin Crusader kingdoms and Italy	169
The Empire, central and northern Europe	172
Conclusions	176
For further research	179

4 **Queenship in a Crisis of Monarchy, c. 1350–1500** — 183

A woman writing about queens: Christine de Pizan and medieval political theory	192
France	195
England	203
Scotland	219
Iberia: Castile, the Crown of Aragon and Portugal	225
The Empire, Hungary, Poland and Scandinavia	235
Conclusions	238
For further research	242

5 **The Transformation of Queenship from Medieval to Early Modern Europe** — 247

Notes	259
For Further Reading	291
Bibliography	301
Index	339

List of Illustrative Material

Illustrations

1.1 Byzantine ivory diptych panel depicting Byzantine Empress Ariadne (d. 515 CE). Kunsthistorisches Museum, Vienna, Austria. © Erich Lessing/Art Resource, New York. 41
1.2 Balthild's chasuble (linen with silk embroidery, Musée Alfred Bonno, Chelles), from the reliquary of Queen Balthild, the center portion with embroidery. © Genevra Kornbluth. 63
1.3 Balthild seal matrix, c. 650–680 AD, obverse. © Norwich Castle Museum and Art Gallery. 63
1.4 Balthild seal matrix, c. 650–680 AD, reverse. © Norwich Castle Museum and Art Gallery. 63
1.5 Queen Æthelthryth, Benedictional of St Æthelwold, c. 973. London, British Library, Add. 49598, 90v. © British Library Board. 69
2.1 The Antependium of Basel Cathedral, Paris, Musée national du Moyen Âge – Thermes de Cluny, Cl.2350. Photo: Hervé Lewandowski. © RMN-Grand Palais/Art Resource, New York. 83
2.2 Gold solidus of Empress Irene (r. 797–802). British Museum, London. © Erich Lessing/Art Resource, New York. 88
2.3 *Nomisma histamenon* of Empresses Zoë and Theodora (1042), Byzantine, 1042, 2.5 cm (1 in.), gold. © Dumbarton Oaks, Byzantine Collection, Washington, DC. 90

2.4	Queen Emma, The *Liber Vitae* of the New Minster, Winchester (1031), London, British Library, BL Stowe 944, folio 6r. © British Library Board.	111
2.5	Fernando I of León and Castile and his wife Queen Sancha. Miniature from the Book of Hours of Fernando I, 11th century, Archive, Cathedral, Santiago de Compostela, Spain. © Universal Images Group/Art Resource, New York.	116
3.1	Eleanor of Aquitaine. Tombs of the Plantagenet Kings. Fontevrault Abbey, France, 13th century. © Erich Lessing/Art Resource, New York.	141
3.2	Jean Fouquet (c. 1415/20–1481), Coronation of King Louis VIII (1187–1226) of France and Blanche of Castile (1188–1252) at Reims in 1224. From *Les Grandes Chroniques de France*. © Scala/White Images/Art Resource, New York.	156
3.3	Urraca, Queen of Castile and León (1109–1126). Tumbo A, folio 31. Cathedral Library of Coruña, Santiago de Compostela, Spain. © Album/Art Resource, New York.	162
4.1	Christine de Pizan, various works (also known as *The Book of the Queen*), London, British Library, Harley MS 4431, folio 3 (c. 1410–c. 1414) ©British Library Board.	198
4.2	Jean Pichore, '*Des remèdes contre l'une et l'autre fortune. De remedies utriusque fortunae*' (folio 165) by Petrarch (1304–1374), c. 1503, Paris, Bibliotheque Nationale. © Scala/White Images/Art Resource, New York.	202
4.3	Shrewsbury Charter, 1389, Anne of Bohemia and Richard II. © Shropshire Archives, Shrewsbury, doc. ref. 3369/1/24.	209
4.4	Margaret of Anjou and Henry VI being presented with *Poems and Romances* (*The Shrewsbury Book*), Rouen, 1444–45. British Library, Royal 15 E VI, fol. 2v, London, British Library. © British Library Board.	213
4.5	Queen María of Castile (1401–58) with the Consell de Cent (town council) of Barcelona, *Comentarios a los Usatges de Barcelona* (1448), frontispiece, Museu d'Historia de la Ciutat, Barcelona.©Album Art Resource, New York.	231
4.6	Spanish school, *La Virgen de los Reyes Catolicos* (The Virgin of the Catholic Kings), 1490, oil on wood (?), Madrid, Prado Museum ©Album/Art Resource, New York.	241

Table

I.1	Variations in spellings of European royal names	29

Acknowledgments

Writing a book involves many people and I am thankful to, and for, every one of you.

My greatest debt is to my students. You have inspired me from the moment I stepped into a classroom as a graduate teaching fellow at Fordham University, later at Queensborough Community College, and now Seattle University. You taught me what a rich, vibrant, and open-minded intellectual endeavor teaching is. No matter what the course – a survey of medieval history or a research seminar on monarchy – your questions, your love of the rough-and-tumble excitement of ideas bouncing around the room inspire me. No matter where – a classroom, a coffee shop, the student dining halls, the library, an archive in London, or a cathedral in Spain – you challenge me, tease me, and make my work stronger, richer, more meaningful. You have been in my thoughts from the beginning and at every step along the way. When I got stuck or was at a loss for words, I would stop, imagine you in the room, and ask myself 'What would you need to know next?' 'Why should you care?' 'How do I explain to you things like patrimonial lordship, sacral monarchy, chaste marriage, coronation rituals, and the rules of consanguinity in a way that makes sense?' I wish I could name you all, but when I started counting heads and got to 634, I realized that it simply was not possible. There were at least five Allisons, ten Jennifers, and more Davids than you want to know, and I realized that my editors would never go for that. But look closely. You will see yourself on every page. This book is written for you and dedicated to you.

This book would never have come about without the vision of the editors at Palgrave Macmillan, which remains at the forefront of publishing books on queenship that have changed the face of monarchy. This book is the brainchild of Kate Haines, who met with me at the

International Medieval Congress at Leeds in 2009 and asked whether I would be interested in writing a textbook about medieval queens. As teachers, we like to criticize and complain about textbooks. They are too long, too short. We ask why the focus is on this and not that. We often wonder what we would do to if given a chance to write a better one. Well, let me tell you, it was daunting just to think about what a textbook on queens could be. Kate was an expert guide through the all-important early stages of developing a germ of an idea into a concrete project. Jenna Steventon, who took over from Kate, has guided the book with a keen editorial eye that can sort out both the subtlest textual detail and the complex realms of international publishing with vast reserves of tact and diplomacy. I am grateful to the six anonymous reviewers whose comments and criticisms have made this book richer, longer, and more readable. Whatever errors there are in this book, they are mine and mine alone.

I owe a tremendous debt to colleagues near and far who have so generously offered insightful critiques of my work. Like my students, you are too numerous to count but are always in my thoughts. Together, we have scouted out sources, compared notes, shared conference panels, read each others' works, and then celebrated the lives of queens. I hope this book gives us another chance to continue that celebration. My work has been supported by grants and fellowships from the Fulbright Scholarship Program, the National Endowment for the Humanities, the Spanish Ministry of Culture, and Seattle University.

Are there sufficient thanks to my beloved family and friends? You have listened patiently while I talked about why anyone should care about women who died so long ago and I could not have done this without you. Thanks, Frank's, for holding my body and soul together, and doing it with a sense of humor. *Mil gracias*, Warren – you light sparks that illuminate every word I write and make everything I do better, more joyful, more meaningful.

<div align="right">THERESA EARENFIGHT</div>

Acknowledgments

The authors and publishers wish to thank the following for permission to use copyright material:

Art Resource, NY, for Byzantine ivory depicting Byzantine Empress Ariadne (Illustration 1.1) on p. 41; The Antependium of Basle Cathedral (Illustration 2.1) on p. 83; Gold solidus of Empress Irene (Illustration 2.2) on p. 88; Book of Hours of Fernando I (Illustration 2.5) on p. 116; Effigies in the nave of the church of Fontevraud Abbey (Illustration 3.1) on p. 141; Jean Fouquet, *Les Grandes Chroniques de France* (Illustration 3.2) on p. 156; Tumbo A, Urraca, Queen of Castile and León (Illustration 3.3) on p. 162; Jean Pichore, *Des remedes contre l'une et l'autre fortune. De remediis utriusque fortunae* (Illustration 4.2) on p. 202; Bernat Martorell, *Comentarios a los Usatges de Barcelona* (Illustration 4.5) on p. 231; and *La Virgen de los Reyes Catolicos* (Illustration 4.6) on p. 241.

Dumbarton Oaks, Byzantine Collection, Washington, DC, for *Nomisma histamenon* of Empresses Zoë and Theodora (Illustration 2.3) on p. 90.

Genevra Kornbluth, for Balthild's chasuble (Illustration 1.2) on p. 63.

Norwich Castle Museum and Art Gallery, for Balthild seal matrix (Illustrations 1.3 and 1.4) on p. 63.

Shropshire Archives, Shrewsbury, for Anne of Bohemia and Richard II in Shrewsbury Charter, 1389 (Illustration 4.3) on p. 209.

The British Library Board, for the *Benedictional of St Æthelwold* (Illustration 1.5) on p. 69; The *Liber Vitae* of the New Minster, Winchester (Illustration 2.4) on p. 111; Christine de Pizan, *The Book of the Queen* (Illustration 4.1) on p. 198; and *Poems and Romances* (*The Shrewsbury Book*) (Illustration 4.4) on p. 213.

Every effort has been made to trace all the copyright-holders but, if any have been inadvertently overlooked, the authors and publishers will be pleased to make the necessary arrangements at the first opportunity.

Introduction: Not Partial, Prejudiced or Ignorant: The Study of Queens and Queenship in Medieval Europe

Jane Austen, in her famously witty 'History of England from the reign of Henry the 4th to the death of Charles the 1st, By a partial, prejudiced, & ignorant Historian', written in 1791, opens with this description of King Henry IV:

> Henry the 4th ascended the throne of England much to his own satisfaction in the year 1399, after having prevailed on his cousin & predecessor Richard the 2d to resign it to him, & to retire for the rest of his Life to Pomfret Castle, where he happened to be murdered. It is to be supposed that Henry was married, since he had certainly four sons, but it is not in my power to inform the Reader who was his wife. Be this as it may, he did not live for ever, but falling ill, his son the Prince of Wales came and took away the crown; whereupon, the King made a long speech, for which I must refer the Reader to Shakespeare's Plays, & the Prince made a still longer. Things being thus settled between them the King died, & was succeeded by his son Henry who had previously beat Sir William Gascoigne.[1]

Austen's tongue may have been in her cheek when she said that 'it is not in my power to inform the Reader who was his wife', but she clearly had her wits about her. She knew her history – and her historiography,

too – when, as a precocious fifteen-year-old, she wrote this parody of Oliver Goldsmith's *History of England* (1771). Her barb was aimed not only at Goldsmith, but also a long and illustrious line of historians who knew that queens must have been present but they could not remember exactly who they were.

Such forgetfulness is not confined to England. Until the 1980s, professional scholars did not consider queens worthy of serious study. The study of queens was something intelligent and often well-educated gentlewomen did, but they most often wrote biographies for female readers that were rarely, if ever, read by a university student – who was most likely male. Even the most well-educated people could name only a few queens – Isabel of Castile (r. 1451–1504), Elizabeth I (r. 1558–1603), Marie Antoinette (d. 1793), and Victoria (r. 1837–1901) – and they would not know that Henry IV had not just one but two wives. The first, Mary de Bohun, was the mother not only of his five, not four, sons (one died in infancy), but also two daughters. She died before Henry came to the throne and so was never queen, unlike Henry's second wife, Joan of Navarre. Neither Mary nor Joan were unknown to their contemporaries: Mary's family was one of the oldest and most distinguished noble families in England, descendants of the Welsh king, Llywelyn the Great; Joan was the daughter of King Charles II of Navarre, the dowager duchess of Brittany, and had blood relations among the royal families of Spain and France.

Mary de Bohun, Joan of Navarre and countless other queens and royal women were highly visible to their contemporaries.[2] Their lives were recounted in chronicles; the management of their estates and households recorded in fiscal documents; their letters collected in archives; and their religious and artistic patronage remembered in the books, buildings and works of art they sponsored and treasured. Yet, later scholars put kings at the center of the history of medieval Europe and ignored most queens, dismissing them as unimportant, forgetting their actions and obscuring their lives.[3] History was told by men about kings, their governance, their advisers and their exploits. Generations of schoolchildren learned history as a march through time, organized around the lives of kings. Entire periods of history were named for certain kings or dynasties: Carolingian, Capetian, Valois, Plantagenet, Georgian, Romanov, Edwardian, Ottonian, Tudor, Hohenstaufen. Like Austen's recounting of Henry IV's family history, genealogical charts at the back of older history textbooks describe families without women. For example, the classic work on Capetian France by R. W. Fawtier has a genealogy that lists generations of kings, and their brothers and cousins, from 987

until 1328.⁴ However, only two women are noted, Louis IX's mother, Blanche of Castile, and Philip IV's daughter, Isabelle. It would appear from this that most French kings were motherless, that they sprang up spontaneously from the loins of their fathers. This biological impossibility is depicted without wit or irony; it is evident in all the standard texts of medieval history written before the 1970s. Earlier generations of readers may not have noticed that women were absent because they did not expect to see women there. They were accustomed to thinking of monarchy as a man's world, to expecting the lineal descent of royal families to be traced from father to sons, with women included only when absolutely necessary, when they were simply too famous to ignore, or were considered moral lessons on what not to do. So, when medieval writers were not neglecting queens they told stories about queens – some relating actual fact, some repeating unfounded rumor: lustful queens, adulterous queens, queens who gave bad counsel, poisoned relatives and enemies, or instigated civil war.⁵ Historians, both medieval and modern, who neglect queens reflect anxieties that reveal the truth of the power of a queen.

Elizabeth I and Victoria have their names attached to an age because they inherited their realms, reigned in their own right and, for decades, they were directly involved in politics, warfare, economics, legislation, taxation and the Church. A few other queens also ruled inherited realms, notably Melisende of Jerusalem (1105–61), who ruled from 1131 to 1153; Berenguela of León-Castile (1180–1246), who relinquished her claim in favor of her son, Fernando III (r. 1217–52); Urraca of León (1079–1126), who dominated politics in two Iberian realms during her reign from 1109 to 1126; and Isabel of Castile.⁶ Only Isabel is well-known outside scholarly circles. It is a mistake, however, to consider these queens the exceptions that prove the rule. For most of the Middle Ages there was no rule, simply an ancient preference for rule by a man.⁷ But, in practice, laws pertaining to a queen's right to inherit and succeed varied widely and changed over time. But the right to rule did not always ensure that a woman did rule. King Henry I of England, after the death of his son and heir, secured the consent of the nobles for the throne to pass to his daughter Matilda (d. 1167), dowager-empress of Germany. After his death in 1125, she took up arms to defend her claim against that of her cousin, Stephen of Blois, until his death in 1154. These years, known as 'the Anarchy', tore England apart and ended when Stephen agreed to allow her to transmit her rights to England to her son, who ruled as Henry II (r. 1154–89). When women overcame patriarchal custom and tradition, or when circumstances propelled them towards the throne,

and they were able to exercise substantial political authority, it was most often because the need to perpetuate a dynasty superseded even the most entrenched attitudes and prejudices. Whether consciously or not, scholars tend to divide power into more or less legitimate forms, giving pride of place to public political, religious and military power. For example, Charles Odegaard's study of Engelberga, wife of Louis II, son of Lothar I and emperor of Italy from 855 to 875, rightly pays close attention to her skillful political actions.[8] But a queen who was not active in public action and did not leave a paper trail of official documents, who focused her attentions on her more private role as a king's wife or daughter or mother, fared worse in modern historical study. They were deemed unimportant to monarchy, meddlers in governance and politics, or dabblers in the patronage of art and literature. Their voices were suppressed unless they spoke the language of charters and public pronouncements.

This is why, from at least the late nineteenth century, most of what was known about queens in the Middle Ages came from biographies of famous heroic queens written by gentlewomen for gentle readers. Because women were not seen as suitable subjects for serious historical study, queens were portrayed as sentimental, passionate and often ill-fated Great Women married to Great Men, or doing unexpected things. By paying attention to individuals, these works followed kingship studies but, instead of focusing on law, governance and war, the books on queens were romantic representations that emphasized the emotional life of a queen. This trend continued into the twentieth century. Eleanor Hibbert (writing under the pseudonyms Jean Plaidy, Victoria Holt and Philippa Carr) entertained readers in the mid-twentieth century just as Alison Weir and Philippa Gregory, who publish enormously popular biographies of medieval queens, do today. Even books by the most serious-minded authors, like Mildred Boyd's *Rulers in Petticoats* and Joseph Henry Dahmus's *Seven Medieval Queens*, read more like romance novels than history.[9] To their credit, very often these works were grounded in sound archival research and they remain useful sources for the edited material included as appendices or photographs of texts, images, buildings, or artifacts that have since been destroyed or lost, such as Hannah Lawrance's *Historical Memoirs of the Queens of England, from the Commencement of the Twelfth Century* and Francisco da Fonseca Benevides's study of the queens of Portugal, *Rainhas de Portugal; estudos historicos com muitos documentos*.[10] A notable exception is Antonia Fraser, whose erudite biographies, such as *Mary Queen of Scots*, *The Warrior Queens* and *The Six Wives of Henry VIII*, appeal to a wide audience.[11]

Introduction: Not Partial, Prejudiced or Ignorant 5

Recent scholarly work on queens differs from earlier work in terms of sources, methods and theoretical frameworks and, since the 1960s, has owed a debt to research paradigms established by scholars of feminist and women's studies. Social history ushered in the study of families, which opened the door to the study of women of all ranks. A few scholars had taken up the subject of queens, notably Amy Kelly, Marion Facinger and Eleanor Searle, but queenship as a field of study gained prominence in the late 1980s and early 1990s.[12] Feminist thought challenged the premises of political history and galvanized a generation of graduate students. Two essays on gender, politics and power were particularly influential for the study of queens and queenship. In 1973, medieval historians Jo Ann McNamara and Suzanne Fonay Wemple traced the sources of medieval women's power in 'The Power of Women Through the Family in Medieval Europe, 500–1100', and Joan Wallach Scott proposed a vocabulary for female power in her 1986 essay 'Gender: A Useful Category of Historical Analysis'.[13] These were followed by two groundbreaking essay collections – Mary Erler and Maryanne Kowaleski's *Women and Power in the Middle Ages* (1988) and Louise Olga Fradenburg's *Women and Sovereignty* (1991) – that articulated theoretical parameters for the study of women and power.[14] Three further works led to an explosion of studies on queens and queenship: Lois Hunneycutt's essay 'Medieval Queenship' (1989) and two edited collections of essays devoted exclusively to queens – John Carmi Parsons's *Medieval Queenship* (1993) and Theresa M. Vann's *Queens, Regents, and Potentates* (1993).[15] Interest in the field has continued unabated as scholarly organizations such as the Society for Medieval Feminist Scholarship and the Society for the Study of Early Modern Women have sponsored numerous sessions at international conferences focused on queens and queenship.

Even as women's history, feminism and gender studies have changed society and scholarship in important ways, the demand for historical fiction on queens continues unabated, and books with catchy titles still sell in impressive numbers (for example, Eleanor Herman's *Sex with the Queen: 900 Years of Vile Kings, Virile Lovers, and Passionate Politics*).[16] So great is the demand for books on queens, that even authors with academic credentials have published serious books for a popular audience that fill the shelves of mass-market bookstores, such as Jeannine Davis-Kimball and Mona Behan's *Warrior Women: An Archaeologist's Search for History's Hidden Heroines*, Marilyn Yalom's *Birth of the Chess Queen* and Lisa Hilton's *Queens Consort: England's Medieval Queens*.[17]

The hundreds of articles and books published since 1993 clearly show that far from being ancillary, queens were fundamental to the smooth running of a realm.[18] A queen was more than just a ruler or a mother, so much so that she needed an adjective to clarify precisely who she was and what she did. A queen who governed in her own right might be called 'female king', 'sole queen', or a 'female monarch' who exercised 'kingly power' or 'regal power', or an 'autonomous monarch'. She was a queen-consort when she married a king, a queen-mother when she bore his children, a queen-regent when she governed for or with her husband and possessed 'female sovereignty'. When her husband died, she was queen-dowager. To complicate matters, a queen could be some, or all, in sequence or simultaneously. Only a regnant queen or empress stood alone. All other queens stood beside a king. A queen-consort's proximity to the king was central to her identity and all that she did as queen. When she was physically where the king was, his acts and decisions could be approved, mediated, or contended by the queen – because custom and tradition accepted that the queen was a partner in governing the realm, no matter what form the partnership took. As a regent or lieutenant, she stood in his place while he was physically elsewhere. A queen was a nexus between a king and his subjects, a symbol of how royal dynasty can create social cohesion and form alliances. But, just as queens embodied the unity of realm or people, they also embodied the same forces – family, foreign birth – that might tear that unity apart.[19] It was a precarious spot, situated both inside and outside official power, that placed queens-consort in a perilous position during a crisis. They were easy scapegoats for disgruntled enemies, or for anyone more interested in self-protection than guarding the realm or the royal family. There is no more vivid sign of the power of proximity than when a king orders the exile or imprisonment of a queen.

Through their vital family connections, via marriage or inheritance, queens often had public governmental authority, short- or long-term, substantial or ancillary, official or unofficial. Governance may not have been their main occupation, but they were too prominent to never, or very rarely, be uninvolved in some way in public political action. Powerful women, no matter how they exercise or express their power, will only be fully understood within their wider political framework, and that framework will only be fully understood when women are taken into account. Their involvement may have taken the form of parentage of an heir, secular or ecclesiastical patronage, intercession in legal or fiscal matters, or diplomatic finesse in arranging marriages that

cemented allegiances. Together, the king and queen formed a continuous unity, and the public display of marital unison to their subjects was critical in shaping the official face of each partner. They were part of a dynamic and discursive public conversation on masculinity, femininity and the proper ordering and behavior of men and women; they followed social norms concerning masculinity and femininity, and were active in the creation of those norms.

The queen's sexual role was of central importance to the realm in an age when the marital debt of sexual relations was understood as a cultural imperative in a patriarchal society. Royal maternity was the matrix of future kings, and a pregnant queen was seen as the guarantor of the realm's survival and integrity, and so of peace and control.[20] The influential theologian, Alcuin of York, articulated this idea in 793 when he wrote that 'the king's virtue equals the welfare of the whole people, victory by the army, good weather, fertility, male offspring, and health'.[21] Pregnancy, according to John Carmi Parsons, was 'a powerful image of male versus female [...] that forcefully opposes the power to give life and the power to take it away – a conflict as epochal and eternally tragic as that of Cain and Abel. For late medieval English queens, the maternal duty was part of the coronation oath, as was intercession, which was explicitly linked to maternity.'[22] As wives, mothers and guardian of the heirs, the maternal duties of queens were both public and private. That motherhood combined a queen's practical role and political importance, has prompted scholars to think more deeply and carefully about modern constructs, such as public and private, not as discrete or delineated states or places, but as a continuum.

But motherhood was not without risks. In an age of high infant and early childhood mortality, a queen who bore too few children – specifically, too few sons – might be repudiated for a younger and, hopefully, more fertile replacement. Too many sons created tensions, as Eleanor of Aquitaine found with the ambitious and restless young Henry, Richard, Geoffrey and John. Pregnancy, in and of itself, was a powerful way for a queen to establish legitimacy. It could be faked, as Queen Violant de Bar of the Crown of Aragon did in the fourteenth-century. When her husband died, she declared herself to be pregnant to prevent rivals from claiming the throne and displacing her and her family.[23] Pregnancy could be used by chroniclers for dramatic effect, as when Froissart claimed that Philippa of Hainault (d. 1369) was extremely pregnant (when she could not have been) when she begged her husband, Edward III of England to spare the lives of the burghers of Calais.[24]

Given that the main purpose of a queen was to provide an heir, it says a great deal about queenship and maternity that one need consider the problem of childlessness. To be childless meant to fail at the one thing a queen was expected to do, a fate that befell more than a few queens. Royal childlessness almost, but not always, resulted in a crisis in the royal family euphemistically and ominously termed 'dynastic failure' that could have potentially catastrophic political and social consequences. A childless queen might be called 'diseased' or 'defective', out of favor with God as a result of sin. As long as a king had sexual relations with his wife, he was rarely blamed for a woman's failure to conceive. Only when he was spending too much time with men was he considered at fault, and then it was presumed homosexuality was to blame for his impotency. A royal couple's childlessness can be understood as both a medical condition and a political one, with wide-ranging social, cultural and religious implications. Scholars recently have begun to examine the political and personal implications of a childless queen, and their work is joined by that of historians of medicine who study fertility, infertility and impotency.

Even the childless queen-consort could retain her status and influence as a chaste model for the pious Christian queen. This contradiction of marriage and chastity is vexing to the modern mind, so accustomed to regarding sex as part and parcel of marriage and infertility as a condition reproductive medicine can solve. But a chaste queen, particularly in the early Middle Ages, did not seem any more unusual than the Virgin Mary, or the story of the elderly St. Elizabeth's pregnancy. Recalling saints worked as a way for a particularly pious woman to marry but remain true to her desire for chastity. Æthelthryth (d. 679), queen in Northumbria, consort of King Ecgfrith (645/6–685) and later abbess of Ely, remained a virgin despite two marriages. In some chaste royal marriages, both wife and husband were considered saintly – for example, Edith of Wessex (d. 1075) and the English King Edward the Confessor; and Cunigunde of Luxembourg (d. 1040) and the German Emperor Henry II. Edith explained her childlessness in the *Vita Ædwardi regis*, the life of Edward she commissioned to advance his canonization, stating that she chose childlessness and elevated chastity as a queenly virtue.[25]

Queens and kings who tried but failed to have children reacted to this in various ways. A king or queen could legally adopt an adult man, not necessarily a relative, as Giovanna II of Naples (d. 1435) did when she adopted King Alfonso V of the Crown of Aragon, who then succeeded her and incorporated the kingdom into the Crown, where it remained until the sixteenth century. Or the queen and king coped by simply

getting down to work. María of Castile (d. 1458), wife of Alfonso V of the Crown of Aragon, ruled alongside her husband as his queen-lieutenant in Spain for nearly three decades while he conquered and governed the kingdom of Naples. Alfonso had three illegitimate children, but María was sufficiently valuable to him that only very late in his reign did he consider a divorce, and then only at the urging of a mistress who wanted to be queen.²⁶

To understand the many facets of medieval queenship, it is important to have an inclusive definition of monarchical power that offers a definition of queenly monarchical power and considers familial, social, cultural, religious and political elements. The fact that, in a monarchy, male rule was always and everywhere privileged, and that women governed only at the discretion, permission and, ultimately, at the pleasure of a man (or group of men) does not exclude queens from discussions of rulership. Monarchy was never simply rule by one, a man, who stood alone at the center of the political sphere, and it is not a synonym for 'rule by a king'.²⁷ Queens were inextricably linked to kings by legal and political theory as well as shared familial and dynastic concerns, forming an integral part of the interlocking political, social, economic and legal institutional structure of each kingdom.²⁸ The charisma of royalty is a powerfully magnetic force, even today as kings and queens dwindle in numbers and seem anachronistic from the standpoint of modern politics.²⁹ But monarchs – both kings and queens – ruled societies throughout the world for most of recorded history. In 1900, only three countries in Europe – France, Switzerland and San Marino – had democratically elected heads of state. By the 1970s, most monarchies in Africa, Asia (except in Islamic states) and the Americas were abolished. Of the twelve hereditary monarchies that remain in Europe, three are ruled by queens: Margarethe II of Denmark, Beatrix of the Netherlands and Elizabeth II of the United Kingdom of Great Britain and Northern Ireland (the remaining nine monarchies are Andorra, Belgium, Liechtenstein, Luxembourg, Monaco, Norway, Spain, Sweden and the Vatican City). In many ways, not much has changed in terms of gender equality in the royal workplace. In 2011, the sixteen Commonwealth countries where the queen of England is head of state unanimously approved the abolition of male-preference primogeniture, meaning that a princess may now govern a realm that would once have been the inheritance of her younger brother. But modern queens, and kings, are constitutional monarchs, at the head of modern democratically elected governments. They are more ceremonial than political, with less political authority than their medieval counterparts.

Medieval monarchy, on the other hand, was the paramount institution of governance, centered on the family, and queens could rule in their own right or alongside a husband or father. A king is a man who governs; he could become a king by conquest or inheritance. A queen's identity was derived from her position in the family – daughter, wife, mother, widow. A relational status such as that, rooted in custom and tradition, was a relatively weak institutional platform unless it had some form of legal legitimization, such as a coronation oath. This makes it difficult at times to pinpoint precisely who a queen was and what she did or was supposed to do. Queens could be a key part of the administration of justice, but often did not hold an office to do so. An example is Fastrada (d. 794), wife of Charlemagne, who ordered the confiscation of property of a noble who killed a man at court in her presence while Charlemagne was away.

Many queens served as regents for sons and absent husbands. The prevalence of queens-regent represented the loyalty to a particular line of descent within a dynasty, functioned to hold realms together and represented a convergence of power and affiliation with nobles. There are many examples, but some of the best-known are Brunhild (d. c. 613), regent for her grandsons and a great-grandson; Theophanu (d. 991), regent for Emperor Otto III; and Adéle of Champagne (d. 1206), regent for her grandson, Louis VIII. Elvira (d. c. 986), aunt of King Ramiro III of León, took the title of queen-regent and presided over a judicial assembly when he was away. Matilda of Flanders (d. 1083), wife of William the Conqueror, assumed some control over royal justice, but did not have official authority to do so. Another Queen Matilda (d. 1152), wife of King Stephen, operated as his regent in twelfth-century England without a formal title. The regency of Blanche of Castile (d. 1252) for her son, Louis IX of France (r. 1226–70), spanned decades while he was on Crusade, but it was rarely formalized. Margaret I of Denmark (d. 1412) inherited Denmark from her father and was recognized as queen in 1375, but her Norwegian and Swedish subjects refused to accept her right to rule in her own right and simply referred to her as the 'Lady Queen' without specifying over which realm she ruled. The English were uneasy about a queen-regent. Margaret of Anjou (d. 1482), although never officially a regent for her mentally unstable husband Henry VI, exerted formidable power within the Lancastrian court that aroused vociferous opposition (her foreign birth compounded the problem). The best examples of queens with official portfolios are the seven Aragonese queens-lieutenant who, while their husbands were attending to business in far-flung Crown territories,

governed various realms of the Crown of Aragon with full official authority to do so. Widowed queens (queens-dowager) were stakeholders in the realm who conveyed a realm from one king to another, such as Brunhild and, later, Emma, wife of the Anglo-Saxon king Æthelred and subsequently his Danish successor, Cnut.

Informal influence could be just as powerful as official authority. Ingeborg (d. 589), wife of King Charibert, tried to rid her household of her husband's two low-status concubines only to find herself exiled from court. Judith of Bavaria (d. 843), wife of Louis the Pious, was an influential figure at the palace; Ingeborg of Denmark (d. 1236), second wife of King Philip II 'Augustus' of France, mobilized ecclesiastical officials in a failed campaign to challenge Philip's attempts to repudiate her. Some wielded considerable influence with popes, such as Bertha of Kent (d. c. 612); Theodelinda, queen of the Lombards (d. 628); and Louise of Savoy (d. 1531). Others, notably Anne of Bohemia (d. 1394), wife of Richard II of England, were influential with city officials. From the standpoint of a queen's subjects, perhaps the most appreciated form of queenly work was her intercession on behalf of her subjects. Empress Judith, on the battlefield of Fontenoy in 843, begged for the life of the treacherous archbishop of Ravenna. Philippa of Hainault successfully begged her husband King Edward III of England for the lives of the burgers of Calais. Violante (d. 1301), wife of King Alfonso X of Castile, personally pleaded for tax concessions to towns in Extremadura at the Cortes in Seville in 1264.

Intercession was a key element of queenship and accounts of a queen's intercession dominate many of the sources on queenship. Intercession was not simply informal influence that checked the king's exercise of power. It could be pre-emptive, as when the queen sought redress because she was unable to institute redress on her own; or it could take place after the fact, when a queen aimed to change the king's resolve. Whether pre-emptive pleading or a post facto change of course, intercession was an official influence in that it was accepted as part of queenship as office. Queens relied on spiritual models of intercessions, such as the practical wisdom and worldly authority of the abject Virgin Mary and the sage Esther. John Carmi Parsons and Paul Strohm argue that intercession was expected of a queen, evident in the sources as petitions she would receive from her subjects to act on their behalf and praise she received when she mediated or intervened. Intercession functioned in three ways: first, by supplying the intercessory function lacking in a male-dominated institution of monarchy; second, by permitting royal reconsideration; and, third, by affirming

the masculinity of monarchy. Queenly intercession was part of the masculine–feminine division of labor that often reinforced cultural stereotypes of women as fickle and men as obtrusive, paternal, proud and legalistic. Less threatening than displays of outright political control, intercession was seen as feminine pleading that made it permissible for a king to change his mind. It was socially constructed femininity but, even as it celebrated the triumphant king, it also served as a critique of male behavior. Ultimately, it is not about women, but about men.[30]

Intercession was part of the performance of queenship that could be staged for effect, or reported in such a way as to highlight either femininity or masculinity. Fiona Downie, writing about queens of Scotland, argues that the queen's pleading was part of a familiar ritual staged to achieve a predetermined objective. It served to clarify the relationship between the king and his subjects, to portray the king as merciful and omnipotent, and to remind both participants and onlookers that the king's subjects – his queen, bishops, earls and barons – could advise, but that he alone could judge. Staged public acts of intercession conveyed to everyone, whether present at the act or reading about it later, that the queen possessed and could use her influence over her husband. The queen was publicly represented as a political figure with a valid and important role in government; her intercession was proof of royal partnership, albeit unequal, rather than a demonstration of kingly authority and queenly subordination.[31] But intercession could be a very effective form of queenly power. In England, for example, a queen could use the fees generated from the formal request for her intercession to fund poor relief, hospitals and other charitable acts that worked to strengthen the queen's public expression of power.

No matter what a queen did, no matter how much power she had or did not have, she was essential to the functioning of medieval government. Her actions, whether private or public, echoed beyond the confines of a palace and influenced law and custom, which affected all women, regardless of rank or marital status. Just as monarchy is not simply rule by one person, it is not merely a political structure. The private royal sphere is a public creation. Monarchy is relational, dependent entirely on one's position in a family: a king, his queen and their extended royal family members as support staff. Thinking of it in this way leads me to conclude that 'rulership' is a better word than 'monarchy', because it shakes loose powerful associations with sole male rule and allows space for queenship.

The geographic contours of European queenship

This book examines queenship in medieval Europe, encompassing realms from Scandinavia to the Mediterranean, and from the British Isles to Russia. The Byzantine Empire, where there were no queens, is included because empresses were the heiresses of the rich Roman political tradition that permitted imperial women considerable latitude in the public sphere, much of which was lost to many of the western realms until later in the Middle Ages. These empresses are, in many ways, the precursors of medieval queens and, although quite different in key ways, they were models of queenship that inspired their western counterparts.³² Also included are empresses whose husbands governed the Holy Roman Empire and considered themselves the heirs of Rome in the west. Their influence on medieval queens varied, with the Byzantine empresses able to have greater public political authority than their western counterparts but, in both cases, their experiences are strikingly different compared to those of queens, and they show the range of options for women at the pinnacle of the social hierarchy.

Geography is a useful framework for thinking about queens because most modern studies focus on individual queens from particular regions, with some comparative work noting the similarities within realms. The British Isles (especially England, but also Scotland, Ireland and Wales), France, the German kingdom, the Holy Roman Empire and Spain (Castile, the Crown of Aragon, Navarre, Portugal) predominate, but newer work on queens from, or ruling over, eastern Europe (Scandinavia, Russia, the Balkans, Bohemia and Hungary) has expanded the range and poses fresh challenges to long-held notions of queenship. But geography does not always accurately describe a queen as it does a king, who was defined by the subjects he ruled (Alfred the Great was king of the English) or his realms (Edward II was king of England who inherited a realm from his father). Kings were rooted in a place, their language and cultural traditions were those of their ancestors, their royal revenues stemming from the agriculture and commerce of the lands they inherited. Medieval kings were peripatetic; they moved around to govern far-flung regions of their realm or to conquer another piece of land, but their title was stable. In short, they were synonymous with their realms. Queens, on the other hand, except for a small minority of exceptions, did not inherit a realm from their father. Instead, they moved from the realm of their birth to marry and live with a king. This move might be just a short distance, involving little more than a day's journey – for example, from Kent to Westminster. Or the distance could be considerably greater, like the trip

that Anna Agnesa Yaroslavna, the Grand Duchess of Kiev, made when she moved to Paris to marry Henri I, king of France in 1051. She was queen of the French, but not a French queen. Unlike her husband, a foreign queen's personal and familial identity was a fusion of two cultures: she left her family, embraced a new one, adapted to a new culture and learned what was expected of her. So, to call Edward I of England's wife an English queen is both correct and incorrect. Her name at birth was Leonor and she grew up speaking Spanish. She had a French mother and an English grandmother, and lived her entire adult life as a queen of England. Foreign-born queens forged important links across the wide and diverse geography of Europe through the retinue of noblemen and women (scholars, clerics, writers, artists, architects, musicians), and books, music, fashion and food they brought with then. Eleanor, in her letters to her family in Castile, asked that ships coming to England bring her oranges – a touch of the Mediterranean to comfort her in the cool rainy winters of her new home. Foreign-born queens faced the sort of challenges a newcomer often does – new language, new customs, hostility from local nobles suspicious of outsiders. However, in ways both large and small, a queen was a powerful force for political, economic, intellectual, religious and cultural dispersion.

Still, no matter where she was born or where she lived, a queen's life and her actions were rooted in commonly held socially and culturally constructed attitudes toward masculinity, femininity and monarchical power that a royal bride had to learn. A queen was expected to conform to the political culture of her husband's realm, but her role as wife, mother and tutor of her children changed little across time and differed only slightly from realm to realm. In the first centuries after the fall of Rome, when kings began to create stable realms, marriage was not formalized and the status of the queen was unstable. A few centuries later, under the influence of Christian teaching and legislation, marriage was formalized and the queen, as the king's wife, legitimized the dynasty. Maternity was linked to dynasty and queens were essential for the legitimate continuity of the royal family. A canny queen regnant like Isabel of Castile found that prolific maternity could calm anxious noblemen and bishops who feared domination by a sovereign queen.

With or without children, queens were a key element in a dynamic relationship that involved the entire royal family and that provided queens with several avenues for political power. Because a queen was regarded as a trusted confidant of the king, she could be an unofficial adviser (as queen-consort, queen-dowager); she could stand in for an ill, absent, or minor king (as queen-regent or queen-lieutenant). If she were

too assertive, or her husband too weak and insufficiently masculine, anxieties about an upset to the social and political order were often expressed as fear of a powerful queen. Queens were intimately linked to their husband and his realms so that, although they were the less dominant partner in the monarchical relationship, subtle shifts in political theory and practice, culture, religion, gender norms, marriage and family and education and literacy that affected kings naturally affected queens.

The temporal boundaries of medieval queenship

Geography is not the only determinant of queenship in the Middle Ages. The central thesis of this book is that a distinct and coherent medieval form of European queenship, based on Christian notions of monarchy, began to take shape around 300 CE. By 1500, the religious and political framework for the institution of medieval European queenship had emerged as a coherent phenomenon from Byzantium to Scandinavia. This long sweep of time and wide geographical scope does not mean that queenship was fixed and unchanging. It is more accurate to think of queenship between 300 and 1500 as an institution that was relatively stable across time and space in its central core of family, dynasty and patriarchal rule, but transformed by events and processes that affect regional political culture and account for variations. Medieval queenship bears a faint resemblance to Roman notions of empire, but it is Christianity that makes it distinct. It was forged in the period roughly bounded by 313 CE, when Christianity was first tolerated, and 476, when the city of Rome fell to invaders. During this period, Christianity became the official religion of the Roman Empire and its successor in the east, the Byzantine Empire. Much of what happens in the Middle Ages stems from these earlier models and practices, with medieval queens often comparing themselves with Byzantine empresses.

The organization of this book follows a conventional timeline based on political events, so that it may read at times like an old-style political history with queens instead of kings. Just as all professors who design syllabi for history courses wrestle with questions of explaining when something began and ended, they also must come to terms with how to organize the material. For some, using political events seems like a reversion to a 'master narrative'. But queens were part and parcel of the institution of monarchy, which was fundamentally charged with governance, and therefore political events are an essential part of the progression of a queen's life, and those of the queens who preceded and

succeeded her. What touched the king, touched the queen. The focus for each queen, however, depends on how she led her life, what mattered to her, and how she adjusted to the circumstances of her life and the demands of the moment. It is, therefore, a hybrid organization with a familiar timeline punctuated by themes and variations.

The book therefore follows two intersecting axes – one across time, the other across space – as it traces the development of queenship from the Christian conversion of Europe as it spread northwards and westwards. As the Roman Empire broke into regional kingdoms, queenship retains certain key elements but responds to local needs. The book ends at 1500, with the development of Renaissance and Reformation monarchies, which had distinctly different notions of the role of monarchy, the king and the queen. The considerable changes in attitudes towards women, which translated into political theory and law during this millennium, affected all women regardless of status or place of residence. Because monarchy is, at its core, constructed around the family, the most important element of this change over time is the tremendous impact of Christianity on law, particularly changes that pertained to marriage, sexuality and family life. As once-common practices such as polygamy, concubinage and divorce were outlawed, starting with the eleventh-century church reforms, the queen took on even greater importance as wife and mother, as a more bureaucratic, university-trained staff of officials serving the royal court took over her role in the public politics of governance.

Queens were involved in more than politics but, because monarchy was first and foremost a political institution, the discussion of what queenship was and how it functioned in terms of family, culture, art, religion, society and the economy must necessarily follow from an outline of political events. Social attitudes toward female rulership, and ideas on who is fit to rule and who is the preferred ruler, took shape in the ancient patriarchal, monotheistic societies of the Mediterranean. These ideas on queens and their role in society were strongly influenced by ancient ancestors, Jewish queens from the Old Testament (such as Esther and Deborah), practices of Greek and Roman kings and emperors, and the myths of Amazon queens. It is a story of trade-offs, of the fragile power exercised by early medieval queens ceding to an increasing emphasis on dynasty and legitimacy that made the queen a more secure part of monarchy, but also circumscribed her actions by creating acceptable spheres of influence, such as the regency or lieutenancy.

This book traces roughly four distinct moments and pinpoints key points of change in the history of medieval queenship. Chapter 1 takes

up the first period, approximately between 300 and 700, when both kingship and queenship were poorly defined. Newly-Christian Visigothic, Ostrogothic, Lombard, Anglo-Saxon and Merovingian kings – the descendants of Germanic, Celtic, Welsh, Pictish, British, Gothic, Scandinavian and Icelandic chieftains and warlords – survived the collapse of Roman power. They established settled realms with wives and concubines who differed greatly from queens as we know them; they may not have even been described as queens. Polygamy and concubinage were accepted practices, making the status of a king's wife informal, her role in court ambiguous and her status dependent on whether one of her sons was designated as heir. The importance of battlefield prowess made governance a masculine domain but, in this rough-and-ready milieu, the longevity of warrior kings and chieftains depended on the participation of the whole family. Queens were vital to the success of a king as his wife and as the mother of his children, but they also possessed personal, material and symbolic resources that were vital to the realm. The treasury was held and managed by the queen, her family connections provided vital allegiances and she governed in her husband's absence. As the realms expanded, many wives of kings ruled alongside their fathers, husbands and brothers as *consors regni* (royal consort, or partner of the king). But the instability of transmission of the realm led to civil wars, scheming sons – both legitimate and illegitimate – and wars between kings, which put the realm at risk. Early medieval saintly queens, recognized by contemporaries for their *fama sanctitatis* (saintly reputation), were key to the Christian conversion of their pagan husbands. Queenliness and saintliness do not necessarily go together. Rather than considering sainthood as an attribute of queenship or queenship integral to sainthood, it may simply be that, as Jane Tibbets Schuleberg and Iona McCleery point out, queens were just more likely to become saints than other women because of their prominence and the presence of hagiographers in royal convents.[33] They worked closely with popes, bishops, monks and abbots who, in return for protection, bestowed their religious authority on the king and provided him with essential services, such as advisers, hagiographers and scribes in the royal chancery. With nuns and abbesses, queens established the Christian foundations of medieval society through the monasteries and convents, churches and schools they endowed.

Chapter 2 picks up the thread at around 700 and continues until approximately 1100. During these centuries, the king, who in many cases had been little more than a *primus inter pares* (first among others) became the pre-eminent lord of a region who put real substance into the

title of king. This period of territorial expansion, together with Scandinavian and Magyar invasions, created unsettled conditions that upset the fragile political organization of the preceding centuries. Kings gradually solidified their power in the face of powerful noble family alliances that fragmented political power to the advantage of anyone seeking power, and queens gained importance. Canon lawyers clarified unclear lines of descent by drafting laws that regulated sexual behavior, discouraged concubinage, obliged kings to marry, and outlawed polygamy. A queen was recognized as distinct from simply a wife or concubine, and she legitimized a king's right to rule by bearing the sons that preserved dynastic rights. This legislation stabilized the position of the queen in monarchy, as did rites of kingship (such as the coronation of both king and queen); however, it also led to an increasing emphasis of the queen as the mother of a legitimate male heir.[34] Even though queens rarely mustered or led an army and were excluded from knighthood, they were not excluded from the inner circle of power, because the threat of warfare necessitated delegated rule by a family member who was often just as likely to be the queen. In most realms, women could inherit land and administer their estates, which they brought as dowry to their marriage. This gave them political and economic power, apart from that over the royal treasury; this had been detached from the household accounts and established as a separate department in royal administration. The dower, whether bestowed as lands or cash, signified the queen as the true wife and guaranteed her status as a widow. But dower wealth was not necessarily secure, and stepdaughters and widowed queens had to fight to keep their dower. Theophanu, the Byzantine bride of Emperor Otto II, was granted a dower of extensive estates in Italy and Germany together with three rich convents, but she had to protect her dower from the hands of her mother-in-law, the dowager Empress Adelaide. Charles the Bald used his marriage in 842 as a chance to seize his mother's wealth and did not give it all to his wife, Ermentrude.

Chapter 3 examines how the increasing influence of the Church in secular politics between 1100 and 1350 concerning marriage and legitimacy continued to limit a queen's role in politics. Popes, especially Innocent III and his legislation at the Fourth Lateran Council (1215), exerted considerable force to legitimize royal claims by providing a legal framework for family structure that had a profound effect on the rest of society. Changes in inheritance and marriage laws cut two ways. On the one hand, prohibition of concubinage and divorce created monogamous, heterosexual and binding marriage that exalted the inviolable and

permanent status of the wife and empowered queens. New inheritance laws stabilized the transmission of the realm to children and protected vulnerable children from predatory lords. Legitimate sons inherited the family's territorial holding – preserving intact both land and lordship, which later became indivisible – and primogeniture attained the force of law by custom. Conversely, the association of primogeniture with the son, not simply the eldest child, limited women as heirs in their own right and had lasting effects on queenship. Illegitimate children were dispossessed, which had profound economic and social effects on both the children and their unwed mothers.

Rising literacy, university education, and increasingly bureaucratic, professional and meritocratic royal offices (such as the chancery and treasury) excluded women from official public political office and limited them to a more domestic, familial, maternal role in court. Dynastic monarchy was visualized in art, heraldry and literature. The coronation of a queen emphasized the legitimacy of the marriage and the heir, and the association of primogeniture with the eldest son, not just the eldest child, solidified a queen's importance to monarchy, but a more domestic position limited the range of a queen's public role. The heavenly realm became a metaphor for earthly kingship, which took on a sacerdotal quality that privileged the priestly aspects of kingship. The sainted, saintly, virginal, or chaste queen made way for queenship as a secular office. In some realms the coronation of a queen was infrequent, as in the Crown of Aragon, where it was used to bolster a weak king or legitimize a queen whose social origins or prior sexual affair with the king called for an official stamp of approval; in others, it was entirely non-existent, as in Portugal. Sacral kingship is most evident in the reigns of the two sainted kings of the thirteenth century, Louis IX of France and Fernando III of Castile. Elizabeth of Hungary (d. 1231) and Isabel of Portugal (d. 1336) were part of a long tradition that was to be revived briefly in the fifteenth century during the reign of one of the most successful practitioners of queenship propaganda, Isabel of Castile.

The later Middle Ages, discussed in Chapter 4, covers the period from 1350 to 1500, when the familial and patriarchal foundations of monarchy, particularly a queen's right to rule or transmit the right to rule, were challenged by a series of crises that reveal deep-seated anxieties over the possibility of female inheritance and rule. Illness, either physical or mental, debilitated kings and left the realm vulnerable to outside interference or internal strife. In all cases, queens were called on to govern but the results varied from place to place. Kings were often absent, sometimes for extended periods, as they conquered and governed distant

realms. After several generations of healthy male heirs, almost every region of Europe faced a dynastic war or civil conflict in the fourteenth century when a king and queen fail to produce a male heir to continue the dynasty. It was an age of foreign queens who spread culture and ideas on monarchy across Europe, and their family ties complicated questions of inheritance and governance. The most dramatic and well-known dynastic failure occurred in France in 1328, when the sons of Philip IV (r. 1285–1314) of France died without male heirs. Extramarital affairs of the French queens complicated matters, leading to the exclusion from the succession of a princess of questionable parentage. Amendments to the early medieval Salic Law, fabricated by late fourteenth-century Valois court lawyers, formalized male privilege by denying queens the right to rule or transmit rights to rule. King Edward III of England challenged this ruling and claimed the French kingdom through his mother, Isabelle, Philip IV's daughter, setting in motion the Hundred Years' War. Similar dynastic crises that plagued long-standing dynasties in Castile (in 1369) and the Crown of Aragon (in 1410) were resolved in favor of male rule. But some realms were open to the queen-regnant, leading to the reign of Maria, Queen of Hungary and Poland (r. 1382–95), eldest surviving daughter of Louis I, of Anjou, and Jadwiga, Queen of Poland (r. 1384–99), younger sister of Maria. In the Mediterranean, Giovanna I (r. 1343–81) and Giovanna II (r. 1414–35) governed Naples. The Scandinavian realms were unified under a single monarch, Queen Margaret I of Denmark (1353–1412: Queen of Denmark, r. 1387–1412; Queen of Norway, r. 1387–1412; Queen of Sweden, r. 1389–1412).

Chapter 5 is both an end and a beginning. Medieval kings were served by university-trained men who were unaccustomed to serving a queen; they exercised official authority and tended to regard her public power and authority with suspicion. Despite this, from 1469 four great queens proved their capability: Isabel of Castile, Mary Tudor, Elizabeth Tudor and Mary Stuart. All four suffered vocal and often virulent opposition to their rule. Their lives are outside the scope of this book, but the hostile rhetoric opposing female rulership can only be understood by a careful study of the development of queenship in the Middle Ages.

Sources and methods

The inattentiveness to queens that Jane Austen noted was not due to a lack of original sources. Medieval queens seem to be everywhere you

look, appearing in illuminated manuscripts and medieval literature. They process through cities and the countryside, and have elaborate coronation ceremonies. Noble women bestow hospitality on the king and queen who demand room and board on their processions throughout the countryside. As patrons of artists, they commission chapels, church sculpture and books of hours. As queens, they wear crowns and sumptuous clothing, and never travel alone. In their dotage, they enter the convents they endowed when they were younger. Some are publicly visible as regents and guardians of their young sons. They sign documents and leave behind a mountain of parchment and paper. It is paradoxical but, until recently, queens have been surprisingly easy to miss. Some of the earliest historical writing consisted of king's lists, chronicles and deeds of the king as a way to commemorate lineage and dynasty while marking events and time. Queens were overlooked by historians who found women in narrative sources, but did not find what they did terribly interesting. Their focus was on the lives and deeds of kings and their advisors, and they were looking for the origins of democratic government, western legal procedure, or feudal landholding, and so they passed over women's activities.

But they are there, and they are not insignificant, as Suzanne Fonay Wemple demonstrated in *Women in Frankish Society: Marriage and the Cloister, 500–900*.[35] Wemple carefully combed secular and ecclesiastical legal sources, saints' lives, literary sources, treatises and charters in massive compilations such as the *Monumenta Germaniae Historica*, the *Acta Sanctorum*, the *Patrilogia latina* and the *Patrilogia graeca*; ample evidence was found for the lives of queens and empresses. Also, Wemple found it interesting. The accompanying genealogical charts of the wives, concubines and children of the Merovingian kings and Carolingian emperors reminded scholars of the many women they were missing by simply reading for men; they are models for what a complete genealogy should look like.

Inspired scholars scoured archives; they uncovered abundant available primary source material such as non-narrative textual sources, charters, letters, official records and financial records. This material – some of which is now available in print, or on the internet – demands highly specialized skills in paleography and linguistics. With a somewhat different purpose than Jane Austen's when she referred 'the Reader to Shakespeare's Plays, & the Prince', feminist literary scholars re-read familiar folklore, poetry and epics – texts such as Malory's *Le Morte d'Arthur*, the *Nibelungenlied* and the chivalric romances of Chrétien de Troyes.[36] Doing so, they revealed important insights into queens in the

cultural imagination.[37] They studied political theory about kings and drew inferences about queens by reading between the lines. Theologians scoured Biblical texts and saints' lives for evidence of a queen's role in conversion, education and religious devotion. Legal scholars analyzed legal and political treatises, letters and coronation oaths, and found a considerable body of literature concerning queens and, by extension, a woman's place in court, plaza and marketplace. They introduced scholars and students to allegories of women, real and imagined, and power in Christine de Pizan's *Book of the City of Ladies* and Boccaccio's mythical and historical women in *On Famous Women* (*De mulieribus claris*).[38] Scholars of gender and sexuality challenge the heteronormative presumptions of medieval society, and have prompted a serious examination of the masculine and feminine aspects of monarchy.

But modern readers reading works about queens written by men – chronicles, poems, treatises, plays – and viewing visual depictions of queens must cast a skeptical eye on texts to discern actual actions from rumor or innuendo. The Latin word *fama* is richly evocative and can mean 'rumor' and 'tradition', but also the more impartial-sounding 'report'. *Fama* is more familiar in modern English as simply 'fame' or 'renown', and has lost some of the connotations to a fabrication meant to defame. To understand its use and power in medieval literature, it is good to recall that *fama* was personified by Greek and Roman writers as female, as a force that disrupts a settled order, diverts action onto a new track, distorts, as the active effect of rumor on what men do, and not just the events themselves, but also the record of those events.[39]

Ovid called rumor 'the mutterings of a low voice, like the noise that comes from the waves of the sea, if you listen at a distance, or like the sound produced by the rolls of thunder when Jupiter has made the black clouds rattle' (*Metamorphosis* 12: 49–52). For modern readers of medieval texts, it pays to be mindful of the fact that many of the authors writing about queens were listening 'at a distance'. When accusing a queen of adultery, a distressingly common storyline in medieval literature, most writers were rarely, if ever, close enough to know with certainty with whom the queen was having dinner, much less taking to bed. Some authors were close enough to the queen to know the details, but it is incumbent on the modern reader to separate that writer from one whose intention was to make 'black clouds rattle', to make kings distrustful of a queen as powerful as the Carthagian Queen Dido by planting the seeds of rumor. Virgil knew exactly how rumor worked when, in his description of the defamation of Dido and Aeneas in Book 3 of the *Aeneid*, he described Fama's flight over Carthage as slippery and

dangerous, as it moves easily and swiftly over the vertical and horizontal axes of time and space.[40] As a queen, Dido's sexuality was feared. Like her, all queens face rumor for their desirability, which could be seen to threaten the king's ability to think rationally. The rumor of sexual infidelity established a link between a queen's influence and bad government. It was unacceptable for anyone to exercise undue influence over the king, but a queen's influence was different from that of other royal advisors and was treated in a gender-specific manner. A king was expected to rule his kingdom as a husband ruled his wife and, if a queen exerted what was perceived as undue influence over the king, this was a double challenge to natural order. By allowing the queen to influence his government, the king was not only less of a king, but also less of a man. Infidelity was regarded as a form of treason against the king that could have fatal consequences. Rumor is a powerful rhetorical device, existing both inside and outside a text, simultaneously bound by time and free from it. Rumor is at home in all recorded ages of history and it may not be part of a queen's story until long after the fact, making it important to pay attention not only to the author's intentions, but when he lived. A powerful queen may well have been perfectly acceptable to her contemporaries, but later generations feared such power and tried to limit it with rumor.

Scholars do not need to depend entirely on sources written by men to know what queens were doing. Women make expressive marks even when these marks are not written personally or are not written at all. Some of the best sources about queens are material objects, rather than writings about them by others, either men (such as chronicles), or other women (hagiography). These material sources are from the queens themselves, something they found meaningful, worth saving, something they treasured and bequeathed to a family member, a friend, a member of the household. Art historians use visual material – marginal miniatures in a book of hours, cathedral architecture, tomb effigies and manuscript illumination – to discuss a queen's patronage of works of art. Queens were charged with dynastic memory, and commemorated their families in convents, monasteries and chapels on pilgrimage roads. They used gifts and gift-giving as an expression of both piety and power, and these gift exchanges are recorded in chronicles and preserved in museums, libraries, churches and noble family houses. Archaeologists analyze artifacts from houses, tombs, palace complexes and the like to reveal not only how a queen lived, but also how she wanted to be remembered. Household accounts and inventories of possessions at a queen's death provide vivid and often moving details of a life lived among loved ones,

with tapestries, bed sheets, fur cloaks, glassware, books, yards of fabric, hair ornaments, jewelry, and, yes, crowns all duly noted and earmarked for a friend or family member. A bit of silk tunic, an embroidered silk pillow, a signature on a letter, a prayer book, a crystal vase, an enameled reliquary and a ring all speak eloquently about what it meant to be a queen, what concerned a woman and what mattered to her.

Having found queens, scholars began to raise issues that touch on *a priori* assumptions about women who live a private life in a public setting and do royal work: whether and how what affects women on the top rung of the social ladder affects women of lower rank; what agency meant to medieval women and how it was related to privilege, power and influence; the limits of oppression and resistance; the specific meanings of 'patriarch'; distinctions between public and private; and the exceptionality of queens.

Theoretical frameworks

The overlap of the many roles of a medieval queen – wife, mother, regent, dowager, ruler in her own right – over the course of her life means that one theory does not fit all. The same is true for kings, of course, but that is how monarchy has been studied. Modern kingship scholars left unexamined widely accepted notions on gender – from Aristotle's gendered ethics, Plato's gendered *polis* and Thomas Aquinas's gendered soul to Machiavelli, John Locke and Thomas Hobbes – that obscured the reality of monarchy and prejudiced an understanding of all queens, not only queens-regnant. These works separated the dynamic relationship of the king and queen, and left intact rigid oppositional categories such as public/private, domestic/political and the king governs/the queen does not. These categories imply a separation of different aspects of power in medieval monarchy that simply did not exist. Some of the most important work on queenship has been to dismantle these artificial dichotomies and break apart the tight linkage of kingship and monarchy; in so doing, gender has been emphasized as a key component of sovereignty. Queenship scholars have uncovered the prejudice of kingship – that kings are rulers, not fathers or husbands, and are somehow genderless by being masculine. Thinking of monarchy as composite of gendered people has opened up new avenues for research on kings; notably, studies by Mark Ormrod and Amy Remensnyder that shift the focus from the political aspects of a king's life to examine masculine and feminine elements in kingship.[41]

Analyzing monarchy as both kingship and queenship reveals a complex institution embedded in a patriarchal political environment that privileged rule by a king, but that could both limit a woman's range of options and propel her forwards in both the personal and the political spheres. Feminist theory has been pivotal in our understanding of how patriarchies shaped queenship. Individual queens drew from a pool of influences available and used them to fashion an autonomous institutional identity – wife, mother, regent, ruler in her own right, dowager – that was filled with contradictions, always contested and precarious, and continually put at risk by the dynamic range of practices that made it subject to transformation. To paraphrase Simone de Beauvoir, a queen was not born, she became one by living as a queen, changing the category as she incorporated and inspired it.[42] Queenship is discursive, an ongoing project, a daily act of reconstruction and interpretation, in a milieu of multiple and overlapping cultures, in which personality and temperament could influence a queen's ultimate expression of her own unique practice of queenship.

The family is the one area where queens held undisputed power and authority, and many scholars have taken up the ideas in McNamara and Wemple's essay to study the queen's power through the family, marriage and motherhood. These works reveal that the fundamental truth about monarchy, that it is an institution devised for governing organized around a family, was obscured by scholars who focused entirely on the king. The reason women could rule at all was because monarchy is, in fact, governance by a single family. Monarchy is an institution for rulership by a powerful kin group organized as a dynasty, a complex blend of the domestic and the political, though not necessarily in equal parts. The royal family was the framework for the transmission and exercise of lordship, as well as the model for attitudes, structures and behaviors towards women in general and queens in particular. It furnished principles of order, and simultaneously adapted and molded those attitudes, structures and behaviors into the institutions of medieval government. One could argue that influence exercised through the family is indirect power, and therefore not true royal authority. But when the family in question was among the most powerful in Europe, this was indeed real political power. A queen's proximity to the king himself, her role as mother and legal guardian of the heir and the myth of kingship distinguished her not only from other family members but also, importantly, from other (non-royal) women. The royal family and its wide social networks served as a form of institutional glue, holding monarchy together. Queens supported kings through an array of services that were

valuable to the institution of monarchy: political, dynastic, economic (bringing land and cash through dowry or inheritance) and cultural (taking responsibility for the dynastic memory). The benefits from these services flowed directly from queens to kings, while the wealth, power and status attached primarily to the king and not the queen.

Studying royal families reveals that kingship was not the rational ordering of the divinely ordained principles of dynastic succession. It was hardly neat and tidy. Rather, it was more likely to be messy, with one contested succession crisis after another. Primogeniture, not a fully-formed juridical theory until after the twelfth century, only worked when nature cooperated with an ample provision of healthy sons who survived to adulthood. The 'ordinary' pattern of inheritance – first-born sons succeeding fathers, generation after generation, in an orderly manner – was, in fact, 'extraordinary' in most Christian kingdoms, and these extraordinary conditions were considered the norm.

A queen's lofty rank and the likelihood that she would work in the public political arena in some way led naturally to the study of women and power. These works start from a definition of authority as 'constituted power', meaning simply any capacity to secure obedience in, or conformity to, a hierarchical chain of command and derived from a title to do so. Her dominion and sovereignty over people and property, no matter how extensive or limited, was legally conferred through dynastic descent, inheritance of lands and title to lordship. A queen may have had substantial real power as a result of personal attributes – intelligence, force of personality, will, charisma, or through family connections and personal wealth; however, without the authority of political status she may have been unable to exercise it. She was, in short, privileged but oppressed. Many queens, especially medieval queens-regent or queens-lieutenant, although not queens in their own right, governed forcefully, always with some form of duly sanctioned public authority.

There are, however, pitfalls to avoid when interpreting queens through political theory. First, individual agency tends to emphasize the lives and deeds of the great man and, by association, the great queen. This privileges the direct public exercise of authority seen through statutes, laws, charters, and the private exercise of influence and power (patronage, clientage, influence) and public authority; however, it diminishes the importance of larger social and cultural factors that make such deeds possible. Second, the literature on rulership, no matter how slanted in favor of male rule, was never entirely univocal. Misogynist and patriarchal ideologies were dominant, but many pre-modern writers differed on women who possessed political power and authority.

Controversies that arose over the political agency of queens, real or imagined, stirred up considerable male anxiety and left behind an important body of commentary on the political agency of queens, much of it written from the perspective of kingship. When queens ruled in their own right, kingship theory adjusted accordingly and political theorists found themselves in the awkward position of having to defend a woman's right to rule. In the *Policraticus*, for example, John of Salisbury wrote scathingly about women's weakness and their inability to rule. Yet, in his *Historia Pontificalis* he actively supported the Empress Matilda, legitimate heir to the crown of her father, Henry I (r. 1100–35), in her struggle against her cousin Stephen for the crown of England.[43]

This is not to say that we should not study the life of Empress Matilda. Rather, we need to remain attentive to the many ways in which a queen could be vitally important to monarchy and yet not once in her lifetime sign a charter or manage an estate. Too narrow a focus on queenship as female political power obscures the variety of practices that fall under the definition of 'political'. A queen's political work could take many forms and derive from a range of sources – the patronage of convents, pious work with the church in general, sponsoring writers and visual artists, the informal diplomacy of marriage, intercession on behalf of her subjects, and governance.

The lives and deeds of the queens who form the core of this book reveal that, as an institution, queenship was inherently ambiguous, uneasily balanced between public authority and private influence, between governance and subjugation. At times, particularly in the later Middle Ages in the wake of changes in inheritance and marriage law, the rise of a bureaucratic staff in charge of royal administration and a shift in kingship ideology, most queens collaborated less overtly with their husbands. They publicly reflected the power of the king, yet continued to wield considerable influence in subtle but powerful ways.

Because monarchy remained the paramount form of governance, the institution of queenship thus remained stable. Queens themselves moved spatially and temporally, from natal to marital family and from home realm to husband's realm, through the life cycle of youth, betrothal, marriage, motherhood, widowhood. A queen's foreignness, whether from her place of birth or her difference in both birth and status, made her unlike all other subjects, regardless of sex and rank. This difference should have been a source of weakness. But, instead, because of her proximity to official power and her link to the next generation, as the following chapters demonstrate, the difference made her stronger.

Organization of the book

Each chapter begins with an introduction that sets out the broad historical context of the period under consideration. Each realm or region is then discussed in detail, beginning with an overview of the political events of the realm and a discussion of the reigns of particular queens. This selection is in no way intended to signify the relative importance of a particular queen. Rather, these queens were selected because they typify a trait or historiographic trend, demonstrate a methodological concern, or embody a noteworthy interpretive theory. It is neither possible to mention all the queens of medieval Europe, nor to discuss them as fully in the text as they deserve. The chapters close with sections that pose questions and pinpoint areas for future research, provide guidance in primary sources, research methodologies and theoretical approaches to the historiography of medieval queens and queenship.

A comprehensive bibliography can be found at the end of the book, together with a section entitled For Further Reading, which provides the publication details of essential works recommended for further study.

The field is rapidly changing, new articles, books and doctoral dissertations are published every month. The sheer abundance of works may seem daunting – the bibliography is impressive – but believe me when I say that this is just the beginning.

A note on place names, translations and proper names

Because most students of queenship have fluency in modern languages but are not necessary expert in Latin, Greek, or medieval forms of modern languages, non-English texts have been translated into modern standard English. Toponyms are given in the modern forms found on maps in current use, but the boundaries of some medieval realms (Francia, or Navarre, for instance) do not always conform to modern places or modern borders and can be confusing. For example, the modern nation of Spain encompasses dozens of medieval Christian and Muslim realms whose inhabitants spoke and wrote several languages, and scholars use both Spain and Iberia interchangeably. Portugal, on the other hand, is far less confusing because it has had remarkably stable borders and a single vernacular language. At the risk of infuriating scholars to whom the fine points of language and geography matter greatly, for ease and clarity, I chose to use Spain, France, England, Germany and Italy as general geographic place-holders and individual realms when

Introduction: Not Partial, Prejudiced or Ignorant

necessary. *The New Cambridge Medieval History* online in[...] useful maps and should be consulted if the place you seek is [not] on the most recent maps of Europe.

Translating texts and place names is fairly straightforward, but personal names are potentially very confusing. Medieval Europe encompassed numerous realms whose inhabitants spoke distinct languages at various points in time. This poses difficulties when writing in English about queens and kings who spoke or wrote in any number of languages: Greek, Latin, Anglo-Saxon, early forms of English, German, Spanish, Norse, to name just a few. I have tried to use the vernacular version of names unless there is a commonly held standard spelling, such as Eleanor of Aquitaine. The French queen Blanche of Castile was christened Blanca, but she is known widely as Blanche and so that is how she appears here. In general, I follow the spelling of names used by WorldCat because it is the standard bibliographic database for research. Latin forenames have been translated into English when it makes sense. Out of respect for the languages spoken by the queens and kings themselves, whenever possible or sensible I have chosen to use the language and regnal numbers (which can vary – conquest and marriage often created dual numbering which can be very confusing to the newcomer) that best convey the speech of the actors. Some names are best left alone. To render Ælfgifu, Æthelthryth, Balthild, Berenguela and Radegund into something modern

Table I.1 Variations in spellings of European royal names

English	French	Spanish	German	Variants
Alphonse	Alphonse	Alfonso	Alphonse	Portuguese: Afonso
Blanche	Blanche	Blanca		
Eleanor	Aliénor	Leonor		
Ferdinand		Fernando		Portuguese: Fernão
Henry	Henri	Enrique	Heinrich	
Isabella	Isabelle	Isabel	Elisabeth	Isabeau is an affectionate rendering of Elisabeth
Joan	Jeanne	Juana		
John	Jean	Juan	Johan	Catalan: Joan; Portuguese: João
Margaret	Marguerite			Denmark: Margarethe
Martin	Martin	Martín	Martin	Catalan: Martí
Maud	Matilde	Matilda	Mathilde	
Peter	Pierre	Pedro		Catalan: Pere
Yoland	Yolande	Violante		Catalan: Violant

would be ridiculous. The index will list and cross-reference variant spellings to make it at least a little easier to find the queen you seek.

Table I.1 should bring some clarity to this richly euphonic collection of names. The most potentially confusing common names are rendered first in English, then French, Spanish and German forms with variants noted.

1
Theme and Variations: Roman, Barbarian and Christian Societies in the Fashioning of Medieval Queenship, c. 300–700

To begin a discussion of the history of medieval queenship in the fourth century C.E. may seem to be starting rather early, but there are good reasons to do so. Periodization is a perennial problem for historians of the Middle Ages, particularly so for those who study the cultures that succeeded the Roman Empire that some prefer to call 'late antiquity' and others simply 'the early Middle Ages'. Scholarly arguments, each based on particular assumptions concerning the relative importance of political, religious, social and economic criteria, will locate the beginning some time after the demise of the last ethnic Roman emperor in 476. But the development of monarchy and its components, kingship and queenship, was a complex historical process that took shape over a considerable span of time; its origins cannot easily be marked by a single event. The early Middle Ages is the story of an ongoing, complex and uncertain process of Roman contact and assimilation, either forced or peaceful, of various ethnic and kin groups with whom they came into contact. In the west, they spoke distinct vernacular languages and were called 'barbarian' by the Greek and Roman authors, who may not have been able to distinguish ethnic identity and who preferred to lump all non-Romans into a single category. There were no national boundaries as we recognize them; instead, there were indistinct borders

of kin groups who identified themselves as, for example, Goth, Frank, or Celt.¹

Early medieval European culture in the west was formed via the accommodation of the Roman provincial heritage (except north of the Alps and the Danube River, which was outside the provinces) with the local conditions of the successor states. The resulting culture is best understood as local variations on a common theme, a patriarchal society that always and everywhere privileged rule by men and accepted rule by women only when necessary. Medieval monarchy was created from the dominant kin groups that survived the political conditions after the collapse of Roman authority. As queenship took shape, it roughly followed the contours of regional ethnic and tribal communities, making it risky to apply a broad adjectival term such as 'Germanic' or 'French' derived from modern political boundaries.

The eastern empire was quite different from the west. Classical Roman traditions, laws, social organization, culture and customs persisted longer in the political imagination and practices of the eastern Byzantine Empire, with the emperor and empress at the center. An empire (Latin: *imperium*) could be any one of a range of early medieval political entities but, in its most basic form, is lordship exercised over a plurality of kingdoms or smaller princely realms. The eastern emperor was elected, sometimes in a pro forma fashion, and he derived the legal basis of his rule from the assent of the aristocracy or high-ranking citizens. Both emperors and kings could come to power through successful military conquests, and both could claim the right to rule through their fathers who, in the early Middle Ages, were just as likely to be peasants as aristocrats. But the eastern Roman, and later the Byzantine, emperor's authority was rooted in well-established law that granted him political supremacy and a deification that separated him from the merely mortal citizens he governed.

Within this context, the empresses were often active public figures, highly visible in a centralized imperial court with a fixed location in Constantinople and a far more elaborate court ceremony than in the west. They were not, however, deified. Even so, because the emperor was technically an elective office, an empress could inherit and rule the empire, or at least share power and authority with her husband. As the legitimate daughter or wife of the emperor, she had a status that set her apart from other women, was influential in the establishment of Christianity, and was an active patron of art and culture.²

The process of the transformation of Roman society was well under way before the reign of the Emperor Constantine I (d. 337), who

temporarily mended the political split that fragmented the empire into smaller administrative regions with Rome, Milan, Trier and Constantinople as the centers of imperial authority. His successors struggled to hold the Empire together using the Roman army in the western provinces to fend off the barbarian *foederati* (subject allies of Rome). But rival factions in Rome tore apart the last remains of the Roman imperial state in the west after the assassination of Emperor Valentinian III and the sack of Rome by the Vandal Genseric in 455. The eastern and western fragments of the Roman Empire drifted apart, separated by language. Greek became the official language of imperial governance and the Church in the east; Latin, in the western kingdoms.

Governmental authority in the west after 476 was more dispersed and localized than in the eastern empire. A collection of plural monarchies led by barbarian chieftains, warlords and kings without fixed courts dominated. There was no single definition of 'queen' across these plural kingdoms; meaning depended in large part on context, with local customs and laws determining practice. Language is only slightly helpful. Scholars debate what people meant when they called a woman *regis uxor* (wife of king), *regina* (queen), *cwene* or *drottning* (Anglo-Saxon and Norse spellings of 'queen'). The problem is compounded by the uncertainty about what a king was – a ruler of a large realm (Latin: *rex*), simply a lord (Latin: *dominus*), or a ruler of lesser rank (Latin: *principes, dux*). For a king, the key word was not the word *rex* or *dominus* but the ethnic designation that followed, such as king of the Franks (*rex Francorum*) or Goths (*rex Gothorum*). The Visigoths ruled the Iberian peninsula, the Franks governed from the Pyrenees to the Weser River, the Angles and Saxons were lords of the continent west of the Elbe and Britain, and Ostrogoths and Lombards controlled Italy. In this new political landscape in the west, lordship was patriarchal, personal, based on kinship affiliations, local and did not rely on an educated bureaucracy. Whereas Roman emperors were quasi-deities who were elected to govern an empire of citizens, a medieval king was very much a human being who came to power via conquest or inheritance and who governed subjects.[3]

It was one thing to conquer lands and seize power, but monarchy and imperial rule in both east and west depended on the family; women were crucial to the holding and consolidation of that power. This is true whether the ruler was an emperor or a king: women were essential to legitimize and stabilize the transmission of the right to rule by keeping the succession within a single family. Within plural kingdoms of the west, more so than in an elective empire, the family was the primary means of transmission of the rights to rule. Kinship was one of the most

important social bonds in much of Europe, and family affiliation was traced not just through a single or central male line but in every way possible, with both paternal kin (agnatic) and maternal kin (cognatic) being of importance.[4] This promoted marriages among ruling families which, in turn, established the primacy of a queen in a family as wife and mother. Kings needed wives who brought wealth – either landed or moveable, who bore sons and who served as diplomatic facilitators, negotiators and peacemakers by smoothing out the tensions that invariably arose when powerful families came to blows in the quest for dominance.

When a king inherited a realm, or conquered it outright, he considered it a personal possession. Women of royal families therefore could wield ruling power alongside their male relatives through their control of royal households staffed by family members. The household was central to royal rule, a key agency of government no matter where it was located – for example, the highly centralized court of Constantinople or the moveable court of the peripatetic kings of the early Middle Ages. The household was the source of a queen's strength, it symbolized the realm, and it was a place where she could legitimately exercise her influence and form alliances. But what made it powerful – an intimate space near the king – also made it volatile. The power of a queen or empress was feared because it derived from her intimacy, particularly sexual intimacy, with the king. No matter how influential at court, nobles and churchmen were excluded from that innermost circle, and would express their frustration and anger at this exclusion indirectly by attacking a queen as dominating her husband, and by relying on stereotypical descriptions of her as sexually manipulative or adulterous. Queens could use this intimacy to their advantage, but their success in mounting a defense of their character depended on a host of factors – the health of the marriage, the status and power of her natal family, her age and experience, alliances with prominent bishops and abbesses and the affection of her subjects.

A woman's social status mattered less then than it would in later centuries, meaning that talent and prowess were as likely as birthright to open the palace doors to ambitious men and women of low social rank. Royal wives and concubines could, and often did, exercise considerable authority and power in governance, religion and culture, both publicly and privately. But they occupied a precarious position. Reproductive biology was notoriously unpredictable and 'dynastic failure', or the lack of a healthy male heir, was more common than orderly succession. At no time in the Middle Ages could a king or emperor take it for granted that his kingdom or empire would simply pass from him to his son. Her uncertain status as wife of the king situated a queen uneasily between

political dominance and wifely subjugation, but early medieval queens made creative use of this ambiguity.

All realms had four things in common. First, the queen was almost, but not always, a wife. Concubinage and polygamy were practiced until well into the ninth century but, to be a queen, a woman should be married. Kings used marriage alliances with other kings and nobles to ensure that they had enough children to live to adulthood and secure the patrimony. But a royal marriage is never without consequences that ripple out beyond the immediate family. When the marriage forged an alliance with a noble family, it upset the equilibrium among powerful families and led to constant jockeying for social status. When the bride was from outside the kingdom, she was regarded with suspicion by those same powerful families who feared that she would favor outsiders. If she were not of high status, she faced formidable opposition that only a strong-willed or wily woman could overcome. Queens forged important cultural, political and economic links across the European continent, which was crucial to the royal family's long-term success. But the numerous children of various legitimate mothers and concubines led, in turn, to family squabbles that turned into civil wars in which parents, children, half-children and cousins fought one another to secure rank and title. Polygamy and concubinage could complicate the succession, and this had serious consequences for queenship. The mother of sons had a privileged status but, if she were a concubine, this blurred the status of the wife of a king, who was then placed in an ill-defined and unstable role in the court. Practices such as coronation, public anointing of a queen, regular attendance of a queen at official public functions, enthronement, the wearing of a crown and esteem for the royal lineage codified and formalized the social role and the specific privileges and responsibilities for queens; however, these practices took shape much later, in the tenth and eleventh centuries.[5] One question this chapter addresses is what exactly queenship was at this stage. Was it an office? A title? Was it just a way to distinguish a chieftain's bed companion from other women?

Second, a queen was not necessarily seen as unfit to rule or govern. This follows family custom that regarded the wife and mother as trustworthy and loyal to family interests, which led to a long-standing tradition of respect for female counsel, as seen in the letters of Popes Gregory I ('the Great', d. 604) and Boniface V (d. 625). For example, the Anglo-Saxon queen Seaxburh (d. c. 674), the only queen to appear in an Anglo-Saxon regnal list, ruled Wessex, perhaps in her own right, for at least one year after the death of her husband, Cenwalh in 672.[6] Queens often ruled

as regents for their young sons or absent husbands, a task that stemmed naturally from their proximity to the king, their responsibilities for tutelage and child-rearing, and loyalty to the family. The exceptions to this were Anglo-Saxon England and Ireland, where inheritance customs allowed distant male relatives to inherit the kingdom, and underage kings could not succeed to the realms.[7]

Third, in both the east and the west, the Christianization of the Roman Empire dramatically transformed political culture and, with it, ideas on women and power. In the east, where Roman imperial traditions persisted, the change was more gradual. In the western regions – Britain, Ireland and the continent – monarchy took on distinctively new forms as it was crafted and re-crafted from the customs and practices of tribes or kin groups that gained prominence as the Roman state declined – most importantly, the Angles, Saxons, Visigoths, Celts, Norse and Franks. As these lordships grew in size and prominence through conquest and marriage, monarchy became the dominant political institution of the Middle Ages. This favored queens who were able to be active participants in secular and religious politics. That is not to say that the early Middle Ages represented a 'golden age' for queens. It did not. The social and political conditions were sufficiently unsettled to provide empresses and queens with just enough leeway to use their talents while, at the same time, making it dangerous for them to do so.

Queens played a fundamental part in the Christianization of Europe, both east and west, through their role in the conversion of their husband and their subjects, their work in founding convents and monasteries, their attention to local saints and the patronage of holy sites, and their commitment to securing places for their children in ecclesiastical institutions. It was not always a smooth transition from pagan to Christian. Eanflæd (d. after 685), wife of King Oswiu of Northumbria, had been raised in Kent with Roman Christian traditions, but her husband was raised in a region with Celtic practices. These conflicting practices meant that they celebrated Easter on different dates, which prompted Oswiu to convene a synod at Whitby Abbey in 684 to resolve the differences. Christianity put a premium on peace, order and continuity, and this often put them at odds with the warrior kings that typify this era. Queens were seen as influential in the civilizing process, and sanctity was a queenly attribute that distinguished them from their warrior king husbands and fathers.

Jo Ann McNamara argues persuasively that royal women collaborated with their hagiographers, sometimes very closely, and that royal saints, both male and female, were a joint creation.[8] This does not mean that

the piety of royal women was a fabrication. For them, acts of piety and charity were logical and self-conscious forms of royal work that offset the militant side of kingship. Neither does it mean that all early medieval queens were saints, or that sanctity was intrinsic to queenship. Their lives were so much more than the sum of their piety, and involved the very secular acts of giving birth, raising children, managing the household, interceding on behalf of their subjects, dispensing charity and commissioning works of art and architecture. Their biographers and hagiographers may have emphasized the saintly actions because, for them, these deeds were of the greatest importance and brought a queen's reputation for piety to the attention of church officials, who then deemed them saints. A queen may have been a saint, but it is also very possible that her reputation for saintliness was little more than a creative re-telling of her life. Sanctity did not make the queen; marriage and motherhood did. Sanctity was, however, a powerful platform from which a queen could act forcefully and publicly to stabilize the realm, protect the king's reputation, act as a counterbalance to a warrior king and use her saintly reputation to promote the interests of the church.[9]

Finally, a queen was expected to create and maintain good relations between the royal family and their noble subjects. One effective way to build strong ties among the nobility was to bestow largesse in the form of hospitality and the exchange of gifts. No matter how big or small the court, hospitality was an essential institutional characteristic of the work of empresses and queens. They were the social and familial glue that bound noblewomen and the wives of court officials in a web of loyalty to the emperor or king. Elaborate rituals at dinners, drinking parties, diplomatic functions, formal receptions and ceremonial processions stage-managed by the empress or queen served to bind the men at court to the king. These rituals of rulership were costly and time-consuming activities that have often been dismissed as a queen's way of passing the time. They were, in fact, as important a part of the royal workload as treaty negotiations were in maintaining the delicate balance of the realm's social and political forces.[10]

Powerful women of the early Middle Ages were mostly chronicled by men, often in all-male monastic communities. The picture is not entirely hostile; however, it is often incomplete, exaggerated, with a focus on salvation and conversion that excluded intra-familial politics, marriage and daily life. The main chroniclers of the Christian early Middle Ages – Gregory of Tours, Bede, Procopius and Cassiodorus – were men who were highly biased sympathizers of one side or another in messy civil strife. Many of these narrative sources have survived only in later copies, or

were written later for purposes other than the impartial recording of events. Early medieval chronicles and saints' lives have been used very effectively by Suzanne Fonay Wemple, Pauline Stafford and Dick Harrison.[11] Their fresh reading of these sources, alongside the study of monastic annals and chronicles in order to double-check the veracity of the biased narratives, reveals much about queens who had been ignored by generations of scholars. Wemple's genealogies, the first of their kind, include the queens and concubines of Merovingian and Carolingian kings, and reveal graphically the vital importance of queens to the success of kings. They were a revelation to many scholars who had been schooled in history without women and they remind readers that to find women in early medieval sources demands tenacity and a keen eye.

Historians turn to the methods of anthropologists and art historians to investigate material objects as public as tombstones, epigraphs and monumental sculpture, or as intimate as jewelry, embroidered textiles, devotional and liturgical objects and books, or as large as tracts of land, houses, castles, monasteries and convents.[12] A burial site might seem a logical place to find evidence of queens, but that has not been the case. For England, perhaps the most important archaeological site is the Sutton Hoo burial mound in Suffolk. This monument contains exceptionally fine artifacts from a king but, like many royal burial sites, has offered nothing relating to a queen. Recent work on burial sites has found convincing evidence of high-status women, including skeletal remains among the grave goods in the tombs, but they have not been identified specifically as queens.[13] Even when the identity of the original owner of a brooch or bracelet cannot be known definitively, the contextual evidence from the dig site may suggest that she was a queen.[14]

When the owner was known to be a queen, art historians have studied the object in terms of iconography and formal style. Together with work by anthropologists and cultural historians, they analyze the political and cultural significance of gift exchange in early medieval society. Art historian Anthony Cutler criticized an earlier hesitance of art historians to use material objects as evidence, noting that until recently:

> [g]ifts have been consigned by historians to that special oubliette where they keep the evidence they consider unhelpful to the understanding of political and economic events. And in many cases this sparing of words is understandable: a political or military alliance, a desired truce or trading privilege, was unlikely to depend on whether twenty rather than thirty bolts of cloth, or one as against a pair of leopards, accompanied the request for a favor.[15]

The act of giving gifts vividly illuminates the complex power relations in the act of giving, rich with gestures such as the donor bowing before the lord or lady. The recipient feels obligated to reciprocate with a counter-gift, although not explicitly compelled to do so by any existing authority and the relative value of the gifts exchanged is not equal. The more powerful the recipient, in this case the king or queen, the higher the symbolic valuable of the gift he or she gives in return, even if the material value is less. Diplomatic gifts, ranging from gem-studded gold brooches to elephants, were important to Christian, pagan and Islamic cultures in early medieval societies. In this context, obtaining gifts from a queen was, for many of her members of court, a way to partake in her and her husband's success and good luck. This unofficial form of power is evident in a wide range of sources including letters, chronicles, inventories of royal households and wills. It is eloquently described in literary texts such as the epic poem *Beowulf*, where hospitality and gift exchange were vitally important aspects of a queen's duty that derived from her role as mistress of the household.[16]

In short, Christian queens and empresses from both the eastern and western realms shared a common theme of Roman heritage but thrived amid a surfeit of local variations. The resultant practice of queenship was a political and cultural hybrid of three powerful traditions – Roman, barbarian, Christian – that fused into a syncretic political form that bore the mark of the distinct individual elements.

Eastern Roman Empire and early Byzantine Empire

The history of the development of medieval queenship begins with the empresses in the eastern Roman Empire during the period of the toleration of Christianity enacted by the Edict of Milan in 313, its later persecution, and its later acceptance as the official religion of the Empire. Roman emperors and empresses in the east were expected to follow gender norms for masculinity that valorized courage, justice, temperance, wisdom, self-control and pursuit of the common good; an empress was expected to be gentle, modest, devoted to family and home.

Romans regarded marital harmony as important to maintaining the health and political harmony of the empire itself, and exalted a virtuous ideal of the faithful matron and devoted mother. But with the conversion of the Empire to Christianity, these ideals of feminine virtue were fundamentally altered. Christian women took their cue from the Virgin Mary as a model, stressing the importance of virginity or chastity and

idealizing a spiritual marriage to Christ over a secular carnal marriage. Kate Cooper, working with literary sources, argues that Christian empresses in the eastern Empire, and later in the Byzantine Empire, took changing ideas about sexuality, family and morality to heart, crafting a form of queenship that had far-reaching implications for monarchy in the Middle Ages. A good empress or queen in the Middle Ages had little difficulty integrating the Roman values of marital fidelity and public harmony with Christian values of piety, philanthropy and humility. Virginity and chastity, however, proved far more difficult to harmonize with the very real demand that an empress or queen bear male children to succeed their father. But both wife and virgin were ambiguous, representing both reluctance and power. Whether a woman chose virginity – and thus refused to bend to the wishes of patriarchal forces, or marriage – and thus accepted her place in society as wife and mother, Christianity offered the possibility of choice. As Cooper notes, the Christian writers of the period found the ideal of the virgin very appealing precisely because it simultaneously invoked 'the conservative values of the hearth while in fact legitimizing social change'.[17]

These gender standards were expressed politically in the eastern Roman Empire, and later the Byzantine Empire, through a system that was a hierarchical, highly organized and bureaucratic state composed of a set of institutions that revolved around the emperor. The eastern empire was the direct heir to the Roman Empire that, after the conversion of Constantine, took on strongly Christian aspects. Whereas Roman emperors were considered deities, the Christian Byzantine emperor was simply God's human representative on earth, a man with divinely bestowed powers who owed his place at the pinnacle of the earthly hierarchy to God's favor. He was the source of law, but not bound by it. He was head of a civil government that was efficient and well-organized, and commander-in-chief of an imperial army that was incorporated within the civil bureaucracy. The emperor was a key part of the ecclesiastical hierarchy, on a par with the patriarch who led the eastern Church, whom the emperor could depose at will. In this period, there was no hereditary monarchy, no right of primogeniture that dictated that the eldest son would rule; in theory, there was no right of succession at all. Son followed father by custom, not by right, so an emperor in this early period could easily have been a peasant and the empress a circus performer.

An empress's authority over the army was limited considerably by her sex, but some empresses overcame this problem by marrying a general, or by appointing a loyal ally to take charge of the army. Likewise, an

empress could not take precedence over the patriarch, having to work through proxies in church matters. Empresses, like queens, were closely tied to conversion, and religious patronage was one area where they had an ample field of play. The empress, unlike her queenly counterparts, was a link that ensured continuity between different emperors. This continuity can be best seen in the portraiture of Byzantine empresses which conveys not individual traits or personality but, rather, an iconic timelessness. An ivory plaque of an empress in full imperial regalia is characteristic of the early Byzantine style (Illustration 1.1).[18] Standing on an

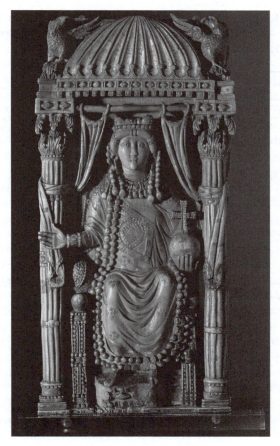

Illustration 1.1 Byzantine ivory diptych depicting Byzantine Empress Ariadne (d. 515 C.E.). Kunsthistorisches Museum, Vienna, Austria. © Erich Lessing/Art Resource, New York.

ornamented pedestal in an intricately detailed architectural niche with fluted columns and imperial eagles over an elaborate *ciborium* (dome), she holds two symbols of imperial authority, a *globus crucifer* (a globe with a cross on top) in her right hand and a scepter in her left. Dressed in a carefully draped *chlamys* (ceremonial cloak) with a *tablion* (a large panel on which is embroidered a portrait of the emperor), edged with a delightful double row of beads that may represent pearls that mimic the gems of her diadem's *prependulia* (dangling medallions), her gaze is typically Byzantine, direct, full-frontal and with a slightly upward glance. The effect is dramatic, dazzling, powerful, serene, pious and, to the modern eye, a little frightening in its otherworldliness. This is not an image of an individual; it is an idealized portrait and a political icon, an effective representation of an empress's power and authority.

Helena, a saintly empress and the mother of Constantine, the emperor who issued the edict that officially granted toleration to Christianity, set in motion a very useful trope for the complementary relationship of women and men in power.[19] To distinguish Christianity from the official Roman religion – where the emperors were deified and empresses shared the emperor's divinity by acting out a public role as his alter ego – early Christian writers emphasized that only Christ had such a dual nature. At this early stage in the spread of Christianity, any association of a Christian emperor with a Christian priest was dangerously close to pagan Roman practices but, once women were forbidden from taking part in any sacerdotal roles, it became palatable to let empresses sidle up closely to saintliness. The saintly side of a complementary pair, queens took their inspiration from the Virgin Mary and were seen as necessary for the restoration of divine sanctions to an institution no longer linked to the Roman gods. Using Helena's life as inspiration, pious queens and empresses gave religious imprimatur to newly-converted pagan warrior kings. Later empresses and queens in the west imitated Helena, as they ritually displayed humility, piety, mercy, charity and reconciliation to link an omnipotent king or emperor and his subjects. Imitating the example of Helena, who made her presence felt publicly in art and architecture, later Byzantine empresses erected monumental sculpture and public monuments.

Helena was born of humble parentage in about the middle of the third century. St. Ambrose, in his '*Oratio de obitu Theodosii*' (Oration on the Death of Theodosius), referred to her as a *stabularia* (innkeeper), but her lowly rank was not an impediment to her marriage to Emperor Constantius Chlorus. Her first and only son, Constantine, was born in 274. In 292, Constantius left Helena to marry the stepdaughter of his

patron Emperor Maximinianus Herculius, but Constantine remained loyal to his mother. When Constantius died in 308, Constantine became emperor. He summoned his mother to the imperial court, conferred on her the title of Augusta, ordered that all imperial honors should be paid her, and had gold coins struck bearing her image (she was the first Byzantine empress so honored). She openly converted to Christianity after her son's victory at the Milvian Bridge in 312, prompting him to promulgate the Edict of Milan that officially tolerated Christianity within the Empire. She is traditionally linked to the building of Christian churches in imperial cities in the west, notably Rome and Trier. She made a pilgrimage to Palestine in 326 after Constantine defeated his last rival and became sole emperor. Her generous acts of charity there, including the freeing of condemned criminals, may have been done as a public penance for scandals in the imperial household that resulted in the execution of Constantine's son and suicide of his wife. She founded two churches in Bethlehem and near Jerusalem, but her most famous act, enshrined in legend and used as a point of comparison to all pious Christian queens of the Middle Ages, was the purported discovery of the Cross of Christ. This act symbolized a new sanctification of imperial power, becoming a model for later queens and empresses in Europe. Constantine was with her when she died, around 330, the year in which the last gold coins known to have been stamped with her name were minted.

Helena's reputation for piety survived her, and she became a model for empresses and queens, both east and west. Her successors benefited from institutional developments in the reign of Theodosius I ('the Great') that put greater emphasis on dynasty as the foundation for imperial authority. Theodosius, his sons and his grandsons reigned during a tumultuous period from 375 to 455, when the Roman Empire was divided into eastern and western empires, non-Roman tribes invaded on the frontiers, and Christian monks and bishops accelerated their conversion of pagans and struggled to define Christian doctrine in the face of various conflicting interpretations of dogma. Imperial women – wives, mothers, daughters, sisters – actively participated in the government's response to these pressures. They were able to do this because Theodosius believed that kin and family were a more stable foundation for rule than abstract principles of law or political ideology. Placing the emphasis on family and dynasty gave women a springboard for a more clearly-defined role in government. Kenneth Holum argues that Byzantine notions of imperial power (*basileía*) and sacral kingship had their origins in the imperial women of this period. Documents from the imperial chancery,

coinage, monumental sculpture, sermons and writings by early Christian fathers are among the sources that show women to be active figures at court. These women modeled themselves after Helena and, by closely associating the emperor and empress with a transcendent God, they brought a measure of stability to their subjects, who were unsettled by momentous political and religious changes.[20]

Theodosius revitalized the eastern Roman monarchy, rebuilt the army, advanced Christianity as the official religion of the empire and put Constantinople on a par with Rome. His impact on empresses is linked to his decision to make his private religion official, and how he used his family as a foundation for his rule. This emphasis on dynasty as a source of imperial power gave women a more clearly defined role in government and the medieval empress began to take shape with his wife, Flaccilla. She was born into a Spanish noble family, had three children and her only foray into public political life was her promotion of orthodoxy. She was crowned, perhaps by Theodosius himself, and was designated 'Augusta' to signify her as the embodiment of dynastic stability. She was the subject of monumental sculptures, and her likeness appeared on coinage wearing a diadem and a cloak adorned with an ornamental broach (*fibula*) bearing the insignia of the emperor. In his funeral oration for her, Gregory of Nyssa praised her as Theodosius's partner in the *basileía* (imperial dominion) who shared the same office. As a genre, funeral orations are flattering embellishments of a life but, to be credible to the audience, there must be some correspondence between fact and fiction. He called her a humble 'ornament of empire', 'rudder of justice', with a 'zeal for piety', a woman who occupied the 'secret places of the emperor' with 'wifely love' and a generous benefactor to the 'naked and helpless poor'.[21] However, as articulated by Gregory of Nyssa they were combined in a novel way that deliberately sent the message that the empress was integral to a new form of Christian imperial ideology that included women. But it was not a message that would threaten conservative elites – it adhered to conventional gender norms that regarded women in terms of devoted wife and mother, feminine beauty and a generous spirit. These are traits that could describe just about any Roman empress, but what made it novel was the connection to the Christian piety of Helena. Gregory of Nyssa's litany of traits was echoed by later medieval writers when describing queens and empresses.

In her short reign as Empress Eudoxia (r. 395–404), the wife of Arcadius, son of Theodosius and Flaccilla, took advantage of the precedent set by her mother-in-law but used her power in quite different ways. The daughter of a Roman woman and a Frankish general, she went to

Constantinople after her father died and there she was raised by a wealthy and prominent family. She married Arcadius in 395 and bore three daughters and a son before dying of a miscarriage in 404. Arcadius was not a strong ruler, which gave Eudoxia ample space for her to act when necessary. An indication of her influence is evident when Arcadius's chief advisor, Eutropius, threatened to have her sent away. She responded by going to Arcadius with her daughters in her arms, lamented her shabby treatment and convinced him to dismiss Eutropius. She used her maternity more subtly, as leverage with church officials, when her son was born. In return, John Chrysostom lauded her piety and promotion of Christianity as the foundation for the dynasty. She was elevated to the rank of Augusta in 400 and, following the precedent of Flaccilla, coins were minted with an image that linked her explicitly with Arcadius. Her coinage differs from earlier coins in the use of God's hand placing the crown on her head, iconography that had been used in some coinage with the visage of the emperor, but Eudoxia's coinage proclaimed that the office of empress, too, had divine provenance. Holum argues that her coronation and the imagery of her coinage were related to the recent Visigothic incursions on the frontier, and were intended to bolster imperial authority by using the empress to gain the support of people of Constantinople. But she fell out with Chrysostom shortly after her imperial coronation over his expulsion of a cleric she favored. She used her infant son, who would rule as Theodosius II, to underscore her advantage as a mother of the heir, and Chrysostom acquiesced. But he was a harsh critic of women who fell short of Marian perfection, and he blamed her when he lost favor with the emperor, calling her a jezebel and the embodiment of queenly evil, not only demeaning her but challenging the status of the empress.

Her daughter, Pulcheria (r. 413–53), succeeded her mother at around age fourteen and reigned in far more turbulent times after the incursions of Huns and the Visigoths who sacked Rome in 410, but further strengthened the office of empress. She embraced both the piety and humility of Flaccilla and coupled it with a generous philanthropy, founding refuges for beggars and the homeless, endowing churches and monasteries and taking part in the translation of the relics of St. Stephen to Constantinople. Pulcheria played a queenly role in the minority of her young brother, Theodosius II, and supervised his education. But, in a move with significant implications for later empresses, she broke with tradition when she declared herself a perpetual virgin, and her younger sisters did likewise. Hailed a 'new Helena' at the Council of Chaldedon in 451, she collected relics and used her royal robes as altar coverings, ritual

gestures that would remain a dramatic part of the queenly repertory for centuries. As empress, she took control of the government and was praised by some of her contemporaries as an excellent ruler who fended off the military threats.[22]

Pulcheria's unconventional choice of virginity, and her influence and power, alarmed the more traditional men in the empire, and in the 420s they turned to her brother, Theodosius, then only in his early twenties. They selected a bride for him, Eudoxia, a young woman of low social rank; as the wife of Theodosius II (r. 408–50) she refused to let John Chrysostom regulate her charitable patronage and had him exiled. She used imperial wealth for her pilgrimage to Jerusalem in 438, the first empress to do so since Helena, and was acclaimed a 'new Helena'.

The explicit association of empresses with Helena continued for decades. This linkage of empresses to Helena bolstered imperial ruler ideology that set empresses up as embodying the emperor's honor. But, as Leslie Brubaker (2004) notes, this did not come without risk. It confined women in the traditional roles of wife and mother. If they did not marry men, they were obliged to take vows of virginity and marry Christ. Their power – no matter what form it took – was bound to be circumscribed by family, with their identity derived from their relation to their fathers, husbands, brothers, or sons. Only Pulcheria was able to rule on her own, but only because she was a virgin – and that, too, was precarious. When her brother died in 450, she succeeded him, but only after she agreed to marry. This binding of women to family was exclusive neither to Christians nor to the Byzantine Empire but, when fused with the Roman precedent and the barbarian customs and practices rooted in kinship, it led to a form of queenship that privileged a queen's maternal role above all else.

Women thus had access to political power through their relationship with the emperor, but they were not necessarily excluded from the succession.[23] Pulcheria was not unusual, particularly in this early period, as an emperor's daughter, mother, or sister who became empress. Irene (d. 803), mother of Leo III, pushed him aside and became the only woman to rule as sole Byzantine empress.[24] Because political power could be transmitted through female inheritance, the emperor's power could, and often did, depend on his wife.[25] When Emperor Leo I died in 474, his widow, Empress Verina crowned her brother Leo II during his revolt against her son-in-law, Zeno. When Zeno died in 491, his widow Empress Ariadne (d. 515), who inherited the title from her uncle Justinian, was asked to nominate a successor and she chose Anastasios, a court official. Even those who did not rule directly, such as the widowed

empress-regent, could exercise considerable authority in governance, but it is difficult to know precisely the scope of her personal and official authority because the sources are partisan and heavily biased, either in favor of or against a particular empress.[26]

When a queen failed to live up to saintly behavior based on the supposed rules of queenly conduct, mostly written by monastic professionals based on the Virgin Mary and Helena, she naturally fell short of perfection, and was derided as an impious jezebel. There is no better example of how rumor and innuendo can tarnish a reputation than the empress Theodora (d. 548), wife of Emperor Justinian (r. 527–65). She captivated an emperor who could have married anyone but chose her and was devoted to her as 'the most pious consort given to Us by God'. That phrase may be as much the sort of rhetorical flourish often found in official documents that abound in formal expressions of sentiment, but the events of their reign confirm the genuine affection it contains. Much more than the beloved spouse of an emperor, Theodora was a shrewd political operator who paid close attention to the needs of her less fortunate subjects, particularly women without ample financial or social means. In this, she typifies the rise to power and influence possible for both men and women in a time when institutions were in flux and talent mattered more than lofty birth. She worked alongside Justinian and her influence is evident in some of his policies and many of his actions. She was a very human empress, pious but not perfect, who in many ways conformed to the model of Helena, but whose public exercise of political power agitated her contemporary, Procopius, who turned his pen on her after her death.[27] Scholars are skeptical of just about everything that was written about her after her death, much of it rumor and innuendo that does not qualify as credible evidence.[28]

What is clear from all sources is that she was a striver and a tenacious survivor of the tumult and intrigue that marked the wars, plague and social unrest of the sixth century. She had a sketchy childhood and young adulthood. One of the daughters of Akakios, a bear-keeper in Constantinople, Theodora was born around 497 and most likely grew up in the milieu of the underworld of the hippodrome. She was an actress, a profession considered vulgar and scandalous, which lent a dubious air to Theodora's reputation throughout her life and was used by her enemies to discredit her, even when her actions were pious and above reproach.[29] Her father died around 500, leaving his family economically vulnerable. Theodora and her sisters apparently had to scramble to survive, and she may well have turned to prostitution, or perhaps was a courtesan. Many contemporary accounts leave out all references to her past, but this

cannot be taken as proof of anything other than the fact that it was dangerous to engage in public criticism of an empress so beloved of the emperor. It is almost impossible to know definitively what she did between her father's death in 500 and 522, when Justinian met her. He was fifteen years older and, by all accounts, he adored her. Social rank was not an impediment to their marriage because an emperor, and thus an empress, could come from any social rank: Justinian's uncle, the Emperor Justin, was an illiterate peasant warrior. Nevertheless, when Theodora became his mistress, she was elevated to patrician rank. They married in 523 or 524, immediately after the death of Empress Euphemia (a barbarian, or non-native, illiterate ex-slave), and in 527, when Justin died, Justinian succeeded him and Theodora became empress. They had no children together, but she gave birth to a daughter before they met and may have given birth to a son who did not survive.

She was an active member of the imperial court who worked closely with Justinian, and their partnership is beautifully depicted in a pair of mosaics in the church of San Vitale in Ravenna. Anne McClanan cautions us to not overestimate Theodora's political importance from a portrait that balances her alongside Justinian, but there are indications, although no concrete documentary evidence, that Theodora was involved in Justinian's reforms.[30] In *Novel* 8.1 ('novel' means 'new law'), promulgated around 535, which banned the purchase of public offices by officials, Justinian himself mentions that he has taken counsel with Theodora and the law includes an oath to be taken by governors to her as well as to Justinian. His legislation attempted to ameliorate the condition of women. He thought it was wrong that women should have different penalties in divorce cases than those for men; he revised laws on rape, *raptus* (forcible seizure) and seduction of all women; and tried to control prostitution.[31] Theodora may have had a hand in this legislation: Procopius in the *History of the Wars* says that she was naturally inclined to assist women in misfortune. Her influence extended to religion and one of the theological disputes of the early Church. She was an ardent monophysite who denied the human nature of Christ, believing instead that he had one nature only, the divine, but was not ever fully human in an all-encompassing and mysterious way. This belief was heretical to the orthodox patriarchs of Constantinople, and Justinian differed completely with her on this. Still, she openly protected monophysite supporters and publicly supported the community at the palace of Hormisdas, even as Justinian attempted to suppress the believers. Their parallel diplomacy kept the empire free of openly divisive religious tension. The power of her protection extended even after her death. The

Hormisdas community, and other communities for monophysite nuns, thrived and outlived her.

John the Lydian called her 'co-sharer of the empire' – a phrase that also describes queens in the west who governed alongside their husbands, either informally or formally as regent or lieutenant. This form of power, often derided as secret and attributed to a woman's sexual power, was feared because it was shared between a husband and wife, and her enemies accused her of abuse of power. They were especially outraged when it involved the promotion of her family in the imperial court. Theodora's role in Justinian's reign was described by Procopius in *History of the Wars* in a famous incident during the Nika riots in January 532. While rival factions in Constantinople tore apart the capital city, Justinian considered fleeing the city, but Procopius gives Theodora a prominent role in the outcome of the crisis:

> Now the emperor and his court were deliberating as to whether it would be better for them if they remained or if they took to flight in the ships. And many opinions were expressed favouring either course. And the Empress Theodora also spoke to the following effect: 'As to the belief that a woman ought not to be daring among men or to assert herself boldly among those who are holding back from fear, I consider that the present crisis most certainly does not permit us to discuss whether the matter should be regarded in this or in some other way. For in the case of those whose interests have come into the greatest danger nothing else seems best except to settle the issue immediately before them in the best possible way. My opinion then is that the present time, above all others, is inopportune for flight, even though it bring safety. For while it is impossible for a man who has seen the light not also to die, for one who has been an emperor it is unendurable to be a fugitive. May I never be separated from this purple, and may I not live that day on which those who meet me shall not address me as mistress. If, now, it is your wish to save yourself, O Emperor, there is no difficulty. For we have much money, and there is the sea, here the boats. However consider whether it will not come about after you have been saved that you would gladly exchange that safety for death. For as for myself, I approve a certain ancient saying that royalty is a good burial-shroud.' When the queen had spoken thus, all were filled with boldness, and, turning their thoughts towards resistance, they began to consider how they might be able to defend themselves if any hostile force should come against them.[32]

Theodora is daring, decisive and bold; Justinian is cautious, tentative and hesitant. She has an astute awareness not only of her status, but the importance of both emperor and empress in calming the violence by their very presence in the city. She admonishes him, telling him that to be anything other than an emperor is to be dead. Procopius credits her with saving Justinian's reign, a very risky move that could have compromised his masculinity. Emperors are supposed to rule, not be ruled, and in this passage she is treading a very fine line between giving sound and reasoned advice and wagging an admonitory finger.

When reading Procopius, an author so contradictory as to be both reliable and unreliable, it pays to make a careful assessment of both the writer and the message. Procopius, who wrote more about Theodora than anyone else at the time, was secretary and legal adviser to Justinian's adviser general Belisarius. He therefore had access to solid information and wrote both a balanced official history of the reign (the *History of the Wars*) and a very nasty biographical sketch of Theodora and Justinian (the *Secret History*). The *Secret History*, written around 550 but unpublished during Procopius's lifetime, provided the basis for much of what has formed modern interpretations of her life and reign. He knew Belisarius, and his wife Antonina, Theodora's close friend, and many scholars agree that they, not Justinian and Theodora, may have been the original target of his harsh criticism. Some of the *Secret History* may have been written while Theodora was alive, leading some scholars to think it may be reasonably accurate, but it was published long after Procopius's death and it did not circulate widely for centuries.[33]

While *History of the Wars*, written as a public history of the reign, was even in tone, the *Secret History* was inflammatory and vulgar. It viciously insulted both Theodora and Justinian with hostile and negative descriptions of them as cruel and soulless social climbers of low birth who perverted Byzantine gender norms. Justinian is made to be the consort, and Theodora the emperor. Procopius tells a tale of female power, male impotence, sexual manipulation and the dangers of secret power wielded for pure pleasure and self-aggrandizement. Justinian is depicted as a husband overly devoted to his wife, unfit for governance and less of a man because he was ruled by his wife. Procopius calls Theodora immodest, unchaste and a slave to pleasure. He accuses her of murder, prostituting nuns, degrading the honor and sanctity of her subjects, and sanctioning adultery; Justinian is portrayed as weak and foolish, motivated by greed and lust. He colluded with her, robbed the treasury, sold public offices, was cruel to the poor and destroyed Byzantine culture, and

they both consorted with magicians and sorcerers. Procopius accused her of orchestrating the murder of the Gothic queen Amalasuintha, who chose to retain power personally rather than turn it over to her son, Athalaric. Theodora had her imprisoned and soon after she was murdered, in her bath. Procopius in the *Secret History* alleges that Theodora ordered the murder, but there is no convincing evidence to support his claim. There are a few highly suggestive letters addressed to Theodora which allude to a 'delicate hint' that was whispered in an attendant's ear – a common instruction to the bearer of a royal or imperial letter – but even this alone cannot be read as conclusive.[34] The truth is, she could be ruthless in her pursuit of enemies who sought to destroy her husband or the realms. John the Cappadocian, Justinian's secretary and chief financial advisor – a man of low birth, avaricious, unscrupulous and libertine, but very skillful at his job – aroused her anger over fiscal policies that impoverished many people. It took her a decade, but she finally brought enough evidence to bring him down. Her power was formidable even if unofficial, but it had limits: Justinian softened the harsh sentence of exile and financial ruin that the law imposed.

What scholars believe about Theodora and Justinian ultimately depends on how much veracity we are willing to ascribe to the sources. John Moorhead thinks that Procopius made up the speech because he probably was not present, and it cannot be corroborated by other sources.[35] Leslie Brubaker goes a step further and argues, however, that none of the stories in the *Secret History* correspond to what we know to be true about sixth-century Byzantium. She argues that Procopius intended this not as a factual account but, rather, as a work of fiction, a parody on the imperial panegyric that tells us nothing about Justinian and Theodora. It does, however, reveal much about the dynamics of gender, how it was constructed and how those constructs could be subverted for use as social commentary. It is also a signal lesson in how a fiction or a parody filled with rumor and innuendo can become a substitute for genuine evidence and how this, in turn, dramatically affects historical interpretations of empresses and queens.

Reading the *History of the Wars*, we are left with an impression of a resolute woman who was not about to back down and a weak king. Justinian stayed, defended his reign viciously, with a reported 30,000 enemies slaughtered (hardly a credible number), his enemies tried and executed and noble conspirators exiled and their property seized. But Procopius betrays a distinct uneasiness at Theodora's power over Justinian and the nature of government, and he is sending very clear

signals to his readers that he does not like her. His viciousness in the *Secret History* is no surprise. But if we only read the *Secret History*, we see merely a vulgar, sexually voracious, greedy couple who dabble in magic and plunder the treasury. Taken together, faults and all, we get a vivid portrait of how gender works within an imperial monarchy.

When she died in 548 – some reports say of cancer, but this cannot be known for certain – Justinian could have remarried, but he did not. His devotion to her was deep and lasting. On his return from a victory over the Huns in 559, he detoured the victory procession to the Church of the Holy Apostles so that he could light candles at the tomb of Theodora. Her family profited from having a relative wearing the imperial diadem, purple *chlamys* and red shoes.

Theodora very carefully arranged official lucrative positions at court and marriages for her immediate family, most notably her niece Sophia, who married Justin, son of Justinian's sister. Because Justinian had no children, the empire passed to Sophia (c. 535–c. 601), who succeeded Theodora as empress and was crowned Augusta. Sophia, another 'most pious Augusta', was influential in government for over a decade, and held more power, more openly than Theodora, who may well have groomed her for governing. She was far more dominant in the reign than her husband, who suffered from mental illness. They were linked in imperial imagery, and Sophia was the first empress to appear on the day-to-day bronze coins, which made her image far more public to her subjects. Theophanes credits much of the economic policy of the reign to Sophia's influence. The imperial treasury was nearly bankrupt at Justinian's death but by Justin's death, in 578, the accounts had been balanced. This was accomplished through strict attention to expenses – a sound fiscal move, but an unpopular one with subjects of all ranks who felt the cessation of official largesse. More controversial was her embrace of orthodoxy and, ultimately, the persecution of monophysites, who had enjoyed imperial protection under Theodora. Like Helena and Theodora, Sophia was an active builder of palaces and churches, a generous philanthropist and a shrewd diplomat.

Sophia was most active from 572, when Justin began to exhibit signs of serious mental instability. She tried to have him cured and, failing in that endeavor, she had to name a man to govern officially alongside her. She chose Tiberios, an official who had been legally adopted as heir by Justin and was named Caesar. This tactic was one that would be used by a number of emperors and kings in western Europe as a way to avoid a precarious interregnum and ensure, hopefully, the continuation of the former emperor's legacy. Tiberios was her subordinate, leading enemies

to spread rumors that Sophia and Tiberios were lovers, but it was more gossip than truth. Tiberios was married, apparently contentedly, to Ino, who openly sparred with Sophia over prominence in her husband's reign until Justin's death in 578. Sophia, once a powerful Augusta, was demoted to the status of official 'mother' of Tiberios as dowager-empress consort. She tried to regain – or, at least, retain – some of her former power, which led later critics such as Gregory of Tours to denounce her as malicious. But she did conspire to undermine Tiberios, who retaliated by confining her to the palace. She was down, but not out: she refused to move out of the main staterooms in the palace, forcing Tiberios to remodel smaller, older quarters and build an extension to the palace for his family. In further proof of the scope of power she retained, when Tiberios died in 582, she was influential in selecting his successor, Maurice. She spent the next two decades in relative obscurity, having made peace with Ino, and died in c. 601, perhaps a victim of the bloody struggle for the empire in 602.

Frankish and Merovingian realms

As early as the late third century, groups whom narrative sources called Franks had joined with various peoples who had previously settled north and east of the lower Rhine to challenge Roman rule.[36] The Franks are an excellent starting place for a discussion of early medieval queenship in western Europe because the Frankish state endured for a very long time, with many of its central institutions surviving into the modern period.[37] Because it survived for so long as a single large unit, not subject to invasion by outsiders like Iberia or Italy, Francia became the pre-eminent realm in Europe and its culture influenced the neighboring regions of northern Italy, northern Iberia and England. The Franks were a confederate people and one key to their success was their ability to assimilate other groups, beginning in the sixth century with the Gallo-Roman elite. The Franks expanded their territory by conquest and augmented it with acculturation of the neighbors to Frankish customs and practices. The nobility was of mixed ethnicity; noble status was not formally defined – it could be inherited, acquired through service, or could reflect inherited wealth. The nobility, therefore, was not a closed elite; the dividing line between free and noble was indistinct. There were significant differences of wealth and status, but some social movement was possible. Queens, therefore, could come from a wide social range without provoking comment, as when Balthild, a woman of low status, married King Clovis II in 648.

By the sixth century, they were led by the Merovingian dynasty, which ruled the Franks until 751. The success of Merovingian kings was directly related to the wealth and power of the Frankish nobility. This fostered a monarchical regime formed out of consensus between the different powerful family groups but, as nobles grew more powerful and expanded their realms, royal power suffered. Merovingian rulers relied on bishops as key supporters of their authority in the regions and intervened in local aristocratic politics to secure the election as bishops of men they could trust. This delicate balance of king, nobles and bishops meant that the kingdom was stable enough to allow the kings to rule with a light touch and often alongside the queens, but this was not good enough when the kings were young children. Compared with the hierarchical and centrally organized Byzantine Empire, the Merovingian court was loosely organized around kinship affiliation. This gave ample room for queens to step into the gaps and create a place in the monarchy for them to rule alongside their husbands or as regent. Like their Byzantine counterparts, Frankish queens closely followed the model of the Virgin Mary as they converted their families, forged ties with Christian bishops and abbots, and set about creating what we know as medieval queenship. But the relationship between sanctity and queenship is not at all clear-cut. Many early medieval queens had hagiographies written about them and were regarded as saints, but did not actually live the life of a saint. Rather, they worked with clerical writers to create and recreate their own images. These texts cannot, therefore, be taken as definitive evidence of a queen as saint but, rather, must be considered alongside other evidence to discern a more realistic and truthful account of a queen's life.

When the Latin word *regina* (queen) was used in sixth- or seventh-century Merovingian Francia, it seems to denote a king's wife, there being a distinction between queens and concubines. A queen was a fully-married wife with all that entailed in terms of family, property arrangements and public knowledge that protected her and her children's claims. Not all wives of a king were called queen, and a queen was something more than just a king's wife, but it is not clear exactly how the two were different. What is clear is that a Frankish queen faced possibilities and dangers, as much from intimate family members as from enemies outside the family, and sought protection for themselves and their sons and grandsons in the increasingly powerful and effective ecclesiastical institutions of church and monastery. They often collided with entrenched episcopal interests, but were careful to preserve the relationship which served to legitimate their status and authority as queen.

Frankish kings were in violent competition with their closest relatives, and even a Merovingian queen was never free of family encumbrances, even if she came from a family lacking in power. The rules of Christian marriage were not yet coherent or enforced, enabling the Merovingian practice of polygamy and concubinage to persist. This led to complex blended families that were as often at war with one another as with rival nobles. A woman could be easily repudiated or divorced for failure to bear sons, or simply for personal reasons. Because the status of the king's wife or bed-companion was poorly defined so, too, was queenship as office. This left royal women symbolically powerless, but they used their proximity to the king to act out a role of peacemaker, intercessor, patron of the Church and protector of the poor in a way that protected their masterful and warlike husbands. In the fratricide of the Merovingian period, sainthood could only flourish far from the royal sphere, so queens often took refuge in monasteries or convents, or did their work when their husbands were at war. The simple recounting of the life of an early medieval queen shrouds a complex historical conundrum that is common for queens, especially those of the early Middle Ages. The problems are the veracity and completeness of the extant sources, and the problem of authorial bias, particularly that of Gregory, Bishop of Tours, one of the most widely used sources for the period. As a Christian bishop writing *The History of the Frankish People* in the sixth century, his intention was to emphasize Christian values of peace, and his lurid descriptions of the violence might well be exaggerated for effect, to make Frankish royalty look bad.

The Merovingian kings and queens used a complex array of pagan and Christian rituals and symbols to distinguish themselves from their rivals. For a king, these included the insignia of royal rule such as a throne, a spear and a shield. A king's long hair was his most conspicuous distinguishing mark, a visible emblem of royal authority that separated them from their short-haired subjects. This valorization of an overtly heterosexual masculine form of kingship allowed Frankish kings to demonstrate that they could defeat their rivals, protect their family, preserve their authority and still adopt the Christian religion of their foes that promoted peace over warfare. Queens were crucial to monarchy as they offset this long-haired aggressive masculinity by using the Virgin Mary and Empress Helena as models for queenship, as they defined a practice of queenship grounded in Christianity. They joined forces with writers like Gregory of Tours, to write narrative histories that expounded on the virtues of Christian queenship as a civilizing force that legitimized the king's conquests and governance.

Early medieval Frankish queens were seen as apostolic agents of Christian conversion, best exemplified by Clotilde (d. 545), a saint and second wife of the Frankish king Clovis I. Clotilde was the daughter of King Chilperic II of Burgundy, who was slain by his brother Gundobad in 493, and whose wife drowned with a stone hung around her neck; one daughter took the veil and another was exiled. That same year, Clotilde, an ardent Christian, married the pagan Clovis, king of the Franks, who had just conquered northern Gaul. Clotilde worked hard to convert her husband, starting on their wedding night. She finally succeeded, according to Gregory of Tours, when Clovis converted mid-battle against the Alemanni in 496 and was baptized by Bishop Remigius of Reims. Her conversion of him, with its echoes of the conversion of Constantine and advocacy of Empress Helena, was of great significance for medieval society as a whole and queens in particular. Kings were concerned that, by converting at the behest of their wife, they would appear to be as weak and feminine. To counterbalance this, kings went out of their way to display an exaggerated masculinity. Bishop Remigius compared Clovis to Old Testament kings and invoked the precedent of Constantine as a triumphant Christian emperor. Gregory of Tours used Clotilde's feminine sanctity in his narrative to balance the warrior masculinity of Clovis, and her mediation was socially constructed to celebrate the triumphant king and provide a palatable justification for his conversion to a new religion by crediting his conversion to his wife and glorifying the defeat of his enemies, both Christian and non-Christian. After his victory over the Visigoths, Clovis had even assumed some of the imperial trappings at Tours, where he was hailed as 'Augustus'. This made it all the more logical and natural for Clotilde to imitate Helen and build churches and monasteries when Clovis went to war. She understood that the excessive masculinity of a long-haired warrior king needed to be offset by a queen's conventional piety, intercession, mediation and maternity.[38]

They had five children, three of them kings: Chlodomer (d. 524); Childebert I (d. 558); and Chlothar I (d. 561). A fourth son, Ingomer, died young and their daughter, Clotilde (d. 531), married Visigothic King Amalaric. The importance of commemorating the royal family is evident in the time and resources they lavished on Christian burial sites to house family members. They recognized the symbolic significance of the location as long as it was near their power base, and they were willing to transport the body considerable distances, spending large sums of money on the construction of the lavish churches that enveloped their tombs.[39]

After Clovis's death in 511, his four sons divided the kingdom equally, but Clotilde's position was uncertain. She retired to the Abbey of St.

Martin at Tours, but did not shy from violence in her defense of her family and may have used the feud to emphasize her position as daughter of one king and mother of three others. In 523, she avenged the murder of her father and incited her sons to wage war against her cousin, King Sigismund of Burgundy (son of Gundobad), who was deposed, imprisoned, assassinated. In turn, her eldest son, Chlodomer, was killed in battle against Sigismund's successor King Godomar. She may have made the point that she was still queen, but she was unable to prevent the strife among her children or to protect the rights of her three grandsons, the children of Chlodomer, against the claims of her surviving sons Childebert and Chlothar; Chlothar had two of them killed.

Clotilde's life, like that of Empress Helena, has taken on a quasi-mythic quality. A savvy, warlike king such as Clovis, converted by the persuasion of Clotilde and the Christian bishops, reaped the benefits of sharing the new religion with his subjects. Whether purely pious or merely strategic, Clotilde's actions were successful and widely imitated, with varying degrees of success. Her granddaughter Theodolinda, queen of the Lombards (d. c. 628), was pressured by the pope to convert her husband Agilulf, but he reacted violently, and abused her so badly that she died of her injuries.[40] Stories such as these, even the more wildly sensational and barely credible ones, attest to the fundamental incompatibility of monastic and royal milieus. As Christianity became the dominant, and then the official, religion of European monarchies, pious queens fared better but, in each case, the apostolic queen was recognized as a saint but the warrior king was not, unless he died as a martyr in battle.

This tension between the court and the convent are vividly illustrated by the life of Brunhild, queen of Austrasia and Burgundy (d. c. 613). The daughter of Visigothic King Athanagild of Spain (d. 567), she was twice married to kings: Sigebert of Austrasia (d. 566) and Merovech, the son of Sigebert's half-brother, Chilperic of Neustria. Merovech took refuge in, or was confined to, a monastery and played no real part in Brunhild's life, but male heirs were important to Brunhild, one of the earliest queens in the Middle Ages to serve as regent, work which occupied her for thirty-eight years. She ruled Austrasia and Burgundy for, and then with, her son, Childebert II, until his death in 596. Brunhild is credited with stopping Childebert from marrying the powerfully connected Theodelinda and approving his marriage to his concubine, Faileuba, presumably because she was less threatening to Brunhild's own interests. After Childebert's death, she ruled for her grandsons, Theodebert II (heir to Austrasia) and Theoderic II (heir to Burgundy).[41]

Unlike some contemporary queens who converted their husbands to orthodox belief, Brunhild was an Arian Christian who was converted to orthodoxy when she married Sigebert. She maintained diplomatic relations with Spain, the Byzantine Empire and Pope Gregory I, and a number of her letters survive. Gregory of Tours, whose election Brunhild probably influenced, praises her, but her policy of encouraging concubines rather than royal wives and her conflicts with some churchmen left her open to fierce attack. Her political skills and lengthy regencies riled enemies, among them Theodebert's wife (and Brunhild's former slave) Bilichild, who had Brunhild expelled from court. She took refuge with Theoderic in Burgundy and, when he died in 613, Brunhild tried to rule for the eleven-year-old heir, Sigibert.

The narratives of Brunhild's reign emphasize the violence, feud and vendetta in Frankish society and how women sometimes were able to use this to their advantage. This is evident, for example, in her life-long effort to avenge the death of her sister, Galsuintha, wife of King Chilperic of Neustria. Chilperic divorced Galsuintha and married his concubine, Fredegund, (d. 597) – the prototype for the scheming, murderous and amoral queen depicted as ruthlessly murderous and sadistically cruel by her contemporaries.[42] As Chilperic's concubine and servant to his first wife Brunhild, Fredegund persuaded him to put his wife in a convent and divorce her, but Chilperic's affections for Fredegund cooled. He repudiated her in 568 and married Brunhild's sister, Galsuintha, who died the same year, purportedly strangled by (or on the orders of) Fredegund, who then became queen. Brunhild plotted revenge against Chilperic, and a bitter and bloody feud ensued that lasted more than forty years. Fredegund is said to have ordered the assassination of Sigebert I in 575, and to have tried to kill Sigebert's son Childebert II, her brother-in-law Guntram and Brunhild. But she was vulnerable. All her wealth and power came to her through her association with Chilperic, who was killed by an unknown assassin in 584. She seized his riches and took refuge in the cathedral at Paris, leading to rumors that Fredegund was behind Chilperic's death. Both she and Clothar II, her surviving son and Brunhild's nephew, were protected by Guntram until he died in 592. Clothar II's cruel execution of Brunhild testified to the depth and longevity of his animosity toward her. In a lurid account, he reputedly had the elderly Brunhild stretched on the rack for three days and then chained her body between four horses that tore her body to pieces.

Both queens lived on in myth and legend. Brunhild is certainly a model for the fictional character of Brunhild, a powerful queen in Frankish and Norse legend, lover of Siegfried. Traces of that tradition are

found in the *Nibelungenlied*, well-known to opera-lovers in Wagner's Ring cycle. Fredegund is considered by some to be the source for the Cinderella story, based in part on an incident related by Gregory of Tours, who alleged that jealous competition between mother and daughter, Rigunth, grew so bad that Fredegund lured Rigunth to the treasure room and, while showing her jewels in a large chest, clamped down the lid on her daughter's neck and would have killed her had not the servants finally rushed to her aid.[43]

When the subject was more saintly, as in the case of Radegund and Balthild, churchmen depicted the queen in an entirely different light, one that naturally emphasized religious life. These biases make it very difficult to separate the saint from the queen, but other sources reveal much about Merovingian queenship. Radegund (d. after 590) was raised in the household of an uncle who had killed her father, king of Thuringia, in battle. When Frankish King Clothar I conquered Thuringia in 531, he killed most of the royal family and took Radegund and her only surviving brother as his share of the booty. She went from hostage to reluctant bride seven years later when Clothar, wanting to legitimize his claim to Thuringia, married her. They lived together for over ten years but she devoted her life to the Church, bringing churchmen into court and giving them gifts, making charitable donations, collecting relics and going on pilgrimage – causing Clothar to complain that he married a nun, not a wife. When he had her brother killed in 550, Radegund fled and refused to return.

Venantius Fortunatus (530–609), later bishop of Poitiers, was a frequent guest at the monastery, the queen's close friend and the author of the *Vita Radegundis*, a memoir of Radegund written around 600. He tells us that Radegund deliberately violated Clothar's expectations of a queen and that he was furious when he found out what she had done. Venantius then uses her renunciation of the queenly role as the basis of her sanctity. To him, sanctity and queenship were in opposition, not in harmony. But Clothar nevertheless supported her financially until his own death in 561. She founded a monastery in Poitiers with land and buildings provided by Clothar. Radegund entered it, probably after Clothar's death and, according to Gregory of Tours, worried about the fate of the monastery after her death. In a letter to local bishops, written perhaps in the mid-560s, she asked that they and their successors prevent anyone from disturbing the nuns, changing the Rule, or alienating the monastery's property.[44] Radegund was buried outside her monastery in Poitiers, much to the sorrow of the nuns who were unable to leave the cloister and could not visit her grave.[45] Two poems attributed to

Radegund, written in the form of letters to family members about the loss of loved ones and her isolation at court, may have been written with Fortunatus. Another contemporary, Baudonivia, a nun at Poitiers, wrote her life a few years later. Together with Venantius's *Vita Radegundis* and Gregory of Tours's *History*, these sources list the requisite miracles and pious deeds, but they also show her dealing with family quarrels and stubborn bishops, acting as a spiritual mentor to the women around her and living a pious and probably chaste life that served as a model for later queens such as Balthild (d. c. 680).[46]

The two contemporary accounts by Venantius Fortunatus and Baudonivia show how a queen's image was tailored to satisfy various audiences. With each telling of Radegund's story, the core details remained the same, but the authors or artists shifted the emphasis to satisfy new attitudes toward queenship and sanctity, new forms of piety and new patrons. Fortunatus emphasized Radegund's rejection of her royal status, presenting her as a saint who literally shed the wealth and clothing of a queen in order to embrace a monastic life where she endured a living martyrdom through silent self-mortification. Radegund's sister-nun Baudonivia, writing shortly after Fortunatus, also emphasized the monastic life but rejected the language of martyrdom, instead focusing on her work on behalf of her abbey and her collection of relics. She also shows Radegund as a maternal figure, an aspect of her life that was picked up later in an eleventh-century illuminated manuscript of her *vitae* written by the nuns of Sainte-Croix. The text of this version of her life again emphasized monastic life but placed the focus on the dramatic moment when Radegund removed her royal clothing and donned the habit of a nun. This manuscript contains a new angle in the story but includes representations of infants she healed. She appears in that humble dress for the rest of the manuscript, which primarily emphasizes Radegund's miraculous healings, worked within the walls of her abbey.

This vision of Radegund's holiness was contested in the thirteenth century by the chapter of male canons attached to the saint's funerary church of Sainte-Radegonde, when they added a set of stained-glass windows in the area closest to Radegund's tomb. Here, the canons relied on scenes from the nuns' earlier manuscript, but shifted the focus once again, this time to argue subtly for Radegund's continued royal authority by depicting her crowned and covered in fleurs-de-lis, the symbol of Capetian monarchy. This was done at the behest of the man who commissioned the windows, Alphonse de Poitiers, brother of King Louis IX, the sainted son of the formidable queen Blanche of Castile. In so

doing, they shifted the emphasis from the nuns in Radegund's cult to Radegund as queen of France. This image of the saint-queen remained popular through the Middle Ages and into the early twentieth century, when Radegund was named '*mère de la patrie*' by the French government in 1920. With that new focus on royal maternity, Radegund was fully transformed across time from a saint-queen to a queen-saint and, finally, to a queen-mother-saint.[47]

Like Radegund, Balthild, queen-consort of the King Clovis II (d. 657), was a queen for whom sanctity was integral to her queenship and not merely a familiar trope repeated in a heavily constructed source.[48] The most complete narrative source for her life is the *vita* written shortly after death, perhaps by a nun at Chelles who likely knew her and finessed details to make a convincing case for her as a saintly queen. But key details remain unclear. The author of her *vita* stresses Balthild's lowliness, describing her as a Saxon from Britain who was enslaved as a child, acquired 'for a low price' as a domestic personal slave by Erchinoald, mayor of the palace of the Merovingian kings. This description may be more the trope of conventional humility than truth. Janet Nelson argues that Balthild was not a low-born slave, but a hostage of loftier social rank used to leverage power among the Anglo-Saxon and Frankish elites. Using a range of evidence from sources other than her *vita*, Nelson points out that Balthild seemed more an insider than a lowly slave from another realm. She appeared completely comfortable with the complex politics of Merovingian monarchy, strategic in her thinking, at times unscrupulous. Stephen of Ripon, in his the life of Wilfrid, accused Balthild of ordering 'nine bishops to be put to death […] She was just like the most impious queen Jezebel' (*Eddius Stephanus*, c. 700). Balthild, whether of low or high birth, is a good example of the fluid, almost porous social status in early medieval society. The author of the *vita* knew how to exploit Balthild's non-royal status in a society where the nobility was not a closed elite and a woman of low status could be raised to the rank of queen. A poor person raised to high rank is a common theme in hagiographies, but some Merovingian kings did indeed marry low-born women, even slaves. Like Empress Theodora, a woman of low status, although rarely an ex-slave, could achieve effective power through her husband and with the Church.

But Balthild was isolated from her natal family, and the absence of family at hand may have been the reason she was spared the sort of violence faced by, or incited by, Brunhild and Fredegar. Erchinoald sought to marry her but, in a remarkably skillful maneuver, she avoided him by marrying Clovis instead, in 648. Clovis and Balthild had three

sons, all kings – Clothar III, Theuderic III and Childeric II; after her husband's death, she served as regent for Chlothar. Her feminine sanctity offered a face-saving compromise for Clovis, portrayed by his contemporaries as a drunken brute of a warlord who could afford no sign of weakness. She took refuge in monasteries and devoted herself to work on behalf of the church as a substantial patron of the prominent basilicas of St. Denis and St. Germain (Paris), St. Médard (Soissons), St. Peter (Sens), St. Aignan (Orleans) and St. Martin (Tours). She founded and secured episcopal privilege for the monastery of Corbie and refounded the convent at Chelles, where she lived a life that served as a moral model for future queens. In work that must have had deeply personal significance to her, she forbade the enslavement of Christians, prohibited the export of slaves abroad and ransomed captives. She sought to end simony and infanticide and generously gave to the poor – all quintessentially queenly things to do, but she took it further and had her own almoner. After her death in the early 680s, Balthild was revered as the latest in a line of holy Frankish queens.

Scholars are fortunate to have two additional pieces of unique evidence for Balthild: an article of clothing and a fragment of a signet ring. Balthild's so-called 'chasuble' is a testament of her personal piety (Illustration 1.2). This fragment of finely woven linen is the surviving front part of a two-piece tabard (apron), about 46 by 33 inches, embroidered with two concentric necklaces – a large pectoral cross and a large deep necklace with pendant medallions. It is significant that the embroidery was made of silk instead of the conventionally regal gold or silver threads, suggesting the riches of a queen's ceremonial dress but without the extravagant dazzle. Like her predecessor, Radegund, she was careful to evoke the splendor of a Byzantine empress like Sophia, but renounced costly splendor, going so far as to offer her gold jewelry to God. Whether or not Balthild wore this linen apron with silk embroidery when she served the monastic community, she seems to have self-consciously lived out the part of a saintly queen. The gold swiveling seal matrix, apparently from the bezel of a signet ring, found in 1999 near Norwich, bears stylistic affinities to Frankish seventh-century seal rings, but the contrasting images on its two sides are unusual (Illustrations 1.3 and 1.4). On one side is the face of a queen, bearing the legend BALDEHILDIS in Frankish lettering, and on the reverse is a very personal impression showing two naked figures in an erotic position beneath a cross. If this was a personal seal of Balthild, it may have been returned to her family in England after her death. Further study is needed to determine more conclusively whether this did, indeed, belong to Balthild.[49]

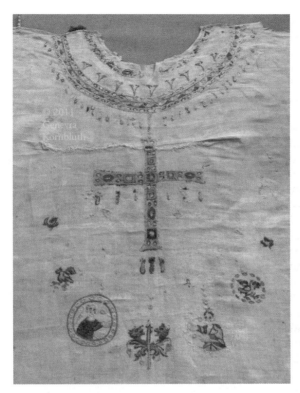

Illustration 1.2 Balthild's chasuble (linen with silk embroidery, Musée Alfred Bonno, Chelles), from the reliquary of Queen Balthild, the center portion with embroidery. © Genevra Kornbluth.

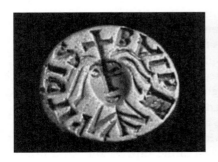

Illustration 1.3 Balthild seal matrix, c. 650–680 AD, obverse. © Norwich Castle Museum and Art Gallery.

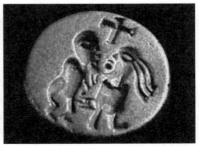

Illustration 1.4 Balthild seal matrix, c. 650–680 AD, reverse. © Norwich Castle Museum and Art Gallery.

Early medieval Britain and Ireland

Very little is known of queens in the political and social structure of Britain and Ireland before the Roman conquests of Julius Caesar in 55–54 BCE. This agrarian economy was organized around kin groups with chieftains leading extended families who often spoke different languages. The Roman invasions unified these disparate groups, lightly and temporarily, under the banner of opposition to Roman authority. Much of what we know of this period comes from the Roman historians Tacitus and Dio Cassius, who are naturally harsh in their depictions of the native populations, and archaeology (tombs, urban architecture, inscriptions), which confirms much of what the Roman historians said but also is useful for more clear-eyed evidence for cultural and social history.[50] The period may not have produced much historical writing on queens *per se*, but it is thick with stories of fictionalized queens, visual art, saints' lives and songs. Mythic and legendary queens appear often in poetry and prose works whose cultural imagination shaped ideas on women and power, and authority.

Two queens stand out amid a torrent of men in these histories, but the references are brief and many elements of the contemporary accounts may include more mythic details than hard evidence. These accounts are further evidence of how authors, in this case Roman pagan authors, used gendered ideologies to construct the images of queens. Cartimandua, the only female ruler in the British Isles of this period, referred to by the Romans as a queen, ruled the Brigantes, a Celtic people in what is now northern England, from around 43 to 69 CE. She appears to have been widely influential in early Roman Britain, having come to power around the time of the Roman conquest of Britain, and forming a large tribal agglomeration that became loyal to Rome. It is not clear how she came to power, but she allied with the Romans under Emperor Claudius and, in 57, surrendered her fellow Brigantes to the Romans in return for wealth and influence, only to be defeated and exiled in a revolt ten years later. Far better known was Boudicca, queen of the Iceni, best-known as the widow of King Prastutagus. She sought vengeance on the Roman armies who seized her household, flogged her and raped her daughters.[51] Cassius Dio described her as an awe-inspiring, heroic woman, 'very tall, in appearance most terrifying [... with] a harsh voice, and with a great mass of the tawniest hair [which] fell to her hips'.[52] She led a revolt against the Romans, sacked Colchester and wiped out part of the Roman Ninth Legion, only to be defeated and killed in 60 or 61 by the forces of governor Paulinus, whose rampage in the region subdued the local tribes

for generations. Her name can be roughly translated as 'Victoria', which accounts for the monumental Victorian-era statue of Boudicca erected in London on the Embankment, close to the Houses of Parliament.

Both Cartimandua and Boudicca are highly-gendered depictions of fierce females who tried unsuccessfully to defeat the valiant Roman army. They are noteworthy to the Romans only because their valor matched that of Rome and they failed because they were women and not Roman. Like the women in Tacitus's *Germania* who stand on the sidelines and goad their men into fighting harder, they function as critiques of Roman matrons, whom we can presume the authors felt were indolent and disloyal. It would be wonderful to have more substantial sources for the lives of Cartimandua and Boudicca, but the absence of evidence is not necessarily evidence of absence. Roman armies may well have encountered women like Cartimandua and Boudicca, whose lives ring true when we consider the real-life women of the early Middle Ages.

The metaphors of queenship employed by authors, Christian and non-Christian, were powerful political statements that endured throughout the Middle Ages. A good example of how queens functioned in legendary literature is Medb, the legendary Irish queen who led the men of Connacht against the men of Ulster to seize the great bull of Cooley in *Táin Bó Cuailnge*.[53] She had a reputation as a nymphomaniac who married nine husbands and took one illustrious love, Fergus mac Róich. She symbolizes the threat of a voracious, powerful woman to men, particularly threatening their manliness. Her name, which literally means 'the intoxicated one', links her to a drink consumed by a new king at his inauguration. Legend has it that the drink was given as a token of true kingship by the goddess of sovereignty, who also sleeps with him. In one version of the story, she had Fergus's sword, and thus his sexual potency, stolen from him. In stories such as this, and in depictions in art and material culture, whatever really happened is less important than the way women functioned as part of the founding myths of the early Middle Ages.[54]

The figure of the queen in literature and visual art served to convey and model cultural ideals of women and power in this period of great flux as Roman power finally collapsed in the fourth and fifth centuries. Local groups – Picts, Scots, British, Angles, Saxons and Jutes – began to migrate or invade widely, from Ireland to England and Scotland to Brittany. Raiding, settling and intermarrying forged a form of rulership in these societies that depended on success in battle and the accumulation of wealth. Literary and visual sources are creative works of imagination that describe an idealized archetypal image of queens that reflects

truths about queens and queenship but may not be, in fact, based on people who actually lived. But these images, no matter what the form, brought the queen and empress into the daily lives of her subjects in the church and the marketplace. In this, they are mediatory figures, the bridge (some local, some foreign-born) of various tribes, Church and 'state', and literate and non-literate culture. In this society, women are meant to contrast heroic masculinity, and they participate in the creation of new political and social forms. These depictions of strong women are strongly gendered. The queen's power, no matter how substantial, derived from her status as daughter, wife and mother. The expectations and actions of publicly powerful queens, whether legendary or real, were determined largely by the fact that they were women and that they were also part of a broader category of 'woman'. They were subject to the Western stereotypes of sexual temptress, of weakness and incapacity, adultery, fickleness. Even though they may have gained their power and authority as mother or wife, it was as 'woman' that they were most often judged.

Flesh-and-blood queens in early medieval England were extremely powerful. Seventh-century England was not a kingdom but a series of kingdoms held together with an overlordship, often cemented through marriage. There were no regents, no women ruling alongside sons. Female regency in general in the early Middle Ages was not a universal practice in a society that valued warrior kingship and preferred an adult male ruler. But in Europe, by the tenth century, there was a growing acceptance of direct succession to royal inheritance from father to son, and fears that a rival dynasty would seize power from a child king could make female regency unlikely.

This age, termed 'Anglo-Saxon', was a blend of the complex cultural and political society with roots in the Frankish immigration and British survival. From this amalgam, queenship was a construction of new lineages of power, family and religion. The Angles and Saxons migrated to England from the continent, bringing their language and their cultural, political and social traditions with them to Britain. From these roots of the Anglo-Saxon language, we have the word *cwen*, the etymological root of the modern word for a queen. A feminine noun, it was first used in the *Anglo-Saxon Chronicle* (722) as a title for a queen, or any noblewoman or wife. Related, but distinct, is the word *cwene*, a 'weak' word (archaic: *quean*) used more broadly than *cwen* to denote a wide range of women, not only those of noble or royal status but also a female serf, hussy, or prostitute. The definition depended on context. Among those of royal status, a queen was always a king's wife, not excluded from the succession

and not necessarily seen as unfit to rule or govern. Anglo-Saxon society inherited a long tradition of reverence for female counsel, as is clear in Tacitus's *Germania*, where he lauds the women for the wisdom of their advice and the men for seeking it.

The principal narrative source for this period, Bede's *Ecclesiastical History of the English People* (734), is, like so many sources for the early Middle Ages both useful and problematic. He selectively focused on a single issue, the progress of Christianity and, particularly, the special role of the Northumbrians in the history of salvation. He avoided difficult contemporary events and was not interested in political or material culture; however, queens figure prominently in his narrative as part of the process of converting – and, in his view, civilizing – pagan kings. Anglo-Saxon England, in his hands, was an age of the saint-queen. Balthild's monastery at Chelles was one link that bridges the continent and Anglo-Saxon Britain through Christian missions that were active by the sixth century and provided the models for queenly practice. For example, two conditions of the marriage of Bertha (d. 612), daughter of Merovingian King Charibert and his queen Ingeborg, to Æthelbert of Kent were that she be allowed to practice her faith unfettered and to bring a Christian bishop with her. She converted Æthelbert and their subjects.

This model of Anglo-Saxon queenship was continued by Æthylthryth (d. 679), queen in Northumbria, consort of King Ecgfrith (645/6–685) and abbess of Ely. Bede tells us that Æthylthryth remained a virgin despite two marriages. However, his style of writing history is heavily exegetical and he relies on conventional types of women to make his point. We cannot fathom her motives, but it may be that her career as a saintly queen developed because the marriage produced no children, rather than that the marriage produced no children because she actually lived a chaste life. She was one of four daughters of King Anna of East Anglia (d. 653), all of whom eventually retired from secular life, founded abbeys and were venerated as saints. According to a local twelfth-century source, the *Liber Eliensis*, Æthelthryth was born in Exning, in west Suffolk. In 652, probably while still very young, she married Tondberht, an ealdorman or prince of South Gyrwe. He died three years later and, in 670, she married Ecgfrith, the son of King Oswiu of Northumbria: it seems that this marriage was chaste, too. Like Radegund, she sought protection and solace in a convent. In 682, she was consecrated a nun by Bishop Wilfrid and entered the monastery of Coldingham, where her husband's aunt was abbess. One year later, she founded and ruled a monastery on her estate at Ely and later gave Bishop Wilfrid the large estate on which he founded the monastery of Hexham. Bede, in the

Ecclesiastical History of the English People, described her life at Ely as strictly monastic and ascetic, and she may have showed prophetic powers. In 695, sixteen years after her death, at the translation of her relics organized by Abbess Seaxburh to seal her sister's status as a saint, her body was found incorrupt. Queen Æthelthryth's saintliness, not her regal status, is given special prominence in a lavish illustration in the Benedictional of St. Æthelwold. The manuscript was made for the personal use of Æthelwold, Bishop of Winchester, one of the leaders of the late-tenth-century monastic revival in England, and the text, written in Latin, contains special prayers for use by the Bishop when pronouncing a blessing over his congregation at mass. A number of the most important saints are represented among its twenty-eight surviving miniatures painted with bold, incisive lines and luxurious ornamentation. In a full page illustration, Æthelthryth the saint stands inside a heavy border decorated with a design of acanthus, with a halo encircling her head and clothed in robes of gold (Illustration 1.5).

Her cult continued throughout the Middle Ages, but her life and those of a number of virginal or chaste queens who followed her beg the question: what did a king achieve by remaining in a chaste marriage? Ecgfrith divorced Æthelthryth in 678 and took another wife; this was to be expected in a warrior culture that valorized virility and in a society that recently had converted to Christianity, a conversion that could best be described as precarious. But what would possess a king to remain married for eight years to a wife who remained a virgin, or at least chaste? Jo Ann McNamara argues that feminine sanctity offered a face-saving compromise for warrior kings who used the queen as a foil for the perceived weakness of conversion to religion of the conquered, suggesting that the king signified the masculine and warlike face of monarchy while the queen was the feminine and spiritual side. Stafford (1983) calls Æthelthryth 'sterile', which suggests that virginity or chastity may provide cover for a queen who cannot bear children. Æthelthryth was successful and widely imitated: in each case, the apostolic queen was recognized as a saint but the warrior king was not, unless he died as a martyr in battle.

Ireland poses challenges for queenship scholars because of the complexity and unfamiliarity of the political structures that characterized sixth- and seventh-century Ireland.[55] At this time, there were many political units (*tuatha*) of exceptionally small size – maybe fifty, maybe a hundred, maybe even more. Each *tuath* had its *rí* (king), who had military and administrative responsibilities. Ireland preserved this system of plural kings longer than other regions of the west, but it may have to do with the way kings and over-kings could be selected from major and minor

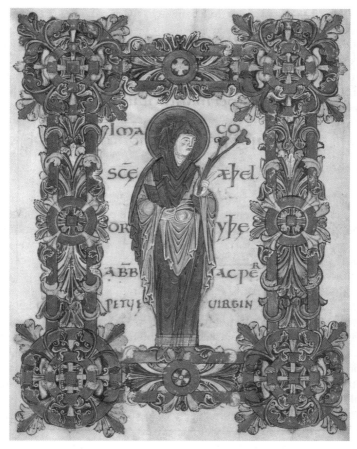

Illustration 1.5 Queen Æthelthryth, Benedictional of St. Æthelwold, c. 973. London, British Library, Add. 49598, 90v. © British Library Board.

branches of the royal family. In this, royal woman may well have been crucial in who ruled. A man could legally have many wives and concubines, and Irish queens are present as witnesses to charters and property transactions, and as brokers of peace among noble families. But, until the tenth century, little is known about these queens except through their sons who gained a kingdom through success in battle or inheritance.

Much more is known about northern Ireland in this early period, which was dominated by the different branches of the Uí Níeill family and the rulers of the Ulster people, the Ulaid. By the late sixth century,

four major Ulaid *tuatha* occupied the extreme north-east of Ireland and were ruled, respectively, by the dynasties of Dál Riata, al nAraide, Dál Fiatach and Uí Echach Cobo. The rulers of the Dál Riata ranged widely across northern Britain and Scotland in the late sixth and early seventh centuries, coming at first into conflict with the English as they sought to establish Bernicia (Aedáin was severely defeated by the English at Dawston) and an mac Gabráin coming subsequently into conflict with the Picts.

The Iberian Peninsula and Italy

In Visigothic Spain, vestiges of Roman law held sway longer than elsewhere in the west and elective kingship made queenship unstable. The Roman provinces on the Iberian peninsula of Hispania and Septimania were politically and militarily unstable as new regional powers, and invading Sueves and the Visigoths took over in the sixth century. Religious unification after the banning of Arian Christianity in 589 strengthened the Gothic nobility and elites of Roman origin as the Church gained prominence in the political life of the kingdoms. Kings, elected rather than dynastic, were weak and had to negotiate with the powerful secular nobility and Church, which was an arbiter between the royal power and the high nobility. The close association with the Church empowered queens who, like their counterparts elsewhere, were active agents of conversion and drew power from their family ties to Frankish royal families.

The best-known Visigothic queen is Gosuintha (d. 589), who married two Visigothic kings and was a significant force not only while they lived, but also as their widow. With her first husband, Athanagild (d. 567), she had two daughters who married Merovingian kings – Brunhild, wife of Sigibert of Austrasia, and Galsuinhta, wife of Chilperic of Neustria – and figured prominently in early medieval history. Gosuintha's second marriage was to King Leovigild, already the father of two sons, Reccared and Hermenegild, whose marriage to his cousin, Ingunda, daughter of Brunhild and Sigibert, tied the royal families even more closely. Family strife, so common among these royal families, erupted into violent civil war in 579, when Gosuintha and Hermenegild staged an unsuccessful rebellion against Leovigild. Gosuintha retreated from politics until Leovigild's death in 586, when she returned to the center of power when Leovigild's son Reccared adopted her as his mother and tried to broker a peace with the Frankish king.[56]

The strong influence Christian bishops had on legitimizing the authority of Visigothic kings, and the importance of queens to what church officials considered proper kingly behavior, is evident in a pair of poetic epitaphs written by Eugenius II, bishop of Toledo, about King Khindaswinth (d. 653) and Queen Reciberga (d. c. 646). Khindaswinth seized power in a coup after a civil war, executed scores of enemies and confiscated their property. He was elected king and anointed by bishops in 642 and later made amends by re-establishing the Visigothic monarchy, promulgating new civil laws and donating substantially to monasteries and churches. The king and queen were buried together at the monastery of San Román de Hornija, the beneficiary of royal patronage. This is the only concrete evidence we have about Reciberga except for her marriage to Khindaswinth and a pair of epitaphs (her signature appears on a charter to a monastery, but scholars doubt that it is authentic). In the epitaph for Khindaswinth, Eugenius wrote in the voice of the king, who described himself as 'ever the friend of mischief; perpetrator of crimes [...] impious, obscene, scandalous, shameful, wicked, never willing the best, always up to the worst [...]' who in death repented his sins, 'The chartered trappings of kingship now profit me naught, naught the green jewels, the diadem's luster.' The epitaph for Reciberga begins with a familiar litany of praise for the queen's devotion to her husband, concern for his soul, rejection of worldly possessions. Eugenius continued, and he spoke for the king with a tenderness that hints at his affection for the queen and that may well have been what Khindaswinth felt for Reciberga.

> Were it allowed to exchange gold and jewels for death,
> No ills could have broken apart the life of these monarchs.
> But since one common lot shatters everything mortal,
> Wealth cannot exempt kings, nor grieving the poor.
> Hence I, O wife, unable to overcome fate,
> Commit you with these rites to the care of the saints
> So that, when devouring flames come to consume the earth,
> You may arise a worthy member of their company.
> So now, Reciberga, my beloved, farewell:
> Thus I, King Khindaswinth, prepare my beloved's bier.
> All that remains is to state the brief span of time
> That contained her life and our union.
> The pact of our marriage endured almost seven years;
> She was then twice eleven years old, plus eight months.[57]

Considerable reading between the lines and through the known facts of Khindaswinth is needed to glean even the most rudimentary information about Reciberga's life. The epitaph tells us that she was 16 when she married and 23 when she died around 646. Khindaswinth was about 76 when he became king in 642, making him close to 73 when he married her in around 639. The age difference of nearly 60 years clearly was not something of concern. From his other works, we know that Eugenius was a harsh critic of unseemly behavior so it is doubtful, but not improbable, that she had been the king's concubine. The reference to the strength of their bond ('No ills could have broken apart the life of these monarchs') suggests that they probably were married legally by the church. No children are mentioned, but the king did have a son Recceswinth, who ruled with him from 649 and succeeded him at his death, so it may be that Recceswinth's mother was a concubine and Reciberga the king's first legal wife.

As with so many Visigothic queens in Spain, so much is not known – her family, whether she was crowned, her religion when she married Khindaswinth. But it is clear that she conformed to the sort of orthodox piety and behavior that made Eugenius so sympathetic to her. It is possible, likely even, that Eugenius was following the rhetoric of his clerical counterparts Gregory of Tours and Bede in using the trope of a good Christian queen married to a less-than-savory king as a way to model kingship and queenship for future generations.

A century later, the outlines of queens' lives becomes clearer and the details are more abundant. Visigothic family squabbles tangled with Merovingian politics of adultery and revenge when Gosuintha's daughter, Galsuintha, was repudiated by her husband Chilperic in favor of Fredegund, who then murdered her rival, or gave the orders for this to be done. A powerful queen dowager such as Gosuintha was probably on the minds of Kings Ervig (d. 687) and Egica (d. 702) when they forbade the remarriage of royal widows to prevent them from exercising too much secular power. Instead, royal widows were forced to enter a convent immediately after the death of their husband.

Italy suffered a dramatic demographic, economic and political decline in the face of the collapse of Roman authority and the onslaught of Gothic migrations and invasions. The center of power shifted when the Byzantine Empire, the eastern and wealthier portion of the Empire, took precedence during the rule of Constantine in the fourth century. But political and military ties between northern Italy and the Byzantine Empire remained strong, and bolstered the strength and prestige of the Ostrogothic and Lombard monarchs. For example, Ostrogothic Queen

Amalasuintha (d. 535), daughter of Theodoric the Great (d. 526), was regent for her son, Athalaric, after her father's death until 534. She governed in the face of Lombard and Frankish invasions, allying with the Byzantine Emperor Justinian, whose General Belisarius had secured a tentative peace in northern Italy. Hoping to bolster her position and her authority, she took the title of *regina* with her cousin Theodahad as a partner but not as her husband (his wife was still living). The strategy backfired, however; Theodahad, either by his orders or with his permission, had Amalasuintha imprisoned and murdered in her bath.

With the death of Emperor Justinian in 565, the center of power shifted again, this time westwards, toward the Frankish realms. Theodelinda (d. 628), daughter of Garibald I of Bavaria, was a diplomatic pawn in complex marital strategies exercised to gain political control. The Merovingians sought an alliance with the Bavarians and proposed a marriage between Theodelinda and King Childebert II of Austrasia, while simultaneously arranging a marriage between Childebert's sister and the Lombard King Authari. Both these proposals fell through. Authari recovered from the slight and agreed to marry Theodelinda, prompting the Merovingians to send troops into Bavaria.

Theodelinda fled to Italy, married Authari in May 589 and, with help from the Byzantine emperor, they defeated the Franks who invaded Lombardy in 590. When Authari died later that year, she married Athuari's cousin Agilulf (d. 616); she served as regent for their young son, Adaloald, and enjoyed a peaceful and creative reign. She was a key figure in restoring the architectural fabric of Italy and engaged in church-building in Lombardy and Tuscany, including the cathedral of Monza and the first baptistery in Florence. Like Empress Helena, she was an avid relic collector and received from Pope Gregory I a reliquary believed to hold a portion of the True Cross.

Conclusions

No matter how much queenship in the Middle Ages resembled earlier Roman forms and adopted or adapted to local customary practices, it was in many important ways a new form of political and social organization. Christianity, whose leaders pioneered a new conception of power as sovereignty, made queenship distinctive. The dominant theme of early medieval queenship is derived from the joining of Roman notions of gender and political power with Christian ideas on virginity and marriage. The distinct customs and practices of the ethnic groups of the

barbarian kingdoms account for much of the variation in queenship and kingship in the early Middle Ages. The political organization of these groups was distinctly different from that of Rome, and their ideas on lordship and monarchy naturally led to new ideas on queens and queenship, centered on the family. The development of queenship can accurately be characterized, therefore, as incremental change along a spectrum of continuity.

The Byzantine Empire retained much of the late imperial Roman culture and law but, in the west, kingship was personal, patrimonial and lodged within the royal family household. Queens owed their position to their families, to the circumstances of their birth, marriage and motherhood. But, as the lives and reigns of early medieval queens and empresses show so clearly, family is not a trans-historical constant. In the early Middle Ages, kinship was one of the most important social bonds and, in much of Europe, the exchange of women in marriage functioned somewhat like gift exchange. As in all gifts, the bride represented the giver to the receiver. She was a constant reminder of friendship or enmity, ally or hostage, or spy. A daughter who represented her natal family was a form of human treasure and how she was given or taken was crucial. Radegund was booty for King Clothar and her family was humiliated. Osthryth was given freely by her father, King Oswiu, to the king of the Mercians to bind peace and friendship. Queens legitimized the dynastic intent of the king and this strengthened them as the bearers and nurturers of the future king.

This period in the development of medieval queenship is noteworthy for the importance of Christian sanctity and piety as a key characteristic that distinguished it from other or older pagan forms. A Roman empress was expected to worship the gods and take part in all the public religious ceremonies, but there was no explicit expectation that she do anything more than that. Maternity and marital fidelity, not virginity and chastity, were the norms. But Christianity changed all that with the figure of the Virgin Mary as a model for queens and empresses. With Empress Helena for a model, later queens were expected to embrace – or, at the very least, were expected to seem to embrace – a form of queenship that blended sanctity and maternity. In this, they were the pious queenly counterpart to warrior kingship and, together, they comprised the nucleus of medieval monarchy. Radegund and Balthild achieved this better than anyone else, but they set a lofty standard. A very human and less-than-saintly queen could face harsh criticism when her very human nature did not live up to such expectations. But the sources for the period make it hard to separate the queen from the saint. The rhetorical sword could cut

many ways, however, and even the most sexually circumspect queen who acted in ways that riled her enemies could find herself the target of rumor and innuendo, accused of infidelity, sorcery, or worse.

What this work on late antique and early medieval queenship in eastern and western Europe makes clear is that queenship and kingship developed side by side from the same raw material of culture, forming two aspects of monarchy. Queenship studies, by making evident the role of the queen or empress in a wide range of activities, in both a public and a private setting, and across a wide swathe of time, have changed the historiography of kingship. Where, once, scholars looked only at long-haired warrior kings and pondered their relationship to the Church and the nobility, now we see how queens were fundamental to the formation of monarchy by legitimizing a king's rule through marriage and by bearing children. This is a theme that will be explored in later chapters, and it will undergo various changes over time, but the essential dynamic role of the queen was central to the theory, construction and practice of monarchy.

Many empresses and queens in the early Middle Ages, endowed with talent and aristocratic descent, could overcome gendered ideologies used by writers to construct the images of queens and as a basis for criticism of them and the kings. The sources for queens of this period raise questions of the extent to which textual representation of queenly behavior influenced the parameters of what was possible for real queens. The different representations of queens such as Balthild and Fredegund highlight important differences, real or imagined or exaggerated, among the queens that mattered greatly to their peers. Early medieval queens were more than ceremonial mead-cup bearers, perpetual virgins or passive pawns in a diplomatic game. Whether empowered by virginity or marriage, queens – whether consecrated as a queen, the king's wife, a concubine or a bed-companion – had shared in the public work of monarchy since the Roman Empire in distinct ways.

For further research

There is still much to be learned about the precise scope of what queens actually did and the significance of changes in the early Middle Ages. There is a wide range of sources for the study of early medieval queens and empresses, but they are not plentiful; also, they are tricky to use and interpret. Many inhabitants of early medieval realms in both east and west were pre-literate and therefore did not leave much in the way of

written records. We are left with a patchwork of material that varies greatly in quantity and type across wide geographic regions and is not continuous for any given time.

Interpreting early medieval textual sources demands a close reading, preferably with a solid command of Latin or Greek, for small details and a methodological approach that filters the evidence like a sieve. It is the art of interpreting scattered evidence, letting the sources speak on their own terms, in their own way. This is particularly true for the early Middle Ages, a period for which we lack the sources that make later periods so rich, such as letters, household accounts and administrative records. In many sources, queens are not the main subject of the chronicle and most often appear alongside kings. Narrative sources composed by elites who worked for the Church or court show a queen at the center of a kin group associated with a king, most likely her husband or her father. Chronicles and annals, so useful for study of kings, pose problems for the study of queens. Women appear from time to time in Roman narrative accounts such as annals and chronicles by Tacitus and Dio Cassius – notably, the early British queens Cartimandua and Boudicca – but only because the queens were engaged in the military actions that form the main point of the narrative. There are distinct differences among the chroniclers themselves that affects our reading of, for example, Bede and Gregory of Tours. They both emphasize the role of queens in the conversion of pagan kings, but Bede's narrative focused on kings and queens in a positive way, while Gregory of Tours wrote harsh critiques of queens based on his misogynist assumption of the inferiority of women.

Queens appear often in the literature of Britain and Ireland, as well as that of Gaul, Francia and Iberia, but references to them are problematic because they are most often written by men and are often slanted in favor of men's deeds. As the field of queenship studies has grown so, too, has grown a demand for new editions of previously unknown, unedited or untranslated, or underutilized narrative sources – such as chronicles and saints' lives, and sources such as epics, sagas, poetry and songs.

Administrative records, particularly land transactions, charters, dower and dowry records, and wills are important testaments to a queen's actions, but their survival in this period is patchy. Secular and canon law codes provide insights into what a non-royal woman could or could not do, and are vital to understanding the society's expectations of a woman. But they are proscriptive, not descriptive; they do not tell us what a queen did, only what she probably could not do. Even though queens were not above the law and were bound by it, their status afforded them a legal leeway that an ordinary woman may not have had.

Even when the source material is a reasonably reliable testimony to actual behavior, the intent was not simply reporting; there was an underlying political motive to establish queens as the 'saving saint' counterpart to their 'worldly warrior' husbands. The author's eyes were often focused on glorifying the queen. Extant administrative evidence, such as laws, estate surveys and charters, is not plentiful but it is highly suggestive of a queen's actions, testifying to her presence at high-level meetings and her lordship of lands, both secular and ecclesiastical. Law codes of the Visigoths, Burgundian and Salian Franks and the Lombards provide important evidence for the legal status of women and political theory on queens and queenship. Latin inscriptions, particularly for southern Europe, and runic inscriptions for Scandinavia and letters written by queens, notably Radegund, although not plentiful, have survived and much of this material has been transcribed and translated. A robust collection of letters by and to queens is available in translation in printed editions and online (http://epistolae. ccnmtl.columbia.edu/) which, even taking into account the fact that the letter was probably written by a royal scribe and may have been composed in part by a learned cleric, demonstrates a high level of literacy and eloquence.

Some of the most suggestive and compelling evidence comes from material culture. 'Stones don't lie', say archaeologists, meaning that material evidence is not inflected with medieval biases or modern presumptions about power and gender. Still, no matter how impartial evidence from digs at grave sites, urban settlements and along trade routes may seem, it is subject to an interpretation of the artifacts and is just as subject to bias as the chronicles. The only difference is that the bias comes from the modern scholar, not the medieval one. Archaeological evidence and art are extremely useful, but this evidence is fragmentary and incomplete, and the evidence is skewed in favor of men. This may be interpreted as the clear sign of the power of a patriarchal culture, or it may be that the sites themselves – grave sites and village or urban settlements – are not the best places to find evidence of queens. Grave sites and the built environment, domestic palaces and military fortified castles have generated a considerable body of literature by archaeologists, art and architectural historians and, recently, bioarchaeologists (who examine human remains). In pagan cultures, grave goods can be more than just weapons. A grave may contain a wide array of personal objects, reliquaries, royal treasuries, clothing, signet rings, seals and jewelry. But it is not at all clear why there appears to be a near absence of queens in royal burial sites. This absence of queens is puzzling. It may have to do with different burial customs; that perhaps a

queen preferred to be interred in a convent rather than alongside her husband. It may be due to the fact that cremation was more common among pagans. Christianity discouraged burial with goods, so the female skeleton found in a convent cemetery without any marker stone to identify the body, and without any jewelry or obvious regalia, may well be a queen. Perhaps it has to do with the fact that queens were not yet routinely crowned and, thus, do not bear the sort of regalia that we normally associate with queens. It may be that the high-status women's objects in a hoard or grave site may have belonged to a queen, but a great deal more work needs to be done to determine this with any certainty.

Archaeology is a highly technical field, and is often daunting for scholars of the humanities. Architectural and art historians and cultural anthropologists are vital to the interpretation of the material found that may provide vital pieces of evidence for the life of a queen. Feminist approaches to archaeology and medical history have opened new pathways for interpretation of evidence long considered mainly to be about men. The journal *Medieval Archaeology* is the logical starting place for research, but many regional and national archaeological societies publish their research in specialized journals, and provide bibliographic references and databases – many with abstracts – that cover all aspects of archaeology and the historic environment with a geographical focus.[58] But, coupled with narrative sources, archaeology can be a powerful tool. For example, knowing that long hair was an attribute of early medieval kings, archaeologists were able to identify a decomposed corpse as one of King Chilperic's sons.

Visual art – such as icons, illuminated manuscripts and tomb sculpture – provide a wealth of eloquent symbolic depictions of queens and their families. Byzantine art is particularly rich with images of empresses on coins, seals and ivory plaques, in mosaics, and, in a unique form of representation, as steelyard counterweights. Architectural remains in the form of Latin inscriptions, epitaphs and runic inscriptions provide details such as birth and death dates, laudatory poems and anecdotes that a saint's life or chronicle omits.

2
Legitimizing the King's Wife and Bed-Companion, c. 700–1100

Empress Adelheid of Burgundy (d. 999), daughter of King Rudolf I and Bertha of Swabia and second wife of Emperor Otto I, was easily the most prominent European woman of the tenth century. A group of queens and empresses related to her by blood or marriage played key roles in various realms of Europe. Queen Emma, Adelheid's daughter from her first marriage to Lothar of Italy, married Adelheid's nephew Lothar, king of the West Franks. Adelheid's son with Otto, succeeded his father, ruled as Otto II and married the Byzantine princess Theophanu. Her nephew, Hugh Capet, was king of France. Adelheid was thus the daughter and sister of rulers of Burgundy, wife and widow of a king of Italy and a German emperor, and mother and grandmother of emperors, kings and queens.[1] Much of north-western Europe was ruled by the women of this family who used a network of family to support one another. They met often to discuss and resolve problems of succession and family relations, presided over legal cases, received the oaths of nobles, granted land, signed as witnesses for legal documents, distributed patronage and petitioned for aid. They worked within an office of queenship that was still unstable and not clearly defined. They worked with, alongside, and for the king, but none of them ruled in their own right as a female king. They normalized female power, making it acceptable, and transformed the theory and practice of queenship, kingship and monarchy.

The first kings of the dispersed kingdoms formed in this period were often little more than 'first among equals', a lord much like any other who gained new lands by conquest or by marriage. These kings initially possessed a title and nominal authority, but little real power over realms, which were loose collections of persons and institutions. It took centuries for kings truly to govern the more centralized and geographically larger proto-national political units. Christian kingship in the eighth and ninth centuries took shape with theories about the king as ruling by the grace of God. This strengthened royal authority, but the price a king paid for this was an increased responsibility to obey God's commandments and, thus, God's earthly representatives – the bishops and popes. The language of monarchy was the language of the bible and canon law as much as it was the language of secular law. A political crisis, therefore, carried the seeds of a theological crisis, which could potentially curtail the king's authority. This, in turn, meant that the bishops and popes who sanctioned a queen as legitimate could also use their authority to declare that marriage illegitimate. The bishops and popes did not always speak with one voice, but the rhetoric they used was a devastatingly effective tool and one of the keys to forming modern interpretations of queenship and gender.

The political history of the period is essentially a period of invasions punctuated by periods of relative calm. There had been sporadic Scandinavian coastal raids on England and the continent, but the Vikings threatened the Anglo-Saxon and West Frankish kingdoms over the next century and left a lasting imprint. They settled in Normandy and in the northern and eastern parts of England (known as the Danelaw), and then, newly reconfigured as the Normans, returned to conquer England in 1066. Merovingian kings were succeeded in 751 by a dynasty known to us as the Carolingians, who crafted an unwieldy empire that stretched across the continent and then divided it a century later. After the division, nobles fought over the regional fragments that, by 1100, had regained their strength and were led by dynasties with remarkable longevity. The Ottonian dynasty began in 919 and lasted until 1024, but Capetian France had even greater longevity, from its origins in 987 until 1328.

The rise and spread of the Muslim states in the Mediterranean in the middle of the seventh century left an indelible mark on the Byzantine Empire and Spain. In the east, the seventh century was a watershed that fundamentally altered political geography as the Empire contracted. The Christian Visigothic kings fled northwards after the Muslim invasion of 711 and maintained a tenuous hold in the kingdoms of Asturias and

Pamplona throughout this period. Their descendants lived alongside and waged a war against Muslim caliphs from the late eighth century until around 1248 and also between 1482 and 1492, finally ending with the conquest of Granada. In the ninth century, Magyars from around the Ural Mountains entered central Europe and disrupted the fragile hold that many kings in the Carpathian basin and the Balkans had forged out of the demise of Roman imperial authority. In Italy, the Lombard kings were absorbed into the Carolingian empire. Only the Byzantine Empire retained the integrity of its geographic and political boundaries but, in the late eleventh century, the threat of Turks in the east and the arrival of Crusaders from the west posed serious challenges to the Empire. But the invaders settled, married and gained political authority so that, by around 1100, European society as a whole was more stable and economically prosperous, with new realms, or realms newly-converted to Christianity, in Saxony, Scandinavia, Kievan Rus', Poland, Bohemia and Hungary.

Queens played a crucial role in these events. They remained active partners with kings, although most often as participants in, but not instigators of, royal governance. The term *consors regni* (royal consort, or sharer in rule), originally used to describe men who shared imperial rule, became a common phrase to describe a queen, and it signaled that men considered queenship as an essential component of monarchy. Queens bore the kings' children, were vital to their education and arranged their marriages. They forged close ties with popes and bishops, crafted marriage alliances, acted as intercessors on behalf of their subjects with the king and were important patrons of art and architecture. The personal nature of ruling made the court the symbolic center of the entire realm and, as queens organized the domestic context of monarchy, they were themselves vital to the spectacle of the public context of court. The practice of queenship changed in response to changing circumstances and reforms enacted both by the royal court and the papacy in Rome. These changes were neither abrupt nor uniform from place to place, but they were perceptible. They were advantageous to men and fundamentally affected the nature of a woman's legal, social and familial position, but not all change was necessarily disadvantageous to queens. This does not mean that queenship was ambiguous or entirely circumstantial, or that some societies were more or less patriarchal; rather, it indicates that social change did not follow a predictable path. This chapter traces these changes, both secular and religious, and outlines how queens adapted their practices in the private and public domains of court and church.

One of the most significant transformations of queenship resulted from newly-articulated ideologies of Christian marriage that combined with political circumstances to make individual queens more secure. Ideology, politics and security encouraged the formalization of another element of marriage into queenship practices: that of partnership. It was hardly equality, but the liturgy articulated ideas of partnership in life and that translated into political partnership. The marital bond was further strengthened by church reform and legislation. Laws, both secular and canon, privileged the inseparable Christian marital bond. A king was still likely to take one or more concubines in his adolescence, while unmarried and under his father's tutelage, and concubines often came from high-ranking families. Several became an official wife to a king once he succeeded his father; the sons of royal concubines could be treated as royal heirs, but only until a legitimate son was born of a marriage. As kings adopted Christianity, they had to accept Christian canon law that, in 400, prohibited concubinage as a form of bigamy. Clerical thinking on concubinage was inconsistent until the eleventh century, although it was strongly discouraged, and most kings felt the sting of papal disapproval sufficiently deeply to cease the practice. It was still possible for a king to repudiate his wife, but by the tenth and eleventh centuries, divorce was becoming much more difficult to obtain. Divorce and remarriage were allowed only when the first marriage proved barren, infringed laws on consanguinity, or where one party was guilty of adultery. Sex outside marriage was prohibited but, unsurprisingly, adultery would continue to be a problem.[2]

In the early Middle Ages, saintly and apostolic queens had served as a moral counterbalance to pagan warrior kings, who bolstered their authority and prestige by allying with the Christian Church, which enacted legislation on marriage to legitimize a king's often tenuous right to rule. Sanctity remained a fundamental attribute of queenship, with art and ritual used more explicitly for propaganda purposes to polish the pious reputation of a dynasty. Over time, however, maternity would displace sanctity as the most prominent attribute of queenship. It is unclear, however, whether the shift from saintly chaste queens to sainted priestly kings meant that queens lost power and authority. It is possible that a queen's power simply changed shape and location from a spiritual marriage to Christ to a carnal marriage to a king. With marriage and children as effective means by which to regularize a king's hold on a realm, maternity became a key measure of a queen's success; therefore few queens remained virgins and even fewer chose chastity. The aristocratic family saints seen in the earlier period upstaged saintly queens, who were

no less pious but were more inclined to be chaste rather than virginal. By the eleventh century, the childlessness of the chaste Queen Edith and King Edward the Confessor left the realm open to a serious succession crisis that led to the Norman invasion in 1066. But it is misleading to think that their marriage was one of abstinence; chastity in marriage could simply mean appropriate sexuality. Similarly, Cunigunde of Luxembourg (d. 1040) and Emperor Henry II (d. 1024) may have given the appearance of having chosen to have a chaste marriage but, as with Edith and Edward, this may be just as much a rhetorical tactic to deflect criticism as an actual choice. Both Cunigunde and Henry were canonized for their piety and works of charity, but their realm met a similar fate to that of Edith and Edward: Henry's death in 1024 signaled the end of the Saxon dynasty. Earthly concerns such as dynastic survival, however, were not the only concerns of Cunigunde and Henry. The Antependium of Basel Cathedral emphasizes both the piety and the marriage of Cunigunde and Henry, the benefactors of the decorative piece adorning the front of an altar (Illustration 2.1). This large (120 cm x 177.5 cm x 13 cm) carved wood panel is covered with hammered gold and studded

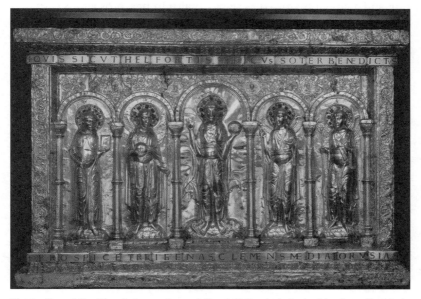

Illustration 2.1 The Antependium of Basel Cathedral, Paris, Musée national du Moyen Âge – Thermes de Cluny, Cl.2350. Photo: Hervé Lewandowski. © RMN-Grand Palais/Art Resource, New York

with pearls and precious stones. The central image depicts Christ and, at his feet, Henry and Cunigunde, flanked by the three Archangels and Saint Benedict. But this iconography gave way very gradually to other depictions. Often subtle changes to marriage practice shifted the emphasis from chaste marriage to carnal marriage intended to produce heirs. Marriage was grounded in Christian practices, which would be inscribed in legal reforms that favored the creation of a nuclear royal family by promoting monogamous, exogamous and indissoluble Christian marriage. The royal family became a more stable institution rooted in the permanency of reformed Christian laws on marriage.

Coronation rituals accompany and provide a useful marker for the changes in the status of a king's wife. The coronation and consecration of a king and queen legitimized their royal authority, enhanced their charisma and made them more remote from their subjects. Coronation was particularly important for a queen because it emphasized her status as wife of the king, secured her prominence in the royal family as part of a monarchical couple, solidified the legitimacy of the heir and provided vital familial and social glue. If a queen was consecrated, the rite constituted her symbolic marriage to the realm, with prayers and blessings, a ring and a crown bestowed as signs of faith in her 'prosperous carrying-out of her office', as described in a late ninth-century Anglo-Saxon liturgy. In a world filled with scheming brothers, uncles, cousins and nobles, a king could securely place his trust in his wife, who was expected to place her husband, children and realm above all else.[3] In 819, Emperor Louis the Pious married Judith of Bavaria, a Frankish princess, and she was made queen in what may have been the first queenly consecration. Hincmar, archbishop of Reims, in his liturgy for the coronation (c. 866), anticipated a new importance of maternity as part of queenship when he blessed the queen: 'May the Lord almighty, who blessed Adam and Eve, saying, "Go forth and multiply" […] bless you and him your spouse in the future, so that according to the command of the Lord it may be brought about that "two are one flesh", "what God joined may no man separate", and may He bless you "with the dew of heaven and the fatness of the earth".' Hincmar's liturgy is linked to his role in the tangled attempts of Lothar II to divorce his childless wife, Theutberga, and marry his mistress, Waldrada, the mother of his son and daughter. This case, described in detail later in this chapter, generated an important body of literature on marriage and rulership, and set an influential precedent that had wide-reaching implications for queenship.

The revival of Roman law in the twelfth century returned some aspects of imperial ideology into later monarchy and inscribed the

changes in law; however, by then monarchy had developed along new and distinctive lines. Legislation concerning inheritance tended to follow royal practice – as, for example, laws concerning the succession. What looks to us like primogeniture, a preference for the eldest child, preferably a son, to inherit and rule was, at the royal level, simply a result of dynastic accident. The Ottonians and Capetians had the spectacular good luck of a succession of queens who bore generations of healthy sons, with the healthiest often ending up as the only one who was able to inherit. Primogeniture was more chance than choice, with inheritance laws promulgated or reformed later to reflect this shift. At around the same time, partible inheritance – a common practice in the early Middle Ages that enabled the kings' sons and daughters to inherit equally – was waning. It fell out of favor because it compromised the integrity of the realm when the royal patrimony was alienated to sons who received small, economically and politically insignificant parcels of land and to daughters who used inherited land as dowry or bequeathed it to the Church. The system was fair but often had disastrous consequences for subsequent generations of kings whose landed wealth – and land was the source of wealth in patrimonial, or feudal, lordship – was dwarfed by that of their peers. Over the course of centuries, inheritance laws were changed to ensure that the eldest child inherited the entire realm, or the bulk of the original realms, while daughters' portions were set aside as dowries, which increasingly were converted into cash payments. Primogeniture regularized the transition from father to son but it nullified the king's prerogative to designate an heir from whichever mother, wife or concubine he chose. He bequeathed the realm to the eldest child, which increasingly was his son, not his daughter. Between the mid-twelfth and mid-fifteenth century in the west, it was rare for a king's daughter to succeed him and rule in her own right. In contrast, Byzantine empresses could inherit and rule in their own right – for example, Zoë (d. 1050) and Theodora (d. 1056), the daughters of Constantine III.[4]

Changes in inheritance practices and laws were not the only force that transformed the power base of queens. This period is notable for an increase in the complexity of the court. By the end of this period, the wardrobe, bedchamber and treasury (once the queen's domain as part of the entire royal household that she supervised) gradually became a separate entity under the control of a royal treasurer and his staff who took control of the management of the treasury. The queen's household accounts, nominally under her control, were smaller, more focused on dower and dowry properties and her own wealth from inherited estates;

they were separate from the royal treasury. This older form of power, where family concerns and matters of state are one and the same, is aptly described by Hincmar of Reims, in his ninth-century treatise, *On the Government of the Palace* (*De ordine palatii*).[5] He noted that the queen is responsible for the 'good management of the palace, and especially the royal dignity, as well as the gifts given annually to the officers'. Gifts and gift-giving were essential to the matrix of royal power, particularly important to queens in societies where rulership was personal and where the visual language of objects conveyed the majesty of monarchy. A queen's ability to dispense gifts and lands as patronage was therefore vital to her own dignity and her ability to wield influence, and could be very personal in nature. Michael Enright, looking at the British Isles in the early Middle Ages, argues that a queen was part of the social glue that held the government together, but later queens found themselves excluded from the exercise of public forms of power and authority. Still close to the centers of influence, as the king's closest companion, they remained powerful, but they wielded their power more privately or informally, via piety, intercession, diplomatic marriage negotiations and patronage.[6]

In sum, these changes meant that kings and queens retained control over the ability to arrange advantageous marriages. They gained stability and some peace as the emphasis on children born to partners of a legitimate marriage minimized the worst forms of intrafamilial violence, while the queen was emphasized as fundamental to patrilineage and legitimacy. But because these laws emphasized implicitly the marital couple, rather than a queen's natal family, the queen was likely to be isolated from her kin. Church laws prohibited closely consanguineous marriages, which over time forced some royal families to seek brides outside their realms. The Carolingians stand out as deliberately avoiding arranging marriages to foreign royalty but, by the early tenth century, many queens were foreign-born. Foreign queens created a dense web of family affiliations throughout Europe but, over time, queens found that they had no protector but the king. Despite reforms to marriage and inheritance laws, most queens were able to wield power in a variety of ways, political, economic, cultural, social, or religious.

The Byzantine Empire

The Byzantine Empire was economically and financially healthy between the eighth and the twelfth centuries, but it was torn apart during the

Iconoclastic Controversy, a religious dispute over the veneration of icons that spilled over into secular politics beginning during the reign of Emperor Leo III (d. 741). The religious conflict divided Byzantine society and increased tension with western European papacy, and drew the Empire farther apart from western European monarchies. Tensions between east and west deteriorated and ended with a schism between the Roman pope and the Byzantine patriarch in 1054. In the face of new threats from Muslim Turks after their victory at the battle of Manzikert in 1071, a weakened Emperor Alexios appealed to the pope for help, which resulted in new alliances, and tensions, during the Crusades, which began in 1096. During this period, three Byzantine empresses ruled in their own right: Irene (d. 803); and Zoë (d. 1050), and her sister Theodora (d. 1056), the only two women in Byzantine history to rule in their own right as *porphyrogenita*, or 'born into the purple' – meaning a ruler of legitimate descent from the previous emperor born in the purple imperial bedchamber.[7]

Irene was the first woman to rule explicitly as sole Byzantine Empress (797–802). Like some notable earlier Byzantine empresses, Irene was not born into the royal family. Like Theodora, she was a forceful empress, referring to herself at times as *basileus* (emperor) and *basilissa* (empress). She was an orphan from a prominent, perhaps noble, Athenian family, and in 769 was brought to Constantinople by Emperor Constantine V to marry his son Leo IV. Some scholars speculate that she was selected in a bride-show, in which eligible women were brought before the bridegroom for him to select. Leo succeeded his father in 775, and when he died in 780, Irene governed as regent for their nine-year-old son, Constantine; her regency would last until 797. Barbara Hill points out that for Irene, the ideology of the widowed mother was a particularly strong foundation for Irene's power.[8] She came face to face with the early Iconoclastic Controversy, and her most notable act in this was her order to restore the veneration of icons in 787. Tensions arose between Irene and Constantine, ending in his overthrow, blinding and probably accidental death leaving Irene in sole control. Her status as sole ruler is evident in documents issued during her reign which refers to her as *basileus* and *basilissa*. In her gold coinage, Irene is depicted with the same image of herself on both sides, with the title *basilissa*. She wears the crown distinctive to empresses, with pyramidal decorations and decorative dangling *pendilia* beside her face (Illustration 2.2). She maintained relations with Charlemagne, even though his coronation as Emperor posed a threat to her as Empress and the integrity of Byzantine assertions as political heirs of the Roman Empire. Irene was harried by restless

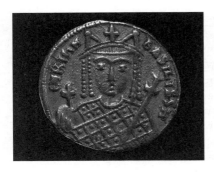

Illustration 2.2 Gold solidus of Empress Irene (r. 797–802). London, British Museum.
© Erich Lessing/Art Resource, New York.

nobles in the Balkans, the growing dominance of Muslim caliphs in Baghdad and, in 802, by elites of Constantinople who deposed her and replaced her with Nikephoros, the minister of finance. She went into exile on Lesbos, where she supported herself by spinning until her death the next year.[9]

Irene's efforts to preserve the practice of venerating icons, which was banned again in 814 and restored once more in 843, were the focus of the efforts of two succeeding empresses during the divisive Iconoclastic Controversy. Euphrosyne (d. after 836) was the daughter of Constantine VI and a former nun; she married Michael II (d. 829), a former soldier, who advocated the banning of icons. But she advocated for the practice behind the scenes and, when Michael was succeeded as emperor by Theophilos, his son from his previous marriage to Thekla, Euphrosyne governed alongside the sixteen-year-old emperor. One of her first and, from the perspective of the Iconoclastic Controversy, most enduring acts was to hand-pick Theodora as her stepson's wife. When Theophilos died in 842, Theodora became regent for his minor heir, Michael III. One year later, like Irene fifty years earlier, Theodora ordered the restoration of icons.

The instability generated by coups like that of Nikephoros or Michael led to an increasing importance placed on *porphyrogenitus* status, and on this foundation was built the Macedonian dynasty in 867, with the accession of Basil I (d. 886), the peasant who rose through the ranks of the imperial court and usurped the imperial throne from Michael III. Such an inauspicious beginning is why so many royal families used the ideologies and symbolic power of a divinely blessed dynasty as a way to bolster their shaky claims. And, when the idea of *porphyrogenitus* is first applied, the necessity to preserve the dynastic claim overrode any concerns about whether the next ruler would be an heir or heiress. Therefore, after the rapid succession of several genera-

tions of short-lived emperors, Zoë and her sister Theodora daughters of Constantine VIII (d. 1028), inherited and ruled in their own right as *porphyrogenita*.[10]

Zoë's life and reign is a lesson in the frustrations of relying on biology to ensure the continuation of a dynasty, and the political and marital gymnastics required to do so. To this end, she married three times and raised four men to the position of emperor after her father Constantine VIII died: her husband, Romanos III Argyros in 1028; her second husband, Michael IV Paphlagon in 1034; Constantine IX Monomachos in 1042; and her adopted son, Michael V Kalaphates (d. 1042). She may have hoped that marrying would mitigate the problems an empress faced when dealing with the army, but it only compounded them. Zoë came to the throne in 1028 when her father, Constantine VIII, died without sons; she remained at the center of governance until her death in 1050. When her uncle, Basil II, was emperor, he faced palace intrigue and coups were his nieces to marry Byzantine noblemen, so he kept both Zoë and Theodora sheltered in a convent for most of their adult lives. When Zoë's father died, she was fifty and concerned for the continuation of the Macedonian dynasty. By 1041, Michael IV was dying and it was obvious that a pregnancy was hopeless. Michael's powerful brother, John the Eunuch, wanted to retain power in his hands and forced Zoë to adopt his nephew, Michael V, who was crowned in 1041. Although he promised to respect Zoë, Michael turned on her, accused her of attempting to kill him and banished her to a monastery. This shabby treatment of a Macedonian Empress *porphyrogenita* caused a popular uprising in Constantinople in 1042 and Michael was deposed. High-ranking members of the court determined that Zoë needed a co-ruler, and decided that it should be her sister, Theodora. After the coronation, the mob stormed the palace, forcing Michael V to escape to a monastery where he died later that year.

Zoë and Theodora formed one of the most unusual ruling arrangements in medieval history. They ruled together as sovereign empresses for only three months in 1042 and, in this short period, coins were minted that bore the likenesses of the two empresses (Illustration 2.3). Although Theodora, the younger sister, was Zoë's junior, symbolically represented by the way her throne was positioned slightly behind Zoë's for public occasions, she was the more dominant member of their joint administration. But joint administrations are tricky business under the best of circumstances: the two sisters had never gotten along well and their reign was fraught from the start. Zoë was less interested than Theodora in the day-to-day work of ruling, but refused to allow

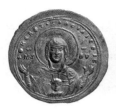 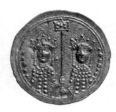

Illustration 2.3 *Nomisma histamenon* of Empresses Zoë and Theodora (1042), Byzantine, 1042, 2.5 cm (1 in.), gold. © Dumbarton Oaks, Byzantine Collection, Washington, DC.

Theodora to conduct public business alone. The court broke into factions and it became clear that the situation was unworkable. Zoë decided to marry once again. Constantine IX Monomachos was her third and last husband: in another highly unusual arrangement, he was formally proclaimed emperor together with Zoë and Theodora. Furthermore, he brought with him a mistress, Maria Skleraina. Both sisters accepted her and let her use the honorific titles of *sebaste* (majestic) and *depoina* (lady), holding a social rank immediately below Zoë and Theodora. Zoë deferred public authority to her husband until her death in 1050. When Constantine died in 1055, Theodora, despite her age (she was seventy), reasserted her right to rule, came out of her retirement and ruled alone, ably and peacefully, from 1055–56 as sovereign empress.

Eudoxia Makrembolitissa (d. c. 1078) was powerful regent twice for her son Michael, first in 1067 when her husband Constantine X died, and again in 1071. When her husband fell ill in 1066, he named Eudoxia regent and had her sign an oath that she would not remarry, which he believed would put Michael's dynastic rights at risk. The transition was smooth and she ruled alongside Michael and a younger son, Constantios. Eudoxia had a taste for rulership and refused to surrender power to her sons when they came of age; she married a general, Romanos IV Diogenes, to solidify her authority. She may have thought he would defer to her, but he did not, and she faced vociferous opposition by rivals at court. Romanos ruled for four years but the tense situation did not improve. After his capture at the battle of Manzikert (1071), where Seljuk Turks defeated the Byzantine army, she tried to bypass him entirely by acting as regent for their son once more. Her enemies came after her with an army and threatened physical violence; she fled to a monastery, and Michael became emperor. Romanos was deposed, sent to a monastery and blinded. It is noteworthy that Eudoxia's contemporaries considered her fully competent and were impressed by her talent for management, approving of her governing as regent not once, but twice.[11]

The Carolingian Empire

The Merovingian ruling family, willfully devoted to a single dynastic bloodline, was replaced in the eighth century more or less peacefully and with the blessing of the papacy by a new ruling dynasty that we know as the Carolingians. Under the first Carolingian rulers, the Frankish hegemony reached its peak and the territorial holdings would fragment into smaller units. Carolingian kings and emperors managed their empire by manipulating the elite families into associating with one another through patronage, receiving lands and office as rewards for loyalty and by marrying their daughters and sons to the prominent lords. With the establishment of Church institutions, the strengthening of law courts and the foundation of monasteries came charters, better-defined property rights and the restructuring of land-holding into estates based on a dependent peasantry. These developments gave the nobility more opportunities to gain wealth, status and prestige. As they grew powerful, they looked to local magnates to safeguard their wealth and status, and resisted royal efforts to impose a central authority over them.

The central theme in the history of eighth-century Francia is the political fallout from the 751 palace coup of Pippin III (d. 768). In a move sanctioned by Pope Zachary, Pippin displaced an inept Merovingian king, and Pippin's son, Charlemagne (d. 814), expanded the realms. Pippin had been anointed king in 752 by the archbishop of Mainz, and Pope Stephen II confirmed this and anointed him a second time in 754, this time along with his wife Bertrada. This coronation, in a lavish ceremony at the Basilica of St. Denis, is the first recorded crowning of a king and a queen by a pope. It is significant that a queen was important to the formal transfer and legitimization of Pippin's authority.[12] These coronations and consecrations were no doubt intended to make it as clear as possible that there was a new ruling family in charge and that the queen was a significant part of that dynasty. But the practice was inconsistent and could have been used to do more than formalize the dynasty. In the case of Ermentrude (d. 869), wife of Charles the Bald, she was probably not consecrated as queen hoping that the blessings would bring children. Ermentrude was consecrated as queen over twenty years after their marriage, when she was thirty-six. By this time she had borne eleven children, although three (perhaps more) of their sons had died in infancy.

Pippin's coup may have had papal blessings, but the Carolingians' fight to dominate their rivals was anything but bloodless. Pippin tried to ensure that the fighting would not be over who succeeded him. He

designated his two sons Charles and Carloman his successors, had them anointed by Pope Stephen and made them agree to divide the kingdom between them. The brothers were competitive and Pippin's settlement exacerbated their antagonism but, in a typical queenly form of intercession and peacemaking that was probably romanticized and exaggerated for effect, their mother Bertrada intervened, leading to them reconciling their differences.[13] They ruled together, more or less amicably, until Carloman's death in 771, and Charlemagne reigned for another forty-three years.

In terms of queenship, one of the most notable features of Charlemagne's reign is his open practice of concubinage throughout his reign. His mother had been his father's concubine before they married, and Charlemagne was one of the last kings to have a series of concubines. His first concubine, Himiltrude, was a Frankish noblewoman. Their relationship dates to before 768 and they had a son, Pippin ('the Hunchback'), born around 770. But Charlemagne repudiated her soon after the death of his father and officially married the daughter of Lombard King Desiderius at the instigation of his mother, who wanted to strengthen diplomatic relations. The fact that the daughter of King Desiderius is unnamed in official records speaks volumes about the shallowness of her importance to Charlemagne, both personal and political. By 771 she, too, was repudiated and Desiderius was furious because the act wrecked the alliance. Charlemagne's next marriage was not accidental, either, but it was much more successful in all ways. His new wife, Hildegard, was the daughter of the powerful count of Alemannia, a strategic part of the realms in East Francia whose support he needed in his campaigns against the Saxons. Hildegard and Charlemagne had, by all accounts, an affectionate twelve-year marriage that produced four sons and five daughters before her death in 783. Within a year, he married again and, in typical fashion, he chose a woman of high status, this time from an east Frankish county. Fastrada left the most visible mark on the written sources: she ordered the confiscation of property of a noble who killed a man at court in her presence while Charlemagne was away from court, and Charlemagne's only surviving letter is to her, asking her to organize prayers for his and his army's success, and expressing concern for her health. But her critics were harsh and they piled on her all the negative qualities of a scapegoat. Charlemagne and Fastrada had two daughters before Fastrada's death in 794. Liutgard, an Alamanni noblewoman, was Charlemagne's last fully legitimate wife, but she may have been his concubine before the marriage: they had no children. After Liutgard's death in 800 and until his own death in 814, Charlemagne was

involved with a series of concubines (Einhard identified four). It is possible that he had concubines while he was married and may well have had children with them, but these liaisons and children are not recorded.[14]

This prodigious marital and sexual history has left behind enough children to generate evidence that is statistically significant. Charlemagne was both the end and the beginning of something new. Despite all his concubines, his reign marks the beginning of the end of the practice. Unlike some of his predecessors, Charlemagne had a clear preference for queens who came from powerful families, and used them to build and cement diplomatic alliances. His dismissal of his Lombard wife is an eloquent statement of his disregard of the importance of Italy. Unlike earlier kings, we know very little about the women in Charlemagne's life, strongly suggesting that – although they were important as private queens, as wives and mothers – they were less important as public queens who played a role at court or in governance. Once he and his successors secured their power, Carolingian queens and empresses were integrated into the king's family but detached from their natal families. But increasingly they were bypassed as mediators. Also striking is Charlemagne's relationship with his daughters, whom he strictly kept from both marriage and the cloister.

Charlemagne may have thought that his liaisons and marriages would ensure that his empire would be governed by one of his sons but, by 813, he had only one legitimate son left, Louis 'the Pious' (d. 840). This made for a smooth transition from father to son, but Louis married twice and had four sons: three sons with Irmengard (d. 818) – Lothar, Pippin and Louis 'the German', and one son, Charles the Bald, with his second wife Judith of Bavaria (d. 843). It was the duty of a queen to protect her children: a second wife with a young son complicated matters greatly. Judith was young, only fourteen, reputedly beautiful and learned, when Louis chose to marry her. The chronicler in *Royal Frankish Annals* reported that 'after having inspected the most of the daughters of the aristocracy, took Judith, the daughter of Count Welf as his wife'. This is the only instance of the 'bride show', a practice attributed to Byzantine traditions but not to those of western kingdoms. Makye de Jong argues this is actually a highly-constructed narrative based on biblical models that related to contemporary discourse on the position of the queen in the realm, the earthly ruler's prerogative to choose his queen, and queenship in general. She argues that, to make sense of this account, it is important to read it alongside a near-contemporary account that includes his nobles' explicit and vocal approval of his choice. Judith was Louis's choice, but she was connected to her people by their assent to the marriage.[15]

She married Louis in 819, and was immediately seen as a threat to her stepsons on the birth of her son, Charles, a rival for the succession.[16] Contrary to precedent, Louis chose to designate Lothar as sole emperor and to divide the empire equally among his sons. This decision worried Judith, who sought to use the tradition of partible inheritance to protect her son. Louis's decision strained family harmony and imperial politics, resulted in civil war and angered Judith, who mustered powerful supporters. Her stepsons Pippin and Louis retaliated and accused her of adultery, incest and witchcraft – common accusations against a queen whose enemies felt threatened by her youth and fertility. As monogamous Christian marriage came to define a queen, her moral contributions to the political health of the realm took on new importance. A faithful, even chaste, queen was important to a virile king and, as Pauline Stafford has observed, accusations of adultery signal not a moral crisis but, rather, the strength of the alliance between kings and churchmen.[17] Even if, as in the case of Judith, the charges were likely polemic without foundation and ultimately unprovable, and even though she was exonerated publicly, her reputation suffered.[18] Her devoted husband was unable to protect her from imprisonment; after his death, she was stripped of her wealth. It is telling, however, that no matter how tangled his family politics were, Louis never seriously tried to repudiate or divorce her because the attacks on her were really proxy attacks on him.

A very different case with a very different outcome concerns the marriage of King Lothar II (d. 869) to Theutberga, and his attempts to divorce her to legitimate his union with Waldrada. This case is a pivotal moment in the history of ninth-century Europe.[19] It is a *cause célèbre*, packed with the salacious details of a lurid scandal in the bedroom, and the technical and nuanced legalist and theological arguments of four kings, two popes and many bishops. It is important not only because it casts a bright light on how the intimate concerns of a royal marriage became a public matter, but also because it had wide-ranging implications for queenship and kingship that extend far beyond the ninth century. The case hinged on politics, for the queen came from a powerful noble family that mustered its legal forces to preserve their standing at court. In terms of wider politics, Lothar was one of three kings who succeeded Louis the Pious and governed the portions of his vast realms that had been partitioned in the Treaty of Verdun in 843. It concerned the Church, which was fine-tuning theologically-based ideas on the indissolubility of marriage.[20] The resolution of the case turned on notions of what constituted a good king and a good queen who ruled a Christian realm.

In 855, Lothar married Theutberga to gain the support of her family to help solidify his control of his inheritance. But before his marriage, he had become involved with Waldrada, a woman from a minor noble family, with whom he had a son. By 857, the alliance with Theutberga's family was no longer advantageous; she had not yet borne a child. Lothar sought to divorce her to marry Waldrada. His case hinged on accusations that Theutberga had committed sodomy and incest with her brother and then aborted their child but, in 858, her champion in a trial by ordeal succeeded and her reputation was restored, but not for long. In 860, her confessor revealed her guilt and she asked to be allowed to enter a convent. At that point, Hincmar, the archbishop of Reims and an ally of Lothar's uncle, Charles the Bald, stepped in.[21] Lothar's marriage was not dissolved until 862, but he was not allowed to marry Waldrada. Lothar's representatives traveled to Rome to plead the case with Pope Nicholas I, who surprised them with his vehement rejection of Lothar's argument. Lothar agreed to take Theutberga back, but a new pope, Hadrian II, was less strict than his predecessor on matters of marriage and divorce, and allowed him to take back Waldrada. It all ended badly for Lothar, however, because all the political maneuvering cost him the vital support of many (but not all) of his nobles, his realm was divided up between his two uncles, and he died in 869. Historians who studied this case tended to focus on the political elements, particularly those that touch on kingship or the church. But scholars recently have turned their eyes toward the queen, her physical and royal body and queenship.

On one level, the case is about the queen as wife, particularly Theutberga's presumed incest and sterility. We will never know for certain what exactly happened between Theutberga and her brother, but it pays to be skeptical of the accusation of incest. Sexual slander was a potent weapon that could be, and often was, a veiled attack on a king. In this case, though, the accusations against Theutberga came from Lothar himself. Theutberga is the victim here, not Lothar. Incest, however, was an ambiguous term and had been the subject of considerable debate and legislation since the Merovingian period. The problem of incest is linked to legislation limiting consanguineous marriage but, in the 860s, the definitions of and laws concerning incest were by no means uniform and would not be clarified until the eleventh century.

On another level, Lothar's divorce case hinges on definitions of marriage, which were also in flux at the time. Unions such as that of Lothar and Waldrada were not prohibited but, in the ninth century, such unions were increasingly frowned upon by churchmen and would be

prohibited only much later. Thus, Theutberga, the wife by law, and Waldrada, the partner by custom, were at opposite ends of a spectrum of marriage options. As Stuart Airlie points out, 'Theutberga's sin, with the penance it required, would have rendered her unfit to be a wife' when compared with the conventional model for a Christian wife, the Virgin Mary.[22] Hincmar accepted, at least in principal, that incest committed before marriage was sufficient grounds for divorce.

It also is important to consider the question of the queen's presumed sterility. She was childless, yes, but not necessarily sterile. As the case wore on, the question of Theutberga's fertility came to the forefront and resulted in a remarkable statement by Pope Nicholas I on the causes of infertility: 'Sterility does not come from the infertility of the body but rather from the wickedness of the husband'.[23] This argument strongly suggests that the king's body was just as subject to control as the queen's. It doomed Lothar with its implications that his 'wicked' relationship with Waldrada was the source of his wife's infertility. Hincmar's formulation was superseded by other arguments about women's physical frailty as the cause of childlessness. However, it remains a fascinating and important reminder of how theology and law can become statements of medical knowledge in the ninth century.

Finally, the case affirmed that ideas on the royal household and its associations with good order within the realm itself were embedded in patriarchal Christian precepts of gender and behavior. Harmony in the royal household symbolized harmony in the realm at large, and the queen had a moral responsibility to maintain properly the order and honor of her person, the household and the realm. A good king ruled his wife, who ruled the household, and together they lived in purity, peace and stability, modeling proper behavior for their subjects. Both Lothar and Theutberga followed familiar gender norms throughout the process. He was active in his defense, and commissioned the Lothar Crystal, a crystal engraved with scenes from the story of Susanna and the Elders, a story replete with false accusations of adultery and a just king, to emphasize his own good kingship. It is an odd choice though, for a king who was engaged in an adulterous affair to choose this image in his defense. It may have been intended as a private gift to Theutberga to reassure her that he was not going to follow through on a divorce.[24] Theutberga, on the other hand, was passive, pleading for support from her family and high-ranking churchmen, including the pope, and she needed to be defended by a champion. Ultimately, the case set a precedent for a cascade of papal, episcopal and royal legislation on marriage that affected all women, not only queens.

Engelberga (d. after 888) was more successful than Theutberga as queen, but no less controversial. Engelberga came from a powerful Italian family, where queens took on more active roles in governance than in most European realms. Around 851, she married Lothar's son, Louis II of Italy, then co-emperor with his father, and was crowned empress in 858. As early as 871, she was active in north Italian politics, serving as regent for her husband while he fought Muslims in the south, and sometimes accompanying him on campaigns, convoking and presiding over an imperial congress in his palace in Ravenna, administering large possessions and presiding at a tribunal to try an imperial envoy. Louis relied on her and chroniclers called her *consors et adiutrix regni* (consort and assistant of the kingdom); coins were struck in both their names, and she intervened in charters. Her actions upset Italian nobles who 'hated Engelberga because of her high-handedness' and in 872 they pressed the emperor to accept the daughter of Winigis in her place. The nobles persuaded Louis to agree to send an envoy to Engelberga telling her to stay in Italy and not to follow him south, to wait until he came back again to Italy. Engelberga, however, paid not the slightest attention to these instructions, but hastened after Louis.[25]

Louis clearly valued her as a partner, so he ignored his nobles' advice and she finished Louis's campaigns in Italy. After Louis II's death in 875, she called a council at Pavia to decide which of Louis's two uncles, Charles 'the Bald' or Louis 'the German', should succeed. Engelberga opposed Charles and Louis succeeded, but died one year later. Charles 'the Bald' ruled until his death in 877. Charles 'the Fat', son of Louis 'the German', had her captured and imprisoned in 880, but released her in 882 when his position as emperor seemed secure.

Engelberga's contemporary, Emma of Altdorf (d. 876), wife of King Louis 'the German' and both queen and empress, was no less active a queen – but was far less controversial. Emma worked more behind the scenes than out in the public eye, and Emma and Louis had a harmonious marriage. They worked together in the governance of the realms, both were deeply pious and, after raising their seven children, she spent much of her later life devoted to the administration of a convent at Obermünster that was dedicated to the Virgin Mary. But this is not known through administrative records and occasional references in the royal or monastic chronicles. Rather, we know a little bit about her from a red silk belt that she gave to Witgar, the royal chancellor and future bishop of Augsburg. She herself may have woven and embroidered it with a gold inscription in Latin: *Hanc zonam regina nitens sanctissima Hemma Witgario tribuit sacro sipramine plenum* ('The shining and most

holy Queen Emma gave this belt to Witgar, a man full of sacred breath').[26] This act of gift-giving as patronage was not an unusual act for a queen and empress whose duties included supervision of the royal household. For historians, the belt is more than just a rare and exquisite object – it is a window through which we can catch a glimpse of Emma's personality. She is proud of her Latin literacy and her skill with a needle, and is confident ('shining and most holy') in giving a gift both intimate and redolent of multiple meanings of sexual purity. The belt, Eric Goldberg argues, 'was essentially a double chastity belt: a liturgical girdle – the badge of a churchman's virginity – that contained a relic of the Virgin Mary's belt'. This gift contains subtle hints that she had taken a vow of chastity after she could no longer conceive a child.[27]

Saxon and Ottonian empresses

Tenth-century Saxony was, in one important way, much like sixth- and seventh-century Frankish realms, in that it was newly-converted to Christianity. Saintly queens were counter-balances to Saxon kings, comparable to Balthild and Radegund, and were firmly integrated into their husbands' lives as a means to bolster the king's shaky claim to rule and to strengthen his ties to the church. Mathilda (c. 877–968), served such a purpose for her husband Henry I, 'the Fowler', the first ruler of the Saxon (later Ottonian) dynasty, and their son Otto I, who succeeded his father as king and was crowned Holy Roman Emperor in 962. As a young girl, Mathilda was educated by the nuns in the convent of Herford, where her grandmother Mathilda was abbess. Her reputation for beauty and virtue, and probably also her Westphalian dowry, attracted the attention of Duke Otto I of Saxony, who betrothed her to his recently divorced son and heir, Henry. They married in 909, she became duchess in 912, and queen in 919 when Henry succeeded his father and was elected king. They had five children who figure prominently in the complex web of family alliances in tenth-century history: Hedwig, wife of Hugh 'the Great' and mother of Hugh Capet of France; Otto, duke of Saxony and Holy Roman Emperor; Gerberga, wife first of Duke Gislebert of Lorraine and then King Louis IV of France; Henry, Duke of Bavaria; and Bruno, Archbishop of Cologne and Duke of Lorraine. She was known as an intercessor, and the author of the *Later Life of Mathilda* noted that Henry, on his deathbed in 936, thanked Mathilda, for she 'diligently tempered our wrath, gave us sound counsel in every situation, often drew us away from iniquity and towards justice, and diligently urged us to have mercy on

the oppressed'. After Henry's death, she was enmeshed in rivalries at court that drove her into a brief exile, but she was brought back to court at the urging of King Otto's first wife, the Anglo-Saxon princess Edith of England.[28]

Mathilda was a model of royal piety, propriety and intercession, venerated in her lifetime and canonized after her death – but her sanctity is presented very differently to that of Radegund. The author used Venantius Fortunatus as a source of inspiration, but made the queen into a partner of the king, a supporter rather than subverter of royal power.[29] She founded a number of religious institutions, most notably Quedlinburg Abbey, a convent of aristocratic nuns, where she retired and where in 966 her granddaughter Matilda became the first abbess. But she was accused of squandering royal funds to pay for her many charitable endeavors. Jane Tibbets Schulenberg notes that this was a common complaint among men who sought to limit women who alienated their inheritances to the Church, prompting strict control of inheritances. This led, in turn, to converting a woman's inheritance into a dowry with legal entailments that prevented it from being used to endow convents or support church-building.[30] Resourceful queens, however, continued to bestow land and money on churches. Instead of using direct funds from the royal treasury, however, they increasingly came to rely on separate funds, sometimes called the 'queen's treasury' or the 'queen's gold', funds that would later be a significant source of revenue for a queen's patronage and power.

Mathilda's life as a pious intercessory queen is closely entwined with that of her daughter-in-law Adelheid of Burgundy, (d. 999), Otto I's second wife and easily the most prominent European woman of the tenth century. Pauline Stafford aptly notes that she was daughter, sister and aunt of three consecutive kings of Burgundy; sister-in-law, mother-in-law and grandmother of three consecutive kings of France; and wife, mother and grandmother of three Ottonian emperors.[31] First married to Lothar II (d. 950), she ruled as queen of Italy after he died without a son and brought those lands to her marriage in 951 to Otto; their daughter Emma married Lothar, King of France (d. 986). Adelheid and Otto were crowned emperor and empress in a joint ceremony in Rome in 962. Piety and humility were fundamental to the secular power and authority of the 'august and forever invincible' Adelheid. She was considered her husband's partner in rulership – which, while not parity, was real authority. Even before Otto's death, Adelheid was considered a *consors regni/ imperii* (co-ruler of the realm or empire) and her name appears jointly with his on documents when she accompanied him in 966 on his third

expedition to Italy. When he died in 973, she was regent twice over, first for their son, Otto II, and, after his death in 983, for their grandson, Otto III. Adelheid shared the second regency with her daughter-in-law, the Byzantine princess Theophanu (960–91), and, despite their differences, they worked together to secure and protect the throne for Otto III. Theophanu was a diplomatic prize for Otto II, even though she was not herself of imperial descent. She was personally impressive and intelligent, and participated in her husband's government, traveling with him even on military campaigns, as the court had no fixed center. Theophanu intervened 76 times during the lifetime of her husband, often making grants that she initiated. She safeguarded the royal treasure when Otto was defeated in southern Italy in 982. As regent for Otto III, she was formally associated with her son in his documents and actions, foreign rulers negotiated with her and she was described as *imperatrix* (imperator) in official documents.[32]

Adelheid and Theophanu were shrewd women who used bishops and foreign rulers to bolster their power. In their hands, the role of the empress was considerable. They were the only two consecrated empresses in the tenth century. With Adelheid's sister, Matilda of Quedlinburg, they led a coalition of secular and ecclesiastical nobles against a coup staged by Otto's cousin, Henry of Bavaria, and forced him to submit to their authority. They continued to act on behalf of Otto and in their own right. Both were well-trained, Adelheid at the Italian royal court in Pavia and Theophanu at the imperial court in Constantinople. As dowagers, both were more powerful in the administration of Otto's reign. After 995, when her son reached his majority, Adelheid devoted herself exclusively to works of charity, notably the foundation or restoration of religious houses. She kept close relations with Cluny, the influential center of the movement for ecclesiastical reform. She died at the nunnery she had founded around 991 at Selz. Adelheid is commemorated in modern art and music – as the heroine of Gioacchino Rossini's 1817 opera, 'Adelaide di Borgogna'; and as a featured figure on Judy Chicago's feminist installation artwork *The Dinner Party* (1974–79), represented as one of the 999 names on the Heritage Floor.

Early Capetian France

The medieval kingdom of France began to take shape politically, if not quite geographically, during the eleventh century. After the Treaty of Verdun of 843 divided Charlemagne's empire into three parts, the western

remains fragmented further into duchies and counties with a nominal, but ineffectual, king. The northern realms were more 'feudal' in landholding and lordship; the southern realms followed Roman law, and vassalage and the fief were almost unknown. The king, such as he was, ruled a tiny principality centered on Paris and tried mightily to dominate (or, at least, subdue) powerful lords in Normandy, Brittany, Aquitaine and Flanders. Seven kings between 888 and 987 held onto power, barely, despite shifting alliances and Viking invasions. As elsewhere, these kings turned to the Church to build alliances that stabilized their realms, and used carefully planned marriages that allowed them to expand their domains gradually. The year 987, when Hugh Capet, Duke and later King of the Franks, began his political ascent, signaled a new era for the nascent realm we now know as France.

Studies on Capetian queens have taken their cue from Marion Facinger's classic article that set out a timeline of growth and decline of queenly power from 987 until 1328, when a series of adultery scandals signaled the demise of the Capetians and the rise of their cousins, the Valois.[33] Facinger argued that the public and private power of Capetian queens was substantial during the tenth and eleventh centuries, when institutions were nascent, power localized in the hands of nobles, and queens were partners with kings. Hugh Capet, and his wife Adelaide (c. 945 or 952–1004), daughter of the ruling family of Aquitaine, produced a family of kings of moderate talent but impressive skills as warriors, administrators and politicians. Adelaide's father, Duke William III, used her marriage as security to guarantee a truce with Hugh. We know little about her except that she was sufficiently involved in Hugh's government that he proposed that she negotiate for him with Empress Theophanu, having agreed in advance to follow whatever decision they reached. This sharing of rule across generations – whether formally, as in the case of a son co-ruling with his father or a queen-regent, or in any number of informal arrangements – would be a key feature of Capetian monarchy. In this way, the queen served as a linkage across generations and as a visible sign of the continuity of the lineage.

The early Capetians followed a familiar pattern of serial marriages, repudiation of older or childless wives and a king living openly with someone other than his official wife. Hugh Capet, unsuccessful in his search for a Byzantine princess, arranged for his son Robert 'the Pious' (so named for later acts of piety, rather than marital fidelity) to marry Rozala, the daughter of Berengar II of Italy and Countess of Flanders from her first marriage.[34] She was considerably older than Robert, who divorced her within one year of his father's death. He had been living openly with

Bertha of Burgundy (d. 1035), Countess of Burgundy, and also a widow. However, Bertha was Robert's cousin: Pope Gregory V refused to sanction their marriage on the grounds of consanguinity, and excommunicated Robert. Robert repudiated Bertha around 1004; she remained unmarried and a force to be reckoned with.

In 1001, Robert married Constance of Arles (d. 1034).[35] She was a formidable, ambitious woman and their marriage, unsurprisingly, was difficult. Bertha's family opposed her, and Robert's advisors despised Constance because she favored southern customs and her Provençal family. When Hugh of Beauvais, close advisor to the king, suggested that Robert repudiate her in 1007, he was murdered by knights of Constance's kinsman, perhaps at her order. Her ambition alienated the chroniclers of her day, who blamed her for several of the king's decisions and accused her of outrageous actions. In the account of a heresy trial of her former confessor, Constance struck out his eye with her staff. In 1010, Robert went to Rome, accompanied by his former wife Bertha, to seek permission to divorce Constance and remarry Bertha. His request was denied, he returned to Constance and together they had several children, with and against whom she plotted revolt against their father. At Constance's urging, their eldest son, Hugh Magnus, was crowned co-king with his father in 1017; after Hugh's death in 1025, Robert and Constance quarreled over which of their surviving sons should inherit. Despite his mother's protests, their second son, Henri, was crowned in 1027. Fulbert of Chartres wrote in a letter that he was frightened away from the consecration of Henri 'by the savagery of his mother, who is quite trustworthy when she promises evil'. Constance continued to encourage her sons to rebel, Robert agreed to their demands, and made peace until his death in 1031. Soon after that, Constance was at odds with both sons, Henri and Robert; she seized her dower lands and refused to surrender them to Henri's wife, Anna. Henri fled to Normandy, where he received aid, weapons and soldiers from his brother, returning to besiege his mother. However, Constance, ever wily and resilient, escaped, surrendering only when Henri swore to slaughter all the inhabitants of a town.

Despite this litany of malicious actions, contemporary critics of Constance also comment favorably on her concern for the royal treasury and her wise counsel to her husband. Her Provençal 'foreignness' isolated her, and she struggled to balance her allegiance to both her natal and marital family. Seen in this light, many of her more notorious actions can be attributed to the absence of familial support and very real fears of repudiation. Penelope Adair argues convincingly that, given the limited resources at hand, Constance's efforts to preserve the royal treasury and

her objections to alienation of royal property were 'the well-founded concerns of a clear-sighted and determined royal consort'.

It is an understatement to say that things calmed down during the reign of Henri I (d. 1060). In part, this is due to the fact that his three marriages were not as stormy as his father's. Twice a widower, Henri married Anna of Kiev (d. 1075), daughter of Yaroslav I, Grand-Duke of Kiev, in 1051 and she was consecrated queen at Reims.[36] Anna brought no land to the marriage, but did bring political connections and considerable wealth. Anna is associated with four of Henri's charters of donation towards the end of his reign, which she signed as his queen and wife (*Reginae uxoris ejus* or *Regina partier*). After Henri's death in 1060, Anna participated in the government of her son Philip I (d. 1108), although her brother-in-law was technically regent. Philip declared that, as a child, he took up the kingdom together with his mother, and the bishop of Chartres spoke of Philip and Anna as his sovereigns. In 1061, Anna married a powerful ally of the king, Raoul, Count of Valois, who, in order to marry Anna, had repudiated his wife, Eleanor of Champagne, on the grounds of adultery. Eleanor appealed to the pope, but Raoul refused to take her back and was excommunicated. When Raoul died in 1074, Anna returned to Philip's court.

Philip was, however, no paragon of virtue in either his personal or his political life. He repudiated his first wife, Bertha of Holland, in 1092, even though the marriage produced the necessary heir, Louis VI.[37] He imprisoned her in her dower chateau and lived openly with Bertrada of Montfort, wife of the Count of Anjou. Many French bishops supported this liaison, even though it bordered on bigamy, but canonist Ivo of Chartres opposed it, and Philip and Bertha found themselves embroiled in the politics of papal reform. The resulting scandal left Philip and Bertha with reputations as lecherous adulterers. Philip was excommunicated in 1094, which act was repeated in 1095, but his affection for Bertha won out and he faithfully returned to her.

England, Scotland and Wales

Seventh-century England was not a kingdom per se but, rather, a series of kingdoms held together with one man exercising overlordship, the alliances often being cemented through marriage. The distinct kingdoms of the British Isles – the Heptarchy of Kent, Essex, Sussex, Wessex, East Anglia, Mercia and Northumbria, together with Scotland and Wales – recognized the overlordship of the Anglo-Saxons, a complex group that

sprang from different tribes in northern Europe. In terms of language, culture, art and political institutions, the Anglo-Saxon conquest and settlement of the fifth and sixth centuries was more profound than that of the earlier Romans or later Vikings and Normans. But the conquest did not immediately unify the various realms: they remained rulers of peoples, not territories, until well into the tenth century. By then, Mercia had risen to the top of the heap, having fought back the Welsh in the eighth century and anointed its first king, Ecgfrith, in 787, having established a tradition of dynastic rule that brought queens to the fore. Anglo-Saxon queens are notably present, often front and center, in the governance and management of the realm, and they do so in a wide range of projects.[38] Cynethryth of Mercia (d. after 798), wife of King Offa (d. 796), was active publicly as witness to his charters and issued coinage in her own name, with her image on the face – the only Anglo-Saxon queen to do so. They worked closely with churchmen on matters of reform, and the foundation and construction of religious houses.[39] What we know of Irish queens at this point suggests some continuity with the earlier period that lasted until the twelfth-century conquest by Henry II.

The practice of marrying one's close kin declined, but slowly. Most queens of this period came from local families and they formed familial bonds that held together the tenuous unity of the realms. It is important to keep in mind that this dense network of alliances made Anglo-Saxon princesses queens of other realms and forged some of the most remarkable royal alliances outside of England. King Edward the Elder (d. 924) sent his daughters far and wide: Eadgifu married Charles the Simple, King of the West Franks; Eadhild married Hugh the Great, Count of Paris, in 926; in 929/30, Edith married Otto, heir to the empire and the future Emperor Otto I. But the first of two profoundly influential queens who came from the continent bookend the Anglo-Saxon period: Judith, wife of Æthelwulf of Wessex, was the daughter of Emperor Charles the Bald; and Emma, wife of Æthelred II and Cnut, was the daughter of the Duke of Normandy.[40]

Judith (d. c. 870), daughter of the Carolingian Emperor Charles the Bald and Queen Ermentrude, was queen of Wessex twice. She married Æthelwulf of Wessex in 856 when she was twelve and became stepmother to the six children from his marriage to Osburh: five sons, four of whom became kings of Wessex – Æthelbald (d. 860), Æthelberht (d. 865), Æthelred (d. 871) and Alfred (d. 899) – and one daughter, Æthelswith, wife of Mercian King Burgred. It is unclear whether Osburh had died or was repudiated by Æthelwulf, but his second marriage to Judith cemented an alliance with the Carolingians that benefited both parties.

More importantly for Anglo-Saxon queenship, when the marriage took place, Judith was consecrated in an elaborate ceremony. Æthelwulf conferred on her the title of queen, something that was not customary before then, but it may have been used once before for Eadburg, daughter of Offa of Mercia and wife of Beorthtic of Wessex. The marriage aroused fears among her stepsons that they would be displaced by half-brothers born of their stepmother. Æthelbald threatened civil war against his father, but father and son struck a deal: Æthelbald was granted rule of western Wessex and, in return, would allow the queen to sit next to the king. This broke with Wessex customs, where the king's wife was referred to not as a queen, but merely as the 'wife of the king'. Judith's status and Carolingian precedent won the day. After this, a queen's consecration became more customary, a rite that enhanced the status of queens and was included with the king's in Anglo-Saxon liturgical texts. Æthelbald's worst fears were not realized: Judith and Æthelwulf did not have children and he succeeded his father. Judith's prestige, youth and childlessness help explain why, when Æthelwulf died in 858, Æthelbald married her. Although there were clear precedents for the practice of stepsons marrying stepmothers, it had begun to raise the eyebrows of some of clerics. For example, Asser found this to be a form of incest, 'against God's prohibition and Christian dignity, and also contrary to the practice of all pagans, [he] took over his father's marriage bed and married Judith, daughter of Charles, king of the Franks, incurring great disgrace'. Judith was childless when Æthelbald died; she married a third time, to Baldwin of Flanders, a marriage which enraged her father, who had hoped to use her again as a diplomatic bride.[41]

Even at this date, when sources are fuller, there is some uncertainty concerning the identity of queens. For example, a woman named Wulfthryth may or may not have been Æthelred I's queen. Æthelred had two sons who were too young to become king when he died in 871, and the crown passed to his brother, Alfred 'the Great'. Alfred married Ealhswith of Mercia (c. 852–905) in 868, before he became King of Wessex. Falling back on customs that predate Judith, Ealhswith was not given the title of queen although she fulfilled the queenly prerogative of bearing the heir, Edward the Elder, who succeeded his father.

Æthelflæd (c. 870s–918), unlike her mother Ealhswith, was much busier in a public setting and left a much clearer imprint in the sources, although she may never have been formally proclaimed as a queen. By 893, and perhaps as early as 887, she had married the Mercian ealdorman Æthelred, who was older than her – perhaps much older. Æthelred, the highest ranking under-king associated with Edward the Elder, ruled over

the English half of the Mercian kingdom that had been partitioned by the Vikings. His marriage to Æthelflæd was intended to cement bonds between the two men. She, and at times her brother, Edward the Elder, led the Mercians against renewed Viking attacks after Æthelred fell ill in the 890s. After his death in 911, Æthelflæd ruled as *Myrcna hloefdige*, 'Lady of the Mercians', a title roughly equivalent to Æthelred's and indicative of the prominent position Mercian queens held, especially as regents. Æthelflæd and Edward are a rare royal combination of a sister and brother joining forces. She built a system of fortified sites (*burhs*) and churches, and with her brother, set about reconquering the Danelaw. Her army captured Derby; she campaigned with her brother to capture the remaining four Viking strongholds, and entered Leicester unopposed. She held sway in the north where the men of York offered her their submission and allegiance. She died in 918, just before her brother completed the reconquest of the southern Danelaw; her daughter, Ælfwynn, briefly held nominal rulership over the Mercians but King Edward the Elder thwarted any ambitions she may have had by depriving her of her inheritance and sending her to Wessex. Æthelflæd's importance in the creation of a unified English kingdom was noted by Henry of Huntingdon, writing two centuries later, who said that 'some call her not only lady, or queen, but even king' and described her as 'worthy of a man's name' and 'more illustrious than Caesar'.

The political culture that favored rule by brother and sister created ample space for Ælfthryth (d. 999–1001), one of the most important tenth-century queens of England; also, one of the most controversial. Daughter of a prominent family related to the kings of Wessex, Ælfthryth married well. Her first husband, Æthelwold, was son of Æthelstan Half-King, one of the most powerful nobles of the age; her second husband was King Edgar (d. 975). She was his third wife. They married in 964 and, in imitation of Judith, she was crowned and anointed as queen in 973 in a lavish ceremony that riled opponents. They had two sons, one of whom died young; the other, Æthelred II 'the Unready', succeeded his father as king. As a royal wife and mother, she exercised her power widely and, some would say, ruthlessly. After her death, her enemies portrayed her as a jezebel who committed an array of dreadful acts: witchcraft, adultery, plotting the death of an abbot, attacking convents, seducing King Edgar with her legendary beauty while still married to Æthelwold and then plotting his death, and murdering her stepson Edward in 978 so that her son, Æthelred, could succeed. It is difficult to know the truth when so much of what is known about her sounds like a conventional list of evil deeds tinged with salacious gossip and innuendo, exaggerated

and embellished much later by authors who clearly feared and resented such a politically active and important woman. When Edgar died in 975, Edward became king, but Æthelred's supporters rallied around him and used his mother's high-born status to bolster his claim. When Edward was murdered three years later by Ælfthryth's own followers, she was accused of taking an active part in her stepson's death. Key details will never be known, but early accounts of the murder do not name her directly; her guilt or innocence will never be known.

What is certain is that Ælfthryth skillfully blended politics and piety, endowing and governing monasteries and convents, allying with key bishops, taking part in monastic reform efforts, using her dower lands to expand the realm. As a dowager-queen, Ælfthryth was especially active as regent, perhaps with Bishop Æthelwold, during Æthelred's minority, and she overshadowed her daughter-in-law (Æthelred's first wife, Ælfgifu of York) by assuming control of educating her many grandchildren. Ælfthryth's reputation suffered again in 1016, when Æthelred was defeated and died while trying to repel the armies of the Danish king Cnut, who married Æthelred's second wife, Emma of Normandy.

Emma, the quintessential dynastic queen, was the daughter of Richard I, Duke of Normandy and a Danish noblewoman, Gunnor. Her two marriages, her political acumen and her dramatic family history combine many elements of eleventh-century queenship that make a compelling biography of a powerful woman but that pose interpretive challenges. 'The most distinguished of the women of her time for her delightful beauty and her wisdom', Emma ruled for fifty years, from her marriage to Æthelred in 1002 to her death in 1052.[42] During this period, the Anglo-Saxon kingdoms collapsed, the Anglo-Danes rose and fell and the Anglo-Normans emerged as the most powerful new dynasty in England. When she married Æthelred after the death of Ælfgifu of York, Emma was given the name of her predecessor, which she used instead of her Norman name on formal occasions or on charters. This may seem strange to us, but it was not unusual for a queen of that period to do so. A number of foreign-born queens changed their name upon marriage. This action symbolized the shift of her loyalties from her father and her natal family to her husband and his realm. Her blended identity – Norman, English and Danish – is reflected in the ways chroniclers refer to her. Imme was the spelling of the name given her at birth, and some versions of the *Anglo-Saxon Chronicle* use both her names, Emma and Ælfgifu, and later English documents call her Ælfgifu Imme.[43]

Little is known of Emma's activities in Æthelred's reign, except that she was more visible at court than his first wife, who was not anointed

queen and never signed charters. Emma appears in the witness-lists of the king's charters, but was not able to advance her sons Edward (later known as 'the Confessor') and Alfred over their elder stepbrothers. Æthelred died in April 1016 while preparing for yet another battle with the Danish king, Cnut, who defeated Æthelred's son, Edmund. Cnut and Edmund divided the kingdom and ruled jointly until Edmund's death in November 1016, at which time Cnut was chosen to rule England. Sometime before August 1017, the *Anglo-Saxon Chronicle* tells us, 'the king commanded that the widow of the late king Æthelred, Richard's daughter, be fetched for him that she might become his queen'.[44] Thietmar of Merseburg, writing soon after the events, notes that Emma was in a London stronghold, grieving with her sons and members of court. Thietmar depicts her as a depraved woman who would sacrifice her sons to save herself, a woman who:

> at once received the reply from the insatiable enemies, that if the queen would give up her sons to death and redeem herself with fifteen thousand pounds of silver, and the bishops with twelve thousand, and with all the coats-of-mail, of which there was the incredible number of twenty-four thousand, and would give 300 picked hostages as security for these things, she could gain for herself and her companions peace with life; if not, all [the messengers] cried out three times that they should perish by the sword. The venerable queen [...] was extremely agitated by this message and after long deliberation in a vacillating mind replied that she would do this.[45]

Thietmar is obviously describing a valuable woman, a 'venerable queen' of great wealth, comparable to a king, and a woman who did not make hasty decisions. His portrayal of Cnut and his allies as 'insatiable' is highly critical of the man who would be the next king, but it was Emma who, in older scholarship, was considered dangerous and immoral because she was willing to trade her sons for power.

However, this account needs to be balanced by that of William of Jumièges, also writing rather soon after the fact, who says that when Cnut:

> heard of the king's [Æthelred's] death, he consulted members of his council and took steps to safeguard the future. He took Queen Emma from the city and married her a few days later according to the Christian rite. In return for her he handed over her weight in gold and silver to the army.[46]

Elisabeth van Houts does not think that Emma was neither entirely nor necessarily a willing bride, arguing that 'fetch' does not fully convey the point of the scene. Her argument hinges on the Latin verb 'abstractam', which she translates as 'kidnapped', which implies that she was forcibly carried off against her will.[47] Contemporary Scandinavian sources tell another side of Emma's attempt to flee London by ship before her capture by Cnut's men. The author of the *Knýtlinga saga* tells us that 'just as her retinue was about to sail [...] they [Cnut's men] brought Queen Emma to King Knut and it was agreed by the king and his chieftains that he should take Queen Emma as his wife'.[48] The Scandinavians are not only tempering the seizure of the widowed queen by setting the account in a passive voice, but the author uses a neutral verb, 'brought', which is closer to 'fetched', rather than the more inflammatory 'kidnapped'. Emma has no voice and makes no choice in this account; rather, it is the consent of the chieftains that matters.

Emma was fully aware of the power of self-promotion and the need to create another narrative of her marriage to Cnut. Some considerable time later, during the reign of her son Harthacnut, she commissioned a monk of St. Bertin to produce the *Encomium Emmae Reginae*, one of the most remarkable political biographies of the Middle Ages. Although written in praise of Queen Emma, sometimes in an exaggerated tone, it is also an attempt to deflect criticism for her alleged complicity in the death of her son Alfred, and to generate support for the new king. About the circumstances of her marriage to Cnut, the author of the *Encomium* says that:

> [the] king lacked nothing except a most noble wife [...] This imperial bride was in fact found within the bounds of Gaul, and to be precise in the Norman area, a lady of the greatest nobility and wealth, but yet the most distinguished of the women of her time for delightful beauty and wisdom, inasmuch as she was a famous queen [...] Wooers were sent to the lady, royal gifts were sent, furthermore precatory messages were sent. But she refused to ever to become the bride of Knútr, unless he would affirm to her by oath, that he would never set up the son of any wife other than herself to rule after him, if it happened that God should give her a son by him. For she had information that the king had had sons by some other woman; so she, wisely providing for her offspring, knew in her wisdom how to make arrangements in advance, which were to be to their advantage.[49]

This account establishes the legal and political foundations for the reign of her sons over those of Cnut's son, Harold Harefoot, alleged son of Ælfgifu of Northampton, his illegitimate consort. The author takes pains to emphasize that Emma is made queen by a legitimate marriage, but there is no mention of her own sons with Æthelred, Edward (who ruled as Edward 'the Confessor') and Alfred Ætheling; they had also had a daughter, Goda. The *Encomium* shows Emma as both empowered and hampered by the dilemma of being a mother of competing sons and stepsons. She typifies the queen who will do just about anything to protect her children, albeit selectively, and preserve their rights to inherit and rule, putting their needs above all else, even, seemingly, her own personal sentiments.

Comparing all four accounts, it is clear that whether fetched, kidnapped, or brought to Cnut, whether against her wishes or willingly, Emma was a diplomatic prize. Her marriage to Cnut confirmed an Anglo-Saxon and Danish alliance that was coupled with the payment in gold and silver to legitimate the union. Her connection to the Anglo-Saxon dynasty mattered most, however, and she was of great importance to Cnut's efforts to play down his usurpation of the realm. Emma and Cnut are mentioned or addressed as a pair in surviving records, suggesting mutual support, as well as superb public relations. This union is symbolically depicted in the famous image that serves as a frontispiece to the *Liber vitae* of Hyde Abbey (Illustration 2.4). The image commemorates an act typical of her generous patronage towards numerous religious houses: Cnut and Emma are shown together, placing a great cross on the altar. She stands to Jesus's right, across an altar from Cnut. Clerics below witness the scene. One angel places a veil on her head, another a crown on Cnut. Above them all, Christ rules from a mandorla (an ancient symbol of wholeness) with the Virgin Mary at his right side and St. Peter on his left. Mary and Emma are linked visually to emphasize a new importance for the Virgin Mary, which would figure prominently later in the sermons of Bernard of Clairvaux, and represent visually the fact that Cnut's kingdom came to him through his marriage to the grieving widow of his enemy, Æthelred.

She was also shrewdly pragmatic, fully aware of the danger of being a king's widow, and was willing to leave Edward and Alfred in Normandy with their uncle, Duke Richard II of Normandy, for safekeeping. After Cnut's death in 1035, Emma was very active in a public political role to negotiate the disputed succession of the four potential heirs: Harthacnut (her son with Cnut), Edward and Alfred (her sons with Æthelred) and Harold Harefoot (Cnut's alleged son with Ælfgifu of

Legitimizing the King's Wife and Bed-Companion, c. 700–1100 111

Illustration 2.4 Queen Emma, the *Liber Vitae* of the New Minster, Winchester (1031), London, British Library, BL Stowe 944, folio 6r. © British Library Board.

Northampton). She was committed to advancing the interests of the realm and Harthacnut against the competing ambitions of Harold Harefoot and his formidable allies. When Harold Harefoot died in 1040, Emma returned to England and governed with Harthacnut, despite vocal opposition. Edward remained on the sidelines until Harthacnut died in 1042, at which point Edward gained the throne and took revenge on his mother by confining her to her estates and confiscating her land and wealth.

Her biography, the *Encomium Emmae Reginae*, is perhaps the most explicit case of a collaboration of a queen and her biographer but, in this case, the author is not trying to consecrate a queen as a saint but, rather, a queen as a political figure. She was a diplomatic and political bride whose purpose was to mend the ruptures of the Norman and Anglo-Saxon lords. She was memorialized in the *Encomium*, but recent scholarship by Helen D'Amico makes a compelling case for her as the model for Wealhtheow, the powerful and memorable north Germanic queen of *Beowulf*.[50] Roberta Frank argues that the epic poem set in the sixth century was composed in the early eleventh-century, and used the ancestral lore of a queen to be reckoned with as a way to discuss contemporary politics.[51] Using a fictional queen as a way to harshly critique a living queen was not uncommon, and the result is often a tale abounding in misogynistic tropes of a litany of personal evil, sexual depravity and sorcery. What is striking in this case is that the author of *Beowulf*, like the author of the *Encomium*, considers the powerful queen to be a positive force, a politically knowledgeable and shrewd queen who put family first and saved her own skin in the process. The name Wealtheow means 'Norman captive' and her forceful, assertive and bold manner of speaking is that of a person to be reckoned with, hardly a submissive hostage. The text of *Beowulf* fuses the eleventh century political culture with an earlier age into what D'Amico calls a 'political allegory of contemporary events and figures'. *Beowulf* certainly circulated among the members of court and it is likely that the *Encomium* did, too, sending a very clear message to her subjects that Emma consented to marriage with Cnut, that their reign was fully legitimate, and that she was a good mother to her sons. She was a queen to be respected, not vilified.

The marriage of Emma to King Æthelred II has often been interpreted as the event that led to the Norman conquest of 1066. It is true that Emma's marriage to Æthelred helped to create the highly-charged political situation during the period following Cnut's death in 1035 until Edward's accession in 1042, which led to the events of 1051–2, leading Edward to make an approach to Duke William that was construed as a promise of the succession to the throne. Emma played a significant role for fifty years and her rule illustrates how much may always have depended on tensions and competing interests within the royal family. When Harthacnut died, in June 1042, he was succeeded by his half-brother, Edward the Confessor, who was consecrated king at Winchester in April 1043, together with his wife, Queen Edith (d. 1075), who was as different as one could be from Emma, yet they both typify essential aspects of Anglo-Saxon queenship.[52] Edith was a highly-educated

woman, praised for her physical beauty, piety, literary accomplishments, artistic skill, efficient management of Edward's household, generosity to the Church, and influence as his counselor.[53] She was devoted to Edward's comfort and took particular interest in the personal appearance of a man uninterested in royal trappings. Notably missing from this list is motherhood. They married in 1045 and theirs was a diplomatic marriage designed to solidify relations between Edward and her father. But the king and earl had a falling out in 1051 that caused Edward to repudiate Edith, perhaps because she was, and would remain, childless. Edward deprived her of her possessions and sent her to a nunnery, taking her back only when he and her father repaired their relationship.

Like her mother-in-law Emma, Edith had a say in writing her own biography but, instead of writing it as a paean to herself, she had it embedded in the life of her husband, in the *Vita Ædwardi regis*, which she commissioned to advance his canonization and to portray her childlessness in the most favorable way. While the *Vita* outlines her secular achievements, it is her piety and her vow of chastity that distinguish her from her peers and receive considerable attention. As lineage, dynasty and motherhood became the pre-eminent qualities of a queen, the *Vita* is a carefully crafted personal narrative that elevated chastity as a queenly virtue and stated that Edith chose childlessness. Edward was canonized, but it is unlikely that he took a vow of celibacy. Unlike her mother-in-law Emma, she was not assertive and the author of the *Vita* remarked that she seemed more 'like a beloved daughter' than a wife, not so much a spouse as a good mother. But she was not a mother. She was at least fifteen, maybe twenty, years younger than Edward and their marriage was supposed to produce sons to secure the dynasty. Childlessness was not an unusual occurrence, but for no other queen has so much attention been devoted to the causes and implications of the failure to bear children. It may have been simple infertility, but it is impossible to know this for certain. Edith used it as an extension of her piety, while Edward used it as a diplomatic asset by offering the right to succeed him as a gift to friends. It is significant that there is no overt anxiety over the couple's childlessness before 1051. Criticism of Edith ranged the spectrum of complaints about a queen: a scheming and venal woman with a passion for collecting relics, plotting the assassination of enemies of her family, unchastity, adultery. But near silence on the absence of children.

Still, no matter what the reasons, their childlessness caused one of the most talked about succession crises in history. Edith could not have been more than forty-six when she was widowed; but it had been generally

accepted after 1052 that, whatever the reason, the couple would remain childless. Edward may have promised William of Normandy the succession in 1051. Toward the end of Edward's reign, Edith and her brothers got tangled in uprisings in the north, a family quarrel that spilled out into royal politics and caused a breach in relations between Edward and Edith. But they appeared to repair the rift. The author of the *Vita* believed that Edith and her four brothers agreed to work together after Edward's death, and it is likely that he entrusted the kingdom to Edith and Harold, who were both in attendance. On the Bayeux tapestry, which Carola Hicks suggests Edith may have commissioned, Edith is shown sitting at the foot of Edward's deathbed – a scene also described in the *Vita* of Edward.[54]

Although the later Anglo-Saxon kings claimed effective rulership of a united England that included Welsh, Irish and Scottish realms, and they may have admitted this overlordship, English rule north of the Humber and west of the Welsh border was more nominal than real. In Scotland, the kings gained in strength and vitality during the Viking invasion of the English coastlines in the ninth and tenth centuries and, by the eleventh century, they had taken shape in ways that are recognizably monarchical. However, it was not an easy enterprise. The kings of Scotland had to contend with powerful clans and noble families in a struggle to build and maintain a dynastic monarchy. In this early period, queens of Scotland were a key part of the process of building a dynasty, but few are well-known and queenship was still very much a work in progress compared with England and France. Until very recently, studies of monarchy in Scotland were entirely devoted the study of kings. Fiona Downie's work is the first formal study of queenship in medieval Scotland that provides in-depth analyses of whether women could succeed in Scotland, how and when they were crowned, and how their households functioned. Most of her work focuses on the later Middle Ages, but she provides useful context for the earlier period.[55] Queens in Scotland were not crowned until 1331, which is quite late by contemporary standards, and Scottish queenship stayed close to Celtic practices, which regarded a queen simply as the king's wife.

The most well-known early queen of Scotland is Margaret (d. 1093), second wife of Malcolm III (d. 1093), the eldest child of Edward Ætheling (d. 1057), who was briefly king of England after the death of his father, Æthelred, in the 1016 invasion of Cnut.[56] Edward went into exile and took refuge at the royal court in Hungary, where he married Agatha, 'the emperor's kinswoman'. Their daughter Margaret was born in Hungary, returned to England in 1057 while she was still a child, but fled to Scotland after the Norman invasion in 1066. There, the Scottish King

Malcolm III wooed her and, despite her preference to pursue an ascetic life, she agreed to marry him in either 1069 or 1070 at Dunfermline. Despite their very different backgrounds, the marriage was successful, lasting for twenty-three years and producing eight children. Margaret was not a publicly active queen but she took advantage of the enormous potential in her role as wife of the king. She was a woman of great learning and worldly sophistication, and took responsibility for the education of both Malcolm and their children. Malcolm supported her, helping her in her charitable activity and her dealings with the Scottish clergy. When Malcolm died in a skirmish into England in 1093, Margaret, who had maintained an ascetic life even though a queen, died three days later. Her life, written at the request of her daughter Queen Matilda, wife of King Henry I of England, relates her compassion towards children (especially orphans) and the poor, her severe ascetic practices, fasting and her work to reform the Scottish church.

Christian Iberia

The Muslim conquest of Spain in 711 transformed the peninsular realms in far more dramatic ways than any other conquest in Europe in the Middle Ages by bringing a fundamentally different religion, Islam, to the region, together with Islamic emirs and caliphs against whom the Christian kings waged war for centuries. The political organization of the caliphate, whether located in Baghdad, Damascus, or Córdoba, was a fully theocratic state with a very distinctive political organization. Within the medieval Islamic world, the wives and mothers of caliphs and emirs were quite different from Christian queens and empresses in how they acquired their status and what their role was in the caliphate or emirate.[57]

The remaining elites of the Visigothic kingdom and their subjects, however, very closely resembled realms north of the Pyrenees. The survivors of the Muslim conquest fled northwards, huddled together. To call them kingdoms would be an exaggeration but, after a century, they had sufficiently regained their equilibrium to be considered viable political entities. This was a rough-and-ready period, with shifting borders and very little time for bureaucratic niceties such as record-keeping, so we know precious little about many of the earliest queens of the early Christian kingdoms of Navarre, Pamplona, León and Asturias. But it is clear that Spanish queens were fundamental to the success of the Christian Reconquest and the creation of monarchies after the Muslim conquest in Iberia. Sancha of León (1013–67), daughter of Alfonso V of

León by his wife, Elvira Mendes, the queen of León, was heiress presumptive when she married Fernando I of Castile (d. 1065).[58] He took possession of León by right of his wife and, in 1038, had himself formally crowned and anointed king in León. Sancha's role as queen leading up to the Reconquest is immortalized in a vivid image in the presentation frontispiece of the luxuriously illuminated Book of Hours of Fernando I (Illustration 2.5). The king and queen flank a figure (whose identity is disputed; it might be the scribe or the painter of the book) who presents it to Fernando, the patron. Fernando is crowned and Sancha is not, and he holds a scepter signifying his kingship. It is significant that she is depicted as the same size as the king, standing beside him on or slightly behind a pedestal, signifying that their status and their dignity, although not her authority, were equivalent.[59]

Many of these early Spanish queens, like their counterparts elsewhere, were regents for young sons or for husbands who were occupied in

Illustration 2.5 Fernando I of León and Castile and his wife Queen Sancha. Miniature from the Book of Hours of Fernando I, 11th century, Archive, Cathedral, Santiago de Compostela, Spain. © Universal Images Group/Art Resource, New York.

battles either with the Muslims or with their rival Christians. Elvira Ramírez (c. 935–after 982), the sister of Sancho the Fat and aunt of the succeeding king, Ramiro III (d. 984), was the first of a series of queens-regent in the Iberian realms. Older Visigothic custom dictated that, as a widow, Ramiro's mother should enter a convent, so Elvira was named regent. She negotiated treaties, signed charters and other official documents for her brother and nephew, gave judgment at court and presided over a judicial assembly when Ramiro was away. In Navarre, Toda Asnúrez, was regent for her son García I Sánchez (d. 970); Urraca Fernández and Jimena González (grandmother and mother, respectively) were regents for Sancho III Garcés, el Mayor (d. 1035).

Eastern Europe, Scandinavia and Kievan Rus'

Kievan Rus', with its political center at the principalities of Kiev and Novgorod, and its conversion to orthodox Christianity in the tenth century, used queens and royal marriages in general to affiliate closely with western Europe, particularly Scandinavia, the Ottonian Empire and Capetian France. It was not simply a question of seeking brides from farther afield to avoid concerns about consanguinity; Novgorod and Kiev were important trading centers.[60] Olga (d. 969), wife of Igor of Kiev, was the first Christian ruler of Rus' (she converted sometime between 945 and 957), strengthened ties with Christian rulers in Europe by sending an embassy to Emperor Otto I in 959. This set in motion a series of political and familial alliances that persisted until the Mongol invasions in the thirteenth century disrupted the bonds. The most influential of these alliances began when Yaroslav I, Grand-Duke of Kiev (d. 1054) sent his daughter Anna to the court of France to marry Henri I. Other children of Yaroslav and his wife Ingegard followed westwards in Anna's path: Anastasia (d. 1096) to Hungary, to marry Andrew I; Elisabeth (d. 1067) to Scandinavia, to marry Harald of Norway and, later, Sven of Denmark; Isiaslav to Poland, to marry the sister of Casimir of Poland; Vsevolod to Constantinople, to marry a Byzantine princess; Vladimir married a niece of a former queen of France. Jaroslav's sister married Casimir, King of Poland. The movement of royal brides was not just westwards. Judith of Swabia (1054–1105), daughter of Emperor Henry III and Agnes of Poitiers, became Queen of Hungary when she married Solomon.[61]

What little we know about early medieval Scandinavia (present-day Denmark, Sweden and Norway) comes largely from archaeological

evidence for the agrarian and mercantile economy, conversion narratives and Old Norse narratives recounting the Norse invasions of Britain, the continent and the Mediterranean.[62] But, based on both artifacts and narrative sources, it seems clear that early kings centered on Old Uppsala were weak – and so, presumably, were queens – until unified kingdoms were established as effective entities after the year 1000.

In early medieval Scandinavia, history is narrated through kings' sagas of Iceland and Norway that include northern royalty, mostly kings but some queens, too, from mythic times to the end of the thirteenth century. The Norwegian kings' sagas focused on a small circle of men, mostly Norwegian kings, whose lives and reigns are continued in sagas and, later, in chronicles. These sources pose a number of problems for a historian trying to discern actual events from the sagas and the skaldic verses embedded in the sagas. Sagas have significant value as historical sources because they are concerned primarily with political history, thus making them the best narrative sources for pagan Scandinavian queens and concubines. Read with care, texts such as these are part of a medieval social imagination that was as concerned with conveying aspirations and using what we might term 'fiction' to convey what an author considered appropriate or inappropriate behavior for a queen. The texts were based on oral narratives that were written and rewritten over decades, if not centuries, which raises questions as to the stability of the narrative, the authenticity of the information conveyed and the interaction of transmission and reception of the story. Even though there may be no reliable way of determining which parts of a poem genuinely date from the purported time of composition, they are very useful texts as long as the reader is mindful that medieval texts need to be historical only insomuch as they describe the cultural and political structures within which social events and literary texts are produced. For example, Gunnhildr (d. around 980), Norwegian queen-consort of Eric Bloodaxe, is depicted as a top-notch politician and *femme fatale* in the *Heimskringla* written by Snorri Sturluson in the thirteenth century. Gunnhildr and Harald may have had as many as ten children, some of whom later ruled as kings. This work and other many sagas such as the *Fagrskinna*, *Egil's Saga* and *Njal's Saga*, are mostly concerned with the king's tyranny.[63] In general, the sagas are concerned less with the actions of a single individual and more with many generations of several families or a group of people living in a particular geographical region. The fictionalization of the histories of Icelandic families and regions is well-known, and references to magic, witchcraft and wizards abound, making these works as tricky for historians as are the source texts for Arthurian romance literature.

When Gunnhildr is mentioned, she is blamed for inciting violence, but this description of her bears a very strong resemblance to other fictional inciters in Icelandic saga literature, calling into question its veracity. But, as in the Arthurian literature, the actual historicity is not as important as what it tells us about Norse perceptions of women in power, as fearsome daughters, sisters, wives and mothers.[64]

As Christian conversion began in earnest around the year 1000, queens are more often recorded in monastic and episcopal records. These sources are better at recording names and dates but, like Bede and Gregory of Tours, the authors have a vested interest in portraying the queen as a saintly foil to a pagan husband. Archaeological evidence such as early Norse, late Viking Age runestones and tomb epigraphs are very useful as ways to verify material in the sagas. Art historians and folklore scholars have begun to examine this material to study Scandinavian women and gender, but little work has been done in terms of queens. For example, one of two massive carved runestones in the Jelling monument in Jutland contains an inscription dating to the tenth century that says: 'King Gorm made this monument in memory of Thyrvé, his wife, Denmark's adornment'. The other stone was erected by King Gorm's son, Harald Bluetooth in memory of his parents, and to celebrate his conquest of Denmark and Norway, and his conversion of the Danes to Christianity: 'King Harald ordered this monument made in memory of Gorm, his father, and in memory of Thyrvé, his mother; that Harald who won for himself all of Denmark and Norway and made the Danes Christian'. Scholars generally agree that Gunnhildr was Gorm's daughter, and Saxo Grammaticus mentions a Queen Thyra. Gorm's reference to his wife as an 'adornment' can mean several things: beauty, a precious asset, a possession to be admired – but she was clearly important enough to both husband and son to merit mention on both stones. It signals her importance to the family, to the king's dynastic claims, and perhaps to her natal family, but we know only the barest of outlines of what queens like Thyrvé and Gunnhildr actually did.

Conclusions

By the ninth century, political developments prompted bishops such as Hincmar of Reims to consider the question of what makes a king a king and, as a result, what makes a queen a queen. Both king and queen had more elaborate coronations, and the practice of anointing a queen began to take hold. Queens benefited from this clarity so that, by the tenth

century, the coronation rites stressed promotion of the faith, suppression of heresy and her partnership in rule with the king. These borrowings from the king's rite for the queen show the extent to which both kings and queens were set apart from the rest of society and demonstrate that both were considered central to monarchy. But the differences are striking. A queen did not receive the sword, scepter or rod – the regalia that signify a king as a crowned warrior and a judge. As the rights of queens to inherit and bequeath property were curtailed under new laws designed to preserve family property, queens were less and less likely to inherit and rule in their own right.

Although most queens did not rule directly, they could be part of the governance of the realm as a regent. It was not a universal practice in a society that valued warrior kingship and preferred an adult male as ruler but, by the tenth century, there was a growing acceptance of direct succession to royal inheritance from father to son, and fears that a rival dynasty would seize power from a child king could make female regency unlikely. Queens were, however, vital to the health of the realm and its good governance, and they expressed this in their piety and maternity. By 1100, the king's wife was recognized as a queen, crowned and, in some cases, consecrated in a religious ceremony, which set her apart from other women. The queen, in turn, legitimized a king's right to rule by bearing children that confirmed God's blessing on their union and their right to rule. The proximity to the king gave queens public authority in managing the household and endowing religious foundations such as monasteries and abbeys. They were visible symbols of dynasty and monarchy who put their family connections to good use as they worked with family members to build alliances through marriage and to maintain these networks through letters and embassies. This emphasis on family linkages is vividly evident in the reign of Emma, wife, first, of the Anglo-Saxon king Æthelred and, then, of the Danish king Cnut.

The Carolingians raised the stakes when they insisted on specific forms of marriage in legislation from the eighth and ninth centuries, and this was brought into the political sphere by the reigns of Louis the Pious and Lothar II. By the end of the eleventh century, changes in inheritance, property-holding, and religious and political ideology not only circumscribed the actions of a king wanting to dispose of a wife, but they also affected a queen's opportunities in both the domestic and the public domains. Legal reforms favored monogamous marriage; this, in turn, emphasized a queen as mother and central to a legitimate dynasty. With divorce increasingly difficult to obtain, a childless queen (such as Edith or Cunigunde) could turn her attention to piety and seek a chaste, almost

ascetic marriage. But a queen's influence over a king remained strong because monarchy remained a personal form of government and, increasingly, queens would step forward to govern as regents or lieutenants for absent kings.

From the eleventh century onwards, new institutions become evident: royal courts of justice met regularly, were staffed by legal experts, and royal accounting and fiscal agencies were staffed by financial experts. This made government more effective and efficient, and it raised necessary revenue, but it changed both how and where a queen could act. Of course, the experts were men because they were trained in universities – which excluded women. Women of high status could no longer exercise political power as extensively or as conspicuously as before, but they continued to exercise it, and in the old ways.

The royal courts were the main power centers, and women inhabited them, too. Women as well as men formed the audience for the serious and not-so-serious displays, including the reading of literary and historical works. Women were the agents of a civilizing process that helped to shape a distinctively western European culture over the course of the Middle Ages. The old forms of familial politics were not superseded by new forms but, rather, supplemented by them. Monarchy – and, by extension, kingship and queenship – was still very much a personal and patrimonial institution but, by 1100, they were constrained by both law and custom in ways that protected queens from arbitrary repudiation or divorce. The invasions of Vikings, Muslims and Magyars had left Europe relatively calm. Kings and queens were equipped with the ideology and the institutional framework that would serve their children well in the coming centuries.

For further research

Despite the Viking, Magyar and Muslim invasions that may have destroyed many of the sources for this period, there are more extant chronicles, and a greater proportion of them contain valuable accounts of (or, at least, more than passing references to) queens. Narrative sources are richer for the Frankish realms and England, but an enormous range of other categories of evidence shed valuable light on queens from elsewhere in Europe: royal charters, secular and ecclesiastical legislation, legislative codes, hagiography, estate surveys, liturgical texts, letters, poems, relics, seals, coins, inscriptions and artifacts of all kinds, including manuscript illumination, jewelry, sculpture and buildings.

For England, annals such as the *Anglo-Saxon Chronicle*, although telegraphic at times, remain valuable. Asser's *Life of Alfred* (c. 893) may be the first Anglo-Saxon political treatise, but it considers queens only as a means of proving dynastic connections. Carolingian and Ottonian chronicles are more generous in their treatment of queens, as is *The Latin Chronicle of the Kings of Castile*, newly translated by Joseph F. O'Callaghan (2002), which has tidbits of valuable information on queens in this period but is richer for the later Middle Ages. Narrative Irish histories, such as *The Book of Leinster*, make reference to queens, but these are still sketchy passing glances. The *Russian Primary Chronicle*, a history of Kievan Rus' from about 850 to 1110 (compiled c. 1113), provides the best descriptions of female rulers – both those in Rus' and princesses who traveled to take their place in western European royal courts.

As coronation became more common, so did the liturgies (*ordos*) for the coronation of both kings and queens of France and England, newly-translated into English. Hagiography continues to be a good source for queens, and a noteworthy source for Ottonian queens and empresses is Sean Gilsdorf's translation of *The Lives of Mathilda* and *The Epitaph of Adelheid*. Extant literature is a particularly rich source, and includes epics, songs, poetry; these, with the saga literature from Scandinavia, are very informative for the lives and deeds of queens. Monastic cartularies document queens' land transactions, and royal and papal letters are more numerous but unlikely to be translated. Royal archives were just beginning to be established towards the end of this period, particularly for England and the Crown of Aragon; letters from and to queens, and texts of royal acts (*diplomata*) formalizing the intercessory acts of a queen appear in significant numbers. The rise in importance of lineage led to the construction of genealogies, some more complete than others, and the art of heraldry gave the symbolic representation of a family. Coinciding with genealogies and heraldry are seals, which were commissioned by a woman for her own use in sealing documents and may be the best self-representation of queenly power in the Middle Ages.

Visual art depicting queens includes manuscript painting, tomb effigies and memorials. Queens who sponsored the building of royal convents and monasteries are vivid expressions of queenship and sanctity. One particularly noteworthy work that reflected the new image of queenship in a visual work commissioned by a queen is the frontispiece to the late eleventh century laud to a queen, the *Encomium Emmae Reginae*, created for Emma of Normandy, Queen of England. Other women were active in the memory-making: Matilda's *vita* of her mother, Matilda of Scotland.

3

'The Link of Conjugal Troth': Queenship as a Family Practice, c. 1100–1350

In an impressive marital coup, Count Ramon Berenguer V of Provence and Béatrice of Savoy married their four daughters to kings. Marguerite (d. 1295) married Louis IX of France in 1234; Eleanor (d. 1291) married Henry III of England in 1236; in 1243, Sancia (d. 1261) married Henry's brother, Richard of Cornwall, who became King of the Romans and Emperor; and Béatrice (d. 1267), heiress to her father's lands, married Charles I of Anjou, brother of Louis IX, who became King of Sicily.[1] These four socially advantageous marriages were astounding enough to catch the attention of Dante who, in *Paradiso*, wrote that 'of Raymond Berenger's four daughters, each became a queen'.[2]

Marguerite and Eleanor are familiar to scholars of queenship for both the longevity of their reigns and their active public lives. Marguerite married Louis, who was later canonized, while he was still under the tutelage and regency of his mother, the indomitable dowager-queen Blanche of Castile who, until her death in 1252, overshadowed her daughter-in-law. With Louis, Marguerite had eleven children, but she was busy beyond the royal nursery. She went on crusade with Louis in 1248, ruled for him briefly in Damietta in 1250, negotiated the terms of his release after his capture and was frequently called on to mediate.[3] In England, Eleanor and Henry formed a powerful ruling couple. She took responsibility for educating their five children, among them a king (Edward I,

who succeeded his father) and a queen (Margaret, who married Alexander III of Scotland) but, when she stepped into the public arena, her actions roused opposition. She was crucial in restoring her husband and son to power after baronial revolt, supported Henry's unpopular taxation and was a tough manager of her household accounts and her income from estates granted to her as queen.[4] Sancia and Béatrice are less well-known than their older sisters, but no less influential. When Sancia married Richard he was a widower and, when he became King of the Germans in 1256, she was crowned queen in 1257 and reigned for four years as Queen of the Germans until her death. Béatrice was one of the most attractive heiresses in medieval Europe, and her prominent role in family matters gave her leverage in wider political matters. When Charles married her, he gained the title of Count of Provence, and when the throne of Sicily became vacant in 1264, Béatrice helped Charles raise an army to defeat Manfred of Hohenstaufen. They were crowned King and Queen of Sicily in 1266, just one year before her death.

The marriages of the King of France and the King of England to Marguerite and Eleanor, and Sancia's marriage to Henry's brother Richard, improved the relationship between the two realms and contributed to the Treaty of Paris in 1259. The Treaty resolved some of the tensions between them that had simmered in the decades since the reign of King John of England and King Philip II Augustus. The relationship of these four sisters was not without conflict, but they linked four realms of Europe in a network of family that was more than just political. They grew up in a court filled with religious luminaries who shaped their intellect and their piety, and all were generous patrons of the church. Béatrice accompanied her brother-in-law Richard on an embassy to Louis in 1250, and went with Marguerite and King Louis IX on crusade to Damietta, where both sisters gave birth. Sancia and Eleanor, both sisters and sisters-in-law, appear to have been in close contact after Eleanor came to England, and all four sisters spent Christmas together in Chartres and Paris in 1254. At present, we know more about Marguerite and Eleanor. Aside from chronicles and official documents that discuss the queen in the context of what the king was doing, a queen's legacy to historians often depends on a busy chancery in a large realm. Much of what we know about both Sancia and Béatrice we know indirectly, from brief mentions in a chronicle or modern history of Eleanor or Marguerite. We are fortunate that quite a few letters survive from the long reigns of Marguerite and Eleanor, but only a handful of Sancia's are extant and none of Béatrice's appear to have survived.[5]

All four sisters were influential to European monarchy because, as

'The Link of Conjugal Troth'

Henry III noted when he sought a wife for his son Edward, 'friendship between princes can be obtained in no more fitting manner than by the link of conjugal troth'.[6] In a patriarchal society like that of medieval Europe, a queen derived her official status from a man – either her father, if she were queen-regnant, or her husband, if she were queen-consort – but she derived considerable power from her mother, sisters and aunts. A queen's position in the family and her loyalty to both her natal and marital kin mattered greatly. This power could be expressed even before she married, as a princess or noblewoman on pilgrimage, bestowing alms and patronage, interceding on behalf of supplicants, tending to family tombs and mausoleums, and participating in royal ceremonies. As a queen, the power of the queen as sister or aunt ranged widely across a political, cultural, religious and economic spectrum that could be anything from high-level peace negotiations to the simple smoothing out of tensions within the family. A methodological move that shifts the focus from a singular queen to the study of queens in the plural opens up the vantage points and allows us to analyze queenship comparatively, across borders, to discern similarities and differences. In so doing, the entire field of monarchy opens up to include the entire royal family, not simply the person sitting center-stage.

Two scholars have used this sort of comparative framework for analysis, looking either at sisters from the same family or at queens in succession in the same realm. Miriam Shadis focused on another family with four daughters, all queens: that of Alfonso VIII of Castile and Leonor of England in the late twelfth and early thirteenth centuries – Berenguela, queen in her own right of Castile; Blanche, wife of Louis VIII of France; Urraca, wife of King Afonso II of Portugal; and Leonor, wife of King Jaume I of the Crown of Aragon.[7] She notes that in this period, when princesses were more likely to move to marry, certain key elements of queenship – such as marriage and maternity, and how a woman was educated for queenship – provide institutional continuity across borders.

Lisa Benz St. John took a different tack and looked at three fourteenth-century English queens from different natal families who married three Plantagenet kings named Edward in succession – Margaret of France (second wife of Edward I), Isabelle of France (Edward II) and Philippa of Hainault (Edward III). The reigns of these queens overlapped and created a sort of political ballast to ensure a continuous transition during an interregnum.[8] Taking either the natal family or marital family as a constant makes it possible to see the extent, compared with circumstance, to which political culture, upbringing and personality shaped a queen's reign. These studies do more than just

...nique perspective on queenship and political culture, ...hey challenge long-standing arguments by kingship scholars ...oyal bureaucracy was the linchpin in a smooth transition onn of a king. Comparative studies like these of Benz St. John and Shadi... reveal that queens were hardly cogs in the works. Like kings, they, too, were integral to the power structure of monarchy.

Marrying outside the realm was not a new dynastic strategy. Kings and queens in the early Middle Ages knew that marrying outside one's realm signified the royal family's standing on a wider scale and raised the royal family above the nobles. This became increasingly common after 1100. These centuries witnessed the rise and flourishing of long-lived dynasties born of strategic marriages that created links across borders, conquest and annexation: the Capetians in France (987–1328), Plantagenets in England (1154–1399), Hohenstaufens in Germany (1138–1254), the descendants of Alfonso VIII of Castile (1158–1369), the descendants of Ramon Berenguer I of the Crown of Aragon (1137–1410), the Komnenos (1081–1204) and Palaiologos families in the Byzantine Empire (1259–1453) and the Árpád family in Hungary (1000–1301). Princesses were denied opportunities to rule in their own right as male primogeniture replaced partible inheritance but, as they moved across Europe, they were vital to establishing and maintaining cross-border family links. Queens had an active unofficial role, mediating and interceding in politics both within and outside the realms in the main political events and processes of the period, notably the Norman Conquest of England (1066), the most active phase of the Crusading movement (1099–1204) and the Hundred Years' War (1337–1453). These events and processes have been interpreted by most scholars through the conventional political history that focuses on the deeds of kings, barons, popes, bishops and monks, with passing references to queens. Yet queens – and particularly questions of queenship, dynasty and inheritance – are pivotal to the success of monarchies with international dimensions.

The strategic use of marriage for expanding boundaries of the royal domain was used skillfully almost everywhere in this period. In England, the Norman Conquest began as a dispute over inheritance that hinged on the claims of Duke William, an illegitimate son of Duke Robert I. William's rights to rule England were acquired through his great-aunt, Emma, the Norman wife of two kings of England: the Anglo-Saxon Æthelred II and the Danish Cnut. In thirteenth-century France, Philip II Augustus reclaimed the French royal domains when he defeated John of England, regaining lands in Anjou, Maine, Touraine, Normandy and the Vexin that his father, Louis VII, lost to England when Eleanor of

Aquitaine married Henry II of England. He and his successors gained the powerful neighboring counties of Artois, Provence and Champagne as dowries.[9] The Crown of Aragon was formed in 1137 when Ramon Berenguer IV, Count of Barcelona, married Petronilla, the one-year-old heir to the kingdom of Aragon, ruling it in her name until his death in 1162, when she renounced the crown in favor of her eldest son.[10]

Not all acquisitions were by marriage *per se*, but queens remained central to the transaction. Queen Berenguela of Castile turned her crown over to her son, Fernando III, who then contested the will of his father, Alfonso IX of León, disinherited Sancha and Dulce, Alfonso's daughters from a prior marriage, and united the realms as Castile. Only the German realms remained more or less independent kingdoms, duchies, or counties under the cloak of Empire. As a result of the Crusades, an entirely new set of realms was created – the Latin Kingdoms of Jerusalem – in which both the queen and the king were foreign. They brought with them from France a set of presumptions about inheritance and ruling; in a place dominated by Jews and Muslims, and facing entirely unanticipated conditions, they constructed a distinctive form of monarchy that was of great significance to queenship. What worked in France, where lordship was based on fiefs and dependent labor to exploit the land, simply did not apply in a semi-arid land with entirely different customs and laws. Queens quite literally held down the fort while their fathers, husbands, brothers and uncles fought against the Muslims. All queens were vital to the realm's survival. Some, such as Queen Melisende of Jerusalem (d. 1162), ruled in their own right, married men who held the title of king-consort and passed rights to land and lordship directly to their female relatives.[11] The origins of the Hundred Years' War can be traced to a foreign bride. This scramble for a legitimate male heir began in France in 1328, when contested claims to the French throne after three successive Capetian kings, the sons of Philip IV, failed to produce a legitimate son to inherit. The English king, Edward III, staked his claim to France traced through his French mother, Philip's daughter Isabelle.

But the movement of women across borders was not only a function of territorial acquisition; it was also prompted by two entirely different stimuli: the increasingly forceful application of ecclesiastical strictures on consanguinity and a burgeoning international economy. Consanguinity prohibitions led many royal families to a search for a foreign bride with diplomatic benefits outside their immediate pool of well-born legitimate princesses, duchesses and countesses. In so doing, the fates and political cultures of distant realms became interwoven. This is best seen in the marriage of princesses from the Crown of Aragon,

centered on Barcelona in north-east Iberia, to Hungarian princes. Not only did they extend their political reach, but also Hungarian and Aragonese merchants profited handsomely from trade across the Mediterranean, the Black Sea and up and down the Danube River.[12] From the late thirteenth century, marrying outside the realm was part of the marriage strategy of the Habsburg princes and their spectacular success brought them to the pinnacle of imperial power in the later Middle Ages.

In this milieu, queens were international ambassadors. They left their home for another realm and, in so doing, became highly effective political and cultural diplomats, acting as conduits of culture and education, and vehicles for conversion. One way that both historians and literary scholars have studied this is through the ownership of books. Royal women in earlier centuries, particularly Carolingian and Ottonian empresses, had owned and commissioned the creation of books – both lavish books used on special occasions or given as gifts, and personal devotional books used every day. For example, in the eleventh century, Judith of Flanders gave an illuminated manuscript to Matilda of Tuscany as a wedding present. But there is a marked upturn in book ownership by women after 1100 and much of it is multilingual.[13] Matilda of Scotland, wife of Henry I of England, commissioned a copy of *The Voyage of St. Brendan* in Latin and later had it translated into Anglo-Saxon, which suggests that she could read, and perhaps write and speak Latin. Queens were links in an international network of artists and scribes when they gave books as gifts; for example, the Melisende Psalter, a wedding gift produced in Jerusalem, is a blend of European Christian, Byzantine and Armenian styles.[14] Books were not just lavish objects intended to please the eyes, they were educational. Around 1247, Marguerite, Queen of France, commissioned Vincent of Beauvais's *De erudition filiorum nobelium* (*On the education of noble children*) and specifically asked him to include a section on the education of princesses.

Art historians have studied the economic and cultural dimensions of queenship beyond books. For example, Clémence of Hungary, wife of Louis X of France, had a library that was inventoried at her death in 1328. She owned forty-three manuscripts, including the *Peterborough Psalter* and other elaborately decorated books. She also possessed an array of jewelry, sculptures in precious metals, textiles, silver and gold devotional shrines, reliquaries and crosses, metalwork objects used in the dining hall, and eighteen gowns, many of fine silk. Mariah Protor-Tiffany argues that Clémence bequeathed these lavish objects to her Angevin and Valois family and her husband's Capetian relatives to maintain her identity when her social status was in jeopardy after the death of her husband in 1316.[15]

Older historiography on queenship in this period took a cue from Marion Facinger's work on Capetian queens. Facinger argued that this period marked the beginning of women's gradual loss of political power and legitimate authority in medieval Europe, pinpointing as the culprits reforms of the eleventh century that changed marriage law, shifts in land-holding, changes in inheritance laws and increasing bureaucracies.[16] According to this line of reasoning, once the monarchy emerged from the royal household to house its work in separate royal offices such as the chancery and treasury, which were staffed by professional and university-educated men, queens were excluded from active official roles in governance and shut out of the center of power. This is correct in some cases, but much of the recent scholarship on individual queens disputes Facinger's thesis.[17] The official, public, political face of medieval monarchy may have become gendered male, but the royal court was hardly a womanless space. Many queens-consort were very much present and active, often their husbands' equals in a wide range of issues that span the public–private continuum that encompasses governance, religion, art, culture and family.

A queen-consort was a partner, official or unofficial, with the king. She worked with or competed with chancellors, exchequers and bishops to govern the realm when the king was absent or ill. Territorial expansion, wars of conquest and the Crusades took kings away from court, posed new challenges, and necessitated new forms of delegated rule. More often than not, the king turned to his family and, for many kings, the most trustworthy person available was the queen, especially a foreign-born queen detached from her natal family and very loyal to her husband. In a notable work of institutional innovation, in the early thirteenth century the Crown of Aragon created a new office, the queen-lieutenant. Blanca of Anjou (d. 1310), wife of Jaume II, and Teresa d'Entença (d. 1327), wife of Alfonso IV, governed the peninsular realms for short periods while the kings conquered and governed an increasingly far-flung congeries of federative realms in the western Mediterranean.[18] When kings returned from crusading, or stopped their involvement and stayed home, the need for queens-regent may have declined, but queens faced new demands on their time and expertise.

Primogeniture eventually limited royal governance to the eldest surviving male heir, prevented women from ruling inherited realms in their own right, and made some queens little more than a vehicle for transferring valuable landed estates via marriage. But family mattered greatly and queens were at the center of the royal family. Kings and queens could not defeat death, but they tried to rob it of its triumph

through inheritance practices that protected the integrity of the family and emphasized the primacy of royal lineage through primogeniture. Marriage, coronation, maternity and memorials formed a four-step process that legitimized a dynasty. Marriage had become fully Christianized and monogamy the norm. Queens were fundamental to the process of dynasty building and consolidation by bringing land as dowry and bearing the sons that kings sought to preserve their dynastic rights to rule. Some queens who found themselves excluded from active governance found personal and political power through motherhood. But the emphasis on primogeniture through male heirs heightened the fearful consequences of childlessness. The search for a son to succeed a king led to complicated marital politics, such as in the case of Louis VII (d. 1180), whose quest led him to marry three times, to Eleanor of Aquitaine, Constance of Castile and Adèle of Champagne. Queens were more likely to be crowned and consecrated alongside their husbands – a ceremony that was merely a taste of the often opulent ceremonial role that queens took up to support and promote the royal family at the center of monarchy.

The emphasis on chastity and the figure of the lifelong virginal queen of the early Middle Ages changed in later centuries. There was no diminution of piety, but queens in this period and subsequently were more likely to take their cue from the maternity of the Virgin Mary, rather than her virginity. A pious queen was still a very influential figure at court, but she was less likely to be consecrated as a saint. This is partly due to Gregorian reforms of the late eleventh century as monks and bishops gradually replaced queens as the saintly face of monarchical rule. Corresponding changes in kingship affected queens as kings themselves began to take on the saintly attributes. Kings Edward the Confessor of England, Louis IX of France and Fernando III of Castile, all canonized saints, typify notions of theocratic kingship that joined the crusader warrior ethos to that of saintly king, creating a charitable image of rulership, and coronation liturgical practices made them priest-like. Even though kings assumed a saintly air, queenship and sanctity remained tightly linked and they remained a powerful complement to kings, sainted or not. The new Franciscan and Poor Clare monastic orders, which emphasized humility and poverty, were particularly appealing to queens. Isabel of Aragon, Queen of Portugal (d. 1336), a decisive advisor to her husband King Dinis of Portugal, retired after his death to Santa Clara-a-Velha in Coimbra, the convent she re-founded in 1314 for the Order of the Poor Clares. Queens often were inspired by family saints, as were Sancia and her husband Robert, King of Naples, both descendants

of the Hungarian royal family who venerated Elizabeth of Hungary as a dynastic saint. After Robert's death, Sancia ruled Naples as regent for his granddaughter Joanna, became a Franciscan nun in 1344 and was eventually buried in her own foundation, Santa Chiara of Naples.[19]

Just as the priesthood excluded women, monarchy likewise found ways to exclude women from ruling in their own right. Political treatises, such as those of John of Salisbury in the twelfth century, justified these ideas but he, and many other writers hostile to rule by women, had to reconcile male privilege with the necessity of female rule, even if that rule were only temporary. Political theory on monarchy remained dominated by treatises on kingship and the revival of Roman law that inflated the pretensions of medieval kings but, when the subject was queens, the focus was on women's right to inherit land and lordship, to transmit those rights to both men and women, and, ultimately, the place of women in a monarchical government.[20] No matter where a woman was born, as queen she was at the center of monarchy and both responded to the particular political culture and transformed it.

England and Scotland

The conquest of England by William I, Duke of Normandy, signaled the end of Anglo-Saxon rule, the rise of Anglo-Norman kings, and a long period where England's possessions in France were larger and wealthier than those of the French royal domain. For nearly a century, the King of England was also the Duke of Normandy, a substantial piece of property. Then, in one fell swoop in 1154, the English domain in France more than doubled as a result of the new king's fortuitous marriage to the wealthy Duchess of Aquitaine, newly-divorced from the King of France. In the cases of both Normandy and Aquitaine, these territorial inheritances passed through the female line and had profound implications for two English queens that dominate twelfth century English history – the Empress Matilda and Eleanor of Aquitaine. In the Anglo-Norman realms, the idea of 'foreign' is almost a moot point when the crown encompassed vast territories in the British Isles and on the continent. Nevertheless, until the fifteenth century, England's medieval kings preferred foreign-born brides such as Matilda of Scotland, Adeliza of Louvain, Eleanor of Aquitaine and Berengaria of Navarre.

The first queen of this new dynasty was Matilda of Flanders (c. 1031–83), daughter of Baldwin V, Count of Flanders, and granddaughter of Robert the Pious, King of France. There were concerns about

consanguinity: Pope Leo IX forbade the union but, in 1059, Pope Nicholas II retroactively approved the marriage on condition that the couple founded one monastery each, which they did. Unlike her predecessor, the chaste Queen Edith, Matilda was a mother, and a prolific one at that. William was the first Norman duke for whom no evidence of concubines or illegitimate children survives, except for an unfounded rumor reported by William of Malmesbury; this suggests that their marriage was a happy one. Over the next seventeen years, Matilda gave birth to eight or nine children, four sons and four (or perhaps five) daughters. She was on excellent terms with her children of whom her eldest, Robert Curthose, was particularly dear to her. Despite Robert's quarrels with his father and his time in exile, Matilda supported him and remained upset by their disagreement. She was a doting mother: without William's knowledge, Matilda would send her son gifts of silver and gold, and upon discovering his wife's generosity, the king threatened to blind the messenger.

Matilda was a conventional but very busy medieval queen: she acted as regent in Normandy for her husband after 1066, where thirty-nine pre-Conquest and sixty-one post-Conquest charters bear her name. Her prominence in the government of Normandy was maintained in the 1070s and 1080s, probably with her son Robert Curthose and sometimes with court officials. She was crowned queen on her first visit to England in 1068, taking part in the great crown-wearings, a key part of William's rituals of kingship in England that symbolized the new dynasty, of which the queen was a key component. She heard land pleas and corresponded with Pope Gregory VII, who encouraged her to use her influence over her husband by quoting the Bible, which says that an unfaithful man can only become faithful through his wife. She was a generous donor to the church – buildings, relics, jewels, tapestries, draperies, candelabra, silver and gold vessels. She left her crown and scepter, the most visible signs of her queenship, to the nuns of Ste. Trinité, a gesture which William imitated when he left his regalia to the monks of St. Étienne at Caen.

William's childless son, William Rufus, was succeeded by his brother Henry, who married Matilda (d. 1118), daughter of a saint, Margaret, and a king, Malcolm III of Scotland. She was christened with an Old English name, Edith, but she took the name Matilda when she married Henry I of England in 1100 to please her new subjects and symbolize her loyalty to England, much as Emma of Normandy did when she took the name Ælfgifu upon her marriage to Æhelred. Matilda was raised by her mother's sister, Abbess Christina, in a convent at Romsey and Wilton,

from which Henry is reported to have 'rescued' her. She purportedly said that she took no vows and, when he proposed marriage, she took off her nun's veil and stomped on it. But her religious ties remained strong. Anselm of Canterbury was her spiritual advisor, and she corresponded with leading religious figures of the day in England and on the continent – Anselm of Canterbury as well as Pope Pascal II, Ivo of Chartres, the bishops of Lavardin.[21] She may have written some of these letters herself rather than use a secretary because letters from the monks of Malmesbury to her brother David, King of Scotland, and to Empress Matilda, her daughter, emphasize the queen's role in their composition.

This union, a potently symbolic union of Norman and Saxon royal families, proved popular among Henry's English subjects. Matilda brought considerable landed wealth and attended meetings of the king's council, which she often chaired when Henry was away from court. She had superb diplomatic talents: she smoothed out the hostilities between Henry and his uncle and rival, Robert Curthose, the Duke of Normandy, and negotiated Emperor Henry V's marriage to her daughter, Matilda (d. 1167).

Like her mother, Matilda was a pious ascetic but not chaste. She and Henry had two children: William, who died in the wreck of the *White Ship* in 1120; and Matilda, wife of Emperor Henry V and then Geoffrey of Anjou, mother of Henry II. She maintained close ties to the clergy and was active in Church affairs throughout her life, from discussions with ecclesiastical figures during the investiture negotiations to chairing a council to deal with the issue of admitting papal legates in England. She witnessed the translation of St. Æthelwold's relics at Winchester and attended the consecration of churches, was a generous patron of the Church and an intercessor on behalf of prisoners, the poor and lepers. She built a leper's hospital outside the walls of London and patronized several other institutions dedicated to their care. She helped establish the Augustinian priory, Holy Trinity, Aldgate, in London. But she did not neglect the secular realm. She sponsored the construction of bridges and a public bathhouse, and had avid literary and musical interests. She was a patron of scholars, poets and singers working in both Latin and French. She commissioned two histories, a life of her mother, St. Margaret of Scotland, and a history of her family, the *Gesta Regum Anglorum*, from the monk William of Malmesbury. The *Gesta* was finished after her death and presented to her daughter, Empress Matilda.[22] She may have been the patron of the Anglo-Norman version of the life of St. Brendan.

After the death of his only legitimate son in 1120, Henry urgently needed a male heir and chose as his next wife Adeliza of Louvain, aged

seventeen or eighteen when she was married and crowned queen in 1121.[23] Unlike Queen Matilda who preceded her and Empress Matilda who succeeded her, Adeliza took little part in governing the realm. She attested a few of her husband's charters, and accompanied him to Normandy in 1125, 1129, and probably 1131. She managed her own household but she never served as his regent and does not appear to have been part of the royal administration. This may have been as much a question of her personal inclination as the declining need for administrative involvement by the queen as Henry's government developed. She was, however, a strong patron of French writers and a devout supporter of the Church. The one thing that queens were most expected to do was bear an heir; the absence of a baby boy before Henry's death in 1135 set in motion a long period of political disarray and the introduction of a new dynasty to the English monarchy: the Plantagenets.

On the other hand, her stepdaughter, Henry's surviving legitimate child, Matilda, succeeded both as 'Henry's daughter, wife and mother, great by birth, greater by marriage, but greatest by motherhood'.[24] That phrase captures the ways that queenship depended greatly on its connection to dynasty, marriage, maternity and kingship, but it omits a brutal fact: Matilda had to wage war to try to take her rightful place as Queen of England. She acted like a queen and fulfilled the duties of a queen, but never received an English coronation. In her charters, she called herself empress and lady (*imperatrix* and *domina*) but not queen. As wife of Henry V of Germany, she was a Queen of the Romans and later empress. She inherited the claim to rule England from her father, but it was her own flinty and tenacious pursuit of that claim that marks her as a daughter, wife, mother and sovereign. She was 'empress of Germany until Henry V's death in 1125, Lady of the English', but never Queen of England. Her effort to be recognized as one is a good example of the vagaries of medieval queens. She was acclaimed as her father's heir in England but her claim was contested by her cousin, Stephen of Blois. Both she and Stephen ruled a divided England during a period known as the Anarchy, as though the realm were his or hers, each one issuing charters, collecting taxes, minting coins and mustering armies, until Stephen's death in 1154 and the succession of Matilda's son as King Henry II (d. 1189).[25]

As daughter of a king and granddaughter of a saint, Matilda was groomed for an illustrious marriage. She probably was educated at court by members of her mother's cultured and religious advisors before she was betrothed in 1109 to Henry V of Germany. She brought to the

marriage a dowry estimated at 10,000 marks in silver, but the marriage carried great prestige for the English. Later that year, when she made her first formal appearance in her father's court she added her cross to a royal charter establishing the see of Ely as 'Matilda, betrothed wife of the king of the Romans'. She was crowned and anointed, learned the German language and customs, and, in 1114, just before her twelfth birthday, she married Henry, then aged twenty-eight, in a spectacular ceremony at Worms. She assumed the title 'Queen of the Romans' and used it on her seal. No children survived from their marriage, although she may have given birth to one child.

For the next sixteen years, she learned to govern Henry's dominions of Germany and northern Italy, which were torn apart by civil wars; bitter quarrels with the pope over investiture led to the king's excommunication. She was a loyal and able queen-consort, who carried out the onerous duties of her office with dignity. One of her first duties was to intercede for the disgraced Godfrey, Count of Lower Lorraine (whose daughter Adeliza would later become her stepmother). She frequently sponsored royal grants, acted as intercessor in presenting petitions to her husband, and served as his regent during his absence on campaigns. She went with him to Italy 1116 in order to establish his contested rights under the will of Matilda, Countess of Tuscany, and to reconcile with Pope Paschal II. When Henry returned to Germany in 1117 to quell a rebellion, Matilda remained with the army in Italy, presided at courts and pronounced judgments. She joined him in Germany in 1119, and witnessed his reconciliation with the church at Worms in 1122, at which time Matilda probably first became acquainted with papal legates, the papal curia and papal politics. When Henry V died in 1125, he entrusted the imperial insignia to her, but as a childless widow she had no further duties in Germany. She was still young and a desirable bride, but her father, Henry I of England, whose only legitimate son, William, had died in 1120, persuaded her to return to Normandy, where he made her his heir. She appears to have surrendered her lands in Germany but kept her jewels, personal regalia and a relic from the imperial chapel, the hand of St. James.

Primogeniture was not firmly fixed as the determinant of rightful succession so, even though Henry had his barons swear an oath in 1127 to Matilda as his heir, one year later she married Geoffrey Plantagenet, the fourteen-year-old Count of Anjou. The difference in their ages was a flash point in the marriage, and the English nobles were not at all pleased with her marriage to someone they considered untrustworthy. Tensions were heightened when she gave birth to two sons in quick succession

(Henry in 1133, Geoffrey in 1134), both of whom would survive infancy, and styled herself not as 'Countess of Anjou' but as Empress or Daughter of Henry. When Henry I died in 1135, Matilda was in France, pregnant with her third child (William, born in 1136), and neither she nor her husband made any attempt to claim her inheritance in England. Her cousin, Stephen of Blois, quickly stepped up, went to England and was crowned less than three weeks after Henry's death, beginning his less-than-effective rule. Three years later, Matilda left her three sons and husband in France and began a dogged campaign to recover what she had lost. From 1139 until 1154, England was torn apart during the Anarchy period, with competing royal governments collecting taxes, minting coins, issuing judicial decisions and conducting diplomacy with popes and foreign kings. One charter (of dubious authenticity) refers to her as queen and only in 1141 was she recognized by an assembly of lords and bishops as 'Lady of the English', but the Anarchy continued. It is significant that she ruled alone; Geoffrey did not come to England for a coronation.

Matilda overcame custom and tradition as circumstances propelled her towards the throne but not completely on to it. She was able to rule to the extent that she did, and to transmit the right to rule to her son, because the need to perpetuate a dynasty superseded even the most entrenched attitudes and prejudices. But she, and her subjects, paid a price when opposition to her rule mounted and continued. Charles Beem considers her assertion of her independence as queen, without any association with a king, to be the reason for her failure to unite the realm under her sole rule. Her contemporaries praised Stephen's wife, who was every bit as tough and did many of the same things Matilda did, such as mustering troops and defending castles, but she was careful to do so in Stephen's name.[26] English nobles were dismayed by Matilda's willing assumption of the masculine aspects of monarchy, including capturing and imprisoning Stephen, without the cover of her husband. In the *Policraticus*, John of Salisbury may have had her in mind when he wrote scathingly about a woman's weakness and her inability to rule. Yet, he softened his tone in his *Historia Pontificalis*, in which he actively supported her in her struggle against Stephen for the crown of England. He had to adjust his ideas on kingship theory accordingly and found himself in the awkward position of having to defend her right to rule.[27] By 1151, when Geoffrey Plantagenet died, Stephen and Matilda's epic struggle had wound down. They agreed to a truce whereby Stephen relinquished his claims to the throne of England and agreed that, when he died, he would be succeeded by Matilda's eldest son Henry, who by then

had married Eleanor, the recently divorced Queen of France and the Duchess of Aquitaine (d. 1204).

Eleanor of Aquitaine has generated a prodigious body of modern scholarship.[28] Familiar and elusive, well-known and yet ultimately unknowable, Eleanor was heiress of a wealthy duchy, Queen of France and Queen of England.[29] She is familiar as the wife of two iconic kings, mother of a flock of children who populated the royal houses of European realms, at the center of a culture of French troubadour literature. She is elusive because so few reliable sources with a neutral tone survive. It may come as a surprise that for all her fame and power, Eleanor of Aquitaine – duchess, queen-consort, mother and dowager-queen-regent – sits in the middle of the spectrum of queenship. For all her fame and for all that has been written about her, Eleanor is a vexing subject, seen by us most often in sidelong glances. She made her first appearance in the sources when she was aged five, but of the only two hundred or so known documents, only twenty extant documents were issued by her during her marriage to Louis, with the remainder for her as Henry's queen. Medieval narratives that document the lives and deeds of her father, uncles, husbands and sons mention her, but often only obliquely, paying far more attention to the four kings in her life, two of them husbands and two of them sons: Louis VII, Henry II, Richard I and John I.

In recent decades, feminist scholars have scoured archives and have generated an impressive body of work that is fundamental to understanding not only Eleanor, but also queens and queenship. These works took up discrete elements of Eleanor's life that have added immensely to our knowledge of the life of this remarkable woman: her long life (she lived to be eighty), her tumultuous marriages, her role in the reigns of Louis VII of France and Henry II of England that consumed 67 years of her life, her prolific motherhood (she had eleven, perhaps twelve children), allegations of adultery and her association with courtly troubadour poets.[30]

For all her fame, she had less official political authority than her mother-in-law, Matilda. It was not for lack of trying. This is due partly to that fact that she married men who held monarchical authority very tightly to themselves, and partly because she was often pregnant and devoted considerable time and effort to her children, two of whom succeeded Henry as kings (three, counting the young Henry who was associate king from 1170 to 1183). She was thirteen in 1137, when she inherited the vast wealthy patrimony of her father, Duke William X of Aquitaine, and brought it with her when she married the King of France,

Louis VII (d. 1180), her distant cousin (both were descended from King Robert II and Constance of Arles). Louis so prized the acquisition of Aquitaine that he used the dual title of 'King of the French and Duke of the Aquitanians' throughout their marriage. In terms of queenship, Eleanor was a very conventional queen during the fifteen years she was married to Louis, doing everything that was expected of a queen. But the marriage was not sound. Their very different temperaments created tensions in the marriage from the start: he was introverted and serious, she was extroverted and vivacious. Most important to a king with lineage and posterity on his mind, after ten years of marriage they had a daughter but no son. Their sojourn in the Holy Land on crusade in 1147 was a military disaster and a personal crisis, with unfounded rumors of an affair with her uncle in Antioch worsening their deteriorating relationship. The pope tried to reconcile them, and it worked for a while. They returned to France, traveled together to Aquitaine and their second daughter was born. But their differences were too serious and there is little doubt that personal desires and dynastic need for a son motivated Louis's decision to obtain a divorce in 1152, pleading consanguinity.

A few chroniclers wrote about her directly, and even fewer extant sources were written by her during her years as Duchess and Queen of France. Those who do write about her are not entirely reliable sources, and often repeat gossip and rumor, such as William of Tyre, the source for allegations of adultery with her uncle, Raymond of Poitiers.[31] The rumor of Eleanor's infidelity in the Holy Land is related to the creation of the mythic Queen Guenevere, the adulterous wife of Arthur at roughly this same time.[32] Although the original story of the legendary King Arthur was first outlined by Gildas in the sixth century, this sort of gendering of sovereignty through a woman's sexuality was prominent in the historiography of Empress Theodora. It gained traction with what Peggy McCracken terms the 'romance of adultery' when the twelfth-century writers Geoffrey of Monmouth (*History of the Kings of Britain*), Wace (*Roman de Brut*) and Layamon (*Brut*) wrote in response to the Norman Conquest.[33] McCracken argues that rumor affected how Eleanor lived her life; how her life was reported, read and misread no matter what the medium or when the work was composed. The trope of adultery signified a man's anxiety that the rule of women disrupts the settled order, and their use of unsubstantiated sources and rumor distorted what actually happened and the record of those events, and thus discredited the queen and diverted action back to the masculine realm. The rumor took on a life of its own, as the fictional story of the adulterous queen was further

elaborated on and popularized in the twelfth century in Chrétien de Troyes's romances, the fourteenth-century *Sir Gawain and the Green Knight* and the fifteenth-century *Morte D'Arthur* by Thomas Malory.[34]

It is unlikely that Eleanor, a wealthy duchess still able to bear children, would have remained unmarried, even had she wanted to do so. But her remarriage shortly after the divorce in 1152 was shockingly swift to many of her contemporaries. So was her choice of husbands, the nineteen-year-old Henry, Duke of Normandy and Count of Anjou and son of Empress Matilda. Once again, consanguinity was an issue. Eleanor and Henry were both descendants of Robert II of France and, as cousins, were more closely related than she and Louis had been, but they secured the necessary papal dispensations. For Henry the marriage was a coup, but Louis lost a wife and Aquitaine. Eleanor was crowned Queen of England in 1154 at the same time as Henry was consecrated king. What happened next pleased Eleanor and Henry as much as it annoyed Louis. Over the next fifteen years, she bore eight children, five of them boys who lived to adulthood: William (died in infancy), Henry the Young King, Matilda, Richard, Geoffrey, Eleanor, Joanna and John. As important as motherhood was for a queen, Eleanor's life demonstrates just how problematic it was have an abundance of sons. Much of the blame for this goes to the domineering Henry, who promised his sons a landed legacy and then resisted their desire to work with their father in governing. It is difficult to gauge just how much Eleanor herself was involved as queen in Henry's reign. Most scholars agree that while she was pregnant between 1153 and 1166 she was not directly engaged in government and administration but was, instead, influential on a limited scale. She witnessed royal charters, issued writs in her own name and actively participated in governing parts of the Plantagenet realms, particularly Aquitaine until 1173. She appears to have had a hand in some ecclesiastical appointments and her presence was specifically noted at many great ceremonial courts held throughout the realms.

After the birth of her last child in 1166, Eleanor returned to a more direct and active role in Aquitaine. She brought her son Richard to the duchy, where he began to take part in its administration. But, by 1173, their sons' frustration with Henry's tight leash on them boiled over and, with Eleanor, they plotted against their father. Eleanor may have been provoked by Henry's harsh treatment of their sons, or out of resentment for the limits he placed on her authority in her duchy. Henry the Young King fled to the protection of his father-in-law, Louis VII, who was probably behind the rebellion. Eleanor fled, dressed as a man, and King Henry had her arrested, held her in confinement until 1184 and, only after a

plea from Henry the Young King, on his deathbed in 1183, did Henry relent a little and relax the terms of her imprisonment. In 1185, Henry ordered Richard formally to return power in Poitou to his mother, although it is not clear whether she actually exercised political authority. She had no part in English government and Henry kept a close watch over her until his death in 1189. One of Richard's first acts after his father's death was to order his mother's release, restoring to her control of her lands and revenues in Aquitaine, which she ruled on Richard's behalf.

In the last fifteen years of her life, after the death of Henry, Eleanor was dowager-queen and at times a regent, although she acted as though she had vice-regal authority. She returned to government with a vigor and verve unmatched by any contemporary ruler. She was about sixty-seven years old and would live longer than both her husbands: Louis died at age sixty, Henry at fifty-seven; her son John was almost fifty when he died, and Henry, the Young King, Geoffrey, and Richard did not live to forty. She filled these years with governing as regent for Richard when he went on Crusade. She took charge of improving English coastal defenses, went from city to castle, held court, released prisoners and exacted oaths of loyalty to her son. She negotiated Richard's marriage to Berengaria of Navarre, daughter of Sancho VI of Navarre, and brought the bride to him at Messina. The marriage alliance was intended to protect his southern frontiers while he was on Crusade. On the journey to the Holy Land, Berengaria was shipwrecked off Cyprus; Richard captured the island to use as a supply base for campaigns in Palestine, and married Berengaria in 1191. Questions of Richard's sexuality always arise and cannot be resolved, but it is clear that their marriage was not a love match. She saw her husband rarely and England never, they had no children, and she is absent from nearly all documentation of Richard's reign.[35] When Richard was captured, it was Eleanor who traveled to Germany to secure a huge ransom for him, and mediated a dispute between Richard and his rebellious brother, John, who had allied with the French king Philip II Augustus.

After Richard's death in 1199 and John's accession, Eleanor's direct intervention in English affairs ceased. In early 1200, she traveled to Castile to select one of her granddaughters, Blanche of Castile, daughter of Eleanor's own daughter and namesake, as a bride for King Philip II's heir, the future Louis VIII. She returned to Aquitaine and directly administered the duchy. She was unstoppable and, as late as 1203, the year before her death, documents were still being issued in her name. She and some of her loved ones are memorialized in four extant polychrome

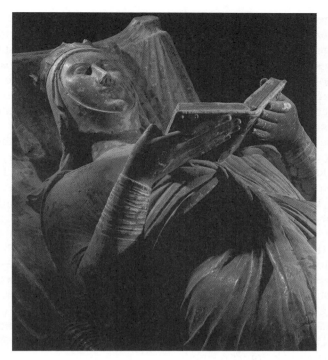

Illustration 3.1　Eleanor of Aquitaine, Tombs of the Plantagenet Kings. Fontevrault Abbey, France, 13th century. © Erich Lessing/Art Resource, New York.

tomb effigies in the nave of the church of Fontevraud Abbey, which most scholars agree are those of Eleanor, Henry II, their son Richard, and Isabelle of Angoulême, wife of King John (Illustration 3.1).

The complicated lands of Henry and Eleanor continued to create strife into the reign of John, and the status of her dower lands had important implications for future queens of England. For a king called 'Lackland', the youngest of five sons who received the smallest inheritance, it is no surprise that so much of his reign was concerned with the dower lands of his mother and the inherited lands of his second wife. His first marriage, to Isabella of Gloucester in 1189, was annulled in 1199 because of consanguinity, and he married Isabelle of Angoulême (d. 1246). She was about twelve years old when they married in 1200.[36] It was a strategic match, but a risky one. Her family, the Counts of Angoulême, controlled a wealthy and strategically significant province wedged between two Plantagenet strongholds. The problem was that Isabelle had been

betrothed to Hugh, Count of Lusignan. John's marriage violated Hugh's patrimonial rights and caused an uproar in France. Hugh, formerly a Plantagenet ally, defected to the French king, Philip II Augustus. For three years, Philip used John's action as a pretext for a campaign of conquest that ended with John forfeiting his feudal rights and losing much of the Plantagenet continental inheritance. One marriage brought the duchy of Aquitaine to the English realms, while another one took away ancestral property.

Though Isabelle was rarely in John's company after 1205, she gave birth to five of John's legitimate children: the future King Henry III (d. 1272), Richard (first Earl of Cornwall), Joan (Queen of Scotland), Isabella (Holy Roman Empress) and Eleanor (Countess of Pembroke). Her reign, though short, had a lasting impact on the queen's household and treasury. Isabelle's expenses were paid from the king's accounts, but she struggled to keep Eleanor's dower lands in England, Normandy, Anjou and Poitou that she had been promised she would receive on Eleanor's death. When John was alive, it seems that she was able to administer these lands and revenues on her own. She was with John in France in 1214 when he established control over her inheritance in Angoulême but, during the ensuing civil war in England, she stayed in relative safety in western England. After John's death in 1216, she continued to use her title and her seal as Queen of England, and granted wealth from her dower lands to monasteries in John's memory.

His death set in motion a titanic and bitter struggle over the queen's dower properties. Isabelle was denied possession of lands in England, supposedly part of her dower, and money that she claimed was willed to her by John. In 1217, she abandoned her children in England, took up her family inheritance in France and, in 1220, she married Hugh, Count of La Marche, son of her former fiancé. In 1224, the lands were confiscated, and Hugh joined in alliance with the French king, Louis VIII, which led to a French invasion of Poitou. In 1226, both sides reconciled; in 1230, Isabelle met her son, Henry III, for the first time in more than a dozen years, but the relationship soured in 1242 when she deserted him again in favor of the French. Isabelle had nine children with Hugh, retired to the abbey of Fontevrault, took nun's vows, died there in 1246 and was buried alongside the other forceful Plantagenet queen of the twelfth century, her mother-in-law Eleanor.

Isabelle of Angoulême was the first English queen who was also Queen of Ireland. Henry II's invasion of Ireland in the 1170s and the Treaty of Windsor in 1175 left the last true Irish king, Rory, with a small kingdom outside the provincial kingdoms of Leinster, Meath, Dublin and County

Waterford in return for tribute to the English kings. John was created Lord of Ireland in 1177 and, when he became king in 1199, Ireland was absorbed into the English realms. After that, monarchs of medieval England were Lords and Ladies of Ireland, but there were no native Irish queens of Ireland. Their son Henry took a French wife, Eleanor of Provence, the second of four daughters of Count Ramon Berengar V and his wife Béatrice. A woman of great courage and tenacity, Eleanor was Henry's trusted adviser whose influence in his reign was decisive and a vital voice in the early years of the reign of their son, Edward. Eleanor was deeply devoted to her family, both natal and marital. She bore four children before she was twenty-two – among them the heir, Edward, and Margaret, who married Alexander III of Scotland. Eleanor fiercely protected her children's interests, spent considerable time with them when they were young and later used them to further her own ambition. Eleanor's shrewd Savoyard uncles shaped her early role in politics and encouraged her to use motherhood to bolster her position at court. She also used her position as queen to arrange offices and lucrative marriages for members of her Provençal relatives, which aroused criticism from the king's Lusignan relatives.

An able and trusted adviser to her husband, Eleanor was central to many of the most momentous events of his reign. Often in France on military expeditions, Henry named Eleanor his regent. Her Provençal family connections worked in their favor in 1254 when they were the guests of Queen Marguerite, her sister, and King Louis IX of France: a visit that smoothed tensions between England and France. But, at times, those connections failed. She was unable to secure the crown of Sicily for their second son, Edmund, and her role in the rebellion against Henry III's government in England had disastrous consequences. Eleanor angrily opposed the terms imposed on the king by Simon de Montfort and the rebels. While trying to reach her son Edward in Windsor Castle by river, an angry crowd stopped her at London Bridge, insulted her and pelted her with stones. Eleanor was instrumental in the terms of Louis IX's judgment in favor of Henry III in 1264, but it led to civil war in England. Eleanor was a formidable opponent in the face of the defeat and captivity of Henry and Edward. She mustered troops, used a prodigious network of family and allies remorselessly and skillfully against Simon de Montfort, and was instrumental in Henry's victory in 1265.

Eleanor was also a tough administrator of the queen's finances which made her unpopular but she does not appear to have spent her money selfishly. She gave generously to the hospital of St. Katharine by the Tower, founded the Dominican priory at Guildford, and was patron and

benefactor of Cistercian nuns and the Franciscans. Although the queen's finances were technically under her purview, one incident was a clear reminder that the king was ultimately in charge. In 1252, she briefly lost control over her finances when she promoted a candidate for a position that Henry did not favor. Henry signaled his displeasure by seizing briefly all revenues from both Eleanor's accounts and the lands she held in custody. The message was clear: the queen's account was hers to use, but it was not hers. It was held for her, to be used by her, but at the king's pleasure. After Henry III's death in 1272, she controlled substantial wealth from her dower annuity and lands that reverted to the Crown on her death. After the deaths of her sisters Béatrice and Sancia, she took a keen interest in the administration of Provence.

The strategic marriage in 1251 of Margaret (d. 1275), the daughter of Eleanor of Provence and Henry III, to Alexander III of Scotland was a clear sign of Scotland's growing prominence in the politics of this period.[37] The marriage was intended to pacify two realms that had been fighting for at least a century after King David I intervened on the side of King Stephen against the Empress Matilda over lands in Northumbria and eastern England that the Scots acquired when David married Matilda, Countess of Huntingdon. After that, in what will be a familiar pattern, the preferred Scottish queen was a princess or noblewoman from England or France, depending on immediate Scottish needs. King Alexander II married Joan (d. 1238), daughter of English King John I and Isabelle of Angoulême, and Marie de Coucy (d. 1285), a French noblewoman, which gave the Scottish monarchy a slight edge against rival Scottish noblemen. But Scotland's fragile stability was disrupted when the two sons and one daughter of Margaret and Alexander III died before the king, leaving only an infant granddaughter, Margaret, known as the 'Maid of Norway' to inherit. Her mother (also named Margaret) married Erik II of Norway in 1281 to reconcile and resolve tensions between Scotland and Norway. At Scone in 1284, the Scottish barons swore to accept and uphold Margaret as *domina* (lady) and rightful heir unless Alexander III had another child. After the death of Alexander III in 1286, the succession remained unresolved because his widow Yolande de Dreux was pregnant, but the baby was either stillborn or died soon after birth. Margaret then became heir, although it is unclear if the Scottish nobles agreed that she rule directly or through a husband. King Edward I of England took advantage of the situation and proposed that she marry his son, Edward, with assurances of the protection of Scotland's independence and designating Margaret as queen. But Margaret died on the voyage from Norway so that, even though traditionally considered

queen, Margaret was never crowned or recognized as queen in Scotland during her lifetime. Margaret's death led the Balliol and Bruce families to fight for succession and set in motion a series of wars that led to Scottish independence from England.[38] Her death also marks a turning point in Scottish queenship. Robert I Bruce's marriage in 1302 to Elizabeth de Burgh (d. 1327), daughter of the Earl of Ulster, his seizure of the throne, and their coronation in 1306 mark a new expression of queenship and kingship (discussed at length in Chapter 4).

Edward I, son of Eleanor of Provence and Henry III, married Eleanor of Castile (d. 1290) in 1254, creating the quintessential power couple of the thirteenth century. Daughter of Fernando III of Castile (d. 1252) and his second wife, Jeanne de Dammartin, Eleanor was crowned with Edward in 1274, after the death of his father. She exceeded conventional expectations of a queen, producing sixteen babies in twenty-nine years, among them the heir, Edward II. She tenaciously protected the interests of her children, safeguarded and expanded the queen's household account and assisted but did not dominate her husband. She was masterful at arranging strategic marriages for her family and members of court. Her devotion to Edward is legendary but not necessarily verifiable. For instance, she accompanied Edward on Crusade in 1272, where it was said that when Edward was a victim of an assassin's knife attack, she sucked poison from the wound. A good match in terms of temperament, they had one of the most successful royal marriages of the Middle Ages. She commissioned a copy of Vegetius's *Art of War* as a gift for him and he later gave her a chess set. He valued her advice, but allowed her no part in the affairs of the realm, although she was active in Anglo-Castilian relations. Her political influence was minimal, but her tough approach to administration, her foreign birth, and, ironically, her close relationship with Edward led some to suspect that she was responsible for the king's strict rule.

But she was not well-loved by all of her English subjects in her lifetime. The marriage was diplomatically advantageous, reinforcing links between England and Castile that were forged by Henry II and Eleanor of Aquitaine. But her status as a foreign queen raised fears that she would bring with her a number of Castilians who would involve England in the Spanish Reconquest.[39] She arrived in England speaking Spanish and some French, and was derided for the use of carpets and her love of chess, both Spanish customs. Her protection of Castilian merchants caused the men of Southampton to complain. During the barons' wars, she supported Edward's turn to the Lusignans and it was thought that she was hiring Castilian mercenaries. The most persistent source of friction between the queen and her subjects, however, was her management of

the queen's finances, her household accounts and her properties. Her principal source of money was an account known as the 'queen's gold', which originated formally in the reign of Henry II as a ten percent surcharge that the exchequer levied and collected on all voluntary fines made to the king.

The English queen's gold, which had analogs in most European realms by 1350, had its roots in the Anglo-Saxon period when elites paid the queen for her advocacy on their behalf. It may date to the tenth century reign of Ælfthryth, wife of Edgar, but Eleanor of Aquitaine clearly received queen's gold. The official involvement of a royal fiscal officer, such as the treasurer or exchequer, made the queen's gold public and formal, and it was an important source of revenue for the crown to be used to support the queen's household, which included pious donations and benefactions of religious houses and almshouses. The right to collect the queen's gold, however, was not questioned. When debtors wished to avoid payment of queen's gold, they generally claimed their fine was not voluntary (and thus not subject to queen's gold), rather than criticizing the system.[40] Only the queen-consort could claim queen's gold because it was her due while she was married; after the king's death, she claimed her dower and could petition payment of debts owed her. The queen's gold provided the queen-consort with leverage, but it was complicated when queens-consort overlapped, as they did in Henry III's reign. When Eleanor married Edward in 1254, Henry was still living and her mother-in-law, Eleanor of Provence, was still queen-consort. They split the account: Eleanor of Castile received the queen's gold from Ireland; Eleanor of Provence received that of England.

Eleanor of Castile set the queen's gold and the household on firmer ground as a royal institution.[41] After the victory of her father-in-law over the rebels, she received and began to acquire the rich estates for which she became notorious. With Edward's support, from 1275 she began to expand her estates, including lands received from grants of rebels' lands, by cautious and controversial management of her accounts by means of working with usurers. Her bedchamber was, as John Carmi Parsons aptly describes it, not only her private realm, but also an official room where she is known to have received at least one petitioner, an explicit reminder of the power of conjugal relations with the king.[42] The queen's gold was an automatic fine that the queen controlled, at least indirectly if not directly, and was often a source of friction. Edward advised her to stop extorting money improperly, but she needed the funds to support a much larger and more ceremonial court. Isabelle of Angoulême and Eleanor of Provence had paved the way for her in their astute handling

of dower properties, but economic activity on this scale was unprecedented for a queen; overburdened tenants criticized her and complained of harsh practices by her officials.

On the other hand, the queen's gold very often supported advocacy or acts of mediation. Eleanor used her wealth to support an increasingly vibrant circle of artists and newly-founded English universities, and was a generous patron of religious institutions. Kristen Geaman argues that both in the sources of income, which were often paid by a donor anticipating a queen's intercession or mediation, and in the uses of the money, a queen's gold expenses should be considered part of her intercessory acts. Just as the queen's intercession remedied the king's lack of the ability to reverse course or act sympathetically, the king remedied the queen's lack of money.[43] Whatever her subjects may have felt about Eleanor of Castile, when she died of a fever in 1290 she was survived by a son, five daughters and a grief-stricken husband who marked her funeral procession with twelve monumental crosses between Lincoln and Westminster, three of which still survive. She was buried in Westminster Abbey with great ceremony and her tomb with its exquisite gilt bronze effigy survives.

It is an understatement to say that a second wife following someone like Eleanor of Castile would find the situation difficult. But Margaret of France (d. 1318) did the unthinkable. She overcame the shortcomings of her youth and inexperience, and kept alive the memory of a beloved queen and her many children by bringing something more valuable than a landed dowry. She brought tact and sensitivity to her marriage and was able to moderate the acrimony that had soured the relationship of father and son, and sought to harmonize the royal family. The last child of Philip III of France (d. 1285) and his second wife, Marie de Brabant, Margaret was twenty when she and Edward were married amid ceremony at Canterbury in 1299. Although she wore a crown at her wedding and on great occasions, she was never anointed queen. Together they had two sons, Thomas of Brotherton and Edmund of Woodstock; a daughter, graciously named Eleanor, died in childhood. Contemporary chroniclers took note of Edward's love for her, and his letters to her show a tender attentiveness to her and their children. She cut a far more private figure than Eleanor, but Margaret was a busy intercessor between Edward and his subjects until his death in 1307, and remained devoted to her stepchildren until her death in 1318.[44]

The reign of her successor, Isabelle of France (d. 1358), wife of King Edward II (d. 1327), was strikingly different. Both were French princesses,

educated in the subtleties of life at court and the complexities of politics, but Margaret used her position as queen to bind the family, while Isabelle used it as a platform for her own impressive ambitions and talents for rulership. Where Margaret was content to operate from the sidelines, Isabelle occupied a central position in the reign of her husband, who was in many ways her inverse. The marriage of Isabelle and Edward was troubled from the start and never really improved. Edward preferred his favorites Piers Gaveston and Hugh Despenser to his wife and, often, to his inner circle of advisers. His actions were divisive, and Isabelle leveraged his weaknesses in administration to her own advantage. Ultimately, her strong personality and over-reaching made her position untenable, but her reign is a good example of how kingship and queenship in a strongly patriarchal society operate best when the two are balanced in favor of the king's masculinity. After 1322, the instability of Edward's rule prompted Isabelle to take charge but, by dominating an anointed king, she upset social gender norms and set in motion her own downfall.[45]

Isabelle was the only surviving daughter of Philip IV of France (d. 1314) and Jeanne of Champagne, Queen of Navarre. The reign got off to a bad start when Edward and Philip struggled over Isabelle's dower and Edward's rights in Aquitaine. To make matters worse, before the couple reached England for their coronation in 1308, Edward sent Philip's wedding gifts to his favorite, Piers Gaveston (d. 1312). Some said that Edward was in Gaveston's bed more often than Isabelle's, and she complained to her father that Gaveston usurped her place. When she complained that her funds were inadequate, Edward gave Isabelle the county of Ponthieu, and, after the dowager-queen, Margaret of France, died in 1318, Isabelle received the queen's usual dower lands. Edward very regularly granted pardons and bestowed lands, money, or offices at his new wife's request. These actions calmed her family, but their marriage remained tense.

Through it all, they had four children together: Edward III (1312); John (1316); Eleanor (1318) and Joan, Queen of Scotland (1321). Edward claimed parentage of his children, complicating speculation that Edward was homosexual, or at least bisexual.[46] Definitions of sexual identity and practices are complicated to know in any age and even more so with medieval sources. We may never know the truth of Edward's sexuality, but it is clear that his peers, as well as his wife, considered his weaknesses as king to be unmanly and therefore unsuitable.

Until Hugh Despenser's rise, however, Isabelle was a consistent supporter of Edward. After Gaveston's death in 1312, she began to take a

central role in diplomacy and skillfully stage-managed the public performance of intercession expected of a queen. In 1321, for example, she publicly went to Edward on her knees and begged for the sake of the people. Her display of appropriate femininity made her popular with the English, but her intercession alone could not have reconciled Edward with his opponents. After 1322, she took a dominant role at court when she opposed the Despensers, incurred Edward's displeasure, and became embroiled in accusations of intrigue and treason with her relatives. By 1326, it was known in England that Isabelle had taken a lover, Roger Mortimer, a wealthy baron from the Welsh Marches and a long-standing prominent opponent of Edward and the Despensers. This emphasized Edward's weakness, and the elites of London rose to support her when she issued a proclamation that violently denounced the Despensers. Her liaison with Mortimer together with Edward's personal life exposed the king's failure to defend his exclusive sexual rights to his wife's body and gravely undermined his authority. When she betrothed her son to Philippa of Hainault, she used the bride's dowry to hire mercenary troops commanded by Mortimer. Edward's authority began to collapse and, with impressive military support, Isabelle assumed the regency, proclaimed her son guardian of the realm and had the elder Despenser captured and executed. Edward and the younger Hugh were captured; Hugh was executed, Edward abdicated and his son was crowned. Edward stated he would kill his mother if she rejoined him, though in a public display of loyalty, she still sent him gifts. In 1327, Edward II was nearly rescued, but another plot was exposed, and he was killed in Berkeley Castle, unquestionably at the new regime's tacit or express wishes. Isabelle governed not as sovereign-queen or dowager-queen but, rather, as regent with Mortimer for her young son, Edward III. It is unclear if or how much Mortimer directed Isabelle during the period 1326–30, but their actions are linked. The pair seized all the Despenser lands, and Isabelle assigned herself so much of the royal demesne that only one third of its revenue remained to her son. In France, she had secretly agreed to recognize Robert I Bruce as king of Scotland and to abandon English claims to the overlordship of Scotland.

This dramatic story of a king's abdication and murder, and his queen's assumption of the reins of government, has no parallel in medieval European queenship. She and Mortimer concluded peace with France (1327) and the Treaty of Edinburgh (1328) recognizing Scottish independence, and arranged the marriage of her daughter Joan to King Robert I Bruce's son, David. The Treaty, Isabelle's greed and her lover's arrogance outraged many barons, who tried to diminish Mortimer's

influence over the young king. In a rapid chain of events in 1330, Edward III and his friends arrested Mortimer. Isabelle's affection for Mortimer is attested by her cry at his arrest in 1330, 'Good son, good son, have pity on gentle Mortimer'. Her intercession failed. Mortimer was executed as a traitor and Isabelle was briefly kept under guard, but she lived and traveled freely with all the respect due a dowager-queen.

Isabelle's practice of queenship is extraordinary. In terms of its linkage of sexual politics, raw ambition and treachery, it speaks volumes about the interplay of masculine and feminine in the institution of monarchy. Isabelle had all the attributes of a king except the title. She never ruled in her own right, but she acted like someone who did. Before 1322, she was, in some ways, a conventional queen, supportive of her husband, bearing children and acting as intercessor on behalf of her subjects. But Edward's inept governance activated her competence and, on some level, her actions can be seen as simply a practical but brutal response to bad kingship. A queen's sexuality was feared, and sources for the reign should be read carefully for bias and rumor, but it is clear that Isabelle's femininity, desirability, intercession and unofficial influence reinforced the king's masculinity. It was unacceptable, however, for anyone to overpower the king. Isabelle's influence was different from that of other royal favorites and was treated in a gender-specific manner. Edward was expected to rule his kingdom as a husband ruled his wife, and when he could not rule her, Isabelle's undue influence over the king established a link between her and bad government, and constituted a double challenge to the natural order. By allowing her to influence his government, he was seen as not only less of a king, but less of a man. Her queenship was, however, far from exemplary, and her son's treatment of her was justified and quite fair. Her legacy extends beyond England, though, to her natal family in France which had reached the end of the line in 1328. Her generation of the Capetian family, which had come to power in 987, would be the last to inherit and govern France.

France

From the death of Philip I in 1108 to the death of Charles IV in 1328, Capetian French kings steadily asserted their authority over an increasingly large and powerful France. They expanded the boundaries of their realm both by strategic marriages that brought neighboring counties as dowries into the royal domains and by conquest, most notably the acquisition of territory that once was held by the English kings. The long

reigns of Louis VI (r. 1108–37), Louis VII (r. 1137–80) and [Philip] Augustus (r. 1180–1223) stabilized royal authority while fending o[ff chal]lenges from the English, Flemish and barons of northern France. [The] repercussions from the eleventh-century investiture conflict and later disputes between Philip IV of France (r. 1285–1314) and Pope Boniface VIII recalibrated papal and royal power.

Queenship closely followed changes in theory and practice of Capetian kingship that was grounded in dynastic rights to the Crown and relied on patrilineal succession to assure the integrity of the patrimony.[47] Hereditary succession to the Crown was reinforced by the designation or consecration of the eldest son during his father's lifetime. Queens were vital to this transfer of power as they legitimized the lineage through marriage, coronation and the birth of children. Following the Carolingian precedent of 751, the Capetians took pains to be consecrated and anointed by the Archbishop of Reims, and created a theocratic monarchy articulated in 1137, just after the accession of Louis VII, with the aid of Abbot Suger of St. Denis. This tight association of kingship and sanctity had tremendous implications for French queens, who more closely modeled themselves after the motherhood of the Virgin Mary. The queen's maternity and sexuality together with anxieties over legitimacy profoundly affected late-medieval French queenship. Generations of healthy baby boys born to Capetian queens limited the possibility of a princess inheriting and ruling, but it took a series of adultery scandals in the royal family between 1314 and 1328 for royal scribes to append a fraudulent clause to the French Salic Law, the law code written in the fifth century during the reign of Clovis, only a few decades later but made to look as though it were part of the original law. This excluded queens from any claim to rule, but they were hardly powerless. They wielded tremendous influence in education, art and religion as patrons and consumers. Queens were particularly influential intercessors and mediators, and often worked informally alongside their husbands, fathers and brothers. Kings often were absent from their realm during the Second and Third Crusades (1147–9 and 1190–1, respectively) and other military campaigns, and, in the king's absence, queens took up the reins of governance as regents.[48]

Marion Facinger's classic thesis of medieval French queenship and regency traced a steady increase in queenly power and located the pinnacle of queenly power as being during the reign of Adélaïde of Maurienne (d. 1155), Louis VI's competent and effective queen. Adélaïde freely shared power with Louis as a matter of right. She not only signed charters with Louis – the royal acts include the queen's regnal year with that of

the king, she issued acts in her own name and joined Louis in his allegiance to Pope Innocent II against an anti-pope.[49] This is serious and important queenly work but, as Miriam Shadis pointed out, Facinger's thesis is not the final word on Capetian queenship because it privileges masculine forms of power.[50] Facinger considered queenship only in its official public guise, which is a narrow frame of study that neglects the full dimension of queenly power along the public–private continuum. Her sources were primarily public royal documents and, from these, Facinger tracked a significant decline in the early thirteenth century. But, since 1968, significant empirical research, particularly in regional archives, and theoretical developments have presented a rather different, far more complex picture. For example, Eleanor of Aquitaine, first wife of Louis VII, rarely appears in royal documents from their marriage in 1137 until 1147, and is evident after that only because she went with Louis on Crusade and they then divorced. But she was occupied with bearing two daughters, busy with the administration of her lands in Aquitaine, and an active patron of arts and culture.[51]

Furthermore, any number of circumstances may force what appears to be a change of a clearly misogynistic attitude. Louis VII's third wife, Adèle of Champagne (d. 1206), gave the king his long-awaited son, Philip II Augustus (d. 1223), who Louis called the 'progeny of the better sex' after he had been 'terrified by a multitude of daughters' (he had two with his first wife, Eleanor of Aquitaine, and two with his second wife, Constance of Castile). Philip shared his father's aversion to rule by strong women and used queens as indirect instruments of power. He married three times and tried to divorce his first two wives, Isabelle of Hainault and Ingeborg of Denmark, but they both vigorously defied his attempts. When Philip tried to divorce Isabelle, then aged fourteen, she shamed him into stopping the proceedings by dressing in a pauper's shift and publicly begging for his mercy in the streets of Senlis. She prevailed only because the king's uncle, Robert, reminded Philip that a divorce would not only rouse the anger of nobles, but he would also have to forfeit her dowry, the wealthy county of Artois. They remained married and Isabelle bore Philip his son and heir, the future Louis VIII (d. 1226) before her death in 1190. Ingeborg fared less well, but not for lack of trying. She married Philip in 1193, he repudiated her soon after, and she fled to a convent. She had a solid legal case and Pope Celestine III ruled against Philip, who had his advisors draw up a false genealogy to demonstrate close consanguinity. Philip ignored the papal ruling, virtually imprisoned Ingeborg and, in 1196, married Agnes of Meran. Papal interdict and threats of excommunication persuaded Philip to repudiate Agnes in

1200 and he finally reconciled with Ingeborg in 1213 in an attempt to use her connections to the English throne.[52]

Philip did not suddenly have a change of heart or put aside his qualms about women in 1190 when he asked his mother Adèle to take control of government as regent when he went on Crusade. This is not simply a case of a king who suddenly realized the value of women, nor a man dominated by his mother. As regent, the queen was where the king was, 'his every act and decision was approved or assisted or contended by the queen *because she was there*, and because custom and tradition allowed that the queen was an ally and partner in governing'.[53] He must have felt comfortable with a queen-regent as a palatable substitute for a king because the regency is an extension of the queen as mother in charge of the tutelage and guardianship of royal children. Adéle had limited authority, but she signals the ascendancy of the office of queen-regent and is succeeded by many women who can hardly be considered invisible or powerless. But the queen-regent, no matter how much authority she did or did not wield, was still an instrument of kingly power.

Facinger also attributed the diminution in a Capetian queen's power to changes in administrative practices that separated the king's and queen's households. Shadis agrees but takes the argument further, noting that, since 1968, scholars have used new feminist, gender and anthropological theories to understand the operations of power. Changes in marriage and bureaucracy – accession to the throne was linked to legitimate lineage, dynasty and inseparable monogamous marriage – together with a more elaborate court ceremonial, placed new demands on a queen. A queen may have lost her job as the manager of the treasury and co-ruler with her husband, but she was increasingly visible and important as the embodiment of monarchy at court ceremonial events and the connective tissue between generations in the dynasty. Facinger also notes, however, that, as part of his administrative reforms, Philip paradoxically opened up a space for the queen as mediator and intercessor when he created a small circle of advisors that excluded powerful magnates in the realm. In these spaces, what Louise Fradenburg terms 'interstitiality' or 'in-betweenness', the queen worked behind the scenes at the 'nodal points of cultural work'.[54] The queen's proximity to the king made her the nexus between him and others, and in this she symbolized the possibility of social cohesion, as she acted on behalf of their subjects seeking redress for injustice or simply the king's ear. In order to trace these changes, scholars need to look beyond fiscal records and charter documents of the royal curia and take note of material culture and royal ritual practices. In other words, just because a queen

did not exercise direct, formal, official authority that appeared in charters or royal acts does not mean that she was meek, silent, or powerless. The actions of Isabelle of Hainault against Philip II Augustus show clearly that she knew the value of a queen's public image and how to use it in an aggressively masculine royal court. The indomitable Blanche of Castile (d. 1252), the wife of their son Louis VIII (d. 1226), provides an important case that demonstrates the wide range of opportunities open to queens that scholars miss when they focus too much on masculine forms of power.

Blanche was the daughter of King Alfonso VIII of Castile and Leonor of England, wife of King Louis VIII (d. 1226), and mother of the sainted King Louis IX.[55] She was aged twelve when she arrived at the Capetian court in 1200 to marry the thirteen-year-old heir, Louis. A highly educated foreign princess, she was a strong-willed, tough-minded queen consort, queen-regent for her son while he was on Crusade, astute household manager, generous donor to the Church and vital to the strength of the French monarchy in the later Middle Ages.[56] She had a rough start as a foreign princess, noted by Jean de Joinville as having no friends or relatives in the whole kingdom of France. Bishop Hugh of Lincoln, who happened to be in Paris at the time of the wedding, comforted her as she wept in homesickness for the customs and language of Castile. She was joyful when she received news in 1212 from her sister Berenguela that their father had just won an important battle against the Muslims:

> I have joyful news for you. Thanks to God, from whom all power [comes], the king our lord and father conquered in pitched battle Ammiramomelinus [emir Muhammad-el-Nasir], in which we believe the honor won was outstanding, since up to now it was unheard of for the king of Morocco to be overcome in pitched battle. And know that a servant from our father's household announced this to me; but I did not believe him until I saw the letters from our father.[57]

From letters such as this, one of many extant letters (some translated into English), written no doubt by a chancery scribe and with some details perhaps exaggerated for effect, it is possible to see the relationship of the two sisters, their concerns for the family and beyond their individual realms. Princesses were not sheltered from political life, they wrote to one another as a matter of course, and their letters open a small window onto the Spanish dimension of the personality of the queen of France. Both sisters were very much their mother's daughter, and Leonor of

England's influence can be felt in their taste in art and their memorialization of the family.[58]

Before Blanche arrived in France, she had been well-educated in the nuanced operations of court life and was not entirely bereft of support; she had allies among the high-ranking bishops and was related to some noble families. But in this period, when monarchy depended on charisma and personal connections, motherhood became the significant element of Blanche's practice of queenship. She was pregnant at least twelve times, only five of these children surviving to adulthood. It was through them, particularly as regent for her son, that Blanche crafted her own political space, overcame the resistance of French lords and became a French queen.

When Philip died in 1223, Louis VIII and Blanche were crowned king and queen, and they ruled France until his death in 1226. Their coronation at Reims was depicted in a beautiful illuminated manuscript, *Les Grandes Chroniques de France*, a history of the kings of France commissioned by Louis and Blanche's son, Louis IX, but illustrated by Jean Fouquet in the mid-fifteenth century (Illustration 3.2). The image is redolent with iconography of medieval French monarchy – the queen and king wear rich royal blue robes covered in fleur-de-lis and they are surrounded by clergy. The queen is alongside the king, which suggests a parity, but the prominence of the clergy highlights the French ideology of a sacral kingship in which the king alone is anointed with a holy oil that imparts a priestly aura to his rule. The French queen's coronation does not have a sacral dimension, so that no matter how pious, she would remain less lofty in status than the king. The importance of this difference was not fully realized during the reign of Louis and Blanche, but it would have profound implications in the fourteenth century when the Capetian dynasty gave way to the Valois, and French queens were permanently barred from inheriting and ruling in their own right.

By then, Blanche was an experienced sophisticated woman, familiar with the realm and its distinct culture, and her acuity is no doubt what led her husband to select her to be regent for their eleven-year-old son, Louis IX. She then was regent twice: from 1226 to around 1234 (the precise end of the first regency is not known), when Louis married Marguerite of Provence and during his first Crusade; and then from 1248 until her death in 1252. André Poulet noted that Blanche had her grandmother-in-law Adèle as an immediate model for a queen-regent, but Blanche was far more active.[59] The charter evidence makes it clear that Louis's legitimacy as king was connected to his mother, who appears in the documents as 'Queen Blanche, our dear mother' and 'lady queen'.[60]

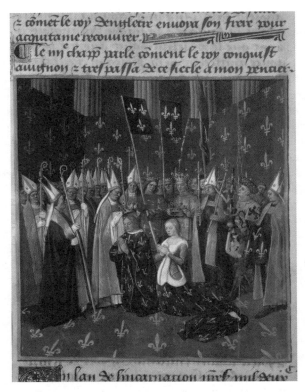

Illustration 3.2 Jean Fouquet (c. 1415/20–1481), Coronation of King Louis VIII (1187–1226) of France and Blanche of Castile (1188–1252) at Reims in 1224. From *Les Grandes Chroniques de France*. © Scala/White Images/Art Resource, New York.

This is in keeping with the Capetian tradition of co-rule between generations, which usually meant that a king was formally associated with his son, but the first Capetian queen Adélaide had shared governance with her husband, Hugh Capet, and was active in her son's early government. Throughout his reign, Blanche was ever-present, so much so that Louis's wife Marguerite had to be vehement in asserting her own authority as queen-consort.

But Blanche's queenship encompasses much more than just her as mother and a regent. Her management of the household reveals more than meets the eye. When sources such as household accounts are read not merely in terms of how much money she spent but in terms of what she spent her money on, we can get a sense of one of a queen's most

important functions as a queen, the ritual of gift-giving. The queen was the representative of the king at court ceremonies, and in this way the queen served as a mediator that bound the king and his followers. Gift-giving is associated with patronage, which for Blanche, who had a strong sense of piety and religious duty, made her a prodigious supporter of the Cistercian order.[61] Queens spent considerable amounts of money on family tombs as the visual bearers of dynastic memory and they commissioned their own mausoleums in what can be seen as a way to continue their family ties. For Blanche, it was particularly the mausoleums of her parents and female relatives, visually mediating the living and dead. Blanche's attention to her sisters and not her brothers or sons may seem odd, but it suggests that she felt secure that the men in the family were likely to be memorialized publicly and she wanted to be sure that her sisters were not forgotten.[62] Blanche did as much as, or more than, most French kings did in laying the foundations of a strong French monarchy. As a Castilian princess and French queen, Blanche was part of an increasingly important network of political and cultural connections that crisscrossed political boundaries and spread an international style of visual art and literature that, for example, brought Arabic literature northwards and took French architecture southwards.[63]

It could not have been easy for Marguerite to hold her own with Blanche as such as effective and dominant regent for Louis. She was less publicly active while Blanche was alive, more likely to engage in mediation and patronage, and busy raising their eleven children. Although more low key than Blanche, she was no less important to the French monarchy. The linkage of the royal families of England and France with two Provençal sisters was effective at smoothing tensions. This was evident in 1259 when Marguerite, her three sisters and their mother were present during the negotiations of the Treaty of Paris. The family harmony represented by Marguerite and her sisters symbolized the possibility of peace, at least for a while, between Louis IX and Henry III after decades of tension over English claims to French lands in Normandy. Like her mother-in-law, Marguerite used her influence to her advantage at court through gift-giving, so much so that Louis IX limited her from giving and receiving valuable gifts from courtiers. She was one of a growing number of queens as book-owners and was, no doubt, the recipient of books as gifts from scribes, monks or nuns. She was vital to the transmission of culture as an owner of books, whether purchased or inherited, and a patron of writers. This was a shared interest. When Louis commissioned Vincent Beauvais's *Speculum Historiale* (*Mirror of History*), Marguerite ordered a French translation to be completed at the same time.[64]

After Louis's death in 1270, she returned to Provence, but remained a force in the reign of their son, Philip III (d. 1285), particularly in the selection of his first wife, Isabel of Aragon, daughter of Jaume I of the Crown of Aragon and Violant of Hungary. Isabel, mother of three sons who survived Philip, including the heir, Philip IV, reigned as queen for barely six months before dying at the age of 24. Philip's second queen, Marie of Brabant, struggled as a second wife following a beloved first wife, as stepmother to her husband's three sons with Isabel, and trying to secure a place for her son and two daughters. She and Marguerite did not get along well, and when Louis, Philip and Isabel's eldest son, died suddenly, unfounded rumors flew that Marie had a hand in his death. Her youngest child, Margaret, may well have watched and learned from her mother about how to succeed as a second wife. Like her mother, she married a widower king, Edward I of England, and followed his adored wife, Eleanor of Castile. But she adroitly managed to smooth out the rough spots of a second marriage, and ease the tensions of father and son.

When Jeanne of Champagne married Philip IV (d. 1314), second son of Isabel of Aragon and Philip III, she was Countess of Champagne and Queen of Navarre. She was still an infant when she inherited these realms in 1274 when her father died, and her mother, dowager-queen Blanche of Artois, governed as regent. Although Navarre did not prohibit women from inheriting and ruling a realm in their own right, the nobles of Navarre sought to exploit the minority. Blanche sought protection from Philip III, who took advantage of the situation and arranged the marriage of Jeanne to Philip. When Philip III died one year later, the ten-year-old Jeanne became both Queen of Navarre and Queen of France. Her husband, an opportunistic and canny king, had his seals identify him as the first king of both France and Navarre. To enlarge the realm further and ensure that the lucrative duchy of Burgundy came into the French royal domain, all three of Philip's sons married daughters of the Burgundian family. When Queen Jeanne died in 1305, the Navarrese, no doubt fearful that they, like the Burgundians, would be swallowed whole into the French domains, insisted that the succession bypass the king and follow the queen's side of the family to their oldest son, Louis X.

Then, a stunning series of events unfolded that undid Philip IV's well-laid plans. He died in 1314, followed two years later by his son Louis, whose only surviving child was a daughter, Jeanne. Complicating matters, his widow, Margaret of Burgundy, may have been involved in an adulterous affair, casting doubts on Jeanne's parentage. With his second wife, Clémence of Hungary, Louis had a son, Jean, but the boy died when only a few days old. At that point, Louis's daughter Jeanne might have

become Queen of France and Navarre, but the regents, her uncles Philip and Charles, bypassed her. Philip took the throne on Jeanne's behalf and promised to take care of it during her minority. He never returned it and, instead, arranged a hasty coronation at Reims and declared his niece ineligible. He ruled as Philip V until his death in 1322 when, instead of one of his three daughters inheriting, the Crown was passed to his brother, Charles IV. When Charles died in 1328 he had only one child, a daughter – Blanche, with his third wife, Jeanne d'Évreux (he had annulled his first marriage to Blanche of Burgundy on grounds of adultery; his second wife, Marie of Luxembourg, had died in childbirth). The only legitimate claimant left with direct connections to King Philip IV was his youngest daughter Isabelle, dowager-queen of England, the widow of Edward II, and regent for their sixteen-year-old son, Edward III. Isabelle's sex and her English son made her unacceptable to the French nobles, who feared both the power of a competing realm and rule by a woman.

This complex family history makes it clear that what kingship scholars call 'dynastic failure' is a euphemism for a shortage of healthy royal baby boys and an unwillingness to accept female rule. The crisis led royal advisers to perform feats of mental gymnastics to resolve the problem of legitimacy of rule; specifically, who should inherit and rule when only females are left in the lineage. In this instance, misogyny trumped dynastic succession through the main line of descent. It was simply assumed that the throne would once again bypass the king's daughter, and so it did. The nearest male relative was Philip of Valois, the nephew of King Philip IV. Because he was not rightful heir, Philip ceded his claim to Navarre to Louis X's daughter Jeanne and, in return, gained the French royal domains. Amid muted grumbling among the French, Philip's coronation went off without a problem, but the English were outraged. King Edward III and his advisers argued that he had a superior claim. The conflicting political notions on the succession created a dynastic crisis that reverberated widely and violently across Europe as the principal cause of the Hundred Years' War.

The French legally cemented their denial of French princesses' claims to inherit and rule around 1413. The Valois kings were in need of legal support against the English, whose armies had been devastating the French countryside with sporadic raids since 1356, and whose king, Henry V, a lineal descendant of Edward III and Isabelle, was reiterating the claim to rule France by right of inheritance through his mother. Henry's case was not airtight, however. He was not the hereditary claimant (that right belonged to the Mortimer Earls of March and later the Dukes of York); rather, his claim derived from his father's deposition

of King Richard II in 1399. A royal notary appended, post facto, a clause to an ancient law code, the Salic Law, to justify excluding women from the royal succession. The cited clause came from the chapter 'De allodio' in the Salic Law, which dictated that men should inherit their ancestors' landed property but women were to receive only personal property. To make this statement apply to the French kingdom, he added '*in regno*' to an inaccurate transcription of the clause. This fraudulent clause was good enough to prompt subsequent writers employed by the Valois monarchy in the royal chancellery to use the Salic Law to defend the exclusion of women from the French royal succession. There were scattered attempts to import this convenient bit of chicanery in the chancery to other realms, but none succeeded. Valois queens were nothing if not resilient. They may have been excluded from ruling directly but, like their Capetian ancestors, they took their place among the most vitally powerful queens-regent in the later Middle Ages.[65]

As for Louis X's daughter, Jeanne (d. 1349), she found a more receptive realm south of the Pyrenees. In 1329, just after the Valois family came to power, she signed a treaty with her Valois rival, Philip VI, who could not invoke a rule against female succession in Navarre. She was crowned Queen of Navarre and ruled together with her husband, Philip d'Évreux, as king-consort, but only after she renounced her claims to the crown of France and some of her estates in northern France. At his death in 1343, she ruled alone for one year for her son. The family rift was mended later when her daughter, Blanche d'Évreux, married King Philip VI of Valois. Blanche's sister-in-law, Jeanne d'Évreux (d. 1371), third wife of Charles IV, left an extraordinary legacy in the form of some of the most exquisite works of art of the Middle Ages: a lavish illuminated manuscript of her *Book of Hours*, known as the *Hours of Jeanne d'Évreux*, a book no larger than the palm of her hand, and a much larger but equally opulent gilded silver and enamel statue of the Virgin and Child.[66]

The Iberian Kingdoms: León, Castile, the Crown of Aragon and Portugal

In the eleventh century, a string of military successes of the Christian kings in the Reconquest expanded the borders of their realms in the aftermath of the fragmentation of the Muslim caliphate of Córdoba. These conditions made it possible for settlers tentatively and carefully to populate the frontier of the newborn kingdoms of León and Castile. There would still be sporadic fighting punctuated by major military

campaigns during this period but, for the most part, conditions had settled down, allowing kings and two remarkable queens to craft stable, prosperous and powerful realms of Castile, León, Portugal and the Crown of Aragon. Many of the successes of the later eleventh century are due to the military exploits of Alfonso VI (d. 1109) and the work of his two daughters, both queens. They and their successors ruled with enough clout, both within and outside the peninsula, to play a vital role in politics in England, France and Germany, and with the papacy. Their practice of kingship was distinctive, however, and did not have the overtly sacral elements of French monarchy; kings and queens had formal coronations only sporadically.[67] This may explain in part why one queen of medieval Iberia was able to govern in her own right and why Aragonese queens took on an essential and official public political role as the king's lieutenant.[68]

Urraca of León-Castile, daughter of Alfonso VI, and his wife, Constance of Burgundy, was the last woman to rule an Iberian realm as queen in her own right until the accession of Isabel I in 1474. Urraca inherited her realms in 1109 on the death of her father. She governed virtually as sole ruler until her death in 1126; her first husband played little part in official governance, and her second, king in his own right of Aragon, created a host of territorial and dynastic problems that Urraca spent the rest of her reign resolving.[69] She could inherit directly because in medieval Castile women could legally inherit both land and lordship from their fathers. But no one at the time would have wagered that Urraca would inherit or govern a realm. Her father's five marriages and extramarital relations, one with the daughter of the Muslim king of Seville, resulted in a realm with many potential heirs. But his eldest son, Sancho was killed in battle in 1108 and Urraca was the eldest of the surviving children. Both Urraca and her half-sister (later her rival) Teresa of León (c. 1080–1130), Alfonso's illegitimate daughter and the first ruler of, first, the county and subsequently the kingdom of Portugal, dominated Iberian politics during the first half of the twelfth century.[70] Teresa married Henry of Burgundy and he was named Count of Portugal in 1094; their son, Afonso Henriques (d. 1185), seized the realm from his mother and was the first to call himself King of Portugal. Teresa's status, either countess or queen, was a source of confusion in the twelfth century and is a topic of scholarly debate today. Like her half-sister, she clearly was in control of the county of Portugal, but she called herself Queen and was so called by Pope Pascal II.[71]

Urraca's marriage at the age of eight to Raymond, Count of Burgundy, her mother's kinsman, no doubt calmed whatever anxieties the nobles

and clergy might have had about sole rule by a woman. They had two children, a son who succeeded her and ruled as Alfonso VII (born 1105) and a daughter, Sancha. Urraca, was however, very much in control of the government of León and Castile; her husband was accorded the title of King of Galicia and made a Count of Castile, subordinate to Urraca. Her status as a queen-regnant is clearly depicted in a full-page painting in a manuscript that shows her crowned, seated on a throne, and reigning over her court (Illustration 3.3). Public records and private observations

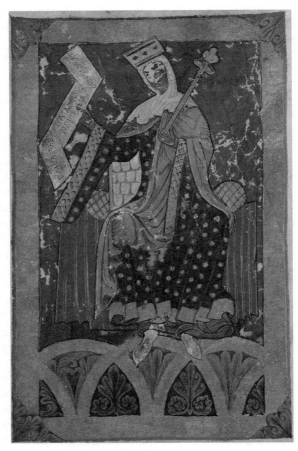

Illustration 3.3 Urraca, Queen of Castile and León (1109–1126). Tumbo A, folio 31. Cathedral Library of Coruña, Santiago de Compostela, Spain. © Album/Art Resource, New York.

by her contemporaries clearly show that her decisions were ultimately her own. When Raymond died in 1107, Alfonso VI rejected a proposal that she marry a Castilian noble, fearing that it would engender factional strife, and agreed that she should marry Alfonso I, King of Aragon in 1109. He was a proven military leader, which earned him the nickname 'the Battler', and his royal status put him on a par with Urraca. But the marriage was a disaster legally, politically and personally. Urraca and Alfonso were closely related – too much so for the comfort of the popes, who condemned the marriage. The Aragonese were concerned that a foreign queen would compromise their independence. Neighboring realms feared that the union would endanger their own fragile sovereignty, and, before the wedding but immediately after the death of Alfonso VI, Count Henry of Portugal invaded León, claiming that realm as Teresa's birthright. Also, the couple was not at all suited in terms of temperament, both insisting on sovereign rights and prerogatives and unwilling to budge. Urraca protested the match, but she respected her dead father's wishes. Strains were apparent in the marriage at the start and, by 1111, it was clear that it had been a mistake. Urraca made a strategic decision to associate her son with her rule in order to stabilize the realm and, shortly after his coronation, she agreed to annul her marriage on grounds of consanguinity. Tensions between Urraca and Teresa (Henry had died in 1112) continued, as the two sisters fought over disputed lands adjacent to their borders from 1116 until 1120, when Urraca won a victory against her sister that ended the strife. She negotiated a truce with Aragon in 1117 that protected the borders and secured peace for her son. Urraca was not active in the Reconquest and did not acquire new lands, but she held the borders and in 1124 made inroads against the Muslims in the south and east.

 Urraca and Teresa were remarkable for navigating political maelstroms not only in their individual realms, but also among their Christian neighbors and Muslim opponents, diplomatically maneuvering around and with newly-empowered reform-minded popes. Like the eleventh-century Byzantine sisters and co-empresses Zoë and Theodora, they were not always in harmonious familial unity, but they left a legacy that had both immediate and long-term consequences. When Urraca died, her son inherited a realm that was intact, at peace, and well-situated for the new challenges of the Reconquest. Teresa, who had acquired the county of Portugal, tenaciously protected it, lost it to her son, and ultimately bequeathed it to him. He turned it into the kingdom of Portugal and ruled as Afonso I. Until well into the fourteenth century, Portuguese kings married outside the realm, choosing to use their queens

as diplomatic capital to forge alliances with Savoy, the Crown of Aragon and Castile. Portuguese queens, until the reign of King Dinis (d. 1325), were close advisors to the king, regularly participating in the royal curia, witnessing royal charters, securing peace and formally approving royal acts. In short, they acted much like Frankish, Anglo-Saxon and earlier queens in Iberia, who had pitched in with the work of governing and converting a newborn realm. And they, like their Castilian and Aragonese counterparts, transmitted dynastic rule by creating an ample supply of baby boys to inherit and rule.

The reign of Berenguela of Castile, queen-consort of León from 1197 until 1204 and queen-regnant of Castile for a brief moment in 1217, illuminates the dense familial connections created by the royal families of Europe in the twelfth century.[72] Berenguela was the daughter of Alfonso VIII of Castile (d. 1214) and Leonor of England; her sister Blanche, married to King Louis VIII, was Queen of France. She was closely linked not only to Urraca of León-Castile and Teresa of Portugal, but also to her grandparents, Henry II of England and Eleanor of Aquitaine. This rich lineage made Berenguela a highly sought-after bride, and she caught the attention of German emperor Frederick Barbarossa, who betrothed his son, Conrad, to her in 1187. But when her brother was born and she was demoted in the line of succession, the emperor had the marriage proposal officially annulled. In 1197, Berenguela married her ambitious first cousin, Alfonso IX of León (d. 1230). It is likely that both parties requested dispensations from Pope Celestine III, but there is no proof of this. Pope Innocent III, a stickler for adherence to Church law on matrimonial issues such as obvious consanguinity, moved to annul the marriage. However, he did not take final action until 1204, after Berenguela had given birth to five children. This was the second annulment for both Berenguela and Alfonso, and they fought to keep the marriage intact, but the pope denied their request, although their children were deemed legitimate.

Berenguela's reign also illuminates the risky choices a queen sometimes had to make to ensure the success of her family and the realm. When her father died in 1214, he was succeeded by his ten-year-old son Enrique; dowager-queen Leonor was regent for him for just a few weeks until her death. Berenguela then stepped in as regent for her brother until 1217, but leaped to the head of the line of succession when Enrique died in a freak accident. In that instant, Berenguela went from ex-queen-consort of León and busy mother of five children, to heiress and queen-regnant of Castile. She was in a dangerous position, poised precariously between her former husband – who could easily claim the crown as

Enrique's closest male relative, the powerful Lara family – who had been making trouble for a decade, and trying to protect her son, Fernando, then sixteen. For over one month, she refused to tell Alfonso the news of her brother's death and her own accession, waiting until just before she abdicated the Crown in favor of their son:

> Therefore the noble queen went out with her sons Fernando and Alfonso and with the bishops – namely, of Burgos and Palencia – and with other men of religion, and with the barons who supported her, and came to the aforesaid place, where a crowd of people awaited her arrival. One of them, speaking for all of them since they had agreed on this, recognized on behalf of the populace that the kingdom belonged by right to Queen doña Berenguela, and that everyone recognized her as *domina* and queen of the kingdom of Castile. Nevertheless, they all unanimously begged her to grant the kingdom, which was hers by proprietary right, to her elder son, don Fernando, because since she was a woman, she could not withstand the burdens of ruling the kingdom. Seeing what she had most ardently desired, she joyfully agreed to their request and granted the kingdom to her son.[73]

Shadis convincingly critiques scholarship that dismisses Berenguela as 'queen for a day' and argues, instead, that Berenguela's famous grant of kingship to Fernando in 1217 was co-rulership, not abdication. Her choice made perfect sense at the time. Military concerns were probably paramount, with the Christian armies still at war against the Muslims, and with restive and ambitious nobles ready to seize on any weakness. There is nothing like an interregnum to raise the stakes, as the reign of Empress Matilda made clear. Even a queen who inherited directly, had explicit support from nobles and ruled in her own right still needed a husband to lend a hand on the field with an army. Still, as Jana Bianchini notes, contemporaries took pains to note that, although Fernando was king, he humbly and devoutly took counsel with his mother, obeyed her. However, they also note that Berenguela was always was careful not to overstep her bounds or make him seem a passive receptacle of her wishes, which would make him appear effeminate and not worthy of the title of king. Her authority was always presented in a non-threatening manner. She was, in short, highly attuned to the careful balance of masculine and feminine elements in a successful monarchy.

Berenguela was hardly an absentee queen in other areas, either. She controlled properties known as the *Infantazgo* that formed the implicit

domain of Leonese-Castilian royal women and constituted a significant share of the Crown's demesne. Akin to the English queen's gold, many of these lands were economically valuable and nearly all were situated along the strategically important borders of other Christian kingdoms. Bianchini has studied the *Infantazgo* and notes that it was given only to royal women who had become consecrated virgins – a status somewhat short of nunhood, but which nonetheless barred these women from marrying and bearing children and meaning they could not alienate the Crown's properties to husbands or children. Sancha Raimúndez (d. 1159), who reigned with her brother Alfonso VII, may have been a consecrated nun with properties in the *Infantazgo*. But Sancha's mother, Queen Urraca of León-Castile also held large portions of the *Infantazgo* during her widowhood, while she was married to her second husband, and throughout her extramarital affair with a Castilian noble. A patron of the Church, she personally supervized construction of cathedrals and commissioned Lucas of Tuy to compose a chronicle on the kings of Castile and León.

She was at Fernando's side as an advisor, intervening indirectly in royal policy, negotiating the marriages of her children. Her intervention on Fernando's behalf in 1230 had far-reaching consequences. When her former husband, Alfonso IX, died, he designated as his heirs Sancha and Dulce, his daughters from his first marriage to Teresa, daughter of Sancho I of Portugal.[74] His claim that the Crown should pass to the eldest child, not the eldest son, effectively superseded what Berenguela considered the birthright of her son, Fernando. Berenguela met with the princesses' mother and they negotiated a treaty stipulating that Sancha and Dulce would renounce their rights to the throne in exchange for lifetime annuities. This was an enduring achievement. It prevented civil war and united León and Castile – not minor feats – but solidifying primogeniture as the right of a king's eldest son, not eldest daughter, had far-reaching consequences for queenship.

For immediate successors, it meant that the imperative to bear a son took on even greater importance. Violant of Aragon (d. 1301), wife of Alfonso X (d. 1284), was ten years old in 1246 when she married. Canon law frowned on sexual relations until the girl had reached puberty so, to no one's great surprise, she did not get pregnant for several years. Alfonso, who already had fathered an illegitimate daughter, feared the worst and almost had their marriage annulled, but by 1252 she was pregnant and bore him eleven children, six of them sons, including the heir, Sancho IV. Alfonso wrote, or commissioned, one of the first expressions of queenship as office in two works, the *Espéculo* (*Mirror*) and the great

law code the *Siete Partidas* (*Seven Parts*). He was primarily concerned with the queen as mother of the heir, but he also articulated a vision of monarchy as a collaboration between king and queen, the queen being depicted as queen-consort and not queen-regnant. The couple devoted themselves to the stability and good government of the realm. In some ways conventional documents, these two works articulate the expectations of a queen that would be just as applicable to England or France at the same time. A queen was to be an honorable wife and mother, take responsibility for the education of her daughters, arrange good marriages for the children, be pious and manage the household with discretion and tact.[75] Queens continued to serve as regents for kings away for long periods of time on military campaigns in this period, the most active phase of the Reconquest. María de Molina, widow of Alfonso X's son Sancho IV (d. 1295) was regent for both her son, Fernando IV (r. 1295–1312), and grandson, Alfonso XI (r. 1312–50), and successfully protected their rights. She was an especially forceful presence in the Cortes of Castile and often worked side-by-side with Sancho. A skillful negotiator, she worked actively to muster the support of the towns, which she rightly judged to be crucial to Sancho's authority, in the Cortes of Valladolid in 1293 and 1307, and in Medina del Campo in 1305.

Isabel of Aragon (d. 1336), the daughter of Pere III of Aragon and Constance Hohenstaufen, was the great-niece of St. Elizabeth of Hungary, who no doubt inspired Isabel's piety. She was actively engaged in the affairs of Castile, Portugal and the Crown of Aragon, arranged marriages, intervened in legal cases and mediated treaty negotiations in 1297 that fixed the borders between Portugal and Castile. Her marriage to Dinis of Portugal was not entirely happy, however, owing in part to a civil war between 1319 and 1323 that pitted her and her son, the future Afonso IV, against her husband and his illegitimate son Afonso Sanches. She forcibly prevented her husband from killing their son by stationing herself between the two on the battlefield. After Dinis's death in 1325, she retired to Santa Clara-a-Velha in Coimbra, the convent she refounded in 1314 for the Order of the Poor Clares, but remained involved in Portuguese politics. She was buried in the Franciscan habit and was canonized in the sixteenth century.[76]

Queenship in the Crown of Aragon took a markedly different course from both Castile and Portugal for entirely different reasons. The Crown was a composite realm created in 1137 when Petronila, queen of the kingdom of Aragon (d. 1173), married Ramon Berenguer IV (d. 1162), Count of Barcelona. She ruled in her own right until her son, Alfonso II, came of age in 1164. A long string of Aragonese queens from the late

twelfth to the late thirteenth century fit the mold of queenship in all ways: valiant advisors to the kings, mothers of heirs, pious, generous, intercessors. What makes the Aragonese queens distinctive is that, starting in the late thirteenth century, they officially shared governing responsibilities with their husbands. This sounds like the regency but, instead of governing for a young son or an ill king, or with limited ad hoc powers, the Aragonese queen-lieutenant was an established office that formed a key part of the royal court bureaucracy. It was an innovation created out of necessity by pragmatic kings. As the Crown expanded, it accumulated an array of realms across the western Mediterranean. By 1229, it was a sprawling kingdom composed of other kingdoms and, by 1300, was not quite an empire but had the political reach and economic power of one. Each of the constituent realms retained a fair measure of autonomy over its laws and governance, and posed vexing long-term challenges for ruling that had significant implications for queenship. Aragonese kings, fully capable mentally, completely healthy and competent but away from court for long periods of time, needed an institution with the stature and strength of the regency, but sufficiently flexible to enable the king to respond quickly to changing circumstances. They perfected the art of delegating authority and developed an office, the governmental lieutenant, to meet their needs. The Lieutenant General was originally established in the thirteenth century as both an ad hoc adjunct to the king and a training ground for princes but, by 1330, kings turned to the queen to staff the office, which became a well-established institution by the fifteenth century.[77]

A queen-lieutenant in the Crown of Aragon was, in the terminology of the documents, the king's alter ego, occupying his place when he was absent and relinquishing the office when he died, when the eldest son would succeed his father as king and any other siblings remained lieutenants at the discretion of the new king. Seven queens-consort ruled as queen-lieutenant in the Crown of Aragon. The queen first became associated with the lieutenancy in April 1310, when Jaume II (d. 1327) appointed his wife, Blanca of Anjou, to serve as his lieutenant while he was on Crusade in Almería. Her tenure was brief, no more than two months, and little is known of her actions, but her exercise of legitimate political authority set the precedent for six subsequent Aragonese queens-lieutenant. A generation later, Teresa d'Entença certainly governed for her husband, Alfonso IV, in 1327, and perhaps earlier, but the documentation for her reign is unclear. There is no official document naming her lieutenant, and she may have been more a regent than a lieutenant. This office would grow into maturity in the fourteenth century

and was the means by which seven queens would make their mark in government and politics in the late Middle Ages.

Queenship in the Crown of Aragon was much more than political work. Constance of Hohenstaufen (d. 1302), wife of Pere III, founded and lived in a Franciscan nunnery in Sicily after she was widowed, bequeathed money in her will to found Franciscan hospitals in Barcelona and Valencia, and was buried in the Franciscan habit in Barcelona.[78] Violant of Hungary (d. 1251), wife of King Jaume I, was described by her husband as a model queen in his autobiographical *Llibre dels feits* (*Book of Deeds*) and as his valued adviser, interceding on behalf of her subjects, mediating quarrels between Jaume and his son-in-law, King Alfonso X of Castile. He relied on her advice when negotiating a treaty with the newly-conquered Muslims of Valencia, rebuffing his royal council for three days until he could 'discuss the matter with the queen alone, who is in our counsel' and commenting that 'if I thought we should accept those terms, then she thought it right also'. The intimacy of their political and marital relationship is evident in his own description of an evening he spent waiting for her to join him for dinner. She was late, and asked him to dine without her, but he protested: 'I waited for her at the foot of the castle's hill. She and I entered joyfully into the castle, and ate together in great delight.' Sentiment and perhaps a bit of exaggeration notwithstanding, this is a remarkable glimpse of what co-rulership could be.[79]

The Mediterranean: the Byzantine Empire, Latin Crusader kingdoms and Italy

Emperor Alexios Komnenos (d. 1118), about whom we know so much from the pen of his adoring daughter, Anna, owed his throne to three women: his biological mother Anna Dalassene (d. c. 1100), who planned it; his adoptive mother, Maria of Alania, the widow of his predecessor, who supported him and adopted him so that he could gain recognition as heir; and his wife, Irene Doukaina (d. c. 1123/33), who married him when she was eleven and bore him eight children. As Barbara Hill aptly noted, 'if you want to get ahead, get a mother. Alexios had two', and he needed them.[80] He came to the throne in 1081 in a coup, and his two mothers smoothly placated the Byzantine sentiment for continuity of rulership and legitimacy conferred by the prior emperor or empress. Irene's family was instrumental in securing her as Alexios's bride over Maria of Alania, the former wife of both Emperors Michael VII and

Nikephoros III. Both mothers continued to live in the imperial palace, and possibly Maria of Alania, too, which led to a host of unsubstantiated rumors of Alexios's infidelity. Irene preferred to work behind the scenes, which caused her critics to call her a schemer, but Alexios relied on her for advice and support, and she traveled with him on military campaigns. When Alexios died, she unsuccessfully supported their daughter Anna to succeed and rule, and mother and daughter went into exile at a monastery that Irene founded at Kecharitomene.

The empresses that succeed them, Maria of Antioch (d. c. 1182) and Euphrosyne Doukaina (d. 1203), were no less influential, but they were overwhelmed by the circumstances of the period – the advances of the Muslim Turks in Asia Minor, and the arrival of Latin armies in the Crusades.[81] Also, Maria and Euphrosyne had many children, many of them male, all of them backed by hostile factions, and no reliably effective mechanism for unchallenged succession from generation to generation. This combination of internal and external factors made the Byzantine Empire vulnerable to the utterly unexpected arrival of an army of Christian European crusaders in the Fourth Crusade of 1204 who set about conquering the city, deposing the last of the Komneni family, and claiming the Empire for themselves.

Following the Byzantine reconquest of the Empire and the restoration of the Palaiologan dynasty in 1261, a number of empresses had opportunities to engage in public politics and the succession, but they were largely unsuccessful. This is due to a number of factors, cultural differences due to the fact that, for the most part, these empresses were foreign-born and had no network of family or allies to help them negotiate the unfamiliar complexity of the Byzantine imperial court. Because the dynasty persisted until the fall of the Empire to the Turks in 1453, there were few chances to have a hand in determining the succession. Considerable tension within the imperial family itself during these centuries made it difficult for an empress to take on any public role, but it was not for lack of trying. These empresses had personal wealth and influence, and worked to support their husbands; however, research to date has shown that their impact on politics was minimal.[82]

The Crusades brought Byzantine empresses face to face with new counterparts in the eastern Mediterranean: queens who inherited and governed the Christian kingdom of Jerusalem during the twelfth century. The Crusader States, a group of principalities, counties and the kingdom of Jerusalem, were entirely new entities formed by the victorious Christian armies who stayed in lands that once were Muslim and, before that, Jewish, Roman and Christian. The armies were led by

French, English and German nobles who superimposed a western European model of fiefs and patrimonial lordship over large swathes of desert and coastline that bore no resemblance to northern Europe. Their political ideas were drawn from their own experience, so they used monarchy as the guide; but they also had to be flexible because the conditions were unsettled at best and often violently unstable. If a king or count died without a male heir, they did not have the luxury of calling on a surplus of nearby brothers or male cousins. These knights from Champagne, or Gascony, or Norfolk, or Saxony did exactly what they would have done back home. They preferred a male heir, and did everything they could to get this. Failing that, they relied on their wives, daughters and sisters, and did so in sometimes innovative ways. The Christian kingdom of Jerusalem during the twelfth century was, for a time, a queen's inheritance.[83]

Women in the Crusader States who inherited territory usually did so because war and violence meant that women outlived men. Queens who were recognized as heirs could exercise their authority directly, but many granted their husband authority. The best example of the Crusader queen is Melisende, (d. 1161), eldest daughter of King Baldwin II of Jerusalem.[84] As his eldest child, she was educated to rule, and rule she did, as queen-regnant of Jerusalem from 1131 to 1153 and queen-regent for her son Baldwin III between 1153 and 1161 while he was on campaign. During her father's reign, Melisende was titled 'daughter of the king and heir of the kingdom of Jerusalem'; she was associated with her father on official documents and had a council comprised of the nobility and clergy. It was not easy: Melisende had to contend with an ambitious husband, Fulk V of Anjou, who regularly called into question her authority to rule. His death in 1143 made it possible for her to rule in her own right, and she set about rebuilding the city of Jerusalem, leading military campaigns and struggling with her son, Baldwin, who sought to supplant her authority. Melisende's granddaughter, Sibylla of Jerusalem (d. 1190), was the legal heir and successor to her father, Amalric. She became queen of Jerusalem in 1186 after her father and her only son died in quick succession, and ruled alone, in her own right, after overcoming partisan appeals to rule with her second husband, Guy of Lusingnan. Her legal successor was her half-sister Isabella (d. 1205). It was not uncommon for land, moveable goods and lordship to pass from father to daughter, but sororal transmission was rare. She was succeeded by her eldest daughter, Maria of Montferrat (d. 1212). After Maria's death, the realms passed again to sons and the kingdom itself declined in importance as the Crusader States were conquered by Muslim armies. This century of

rule by women, transmitted to their daughters and their sisters highlights the importance of dynasty and lineage over strict rules on male rulership when the political conditions are unsettled.

The Empire, central and northern Europe

Kurt-Ulrich Jäschke dismissed German empresses as a descent 'From Famous Empresses to Unspectacular Queens'.[85] He looked at the renowned women of the earlier period and noted acidly that their thirteenth- and fourteenth-century successors were 'pale shadows'. It may well be that Jäschke's definition of 'famous' depends too much on what chroniclers said, or what was recorded in official documentation. It may be that his definition is limited to secular power. It is true that only a few of the central European queens studied by Gábor Klaniczay could exercise much political power because the monarchy relied upon the cult of royal saints for legitimacy. Saintliness was prized, monarchy was dominated by kingship, and those queens who were active in politics usually paid a high price for their actions. Queen Gertrude of Meran, first wife of King Andrew II of Hungary and mother of St. Elizabeth of Hungary, regent in Hungary for her husband, was murdered by nobles in 1213 who considered her regency a threat to their power. Princesses like Elizabeth and her niece Margaret of Hungary, largely powerless in secular politics, found that their piety permitted them to intervene in dynastic disputes and maintained dynastic cults.[86] It is also likely that his definition of 'spectacular' was based on masculine norms of success but, by any standard, he is wrong on at least one count: the Empress Matilda, wife of Henry V. Research on German queens and empresses has not kept pace with that of England, France and the Iberian realms but, since 1997, has uncovered more examples of fame and spectacle among imperial and royal women.

As elsewhere, lineage and birth were paramount considerations, but the elective nature of the empire tended to make the role of the empress quite different from that of a queen. In theory, the office of Holy Roman Emperor had been elective but, since the Carolingians and Ottonians, it had been dominated by a single family whose sons inherited the rights to rule but were officially elected. Noble and royal women could not succeed directly or rule the Empire in their own right; however, they could transmit inherited lands to their sons and were essential to the political networks of the two families who dominated the later Middle Ages. Hohenstaufen and Habsburg empresses were instrumental in secur-

ing the marriages of their daughters from a close family circle of the imperial electors, thus hoping to ensure that future imperial elections would stay in the family. They succeeded in joining a prodigious number of royal and noble families throughout Europe, creating alliances that extended the hegemony of the empire.[87]

The Hohenstaufen family dominated the empire from 1138 to 1254 but many of the queens and empresses are little known, in part because their marriages to kings or emperors were relatively brief, as was Adelheid of Vohburg's (d. 1190) five-year marriage to Emperor Frederick I Barbarossa (d. 1190), which was annulled after five childless years of marriage. Frederick had better luck the second time when he married Béatrice of Burgundy (d. 1184). She was active at the imperial court as a patron of chivalric literary works. Mother of twelve children, she accompanied her husband on his military campaigns, and was a guiding force in the education of their son and heir, Frederick. Some ruled as queens in their own right before marriage, notably Constance of Sicily (d. 1198), heiress of the Norman kingdom of Sicily and the wife of Emperor Henry VI (d. 1197). She was Queen of Sicily from 1194 to 1198, jointly with her husband from 1194 to 1197, and with her infant son, Emperor Frederick II in 1198.[88] But, for most German empresses, the institutional constraints meant that they would focus on motherhood, patronage of art and the Church, education of their children, intercession and as unofficial advisers to their husbands.

Marriage alliances were always important to dynastic survival, but in the hands of Habsburg empresses, negotiating these alliances was a finely honed talent. The Habsburg family first reached the imperial throne in the late thirteenth century with the accession of the relatively minor noble Count Rudolf IV of Swabia and his wife, Gertrude of Hohenberg (d. 1281). Rudolf was never crowned emperor, but he and Gertrude skillfully enlarged their realms, wealth and power at the expense of the Bohemian kings.[89] Their astute strategy of arranging the marriages of their eleven children from German realms with virtually every royal house in Europe built the foundation of a powerful dynasty. Six of their daughters married well, creating alliances essential to Rudolf's election as German king in 1273, his expansion eastwards into Austria, and the success of the Habsburgs in the later Middle Ages. Matilda married Duke Ludwig II of Bavaria; Katherina married Duke Otto III of Bavaria; Agnes married the Saxon Duke Albrecht II; Hedwig married Otto IV, Margrave of Brandenburg; Clementia married Charles Martel of Anjou, the papal claimant to the throne of Hungary and Croatia; and Judith (d. 1297) married King Václav II of Bohemia. At Rudolf's death in 1291, his son

Albrecht I was elected emperor, but the transition was filled with political unrest: Albrecht was assassinated, the results of the imperial election were disputed and civil war ensued. The tumult destroyed the male branch of the family and, in 1322, Matilda's son, Louis IV ('the Bavarian'), inherited regnal rights from his mother and ruled as emperor; Matilda governed as regent during his minority. Succeeding generations of Habsburg women continued to be important to imperial power throughout Europe. King Albrecht I married Elisabeth of Carinthia (d. 1312) who, as a descendant of Emperor Henry IV and niece of the Dukes of Bavaria, had a more impressive lineage than that of her husband. In what soon became a familiar pattern, their twelve children married far and wide. Their daughter Agnes (d. 1364), married the last Árpád king of Hungary, and their son Frederick the Fair succeeded and married Isabel of Aragon (d. 1330), continuing a strategic linkage with the Crown of Aragon.

A kingdom in early medieval Hungary had begun to take shape in the late ninth century as the Hungarian tribal alliance moved into the Carpathian basin. By the late-tenth century, royal power was established: Christian missionaries had brought the territory into the Latin Christian world with a significant number of Byzantine converts in the east. In the eleventh century, it was a regnal community, structurally part of the Latin Christendom and an important force in medieval Europe. Like their Habsburg counterparts, medieval Hungarian kings very skillfully and frequently used marriage outside their realm to extend their political reach. They often sought alliances across Europe: in the Byzantine Empire, Maria Komnene (d. 1190) and Stephen IV and Maria Laskarina (d. 1270) and Béla IV; in the Crusader kingdoms, Agnes of Antioch (d. 1184) and Béla III; in the Crown of Aragon, Constance of Aragon (d. 1222) and Emeric; in Angevin Sicily, Elizabeth of Anjou (d. 1303) and Ladislaus IV; and, in Poland, Fenenna of Kuyavia (d. 1295) and Andrew III. These marriages forged diplomatic, political, economic and cultural ties across Europe that bore fruit in the rich, cosmopolitan culture of the later Middle Ages.[90]

Many of these queens have received little scholarly attention because only fragments of their lives have been found, mostly in genealogies or hagiographies. But, as Charlotte Newman Goldy and Amy Livingstone note, a fragment of a life is a window on an ordinary, or sometimes extraordinary moment.[91] Locating and piecing together fragments of the lives of queens of realms such as Hungary and Bohemia was complicated until the late 1980s, when scholars from the Soviet bloc countries were able to travel more freely to conferences, and colleagues from western

countries began to work in archives in Budapest and Prague. But scholars are fortunate that many Hungarian and Bohemian queens left a paper trail to follow in the form of letters. For instance, much of what we know of Constance of Hungary (d. 1240) beyond the outline of her married life comes from her letters. The daughter of Béla III, king of Hungary, she married Premysl Otakar, king of Bohemia, in 1199 (she was his second wife) and they had nine children, including Wenceslas I, Otakar's successor. Constance came from a saintly family – Gertrude, the wife of her brother Andrew II, was a sister of St. Hedwig, and they were the parents of St. Elizabeth. But we get glimpses of her personality in the letters she wrote to religious officials and received from her husband, her son Wenceslas, and Pope Gregory IX. These fragments of a life show her to be a generous donor of land to convents and monasteries.[92] Constance is best-known to modern scholars as the mother of the nun Agnes of Prague, a follower of Clare of Assisi, whose letters to Clare are important documents in Clarissan history.[93]

Increasingly attentive to laws of consanguinity, and the difficulty a king experienced in trying to annul a marriage after the early thirteenth century – as Philip II of France discovered when he tried to set aside Ingeborg of Denmark – prompted monarchs to look far afield in their search for brides. In this exchange, princesses functioned as conduits of culture as families bestowed lavish gifts on one another and merchants found new markets for their goods. Perhaps the most long-lived alliances involving the kingdom of Hungary were forged outside of central Europe; those with the Crown of Aragon were particularly important.[94] The alliance began with the marriage of Constance of Aragon (d. 1222), daughter of Alfonso II and Sancha of Castile, to King Emeric of Hungary in 1198. They were married a brief six years (he died in battle), but her brother found that the diplomatic and commercial ties with central Europe were highly beneficial and arranged for her to marry Frederick II, King of Sicily, in 1209. Constance, too, profited from the exchange. In 1212, Frederick was elected emperor and she became queen-consort of Germany and Sicily and Holy Roman Empress, going on to rule Sicily as regent for her husband between 1212 and 1220. Returning the favor, King Andrew II sent his daughter Yolande to Barcelona in 1235 to marry Constance's nephew, King Jaume I of the Crown of Aragon, where she was called Violant and was her husband's close advisor. It is unclear whether their close ruling partnership is attributable to personality or political culture – whether it was her Hungarian upbringing, or his Aragonese matter-of-fact ease at governing with an assertive, intelligent woman; whichever, it is a subject worthy of closer

scrutiny. Of their ten children, two were queens: Violant married Alfonso X of Castile, and Isabel married Philip III of France. Hungarian-Aragonese marriages continued into the fifteenth century with the marriage of Beatriz of Naples and Mattias Corvinus, and in the sixteenth century with Mary of Habsburg and Louis II of Hungary and Bohemia – in both cases bringing the culture of the renaissance humanism in music, literature and the visual arts from Italy and the Mediterranean to the northern courts.

Scandinavia until the mid-fourteenth century remains a subject in need of considerably more study.[95] The saga literature and runic inscriptions, so problematic in earlier centuries, are supplemented by equally biased accounts of queens as agents of Christian conversion. While official narrative sources still do not reveal much about many Scandinavian queens of the late Middle Ages, literary sources are tricky to use when studying queens but can be very revealing. William Layher's work on voice and the use of language in these texts points to a potentially very fruitful methodology. He argues that scholars need to use literary sources less for nuggets of actual events and, instead, read them imaginatively, seeking nuances of phrasing and syntax to glean the language of command and power. For example, the widowed Agnes of Denmark (d. 1304) projected her angry and sorrowful voice in response to the murder of her husband via a poet into the legal and political discourse in Middle Low German. Euphemia of Norway (d. 1312), was the patron of poets translating French romances into Old Swedish to build allegiances and bolster her daughter's claim to the throne despite her marriage to a Swedish baron.[96]

Conclusions

This movement of queens consort across borders in 'the link of conjugal troth' complicates historians' study of medieval Europe, which divides space into kingdoms and chronologies into timelines of a king's life. The lives of all queens were complex admixtures of natal and marital families, but only a queen-regnant such as Urraca from León-Castile could honestly claim that her primary loyalty was to her natal family. For queens consort, their loyalties were to more than a single realm, so it is untenable to detach Eleanor of Aquitaine from France or England, the Empress Matilda from Germany or England, or Blanche from Castile or France. All queens – regnant, or consort, or dowager – were integral to political events and queenship in both theory and practice; it is therefore

impossible to detach them entirely from the political history of kings and their marital family. The lives of queens and kings intersected in every way and formed a familial, linguistic, cultural, religious and economic network of power that was simultaneously the product of several political cultures. This multiple crisscrossing provided a queen-consort with a wide variety of ways to express herself as queen and, for many queens, it provided a truly international platform for their actions. Looking at the wider families of queens and kings reveals the full dimensions of queenship, with a scope and range extending beyond just one woman's actions in a single realm. It encompasses two families and the networks of power and influence that link them.

Queens of England, France, the Iberian kingdoms and Latin Jerusalem dominate the literature of this period. Many English queens, whether Anglo-Norman or Plantagenet, worked alongside their husbands and fathers to build what some scholars call an 'empire', a political entity that encompassed lands in England, France and Ireland, and, at times, Scotland. Capetian French queens-consort and queens-regent were key partners with kings who pushed up against their English counterparts in a struggle for dominance through land and lordship. Iberian queens literally held down the fort, or castle, while their husbands and fathers fought Muslim caliphs and kings along a dangerous frontier. They devised a novel institution, the queen-lieutenant, as away to solve their pressing need to govern newly-conquered realms. Queens of Jerusalem, at the front lines of a frontier with the powerful Muslim caliphate and Seljuk Turks, literally had to make it up as they went along to be able to hold together the fragile realms they inherited. In all but two cases – the Empress Matilda and Queen Urraca of León-Castile – these queens were sometimes official regents, but their work was much more than governance. As mothers, they were of key importance to dynastic monarchy, and they fiercely protected their children and their legacy.

Queens had the means to memorialize that legacy and work actively as mediators and intercessors because they had money at their disposal that their predecessors had not enjoyed. The queen's fiscal account – separate from the royal accounts, run by the queen, with expenditures entirely at her discretion – was a genuine innovation with wide implications. Kristen Geaman considers this account as a formal form of power, and, as intercession was recognized by the queen's fiscal account, suggests that queenly power did not diminish as bureaucratic kingship grew.[97] On the contrary, it provided an official venue for queens to do what mattered to them. Royal officials did not put the queen out of work

but were, instead, put to work for her. The powers of queenship changed more than they disappeared. Queens used this wealth to sponsor writers, artists and architects who memorialized the royal family in their chronicles, prayer books and royal mausoleums. No matter how limited a queen's options in her life, she did have considerable control over how she wanted to be remembered, making her tomb or other memorial a poignant expression of her personality.[98] Although queens in this period were less likely than queens from earlier centuries to be saints or chaste, they were no less pious. They actively used their wealth, either inherited or as part of the household or queen's account, to support old and new religious orders – most notably the Cistercians, Franciscans and Dominicans – and maintained strong connections with bishops, popes, monks and nuns.

As a princess or noblewoman moved from the family of her birth to her husband's family, some things did remain the same. Between 1100 and 1350, legitimate marriage became the norm, coronations legitimized the queen as wife, and she legitimized and continued the dynasty by bearing children. The reforms of the eleventh century gave the Church a monopoly on legal matters concerning the validity of marriage, and divorce per se was extremely difficult to obtain. But kings found ways to get out of a marriage they found infertile, politically unwise, or merely inconvenient because the rules on consanguinity provided ample legal ambiguity to be almost impossible to check. Kings like John of England and Philip II Augustus of France, or their advisors, were happy to confect a genealogy or dig deeply into the royal treasury to pay for dispensations. Childless queens-consort such as Emperor Frederick I's first wife, Adelheid of Vohburg, noblewomen who quickly marry again, slip in and out of the official records, posing problems for scholars to say more than a few words about them. But the question is not simply about the nuts and bolts of her life, at present we know very little about the medical history of queens and causes of childlessness.

The Mediterranean islands of Sicily, Naples and Cyprus maintained the tradition of monarchy after the Norman conquests, but queens all but disappeared in Italy as the north shifted from imperial control around 1200 and gradually developed city-states, or, in the case of Venice, a city-republic. Similarly, native Irish queens disappeared after the Plantagenet conquest in 1171, and the fortunes of Scottish queens paralleled those of the kings in an up-and-down movement that would finally stabilize in the mid-fourteenth century. As for the queen-regnant, after Urraca of León-Castile and Berenguela of Castile in the twelfth century, it would be centuries before another queen-regnant would

appear in any of the realms of Iberia. But the reigns and work of these early Iberian and Portuguese queens resonated across the centuries, and their lessons were not lost on Isabel of Castile in the fifteenth century as she struggled to balance her reign with the demands of natal family, her marriage and her religion.

For further research

History is, of course, the product of its sources. Medieval governments in this period began regularly to generate their own documentation and then save it in some organized fashion in a permanent location. The sources in all genres for queenship are much fuller and richer after 1100, due in part to the better survival of documents and to the creation of royal chanceries that document the lives and deeds of queens and their families. Narrative sources are abundant for all realms, particularly chronicles and official royal records. The number of documents written for, by, or about queens is clear evidence of the increasing importance of queens as central to the institution of monarchy. Some sources are, naturally, more useful for queens than others. Chronicles often reveal more than details than older generations of political historians considered important.[99] Useful as narrative sources are, they have limitations for the study of queens who may not have been the subject of the annal, chronicle, treatise, or letter. William Layher's work on Scandinavian texts and his suggestion to read imaginatively to discern a queens' voice offer useful methods for reading all sources.

When official royal words fail us, unofficial written sources can help. Letters, inventories and wills can reveal more about a queen than the simple record of her family background, marriage and annulment; they are mirrors of a woman's personality. Ducal or comital accounts for queens who personally managed their inherited estates are valuable resources for a queen's work outside the royal court; for example, Eleanor of Aquitaine. Letters to and from queens can be found, but are more plentiful after 1300, and translated editions such as those in *Epistolae* and Anne Crawford's collection of letters of English queens are valuable resources.[100]

With the increased emphasis on lineage and legitimacy in the later Middle Ages, genealogical tables are vital sources, but they must be used with care. The medieval creators of genealogies may have fictionalized the origins of a family, and those included in modern works tend to emphasize the men in the family to the neglect of women. Genealogies

are more likely to record more carefully the children who lived to adulthood, but all too often many women (and their less-stellar brothers and sons) are omitted, leaving us with an incomplete picture of the complex family dynamics of medieval monarchy. The many dynastic marriages across borders that crisscross Europe make it necessary to consult more than one genealogy to obtain the full picture of a queen's family.

Anyone seeking a complete genealogy or maternal history of a queen, however, will need to scour the chronicle sources for evidence of miscarriages, stillbirths and children who died in infancy. It is not at all clear how many queens were childless, or even had difficulty conceiving, because so little work has been done on childlessness. Much more work is needed on reconstructing the entire genealogy of a royal family to better understand the causes of childlessness. When a queen did not have children, was it a miscarriage or early infant death? Was it illness or infertility? In what promises to be a fruitful scholarly exchange, historians of medicine have begun to study chronicles, letters and medical reports to determine medieval medical knowledge of fertility, impotency and sexual health. One of the best studies of the maternal history of a queen was written by a historian of medicine, Michael McVaugh, on Blanca of Anjou, wife of Jaume II of the Crown of Aragon, who died in 1310 after giving birth to her tenth child.[101] We know that childlessness was devastating for a queen, and that childless queens and empresses often visited local shrines to pray to the saint for divine assistance in getting pregnant. They no doubt spent time at convents and abbeys, whose records may contain details of their stay and any donations or gifts they made. It is also worth paying attention to sisters, nieces and cousins who may have benefited from the queen's largesse as a dowry, either for marriage or entrance into a convent, or other gifts.

A king and queens' dynastic claims are expressively realized not only in the chronicles that record the marriages, coronations and births of children, but also, and especially vividly, in art, architecture, heraldry and literature. As coronation became more the norm in most realms, chroniclers recorded the oaths and the ceremony. Complementing printed sources on the coronation, typified by the *Ordines Coronationis Franciae* and *English Coronation Records*, are documents from cities such as London and Paris that document royal processions, coronations and celebrations.[102] The literature of this period – troubadour poetry, chivalric romances, epics – is rich in material on queens. This literature, with its emphasis on courtly love and the adulterous queen, is a rich resource for secular elite male attitudes toward women. Fictional works by Chrétien de Troyes, Marie de France, and Thomas Malory complement didactic

works such as political treatises, for example the *Policraticus* by John of Salisbury, which reflect the political ideal rather than the actual practice of queenship, but they are vital sources for the attitudes that shaped monarchy in theory.[103]

Art historians have had a heyday with queens in this period of medieval history. The extant art and architecture of the period, which spans the Romanesque and Gothic styles, is a gold mine for visual representations of queens, but it is just a fraction of what is available in other media.[104] Material culture in the form of chancery seals, clothing, furniture, jewelry, crowns, books, tapestries and personal items have, in some cases, been inventoried.[105] Queens were significant patrons of art and recipients of art objects as gifts, both secular and religious, leaving behind prayer books, books of hours, illuminated Bibles, reliquaries, portable altarpieces and rosaries.[106] The royal mausoleums and necropolises they commissioned, such as those at Westminster (England),[107] Burgos and Poblet (Iberia) and St. Denis (France), are striking visual depictions of lineage, dynasty and royal memory whose architectural styles highlight the international cultural milieu that queens inhabited. Their wills and postmortem inventories of their possessions reveal their taste, their affectionate relationships and their concern for religious institutions and the poor.

As art historians ponder queens in the creation and spread of an international style, it is important to consider how queens were part of an international monarchy. As women traveled across borders, what happened to regional ideas on women and power, and laws on dynastic succession? For example, it would be useful to know more about how other realms regarded the French Salic Law or the Aragonese queen-lieutenant. Were other monarchs and their advisors aware of these developments, and, if so, did they affect local traditions and laws? The strategic marriage patterns of European realms need to be studied more carefully as part of a wider examination of European-wide networks of political, cultural, economic, religious and cultural influence. The exchange of philosophical and political ideas on queenship raises fascinating questions of political theory – a topic that has just begun to be explored, but which is important to filling out the picture of monarchy in the Middle Ages.

Royal household accounts shed light on the workings of the family at court, especially for evidence of a queen's patronage and intercessory acts of piety and charity. This field of study intersects with economic history, creating exciting new areas for research. John Carmi Parsons's work on the household accounts of Eleanor of Castile, Jana Bianchini's on

Castilian queens, Ana Rodrigues's and Manuela Santos Silva's on Portuguese queens and Kristen Geaman's on Eleanor of Aquitaine are just the tip of what could be a massive documental iceberg that may well shift the focus of research and recalibrate our understanding of queens, gender, influence and power.

4

Queenship in a Crisis of Monarchy, c. 1350–1500

In 1440, *infanta* (princess) Blanca of Navarre left her home in the Pyrenees to marry *infante* (prince) Enrique of Castile, the heir to the throne who would reign as Enrique IV from 1454 to 1474. When she reached Briviesca, a town in the north of Spain, she was greeted with elaborate festivities. The royal chronicler described how the town 'prepared the greatest festivities and of the most novel and strange fashion that have been seen in Spain in our time'. He recounted in detail the *infanta*'s solemn entry into town, the lavish fashions of the ladies and processions of the guilds and confraternities, and four days of sumptuous feasts under a background of scarlet tapestries, dancing, mummers, the running of the bulls, the plumed headgear of the soldiers at staged jousts and contests, distribution of alms and a hunt for bears, boars and deer. The chronicler was careful to note that Jews carrying the Torah and Muslims carrying the Qur'an were in the procession, 'in that manner that is the custom to be made for kings of Castile when they come to rule from foreign parts'. This was, no doubt, repeated in town after town as Blanca made her way to her wedding in Valladolid. This royal progress through the countryside was a powerful visible representation of monarchy, replete with pomp and largesse as symbols of the power of queenship and kingship to their Christian, Jewish and Muslim subjects.[1]

Blanca did not govern in any capacity, even though she, her brother and her sister were proclaimed the rightful heirs of the kingdom of Navarre, rights they inherited from their mother not their father, the

king of the Crown of Aragon.[2] Like most queens, her marriage was a diplomatic one, negotiated as part of the peace treaty between Navarre and Castile in 1436. Blanca of Navarre and Enrique IV of Castile had no children, either because he could not or would not consummate the marriage. He claimed that her witchcraft was the cause, had the marriage annulled in 1453, and married Juana of Portugal. When Blanca returned to her family in Navarre, she was kept in the custody of her family and lived quietly until 1461, when her brother died. A group of nobles sought to have her crowned queen in her own right, but her father, King Juan II of the Crown of Aragon, had her confined and kept the kingdom of Navarre under his control. Some suspected that her death in 1464 was due to poison.

Blanca was not an exceptional queen; neither is she is well-known. She left only a trace of an imprint on literature, visual art, or music. But her life opens a window onto some distinctive features of late medieval queenship. First, it is clear that, after centuries of religious, legal and political changes, Europe had become a largely Christian, monogamous society ruled by kings, with queens being an essential part of monarchy. The Jews and Muslims in the procession were no doubt compelled to take part. As subjects of the king and queen, they were protected minorities and had been part of a well-established custom for greeting foreign royalty. There is no hint of the religious tension or persecution that led to their expulsion fifty-two years later. There is no mention in the chronicle of new expressions of lay piety or the religious reform, and no hint that the Church in Rome was on the mend from papal schism that lasted from 1378 until 1417 as popes and anti-popes claimed authority while kings and emperors took sides. Like many late medieval queens, Blanca was pious, and it is unclear whether her chaste marriage was her choice, but she was no sainted queen like Jadwiga, Queen-regnant of Poland (d. 1399), who married a pagan and actively worked to convert her subjects; or Isabel of Aragon, Queen of Portugal (d. 1336), great-niece of St. Elizabeth of Hungary (d. 1231) who was a strong supporter of the Franciscans and Poor Clares.

The 'novel and strange' element of the celebrations in Briviesca, Teofilo Ruiz suggests, had to do with how the festivities highlighted gender differences. The chronicler takes pains to point out use of scarlet in the backdrop for Blanca's party, which anthropologists argue is associated with the female gender, instead of gold, the color of kings. In Castile and Navarre, women could rule in their own right so, when Blanca traveled through Castile, she was treated with the dignity of a queen. Royal wedding festivities such as this show how royal marriages served – or, at

least, attempted to serve – to bind together their various subjects who could, at least for a short while, put aside differences and sit down together to celebrate. A procession and celebration such as this cemented ties between regional lords in a time of political tension. Late medieval queens were much more visible, and not just in public processions. To both to their contemporaries and to modern eyes, we can literally see queens as portraiture came closer to depicting a queen as an individual woman, not simply an iconic image of an ideal queen. The increasing reality of female portraits parallels that found in male portraits, bringing queens and kings to life, began in the early- to the mid-fourteenth century. The quest for a portrait likeness developed in Italy with preplague artists like Giotto and Simone Martini and, coincide with Dante's literary portraits, followed shortly thereafter by artists working in the Paris basin, the Netherlands and London. The appearance of a portrait-likeness in France was in full bloom under King Charles V and his brothers the dukes (and the duchesses) in Berry, Bourges and Dijon.[3] Royal portraits appear in all media – painted portraits, painted altar cloths, carved stone funerary effigies, manuscripts and portal statues.[4] Queens appear in donor portraits, especially in Books of Hours, and shape the iconography of women. For example, the manuscript illuminations of the *Grandes Chroniques de France*, the fifteenth-century chronicle history of France, present lavish paintings of kings and queens, and the variety of the facial features hints at this attempt at verisimilitude.[5] But the intention was to glorify monarchy rather than show kings and queens warts and all. Because the queens were often foreign-born, their influence in shaping the iconography of women fostered international styles of art. Works created in France only a few decades after the *Grandes Chroniques de France* show the emergence of a blending of styles from the Italian renaissance to northern European Gothic styles.[6] By 1500, there is a reasonable expectation that the image of Queen Isabel of Castile and her daughter, Catherine of Aragon, actually resembled them.

This description makes it clear that, by the later Middle Ages, queens are intricately connected to monarchy; what is not so readily apparent, because Blanca was not yet queen, was that queenship had become a recognizable office that had a firmer institutional foundation than previously. This was true in all realms of Europe. The queen-consort had long since been elevated to a position that encompassed more that just the king's wife and mother of the heir, a model of piety and mediator or intercessor on behalf of those seeking her favor in royal justice. In most realms, a late medieval queen-consort had a fiscal account separate from the king's and a staff, sometimes of her choosing but often supervised by

her, to manage expenses in their households and pay for their patronage of court officials, the Church, and artists, writers and musicians. Increasing delegation of royal authority to a professional bureaucracy limited a queen's direct role to some degree, but a king also delegated official political authority, sometimes substantial and for lengthy periods, to the queen to govern in his stead when he was away or too ill to govern. Regencies and lieutenancies were more clearly defined and, although this could work to exclude queens, as it did for Margaret of Anjou in fifteenth-century England, it could empower them, as it did for queens-lieutenant in the Crown of Aragon.

Queens were affected in a variety of ways by the social and economic upheavals of the late Middle Ages – plague, prolonged warfare, economic volatility, persecution of Jews, new religious orders, papal schism, growing power of nobles and urban elites, the development of parliamentary assemblies. Royal families suffered personally as loved ones died in a series of outbreaks of bubonic plague that began in 1347. Within six months, King Pere IV of Aragon lost his wife, Leonor of Portugal, and his daughter and a niece, and Jeanne II of Navarre, daughter of King Louis X, died of the plague. English King Edward III's daughter Joan was struck down by the plague in Bordeaux when she was on her way to marry King Pedro of Castile. Alfonso XI of Castile died of the plague at the Siege of Gibraltar.

The devastation of the Black Death left in its wake more than just population decline. Wage and price instability most likely affected their household accounts, as tax revenues and their own rents and incomes must have declined. The economy rebounded by 1400 in many parts of Europe, so that the entire four-day celebration for Blanca of Navarre in 1440 in Briviesca was paid for by the townspeople and their lord, in this case the Count of Haro. The elaborate planning and costs are clear indications of a more literate, wealthier, more cosmopolitan society that was linked to the corners of Europe, Asia and northern Africa by trade and diplomacy. Unpopular tax measures led to urban unrest – particularly in England, France, Castile and the Crown of Aragon, brought crowds into the streets to protest royal policy, and roused a nascent middling rank of subjects to demand representation in parliamentary assemblies. This social change was one clear sign that the changing times left a mark on queenship. In fifteenth-century England, the expansion of a prosperous middling rank with lands and ambitions propelled one gentry family, the Woodvilles, into the royal circle with the marriage of Elizabeth Woodville to King Edward IV.

Nevertheless, some of what affected their subjects so dramatically

seemed to have had little effect on the practice of queenship. No matter what dowry they brought to the marriage, queens in the later Middle Ages were relatively wealthier than their predecessors because, in most realms, their household accounts had been regularized so that the dowager queen's estates and incomes were passed to the next queen, much like the realms of the king are passed from king to king. They continued to use this wealth to promote the dynasty from marriage to death, as weddings, coronation, births, baptisms and betrothals became increasingly public ceremonials. The queen's coronation, in increasingly elaborate ceremonies that lasted days, was a significant marker of the maturity of a monarchy and the queen's role in establishing dynastic legitimacy.[7]

Queens, no matter how involved they were in the public political governance of their realms, felt acutely the impact of what political historians have termed a 'crisis of monarchies'. This crisis was sparked by any number of issues – authoritarian policies, taxation, noble feuding, regional dynastic warfare, mental illness, economic instability, and it took various forms – civil war, urban unrest, peasant rebellions, *coups d'état*, regicide. But no matter why or how a crisis unfolded, and no matter how much or how little a queen was involved in the governance of the realm, she was at the center of events. Royal families were entrusted with governing, and so both king and queen were affected by events. The office of queenship changed in response to changing conditions alongside kingship and adjusted to each realm's subtle but distinct social, political and cultural differences. Most, but not all, queens occupied a subordinate role in the monarchy, either as an unofficial advisor or as an official regent or lieutenant; by no means entirely shut out of power, but not inheriting and ruling with the same force and duration as they had before. Some realms, such as Castile and France, were comfortable with queens as regents; in England, the controversial four-year regency (from 1326–30) of Isabelle for Edward III prompted kings and their noble advisors to devise an alternative: the Protector. At the very least, queens had custody or guardianship of their children with responsibilities for tutelage and education.

As had their predecessors, late medieval queens played their part in the work of the monarchy by legitimizing the dynasty through marriage and children, tutelage of the heir and his siblings to take their place in another royal family, governing in the absence of their husband or in the event of his death before their son reached adulthood and memorializing the dynasty. Her status was rarely at risk unless she failed to produce a male heir. Generations of kings had grown accustomed to having an ample brood of healthy princes succeed them, and thought they had

worked out the legal apparatus for ensuring continuity of the inheritance. In the fourteenth century, however, almost every king and queen in Europe faced the fear of failing to produce a legitimate male heir. Blanca of Navarre and Enrique IV of Castile were hardly alone. Each realm tried to avoid what is euphemistically called 'dynastic failure' and the potentially violent transfer of power. The failure to do so is acutely evident in the Hundred Years' War, an intermittent series of crises and conflicts, principally between England and France, which eventually involved almost every realm in Europe from 1337 until 1453. Dynastic tensions dated back to the marriage of Henry II of England and Eleanor of Aquitaine in 1152 and worsened in 1259, when Louis IX made the English King Henry III his vassal. The immediate pretext for war, however, was a dynastic crisis in France following the death, in 1328, of Charles IV, the last Capetian king. The succession of the French crown to Philip of Valois, the dead king's cousin, provoked an outcry from his nephew, the English king, Edward III, who claimed a right to rule transmitted by his mother, Isabelle, the daughter of Philip IV. The war was the defining political condition for the later Middle Ages, with widely violent repercussions that led to or exacerbated internal civil conflicts in individual realms.

The Hundred Years' War was fought largely in France but involved just about every European realm and took a terrible toll that did not spare royal families. But violence was not limited to pitched battle. In England, there were periods of political instability between 1370 and 1410, and intermittently from the 1450s to the 1480s. This instability can be linked, in part, to the personal failings of royal rulers, but can also be attributed to the demands and expectations of a complex and sophisticated political society and administrative machinery. France, which had only really taken shape in the early thirteenth century, was still in some parts an amalgam of provinces that exposed fissures that would burst open violently in the fifteenth century. The union of Scandinavian realms fundamentally altered royal traditions in Norway, Sweden and Denmark that would lead to conflicts. Spain and Bohemia, too, experienced dynastic crises and unprecedented levels of internal warfare stemming from disputes over the rights and responsibilities of those monarchies. As kings and emperors struggled to rule the unruly, they had to contend with a general ideological crisis of monarchy brought on by the empowerment of the middling ranks represented in the parliamentary assemblies.

In some cases, however, protracted and bitter dynastic wars were fought; not because there were no sons, but because those sons had

ambitious siblings. In Castile, the legitimate children of María of Portugal (d. 1357), the wife of Alfonso XI, and his illegitimate children with his mistress Leonor de Guzmán, led to competing dynastic claims and a protracted civil war.[8] In 1369, Enrique, Alfonso's illegitimate son, fought and then murdered Pedro, his half-brother: an act that brought Enrique and his Trastámara family to the throne. Civil war might also break out were a king considered weak. In England, Richard II was deposed in 1399 because he was considered ineffective and authoritarian, and the fact that he had no son did not help matters. His usurper, his cousin Henry IV, ushered in another succession crisis in the fifteenth century that led to the Wars of the Roses – localized warfare between the Dukes of Lancaster and York. In Portugal in 1385, the Avis family came to power when the heir, Beatriz, and her husband, King Juan I of Castile, were defeated in battle.[9] In two notable instances, a succession dispute was settled peacefully. Nobles and bishops in the Crown of Aragon spent two years, from 1410 to 1412, negotiating a legal agreement to award the Crown to a Castilian prince, Fernando of Antequera, whose grandson married Isabel of Castile and united the realms. But Isabel had to fight a civil war to defend her claim to rule when her brother died. Scandinavia managed to weather a succession crisis without pitched battle, and it did so through the diplomatic talents of Queen Margaret I.

No matter what the root causes of these conflicts or where they were fought, queens were central figures. The Trastámara queens of Castile and the Crown of Aragon in the later fourteenth and fifteenth centuries were active in governance during bursts of violence and conflicts, and were of key importance to bringing peace to warring brothers and cousins. Queens faced the brutal reality of this when their husbands or sons died young, or when illness – either physical or mental – debilitated their husbands or sons. In fulfillment of an expectation of queenship to protect their family interests, they stepped in to govern. When they did so, they often faced hostile opposition from nobles, whose misogyny was more strident and more legally enshrined in laws that privileged men as heirs and rulers. This is clearly the case in both fifteenth-century France and England when Queen Isabeau of Bavaria, wife of Charles VI, and Queen Margaret of Anjou, wife of Henry VI, valiantly strove to maintain royal equilibrium and govern for their mentally ill husbands amid hostile allegations of adultery and civil war.[10] But such reactions were not the rule. In the Crown of Aragon, the office of the queen-lieutenant continued with the tactical support of the elites, and was crucial to the development of the Crown as an economic and political powerhouse in the Mediterranean.

The Hundred Years' War did have unintended positive consequences: it led to marital alliances between Spain and England. John of Gaunt's daughter Philippa (1359–1415) married King João I of Portugal, and another daughter, Catalina (1372–1418), married King Enrique III of Castile. These marriages fostered not only a political exchange, but also a cultural one, as Philippa and Catalina sponsored translations of English texts, such as John Gower's *Confessio Amantis*, and promoted a rich and lively artistic exchange.[11] In terms of political theory, the war had a lasting impact for queens. The death of the last Capetian without male heirs set in motion the Hundred Years' War, prompting the Valois kings to legitimize their accession by amending the early medieval Salic Law to deny queens the right to rule or to transmit the rights to rule. They did so by inserting a clause from the chapter *'De allodio'* ('Concerning landholding'), which stipulated that men should receive ancestors' heritage (the *terra salica*, their landed property) and women only personal property. To make this statement apply to the French kingdom as a whole, in around 1413 a royal secretary inserted the words *in regno* (in the kingdom) into an inaccurate transcription of the clause.[12] However, some realms, such as Castile, were open to a queen-regnant. Portugal and Navarre both had queens-regnant but, in the case of Beatriz of Portugal, it was a role in name only. In Navarre, Blanca (r. 1425–41) was overshadowed by her husband, Juan of Aragon (later Juan II of the Crown of Aragon), who ruled with her. Catalina of Foix (r. 1483–1517) inherited the kingdom of Navarre when she was fifteen but her claim was contested by her uncle, Jean, who unsuccessfully tried to apply the Salic Law. Catalina's mother ruled as regent until 1494, when she was taken hostage by King Fernando of Aragon, and the rest of her reign was dominated by both Spanish and French interference. Four noteworthy queens broke this trend.

It is significant that many queens-regnant were from Mediterranean island kingdoms distant from the French/English model of masculine kingship as the norm. These queens ruled for short periods of time and often in moments of crisis. Giovanna I of Naples, countess of Provence, queen-consort of Majorca and titular queen of Jerusalem and Sicily, inherited her realms from her grandfather in 1343 and reigned alone through four marriages. Childless, she was deposed and murdered in 1382 by a close male relative. Giovanna II of Naples (d. 1435), a childless widow, succeeded her brother, Ladislas in 1415. She remarried but removed her husband in 1419, was crowned in 1421 and adopted King Alfonso V of the Crown of Aragon, who succeeded her and incorporated the kingdom into the Crown where it remained until the sixteenth

century.[13] Maria of Sicily succeeded her father in 1377, was kidnapped by the Aragonese and married in 1391 to Martí the Younger, Prince of the Crown of Aragon. She died childless in 1401 and Martí succeeded her. Charlotte of Cyprus (d. 1487) inherited the kingdom, married Louis of Savoy in 1459: they ruled together until 1461, when she was deposed by her illegitimate half-brother, James. Caterina Cornaro (d. 1510), young widow of James II of Cyprus, came from a family that produced four doges and was legally adopted by the Venetian Republic so that they could claim control of Cyprus. After her infant son died in 1474, the Venetians proclaimed Caterina a monarch, but deposed her in 1489.[14] That even the city-republic of Venice, governed by a doge, an office that was not hereditary and was often held by an elderly man who had no hope of having an heir, toyed with the idea of a ruling queen says much about the centrality of family to monarchy. The dynastic imperative explains, partly, why there were no queens elsewhere in Italy, particularly in the north. The Italian city-state preferred rule by urban oligarchs until the resurgence of Italian nobles in the early renaissance.

Queens-regnant were also important in newly-converted realms in eastern and northern Europe. In two cases, the queen inherited the realm but shared governance. Maria, Queen of Hungary and Poland (r. 1382–95), and Jadwiga, Queen of Poland (r. 1384–99), both ruled with their husbands. Two queens-regnant left an enduring legacy: the Scandinavian realms were unified under a single monarch, Queen Margaret I of Denmark (1353–1412); Isabel of Castile ruled in her own right from the death of her father in 1474 until her death in 1504, with her king-consort, Fernando II, governing his inherited realm of the Crown of Aragon.[15]

Byzantine empresses stood in the shadows behind husbands and sons, but were not without influence or power. After it became apparent that her three sons would not inherit, Yolande-Irene of Montferrat (d. 1317), second wife of Andronikos II (d. 1328), kept a separate court at Thessalonika from 1303 until her death. She treated this court as her own domain, issuing decrees, maintaining diplomatic relations with foreign courts, plotting against her husband (largely unsuccessfully) with Serbs and Catalans. The regency of Anne of Savoy (d. c. 1365), second wife of Andronikos III (d. 1341), on behalf of her son John V, provoked the ire of her husband's advisor, the powerful John Kantakouzenos. In the resultant civil war, Anne hired Turkish mercenaries, nearly bankrupted the treasury and pawned the imperial jewels to Venice. Unable to quell the furor, Anne, like Yolande-Irene, took refuge in Thessalonika and held court there. The last Byzantine emperor, Constantine IX, owed his crown

to his mother, the Serbian princess Helena Dragash. While he was away from Constantinople, Helena successfully protected his claims from usurpation by her younger son, Demetrios, and then served as Constantine's regent until he returned to the imperial city. But, for the most part, Byzantine empresses of the later Middle Ages were occupied principally with matters of family, Church and culture – commissioning the production of manuscripts, founding and restoring convents and protecting their family's interests.

A woman writing about queens: Christine de Pizan and medieval political theory

The prominence of queens ruling in their own right or as regent, together with the anxieties provoked by crises concerning female inheritance and rulership, had generated an impressive body of political theory on queens. Most of it was written by men opposed to rule by women; notably, John of Salisbury, Thomas Aquinas, Brunetto Latini, Giles of Rome and Marsilius of Padua.[16] But, in the early fifteenth century, one entirely original and refreshing female point of view emerges: that of Christine de Pizan.[17] Her work is rooted in the concerns of an age of pessimism, discouragement and despair, and is filled with pleas for justice for widows, the powerless and anyone victim to unscrupulous lords engaged in a civil war that tore France apart. Italian by birth, Christine witnessed much of the excesses and contradictions of the age, from the vantage point of the splendor and violence of the French royal court. Her father was appointed court astrologer to King Charles V of France, and he moved his family to Paris when she was a child. Educated privately, she studied Latin, philosophy and the sciences, and was well-acquainted with both classical literature and the scholarly disputations of the time. She was not trained in law or political theory but, through her father's court appointment, she had access to exceptional libraries. At fifteen, she married Etiene du Castel, a secretary in the French royal court, who supported her education and writing. It was a happy marriage by her own admission ('A sweet thing is marriage/ I can well prove it by my own experience').[18] The death of her father in 1387, followed by that of her young husband in an epidemic in 1390, left her devastated and in need of work to support herself and her three children.

Christine de Pizan wrote from experience, that of a foreign woman, a widow with small children to support, residing at the court of France. It

was at court that she met Queen Isabeau of Bavaria, wife of Charles VI, who had a prominent and controversial role in public affairs during the disastrous later years of her mentally ill husband's reign. In *The Tale of the Rose* (1402), *The Book of the City of Ladies* (1405) and *The Book of the Body Politic* (1407), Christine demonstrates her wide knowledge about the classical tradition of political discourse. She either read John of Salisbury, Thomas Aquinas, Brunetto Latini, Giles of Rome and Marsilius of Padua, or absorbed their ideas from less well-known contemporaries.[19] They wrote primarily of kings and popes but knew full well that queens were part of monarchy. Unlike them, and closer in many ways to Machiavelli a century later, Christine envisions a secular polity where theology governs virtue, but very real humans govern each other. *The Tale of the Rose* was a direct attack on Jean de Meun's popular *Romance of the Rose*, a vernacular work written in the genre of courtly love that took up in detail the philosophical, political and ethical debates of his time. Christine found de Meun's characterization of women as seducers to be misogynistic, vulgar, immoral and slanderous to women. In *The Book of the City of Ladies*, her most well-known work, she has a discussion with three ladies, introduced as Reason, Rectitude and Justice, about the oppression of women, and the misogynistic subject matter and tone used by her contemporary male writers. With Christine as a guide, the women create their own city where only women of virtue may live. This ideal city bore some resemblance to the real cities and courts inhabited by European queens between 1350 and 1500.[20]

Christine's most important work in terms of queenship was the *Treasury of the City of Ladies* (1404 or 1405, also known as *The Book of Three Virtues*). It was written as a guide for Marguerite of Nevers, the Dauphine of France, as she grew up at the French court, and later circulated around European courts. Its popularity stemmed in no small part to the fact that it was addressed to women of all ranks – queens and princesses, noblewomen and all other women. The *Treasury*, a moral treatise written in the genre of a behavior manual, took up conventional aspects of queenship, such as living a discreet and prudent life, taking care in raising children, exercising caution in spending money and staying faithful and in the good graces of one's husband and lord. Its novelty lies in its discussion of how a woman could live an active life no less virtuous than that of a contemplative nun. The pious princess 'who loves Him will demonstrate it by her dutiful labor in her exalted occupation', leading an active life in public rather than one in prayerful seclusion in a cloister.[21] Allegorical and instructive in the genre of the 'mirror of princes', the work complements *The Book of the City of Ladies*, and

exemplifies her understanding of male and female sexes as complementary – an idea that modern feminism regards as essentialist:

> If the neighboring or foreign prince wars for any grievance against her lord, or if her lord wages war against another, the good lady will weigh the odds carefully. She will balance the great ills, infinite cruelties, losses, deaths, and destruction to property and people against the war's outcome, which is usually unpredictable. She will consider whether she can preserve the honor of her lord and prevent the war. [...] The proper role of a good, wise queen or princess is to maintain peace and concord and to avoid wars and their resulting disasters. Women particularly should concern themselves with peace because men by nature are more foolhardy and headstrong, and their overwhelming desire to avenge themselves prevents them from foreseeing the resulting dangers and terrors of war. But woman by nature is more gentle and circumspect.[22]

A queen, Christine argued, was more than just an object in a marriage exchange, and queen's work involved more than charity towards the poor. She could, and should, play an active role in the pursuit of peace, as an intercessor between her husband and his enemies. This point extended the more familiar form of intercession fundamental to queenship where a queen acted as intermediary in matters of law between a subject and the king. Moreover, a queen was obliged to hire and 'listen gladly' to 'fine administrators', and to supervise them carefully.[23] Moving the act of intercession from a feminine form of piety to the more masculine concerns of war imbued queenship with a more volatile political dimension. Christine's work had real relevance to many of the fifteenth-century queens who found themselves poised between armed forces in factional strife in France and England; for example, Isabeau of Bavaria and Margaret of Anjou. When these queens entered into the masculine arena to make peace, they touched a sore spot among kings and their nobles who, during interludes of truce, played at nostalgic feats of arms and itched for real war. Mark Ormrod notes that questions of masculinity surfaced a generation earlier in England during the reign of Richard II.[24] Royal masculinity in England was threatened once more in the fifteenth century when King Henry VI, too, fell to mental illness and his wife, Margaret of Anjou, struggled to maintain peace.[25] Knights and nobles in France – defeated by the English in pitched battle as well as raids that devastated the French countryside, together with the mental illness of Charles VI – no doubt found their masculinity under assault, too.[26]

France

The kingdom of France was one of the most significant political entities in Europe during the later Middle Ages, especially after the end of the Hundred Years' War in 1453. The Valois kings, who gained the throne in 1328 by successfully negotiating the dynastic crisis after the death of the sons of Philip IV, were active in continuing conflicts with the powerful but geographically fragmented duchy of Burgundy, city-states in Italy and the Spanish kingdoms of Castile and the Crown of Aragon. But France remained a complex political amalgam, and a dangerous set of webs of allegiance and loyalty. Friends often became enemies and the royal family tore itself to bits as kings, weakened by war with England, were challenged by their wealthy and powerful brothers, cousins and uncles in a contest for power. Valois queens responded to the devastation of the English troops and the mercenaries in their pay during the Hundred Years' War by focusing their attentions on the less controversial aspects of queenship – maternity, piety, charity, patronage and intercession. The French queen's coronation ceremony reflected this emphasis on a queen as mediator and intercessor. She did not receive clerical robes; neither was she anointed from the Holy Ampoule – when she was anointed with oil it was just in two spots (head and chest), not the nine received by the king. She received a ring, scepter, hand of justice and crown, but not the grand scepter with the fleur-de-lis. The liturgy emphasized an association with Esther and the Virgin Mary, both notable figures of intercession and mediation.[27] The two acts are related, with mediation implying a more active role in the process of making decisions, whereas intercession takes place after a decision has been made or justice rendered, when the queen steps in to plead for mercy or justice. This work of queenship takes on added significance after the amendments to the Salic Law excluded women from ruling, but did not prevent queens from maintaining an active, albeit indirect, role in governance.

French queens were especially busy during the Hundred Years' War when the king was engaged with military campaigns. Both the dowager queen Jeanne d'Évreux, widow of Charles IV, and Blanche of Navarre, the aunt and sister of King Charles of Navarre, helped the French and English avoid pitched battle in 1354. Charles had just allied with Edward III of England who was about to invade France at the start of the Hundred Year's War, and Jeanne and Blanche successfully intervened and asked King Jean II to forgive Charles in return for seizing his properties. Philip IV named Jeanne of Navarre administrator of the realm and tutor of their children should he die before his son came of age. Philip VI's queen,

Jeanne of Burgundy (d. 1348), proved a capable regent, but her competence exceeded her husband's and she was perceived as the driving force behind Philip's rule. For this, Jeanne and her husband were scorned. Her physical deformity, considered by some of her contemporaries to be a mark of evil, led her to be known as *la male royne boiteuse* (the lame evil queen). Charles V gave his wife, Jeanne of Bourbon (d. 1378), precedence over all others as guardian if he died before his son were old enough to rule. Of her eight children, only Charles and Louis survived. When Charles V died in 1380 leaving a minor king, Charles VI (b. 1368), the new king's uncle, Philip of Burgundy, successfully stripped the regency from his brother, Louis of Anjou. Queen Jeanne's family had a history of mental illness and she suffered a breakdown late in her life, after the birth of her seventh child. This history of mental illness continued with her son, Charles VI (d. 1422), whose wife, Isabeau of Bavaria (d. 1435), struggled mightily with the personal and political effects of her husband's physical and mental decline.

Queen Isabeau dominates the scholarship on Valois queenship, and for good reason.[28] Hers is a long and complex story that encapsulates many of the challenges faced by a queen in the midst of a genuine crisis of monarchy. The daughter of Stephen III, Duke of Bavaria, and Taddea Visconti, and a distant relative of St. Elizabeth of Hungary, Isabeau served as regent for her husband during his frequent bouts of illness. For her efforts, she was denounced by generations of historians as a bad wife, bad mother and bad regent. This prevailed until Rachel Gibbons and Tracy Adams took a fresh look and argued that the construction of 'an historical villainess' took place much later and is not supported by contemporary evidence. Cutting through the rumor, misogynist tone and partisan bias in the contemporary accounts that scholars have for generations accepted as reliable, Gibbons and Adams carefully examined extant administrative records and a range of chronicles, and found not only that Isabeau was a devoted wife, good mother and a competent regent, but also that many of her contemporaries regarded her with respect.[29] Isabeau was aged twenty-two and the mother of three children in 1392 when Charles was first struck with a bout of mental illness. She made a quick study of court politics and carefully negotiated her role in a society of feuding men; notably, her brother-in-law, Duke Louis of Orléans, and two Dukes of Burgundy, Philip 'the Bold' (d. 1404) and John 'the Fearless' (d. 1419). As guardian of the throne during a crisis that lasted for decades, Isabeau had to contend with a complex conflict of tremendous magnitude that arose out of Charles VI's mental illness.

Feud was endemic in medieval Europe as a way to resolve disputes, but

this situation was worse because it intimately involved the dukes and all members of the royal family. Because there was no effective system of checks and balances to set things right, King Charles VI had good cause for concern that any one of his brothers would dominate government when he fell ill. In 1402, he assigned Isabeau to arbitrate among his brothers and to preside over the Royal Council when he was incapacitated, with the understanding that on his death his son would be immediately crowned and there would be no regent. This empowered the queen because it positioned her in-between as a mediator, a task much like the regency but without the legal framework. But she was caught in the middle of ugly and violent family disputes, starting in 1405 with the seizure of her son, Louis of Guyenne, by his uncle Jean 'the Fearless', Duke of Burgundy, when the king was ill. She did not take a dominant position but, rather, tried to mediate both sides in order to minimize conflict and not let either side get the upper hand.

Isabeau was probably on Christine de Pizan's mind in 1404 and 1405 when she wrote in *The Book of the City of Ladies* that women could take up the work usually reserved for men when the latter could not, or would not, do so. Arguing that women were by nature peacemakers, Christine articulated a critical role for the mediator queen. In the manuscript painting of a presentation copy of the book, the artist depicts Isabeau surrounded by her ladies and with a small dog at the foot of the bed, signaling her marital fidelity (Illustration 4.1). As a donor portrait, it also captures the personality of the queen, a noted bibliophile who owned dozens of books, including several Books of Hours and over a dozen books of devotion. For Isabeau, books were about both beauty and edification. When she commissioned a Book of Hours for her daughters, she insisted that the artist use the royal French colors (gold and azure) as the dominant colors, and she ordered instructional books for their education.[30] The image captures Isabeau as queen and collector in a moment of luxurious calm, which was hardly the norm at that moment. In the portrayal of Isabeau, she is surrounded by her entourage of ladies and Christine kneels before her, her book in her hands, presenting the queen with the *Book of the City of Ladies*. Adams points out that the depiction is similar to an image in the *Book of the City of Ladies* where Justice, with outstretched hands and carrying a book, welcomes the Virgin Mary and her entourage of saints.[31]

The queen as intercessor in pursuit of peace, set out by Christine de Pizan in *Treasury of the City of Ladies*, had particular importance as civil strife ripped through Paris and threatened the stability of the Crown. Christine takes this idea further in a letter dated 5 October 1405, when

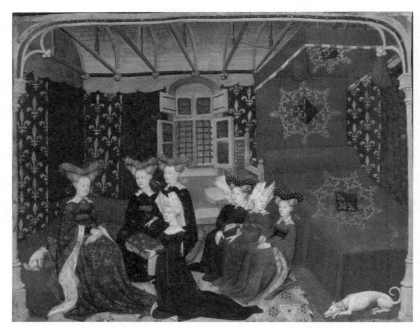

Illustration 4.1 Christine de Pizan, various works (also known as *The Book of the Queen*), London, British Library, Harley MS 4431, folio 3 (c. 1410–c. 1414) © British Library Board.

the queen and her allies were at Melun, assembling an army to march against allies of the Duke of Burgundy. Christine wrote to Isabeau, imploring her not to take up arms but, instead, to pursue peace on behalf of her:

> grieving French supplicants, at present oppressed by affliction and sorrow, who with humble voice drenched in tears cry out to you, their sovereign and esteemed lady, begging mercy for the love of God that humble pity reveal to the kindness of your heart what desolation and misery is theirs, that you may seek and obtain a ready peace between these two worthy princes, cousins by blood and natural friends, but at present moved by a strange fortune to contention with each other. [...] Most excellent and noble lady, may it please you to note and remember three great benefits that would accrue to you through the procurement of this peace. The first pertains to the soul, which would acquire a most excellent

merit if through you such great and shameful effusion of blood were avoided by God's Christian kingdom as well as the confusion that would result if such a wrong were to endure. *Item*, the second benefit, that you would be the instigator of peace and the restorer of the welfare of your noble offspring and of their loyal subjects. The third benefit, which is not to be despised, is that you would be perpetually remembered and praised in the chronicles and records of the noble deeds of France, doubly crowned with the love, gratitude and humble thanks of your loyal subjects.[32]

Christine's eloquent and impassioned argument for intercession in a political matter touches on the three spheres of a queen's life – self, family and subjects. Because she senses that Isabeau might benefit from some historical precedents lest she suffer criticism for her innovative action, Christine then lists queens who have stepped in to make peace – an unnamed Roman princess, Queen Esther, Bathsheba, Alexander's mother Olympias and Louis VIII's wife Queen Blanche of Castile. With piteous examples of the evils of violence, Christine appeals to the queen's emotions, her love of her subjects and her sense of justice and charity. She returns to her argument in the *Treasury of the City of Ladies* that women are natural peacemakers:

Alas, great lady, if pity, charity, clemency, and benignity are not to be found in a great princess, where then can they be expected? As these virtues are a natural part of the feminine condition they should rightfully abound in a noble lady, inasmuch as she receives a greater gift from God, so it is to be expected that a noble princess or a lady should be the means of bringing about a treaty of peace.[33]

Adams argues that this letter was not so much intended as a private missive exclusively for Isabeau but, rather, had a performative function that sought to define and justify the queen's authority to intervene in the conflict. Christine wrote the letter, or at least dated it, after Duke John of Burgundy had made tentative moves to make peace, suggesting that the letter was meant to be read by a wider audience and that Christine wrote it to control public opinion. The French audience needed to be reminded of the precedents for queenly action and put pressure on the dukes.

In any case, calm was shattered as subsequent events spun out of control. Civil war broke out in 1407 when the king's brother, Louis of Orléans, was murdered on a Paris street, in which murder the Duke of

Burgundy was implicated. He was banished from court and two royal factions took shape: the Burgundians against partisans of Orléans, and the Armagnacs. Isabeau had no choice but to step forward and assume the regency for their son, the *dauphin* (prince and heir) Louis of Guyenne. By 1411, Burgundians had seized control of Paris and, in 1415, Louis died and Henry V of England scored a stunning victory at Agincourt. Two years later, in 1417, another son, the Dauphin Jean, died. Both Louis of Guyenne and Jean had been married but neither had a son to succeed, and only one son of Charles and Isabeau now survived, Charles. Rival governments formed, conditions worsened as Charles openly opposed Burgundian rule and sided with the Armagnac faction, which arrested and imprisoned Isabeau, sending a clear signal that they considered her dangerously powerful. In 1419, John of Burgundy was murdered as he knelt in homage before Charles, an act orchestrated by the Armagnac family and probably with the Charles's approval. Isabeau, horrified by the violence, allied herself and her increasingly feeble husband with Duke Philip 'the Good' of Burgundy. But she was cautious, never more so than in the halting negotiations that led to the 1420 Treaty of Troyes that arranged the marriage of her daughter, Catherine, to the English prince. This treaty, Isabeau's most controversial decision as queen-consort, was an extraordinary act that disinherited her son Charles in favor of the English King Henry V as the successor to the realms of England and France, and arranged for Henry's marriage of their daughter Catherine.

It is no surprise that her reputation suffered once Charles VII became king in 1422. The acrid partisan politics created a black legend, but there is no evidence of promiscuity. In the sixteenth century, writers who feared the power of a female regent developed the rumor of her promiscuity as a way to undercut the queen-regent in general.[34] They criticized her political flexibility, citing her alliance with the Duke of Burgundy and the Treaty of Troyes, which later scholars regarded through a lens of national pride. She switched sides when necessary; however, Adams argues that this was not out of weakness but, rather, was a strategy designed to stabilize government made unstable by the king's illness, which made the queen's position unstable, too. She points out that Isabeau was not criticized at the time for switching sides because the situation was fluid and volatile and, at one point or another, nearly all the major lords involved switched allegiance. If we interpret the queen's actions as part of a strategy to restore peace and keep the Valois monarchy intact, then the Treaty of Troyes was not an unspeakable act by a bad mother but a reasonable attempt to resolve a bitter civil war. In short,

modern scholarship has redefined the reign of Isabeau as an active force in politics early in the reign, viewing her as a diligent peacemaker, devoted to her mentally unstable husband, and dedicated to saving the throne for the *dauphin*.

After his estrangement from Isabeau, Charles relied on his mother-in-law, Yolande of Aragon, Duchess of Anjou, following his engagement and marriage to her daughter Marie. Yolande was a formidable power behind the scenes, using an impressive network of alliances and informants. She served as mediator between the king and his counselors, especially in the promotion of Jeanne d'Arc's mission and as the French alliance with the English ultimately gave way to a reassertion of French royal power. The Hundred Years' War wound down after Charles VII was officially recognized as king by Philip of Burgundy at the Treaty of Arras in 1435, the year of Isabeau's death, and the French gained against the English in the war in 1442. As for Queen Marie, aside from her bearing twelve children, little is known of her reign. In 1445, Charles's niece, Margaret of Anjou, married King Henry VI of England, an effort to foster amity between the two realms. However, the French got the upper hand in 1450 when England was distracted by its own civil war and, in 1453, more than one hundred years of war over the royal succession to France finally ended.

The two wives of Louis XI – Margaret of Scotland (d. 1445) and Charlotte of Savoy (d.1483) – suffered his neglect. The marriage of Margaret, the eleven-year-old daughter of James I and Joan Beaufort, to Louis was an effort to use Scotland to counterbalance English power, but she died childless, aged twenty, before Louis was crowned. Queen Charlotte, married at age nine to the 27-year-old Louis, outlived him and bore him three children, one of whom succeeded Louis as King Charles VIII. It is fitting that a king so unfriendly to queens should be followed by a formidable pair of women – his daughter-in-law Anne, Duchess of Brittany (d. 1514), and his eldest daughter, Anne of Beaujeau (Anne of France, d. 1522).[35]

Anne, Duchess of Brittany, almost an empress and twice queen of France, was earmarked as a child for marriage to anyone but a French king. Her family wanted to avoid the duchy's annexation to the French Crown and, when she inherited the duchy after her father's death, she was married by proxy to Emperor Maxmilian of Habsburg. But the French king, Charles VIII, protested, invoked the law that required his permission for her marriage, and proceeded to marry her himself. The marriage, to no one's surprise, did not go well. The marriage produced four living children, none of whom survived early childhood. When her

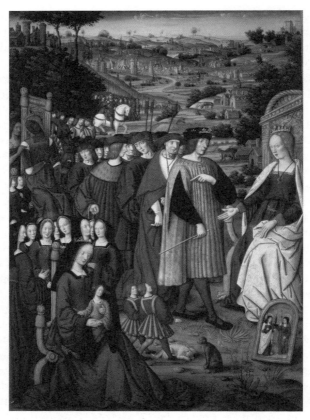

Illustration 4.2 Jean Pichore, '*Des remèdes contre l'une et l'autre fortune. De remedies utriusque fortunae*' (folio 165) by Petrarch (1304–1374), c. 1503, Paris, Bibliotheque Nationale. © Scala/White Images/Art Resource, New York.

husband fought in the wars in Italy, the regency powers were exercised by the king's sister, Anne of Beaujeau, one of the most powerful women of the late fifteenth century. In some ways, she was more queen than the Queen. She was regent during Louis's minority from 1483 until 1491, and had a hand in most of the momentous political events of the age. She supported Henry Tudor against his rival, King Richard III of England, and supplied French troops for Henry's 1485 invasion; she was part of the drafting of the Treaty of Étaples that ended the Hundred Years' War; and, in 1491, she arranged the marriage of her brother Charles to Anne, Duchess of Brittany. When Charles ended the regency in 1491, his sister

felt his wife's wrath as she fiercely protected the interests of Brittany. When Anne, as dowager-queen, married King Louis XII in 1498, she fought to be recognized as sovereign duchess. Louis had nominal control in Brittany, but he formally recognized her rights as duchess and to issue decisions in her name.

Both Anne of Beaujeau and Anne of Brittany were prodigious patrons of the arts. Anne of Beaujeau wrote *Lessons for My Daughter*, an instruction book in the genre of the mirror of princes. Anne is no Christine de Pizan and the work is conventional, with advice for her daughter Suzanne to surround herself with frugal people and that true nobility comes from being humble, benign and courteous.[36] Anne of Brittany inherited the enormous library of her two husbands, was an avid book collector and noted patron of writers. She was depicted in a lavish illustration to the French translation of Petrarch's *Les Remèdes de l'une ou l'autre Fortune* (Illustration 4.2). She is shown in the lower left, holding her young daughter Claude, future queen of France, below the commanding presence of Lady Reason enthroned on the right, with a dour and accusatory King Louis XII advancing toward Reason while indicating his wife Queen Anne. Instead of the expected imagery of women and power, this miniature conveys the anxieties of a king over the lack of a male heir. Anne and Louis had just suffered the death of their three-week-old son. Reason seems to be consoling the king, and the downcast eyes of the queen express both her sorrow at the loss of her son and the sense of failure at her first task as queen to provide a healthy male heir. This image, says Cynthia Brown, encapsulated the tensions and contradictions of late medieval French queenship and the gender dynamics of power at court. Women were central to dynasty, and Anne is glorified, yet the insistence on a male heir placed both the Crown and the queen at risk and subject to the uncertainties of reproductive biology.[37]

England

Almost all queens of England for the preceding four centuries had been French, with the exception of Matilda of Scotland and Eleanor of Castile. Between 1350 and 1500, it became much more common for a king to marry an English woman; one king, Edward IV, married a woman of gentry status. Thanks to the precedent of Eleanor of Castile's astute management of her household, they were also more likely in this period to have more control over their finances than earlier queens of England, and there is evidence that the queen had a council separate from the

king's.[38] These nuances of queenship matter greatly because these were sources of power and influence that were available to the English queens who were embroiled in two violent conflicts: the Hundred Years' War and the Wars of the Roses. Two queens – Margaret of France (d. 1318), second wife of Edward I, and Isabelle of France, wife of Edward II – exercised considerable power and authority as consorts and dowagers for overlapping periods, from the stability and expansion of the realm under Edward I to the fractious and contentious politics of Edward II. Lisa Benz St. John argues that kingship was volatile when the king died, whether a natural death like Edward I's or a violent death like that of his son, but queens were key to smoothing the succession and provided a solid foundation for the accession of Edward III and his queen, Philippa of Hainault (d. 1369).[39]

In 1328, Philippa of Hainault married Edward (d. 1377), son of Edward II and Isabelle of France, as part of a strategy plotted by Isabelle and her lover, Roger Mortimer, to depose Edward II and replace him with her son.[40] Philippa was a highly desirable diplomatic bride because she brought the support of Hainault, an increasingly important principality in Europe independent of France, and consolidated the position of Edward III as king. In addition, the alliance provided military support against the restive Scots and it bound England closer to the Low Countries. Philippa and Edward's first child, Edward, later known as the Black Prince, was born in 1330; he was soon joined by at least eleven siblings: seven brothers and five sisters. The plan worked well for Edward, who benefited from his strong position to succeed his father, but had less happy consequences for his mother. Edward seized power from his mother Isabelle and Mortimer in 1330, and began his own rule as Edward III.

Philippa came into her own as queen and, unlike her mother-in-law, was one of the most beloved English queens of the Middle Ages. Isabelle was an ambitious queen-consort unhappy in her marriage, a shrewd and canny political manipulator and a ruthless queen-regent, interested in public political forms of queenship. Philippa took the opposite tack. She was contentedly married, more focused on motherhood and family, and paid close attention to the intercessory acts of queenship. What they both shared was a concern for the well-being of their children. The fact that Philippa was often her husband's companion and her many pregnancies indicate that their marriage was a happy one. She was with him on campaigns to Scotland and the Low Countries during the early campaigns of the Hundred Years' War, and some of their children were not only conceived, but also born on these trips. She directed her atten-

tion outwards, toward her subjects. They, in turn, responded with outpourings of affection for her public acts of intercession to secure justice. She paid particular attention to poor girls and women, petitioned the pope on behalf of her family and members of her household, and advocated for members of her chapel and household.

Two incidents – the first one real, and the second likely highly exaggerated by contemporary authors – increased her reputation for mercy, charity and intercession. In 1331, she was uninjured when a viewing stand at a tournament at Cheapside in London collapsed, and intervened with the king on behalf of the negligent carpenters. The second, an incident related by the poet and chronicler Jean Froissart, took place in 1347 after the siege of Calais, when Philippa persuaded a recalcitrant Edward to save the lives of six burghers of Calais after he had ordered their execution:

> Then the noble queen of England, who was extremely pregnant, humbled herself and besought his [King Edward's] pity so tenderly that she could not be withstood. The valiant and good woman threw herself on her knees before the king her lord and said, 'Ah, my dear lord, since I passed over the sea in great peril, as you well know, I have asked nothing of you, nor demanded any favor. Now I pray you humbly and ask of you a favor for the son of the blessed Mary and for your love of me, that you show a merciful disposition to these six men'. The king waited for a moment before speaking and looked at the good woman his queen who was so very pregnant and besought him so tenderly on her knees. And he softened his heart, and his anger abated, and when he spoke he said, 'Ah, my lady, I would have much preferred that you be anywhere but here. You have prayed so forcefully that I would dare not refuse the favor which you ask of me'.[41]

Scholars read this story with a substantial grain of salt. It is instructive to modern readers as a reminder to read closely and check the details of a text against known facts, and says a lot about how intercession actually functioned. John Carmi Parsons notes that the dates of her supposed pregnancy do not jibe: Philippa was not yet pregnant, or only barely so, when Calais surrendered. But it is just as important to be attentive to the larger interpretive structures that underpin a text and the author's purposes. Paul Strohm suggests that this scene owes more to the 'history of sentiment' and the trope of an intercessory queen who, with limited objectives, seeks to modify her husband's determined resolve. Unlike Isabeau of Bavaria, who used her authority as wife and mother of the heir

to mediate, Philippa petitions, she seeks redress rather than being able to institute redress on her own. Still, queens often intervened at an opportune moment, when it looked like things could not get worse, which was clearly the case with the burghers of Calais. At that moment, Philippa intervened and recommended a course of action that Edward was likely to take but could not adopt without looking malleable and unmanly.

Intercession, therefore, was about face-saving, and a queen's ritualistic acts – such as signing treaties and employing symbols of justice like the kiss of peace – reinforced the king's power. This had a practical, determinative, serious diplomatic function. In Froissart's telling, Philippa very skillfully used conventional narratives of queenship in the service of royal public relations: the pregnancy that announces her role in dynastic survival, clemency, self-marginalization, sudden movement from outside the events in England to the center of the action in Calais, and her caution not to promote her natal family too much. Her queenly mediation in her plea for the king to change his mind, an unmanly thing for a king to do, was a 'sponsored activity' that served both to correct and admonish. It was accepted by kings as a socially acceptable way to do what they knew they should do but were constrained from by the norms of gender. Philippa saved Edward's reputation as a manly king and preserved the integrity of the English monarchy. Her 'socially constructed prescription for femininity' critiqued male behavior as it celebrated its 'triumphant regality' but, ultimately, the story is not about a queen but about kings.[42] Marc Ormrod considers the depiction of the incident as a way to mitigate the fears of a foreign queen, which dogged the reign of Edward II and Isabelle, and the hostility to a weak king that defeated Edward.[43] The narrative of a conventionally feminine queen interceding with a conventionally masculine king was part of a rhetorical strategy to offset the perceived gender imbalances of the reign of Edward II. Philippa's pregnancy and excessive humility before Edward III were exaggerations and cannot be taken literally, but they reveal much about expectations of a gender balance in which a queen is expected to be a persuasive wife and good counselor, telling her lord how to behave in order to gain approval.

But she was so much more than a series of carefully stage-managed intercessions. Born and raised in the sophisticated Hainault courtly milieu, Philippa brought very strong interests in literature and art with her to England. She knew and sponsored Jean Froissart. She commissioned lavish works of art, illuminated manuscripts and tomb sculpture. She promoted education and was instrumental in the founding of Queen's College, Oxford. She guided the expansion of the hospital of St.

Katharine, near the Tower of London, and the collegiate chapel of St. Stephen, Westminster. Philippa was an unofficially powerful queen who used her extensive network of contacts in Hainault and her proximity with Edward to build a web of alliances. She worked closely with Edward to negotiate marriages for their many children and her contacts helped him identify pro-French rivals. In the early stages of the Hundred Years' War, she was vital to supporters of the French cause by providing a diplomatic channel for envoys from the French king and the pope to Edward's court. But she was poorly endowed with lands and revenues, and was in debt by 1360. She remedied the situation by key appointments to her household and, in 1360, the queen's household was merged with the king's. She died as she lived, with an eye towards her subjects. When she died in 1369, she left behind a series of detailed instructions to protect the welfare of her servants, with provisions to ensure that the king carried out her wishes.

It would have been difficult for anyone to follow so beloved a queen as Philippa of Hainault, and Anne of Bohemia (d. 1394), first wife of Richard II, came to England with several strikes against her.[44] First, the marriage in 1382 was arranged by Pope Urban VI to suit his needs, not England's, and the origins of the marriage lie in the politics of the schism in the Church. A marriage of Richard to Anne, the eldest daughter of the Emperor Charles IV, the most powerful monarch in Europe at the time ruling over about half of Europe's population and territory, could provide Urban the much-needed support of the English, Germans and Italians against the French supporters of the anti-pope, Clement VII. Making matters worse, Anne's almost bankrupt brother, Wenceslaus, King of the Germans and Bohemia, supported the marriage as a way to secure a substantial loan from the English. Anne did not have enthusiastic support among the nobles in England, who complained that she promised to bring a dowry but did not.

She may not have brought a dowry but, as a multilingual imperial princess, Anne brought from Prague to London a trilingual translation (Latin, Czech and German) of the New Testament, which won praise from her new subjects.[45] Richard compounded the problem by his generosity to her family and servants. As was often the case with foreign queens, Anne was isolated at court and her only real supporter was her husband. He had a deep affection for Anne throughout their marriage and, like Edward III and Philippa of Hainault, they regularly traveled together.

Anne did much to endear herself to her subjects, however, by staying out of public political actions for most of her reign and using her power

as queen as an intercessor; her subjects expected this of her. On her wedding day, the citizens of London reminded her of their understanding of her role in the monarchy:

> Since it pertains to your most benign piety to assume in the innermost parts of piety the role of mediatrix between your most illustrious prince and most powerful lord the king, just as [did] our other lady Queens who preceded your most excellent highness in your realm of England, may it be pleasing to your most clement and preeminent nobility to mediate with our lord the King in such wise with gracious words and deeds.[46]

Philippa of Hainault may well have been one of the 'other lady Queens' but, here, Anne is called on to mediate, to act pre-emptively as a voice of reason ('with gracious words and deeds') while admitting that she, alone, can neither resolve the situation nor intercede after a judgment has been rendered to seek clemency or pardon. Anne did intervene, however, to rectify unjust decisions, and chroniclers often depicted her on her knees.

Her queenship was spent, it seems, trying to mitigate the actions of a king not inclined towards taking counsel from anyone other than a close associate. It is a telling commentary on contemporary attitudes towards Richard as a king in need of the help of his queen to fulfill their expectations of what constituted good rulership. In 1388, during the Merciless Parliament, she successfully pleaded with the appellants for the lives of the condemned judges, and in 1392, she petitioned Richard to be merciful to Londoners who had offended him by refusing a loan. Anne's mediation and intercession, and perhaps also advice to Richard, are vividly rendered in two highly symbolic representations. The first, is an illuminated initial letter 'R' on the first page of the Shrewsbury Charter (1389), Richard's confirmation of the rights given to the people of Shrewsbury in an earlier charter of Edward III, which depicts Anne kneeling before Richard (Illustration 4.3). Anne was there, where the king was, below him but beside him, signifying that his every act and decision was approved, or assisted, or contended by the queen because she was there, as mediator and intercessor. The second symbolic representation was a gift from Londoners of a female pelican, a bird well-known in the Middle Ages for self-sacrifice by feeding its young with blood from her breast. Anne's mediation and intercession were part of a dynamic of contending ideas on queenship and monarchy that was well-understood by medieval viewers and readers. As a queen, Anne was outwardly submissive, yet possessed sufficient influence to change royal dictates. She was a persua-

sive wife and good counselor who also served as her husband's most visible critic. She was grounded in the concerns of her subjects, yet was lofty enough to be close to the king's ear, a supplement to kingship as well as a potent reminder of its limits. Her good counsel went beyond public governance and extended into literary patronage. She was critical of Chaucer's emphasis on women as unfaithful in *Troilus and Criseyde*, and her patronage prompted him to reply with *The Legend of Good Women* in which a writer is criticized by the god of love and his queen, Alceste, for his works such as *Troilus and Criseyde* that portray women negatively.[47] Chaucer is satiric in *The Legend* and, in intention and tone, it is hardly *The Book of the City of Ladies*, but Anne's intervention in a lively late-medieval literary debate signals the increasing importance and cultural power of the public visibility of a queen.

For all her successes, Anne failed at the one thing a queen was supposed to do – she was childless. It is not clear why, after twelve years of an affectionate marriage, but it appears that she had never been pregnant. The problem may have been as much Richard's as Anne's, for he

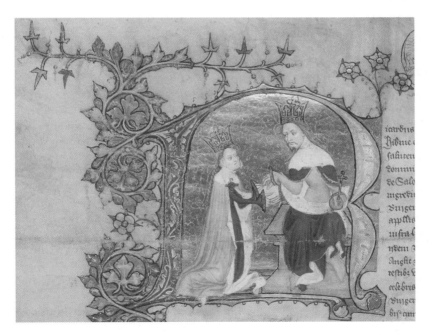

Illustration 4.3 Shrewsbury Charter, 1389, Anne of Bohemia and Richard II. © Shropshire Archives, Shrewsbury, doc. ref. 3369/1/24.

had no children outside marriage. His second wife, Isabelle of France, was only six when she was formally betrothed to Richard in 1396, and his deposition three years later meant that the marriage was never consummated. Some scholars speculate that the marriage of Richard and Anne was chaste, but there is no evidence to support this other than his affection for Edward the Confessor, who purportedly had a chaste marriage with Edith of Wessex. In 1394, at Sheen, Anne died aged twenty-eight, possibly of the plague. Richard, distraught, ordered the palace to be destroyed and commissioned a double tomb to be built over Anne's grave in Westminster Abbey.

Their childlessness, and Richard's unskillful management of the realm, set in motion Richard's deposition in 1399 by his cousin Henry Bolingbroke and his uncles, the Duke of York and the Duke of Lancaster. Condemning Richard as oppressive, unjust and contrary to law, Henry, son of John of Gaunt, Duke of Lancaster, organized a noble rebellion against Richard, deposed him and was crowned king in 1399; Richard died in 1400. Henry had seven children with his first wife Mary de Bohun, five sons and two daughters, but no children with his second wife, Joan of Navarre. Mary died before Henry deposed Richard; she was never queen and is almost invisible to scholars.

Joan of Navarre, however, was a queen consort and is far from invisible. The widow of Duke Jean V of Brittany, Joan met Henry Bolingbroke while he lived at the Breton court in exile from England during his rebellion against Richard. Joan's family had prodigious diplomatic connections with the French Crown, and she and Henry married in 1403. They had no children together (she had seven surviving children from her first marriage), but she was on good terms with Henry's children, often siding with her stepson, the future Henry V, against her husband. Despite her kindness, Henry V accused her of witchcraft in 1419. Although she was never formally tried for witchcraft and the charges were never proved, she was imprisoned for about four years, during which time Joan was provided with a large household, rich clothing, ample food and wine, and she was able to receive high-ranking visitors. Her treatment has led most scholars to conclude that Henry's actions were a pretext for him to seize Joan's revenues to plump up his impoverished treasury. A. R. Myers suggests that if Joan had been tried and acquitted, Henry would have had to free her and restore her income; if she were found guilty, he would have to punish her.[48] Keeping his stepmother imprisoned without trial allowed Henry to profit from her wealth while letting her live well. She did not make a fuss and, six weeks before he died in 1422, Henry ordered her released and restored her dower. She appears to have been on good

terms with Henry VI, who ordered that she receive a state funeral when she died that same year.

Joan of Navarre's life typifies some of the vexing difficulties a queen wrestled with in the face of complex and conflicting demands. She did everything a good queen was supposed to do, except bear a male heir: she was a faithful wife, an exemplary stepmother, and she endured the humiliation of accusations of witchcraft with admirable calmness. Yet, her life is overshadowed by that of her far more famous stepson, the heroic Prince Hal enshrined in William Shakespeare's literary imagination in 'Henry V', and his wife, Catherine of Valois (d. 1437). The youngest daughter of Charles VI of France and Isabeau of Bavaria, Catherine endured the impoverishment of the royal family and violent political divisions between the Armagnac and Burgundian factions in France. Catherine was suggested as a wife for Henry IV's eldest son at various times – in 1408, 1409, 1413 and 1414 – as a way to promote peace between England and France. Despite the unromantic motivations of the Treaty of Troyes, the courtship of Catherine and Henry is loaded with chivalric romantic tones characteristic of late medieval literature. The plans were thwarted by changes in each realm's political and military fortunes. At first, the English demands were excessively high for the French to bear. In 1415, after the French loss at the Battle of Agincourt, negotiations ceased. In 1418 negotiations re-started, and Henry and Catherine finally met in 1419. A gallant Henry kissed a demure Catherine, but the rest of their courtship was long-distance. Henry was said to be so captivated by Catherine that he was prepared to marry her at no cost to her relatives and with a substantial dower in England. He agreed not to call himself 'King of France' as long as he was recognized as regent during Charles VI's lifetime and as heir to the kingdom of France. In 1420, the Treaty of Troyes confirmed the succession to the French throne of him and his heirs with Catherine; they were betrothed and married immediately. Henry skillfully used ceremonial entries into Paris and Rouen to announce the marriage to the defeated French, and then into London for Catherine's coronation.

The queen's ceremonial value was considerable. Catherine was on display to her English subjects as a trophy of war, a symbol of both military victory and dynastic union, made even more evident when she gave birth to a son, Henry, in 1421. In the end, their courtship lasted longer than the marriage, for Henry died less than one year later, in 1422. She was only twenty-one, and her son, Henry VI, nine months old when her father, King Charles VI of France, died a few months later. A young queen-dowager with an infant son posed serious problems. Since the

eleventh century, only four queens of England had been widowed while young: Berengaria of Navarre, who never came to England and, on Richard's death, retired to Maine; Isabelle of Angoulême, who returned to France and married the son of the man she had been betrothed to before John married her; Margaret of France, Edward I's second wife, who lived peacefully as a dowager with her young children; and Catherine of Valois. She had never seemed to press for an active political role in her husband's or her son's reign, but remarriage and the status of her dower properties were of great concern to the English nobles. Two regency councils governed England and France, and Catherine was officially 'Queen of England, the King's mother' but her functions were largely ceremonial and maternal. She normally appears in contemporary records on ceremonial occasions, accompanying the infant king to sessions of parliament. Catherine had already received estates from the Lancastrians' inheritance from Henry's first wife, Mary de Bohun, but her dower was in dispute because some of her dower lands were already held by Henry IV's widow, Joan of Navarre. But a young widow's second marriage, potentially to someone who might exert a powerful influence over the young boy, upset the power relations at court. A statute enacted in Parliament in 1428 that forbade marriage to a queen without royal consent on pain of forfeiture of lands for life was designed to give Parliament some control over the choices of a queen-dowager-regent.

In spite of this, some time around 1428–29 Catherine remarried, though she tried keep it a secret until after her death. Her new husband was an obscure young Welsh squire, Owen Tudor, with few possessions to forfeit and much to gain. The existence of Catherine's second marriage was known by 1432, just five years before she died in 1437. Her reign as queen was brief but her legacy was significant. It was not in the realm of governance, intercession, or patronage but, rather, in the continuation of two royal families in England. First, and most obvious, it was her son from her first marriage, the heir to the throne, Henry VI, but her second marriage to the Welsh soldier and courtier Owen Tudor legitimized him as an English subject. Catherine had granted him lands from her dower estates that were seized at her death, but their two sons, Edmund and Jasper, were created the Earl of Richmond and the Earl of Pembroke, respectively. These titles and the economic, social and political benefits they inherited from their mother – a French princess, English queen and wife of a Welsh courtier – formed part of the nest egg that hatched the Tudor family that would rule England throughout the sixteenth century.

Like Catherine of Valois, her successor, Margaret of Anjou (d. 1482) was married in an effort to generate peace during the Wars of the Roses,

the conflict generated by the factions created when Henry IV deposed Richard II in 1399. The factional struggle continued following the death of Henry V in 1422 and worsened until 1437 during the long regency for his son Henry VI (d. 1471). The marriage of Henry VI to Margaret in 1445, then aged fifteen, was intended to bring peace to England and France (Illustration 4.4). A foreign queen, Margaret struggled to maintain peace but, no matter what she did, no matter how valiant her efforts, her reign was fraught with conflict.[49] Childless for the first eight years of their marriage, she was hounded by unfounded rumors of her infidelity. Joanna Laynesmith argues that Margaret feared she was barren, prompting her critics to blamed her childlessness on a host of factors, all of them familiar and none having any basis in fact – evil councilors, abuse of power as regent, adultery with nobles who defiled the king's chamber,

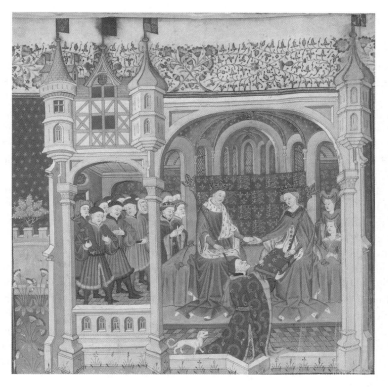

Illustration 4.4 Margaret of Anjou and Henry VI being presented with *Poems and Romances* (*The Shrewsbury Book*), Rouen, 1444–45. British Library, Royal 15 E VI, folio 2v, London, British Library. © British Library Board.

and a punishment from God for what they perceived to be her transgressions.[50] When their son Edward was born in 1453, her enemies questioned his parentage. The motif of the adulterous queen – so prevalent in the rumors connected to Eleanor of Aquitaine and Isabeau of Bavaria, together with the actual adultery of Queen Isabelle, wife of Edward II, and the queens of the sons of Philip IV of France – made an appearance when there was a possibility of a ruling queen. It does not matter that the rumors of adultery had no basis in fact because it was intended to discredit her. To scholars of queenship, the rumors say more about the queen than the English nobles who saw only danger in her assumption of power for her husband when he was stricken by mental illness. Laynesmith, analyzing the criticism of Margaret's reign, notes the connection between sexual lust and lust for power. Her critics' focus on Margaret's sexuality reveals more about contemporary attitudes toward kingship and masculinity than about what Margaret did or did not do.

The situation in England was nearly out of control when Henry's mental illness further weakened him as king. In a significant coincidence, Henry's illness began in 1453, the year in which his son was born and in which the English definitively lost the Hundred Years' War. Tensions that were already high turned on the queen. Margaret's critics linked Henry VI's mental incapacity to physical incapacity, suggesting that the delay of a royal pregnancy was an emasculating form of divine punishment. Above all, they feared her power. The regency of a queen, which would have seemed perfectly acceptable to her – a woman raised in a noble family in France who, no doubt, knew of the regency of Isabeau of Bavaria for Charles VI of France – was unacceptable for some of her English subjects. English nobles, already nervous about the fate of the realm, were skittish about rule by a woman after the controversial regency a century earlier of Queen Isabelle of France, wife of Edward II and regent for Edward III. Because the realm needed to be governed, and the heir, Edward of Lancaster, was a baby when Henry was first stricken, high-ranking barons bypassed existing institutions and created an office they termed the 'protectorate', which they restricted to men only. This allow them to have a stand-in for the king who was not the queen and, ideally, not partisan. Henry's cousin, Richard, Duke of York, was named 'Protector and Defender of the realm'. The title implied a personal duty of English Protectors for the defense of the realm but, for all practical purposes, the Protector functioned as regent without the formal strictures of a regency council but with limited jurisdiction and an ad hoc council to supervise his actions.[51] In sum, it bypassed a queen as regent, which was problematic to them even though the regent implied the

queen's tutelage and guardianship of the heir – natural extensions of the queen's maternal responsibilities.[52] Helen Maurer argues that Margaret was hardly a dangerous innovator but, rather, was a queen who worked hard to balance the subordination and subservience expected of her as a medieval woman. In her defense of royal interests, her husband and her son, she dutifully defended the realm in the absence of a strong, competent royal leader. When Henry VI was able to govern, Margaret mediated as much as possible but then stepped back at the earliest opportunity.

Things went from very bad to much worse, however, as factional fighting spread to the countryside. Trying to placate both sides, Margaret was careful to demonstrate her favor equally. Maurer argues that Margaret seemed to accept Duke Richard's protectorate and has found no substantial evidence to support the claim that she was responsible for the Yorkists' exclusion from the Great Council following Henry's recovery. Whether Margaret was responsible or not, the consequences were fatal. York's exclusion from the Council and the resulting civil conflict lasted for another thirty years and destroyed many of the noble families of England. As the head of royal government with and for her husband, Margaret raised money for the royal army and did what was expected of her as queen. Her actions, intended to protect and preserve her family, ultimately ended in the deposition of her husband in 1461, the death of their only son at the Battle of Tewkesbury in 1471, and Henry's death three weeks later in the Tower of London. Margaret was captured, held at the Tower of London by the victorious Yorkists and was ransomed in 1475 by her cousin, King Louis XI of France, where she lived until her death in 1482.

Maurer notes that 'she pushed at boundaries that were ill-defined to begin with and, in pushing, may have made them more visible and concrete [...] It is her adherence to these standards, rather than a mythic disregard for them, that is striking'. It is clear that, to be effective, a medieval queen needed well-defined institutional authority that was generally agreed upon by the governed. In moments of high tension, any action that has not been explicitly described and accepted risks being perceived as overstepping a boundary. When it is a queen, no matter who her family and what her reputation, the risks are even greater. The problems Margaret faced, much like those of Isabeau of Bavaria, went beyond the bounds of normal governance, and it is unlikely that the tensions and enmity that had been simmering for decades could be contained by any of the legal methods available in the mid-fifteenth century. Her reign makes it clear that good queenship often depended on good kingship, that a feeble king weakened by mental illness and caught up in a vicious

feud could not support even an intelligent, well-educated, well-connected, shrewd and skilled woman like Margaret. Good institutional structures mitigate the uncertainty of circumstance and personality, and having a more successful queen as an immediate precedent paves the way for a queen to be more effective, no matter how she envisioned her role as queen.

As much as Margaret of Anjou's marriage to Henry was the result of careful planning and hope for peace, the marriage of Elizabeth Woodville (d. 1492) to the Yorkist King Edward IV in 1464 was impetuous enough to cause a sensation.[53] Rather than marry a princess with an impressive lineage and a rich dowry, Edward chose Elizabeth, the daughter of an upwardly mobile member of the gentry, Richard Woodville, later first Earl Rivers, and the dowager Duchess of Bedford, Jaquetta of Luxembourg. Edward was the first English king since the Conquest in 1066 to marry one of his subjects, and he chose to marry a woman from a family that was not rich, but was extremely large and very ambitious. We are now accustomed to the notion of a prince marrying a commoner – such as the American socialite Wallis Simpson and Edward VIII in 1936, or the daughter of a wealthy businessman – such as Catherine Middleton and Prince William in 2011. But in fifteenth-century England the marriage was extraordinary. Elizabeth, the widow of a man who tended to be on the losing side in the Wars of the Roses, had two sons and financial difficulties when she turned to Edward IV for assistance. Elizabeth's petition was, indeed, put to the king, apparently by her in person, with the desired effect: Elizabeth recovered possession of disputed properties. She then secretly married the king. There is considerable speculation for the reasons for this unexpected marriage. Thomas More said that, when Elizabeth petitioned the king, he wanted to go to bed with her in return for his assistance; she refused, and he married her to get his way. Another story says that she resisted Edward's advances with a dagger; still another, that Edward was in the habit of luring unwilling gentlewomen to bed with promises to marry. No matter what the actual circumstances, the marriage was clandestine, of doubtful legality and was kept secret for four months.

Edward revealed his marriage only when he had no choice. He had planned to marry Bona of Savoy, sister of the French queen, as part of a treaty negotiated by the Earl of Warwick with Louis XI, but he had to nullify that agreement when he revealed that he was already married. There was universal disapproval. The match served no political purpose and could potentially alienate the King of France. The new queen was not a virgin, but a widow with children and a big needy family. She was

not noble, and the match was about passion and desire, not reason. No matter how virtuous Elizabeth was, and no matter how many children she had with Edward, political disapproval was strong. This was particularly so from the king's mother (Cecily, Duchess of York), his brother Richard (Duke of York and soon to be king) and noble factions jealous of the Woodvilles' rapid rise to power.[54]

Despite the storm of disapproval, the king's council formally received Elizabeth as queen; she was crowned, and a daughter, Elizabeth of York born in 1466 (d. 1503), was heir apparent for four years. Elizabeth was assigned dower from Crown lands and duchy of Lancaster lands that was considerably less than that allowed to previous queens, but her revenues were much more secure and her household less extravagant than that of Margaret of Anjou. When Edward IV died in 1483, his thirteen-year-old son, Edward V, was crowned immediately; Richard, Duke of Gloucester, was Protector of the Realm and Elizabeth her son's de facto regent. Factional strife was reignited by the unofficial nature of Elizabeth's regency and the growing influence of her family. In a rapid unfolding of events, the young king was kidnapped, Elizabeth fled with her second son, Richard, the Duke of York, and her five unmarried daughters; Richard, Duke of Gloucester, usurped the Crown, and the princes Edward and Richard (the famous 'Princes in the Tower') disappeared and died in mysterious circumstances. In 1484, Parliament confirmed Richard's title as king, declared Elizabeth Woodville no longer queen, claiming that she had never been legally married to Edward IV, and denounced their children as illegitimate.

Elizabeth's fragile queenship held steady for a short while as she remained in sanctuary with her daughter and allied herself with Margaret Beaufort, the formidable wife of Edmund Tudor and the mother of Richard III's most serious rival, Henry (the future Henry VII).[55] But Margaret was a dangerous ally who put her son and family above all else. A powerful force in Henry's reign, Margaret reluctantly accepted a lower status than that of Elizabeth Woodville as dowager-queen. Elizabeth Woodville was banished from court in 1487, some say due to Margaret Beaufort, and was deprived of her dower properties. She retired to Bermondsey Abbey, where she died in 1492 in almost the same financial and social state as when she had arrived at court nearly thirty years earlier.

King Richard III and his queen, Anne Neville, ruled for barely two years. Anne was a shadowy figure who rarely appears in the documents, but it is clear that the death of their son, Edward, in 1484 was devastating for both personal and political reasons. Lacking an heir, Richard's

reign was even shakier, and Anne died just before his death at Bosworth Field in 1485. The victor at Bosworth was Margaret Beaufort's son, Henry VII (d. 1509), who sealed his victory three months after his coronation when, in a dynastically brilliant but very dangerous move, he married Elizabeth of York (d. 1503), eldest child of Edward IV and Elizabeth Woodville. Elizabeth was a highly desirable marriage commodity and the marriage was arranged by both their mothers, Elizabeth Woodville and Margaret Beaufort. The marriage was not without risks. Elizabeth became heir to the throne in 1483 after the disappearances of her brothers. In 1483, she had been declared illegitimate by the Parliament that legitimized Richard III's usurpation, and as a bastard she could not be queen. She and Henry were also closely related and shared a common ancestor, King Edward III. Before they married, the Parliamentary act was nullified and a papal dispensation procured, but she was not crowned queen until 1487, which was probably a strategic move on Henry's part so that it would not appear that he owed his kingship to her title. As both heir to the throne and a potent symbol of the union of the warring Lancaster and York families, Elizabeth of York was a double bonus to Henry. Once again, a queen legitimized a dynasty by her marriage, her children and grandchildren, and, in this case, she was part of the creation of the Tudor lineage.

Her popularity with the people helped her husband survive rebellions in the early years of the reign. Her personal warmth contrasted with Henry's coolness, and her gracious handling of supremely sensitive family politics was vital to mending the fractured realm. Elizabeth was a generous patron – particularly to her family, which benefited greatly from her gifts. But she preferred to work quietly, not publicly, so her activity in politics is seldom clear. Many of her appearances in the record are in law court cases involving her natal family and her ten children, and her brothers, Richard and Edward.[56]

The records for court ceremonial are well documented for the early years of Henry's reign and they show Elizabeth as a young queen seemingly overshadowed by her mother-in-law. Margaret Beaufort was not deferential to Elizabeth of York as queen-consort, and often dressed in robes of the same quality as the queen-consort. After 1499, Margaret signed letters and documents with the Tudor crown and the caption '*et mater Henrici septimi regis Angliæ et Hiberniæ*' (and mother of Henry VII, King of England and Ireland). In a more ambiguous manner, she signed as 'Margaret R', which could refer to her royal authority, with the 'R' signifying *regina* (queen, in Latin) or standing for 'Richmond'. But Elizabeth was always given precedence in formal accounts, suggesting that she shared power and that her interventions were uncontroversial and subtle.

Charles Wood argues that the differences between Elizabeth Woodville and her daughter, Elizabeth of York, are important.[57] Woodville was a queen with considerable power, but her daughter had very little. Instead of the family as a route to power, as it was in the case of Elizabeth Woodville, it worked against her daughter. An heir or two is essential for a new and shaky dynasty and, in this, Elizabeth of York exceeded social expectations. Five children survived infancy: Arthur, Margaret, Henry, Mary and Edmund; several others died in infancy. Her son, Arthur, was her husband's key to his own dynasty and safe rule, and, once Arthur was born, her prospects dimmed. Then she almost disappears from sight and has barely any official role in the later part of the reign. By the time Elizabeth died in 1503 of complications in childbirth, however, only Margaret, Henry (future Henry VIII) and Mary survived her. The six wives of Henry VIII – whom he wooed, married, dominated, divorced and/or beheaded – have provided a feast for scholars of queenship. The delicious irony of this feast is well-known: a man determined to have a son to inherit his realms got one, but he died young and ultimately Henry VIII was succeeded by two formidable queens: Mary and Elizabeth Tudor.

Scotland

For Scottish queens and kings, the later Middle Ages were pivotal to the development of monarchy and realm. Robert I Bruce's seizure of the throne in 1306 is the symbolic and material starting point for a royal dynasty but, until the fifteenth century, Scottish monarchy was still dependent on the personal qualities of the king. These centuries were volatile politically as the Balliol, Bruce, Douglas, Donald and Stewart families competed for control of the realm. Until 1474, Scottish kings weathered internal crises and were engaged in an almost unbroken state of war with England. The early queens of the fourteenth century were politically important as the wives and unofficial partners of the kings, but more research is necessary to better understand their impact beyond the outlines of their lives. Scottish royal marriage was not an international alliance but, rather, a strategy that met specific short-term, largely domestic goals – such as those of Robert I Bruce, who solidified his hold on Scotland when he married Elizabeth de Burgh (d.1327), daughter of the Earl of Ulster. They were crowned in 1306 but the validity challenged English claims of lordship over Scotland. The ensuing violence drove into exile Elizabeth and her husband's sisters and stepdaughter, Marjory (Robert's daughter from his first marriage to Isabella of Mar who died in

1296, before Robert was king). Elizabeth was imprisoned, besieged and placed under house arrest. The status of Marjory as the eldest child and potential heir of Robert caused enough anxiety that she was sent into a convent for protection. Through all this, Elizabeth bore four children, including a son and heir: David. She was a peacemaker and moral guide as well as a political actor who played a critical part in negotiations leading to the appointment of her eldest son as lieutenant for his ill father.[58]

The first official and uncontested coronation of a queen of Scotland took place at Scone in 1331, when the bishop of St. Andrews crowned both David II and his wife, Joan of England, daughter of the English King Edward II and Isabelle of France. Their marriage in 1328, when David was five and Joan was seven, was one of the provisions of the Treaty of Northampton that ended over a decade of war with England. The marriage and joint coronation three years later in 1331 had tremendous importance for monarchy in Scotland and queenship. It established Robert I, and his heirs and successors, as the rightful rulers and reinforced the dynasty. As a foreign-born queen, Joan's marriage to David naturalized her as a subject and made her acceptable for coronation; her ceremony's followed David's, signifying the derivative nature of a queen's office and power. Her coronation marked the beginning of a new era for Scottish queenship even though, by contemporary standards, it was a late development. Until then, the Scottish coronation of a king adhered rather closely to Celtic practices, which did not mark any significant change in a queen's status as the king's wife. The queen did not swear an oath at her coronation; the rite emphasized her relationship with the king, and enhanced his power and authority. She was accountable to her husband but not to the political community – meaning that her subjects owed loyalty to the king, not to her. Joan was not, however, an active figure in the reign. The Treaty of Northampton did not hold; war between England and Scotland continued, and David was often on campaign. They were exiled to France, and then he was captured and imprisoned by the English from 1346 until 1357. She visited him in the Tower of London, hence her nickname Joan 'of the Tower', but they had no children.

When Joan died in 1362, David married Margaret Drummond (d. 1375), the widow of a knight, who had been David's mistress before they married. Her relationship with David and her non-noble family, whom she tried to promote, made her vulnerable to considerable criticism. Her critics used her beauty against her, claiming that sexual allure was linked to bad government because it was felt it could cause a king to act irrationally, as they thought David did when he married Margaret rather

than negotiate a favorable political alliance. He tried to have the marriage annulled in 1369 but he died in 1371, childless, before the matter was resolved.

A series of deaths in the family left the royal family without a direct descendant, male or female, prompting the Scots to search back through the family tree of Robert I to find a successor. Like their counterparts in France, laws of succession excluded female heirs from direct rulership, and David II attempted unsuccessfully on several occasions to have the council change the succession procedure. But women in Scotland were allowed to transmit royal rights to inherit and rule to a son. So, the Scots turned to Marjory, the daughter of Robert and his first wife Isabella of Mar. Marjory had married Walter Stewart, the High Steward of Scotland, and they had a son who succeeded his uncle as King Robert II. Once again, the queen's sexuality and social rank mattered greatly. Before becoming king, Robert had married his mistress Elizabeth de Mure (d. c. 1355), a woman from a minor knight's family. Together, they had at least ten children, perhaps as many as twelve or thirteen, among them the heir, but Elizabeth died around 1355, before Robert succeeded in 1371, and was never queen. For his second marriage, in 1355, he moved higher up the social ladder and married Euphemia Ross (d. 1386), a widow from the powerful Earls of Ross. She was crowned a year or so after Robert, in 1372 or 1373. Like other second wives of kings – Emma of Normandy, Margaret of France – she had to compete against the many children from his first marriage to secure influence with him and protect their own children. As a second wife with stepsons vying for power in a volatile political milieu, Euphemia appears more anxious to secure her future through her children than to secure power for herself. She fought for the rights of their children over those of the children of the first marriage, and sought to exclude his children with Isabella of Mar from succession and favors. Ultimately, her efforts to secure the throne for one of her sons failed. After intense rivalry among the king's legitimate and illegitimate sons, primogeniture prevailed and the first son of Robert and Elizabeth de Mure succeeded as Robert III.

Margaret Drummond lived to see the fruits of her ultimately successful advancement of her family's interests when her niece Anabella married Robert in 1367 and then became queen in 1371 when Robert II died. While Anabella contended with both her husband's illness and then early continuous sparring of royal sons and noble families, she relied on the powerful support of her Drummond family during the troubled reign. There was no precedent for a queen-regent as there was in other medieval European realms so, when the king was ill or away from

court, the king's sons or uncles governed as lieutenants. Anabella supported her young sons as they fought for control of the realm through the government of the lieutenant and fought challenges from her brother-in-law, Robert who supported a law similar to the French Salic Law amendments that would bar women from inheriting the throne. In 1394, aged 45, Anabella had her last child, the future James I; this put to rest the fears of rule by a woman.

The 1424 marriage of James I and Joan Beaufort (d. 1445), niece of Henry IV, was part of an Anglo-Scottish truce that resolved an era of armed antagonism between the two realms. The peace left a somewhat more settled realm that allowed Scottish kings to step into a wider arena, and the union of James and Joan was the first of a series of vitally important marriages to foreign brides from strategically placed realms. Queen Joan's reign was unprecedented in many ways. Her coronation in May 1424, just a few months after their wedding and on the same day as James's coronation, was significant in its suggestion that her power was roughly equal to his. James explicitly established the queen as the king's partner in government, which suggests a strong belief that she would carry out his wishes and work to ensure a safe transmission of the crown to their son, the future James II. In 1428, he had his nobles swear an oath to both him and the queen when they received their inheritances and benefices, and, in 1435, representatives of the nobles, church officials and townspeople were asked to give letters of fidelity to the queen in Parliament.

Her reign as queen was difficult, to say the least, but she was intrepid and clearly able to weather the worst crisis. Her public acts of intercession, staged or not, were of key importance to monarchical power and protected James from criticism. As a foreign-born queen, her interests were more closely aligned with those of her husband and her five sons, so she did not face the challenges posed by powerful families of earlier queens, such as the Drummonds and Rosses. The assassination of James in 1437, together with the fact that the assassins tried to kill her, too, suggests that her power was feared. She was awarded custody of their sons, and, although she was not named regent, she was able to rally support and maintained some stability. Her remarriage to James Stewart of Lorne in the aftermath of James I's assassination was a shrewd political decision that reveals an awareness of her inability to retain sole power and control over the minority of James II.

Like Joan Beaufort, Mary of Guelders (d. 1463) used intercession strategically. She was a foreign queen whose marriage to James II was part of an alliance with the Duke of Burgundy. Joan Beaufort had never

regarded herself as an autonomous political figure in royal government; neither had she been regarded as such by others. Mary, unlike Joan, was a key figure in her husband's reign while he was alive and very active in governance after his death in 1460. She assumed a leading role in 1461 as member of a regency government that led Scotland during a period of considerable conflict. She not only gained custody of their son, James III, but was also granted regency powers. She was not formally named regent, but neither was a formal lieutenant named, which strongly suggests that she was the leader of the government during her son's minority to the extent that she was directly involved in military engagements until her death three years later in 1463. For example, during the Wars of the Roses, Mary gave refuge to Margaret of Anjou, Queen of England, and her son Edward when they fled north across the border seeking refuge from the supporters of the Duke of York. Mary provided Scottish troops to help Margaret, but the increasingly friendly alliance between King Edward IV of England and Duke Philip of Burgundy forced Mary to withhold her support of Margaret. In 1462, she paid Margaret to leave Scotland and made peace with Edward IV.

The marriage of Margaret of Denmark (d. 1486), daughter of King Christian I and Queen Dorothea of Denmark, Norway and Sweden, to James III was intended to resolve disputes over the Hebrides. Like Joan Beaufort and Mary of Guelders, she was appointed as tutor to her sons – because of her foreign birth, she did not rouse the fear and hostility of nobles; neither did she provide any ambitious male relatives with a chance to gain advantages at court. She was not a major public figure beyond being the mother of three sons; however, her role in 1482 when James was imprisoned in the castle at Stirling demonstrates that she was influential in the reign. Stirling was part of the queen's dower and a key component of her fiscal assets, and her control of the castle allowed her to stay in contact with James and work to resolve the crisis.

In the almost two centuries between the reign of Robert I Bruce and the death Mary of Guelders, the official status of queens shifted from that of an uncrowned partner of the king to the appointed regent of a child king. By the reign of James IV and Margaret Tudor (d. 1541), the queen's authority and influence was well-established as a fundamental element of monarchy. When James died in 1513, Margaret was named regent for their son James, an act that joined maternal rights of custody with the powers of formal public governance. She was the first person to be identified as regent instead of guardian or governor and, significantly, this was the same year that Catherine of Aragon was named regent for Henry VIII when he was in France. The regency in Scotland

was distinctive in that it separated the power between the regent (who could also be a lieutenant), who ran the government, and the tutor or guardian who was entrusted with the custody of the young king. The queen's role as tutor or guardian, therefore, derived from maternity, not authority. Fiona Downie suggests that a queen-regent up to this point was acceptable to the Scottish because queens exercising official public authority, such as Mary of Guelders, had done so with skill and tact, and therefore did not raise too many anxious fears regarding rule by a woman. It may well also be that both Joan Beaufort and Mary of Guelders knew of Christine de Pizan's work prior to their arrival in Scotland. Fifteenth-century Scottish ideas about female power were conventional in that that women could not possess authority, but contemporary writers tended to be imprecise about what women could do, which left some leeway for a resourceful and enterprising queen who did not exercise power or authority in her own right but, rather, with or for her husband or son.

Evidence from seals and sealing practices confirms the changing nature of Scottish queenship. The seals of fourteenth-century queens Margaret Drummond and Euphemia Ross depict the differences between a queen's power and that of a king. Their seals depict a full-length figure of the queen bearing a scepter, wearing a crown, surrounded by arms of the queen's family and the royal Scottish family, which emphasized the queen's powerful natal family. The fifteenth-century seals of Joan Beaufort and Mary of Guelders no longer show queens possessing the regalia of ruling; however, in other ways the king's and queen's seals look considerably more alike. Both of these queens-consort possessed powers nearly equivalent to those of a regent, and it may be that their seals symbolize the rough equivalency of the king and the regent.

By the mid-fifteenth century, the Scottish queen's economic power was substantially greater than before, a trend noted elsewhere as early as the thirteenth century with the reign of Eleanor of Castile in England. Scottish queens derived revenue from an array of castles, especially Stirling, and customs from towns (Aberdeen, Edinburgh, Linlithgow, Dundee and Perth).The household of a late medieval Scottish queen-consort maintained chambers, wardrobes, kitchens and stables separate from those of the king. Although the accounts themselves are not extant, the king and queen probably kept separate household accounts. Expenditures for Scottish queens can be found in other accounts, however. From these, we know that Joan Beaufort and Mary of Guelders each owned a ship, and that all queens spent money in much the same way – on jewels, books, art, devotional objects and on donations to monasteries, convents, hospitals and universities.

Iberia: Castile, the Crown of Aragon and Portugal

The Trastámara queens of the late-fourteenth and entire fifteenth centuries were part of the densely intertwined branches of a dynasty that governed Castile, Navarre and the Crown of Aragon, and were influential in Portugal and England. The kingdoms of Christian Spain remained separate realms until 1479, but their densely interconnected families linked them very tightly during civil war in Castile that bled out into the Hundred Years' War. Their family connections crisscross a genealogy and their marital strategies littered the papal curia with dispensations to marry close relatives. The family has its origins in the rivalry between Castilian King Alfonso XI's legitimate children with his wife, Maria of Portugal, and his illegitimate children with his mistress Leonor de Guzmán. Most of the political havoc in Castile in the mid-fourteenth century stems from their complicated personal and marital lives. What we know so far of the queens and mistresses suggests that kings considered them to be secondary to their own ambitions and military exploits against the Muslims in the Reconquest. Queens appear in chronicles as wives, lovers and mothers involved in significant ways in the king's public or political work.

Alfonso XI (d. 1350), married Costanza Manuel of Castile in 1325, but divorced her two years later; in 1328, he married Maria of Portugal (d. 1357), daughter of Afonso IV of Portugal. They were not happy together, despite the fact that she bore him two sons – one of whom died in infancy, the other succeeding Alfonso as Pedro I (d. 1369). Their marriage was troubled: throughout, Alfonso neglected Maria and lived openly with his mistress, Leonor de Guzmán, with whom he had ten children. Maria apparently accepted her husband's affair but supported the interests of her own son, Pedro. She prodded her husband and her father in an effort to forge the alliance that resulted in their victory against the Muslims at the Salado in 1340, and ordered the execution of her rival Leonor in 1351.

In 1353, Pedro secretly married a Castilian noblewoman, María de Padilla (d. 1361), who had been his mistress. That summer, pressured by family and nobles, Pedro denied the fact of his marriage to María to marry Blanche of Bourbon; however, he denounced that marriage immediately and continued his relationship with María. They had at least four children. Their son, Alfonso, died young, in 1362, but two of their daughters married sons of the king of England to build alliances between the two realms for support in the Hundred Years' War. In 1369, Enrique of Trastámara, son of Alfonso and Leonor, deposed his half-brother Pedro I and ruled as King Enrique III until his death in 1379.

Of the children born to Pedro and María de Padilla, Constanza, the eldest, married John of Gaunt, the Duke of Lancaster, an ambitious man who used the marriage to claim the crown of Castile on behalf of his wife. The younger daughter, Isabel, married Edmund of Langley, Duke of York. Constanza and Isabel were not queens, but were instrumental in the careers of two: Philippa and Catalina, both of whom married Trastámara kings as part of Gaunt's scheme to secure what he thought was his place on the Castilian throne. Gaunt never gained a crown of his own in Spain, but his daughters did.

When Philippa (d. 1415) married João I of Avis (d. 1433), she married the man who usurped his crown from a queen who ruled in her own right. In 1383, Beatriz of Portugal, then aged ten, succeeded her father, King Fernão I of Portugal, but her mother, Queen Leonor Teles, governed as regent until Beatriz married Juan I of Castile in 1383.[59] Beatriz and Juan claimed the kingdom of Portugal, but lost the realm in that year when João of Avis, her uncle, Fernão's half-brother, defeated them at the Battle of Aljubarrota and seized the throne. Beatriz and Juan continued to call themselves King and Queen of Portugal, but she died childless and the realm remained in the hands of the Avis dynasty – João and Philippa, the mother of scholarly children; Henry the Navigator; Pedro, a world traveler; King Duarte (1433–38) an intellectual, a linguist and author of two books; Isabel, Duchess of Burgundy after her marriage to Philip the Good in 1430.[60]

Philippa was a patron of both secular and ecclesiastical writers, notably John Gower, whose *Confessio Amantis* was translated into Portuguese at Philippa's instigation and then into Castilian, probably by way of her sister, Catalina (1372–1418), who married Enrique III of Castile (d. 1406). Later, Leonor of Viseu (d. 1525), wife of João II (d. 1495), carried on this tradition of the queen as patron of art and literature, funded largely by *Terras da Rainha* (the queen's estates), a fixed patrimony for the queen. This comprised rents, taxes, monopolies and income from mercantile transactions from several towns and the agricultural revenue from the surrounding countryside. The patrimony had been constituted by three successive kings in the fifteenth century, and it gave late-medieval Portuguese queens an impressive fiscal portfolio which they could use however they chose.[61] Many late-medieval Portuguese queens continued to foster literature and translation. Empress Leonor of Portugal (d. 1467), wife of Emperor Frederick III, commissioned a sumptuous illustrated copy of Pope Pius II's *De liberorum educatione* for the education of her son, the future Emperor Maximilian I.[62] Christine de Pizan's *The Treasure of the City of*

Ladies became well known in Portugal after another Isabel (d. 1472), daughter of João I (1385–1433), admired the work when she became Duchess of Burgundy in 1430, and sent it to her niece the Queen of Portugal, also named Isabel (d. 1455), who had it translated into Portuguese. It was eventually published as *Espelho de Cristina* (*Christine's Mirror*) in 1518 at the instigation of Queen Leonor (d. 1525), widow of João II (d. 1495).[63]

Catalina was active in governing Castile twice as regent, once for her husband during his minority (1390–93) and then for her infant son, Juan II (in 1406); she was deeply involved in the political life of the realms.[64] Her sister-in-law Leonor of Albuquerque (d. 1445), wife of Fernando I of the Crown of Aragon (d. 1416), was an intelligent, beautiful, powerfully rich, prodigiously talented, ambitious heiress. Leonor's estates were so vast that it was said she could walk across northern Spain, from Aragon to Galicia, and never step off her lands. Her landed wealth, combined with that of Fernando, created territories that overlapped the borders of the two realms and led to conflicts of allegiance. Wealth, beauty and charisma notwithstanding, much of her influence surely stemmed from the fact that she was Fernando's aunt and six years older than him. The mother of six children, she governed alongside him during his four-year reign as King of the Crown of Aragon (1412–6), and remained a constant and forceful presence in Spanish politics until her death in 1435.[65]

The queens-lieutenant of the Crown of Aragon continued to govern alongside their husbands but, at moments of political stress, they faced opposition to their actions. What was customary for a prince as regent could be controversial for a queen. Pere IV's third wife, Elionor of Sicily, took over for him, in his name and at his expressed request, at a parliamentary assembly in 1364 because he was on the battlefield in Castile. She did so without official capacity – she never held the office of lieutenant, simply stepping in when needed and stepping aside when he returned to preside personally.[66] Their son Joan (d. 1396) took over briefly for her when she joined Pere to celebrate Christmas in 1364. The state of emergency, the brevity of her convocation and the proximity of the king no doubt smoothed over any opposition to her actions and calmed any suspicion of institutional innovation. Violant de Bar, the politically astute second wife of Joan I, was his lieutenant from 1388 to 1395. She governed ably for and with her husband during his frequent illnesses, stood in for him at parliamentary assemblies and calmed the unrest of anti-Jewish riots in 1391.[67]

Violant's lieutenancy is intertwined with that of her sister-in-law, Maria de Luna, regent and queen-lieutenant for her husband, Joan's

brother, Martí (d. 1410) from 1396 to 1397 and again in 1401.[68] Martí was king of Sicily when Joan I died without leaving adult sons to succeed him. Violant falsely claimed to be pregnant and, as regent, Maria had to secure official recognition for Martí. She summoned and convoked two sessions of a local parliamentary assembly to legitimize Martí's right to succeed, to determine whether or not Violant was pregnant, and to establish a council to advise her until Martí returned. Maria pacified the kingdom and governed until Martí's return one year later; she remained active throughout his reign. She served a second term as lieutenant in 1401 while Martí was in Navarre and Valencia, and remained one of her husband's most able advisors.

The absences of the kings of the Crown of Aragon propelled their wives to official positions of authority, but the separation was not easy. The strains on the queen are poignantly described by Violant (d. 1372), second wife of King Jaume of Mallorca, last king of that island realm, which was subsumed into the Crown after his death in 1349. Violant and Jaume married in 1347, when she was twenty-seven (or older; her birth date is not firmly established), and he was occupied with military campaigns for most of their reign. She had one child, a daughter who died young. Violant expressed her frustrations and loneliness, and her love for her husband, in a love lyric:

> I love one who's good and handsome;
> I'm as happy as the white bird
> Who, for love, bursts out in song;
> I am a sovereign lady,
> And let him I love make no appeal,
> Because I love more than any other woman,
> Since I have chosen him of greatest worth,
> The best in the world; I love him so
> That in my mind I think I see him
> And hold him close;
> But this is not true,
> And great despair sweeps over me
> When I realize he's away in France.
>
> My longing and the great desire
> I have for you have all but killed me,
> My sweet, beloved lord;
> I could easily die ere long
> Because of you whom I love and want so much,

> If I don't see you soon return:
> I'm so impatient for our kisses,
> Our intimate talks,
> And all the rest.
> When I think of how you went away
> And haven't come back
> And how far away you are,
> My despairing heart barely beats:
> I'm as good as dead
> If I'm not cured fast!
>
> Have pity husband; in pain I endure
> The sufferings you give me: please return!
> No treasure
> Is worth a heart
> That dies for you
> With loving thought.[69]

It is significant that she calls herself 'a sovereign lady', which suggests that she considered herself to possess some official political influence; however, it is not known whether Pere appointed her as lieutenant while he was away. Or it can simply mean that she was not powerless in the marriage, a sentiment made clear by her assertion that she has 'chosen him', not the other way around. The phrase 'intimate talks' is ambiguous and can be read as sexual, because it is paired with the coy phrase 'all the rest' in the same verse, or political, meaning that she is his close advisor. Her many references to physical pleasure in kisses and embraces, and her 'despairing heart', may be simply poetic expressions common in other late medieval poetry. However, if genuine, they are not the sentimental and overheated yearnings of a young bride. Violant was at the least in her late twenties when she wrote this. It is reasonable to take this poem at face value, as evidence of a close emotional and physical relationship that was straining under the weight of an absent king.

The political strain of absentee kingship is best seen in the reign of Queen Catalina's daughter, María of Castile (d. 1458), wife of Alfonso V of the Crown of Aragon (d. 1458) and, thus, Leonor of Albuquerque's daughter-in-law.[70] María governed officially in her husband's stead for over two decades as queen-lieutenant of the Crown. María was heir to the Castilian throne until the birth of her brother, Juan, in 1406, when she gave up any expectation of ruling in her own right. But as queen-lieutenant, she governed Catalunya from 1420 to 1423 and also from 1432

to 1453 while Alfonso conquered and governed the kingdom of Naples. She possessed full governmental powers over the kingdoms of Aragon and Valencia, the principality of Catalunya, and the island of Mallorca. She had the authority to rule independently, with full sovereign power over all civil and criminal jurisdictions, including the army and the military orders: in other words, she governed like a king.

The scope and range of her governing authority is exemplified by her handling of a crisis that polarized Catalan society and nearly halted government from 1447 to 1453. The semi-servile peasants had been agitating for their freedom for decades. María strongly supported the peasants' efforts: she met personally with delegated peasant representatives and forcefully implemented royal decrees ordering their manumission. Nobles and landlords tried to go over María's head to Alfonso, attempted to bypass her authority by stalling, and threatened her with armed resistance. In response, she punished belligerent secular and ecclesiastical lords. Through it all, she worked with Alfonso, in his place and always on his behalf, but this did not diminish her prestige; neither did it undercut her subjects' recognition of her authority. The respect of her peers is evident in an image of her from 1448 where she is presiding over a meeting of the town council of Barcelona, seated on a throne receiving a legal treatise and being acknowledged as the source of law in the region (Illustration 4.5). She recognized Alfonso's authority as superior to hers, while Alfonso supported her actions. With tact, tenacity and shrewd political skills she carried on until the summer of 1453 when, frustrated by Alfonso's decision to revoke manumission decrees relating to *pagesos de remença* (semi-servile peasants), in an audacious and unprecedented act, she resigned her lieutenancy.

María's extraordinary resignation defied royal traditions and legal precedents. Queens had been banished or sent into seclusion, as Eleanor of Aquitaine was by Henry II of England when she plotted against him with their sons. Queens relinquished their rights to rule in favor of their sons, most notably in Spain when Queen Berenguela of León passed the throne to her son, Fernando III. As regents, queens technically were obliged to step down when their sons were old enough to rule on their own. As dowagers, queens retired. But no Aragonese queen-lieutenant had ever resigned. Her move was the result of several, undoubtedly linked causes. First, and most important, it is a clear statement of her frustration with Alfonso's policies. She could not have sent a more powerful signal of her disapproval of his actions. He could prevaricate or procrastinate when he read her letters containing protests and warnings, but the message that arrived with this letter to Alfonso was unambiguous: it left

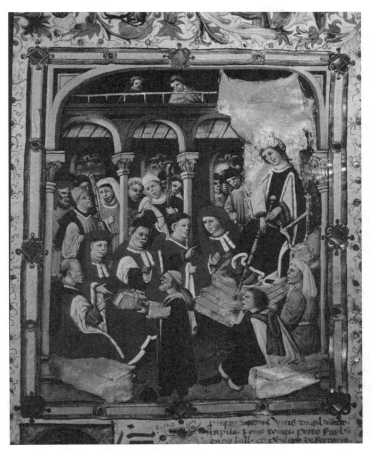

Illustration 4.5 Queen María of Castile (1401–58) with the Consell de Cent (town council) of Barcelona, *Comentarios a los Usatges de Barcelona* (1448), frontispiece, Museu d'Historia de la Ciutat, Barcelona. © Album Art Resource, New York.

him alone with his decisions about the manumission decrees. In her letter of resignation, María expressed her sadness at spending five years negotiating fruitlessly in the Corts (*'non ha sortit algun fruyt ni algun util'*), and predicted that the quarrels over Corts and peasants would continue.

Second, María's decision may have been prompted by concerns about her failing health. She was fifty-two, still active and vibrant mentally, but old enough that the prospect of more years of wrangling with both her husband and the *remença* peasants could not have been appealing.

Finally, and most important for the institution of the queen-lieutenant, her decision underscores the limits of her power. She could disagree with Alfonso, she could harangue and plead and send embassy after embassy to him to try to get him to change his mind. But she had gone as far as she could go: she could not overstep her authority. She was the king's lieutenant and, powerful as that office was, it was always held at her husband's pleasure. It is just as extraordinary that her resignation prompted no serious outcry from any of their Catalan subjects. The lieutenancy passed to the king's brother, who succeeded him as King Juan II in 1458.

Two centuries of rule through lieutenancies chosen from the royal family made it easy for Juan to endow his second wife, Juana Enríquez (d. 1468) with powers very similar to those possessed by María of Castile.[71] In many ways she was truly co-ruler with Juan, who was no stranger to ruling with a queen. In 1425, his wife, Blanca of Navarre, inherited the realm from her father, Carlos III. Juan and Blanca were jointly crowned when her father died in 1429, and ruled together until her death in 1441.

Throughout her marriage to Juan, Juana was one of his closest advisers and most valuable allies, traveling with him throughout Navarre and the Aragonese realms. Juan relied on her intelligence and discretion; her prodigious familial, financial and political connections in Castile; and her tenacious and formidable negotiating skills. Juana was nothing if not intrepid and, no newcomer to politics, she shrugged off personal attacks after the death of Carlos, Juan's son with Blanca, and succeeded him as lieutenant-general. She took full advantage of the office of queen-lieutenant that was in no way diminished by María's resignation. Like María, Juana maintained an extensive court with a separate chancery and treasurer. Amid widespread civil unrest, she suppressed opposition, negotiated treaties, presided over parliamentary assemblies and took the side of the peasants. Unlike the six Aragonese queen-lieutenants who preceded her, Juana is noted for her active military involvement; notably, the early campaigns of the ten-year civil war (1462–72).

The final linkage of Castile and the Crown of Aragon through the Trastámara family began in the mid-fifteenth century with roots in a complex set of marriages, questions of legitimate birth and weak kingship – all of which had implications for queens. King Juan II of Castile (d. 1454) married Maria of Aragon (d. 1445) in 1419. For the first four years of their reign, they were on the run from her brother Enrique, who staged a coup, which prompted a civil war that took decades to resolve. Maria joined forces with her mother, Leonor of Albuquerque, and her sister-in-law, María of Castile, and together they engaged in a

flurry of correspondence with various members of the extended families, nobles, and royal, noble and municipal officials. Leonor and María of Castile took the lead in the negotiations for peace and Maria of Aragon was a messenger and go-between in the negotiations, which included the pope. Their letters reveal how deeply the three queens were involved in negotiations throughout the coup. This type of network of royal women was not unusual – queens and princesses in all realms called on family members for material, fiscal and emotional support.

Maria and Juan had three children: two daughters who died very young, and a son, Enrique. When Maria of Aragon died in 1445, Juan was concerned about the succession because Enrique had been married for five years to Blanca of Navarre and they still had no children; it is likely that the marriage was never consummated. In 1447, Juan married Isabel of Portugal, and the birth of a daughter in 1451, also named Isabel, allayed some of his fears; the birth of Alfonso in 1453 must have caused him more than a sigh of relief. Again, sexual politics dominated the reign of a king. Enrique IV was not a strong king in a distinctly masculine sense. He bypassed high-ranking nobles and preferred to take counsel from favorites. In 1453, after thirteen years of marriage to Blanca, Enrique had that marriage annulled; he then married Juana of Portugal. But he was pounded with questions concerning his fitness as king. In a remarkable inversion of the usual finger pointing at an infertile queen as defective or morally questionable, in this instance Enrique was presumed impotent or homosexual, both of which formed the basis of arguments brought by his critics to explain his perceived weakness as king. Much of Enrique's reign was spent in fruitless battles with his restive nobles, and many of his troubles can be attributed to bitter factional fighting that had its roots in earlier decades. But his enemies seized not only on his masculinity, but also on the reputation of the queen, calling her adulterous. They claimed that the Duke of Albuquerque, Beltrán de le Cueva, not Enrique, was the father of their daughter, Juana, whom they insultingly called 'la Beltraneja'. The question of Juana's paternity can never be resolved, but the situation is made murkier because the royal chronicles of Enrique's reign were written or revised during the reign or under the influence of his sister Isabel who, having fought to gain and hold the Crown, had an interest in proving Juana illegitimate and stigmatizing her brother Enrique as effeminate. Open revolt broke out in 1464, and enemies of the king called Juana illegitimate and denounced her claim to inherit and rule. They deposed the king in effigy, and declared the king's brother, Alfonso, the heir. Alfonso's death in 1468 added to the instability, and the

Castilian nobles began seriously to consider the king's sister, Isabel, as heir.

Isabel was educated to be a queen-consort but, until Alfonso's death, it was not anticipated that she would be queen in her own right.[72] In 1469, defying a prohibition on her marrying without the consent of the realm, on her own initiative and knowing full well what she was doing, Isabel married Fernando of Aragon. When Enrique IV died in 1474, Isabel and Fernando seized the throne of Castile in her right, but her succession was contested by Afonso V of Portugal, who supported Juana's claim. He attacked Castile but was defeated by the Castilian army in 1476. Three years later, after the death of his father, Fernando succeeded to the throne of the Crown of Aragon. This union of the two main Spanish kingdoms laid the foundation for an empire that spanned two continents. They had five children, including Catherine of Aragon, the first wife of Henry VIII of England, and Juana I, mother of Charles V, King of Spain and Holy Roman Emperor.

The marriage of Fernando of Aragon and Isabel of Castile in 1469 and their succession in 1479 to the united realms of the Crown of Aragon and Castile dramatically altered the institutions of government. The situation was unique in many ways, largely because Isabel was Queen of Castile in her own right from 1474 to her death in 1504. To her, the lieutenancy was superfluous and, in 1479, the lieutenancy lost forever its association with queenship. She governed Castile as sole monarch, with Fernando as King of Aragon, skillfully using feminine elements of queenship as a foil for the power she exerted, which caused considerable anxiety among her male advisors, nobles and bishops. As the direct beneficiary of the questioned paternity of her niece, Juana, Isabel knew how to use the rhetoric of femininity and masculinity to good effect. When she rode into the city of Segovia in triumph for her the coronation in 1474, she carried an unsheathed sword of justice, removed from its 'vaginal shield', which Barbara Weissberger noted flaunted masculine symbolics of rule.[73] But, as Elizabeth Lehfeldt argues, she tempered that obviously masculine gesture by also flaunting the feminine symbolics of maternity, with her many children, and by publicly showing herself to be a dutiful wife who flirted with her husband, looked away from his infidelities, and embroidered his shirts.[74] She was a tough queen, responsible for the Inquisition, and, in 1492, for completing the Reconquest of Spain with the defeat of the Muslim kingdom of Granada, and for the ruthless expulsion of the Spanish Jews. That same year, she and Fernando sponsored the voyage of Christopher Columbus that led to the creation of the overseas Spanish colonial empire, bringing wealth, prestige and power to Spain.

The Empire, Hungary, Poland and Scandinavia

With stunning success, the Habsburg family continued to use royal marriages to build and maintain the family's influence. If there were a prize for dynastic survival in Europe, the Habsburgs would surely win. Men may have governed the Holy Roman Empire, but Habsburg imperial women – princesses, noblewomen, queens, empresses – were a key part of imperial political strategy, particularly important to the imperial dynastic ambitions beginning in the late thirteenth century. To date, little attention has been given to Habsburg women who left home to marry men from rival dynasties – such as the Valois in France, the Přemsyls and Wittelsbachs in Bavaria, and the Jagiellons in Bohemia, Hungary, and especially Poland. But these marriages forged crucial bonds that established the foundations of Habsburg power. Far more attention has been paid to Habsburg women in early modern Europe, when the family dominated central Europe and Spain. The sisters and aunts of Habsburg emperors continued the work of their imperial ancestors, and took it one step further when they served as governors or local rulers of the family's vast and complex territorial possessions, particularly in the Low Countries.[75]

The Golden Bull of 1356 signed by Emperor Charles IV formalized the elective process for an emperor, but seemingly left untouched, or unconsidered, the subordinate status of the empress who, unlike Byzantine empresses, remained simply the emperor's wife and would never succeed to rule in her own right. After Louis IV (d. 1347), the imperial title was contested among various claimants, with Habsburgs of the male side excluded from inheritance. Claims to imperial right to rule passed through female side of the family until the election of King Albrecht II in 1438. On the death of her father, Queen Mary of Hungary (d. 1395), first wife of Emperor Sigismund, was queen-regnant of Hungary at the age of ten, with her mother Elisabeth as regent. Hungarian nobles challenged her direct rule and, from 1387, she ruled with Sigismund. She died childless, and Sigismund married Barbara of Celje, one of Mary's kin, who became an empress in 1410 when Sigismund was elected emperor. They had no sons but their only child, a daughter, Elisabeth, married Albrecht V, Duke of Austria in 1421. Like her mother, Elisabeth was active in the governance of the realms as regent of Hungary in 1439–40. After the death of her father in 1437, she was passed over in the succession; Albert was elected King of Hungary, Bohemia and Germany, and was crowned in 1438. After his death one year later, she was a candidate for the Hungarian throne but, in a move reminiscent of Berenguela of León in the early thirteenth century, she

ceded her rights to her infant son Ladislaus. She ruled Hungary as monarch until 1441, when the Hungarian council, facing military threats from the Ottoman Empire, decided in favor of her son.

With the accession of Frederick III and Leonor of Portugal (d. 1467), daughter of King Duarte and Leonor of Aragon, the Habsburg family reasserted its dominance in European politics and this skillful use of a particularly strategic marriage merged Austrian, Spanish and Burgundian inheritances into a single potent political entity. The marriage of their son Maximilian to Mary of Burgundy, the only child of Duke Charles 'the Bold' and Isabelle of Bourbon, brought to the Habsburgs a congeries of lands and wealthy mercantile cities in the Low Countries, and the vast wealth of one of the largest apanage realms of France.

In February 1477, Mary inherited her father's duchy; by August she had married Maximilian. Mary died aged twenty-five, leaving behind a legacy of artistic patronage and two children whose double marriage was designed to counterbalance the power of both France and England. Their son and daughter married the daughter and son of Fernando of Aragon and Isabel of Castile: Archduke Philip IV married Juana in 1496, and Margaret married Juan in 1497. Both wives outlived their young husbands: Juan died six months after the wedding, Philip in 1506. Nevertheless, Mary of Burgundy fulfilled the expectations of a Habsburg empress through her grandson, Charles, the son of Juana and Philip. Charles succeeded his paternal grandfather as Holy Roman Emperor and his maternal grandparents as King of Castile and Aragon. Mary's granddaughter, Margaret, was childless and twice-widowed – her second husband, Philibert of Savoy, died in 1504. Margaret's legacy, however, was as a woman who was publicly politically active and who ably governed the Low Countries as regent for her nephew Charles from 1507 to 1515, and again from 1519 to 1530. In this, she followed the lead of her Spanish aunts in the Crown of Aragon who had served in a similar office as queen-lieutenants. The Austrian and Spanish branches of the family would rule various parts of Europe until 1918.

The Habsburg family ties remained strong in Hungary. Agnes (d. 1364), one of the twelve children of Habsburg Emperor Albrecht I and Elisabeth of Carinthia, married Andrew III, the last Árpád king of Hungary. After his death, she had to deal with civil war, adjudicated disputes among her relatives and administered western Habsburg territories. She and her mother established the abbey of Königsfelden in memory of Albrecht, and the site became important in the commemoration of the Habsburg family. Noted for her piety, the German mystic Master Eckhart dedicated writings to Agnes.

Queens involved in cultural patronage were instrumental in the north and eastward spread of Italian renaissance humanism. Beatriz of Naples (d. 1508) was the daughter of Ferrante I of Naples and Isabella of Taranto. Educated in Naples, where queens ruled in their own right, Beatriz was queen-consort to two kings: Mattias Corvinus of Hungary and, subsequently, Vladislaus II of Bohemia and Hungary. Her cultural influence was also important, and she was instrumental in introducing Italian renaissance ideas to the court of Hungary. She promoted Mattias's work on the Bibliotheca Corvniniana, supported the building of the Visegrád Palace as a residence for the court and created an Academy. In 1477, she accompanied Mattias during the invasion of Austria and, in 1479, she was present during the peace treaty between Mattias and Vladislaus II. Beatriz was childless, and conceded that her husband's illegitimate son János Corvinus should succeed. When Mattias died in 1490, Beatriz had strong allies among the Hungarian nobility who insisted that Vladislaus marry her. This marriage was, yet again, childless and contested. Vladislaus had not been officially divorced from his first wife, he claimed that he had been forced to marry Beatriz against his will, and therefore his marriage to her was not legal. In 1500, the pope declared the marriage to be illegal, and Beatriz was forced to pay the costs of the trial.[76]

A few queens in eastern Europe ruled in their own right, even if only briefly. Maria, Queen of Hungary and Poland (1371, r. 1382–95) was the eldest surviving daughter of Louis I of Anjou. Maria was crowned king (rather than queen) at the age of twelve, with her mother as regent, but was deposed in 1384. Her usurper was murdered on her mother's instructions, and her mother was also subsequently murdered. Maria ruled jointly with her husband, Sigismund of Luxembourg, but died childless and was succeeded by her husband.[77] Jadwiga of Hungary, Queen of Poland (b. 1373, r. 1384–99), younger sister of Maria, was married in 1384, aged twelve, to the newly-converted pagan Jagiello of Lithuania. Jadwiga took a cue from earlier queens who married pagan husbands and used Christian piety as a way to emphasize both holiness and legitimacy, and practiced abstinence when pregnant and was chaste after the birth of three children. Jadwiga and Jagiello ruled jointly until Jadwiga died in 1399, one month after giving birth to a child. The Habsburg princess Elizabeth (d. 1505) married King Casimir IV of Poland in 1454; they had twelve children, and firmly established the Jagiellon dynasty. Three of Elizabeth's children became kings of Poland-Lithuania; she supported her family members embroiled in the various Habsburg family rivalries.[78]

The Scandinavian Queen Margaret of Denmark (d. 1412) may well be the medieval queen who inherited and governed more realms than any

other queen.[79] Daughter of Valdemar IV (d. 1375), Margaret was queen-consort of Norway and Sweden upon her marriage to Swedish King Haakon VI in 1363; queen-regnant of Denmark, Norway and Sweden; and founder of the Kalmar Union which united the realms under a single ruler for over a century. Until her reign, Denmark did not have a tradition permitting women to rule, and the confusion over the status of queenship is evident in the various titles she used. When her son died, she was named 'All powerful Lady and Mistress' (regent) of the kingdom of Denmark. After her father died, she called herself Queen of Denmark; in 1387, when her seventeen-year-old son, Olaf, died, she was named regent. She sometimes referred to herself as 'Valdemar the King of Denmark's daughter' and 'Denmark's rightful heir', but Pope Boniface IX simply called her 'most excellent queen of Denmark, Sweden and Norway'.

Like her predecessors Elisabeth of Luxembourg and Berenguela of León, Margaret's first political act was to abdicate and finesse the election of her infant son as King of Denmark; she then ruled as regent of Norway and Denmark until 1380. Margaret convinced the Swedes to expel King Albert of Mecklenburg in 1386 and to elect her son Olaf to the throne. After his death one year later, Margaret was chosen as regent of Norway and Sweden – a clear indication of how uneasy the nobles were to have a queen rule alone. Margaret was careful not to risk alienating her nobles, but each of the three realms had rather different ideas on what should be done, with Norway favoring a co-rulership of Margaret and a king. She chose her great-nephew, the young Erik of Pomerania, and adopted him as her successor to Norway, Sweden and Denmark; however, she was the source of authority until her death. Margaret was a tough-minded queen, who ordered the destruction of private castles, prohibited private warfare, strengthened the royal court system and improved relations with church. Her legacy of diplomacy was enshrined in what is perhaps her most significant act. In June 1397, Margaret summoned a council in Kalmar that approved the Act of Union of the three realms.

Conclusions

Late medieval political theories of power and gender, based in the age-old belief that women were not suited to governance but were ideal custodians of their children, were put to the test over and over in the later Middle Ages. For the most part, these ideas held steady but, almost as often as not, circumstance trumped theory and queens were active

everywhere – at court, in the royal household, in church, with their family, in their libraries. The geographic variation in practices is striking, and comparisons across space seem to show more contradictions than continuity. However, on closer inspection these differences appear only when the subject is political involvement. Geography mattered. Differences in custom, law and historical precedent created regional political cultures with distinct ideas regarding the interplay of kings and queens in monarchy. In some realms, notably France, the queen's direct and formal involvement in government as queen-regnant was curtailed, but queens-regent grew more influential. In England, the queen-regent was abandoned in favor of a male Protector; however, one century later two queens in succession inherited and ruled. Queens were more likely to step forwards formally as a queen-regent. In late medieval Scotland, this was acceptable because of the Scots' favorable experience of a queen acting as a regent, as in the case of Mary of Guelders. Likewise, two centuries of Aragonese queens-lieutenant made it easy for Fernando of Aragon, whose mother was a queen-lieutenant, to accept his wife Isabel of Castile as a queen in her own right.

Queens of England, Spain and France dominate the scholarly work of the history of the later Middle Ages; however, they do so not because they were more important, but because the sources for their reigns are more accessible in translation and in print. A cursory glance at the bibliography reveals an important fact: queens from eastern and central Europe have gained prominence in the scholarly literature in English, French and Spanish since 1989, when the libraries and archives of Hungary, the Czech Republic and Poland were opened to foreign scholars. Two trends are apparent from this new work. First, the late date of Christian conversion of eastern Europe means that older forms of social and political organization created a monarchy rather similar to that of the early medieval Frankish realms, where queenship was poorly instituted as an office: queens were more likely to rule in their own right, but they ruled an unstable realm and their reigns were often brief and volatile. And among these queens are the most prominent late medieval saint queens such as Jadwiga of Poland, who took up the work of founding religious institutions, converting their subjects and working closely with Church officials.

Second, the single most important constant across time and space was the fact that monarchy is about family. Dynasty, marriage and motherhood shaped the course of a queen's life and reign. In most, but not all, parts of Europe, the queen's coronation became the key to legitimizing a king's family as a dynasty. Even in places such as Castile and

the Crown of Aragon, where coronation of both king and queen was intermittent, it was used to legitimize a foreign queen or a former mistress. Although some queens came to their marriage with inherited lordships that enhanced their standing in the realm, for most queens it was their status as wife and mother that gave them access to formal official political authority. However, the lack of a solid institutional framework, particularly in Hungary, seriously weakened queens' ability to work effectively.

As part of the creation of a dynasty, a queen's proximity to the king determined her ability to do almost anything. She was a nexus between him and others, and she symbolized the possibility of social cohesion. The marriage of Elizabeth of York and Henry VII in the Wars of the Roses unified the feuding houses of Lancaster and York, ended the Wars of the Roses and propelled the Tudor dynasty from its royal origins with the marriage of Catherine of Valois and Owen Tudor. Elizabeth was superbly well-connected – she was the daughter of a king (Edward IV), sister of a king (Edward V), niece of a king (Richard III), wife of a king (Henry VII), mother of a king (Henry VIII), and grandmother of two queens (Mary I and Elizabeth I) and a king (Edward VI). However, being situated both inside and outside of official power placed queens-consort in a perilous spot during a crisis. Queens such as Isabeau of Bavaria and Margaret of Anjou were easy scapegoats for disgruntled enemies or anyone more interested in self-protection rather than guarding the realm or the royal family. But, unlike Margaret of Anjou, who was also propelled into a position of authority when her husband was incapacitated and was vilified in contemporary chronicles, Isabeau was never condemned for overstepping the bounds of her office as queen and regent.

As mothers, queens took their cues from the Virgin Mary and, as the centerpieces of their reigns, used her example of maternal devotion, and mediation and intercession (Illustration 4.6). A common story is that of the self-sacrificing queen who would fall on her sword – if she had one – for her children. The best examples are the English queens during the Wars of the Roses but even Isabeau of Bavaria, who disinherited her son and married her daughter to the enemy king, had acted in defense of her sons until it seemed to her impossible to do so. Pregnancy, real or imagined, was in and of itself a powerful trump card that so many queens played brilliantly. Froissart made Philippa of Hainault pregnant to emphasize the lengths to which she would go on behalf of her subjects. Isabel of Castile used pregnancy to offset perceptions of masculinity aimed at a ruling queen and quietly, at least in public, never scolded Fernando for his extramarital affairs. This is what makes the problem of

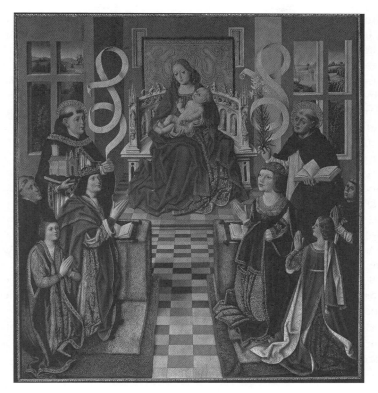

Illustration 4.6 Spanish school, *La Virgen de los Reyes Catolicos* (The Virgin of the Catholic Kings), 1490, oil on wood (?), Madrid, Prado Museum. © Album/Art Resource, New York.

the childless queen so vexing and the case of María of Castile so striking. Childless for decades, her husband Alfonso never seriously considered an annulment, and her work as his lieutenant made possible his conquest and governance of the kingdom of Naples.

Most queens, but not all, left the work of governing to the university-educated professional bureaucrats of the chancery, treasury and household. But they were invaluable as advisors to the king, tutors of the children and managers of their own households. They were more literate, in more languages, than their predecessors and many took a greater interest in the arts. They were spurred by the excitement of new religious forms, new translations of ancient texts, new ideas circulating among the poets of the renaissance. The impressive literary patronage of queens like

Anne of Brittany and Beatriz of Naples typifies the cultural power and influence available to queens in the early renaissance. Trastámara queens Catalina of Castile, Leonor of Albuquerque, and María of Castile, and the Habsburg queens and empresses point to the importance of studying queens in groups, and highlight the fact that monarchy truly was a family affair. It is clear that the whole family was part of the circulation of power and influence in all its forms, even the education of children, particularly princesses. Anne of Beaujeau's *Lessons for My Daughter* is a genre like the mirror of princes that is invaluable for its insights on how queens raised their daughters.

Finally, recalling the vignette with Blanca of Navarre on a royal procession that opened this chapter, court ceremonial was a key part of establishing and emphasizing the importance of the queen as bride-to-be, wife and mother. Her coronation and related complex ceremonials infused with social hierarchy, religious significance and the majesty of monarchy are part and parcel of the royal court. By the late Middle Ages, the court was a place of theatre, dancing and gallantry, and the moral ordering of court was a model of religious observance and patronage. A queen was intricately part of this display of monarchy before subjects who paid homage, paid taxes, danced at the ceremonies for her coronation, petitioned for the queen's intercession, feted her at her wedding, cheered the birth of her children, fought in wars, feared her power, and prayed for her soul when she died.

For further research

For all we do know about late medieval queens, there is still so much we do not. But the abundance of sources, new methodological approaches and new theoretical frameworks makes this a particularly ripe field for queenship research. First, we need basic research on the lives of German queens and empresses, Byzantine empresses, eastern and central European and Scandinavian queens. It is curious that, except for Isabeau of Bavaria, medieval Valois queens have not been studied extensively. Moreover, we know little about Yolande of Aragon, yet her link with Isabeau and Charles VIII suggests that connections of queens across family lines and political borders were important to a king's success. This is potentially a rich new field of inquiry that combines feminist and gender theory with social theory on networks and alliances, and is facilitated by collections of extant letters in many royal archives.

For as much as marriage and maternity mattered, we need more infor-

mation about medieval knowledge of the medical aspects of pregnancy, infertility and impotency. We know that queens were important to the legitimation of marriage, but surprisingly few comparative studies have been undertaken to study the queen as second wife, and the impact of legitimate and illegitimate children. Genealogical charts from the Middle Ages are fountains of family data, but their modern forms are shockingly incomplete. It will take decades of work to compile complete genealogies of royal families that include not just all births, but all pregnancies, miscarriages and stillbirths. We know very little about the childless queen – the circumstances of her inability to bear a child, the medical records of her pregnancies, and information on the king's fertility. Fertility was of paramount importance for queens and, in order to understand this dimension of queenship more fully, considerably more work is needed on the maternity of queens.

As royal bureaucracies grew in size, more and more chroniclers' writings included detailed information about queens. At the same time, royal secretaries wrote the letters for queens and then preserved copies in archives, and royal fiscal officials recorded and preserved their household accounts. With more people literate, a growing economy that provided enough wealth to permit discretionary spending, the rise of middling ranks, and the invention of printing increased both a demand for and a supply of narrative sources. Literature in the vernacular in the form of poetry and plays tells of fictional queens, which was often a safe stand-in for the real woman, and provides valuable insights into attitudes towards queens. But, as we work with narrative sources, it is important to be attentive to how medieval narratives were fabrications whose truths reveal the anxieties and perceptions of their writers along with details on what queens did and where they went. By focusing on both gender and genre, the methods of literary scholars are useful in understanding how deeply-embedded literary narratives reverberate among various texts such as chronicles, parliamentary proceedings, diplomatic correspondence, ballads, poetry and drama.

The economics of queenship is a relatively new field but one that begs to be exploited. For all queens of this period, scholars have at least some records of the dower and dowry transactions, often preserved as treaties or in the fiscal accounts of the kings. Some of this material has been transcribed, translated and edited; increasingly, records such as this are available in digitized form. Some of the household accounts, estate records, wills and inventories are rich resources for what the queen owned, purchased, received, or gave as a gift. These are fascinating traces of the material culture of queenship from the dining hall to the wardrobe and

from the library to the stables. The bureaucratization of royal government generated mountains of parchment and paper that makes it possible to trace a queen's patronage, donations and gifts to family and household servants through royal financial records, household accounts, queen's personal accounts, or the ducal or comital accounts of their inheritances. Survival of documents is sporadic and depends greatly on how badly damaged royal archives were in warfare, or simply the devastations of time, water, rodents, fire and haphazard collection practices. But there are rich resources awaiting the intrepid scholar.[80] In Portugal, there has been considerable work undertaken on the administration of the queens' lands. What is needed is an analysis of queens' accounts and how they were affected by wider economic trends in history. For instance, how did the economic instability after the demographic decline of the mid-fourteenth century affect queens' household accounts? How did this change their charitable donations and patronage? Using urban records of royal entries, city plans and maps, royal itineraries and letters, it should be possible to reconstruct the cost of hosting a royal procession and determine who paid for it. Existing studies on royal taxation and fiscal accounting coupled with analyses of the economics of queenship are important in order fully to understand the economics of monarchy.

There is a considerable body of scholarship on the political theory of late medieval kingship, but very little on queenship. Christine de Pizan is the natural starting place, but basic questions still remain unanswered. For example, how does the 'crisis of monarchy' in the later Middle Ages affect queenship? What can scholarship on a king's illness, mental or physical, tell us about queenship? Can it tell us something about the actions of a queen like Isabeau of Bavaria and the reactions of her subjects that we do not already know? We still do not know how late medieval developments in government – parliamentary institutions, conciliar theory, papal-royal dynamics, town councils – affected the role of the queen in the public political sphere.

For the first time in the Middle Ages, the sources include a woman writer of a political treatise, Christine de Pizan. Political theory needs to include more than just the responses to the Valois version of the Salic Law, but many of these treatises are not available in translation, and some exist only in archived originals. This is a potentially rich area that needs to be studied alongside theories on kingship, absolutism and divine right that have profound implications for queenship. The abundant work on Christine de Pizan, and early modern and renaissance studies that read medieval political theory through gender, have begun to

connect theories of kingship and queenship but, on the whole, there are very few studies on the Middle Ages. For example, conciliar theory written as result of papal schism trimmed the authority of kings, but its effect on queens has not been studied, and there is very little work on queens who worked closely with the parliamentary assemblies. Much more research is needed on how queenship and a queen's role in society were expressed by male authors; for example, John Gower's *Confessio Amantis*.[81]

Art and literary patronage is an exciting field of research. For example, Isabeau of Bavaria had an impressive personal library that she took with her when she traveled; she also possessed a large collection of pious works. Wills and inventories are treasure troves of information that have just begun to be examined and, in terms of both method and theoretical approach, this work sheds valuable light on queens while offering a promising avenue of research on many other queens who were book-owners and important arbiters of culture. Extant letters are more plentiful for late medieval queens and, although many are still unpublished, they are rich and provide a vivid glimpse into a queen's intellect.

For English queens, the official documentation is quite rich, increasingly so in the late fifteenth century. Evidence for queens who were active in governance, particularly Margaret of Anjou as regent for Henry VI, is abundant in the Acts of Parliament, calendars (of Charter Rolls, Close Rolls, Patent Rolls, State Papers), chronicles, exchequer accounts, household accounts, letters (both royal and from private subjects such as the Paston and Lisle families), records of the justices of the peace and records of the Privy Council.[82] For queens less active in a public political setting, coronation records, accounts of royal processions and civil ceremonies and wills are valuable documents of more subtle forms of power and influence.[83]

France at one point no doubt had similar records, but many of the royal and regional archives were destroyed in centuries of warfare, most significantly during the French Revolution. However, in the later Middle Ages, artists and artisans produced an astounding wealth of manuscript painting, architecture, sculpture, literature and music, and a plethora of personal objects such as jewelry, hats, shoes, clothing and personal objects, both devotional and for pure secular pleasure. Art historians and cultural historians use anthropological theories as a way to interpret the dizzying signs and symbols of gendered power.

5

The Transformation of Queenship from Medieval to Early Modern Europe

For all the changes that took place between 300 and 1500 CE in both theory and practice, monarchy in the Middle Ages remained a strongly gendered institution. The expectations and actions of a queen or empress were determined largely by the fact that she was a woman. As such, queens were part of the broader category of 'woman' and subject to the western stereotypes of sexual temptress, frailty, incapacity and adultery. No matter how they gained their power and authority, as mother or wife, it was as 'woman' that they were most often judged. This is evident in all aspects of a queen's life, but Christianity made a queen's gender most visible even as local customs made it variable from place to place. The Virgin Mary and Empress Helena served as models for queens and empresses, who were expected to embrace a form of queenship that blended sanctity and maternity. A very human and less-than-saintly queen could face harsh criticism when she did not live up to such expectations, and even the most proper queen who agitated her enemies could face rumor and innuendo, or accusations of infidelity.

Dynasty, marriage and motherhood were constants that shaped a queen's life and reign. In most, but not all, parts of Europe the queen's coronation became the key to legitimizing her status in the royal family and the realm, and a king's family as a dynasty. Even in places where coronation of both king and queen was intermittent, such as the Iberian

realms, it legitimized a foreign queen or a former mistress. In some realms, the lack of a solid institutional framework for queenship in the institution of monarchy seriously weakened their ability to work effectively. No matter when or where, empresses and queens owed their position to their families, to their circumstances of birth, marriage and motherhood. Even a queen who ruled in her own right gained that through her status in a royal family. But, as the lives and reigns of medieval queens and empresses show so clearly, family as a legal and social form was not constant and circumstances of health and fertility made queenship vary even when legal and social conditions were optimal for queens. In the early Middle Ages, a family was a more fluid and capacious entity, more horizontally structured as a kin group; but subsequent laws on incest and consanguinity made the family a narrower, more nuclear and more tightly-knit unit bounded by law. Family was, however, an important social bond and, throughout the Middle Ages, the exchange of women in marriage legitimized the dynastic intent of a king. Queens were vital to the health of the realm and its good governance, and they expressed this in their piety and maternity. However, as the lives of many queens attest, a queen's success was not entirely dependent on her religious devotion or her ability to bear children – much still depended on her relationship to her father or husband.

As mothers, queens took their cues from the Virgin Mary and used her example of both maternal devotion, and mediation and intercession as the foundation of their reigns. A common story is that of the self-sacrificing queen who would do anything for her children. Isabeau of Bavaria, Philippa of Hainault and Isabel of Castile all used maternity and pregnancy to augment or bolster perceptions of their husband's masculinity. This is what makes the problem of the childless queen, especially one not repudiated by her husband, so vexing. The number of childless queens is surprising, given the strongly held cultural expectation that a queen bear children. One constant through the Middle Ages is that queens – as the mothers, wives, sisters and daughters of kings – were responsible for preserving the family memory. They used their wealth to sponsor writers, artists and architects who memorialized the royal family in their chronicles, prayer books and royal mausoleums. They supported old and founded new religious orders – the Cistercians, Franciscans, Dominicans – and maintained strong alliances with bishops, popes, monks and nuns as a way to ensure that the souls of the royal family were remembered in prayers.

Queenship studies has clarified the role of the queen or empress and, in so doing, has changed the historiography of kingship and monarchy.

Early medieval queens, empowered by virginity or marriage, shared in the public work of monarchy. The ninth-century political developments in the wake of the divorce case of Lothar and Theutberga prompted a learned consideration of the question of what makes a king a king and, as a result, what makes a queen a queen. Coronation rites for a queen stressed piety, fidelity and her partnership in rule with the king. Although most early medieval queens did not rule directly, they could be part of the governance of the realm as a regent or guardian of the heir. By the end of the eleventh century, changes in inheritance, property-holding and religious and political ideology affected a queen's opportunities in both the domestic and the public domains. Monogamous marriage emphasized a queen as a mother and central to a legitimate dynasty. The royal courts were the main power centers and women as well as men inhabited them; from the eleventh century onwards, the monarchy was increasingly complex and bureaucratic. Royal courts of justice met regularly, they were staffed by legal experts, and royal accounting and fiscal agencies were staffed by financial experts. High status women could no longer exercise political power as extensively or as conspicuously as before, but they continued to exercise it, and in the old ways.

Moreover, queenship studies has transformed traditional interpretations of medieval history. For example, the movement of queens-consort across borders in 'the link of conjugal troth' challenges traditional analyses of medieval Europe that divide space into kingdoms and chronologies into timelines of the life of kings. In the period between 1100 and 1350, many English queens worked with their husbands and fathers to build a political entity that encompassed lands in England, France and Ireland and, at times, Scotland. Capetian French queens-consort and queens-regent helped the kings who struggled against England for dominance. Iberian queens literally held down the fort, or castle, while their husbands and fathers fought Muslim caliphs and kings along a dangerous frontier. Trastámara queens and Habsburg queens and empresses highlight the fact that monarchy truly was a family affair. The multiple crisscrossing of the lives of queens and kings intersected in every way, creating a powerful network of power – familial, linguistic, cultural, religious and economic – that provided a queen-consort with a wide variety of ways to express herself as on a truly international platform. This work challenges older political theory that posits power and authority in descending or ascending arcs, either derived from God or from the governed. Thinking of political power as networks organized horizontally across families is more attuned to sociological theories of association and opens up a wider field of research on monarchy.

Medieval political theories of power and gender were put to the test over and over again in the later Middle Ages. These ideas remained strong, but circumstance often trumped theory and queens were active everywhere – at court, in the royal household, in church, with their family, in their libraries. The geographic variation in practices is striking. Differences in custom, law and historical precedent created regional political cultures with distinct ideas regarding kings and queens. In France after 1328, the queen's direct and formal involvement in government as queen-regnant was curtailed, but the office of queen-regent remained powerful. In England, the role of queen-regent was abandoned in favor of a male Protector, but one century later two queens in succession inherited and ruled. The Aragonese queen-lieutenant, a novel institution, was devised as a way to solve their pressing need to govern newly-conquered realms. And two centuries of Aragonese queens-lieutenant made it easy for Fernando of Aragon, whose mother was a queen-lieutenant, to accept his wife Isabel of Castile as a queen in her own right. Kingship was as much in flux as queenship, a case in point being the French amendments to the Salic Law that excluded women from the succession. This was not firmly established until after 1420; neither was it settled definitively whether the king had the right to determine his heir. Thus, Isabeau of Bavaria was not entirely incorrect when she assumed, as she signed the Treaty of Troyes, that the crown would pass through her daughter Catherine. Queens of Jerusalem, at the front lines of a frontier with the powerful Muslim caliphate and Seljuk Turks, literally had to make it up as they went along to be able to hold the fragile realms they inherited. The Mediterranean islands of Sicily, Naples and Cyprus retained a monarchy after the Norman conquests, but queens all but disappeared in Italy. Similarly, native Irish queens disappeared in the twelfth century. In the twelfth century, three prominent queens ruled in their own right – the Empress Matilda, Queen Urraca of León-Castile and Berenguela of Castile. But it would be four centuries before another queen-regnant would appear in any of the realms of Iberia. Isabel of Castile struggled to balance her reign with the demands of natal family, her marriage, and her religion, and took a cue from her predecessors.

By the later Middle Ages, most but not all queens left the work of governing to the university-educated professional bureaucrats of the chancery, treasury and household. But they remained valuable advisors to the king, tutors of the children and managers of their own households. Spurred by the excitement of new religious forms, new translations of ancient texts, new ideas circulating among the poets of the renaissance, they found new avenues of expression. The impressive literary patronage

of queens like Anne of Brittany and Beatriz of Naples typifies the cultural power and influence available to queens in the early renaissance. Court ceremonial and coronation, imbued with social and religious significance, symbolize the majesty of monarchy. By the late Middle Ages, the court was a place of theatre, dancing and gallantry, and the moral ordering of court was a model of religious observance and patronage. A queen was intricately part of this display of monarchy before subjects who paid homage, paid taxes, danced at the ceremonies for her coronation, petitioned for the queen's intercession, feted her at her wedding, cheered the birth of her children, fought in wars, feared her power, and prayed for her soul when she died.

In the early modern period, after 1500, perhaps the most visible change is that the office of the queen-regnant continued, against all the efforts to prevent it, in the celebrated reigns of Mary Tudor, Mary Queen of Scots and Elizabeth Tudor. Not only was Elizabeth a virgin queen, but also she broke all the rules by not marrying at all.[1] Far more common was the queen as a stand-in for her father, her husband or her young son. She embodied two twinned concepts: female exclusion from direct inheritance and ruling, and inclusion in the vital interests of the royal family as mediator or regent.

Starting in the later Middle Ages and continuing into the early modern period, the office of the queen-regent took on new prominence. In England, Catherine of Aragon governed England briefly in 1513 while Henry VIII was on campaign in France, which was a significant change from the exclusively masculine office of Lord Protector during the later Wars of the Roses.[2] In Spain, Isabel of Portugal governed at various points for her husband, Emperor Charles V, who spent more time outside Spain than in it.[3] Beginning in the fifteenth century, the queen-regent in France took on new levels of influence. Isabeau of Bavaria's regency has been interpreted by some historians as either the culmination of medieval developments that place the regent as a placeholder for the king, or as the first of six early modern French queens-regent who governed the kingdom between 1483 and 1651. She was followed by Anne of Beaujeau, Louise of Savoy, Catherine de' Medici, Marie de' Medici and Anne of Austria.[4] Anne of Beaujeau raised regent Louise of Savoy and Marguerite of Austria, who became regent for the Netherlands for the Emperor Charles V.[5] Anne of Beaujeau's advice to her daughter in *Letters* is strikingly similar to Christine de Pizan's *Book of Three Virtues*.[6] But, in the early modern period, the king came to rely increasingly on a new class of royal official: the secretary. These were powerful men, indeed – Mazarin and Richelieu in France, Olivares in Spain – and, in

some ways, they displaced the queen as the king's confidante; however, at the same time, they could very useful to a shrewd queen.

When not bound by ideology or tradition, as in the medieval Crown of Aragon and the office of the queen-lieutenant, they tweaked the mechanisms of governance and were opportunistic, taking advantage when they could of local legal and political customs. The viceroy supplanted the office that Isabel abandoned in the fifteenth century, but queens remain vital to monarchy as regents and guardians of the heir. These strategies and practices were embedded in the institution of monarchy that operated within the public political sphere where both king and queen were capable of exercising both political power and authority through official and unofficial channels.

A queen's proximity to the king mattered in the early modern period as much as the medieval. She was a nexus between him and others and, in this, she symbolized the possibility of social cohesion. But being situated both inside and outside of official power placed queens-consort in a perilous spot during a crisis. Queens who exercised public authority were easy scapegoats for disgruntled enemies or anyone more interested in self-protection than guarding the realm or the royal family. Renaissance and early modern queenship superficially looks much like that of the Middle Ages, with a queen as wife, mother and guardian of her children, and responsible for their education. But queens Catherine of Aragon and Mary Tudor suffered the consequences facing a queen who does not bear sons, or whose sons do not survive infancy, or a childless queen.

Queenship took on a truly transnational character in the Habsburg empires of Spain and Austria. In 1452, Frederick III (d. 1493) became first and last Habsburg to be crowned Holy Roman Emperor by the pope in Rome, and the dynasty survived in various forms until 1918. Frederick's shrewd skills in marital alliance-building gave the family a wider influence in Europe with the marriage of his oldest son and heir Maximilian (d. 1519) to Mary of Burgundy, which secured, precariously, the Low Countries. Maximilian, in turn, negotiated a brilliant set of marriage alliances that gave the Habsburgs hegemony over central Europe, the Low Countries and Spain, and, for a short time, Spanish possessions in the Americas. His eldest son, Philip the Fair, married *infanta* (princess) Juana and his daughter Margaret married *infante* (prince) Juan, the daughter and son of Fernando of Aragon and Isabel of Castile. Juan died young and had no children with Margaret, but the children of Philip and Juana became Emperor Charles V (d. 1558) and Emperor Ferdinand I (d. 1564). Princesses carried with them of the cultural dominance of their Habsburg upbringing; they may have been foreign by birth to their new

subjects, but they were part of a Habsburg family wherever they went. Habsburg princesses continued to protect their family's interests and power across the continent. They had been vital to establishing the dynasty on the imperial throne in the thirteenth century, guided it back into power in the fourteenth and they were firmly situated in power in the fifteenth century. Habsburg women were crucial to the later success of both the Spanish and Austrian Habsburg kings and emperors. Some held the royal office; some governed local territories as regents, and continued to negotiate the marriages that held the family together across a wide geographic expanse. They were key figures in diplomacy in both religious and political disputes. Without them, it is doubtful that the Habsburg family would have been able to secure and hold their far-flung realms.[7]

For all the continuity from the Middle Ages, there are striking differences that are visible after 1500. Queenship in early modern Europe was decidedly ceremonial, far more public and lavish than in the Middle Ages. It was located in more capital cities such as London, Paris, Vienna and Madrid, with increasingly elaborate public pomp, processions and festivities in both cities and lavish palace complexes such as Buen Retiro, Fountainbleau, Versailles, Greenwich and Hampton Court. Queens were more likely to be formally educated and more literate, and they were both patrons of artists and subjects of their work. Portraiture as we now know it, with an intention of verisimilitude, has given us a wealth of visual imagery on a scale unheard of in the Middle Ages.[8] In the multiconfessional early modern world, so different from the religious unity of the Middle Ages, queens and empresses remained models of piety no matter what their personal faith. In Spain, queens founded new convents or endowed existing ones with counter-Reformation zeal. They may seem to take on a more private than public dimension, to leave the arena of politics and government to the king and his advisors. This may seem the case for the Spanish queens after the death of Isabel. To earlier scholars they seemed to disappear into the private corners of the court but, in fact, as Magdalena Sánchez argues, they were still formidably influential.[9] They just used the private spaces, such as a royal convent, as a way to have a quiet personal conversation with the king who, as a family member, was allowed into the private rooms of the convent, while his secretaries and ambassadors had to cool their heels outside, on the pavement. Queens had always been active in the promotion of art and culture but, in the later Middle Ages and early Renaissance, they were more prominent in the patronage and transmission of art of all types – painting, secular and ecclesiastical architecture, literature, drama and music.[10]

This means that there are many more sources available for the study of early modern queens that simply were not available in the Middle Ages, such as state papers and diplomatic papers and dispatches, tapestries, memoirs, published tracts and newspapers, popular fiction and cartoons.[11]

The consequences of the harsh misogynistic rhetoric of early modern writers and the increasingly bureaucratic state on queenship are most evident after 1650.[12] Queens had, by then, lost their rights to inherit and govern, and did not regain them until well into the nineteenth century. Monarchy became increasingly masculinized in the early modern era with the growth of ministers and secretaries, and the exclusion of women from the public political aspects of monarchy; this was abetted by authoritarian and absolutist tendencies across western Europe. In Spain, it is significant that the last two queens-lieutenant, María of Castile and Juana Enríquez, were Fernando's aunt and mother, respectively, and that their practice of queenship shaped kingship and, with it, monarchy. The degree of political engagement of these two women, as well as the partnership forged by them with their husbands, was not lost on him as he governed alongside Isabel and sought solutions to absentee rulership in a widely-dispersed collection of realms that included Castile, the Crown of Aragon and the Americas. He was well-trained in a monarchy that took full advantage of the entire royal family and, despite some early struggles to make shared sovereignty work effectively, Isabel and Fernando forged a monarchy in which king and queen were on equal footing.

Juana, queen-regnant in Castile, succeeded her mother, Isabel, in 1504 and jointly inherited her father's Aragonese realms with her husband and king-consort, Philip of Burgundy. At his death in 1506, her mental instability prompted her abdication of all responsibilities to rule. Bethany Aram argues that this was coerced and that her madness was used as a ploy for Fernando to rule in the name of his grandson, Charles V.[13] Juana's uncertain legal status – Fernando and Charles both consulted with her, and she continued to sign documents as queen throughout her life – created confusions that were only cleared up in 1555, when she died and Charles abdicated. It is significant that when Charles needed someone to govern one of his European realms when he was absent, which was often, he turned to the regency and appointed his wife, Isabel of Portugal, as well as his aunt, Margaret of Austria, and his sister, Mary of Hungary.[14] These were formidable women. Isabel, regent of Spain for Charles at several key points in the reign, was very much her husband's political partner. Margaret was regent of the Netherlands for her father,

the emperor Maximilian, from 1507 until 1514, and then from 1519 until 1530 for Charles. Mary was regent in Hungary after the death of her husband, Louis, and then succeeded Margaret as regent in the Netherlands from 1531 until 1555, where she was important to Charles late in his reign as he confronted the Protestants.

The year 1555, when Philip succeeded his father as King of Spain, signals an important shift in Spanish political life. The pragmatic and, in the Crown of Aragon, contractual, political culture of medieval monarchy transformed into an increasingly absolutist and bureaucratic form. The legitimate, officially sanctioned office of political authority of the Aragonese queen-lieutenant was curtailed sharply as Castilian institutional forms dominated the resulting Habsburg monarchy. Queens-lieutenant were replaced by powerful viceroys, secretaries and ministers, educated in universities and trained professionally, who governed for kings when they were absent, either physically or mentally. As a result, a previously dynamic relationship of monarchy that relied on both king and queen for its functioning became fixed in a position where the king was the superior authority and the queen relegated to a subordinate status. Monarchy in Spain ceased to be a working political partnership shared by a king and queen. This is not to say that early modern Spanish Habsburg queens and empresses were powerless, for they were influential women. However, their power was less likely to be official, legitimate authority and more likely to be unofficial, exercised privately. No matter how powerful any single Habsburg queen may have been, once the institutional linkage of queenship with the Aragonese lieutenancy was broken, the nature and location of a queen's power changed fundamentally and profoundly from that of her medieval predecessors.

In 1526 in Austria, the hereditary Habsburg lands had passed to Ferdinand (d. 1564), the brother of Charles V, who ruled a vast and disparate group of princely states that spanned central Europe. He and his successors had to contend with the impact of the Protestant Reformation that fragmented the realms into Protestant and Catholic territories, and the military forces of the Ottoman Turks that threatened the eastern borders. In this milieu, Habsburg empresses resembled their medieval counterparts in that they were particularly important to family politics. They were important as mothers, giving birth to exceptionally large families who continued to marry into the royal families across the continent. They were fundamental to the foundation of religious institutions, and were highly visible patrons of art, music, architecture, and literature. They maintained very close ties with their Spanish relatives. Habsburg women routinely married outside their natal realms, even

when they married cousins, but they were hardly 'foreign queens' because they brought with them a distinct idea of the Habsburg way of doing things, from court ceremonial to fashion that transcended Vienna and Madrid. Magdalena Sánchez opened the question of public and private power in her study of Habsburg women who were all from the same family in her book *The Empress, the Queen, and the Nun*. Since then, work on Habsburg women has taken her cue to study the interplay of public and private, family and dynasty, political and personal.

In England, the Tudor dynasty – which ascended to the throne in 1485 with Henry VII (d. 1509) and ended with the death of Elizabeth I in 1603 – faced problems of dynastic continuity. Unlike the Habsburgs, who had problems with the surfeit of sons who had to be provided with wives and lands, Henry VIII struggled to produce a male heir. His son Edward VI died in 1553 aged sixteen and the next two monarchs were women – Mary Tudor (Mary I) and Elizabeth Tudor (Elizabeth I). As elsewhere in Europe, queens struggled with religious divisions that tore apart the social and political fabric as Mary restored Catholic practices and then, when she died in 1558, Elizabeth restored Protestant practices. The political and philosophical implications of queens-regnant occupied some of the finest minds of the age. Political theorists and jurists began to take up in earnest the question of when women should or could rule as queens. Theorists such as Machiavelli admitted the possibility of women as princes, but left the question sufficiently open for various interpretations. Ideas on absolute monarchy began to take hold as a political ideology in an atmosphere of misogyny fueled by John Knox and his hostile treatise on the monstrous regiment of women. It is ironic that, for both Mary and Elizabeth, it was the queen's failure to bear a male child – and, in the case of Elizabeth, her failure to marry at all – that brought to power the Stewart family in the person of James I/VI, son of Mary, queen-regnant of Scotland.

In France, it took a century or two for absolute monarchy to take hold and, until then, there was a wide variety of options for royal women, but mostly as regent for their sons. French queens, too, had to struggle with Catholic and Protestant divisions, but none had a bloodier reputation than Catherine de' Medici, regent for her son King Charles IX, when French royal troops killed hundreds of Huguenots in the St. Bartholomew's massacre of 1572. Catherine was, however, one of many French queens-regent in the early modern period who ruled publicly alongside their sons, hand-in-hand with powerful secretaries – Marie de' Medici with Cardinal Richelieu for Louis XIII and Anne of Austria with Cardinal Richelieu and later Cardinal Mazarin for Louis XIV.

Queenship in the Middle Ages, both as a social status and a practice, admitted a wide range of ways for a woman to live and be a queen. Because it was fundamentally connected to kingship as part of monarchy, they formed a relational pair. Political partnerships that began out of necessity continued to thrive in realms driven more by pragmatic and practical concerns rather than dogmatic ideology, and where the people in charge were open to innovation. No matter what we call that partnership – queen-regnant, queen-regent, queen-mediator, queen-lieutenant, tutor of the royal children – and no matter whether formally established or informally practiced, and no matter when or where, medieval queens who were active in the public political realm faced similar challenges. They still faced the demand to have a male heir, and this imperative resulted in a divorce case in the sixteenth century – that of Henry VIII and Catherine of Aragon – that, for significance, rivaled that of Lothar and Theutberga in the ninth century.

Notes

Introduction: Not Partial, Prejudiced or Ignorant: The Study of Queens and Queenship in Medieval Europe

1. J. Austen, *The History of England from the reign of Henry the 4th to the death of Charles the 1st. By a partial, prejudiced, & ignorant Historian* (1791, The British Library Add. MS 59874; http://penelope.uchicago.edu/austen/ austen).
2. T. Earenfight, 'Highly Visible, Often Obscured: The Difficulty of Seeing Queens and Noble Women', *Medieval Feminist Forum* 44(1) (2008): 86–90; C. Beem, *The Lioness Roared: The Problems of Female Rule in English History* (Basingstoke: Palgrave Macmillan, 2006).
3. E. Kantorowicz, *The King's Two Bodies: A Study in Mediaeval Political Theology* (Princeton: Princeton University Press, 1957); F. Kern, *Kingship and Law in the Middle Ages* (Oxford: Oxford University Press, 1956); W. Ullmann, *A History of Political Thought: The Middle Ages* (Harmondsworth: Penguin, 1975); and J. M. Wallace-Hadrill, *The Long-Haired Kings* (London: Metheun, 1962).
4. R. W. Fawtier, *The Capetian Kings of France: Monarchy and Nation, 987–1328*, (trans) L. Butler and R. J. Adam (London: Macmillan, 1960).
5. P. McCracken, *The Romance of Adultery: Queenship and Sexual Transgression in Old French Literature* (Philadelphia: University of Pennsylvania Press, 1998).
6. A. Wolf, 'Reigning Queens in Medieval Europe: When, Where, and Why?' in J. C. Parsons (ed.), *Medieval Queenship* (New York: St. Martin's Press, 1993): 169–88.
7. J. L. Nelson, 'Medieval Queenship', in L. E. Mitchell (ed.), *Women in Medieval Western European Culture* (New York: Garland, 1999): 179–207.
8. C. E. Odegaard, 'The Empress Engelberge', *Speculum* 26(1) (1951): 77–103.
9. M. Boyd, *Rulers in Petticoats* (New York: Criterion, 1966); J. H. Dahmus, *Seven Medieval Queens* (Garden City, NY: Doubleday, 1972).

10 H. Lawrance, *Historical Memoirs of the Queens of England, from the Commencement of the Twelfth Century* (London: Edward Moxon, 1838); F. da F. Benevides, *Rainhas de Portugal; estudos historicos com muitos documentos* (Lisbon: Castro Irmão, 1878–79; repr. edn, Lisbon: Livros Horizonte, 2007).

11 A. Fraser, *Mary Queen of Scots* (New York: Delacorte, 1969); A. Fraser, *The Warrior Queens* (New York: Knopf, 1989); and A. Fraser, *The Wives of Henry VIII* (New York: Knopf, 1999).

12 A. Kelly, *Eleanor of Aquitaine and the Four Kings* (Cambridge: Harvard University Press, 1950); M. Facinger, 'A Study of Medieval Queenship: Capetian France, 987–1237', *Studies in Medieval and Renaissance History* 5 (1968): 3–47; E. Searle, 'Women and the Legitimisation of Succession at the Norman Conquest', *Anglo-Norman Studies* 3 (1980): 159–70.

13 J. McNamara and S. F. Wemple, 'The Power of Women through the Family in Medieval Europe, 500–1100', *Feminist Studies* 1 (1973): 126–41; J. McNamara, 'Women and Power Through the Family Revisited', in M. C. Erler and M. Kowaleski (eds), *Gendering the Master Narrative: Women and Power in the Middle Ages* (Ithaca, NY: Cornell University Press, 2003): 17–30; J. W. Scott, 'Gender: A Useful Category of Historical Analysis', *American Historical Review* 91(5) (1986): 1053–75; J. W. Scott, 'Gender: Still a Useful Category of Analysis?', *Diogenes* 57(225) (2010): 7–14; and S. L. Smith, *The Power of Women: A Topos in Medieval Art and Literature* (Philadelphia: University of Pennsylvania Press, 1995).

14 M. Erler and M. Kowaleski (eds), *Women and Power in the Middle Ages* (Athens: University of Georgia Press, 1988); L. O. Fradenburg (ed.), *Women and Sovereignty* (Edinburgh: University of Edinburgh Press, 1991). Later works on the subject of women and power include R. Averkorn, 'Women and Power in the Middle Ages: Political Aspects of Medieval Queenship', in A. K. Isaacs (ed.), *Political Systems and Definitions of Gender Roles* (Pisa: Edizioni Plus-Università di Pisa, 2001): 11–30; J. Carpenter and S. B. MacLean (eds), *The Power of the Weak: Studies on Medieval Women* (Urbana: University of Illinois Press, 1995); T. Earenfight (ed.), *Queenship and Political Power in Medieval and Early Modern Spain* (Aldershot: Ashgate, 2005); Erler and Kowaleski (eds), *Gendering the Master Narrative*; C. Levin, and R. Bucholz (eds), *Queens and Power in Medieval and Early Modern England* (Lincoln: University of Nebraska Press, 2009); J. C. Parsons, 'Family, Sex, and Power: The Rhythms of Medieval Queenship', in Parsons (ed.), *Medieval Queenship*: 1–11.

15 L. Huneycutt, 'Medieval Queenship', *History Today* 39(6) (1989): 16–22; and T. M. Vann (ed.), *Queens, Regents, and Potentates* (Denton, TX: Academia Press, 1993).

16 E. Herman, *Sex with the Queen: 900 Years of Vile Kings, Virile Lovers, and Passionate Politics* (New York: Morrow, 2006).

17 J. Davis-Kimball and M. Behan, *Warrior Women: An Archaeologist's Search for*

History's Hidden Heroines (New York: Warner, 2002); M. Yalom, *Birth of the Chess Queen* (New York: HarperCollins, 2004); L. Hilton, *Queens Consort: England's Medieval Queens* (London: Weidenfeld & Nicolson, 2008).

18 T. Earenfight, 'Without the Persona of the Prince: Kings, Queens and the Idea of Monarchy in Late Medieval Europe', *Gender & History* 19(1) (April 2007): 1–21.

19 L. O. Fradenburg, 'Rethinking Queenship', in Fradenburg (ed.), *Women and Sovereignty*: 1–13.

20 J. L. Nelson, 'Inauguration Rituals', in P. H. Sawyer and I. N. Wood (eds), *Early Medieval Kingship* (Leeds: University of Leeds, 1977), repr. in J. L. Nelson, *Politics and Ritual in Early Medieval Europe* (London: Hambledon, 1986): 283–307, esp. p. 304.

21 *Alcuini Epistolae*, in E. Dummler (ed.), *Monumental Germanica Historia (MGH) Epistolae*, vol. 4 (Berlin: 1895), no. 18; translated in J. C. Parsons, 'The Pregnant Queen as Counsellor and the Construction of Motherhood', in J. C. Parsons and B. Wheeler (eds), *Medieval Mothering* (New York: Garland, 1998): 39–61.

22 Parsons, 'The Pregnant Queen', quote on p. 42.

23 N. Silleras-Fernández, 'Widowhood and Deception: Ambiguities of Queenship in Late Medieval Crown of Aragon', in M. Crane, M. Reeves, and R. Raiswell (eds), *Shell Games: Scams, Frauds, and Deceits (1300–1650)* (Toronto: Centre for Renaissance and Reformation Studies, 2004): 187–205.

24 P. Strohm, 'Queens as Intercessors', in P. Strohm (ed.), *Hochon's Arrow: The Social Imagination of Fourteenth-Century Texts* (Princeton: Princeton University Press, 1992): 95–120;

25 P. Stafford, *Queen Emma and Queen Edith: Queenship and Women's Power in Eleventh-Century England* (Oxford: Blackwell, 1997).

26 T. Earenfight, *The King's Other Body: María of Castile and the Crown of Aragon* (Philadelphia: University of Pennsylvania Press, 2010).

27 W. Monter, *The Rise of Female Kings in Europe, 1300–1800* (New Haven: Yale University Press, 2012).

28 H. J. Tanner, 'Queenship: Office, Custom, or Ad Hoc? The Case of Queen Matilda III', in J. C. Parsons and B. Wheeler (eds), *Eleanor of Aquitaine, Lord and Lady* (New York: Palgrave Macmillan, 2003): 133–58.

29 C. Geertz, 'Centers, Kings, and Charisma: Reflections on the Symbolics of Power', in C. Geertz, *Local Knowledge* (New York: Basic Books, 1983): 121–46.

30 J. C. Parsons, 'The Queen's Intercession in Thirteenth-Century England', in Carpenter and MacLean (eds), *Power of the Weak*: 147–77; J. C. Parsons, 'The Intercessionary Patronage of Queens Margaret and Isabella of France', *Thirteenth-Century England* 6 (1995): 145–56.

31 F. Downie, 'Queenship in Late Medieval Scotland', in M. Brown and R. Tanner (eds), *Scottish Kingship, 1306–1488* (Edinburgh: John Donald, 2008): 232–54.

32 J. Herrin, *Women in Purple: Rulers of Medieval Byzantium* (London: Weidenfeld & Nicolson, 2001).
33 J. T. Schulenberg, 'Female Sanctity: Public and Private Roles, ca. 500–1100', in Erler and Kowaleski (eds), *Women and Power in the Middle Ages*: 102–25; I. McCleery, 'Isabel of Aragon (d. 1336): Model Queen or Model Saint?', *Journal of Ecclesiastical History* 57(4) (2006): 668–92.
34 J. Bak, *Coronations: Medieval and Early Modern Monarchic Ritual* (Berkeley and Los Angeles: University of California Press, 1990).
35 S. F. Wemple, *Women in Frankish Society: Marriage and the Cloister, 500–900* (Philadelphia: University of Pennsylvania Press, 1981).
36 T. Malory, *Le Morte Darthur. Sir Thomas Malory's Book of King Arthur and of His Noble Knights of the Round Table*, 2 vols (Charlottesville: University of Virginia Library, 1996); *The Nibelungenlied: the Lay of the Nibelungs*, C. Edwards (trans.) (Oxford: Oxford University Press, 2010); Chrétien de Troyes, *The Complete Romances of Chrétien de Troyes*, D. Staines (trans.) (Bloomington: Indiana University Press, 1990).
37 U. Bethlehem, *Guinevere: A Medieval Puzzle: Images of Arthur's Queen in the Medieval Literature of Britain and France* (Heidelberg: Anglistische Forschungen: 2005); N. B. Black, *Medieval Narratives of Accused Queens* (Gainesville: University Press of Florida, 2003).
38 C. de Pizan, *Book of the City of Ladies*, E. J. Richards (trans.) (New York: Persea Books, 1982); G. Boccaccio, *On Famous Women (De mulieribus claris)*, V. Brown (ed. and trans.) (Cambridge: Harvard University Press, 2001).
39 P. Hardie, *Rumour and Renown: Representations of Fama in Western Literature* (Cambridge: Cambridge University Press, 2012): 78–125.
40 *Vergil's Aeneid: Books I–VI*, C. Pharr (ed.), rev. edn (Lexington, MA: Heath, 1964), bk. 3, line 121: 152.
41 M. Ormrod, 'Monarchy, Martyrdom, and Masculinity: England in the Later Middle Ages', in P. H. Cullum and K. J. Lewis (eds), *Holiness and Masculinity in the Middle Ages* (Toronto: University of Toronto Press, 2005): 174–91; A. Remensnyder, 'Marian Monarchy in Thirteenth-Century Castile', in R. Berkhofer, A. Cooper, and A. Kosto (eds), *The Experience of Power in Medieval Europe, 950–1350* (Aldershot: Ashgate, 2005): 247–64.
42 S. de Beauvoir, *The Second Sex*, C. Borde and S. Malovany-Chevallier (trans) (London: Jonathan Cape, 2009; 1st French edn, 1949).
43 John of Salisbury, *The 'Historia Pontificalis' of John of Salisbury*, M. Chibnall (ed. and trans.) (Oxford: Oxford University Press, 1986); John of Salisbury, *Policraticus: of the frivolities of courtiers and the footprints of philosophers*, C. J. Nederman (trans. and ed.) (Cambridge: Cambridge University Press, 1990).

1 Theme and Variations: Roman, Barbarian and Christian Societies in the Fashioning of Medieval Queenship, c. 300–700

1. For a discussion of the word 'barbarian' and its alternatives, see E. James, *Europe's Barbarians, AD 200–600* (London: Longman, 2009): 1–15.
2. J. Herrin, *Women in Purple: Rulers of Medieval Byzantium* (Princeton: Princeton University Press, 2001).
3. F. Oakley, *Kingship: The Politics of Enchantment* (Malden, MA: Blackwell, 2006).
4. I. Wood, 'Genealogy defined by women: the case of the Pippinids', in L. Brubaker and J. M. H. Smith (eds), *Gender in the Early Medieval World: East and West, 300–900* (Cambridge: Cambridge University Press, 2004): 234–56.
5. J. L. Nelson, 'Early Medieval Rites of Queen-Making and the Shaping of Medieval Queenship', in A. Duggan (ed.), *Queens and Queenship in Medieval Europe* (Woodbridge: Boydell Press, 1997), 301–15; J. L. Nelson, 'Gendering Courts in the Early Medieval West', in Brubaker and Smith (eds), *Gender in the Early Medieval World*: 185–97.
6. D. N. Dumville, 'The West Saxon genealogical regnal list and the chronology of early Wessex', *Peritia* 4 (1985): 21–66.
7. L. Bitel, *Land of Women: Tales of Sex and Gender from Early Ireland* (Ithaca, NY: Cornell University Press, 1996); J. A. Smith, 'The Earliest Queen-Making Rites', *Church History* 66(1) (March 1997): 18–35; P. Stafford, 'Powerful Women in the Early Middle Ages: Queens and Abbesses', in P. Linehan and J. L. Nelson (eds), *The Medieval World* (Oxford: Routledge, 2001): 398–415; P. Stafford, 'Queens and Queenship', in P. Stafford (ed.), *A Companion to the Early Middle Ages: Britain and Ireland, c.500–c.1100* (Oxford: Wiley-Blackwell, 2009): 459–76.
8. J. McNamara, '*Imitatio Helenae*: Sainthood as an Attribute of Queenship in the Early Middle Ages', in S. Sticca (ed.), *Saints: Studies in Hagiography* (Binghamton, NY: Medieval & Renaissance Texts & Studies, 1996): 51–80.
9. D. Armstrong, 'Holy Queens as Agents of Christianization in Bede's 'Ecclesiastical History': A Reconsideration', *Old English Newsletter* 29 (Spring 1996): A–28; F. E. Consolino, 'Christianising Barbarian Kingdoms: Queens and Conversion to Catholicism (476–604)', in K. E. Børresen (ed.), *Christian and Islamic Gender Models in Formative Traditions* (Freiburg: Herder, 2004): 103–33; M. A. Meyer, 'Queens, Convents, and Conversion in Early Anglo-Saxon England', *Revue Bénédictine* 109: 40180 (1999): 90–116; J. L. Nelson, 'Queens as Converters of Kings in the Earlier Middle Ages', in C. La Rocca (ed.), *Agire da Donna. Modellie pratiche di rappresentazione (Secoli VI–X)* (Turnhout: Brepols, 2007): 95–107; S. Tatum, '*Auctoritas* as *sanctitas*: Balthild's depiction as "queen-saint" in the "Vita

Balthildis"', *European Review of History – Revue européenne d'histoire* 16(6) (2009): 809–34.

10 J. McNamara and S. Wemple, 'The Power of Women Through the Family in Medieval Europe, 500–1100', *Feminist Studies* 1 (1973): 126–41; P. Stafford, 'Sons and Mothers: Family Politics in the Early Middle Ages', in D. Baker (ed.), *Medieval Women* (Oxford: Blackwell, 1978): 79–100.

11 P. Stafford, *Queens, Concubines, and Dowagers: The King's Wife in the Early Middle Ages* (Athens: University of Georgia Press, 1983); S. F. Wemple, *Women in Frankish Society: Marriage and the Cloister, 500–900* (Philadelphia: University of Pennsylvania Press, 1981); D. Harrison, *The Age of Abbesses and Queens: Gender and Political Culture in Early Medieval Europe* (Lund: Nordic Academic Press, 1998).

12 Y. Hen, 'Gender and the patronage of culture in Merovingian Gaul', in Brubaker and Smith (eds), *Gender in the Early Medieval World*: 217–33; A. L. McClanan, *Representations of Early Byzantine Empresses: Image and Empire* (New York: Palgrave Macmillan, 2002); F. Curta, 'Merovingian and Carolingian Gift Giving', *Speculum* 81(3) (2006): 671–99.

13 D. Hadley, 'Negotiating gender, family, and status in Anglo-Saxon burial practices, c. 600– 950', in Brubaker and Smith (eds), *Gender in the Early Medieval World*: 301–23.

14 B. Effros, 'Dressing conservatively: women's brooches as markers of ethnic identity', in Brubaker and Smith (eds), *Gender in the Early Medieval World*: 165–84, esp. 179.

15 A. Cutler, 'Significant Gifts: Patterns of Exchange in Late Antique, Byzantine, and Early Islamic Diplomacy', *Journal of Medieval & Early Modern Studies* 38(1) (2008): 79–101; quote on p. 81.

16 M. J. Enright, *Lady with a Mead Cup: Ritual, Prophecy and Lordship in the European Warband from La Tène to the Viking Age* (Dublin: Four Courts Press, 1995).

17 K. Cooper, *The Virgin and the Bride: Idealized Womanhood in Late Antiquity* (Cambridge, MA: Harvard University Press, 1996), quote on p. 146; L. Brubaker, 'Sex, Lies, and Textuality: The Secret History of Prokopios and the Rhetoric of Gender in Sixth-Century Byzantium', in Brubaker and Smith (eds), *Gender in the Early Medieval World*: 83–101.

18 McClanan, *Representations of Early Byzantine Empresses*.

19 L. Brubaker, 'Memories of Helena: Patterns of Imperial Matronage in the Fourth and Fifth Centuries', in L. James (ed.), *Women, Men, and Eunuchs: Gender in Byzantium* (New York: Routledge, 1997): 52–75; McNamara, '*Imitatio Helenae*.

20 K. G. Holum, *Women and Imperial Dominion in Late Antiquity* (Berkeley and Los Angeles: University of California Press, 1982): 6–2.

21 Holum, *Theodosian Empresses*: 21–47.

22 J. Burman, 'The Christian Empress Eudocia', in J. Perreault (ed.), *Les Femmes et le Monochisme Byzantine* (Athens: Canadian Archaeological

Institute, 1991): 51–59; E. Habas, 'A Poem by the Empress Eudocia: A Note on the Patriarch', *Israel Exploration Journal* 46 (1996): 108–19.
23 S. Runcimann, 'Some Notes on the Role of the Empress', *Eastern Churches Review* 4 (1972): 119–24.
24 Holum, *Theodosian Empresses*: 79–111.
25 A. Cameron, 'The Empress and the Poet: Paganism and Politics at the Court of Theodosius II', *Yale Classical Studies* 27 (1982): 126–45.
26 L. Garland, *Byzantine Empresses: Women and Power in Byzantium, AD 527–1204* (London: Routledge, 1999); J. Herrin, 'The Imperial Feminine in Byzantium', *Past and Present* 169 (2000): 3–35; J. Herrin, 'In Search of Byzantine Women: Three Avenues of Approach', in A. Cameron and A. Kuhrt (eds), *Images of Women in Antiquity*, 2nd edn (London: Routledge, 1993): 167–89; L. James and B. Hill, 'Women and Politics in the Byzantine Empire: Imperial Women', in L. E. Mitchell (ed.), *Women in Medieval Western European Culture* (New York: Garland, 1999): 157–78; D. A. Miller, 'Byzantine Sovereignty and Feminine Potencies', in L. O. Frandenburg (ed.), *Women and Sovereignty* (Edinburgh: Edinburgh University Press, 1992): 250–63.
27 Brubaker, 'Sex, Lies, and Textuality': 83–101; R. Browning, *Justinian and Theodora* (New York: Praeger, 1971); M. Vinson, 'The Life of Theodora and the Rhetoric of the Byzantine Brideshow', *Jarhbuch der Österreichischen Byzantinistik* 49 (1999): 31–60.
28 M. Vinson (trans.), *Vita Theodora*, in A.-M. Talbot (ed.), *Byzantine Defenders of Images* (Washington: Dumbarton Oaks, 1998): 353–82.
29 A. L. McClanan, 'The Empress Theodora and the Tradition of Women's Patronage in the Early Byzantine Empire', in J. H. McCash (ed.), *The Cultural Patronage of Medieval Women* (Athens: University of Georgia Press, 1996): 50–72.
30 McClanan, *Representations of Early Byzantine Empresses*.
31 Justinian, *Annotated Justinian Code*, University of Wyoming College of Law (2004): http://uwacadweb.uwyo.edu/blume&justinian/novels.asp
32 Procopius of Caesarea, *History of the Wars*, H. B. Dewing (trans) (New York, Macmillan, 1914), 1.24.32–43: 230–3.
33 Procopius of Caesarea, *The Secret History*, G. A. Williamson (ed. and trans.) (Harmondsworth: Penguin, 1966).
34 A. D. Frankforter, 'Amalsuntha, Procopius, and a Woman's Place', *Journal of Women's History* 8(2) (1996): 41–57.
35 J. Moorhead, *Justinian* (London: Longman, 1994): 46–47. See also J. Evans, 'The "Nika" Rebellion and the empress Theodora', *Byzantion* 54 (1984): 380–82.
36 Tacitus, *The* Agricola *and The* Germania, H. A. Mattingley (trans.), S. A. Handford (rev. edn) (Harmondsworth: Penguin, 1970).
37 R. McKitterick, *The Frankish Kings and Culture in the Early Middle Ages* (Aldershot: Variorum, 1995).

38 Gregory of Tours, *History of the Franks*, L. Thorpe (trans.) (Harmondsworth: Penguin, 1976); Stafford, *Queens, Concubines, and Dowagers*; Wemple, *Women in Frankish Society*; S. D. White, 'Clotild's Revenge: Politics, Kinship, and Ideology in the Merovingian Blood Feud', in S. K. Cohn and S. A. Epstein (eds), *Portraits of Medieval and Renaissance Living: Essays in Honor of David Herlihy* (Ann Arbor: University of Michigan Press, 1996): 107–30.

39 B. Effros, *Merovingian Mortuary Archaeology and the Making of the Early Middle Ages* (Berkeley and Los Angeles: University of California Press, 2003): 211–17.

40 R. Balzaretti, 'Theodelinda, "Most Glorious Queen": Gender and Power in Lombard Italy', *Medieval History Journal* 2(2) (1999): 183–207; M. De Jong, 'Queens and Beauty in the Early Medieval West: Balthild, Theodelinda, Judith', in La Rocca (ed.), *Agire da Donna*: 235–48.

41 J. L. Nelson, 'Queens as Jezebels: The Careers of Brunhild and Balthild in Merovingian History', in Baker (ed.), *Medieval Women*: 31–77.

42 Stafford, *Queens, Concubines, and Dowagers*.

43 Fredegar, *The Fourth Book of the Chronicle of Fredegar*, J. M. Wallace-Hadrill (ed. and trans.) (London: Nelson, 1960); Gregory of Tours, *History of the Franks; The* Nibelungenlied: *the Lay of the Nibelungs*, C. Edwards (trans.) (Oxford: Oxford University Press, 2010).

44 Gregory of Tours, *History of the Franks*; J. McNamara, J. E. Halborg, and G. Whatley (eds and trans), *Sainted Women of the Dark Ages* (Durham, NC: Duke University Press, 1992); K. Cherewatuk, 'Radegund and the Epistolary Tradition', in K. Cherwatuk and U. Wiethaus (eds), *Dear Sister: Medieval Women and the Epistolary Genre* (Philadelphia: University of Pennsylvania Press, 1993): 20–45.

45 Effros, *Merovingian Mortuary Archaeology*: 215.

46 M. E. Carrasco, 'Spirituality in Context: The Romanesque Illustrated Life of Saint Radegund of Poitiers (Poitiers, Bibliotheque Municipale, MS 250)', *Art Bulletin* 72(3) (1990): 414–35; S. Coates, 'Regendering Radegund? Fortunatus, Baudonivia, and the Problem of Female Sanctity in Merovingian Gaul', *Studies in Church History* 34 (1998): 37–50; C. Hahn, 'Collector and Saint: Queen Radegund and Devotion to the Relic of the True Cross', *Word and Image* 22 (2006): 268–74; J. E. Jeffrey, 'Radegund and the Letter of Foundation', in L. J. Churchill, P. R. Brown, and J. E. Jeffrey (eds), *Women Writing Latin from Roman Antiquity to Early Modern Europe*, 2 vols (Oxford: Routledge, 2002), II: 11–23; M. A. Mayeski and J. Crawford, 'Reclaiming an Ancient Story: Baudonivia's "Life of St. Radegunde" (circa 525–587)', in A. Sharma (ed), *Women Saints in World Religions* (Albany: State University of New York Press, 2000): 71–88.

47 Personal communication, Jennifer Edwards, 20 July 2012. See also J. Edwards, '"The Sweetness of Suffering": Community, Conflict, and the

Notes 267

Cult of Saint Radegund in Medieval Poitiers', doctoral dissertation (University of Illinois at Urbana-Champaign, 2008).

48 P. Fouracre and R. A. Gerberding, 'Vita sanctae Balthildis,' *Late Merovingian France: History and Hagiography, 640–720* (1996): 97–132; Wemple, *Women in Frankish Society*; J. M. Peterson, (ed. and trans.), *Handmaids of the Lord: Contemporary Descriptions of Feminine Asceticism in the First Six Christian Centuries* (Kalamazoo, MI: Cistercian Publications, 1996).

49 *Treasure Annual Report 1998–1999* (London: Department of Culture, Media and Sport; http://www.culture.gov.uk/publications/8687.aspx): 31.

50 Cassius Dio Cocceianus, *Dio's Roman History*, E. Cary and H. Foster (eds and trans) (New York: MacMillan, 1914–27); Tacitus, *The Agricola and The Germania*.

51 G. Webster, *Boudica and the British Revolt against Rome AD 48–58* (Totowa: Rowman & Littlefield, 1978).

52 Cassius Dio Cocceianus, *Dio's Roman History*, lxii: 2, 3.

53 A. Connon, 'The Banshenchas and the Uí Néill Queens of Tara', in A. P. Smyth (ed.), *Seanchas: Studies in Early Medieval Irish Archaeology, History and Literature in Honour of Francis J. Byrne* (Dublin: Four Courts Press, 1999): 98–108; D. Edel, 'Early Irish Queens and Royal Power: A First Reconnaissance', in M. Richter and J.-M. Picard (eds), *Ogma: Essays in Celtic Studies in Honour of Próinséas Ní Chatháin* (Dublin: Four Courts Press, 2002): 1–19; E. Johnston, 'Transforming Women in Irish Hagiography', *Peritia* 9 (1995): 197–220.

54 J. Ní Ghrádaigh, 'Mere Embroiderers? Women and Art in Early Medieval Ireland', in T. Martin (ed.), *Reassessing the Roles of Women as 'Makers' of Medieval Art and Architecture*, 2 vols (Leiden: Brill, 2012), vol. 1: 93–128

55 Bitel, L., *Land of Women*.

56 Isidore of Seville, *Isidore of Seville's History of the Goths, Vandals, and Suevi*, G. Donini and G. B. Ford (trans), 2nd rev. edn (Leiden: Brill, 1970).

57 'Eugenius II of Toledo, Poetic Epitaphs', J. DuQ. Adams (trans.) in O. R. Constable (ed.), *Medieval Iberia: Readings from Christian, Muslim, and Jewish Sources*, 1st edn (Philadelphia: University of Pennsylvania Press, 1997): 24–5.

58 P. Crabtree (ed.) *Medieval Archaeology: An Encyclopedia* (New York: Garland, 2001) is a very useful guide to the field. For specific regions, see, for example, the British and Irish Archaeological Bibliography (www.biab.ac.uk); for Spain, the Asociación Española de Arqueología Medieval (www.aeam.es); for central Europe, Deutscher Archäologenverband e.V. (DArV) (www:darv. de/der-darv/); for Scandinavia, the Centre for Baltic and Scandinavian Archaeology (www.zbsa.eu/centre).

2 Legitimizing the King's Wife and Bed-Companion, c. 700–1100

1. S. Gilsdorf (trans. and ed.), *Queenship and Sanctity: The Lives of Mathilda and The Epitaph of Adelheid* (Washington, DC: Catholic University of America Press, 2004).
2. D. d'Avray, *Medieval Marriage: Symbolism and Society* (Oxford: Oxford University Press, 2003).
3. J. Bak, *Coronations: Medieval and Early Modern Monarchic Ritual* (Berkeley and Los Angeles: University of California Press, 1990).
4. B. Hill, 'Imperial Women and the Ideology of Womanhood in the Eleventh and Twelfth Centuries,' in L. James (ed.), *Women, Men, and Eunuchs: Gender in Byzantium* (New York: Routledge, 1997): 76–99.
5. Hincmar, Archbishop of Reims, *De ordine palatii*, T. Gross and R. Schieffer (eds) (Hanover: Hahniani, 1971).
6. M. J. Enright, *Lady with a Mead Cup: Ritual, Prophecy and Lordship in the European Warband from La Tène to the Viking Age* (Dublin: Four Courts Press, 1995).
7. L. Garland, *Byzantine Empresses: Women and Power in Byzantium, AD 527–1204* (London: Routledge, 1999); J. Herrin, *Women in Purple: Rulers of Medieval Byzantium* (Princeton: Princeton University Press, 2001); B. Hill, *Imperial Women in Byzantium, 1025–1204: Power, Patronage, and Ideology* (New York: Longman, 1999); L. James, 'Goddess, Whore, Wife or Slave: Will the Real Byzantine Empress Please Stand Up?', in A. J. Duggan (ed.), *Queens and Queenship in Medieval Europe* (Woodbridge: Boydell Press, 1997): 123–39; and L. James and B. Hill, 'Women and Politics in the Byzantine Empire: Imperial Women', in L. E. Mitchell (ed.), *Women in Medieval Western European Culture* (New York: Garland, 1999): 157–78.
8. Hill, 'Imperial Women and the Ideology of Womanhood': 82–91.
9. S. Runcimann, 'The Empress Irene the Athenian', in D. Baker (ed.), *Medieval Women* (Oxford: Blackwell, 1978): 101–18.
10. B. Hill, L. James, and D. Smythe, 'Zoë: The Rhythm Method of Imperial Renewal', in P. Magdalino (ed.), *New Constantines: The Rhythm of Imperial Renewal in Byzantium, 4th–13th Centuries* (Aldershot: Variorum, 1994): 215–29; L. Garland, 'Conformity and License at the Byzantine Court in the Tenth and Eleventh Centuries: The Case of Imperial Women', *Byzantinische Forschungen* 21 (1995): 101–15; L. Garland, '"The Eye of the Beholder": Byzantine Imperial Women and their Public Image from Zoë Porphyrogenita to Euphrosyne Kamaterissa Doukaina (1028–1203)', *Byzantion* 64 (1994): 19–39.
11. J. Burman, 'The Christian Empress Eudocia', in J. Perreault (ed.), *Les Femmes et le Monochisme Byzantine* (Athens: Canadian Archaeological Institute, 1991): 51–9.
12. J. L. Nelson, 'The Lord's Anointed and the People's Choice: Carolingian

Royal Ritual', in D. Cannadine and S. Price (eds), *Rituals of Royalty: Power and Ceremonial in Traditional Societies* (Cambridge: Cambridge University Press, 1987): 137–80.
13 J. L. Nelson, 'Making a Difference in Eighth-Century Politics: The Daughters of Desiderius', in A. C. Murray (ed.), *After Rome's Fall: Narrators and Sources of Early Medieval History* (Toronto: University of Toronto Press, 1998): 171–90.
14 J. L. Nelson, 'Women at the Court of Charlemagne: A Case of Monstrous Regiment?', in J. C. Parsons (ed.), *Medieval Queenship* (New York: St. Martin's Press, 1993): 43–61.
15 M. de Jong, 'Bride Shows Revisited: Praise, Slander, and Exegesis in the Reign of the Empress Judith', L. Brubaker and J. M. H. Smith (eds), *Gender in the Early Medieval World: East and West, 300–900* (Cambridge: Cambridge University Press, 2004): 257–77; M. Vinson, 'Romance and Reality in the Byzantine Bride Shows', in Brubaker and Smith (eds), *Gender in the Early Medieval World*: 102–20.
16 M. de Jong, *The Penitential State: Authority and Atonement in the Age of Louis the Pious, 814–840* (Cambridge: Cambridge University Press, 2009): 30–32.
17 P. Stafford, *Queens, Concubines, and Dowagers: The King's Wife in the Early Middle Ages* (Athens: University of Georgia Press, 1983).
18 de Jong, *The Penitential State*: 195–205.
19 S. Airlie, 'Private Bodies and the Body Politic in the Divorce Case of Lothar II', *Past and Present* 161 (1998): 3–38.
20 Hincmar, Archbishop of Reims, *De ordine palatii*; Stafford, *Queens, Concubines, and Dowagers*: ch. 4; P. Stafford, *Queen Emma and Queen Edith: Queenship and Women's Power in Eleventh-Century England* (Oxford: Blackwell, 1997), ch. 5.
21 K. Heidecker, 'Why Should Bishops Be Involved in Marital Affairs? Hincmar of Rheims on the Divorce of King Lothar II (855–869)', in J. Hill and M. Swan, (eds), *The Community, the Family, and the Saint: Patterns of Power in Early Medieval Europe* (Turnhout: Brepols, 1998): 225–35.
22 d'Avray, *Medieval Marriage*, esp. ch. 2.
23 Airlie, quoting letters from Pope Nicholas to Theutberga and Lothar, in 'Private Bodies and the Body Politic': 31.
24 V. I. J. Flint, 'Susanna and the Lothar Crystal: A Liturgical Perspective', *Early Medieval Europe* 4(1) (1995): 61–86.
25 *Annals of St. Bertin*, J. L. Nelson (trans.) (Manchester: Manchester University Press, 1991): 179.
26 V. L. Garver, 'Weaving Words in Silk: Women and Inscribed Bands in the Carolingian World,' *Medieval Clothing and Textiles* 6 (2010): 33–56.
27 E. J. Goldberg, '*Regina nitens sanctissima Hemma*: Queen Emma (827–876), Bishop Witgar of Augsburg, and the Witgar-Belt', in S. MacLean and B. Weiler (eds), *Representations of Power in Medieval Germany* (Turnhout: Bepols, 2006): 57–95.

28 Gilsdorf (trans. and ed.), *Queenship and Sanctity*.
29 D. Óriain-Raedel, 'Edith, Judith, Matilda: the Role of Royal Ladies in the Propagation of the Continental Cult', in C. Stancliffe and E. Cambridge (eds), *Oswald: Northumbrian King to European Saint* (Stamford: Paul Watkins, 1995): 210–29.
30 J. T. Schulenberg, 'Female Sanctity: Public and Private Roles, ca. 500–1100', in M. Erler and M. Kowaleski (eds), *Women and Power in the Middle Ages* (Athens: University of Georgia Press): 102–25.
31 Stafford, *Queens, Concubines, and Dowagers*.
32 See essays in A. Davids (ed.), *The Empress Theophano: Byzantium and the West at the Turn of the First Millennium* (Cambridge: Cambridge University Press, 2002).
33 M. Facinger, 'A Study of Medieval Queenship: Capetian France, 987–1237', *Studies in Medieval and Renaissance History* 5 (1968): 3–47.
34 B. Rosenwein, 'Family Politics of Berengar I, King of Italy (888–924)', *Speculum* 71(2) (1996): 247–89.
35 P. A. Adair, 'Constance of Arles: A Study in Duty and Frustration', in K. Nolan, *Capetian Women* (Basingstoke: Palgrave Macmillan, 2003): 9–26.
36 W. V. Bogomoletz, 'Anna of Kiev: An Enigmatic Capetian Queen of the Eleventh Century: A Reassessment of Biographical Sources', *French History* 19(3) (2005): 299–323.
37 G. Duby, *The Knight, the Lady, and the Priest: The Making of Modern Marriage in Medieval France* (New York: Pantheon, 1983).
38 P. Stafford, 'The King's Wife in Wessex, 800–1066', *Past and Present* 91 (1981): 3–27; P. Stafford, 'The Portrayal of Royal Women in England, Mid-Tenth to Mid-Twelfth Centuries', in Parsons (ed.), *Medieval Queenship*: 143–67, H. D'Amico, 'Queens and female warriors in Old English literature and society', *Old English Newsletter* 16 (1983): 55–6; J. C. Nitzche, 'The Anglo-Saxon Woman as Hero: the Chaste Queen and the Masculine Woman Saint', *Old English Newsletter* 14(2) (1981): 28–9.
39 S. Ridyard, *The Royal Saints of Anglo-Saxon England: A Study of West Saxon and East Anglian Cults* (Cambridge: Cambridge University Press, 1988); D. Armstrong, 'Holy Queens as Agents of Christianization in Bede's 'Ecclesiastical History': A Reconsideration', *Old English Newsletter* 29 (Spring 1996): A–28.
40 Stafford, *Queens, Concubines, and Dowagers*.
41 S. S. Klein, *Ruling Women: Queenship and Gender in Anglo-Saxon Literature* (Notre Dame, IN: University of Notre Dame Press, 2006).
42 *Encomium Emmae Reginae*, A. Campbell (ed.) and S. Keynes (intro.) (Cambridge: Cambridge University Press, 1998), bk. 2: 16, 32–3.
43 *Encomium Emmae Reginae*, app. 1: 55–61.
44 *English Historical Documents*, 2nd edn, D. Whitelock (ed.) (London: Routledge, 1996), vol. 1: 347–50.
45 *English Historical Documents*, vol. 1: 348.

46 E. van Houts, 'The Political Relations between Normandy and England before 1066 according to the *Gesta Normannorum ducum*', in R. Forevillle and C. Viola (eds), *Les mutations socioculturelles au tournant des xie–xiie siècles* (Paris: Éditions du CNRS, 1984): 85–97.
47 van Houts, 'The Political Relations', 87–9.
48 *Knýtlinga Saga: The History of the Kings of Denmark*, H. Pálsson and P. Edwards (trans.) (Odense: Odense University Press, 1986): 31, 107.
49 *Encomium Emmae Reginae*: 33.
50 H. D'Amico, 'Beowulf's Foreign Queen and the Politics of Eleventh-Century England,' in V. Blanton and H. Scheck (eds), *Intertexts: Studies in Anglo-Saxon Culture Presented to Paul E. Szarmarch* (Tempe: Arizona Center for Medieval and Renaissance Studies, 2008): 209–40.
51 R. Frank, 'The *Beowulf* Poet's Sense of History', in L. D. Benson and S. Wenzel (eds), *The Wisdom of Poetry: Essays in Early English Literature in Honor of Morton W. Bloomfield* (Kalamazoo: Western Michigan University Medieval Institute Publication, 1982): 53–65.
52 P. Stafford, *Queen Emma and Queen Edith: Queenship and Women's Power in Eleventh-Century England* (Oxford: Blackwell, 1997).
53 M. Otter, 'Closed Doors: An Epithalamium for Queen Edith, Widow and Virgin', in C. L. Carlson and A. J. Weisl (eds), *Constructions of Widowhood and Virginity in the Middle Ages* (New York: St. Martin's Press, 1999): 63–92; C. Karkov, 'Pictured in the Heart: The Ediths at Wilton', in Blanton and Scheck (eds), *Intertexts*: 273–85; Óriain-Raedel, 'Edith, Judith, Matilda': 210–29.
54 C. Hicks, 'The Patronage of Queen Edith', in M. J. Lewis, G. R. Owen-Crocker, and D. Terkla (eds.), *The Bayeux Tapestry: New Approaches* (Oxford: Oxbow, 2011): 5–9.
55 F. Downie, 'Queenship in Late Medieval Scotland', in M. Brown and R. Tanner (eds), *Scottish Kingship, 1306–1488* (Edinburgh: John Donald, 2008); F. Downie, *She Is But a Woman: Queenship in Scotland, 1424–1463* (Edinburgh: John Donald, 2006).
56 A. O. Anderson (ed. and trans.), *Early Sources of Scottish History, AD 500 to 1286*, 2 vols (London: Oliver & Boyd, 1922; repr. with corrections, 1990); D. Baker, '"A Nursery of Saints": St. Margaret of Scotland Reconsidered', in Baker (ed.), *Medieval Women*: 119–41; R. Gameson, 'The Gospels of Margaret of Scotland and the Literacy of an Eleventh-Century Queen', in L. M. Smith and J. H. M. Taylor (eds), *Women and the Book: Assessing the Visual Evidence* (London: British Library and University of Toronto Press, 1997): 148–71; L. Huneycutt, 'The Idea of the Perfect Princess: The Life of St. Margaret in the Reign of Mathilda II, 1100–1118', *Anglo-Norman Studies* 12 (1990): 81–97; R. Rushforth, *St. Margaret's Gospel-book: The Favourite Book of an Eleventh-Century Queen of Scots* (Oxford: Bodleian Library Publishing, 2003); and V. Wall, 'Queen Margaret of Scotland, 1070–93: Burying the Past, Enshrining the Future', in Duggan (ed.), *Queens and Queenship in Medieval Europe*: 27–38.

57 G. R. G. Hambly (ed.), *Women in the Medieval Islamic World* (Basingstoke: Palgrave Macmillan, 1998).
58 Collins, R., 'Queens-Dowager and Queens-Regent in Tenth-Century León and Navarre', in Parsons (ed.), *Medieval Queenship*: 79–92; M. T. Horvat, 'Queen Sancha of Aragón and the Royal Monastery of Sigena', doctoral dissertation (University of Kansas, 1994); R. Walker, 'Sancha, Urraca, and Elvira: The Virtues and Vices of Spanish Royal Women "Dedicated to God"', *Reading Medieval Studies* 24 (1998): 113–38.
59 T. M. Vann, 'The Theory and Practice of Medieval Castilian Queenship', in T. M. Vann (ed.), *Queens, Regents, and Potentates* (Denton, TX: Academia Press, 1993): 125–47.
60 S. H. Cross and O. P. Shobowitz-Wetzor (eds and trans), *Russian Primary Chronicle: Laurentian Text* (Cambridge: Mediaeval Academy of America, 1953).
61 J. Chodor, 'Queens in Early Medieval Chronicles of East Central Europe', *East Central Europe* 1(21–3) (1991): 9–50.
62 C. Clover, 'Regardless of Sex: Men, Women, and Power in Early Northern Europe', *Speculum* 68(2) (1993): 363–88.
63 U. Dronke (ed), *The Poetic Edda* (Oxford: Clarendon Press, 1969); M. Magnusson, *Laxdoela Saga*, H. Pálsson (trans.) (Harmondsworth: Penguin, 1972); M. Magnusson, *Njals Saga*, H. Pálsson (trans.) (Harmondsworth: Penguin, 1960); and J. H. McGrew and R. G. Thomas (trans. and eds), *Sturlunga Saga*, 2 vols (New York: Twayne, 1970–74).
64 J. Jochens, *Women in Old Norse Society* (Ithaca, NY: Cornell University Press, 1995).

3 'The Link of Conjugal Troth': Queenship as Family Practice, c. 1100–1350

1 L. Hilton, *Queens Consort: England's Medieval Queens* (London: Weidenfeld & Nicolson, 2008); M. Howell, 'Royal Women of England and France in the Mid-Thirteenth Century: A Gendered Perspective', in B. K. U. Weiler and I. W. Rowlands (eds), *England and Europe in the Reign of Henry III (1216–1272)* (Aldershot: Ashgate, 2002): 163–81.
2 Dante Alighieri, *The Divine Comedy*, A. Mandelbaum (trans.) (New York: Knopf, 1984), *Paradiso* canto 6, ll. 133–35: 54.
3 Gérard Sivéry, *Marguerite de Provence, Une reine au temps des cathédrales* (Paris: Fayard, 1987); E. L. Cox, *The Eagles of Savoy* (Princeton: Princeton University, 1974).
4 M. Howell, *Eleanor of Provence: Queenship in Thirteenth-Century England* (Oxford: Blackwell, 1998).
5 A. Crawford, (ed.), *Letters of the Queens of England 1100–1547* (Dover: Alan Sutton, 1994): 54–67; *Feminae* (http://epistolae.ccnmtl.columbia.edu).

6 J. C. Parsons, quoting T. Rymer, *Foedera, conventions, literae* ... (1816–19) in 'Mothers, Daughters, Marriage, Power: Some Plantagenet Evidence, 1150–1500', in J. C. Parsons (ed.), *Medieval Queenship* (New York: St. Martin's Press, 1993): 63–78; quote on p. 63.
7 M. T. Shadis, *Berenguela of Castile (1180–1246) and Political Women in the High Middle Ages* (Basingstoke: Palgrave Macmillan, 2009).
8 L. Benz St. John, *Three Medieval Queens: Queenship and Crown in Fourteenth-century England* (Basingstoke: Palgrave Macmillan, 2012).
9 J. Martindale, 'Succession and Politics in the Romance-Speaking World', in M. Jones and M. Vale (eds), *England and Her Neighbors 1066–1453* (London: Hambledon Press, 1989): 19–41.
10 W. C. Stalls, 'Queenship and the Royal Patrimony in Twelfth-Century Iberia: The Example of Petronilla of Aragón', in T. M. Vann (ed.), *Queens, Regents, and Potentates* (Denton, TX: Academia Press, 1993): 49–61.
11 B. Hamilton, 'Women in the Crusader States: The Queens of Jerusalem (1100–1190)', in D. Baker (ed.), *Medieval Women* (Oxford: Blackwell, 1978): 143–73; S. Lambert, 'Queen or Consort: Rulership and Politics in the Latin East, 1118–1228', in A. J. Duggan (ed.), *Queens and Queenship in Medieval Europe* (Woodbridge: Boydell Press, 1997): 153–69.
12 *Princeses de terres llunyanes: Catalunya i Hongria a l'edat mitjana* (Barcelona: Generalitat de Catalunya, 2009).
13 S. G. Bell, 'Medieval Women Book Owners: Arbiters of Lay Piety and Ambassadors of Culture', *Signs* 7: (1982): 742–68.
14 J. Folda, 'Images of Queen Melisende in William of Tyre's "History of Outremer: 1250–1300"', *Gesta* 32 (1993): 97–112; J. Folda, 'A Twelfth-Century Prayerbook for the Queen of Jerusalem', *Medieval Perspectives* 8 (1993): 1–14.
15 M. Proctor-Tiffany, 'Portrait of a Medieval Patron: The Inventory and Gift Giving of Clémence of Hungary', doctoral dissertation (Brown University, 2007).
16 M. Facinger, 'A Study of Medieval Queenship: Capetian France, 987–1237', *Studies in Medieval and Renaissance History* 5 (1968): 3–47.
17 Howell, *Eleanor of Provence*; J. L. Laynesmith, *The Last Medieval Queens: English Queenship 1445–1503* (Oxford: Oxford University Press, 2004); T. Earenfight, 'Partners in Politics', in T. Earenfight (ed.), *Queenship and Political Power in Medieval and Early Modern Spain* (Aldershot: Ashgate, 2005): xiii–xxviii.
18 T. Earenfight, 'Absent Kings: Queens as Political Partners in the Medieval Crown of Aragon', in Earenfight (ed.), *Queenship and Political Power*: 33–51; R. Sablonier, 'The Aragonese Royal Family Around 1300', in H. Medick and D. W. Sabean (eds), *Interest and Emotion: Essays on the Study of Family and Kinship* (Cambridge: Cambridge University Press, 1984): 210–39.
19 D. Pryds, 'Sancia, Queen of Naples (d. 1345): Protector of the Orders', in D.

Pryds (ed.), *Women of the Streets: Early Franciscan Women and Their Mendicant Vocation* (St. Bonaventure, NY: Franciscan Institute, 2010): 63–75.

20 John of Salisbury, *The 'Historia Pontificalis' of John of Salisbury*, M. Chibnall (ed. and trans.) (Oxford: Oxford University Press, 1986); Philippe de Beaumanoir, *The* Coutumes de Beaumanoir *of Philippe de Beaumanoir*, F. R. P. Akehurst (trans.) (Philadelphia: University of Pennsylvania Press, 1992).

21 L. Huneycutt, 'The Idea of the Perfect Princess: the Life of St. Margaret in the Reign of Mathilda II, 1100–1118', *Anglo-Norman Studies* 12 (1990): 81–97.

22 S. Kay, 'Proclaiming Her Dignity Abroad: The Literary and Artistic Network of Matilda of Scotland, Queen of England 1100–1118', in J. H. McCash (ed.), *The Cultural Patronage of Medieval Women* (Athens: University of Georgia Press, 1996): 155–74. For primary sources, see William of Malmesbury, *Gesta regum Anglorum: The History of the English Kings*, R. A. B. Mynors, R. M. Thomson, M. Winterbottom (eds), 2 vols (Oxford: Clarendon Press, 1998–1999); Turgot, Bishop of St. Andrews, *Life of St. Margaret, Queen of Scotland*, W. Forbes-Leith (trans.) (Edinburgh: W. Paterson, 1884). English translations of some of her letters can be found at http://epistolae.ccnmtl.columbia.edu/woman/64.html#letterslist.

23 L. Wertheimer, 'Adeliza of Louvain and Anglo-Norman Queenship', *Haskins Society Journal* 7 (1995): 101–15.

24 C. Beem, 'Making a Name for Herself: The Empress Matilda and the Construction of Female Lordship in Twelfth-Century England', in C. Beem, *The Lioness Roared: The Problems of Female Rule in English History* (Basingstoke: Palgrave Macmillan, 2006): 25–62.

25 J. Bradbury, *Stephen and Matilda: The Civil War, 1139–1154* (Stroud: Sutton, 1996); M. Chibnall, *The Empress Matilda: Queen Consort, Queen Mother, and Lady of the English* (Oxford: Blackwell, 1991); M. Chibnall, 'The Empress Matilda and Her Sons', in J. C. Parsons and B. Wheeler (eds), *Medieval Mothering* (New York: Garland, 1996): 279–94; M. Chibnall, 'The Empress Matilda as a Subject for Biography', in D. Bates, J. Crick, and S. Hamilton (eds), *Writing Medieval Biography, 750–1250* (Woodbridge: Boydell Press, 2006): 185–94; J. A. Truax, 'Winning Over the Londoners: King Stephen, the Empress Matilda, and the Politics of Personality', *Haskins Society Journal* 8 (1996): 43–61.

26 C. Beem, '"Greater by Marriage": The Matrimonial Career of the Empress Matilda', in C. Levin and R. Bucholz (eds), *Queens & Power in Medieval and Early Modern England* (Lincoln: University of Nebraska Press, 2009): 1–15.

27 L. Huneycutt, 'Female Succession and the Language of Power in the Writings of Twelfth-Century Churchmen', in Parsons (ed.), *Medieval Queenship*: 189–201; C. J. Nederman and N. E. Lawson, 'The Frivolities of Courtiers Follow the Footprints of Women: Public Women and the Crisis of Virility in John of Salisbury', in C. Levin and J. Watson (eds), *Ambiguous Realities: Women in the Middle Ages and Renaissance* (Detroit: Wayne State University Press, 1987): 82–98.

28 Monographs on the life of Eleanor: J. Flori, *Eleanor of Aquitaine: Queen and Rebel*, O. Classe (trans.) (Edinburgh: Edinburgh University Press, 2007; French edn, 2004); A. Kelly, *Eleanor of Aquitaine and the Four Kings* (Cambridge: Harvard University Press, 1950); D. D. R. Owen, *Eleanor of Aquitaine, Queen and Legend* (Oxford: Blackwell, 1993); R. V. Turner, *Eleanor of Aquitaine: Queen of France, Queen of England* (New Haven: Yale University Press, 2009). Collected essays: W. W. Kibler (ed.), *Eleanor of Aquitaine: Patron and Politician* (Austin: University of Texas Press, 1976); B. Wheeler and J. C. Parsons (eds), *Eleanor of Aquitaine: Lord and Lady* (Basingstoke: Palgrave Macmillan, 2003).

29 R. C. De Aragon, 'Do We Know What We Think We Know? Making Assumptions About Eleanor of Aquitaine', *Medieval Feminist Forum* 37 (Spring 2004): 14–20.

30 Some of this work is collected in Wheeler and Parsons (eds), *Eleanor of Aquitaine: Lord and Lady*: C. B. Bouchard, 'Eleanor's Divorce from Louis VII: The Uses of Consanguinity': 223–35; E. A. R. Brown, 'Eleanor of Aquitaine Reconsidered: The Woman and Her Seasons': 1–54; J. A. Brundage, 'The Canon Law of Divorce in the Mid-Twelfth Century: Louis VII c. Eleanor of Aquitaine': 213–21; L. Huneycutt, *'Alianora Regina Anglorum*: Eleanor of Aquitaine and Her Anglo-Norman Predecessors as Queens of England': 115–32; J. Martindale, 'Epilogue: Eleanor of Aquitaine and a 'Queenly Court?': 423–39; P. McCracken, 'Scandalizing Desire: Eleanor of Aquitaine and the Chroniclers': 247–63; K. Nolan, 'The Queen's Choice: Eleanor of Aquitaine and the Tombs at Fontevraud': 377–405; C. B. M. de La Roncière, 'Queen Eleanor and Aquitaine, 1137–1189': 55–76. See also D. Power, 'The Stripping of a Queen: Eleanor of Aquitaine in Thirteenth-Century Norman Tradition', in M. Bull and C. Léglu (eds), *The World of Eleanor of Aquitaine: Literature and Society in Southern France between the Eleventh and Thirteenth Centuries* (Woodbridge: Boydell Press, 2005): 115–35; and F. Tolhurst, 'The Outlandish Lioness: Eleanor of Aquitaine in Literature', *Medieval Feminist Forum* 37 (Spring 2004): 9–13.

31 William of Tyre, *A History of Deeds Done Beyond the Sea*, E. A. Babcock and A. C. Krey (trans), 2 vols (New York: Columbia University Press, 1943).

32 U. Bethlehem, *Guinevere: A Medieval Puzzle: Images of Arthur's Queen in the Medieval Literature of Britain and France* (Heidelberg: Anglistische Forschungen: 2005); N. B. Black, *Medieval Narratives of Accused Queens* (Gainesville: University Press of Florida, 2003).

33 P. McCracken, *The Romance of Adultery: Queenship and Sexual Transgression in Old French Literature* (Philadelphia: University of Pennsylvania Press, 1998).

34 M. Borroff and L. L. Howes (eds), M. Borroff (trans.), *Sir Gawain and the Green Knight: An Authoritative Translation, Contexts, Criticism* (New York: W. W. Norton, 2010). Chrétien de Troyes, *The Complete Romances of Chrétien de Troyes*, D. Staines (trans.) (Bloomington: Indiana University

Press, 1990); Marie de France, *The Lais of Marie de France*, G. S. Burgess and K. Busby (trans) (New York: Penguin, 1986); E. Vinaver (ed.), *The Works of Sir Thomas Malory* (Oxford: Clarendon Press, 1967).

35 A. Trindade, *Berengaria: In Search of Richard the Lionheart's Queen* (Dublin: Four Courts Press, 1999).

36 W. C. Jordan, 'Isabelle d'Angoulême, By the Grace of God, Queen', *Revue Belge de Philologie et d'Historie* 69 (1991): 821–52.

37 J. Cooke, 'Scottish Queenship in the Thirteenth Century', *Thirteenth Century England* 11 (2007): 61–80; L. Huneycutt, *Matilda of Scotland: A Study in Medieval Queenship* (Woodbridge: Boydell Press, 2003); L. Huneycutt, 'Public Lives, Private Lives: Royal Mothers in England and Scotland, 1070–1204', in Parsons and Wheeler (eds), *Medieval Mothering*: 295–312; J. Nelson, 'Scottish Queenship in the Thirteenth Century', *Thirteenth Century England* (2007): 61–81.

38 M. Prestwich, 'Edward I and the Maid of Norway', *Scottish Historical Review* 69 (1990): 157–74; N. H. Reid, 'Margaret Maid of Norway and Scottish Queenship', *Reading Medieval Studies* 8 (1982): 75–96.

39 B. Hamilton, 'Eleanor of Castile and the Crusading Movement', *Mediterranean Historical Review* 10 (1995): 92–103.

40 H. Johnstone, 'The Queen's Household', in J. P. Willard and W. A. Morris (eds), *The English Government at Work, 1327–1336* (Cambridge: Harvard University Press, 1940): 263–64.

41 J. C. Parsons (ed.), *The Court and Household of Eleanor of Castile in 1290: an edition of British Library, additional manuscript 35294 with introduction and notes* (Toronto: Pontifical Institute of Mediæval Studies, 1977).

42 J. C. Parsons, 'The Queen's Intercession in Thirteenth-Century England', in J. Carpenter and S. MacLean (eds), *Power of the Weak: Essays in the History of Medieval Women* (Urbana: University of Illinois Press, 1995): 147–77; J. C. Parsons, *Eleanor of Castile: Queen and Society in Thirteenth-Century England* (New York: St. Martin's Press, 1995).

43 K. Geaman, 'Queen's Gold and Intercession: The Case of Eleanor of Aquitaine', *Medieval Feminist Forum* 46 (2) (2010): 10–33; M. H. Caviness, 'Anchoress, Abbess, and Queen: Donors and Patrons or Intercessors and Matrons?' in McCash (ed.), *The Cultural Patronage of Medieval Women*: 105–54; L. Huneycutt, 'Intercession and the High-Medieval Queen: The Esther Topos', in Carpenter and MacLean (eds), *Power of the Weak*: 126–46.

44 J. C. Parsons, 'The Intercessionary Patronage of Queens Margaret and Isabella of France', *Thirteenth-Century England* 6 (1995): 145–56.

45 E. A. R. Brown, 'The Political Repercussions of Family Ties in the Early Fourteenth Century: The Marriage of Edward II of England and Isabelle of France', *Speculum* 63 (1988): 573–95; Howell, 'Royal Women of England and France in the Mid-Thirteenth Century'; H. Johnstone, 'Isabella, the She-Wolf of France', *History. The Journal of the Historical Association* 21 (1936): 208–18; C. Lord, 'Queen Isabella at the Court of France', *Fourteenth*

Century England 2 (2002): 45–52; S. Menache, 'Isabelle of France, Queen of England: A Reconsideration', *Journal of Medieval History* 10 (1984): 107–24.
46 M. W. Ormrod, 'Knights of Venus', *Medium Aevum* 73(2) (2004): 290–305; M. W. Ormrod, 'Monarchy, Martyrdom, and Masculinity: England in the Later Middle Ages', in P. H. Cullum and K. J. Lewis (eds), *Holiness and Masculinity in the Middle Ages* (Toronto: University of Toronto Press, 2005): 174–91; M. W. Ormrod, 'The Sexualities of Edward II', in G. Dodd and A. Musson (eds), *The Reign of Edward II: New Perspectives* (York: York Medieval Press, 2006): 22–47.
47 K. LoPrete, 'Historical Ironies in the Study of Capetian Women', in K. Nolan (ed.), *Capetian Women* (Basingstoke: Palgrave Macmillan, 2003): 271–86.
48 H. Lightman, 'Political Power and the Queen of France: Pierre DuPuy's Treatise on Regency Government', *Canadian Journal of History* 21 (1986): 299–312; H. Lightman, 'Sons and Mothers: Queens and Minor Kings in French Constitutional Law', doctoral dissertation (Bryn Mawr College, 1981).
49 L. Huneycutt, 'The Creation of a Crone: The Historical Reputation of Adelaide of Maurienne', in Nolan (ed.), *Capetian Women*: 27–43.
50 M. T. Shadis, 'Blanche of Castile and Facinger's "Medieval Queenship": Reassessing the Argument', in Nolan (ed.), *Capetian Women*: 137–61.
51 Bull and Léglu (eds), *The World of Eleanor of Aquitaine*; F. Swabey, *Eleanor of Aquitaine, Courtly Love, and the Troubadours* (Westport: Greenwood, 2004).
52 G. Conklin, 'Ingeborg of Denmark, Queen of France, 1193–1223', in Duggan (ed.), *Queens and Queenship in Medieval Europe*: 39–52; A. G. Hornaday, 'A Capetian Queen as Street Demonstrator: Isabelle of Hainaut', in Nolan (ed.), *Capetian Women*: 77–97.
53 Facinger, 'A Study of Medieval Queenship': 27 (emphasis in original).
54 L. O. Fradenburg, 'Introduction: Rethinking Queenship', in L. O. Fradenburg (ed.), *Women and Sovereignty* (Edinburgh: University of Edinburgh Press, 1991): 1–13, quote on p. 5. See also Parsons, 'The Queen's Intercession in Thirteenth-Century England': 147–77.
55 R. Pernoud, *Blanche of Castile*, Henry Noel (trans.) (New York: Coward, McCann & Geoghegan, 1975; 1st French edn, 1972).
56 S. L. Field, 'Reflecting the Royal Soul: *The Speculum Anime* Composed for Blanche of Castile', *Mediaeval Studies* 68 (2006): 1–42.
57 *Episotlae* (http://epistolae.ccnmtl.columbia.edu/letter/709.html)
58 M. T. Shadis, 'Piety, Politics and Power: The Patronage of Leonor of England and Her Daughters, Blanche of Castile and Berenguela of León', in McCash (ed.), *The Cultural Patronage of Medieval Women*: 202–27; M. T. Shadis and C. H. Berman. 'A Taste of the Feast: Reconsidering Eleanor of Aquitaine's Female Descendants', in Wheeler and Parsons (eds), *Eleanor of Aquitaine: Lord and Lady*: 177–211.
59 A. Poulet, 'Capetian Women and the Regency: The Genesis of a Vocation', in Parsons (ed.), *Medieval Queenship*: 93–116.

60 T. C. Hamilton, 'Queenship and Kinship in the French "Bible moralisée": The Example of Blanche of Castile and Vienna ÖNB 2554', in Nolan (ed.), *Capetian Women*: 177–208.
61 A. Gajewski, 'The Patronage Question under Review: Queen Blanche of Castile (1188–1252) and the Architecture of the Cistercian Abbeys at Royaumont, Maubuisson, and Le Lys', in T. Martin (ed.), *Reassessing the Roles of Women as 'Makers' of Medieval Art and Architecture*, 2 vols (Leiden: Brill, 2012), vol. 1: 197–244.
62 E. Valdez Del Alamo, 'Lament for a Lost Queen: The Sarcophagus of Doña Blanca in Nájera', *Art Bulletin* 78 (2) (1996): 311–33; M. T. Shadis, *Berenguela of Castile (1180–1246) and Political Women in the High Middle Ages* (Basingstoke: Palgrave Macmillan, 2009): 149–50.
63 M. T. Shadis, 'Piety, Politics and Power: The Patronage of Leonor of England and Her Daughters, Blanche of Castile and Berenguela of León', in McCash (ed.), *The Cultural Patronage of Medieval Women*: 202–27.
64 Bell, 'Medieval Women Book Owners': 759–60.
65 C. Taylor, 'The Salic Law, French Queenship, and the Defense of Women in the Late Middle Ages', *French Historical Studies* 29(4) (2006): 543–64; C. Taylor, 'The Salic Law and the Valois Succession to the French Crown', *French History* 15(4) (2001): 358–77.
66 J. Holladay, 'The Education of Jeanne d'Évreux: Personal Piety and Dynastic Salvation in Her Book of Hours at the Cloisters', *Art History* 17 (1994): 585–611; J. Holladay, 'Fourteenth-Century French Queens as Collectors and Readers of Books: Jeanne d'Évreux and her Contemporaries', *Journal of Medieval History* 31(2) (2006): 69–100.
67 A. Remensnyder, 'Marian Monarchy in Thirteenth-Century Castile', in R. Berkhofer, A. Cooper, and A. Kosto (eds), *The Experience of Power in Medieval Europe, 950–1350* (Aldershot: Ashgate, 2005): 247–64.
68 M. T. Shadis, 'Women, Gender and Rulership in Romance Europe: The Iberian Case', *History Compass* 4 (2006): 481–87; Earenfight, 'Partners in Politics': xiii–xxviii.
69 T. Martin, *Queen as King: Politics and Architectural Propaganda in Twelfth-Century Spain* (Leiden: Brill, 2006); B. Reilly, *The Kingdom of León-Castilla under Queen Urraca, 1109–1126* (Princeton: Princeton University Press, 1982).
70 M. T. Shadis, 'The First Queens of Portugal and the Building of the Realm', in Martin (ed.), *Reassessing the Roles of Women as 'Makers' of Medieval Art and Architecture*: vol. 2: 671–702.
71 A. M. Rodrigues, 'Rainhas Medievais de Portugal: Funções, patrimónios, poderes', *Clio* new ser. 16/17 (2007): 139–53.
72 J. Bianchini, *The Queen's Hand: Power and Authority in the Reign of Berenguela of Castile* (Philadelphia: University of Pennsylvania Press, 2012); Shadis, *Berenguela of Castile*.
73 Juan of Osma, in J. F. O'Callaghan, (ed. and trans.), *The Latin Chronicle of*

the *Kings of Castile* (Tempe: Arizona Center for Medieval and Renaissance Studies, 2002): 76–7.
74 B. Lackner, 'A Cistercian of Royal Blood: Blessed Teresa of Portugal', *Vox Benedictina: A Journal of Translations from Monastic Sources* 6(2) (1989): 100–19.
75 J. F. O'Callaghan, 'The Many Roles of the Medieval Queen: Some Examples from Castile', in Earenfight (ed.), *Queenship and Political Power*: 21–32; T. M. Vann, 'The Theory and Practice of Medieval Castilian Queenship', in Vann (ed.), *Queens, Regents, and Potentates*: 125–47.
76 I. McCleery, 'Isabel of Aragon (d. 1336): Model Queen or Model Saint?', *Journal of Ecclesiastical History* 57(4) (2006): 668–92.
77 Earenfight, 'Absent Kings': 33–38.
78 M. Van Landingham, 'The Hohenstaufen Heritage of Costanza of Sicily and the Mediterranean Expansion of the Crown of Aragon in the Later Thirteenth Century', in D. Agius and I. R. Netton (eds), *Across the Mediterranean Frontiers* (Turnhout: Brepols, 1997): 87–104.
79 M. Van Landingham, 'Royal Portraits: Representations of Queenship in the Thirteenth-Century Catalan Chronicles', in Earenfight (ed.), *Queenship and Political Power*: 109–19.
80 B. Hill, 'The Vindication of the Rights of Women to Power by Anna Komnene', *Byzantinische Forschungen* 23 (1996): 45–53.
81 B. Hill, *Imperial Women in Byzantium, 1025–1204: Power, Patronage, and Ideology* (New York: Longman, 1999).
82 J. Herrin, *Women in Purple: Rulers of Medieval Byzantium* (Princeton: Princeton University Press, 2001).
83 M. Bennett, 'Virile Latins, Effeminate Greeks, and Strong Women: Gender Definitions on Crusade?', in S. B. Edgington and S. Lambert (eds), *Gendering the Crusades* (Cardiff: University of Wales Press, 2001): 16–30; B. Hamilton, 'Women in the Crusader States'.
84 H. A. Gaudette, 'The Piety, Power, and Patronage of the Latin Kingdom of Jerusalem's Queen Melisende', doctoral dissertation (City University of New York, 2005); H. A. Gaudette, 'The Spending Power of a Crusader Queen: Melisende of Jerusalem', in T. Earenfight (ed.), *Women and Wealth in Late Medieval Europe* (Basingstoke: Palgrave Macmillan, 2010): 135–48; H. E. Mayer, 'Studies in the History of Queen Melisende of Jerusalem', *Dumbarton Oaks Papers* 26 (1972): 93–182.
85 K. Jäschke, 'From Famous Empresses to Unspectacular Queens: The Romano-German Empire of Margaret of Brabant, Countess of Luxemburg and Queen of the Romans, d. 1311', in Duggan (ed.), *Queens and Queenship in Medieval Europe*: 75–108.
86 G. Klaniczay, *Holy Rulers and Blessed Princesses: Dynastic Cults in Medieval Central Europe* (Cambridge: Cambridge University Press, 2002).
87 J. Bérenger, *A History of the Habsburg Empire: 1273–1700* (London: Longman, 1994); P. Crossley, 'The Architecture of Queenship: Royal Saints,

Female Dynasties and the Spread of Gothic Architecture in Central Europe', in Duggan (ed.), *Queens and Queenship in Medieval Europe*: 263–300.
88 W. Fröhlich, 'The Marriage of Henry VI and Constance of Sicily: Prelude and Consequences', *Anglo-Norman Studies* 15 (1992): 99–115.
89 J. M. Klassen, 'Queenship in Late Medieval Bohemia', *East Central Europe* 1(21–3) (1991): 101–16; J. M. Klassen, *Warring Maidens, Captive Wives, and Hussite Queens: Women and Men at War and at Peace in Fifteenth Century Bohemia* (New York: Columbia University Press, 2000).
90 J. Bak, 'Queens as Scapegoats in Medieval Hungary', in Duggan (ed.), *Queens and Queenship in Medieval Europe*: 223–33; J. Bak, 'Roles and Functions of Queens in Arpadian and Angevin Hungary, 1000–1386', in Parsons (ed.), *Medieval Queenship*: 1–24.
91 C. N. Goldy and A. Livingstone, 'Introduction: Setting the Scene', in C. N. Goldy and A. Livingstone (eds), *Writing Medieval Women's Lives* (Basingstoke: Palgrave Macmillan, 2012): 1–10.
92 Copies of the letters with English translations can be found at *Epistolae*, (http://epistolae.ccnmtl.columbia.edu/woman/85.html).
93 *Feminae* (http://epistolae.ccnmtl.columbia.edu/letter/576.html).
94 *Princeses de terres llunyanes: Catalunya i Hongria a l'edat mitjana.*
95 I. Skovgaard-Peterson and N. Damsholt, 'Queenship in Medieval Denmark', in Parsons (ed.), *Medieval Queenship*: 25–42.
96 W. Layher, *Queenship and Voice in Medieval Northern Europe* (Basingstoke: Palgrave Macmillan, 2010).
97 Geaman, 'Queen's Gold and Intercession'.
98 J. C. Parsons, 'Of Queens, Courts, and Books: Reflections on the Literary Patronage of Thirteenth-Century Plantagenet Queens', in McCash (ed.), *The Cultural Patronage of Medieval Women*: 175–201; A. R. Stanton, 'Isabelle of France and Her Manuscripts, 1308–58', in Nolan (ed.), *Capetian Women*: 225–52.
99 O'Callaghan, (ed. and trans.), *The Latin Chronicle of the Kings of Castile*; Orderic Vitalis, *The Ecclesiastical History of Orderic Vitalis*, M. Chibnall (ed. and trans.), 6 vols (Oxford: Oxford University Press, 1969–1980).
100 Crawford, (ed.), *Letters of the Queens of England 1100–1547*.
101 M. McVaugh, *Medicine before the Plague: Practitioners and Their Patients in the Crown of Aragon, 1285–1345* (Cambridge: Cambridge University Press, 1993): 5–34.
102 R. A. Jackson, (ed.), *Ordines coronationis Franciae: Texts and Ordines for the Coronation of Frankish and French Kings and Queens in the Middle Ages*, 2 vols (Philadelphia: University of Pennsylvania Press, 1995, 2000). L. G. W. Legg, (ed.), *English Coronation Records* (Westminster: Constable, 1901).
103 Marie de France, *The Lais of Marie de France*, G. S. Burgess and K. Busby (trans.) (New York: Penguin, 1986); T. Malory, Le Morte D'Arthur. *Sir Thomas Malory's Book of King Arthur and of His Noble Knights of the Round*

Table, 2 vols (Charlottesville: University of Virginia Library, 1996); John of Salisbury, The 'Historia Pontificalis' of John of Salisbury, M. Chibnall (ed. and trans.).
104 E. Barrett, Art and the Construction of Medieval Queenship: Dynastic Legitimacy and Family Piety (Poole: Cassell, 1998); K. Nolan, Queens in Stone and Silver: The Creation of a Visual Imagery of Queenship in Capetian France (New York: Palgrave Macmillan, 2009).
105 B. Bedos Rezak, 'Women, Seals, and Power in Medieval France', in M. Erler and M. Kowaleski (eds), Women and Power in the Middle Ages (Athens: University of Georgia Press, 1988): 61–82.
106 G. Beech, 'The Eleanor of Aquitaine Vase', in Wheeler and Parsons (eds), Eleanor of Aquitaine: 369–76; K. S. Schowalter, 'The Ingeborg Psalter: Queenship, Legitimacy, and the Appropriation of Byzantine Art in the West', in Nolan (ed.), Capetian Women: 99–136.
107 R. Walker, 'Leonor of England, Plantagenet Queen of King Alfonso VIII of Castile, and Her Foundation of the Cistercian Abbey of Las Huelgas. In Imitation of Fontevraud?' Journal of Medieval History 31 (4) (2005): 346–68; J. A. Holladay, 'Portrait Elements in Tomb Sculpture: Identification and Iconography', in G. Schmidt (ed.), Europäische Kunst um 1300: Akten des 25 Internationaler Kongress für Kunstgeschichte 6 (Vienna: Bohlau, 1983): 217–21.

4 Queenship in a Crisis of Monarchy, c. 1350–1500

1 'Preparations for a Royal Wedding', T. F. Ruiz (trans.), in Medieval Iberia: Readings from Christian, Muslim, and Jewish Sources, O. R. Constable (ed.), 1st edn (Philadelphia: University of Pennsylvania Press, 1997): 317–19; T. F. Ruiz, A King Travels: Festive Traditions in Late Medieval and Early Modern Spain (Princeton: Princeton University Press, 2012): 105–107.
2 E. Woodacre, 'The She-Wolves of Navarre', History Today 62(6) (2012): 47–51.
3 C. R. Sherman, 'The Queen in Charles V's "Coronation Book": Jeanne de Bourbon and the "Ordo ad reginam benedicendum"', Viator 8 (1977): 255–98; C. R. Sherman, The Portraits of Charles V of France (1338–1380) (New York: New York University Press for the College Art Association of America, 1969); T. Husband, The Art of Illumination: The Limbourg Brothers and the Belles Heures of Jean de France, Duc de Berry (New Haven: Yale University Press, 2008).
4 E. Morrison, A. D. Hedeman, and E. Antoine, Imagining the Past in France: History in Manuscript Painting, 1250–1500 (Los Angeles: J. Paul Getty Museum, 2010).
5 A. D. Hedeman, The Royal Image: Illustrations of the Grandes chroniques de France, 1274–1422 (Berkeley and Los Angeles: University of California Press, 1991); R. Strong, The Tudor and Stuart Monarchy: Pageantry, Painting,

Iconography (Woodbridge: Boydell, 1995–1998); D. Howarth, *Images of Rule: Art and Politics in the English Renaissance, 1485–1649* (Berkeley and Los Angeles: University of California Press, 1997).

6 M. Wolff, (ed.), *Kings, Queens, and Courtiers: Art in Early Renaissance France* (New Haven: Yale University Press, 2011).

7 J. Bak, *Coronations: Medieval and Early Modern Monarchic Ritual* (Berkeley and Los Angeles: University of California Press, 1990).

8 J. F. O'Callaghan, 'The Many Roles of the Medieval Queen: Some Examples from Castile', in T. Earenfight (ed.), *Queenship and Political Power in Medieval and Early Modern Spain* (Aldershot: Ashgate, 2005): 21–32; T. M. Vann, 'The Theory and Practice of Medieval Castilian Queenship', in T. M. Vann (ed.), *Queens, Regents, and Potentates* (Denton, TX: Academia Press, 1993): 125–47.

9 A. M. Rodrigues, 'The Queen-Consort in Late-Medieval Portugal', in B. Bolton and C. Meek (eds), *Aspects of Power and Authority in the Middle Ages* (Turnhout: Brepols, 2007): 131–46.

10 T. Adams, *The Life and Afterlife of Isabeau of Bavaria* (Baltimore: Johns Hopkins University Press, 2010); H. E. Maurer, *Margaret of Anjou: Queenship and Power in Late Medieval England* (Woodbridge: Boydell Press, 2003).

11 J. Coleman, 'Philippa of Lancaster, Queen of Portugal – and Patron of the Gower Translations?', in *England and Iberia in the Middle Ages, 12th–15th Century: Cultural, Literary and Political Exchanges*, M. Bullón-Fernández (ed.) (Basingstoke: Palgrave Macmillan, 2007): 135–65.

12 C. Taylor, 'The Salic Law, French Queenship, and the Defense of Women in the Late Middle Ages', *French Historical Studies* 29(4) (2006): 543–64; C. Taylor, 'The Salic Law and the Valois Succession to the French Crown', *French History* 15(4) (2001): 358–77.

13 W. Monter, *The Rise of Female Kings in Europe, 1300–1800* (New Haven: Yale University Press, 2012).

14 D. Hunt and I. Hunt (eds), *Caterina Cornaro: Queen of Cyprus* (London: Trigraph, 1989).

15 Monter, *The Rise of Female Kings in Europe*.

16 Giles of Rome, *The Governance of Kings and Princes: John Trevisa's Middle English Translation of the 'De Regimine Principum' of Aegidius Romanus*, D. C. Fowler, C. F. Briggs and P. G. Remley (eds) (New York: Garland, 1997); Thomas Aquinas, *Summa Theologica* (New York: Benziger Bros., 1947–48); Brunetto Latini, *The Book of the Treasure*, P. Barrette and S. Baldwin (trans) (New York: Garland, 1993); and Marsilius of Padua, *Writings on the Empire: Defensor minor and* De translatione Imperii, C. J. Nederman (ed. and trans.) (Cambridge: Cambridge University Press, 1993).

17 K. L. Forhan, *The Political Theory of Christine de Pizan* (Aldershot: Ashgate, 2002).

18 Christine de Pizan, 'Ballade XXVI', in *The Writings of Christine de Pizan*, C. C. Willard (trans.) (New York: Persea, 1994): 51.

19 Christine de Pizan, *Book of the Body Politic*, K. L. Forhan (ed. and trans.) (Cambridge: Cambridge University Press, 1994).
20 Christine de Pizan, *The Book of the City of Ladies*, E. J. Richards (trans.) (New York: Persea Books, 1982).
21 Christine de Pizan, *A Medieval Woman's Mirror of Honor: The Treasury of the City of Ladies*, C. C. Willard (trans.), M. P. Cosman (ed.) (New York: Persea, 1989): 71.
22 Christine de Pizan, *A Medieval Woman's Mirror of Honor*: 85–6.
23 Christine de Pizan, *A Medieval Woman's Mirror of Honor*: 87, 95.
24 W. M. Ormrod, 'Knights of Venus', *Medium Aevum* 73(2) (2004): 290–305; W. M. Ormrod, 'Monarchy, Martyrdom, and Masculinity: England in the Later Middle Ages', in P. H. Cullum and K. J. Lewis (eds), *Holiness and Masculinity in the Middle Ages* (Toronto: University of Toronto Press, 2005): 174–91.
25 Maurer, *Margaret of Anjou*.
26 S. Hanley, 'The Politics of Identity and Monarchic Governance in France: The Debate over Female Exclusion', in H. L. Smith (ed.), *Women Writers and the Early Modern British Political Tradition* (Cambridge: Cambridge University Press, 1997): 289–304; M. Quilligan, *The Allegory of Female Authority: Christine de Pizan's 'Cité des dames'* (Ithaca, NY: Cornell University Press, 1991).
27 R. Jackson (ed.), *Ordines coronationis Franciae: Texts and Ordines for the Coronation of Frankish and French Kings and Queens in the Middle Ages*, 2 vols (Philadelphia: University of Pennsylvania Press, 1995, 2000).
28 Adams, *The Life and Afterlife of Isabeau of Bavaria*; R. Gibbons, 'Isabeau of Bavaria, Queen of France (1385–1422): The Creation of an Historical Villainess', *Transactions of the Royal Historical Society*, 6th series, vol. 6 (1996): 51–73; R. Gibbons, 'The Piety of Isabeau of Bavaria, Queen of France, 1385–1422', in D. E. S. Dunn (ed.), *Courts, Counties and the Capital in the Later Middle Ages* (Stroud: Sutton Publishing, 1996): 205–24; R. Gibbons, 'The Queen as "Social Mannequin": Consumerism and Expenditure at the Court of Isabeau of Bavaria, 1393–1422', *Journal of Medieval History* 26(4) (2000): 371–95.
29 T. Adams, 'Christine de Pizan, Isabeau of Bavaria, and Female Regency', *French Historical Studies* 32(1) (2009); 1–32; T. Adams, 'Notions of Late Medieval Queenship: Christine de Pizan's Isabeau of Bavaria', in A. Cruz and M. Suzuki (eds), *The Rule of Women in Early Modern Europe* (Urbana: University of Illinois Press, 2009): 13–29.
30 S. G. Bell, 'Medieval Women Book Owners: Arbiters of Piety and Ambassadors of Culture', *Signs* 7 (1982): 742–68.
31 Adams, *Life and Afterlife of Isabeau of Bavaria*: 111–12.
32 Christine de Pizan, *The Writings of Christine de Pizan*: 270.
33 Christine de Pizan, *The Writings of Christine de Pizan*: 271.
34 K. Crawford, *Perilous Performances: Gender and Regency in Early Modern*

France (Cambridge: Harvard University Press, 2004); E. McCartney, *Queens in the Cult of the French Renaissance Monarchy: Public Law, Royal Ceremonial, and Political Discourse in the History of Regency Government, 1484–1610* (London: Routledge, 2007).
35 C. J. Brown (ed.), (ed.), *The Cultural and Political Legacy of Anne de Bretagne: Negotiating Convention in Books and Documents* (Woodbridge: D. S. Brewer, 2010).
36 S. L. Jansen, (ed.), *Anne of France: Lessons for My Daughter* (Cambridge: D. S. Brewer, 2004).
37 C. J. Brown, *The Queen's Library: Image-Making at the Court of Anne of Brittany* (Philadelphia: University of Pennsylvania Press, 2010); E. L'Estrange, *Holy Motherhood: Gender, Dynasty, and Visual Culture in the Later Middle Ages* (Manchester: Manchester University Press, 2008).
38 E. A. R. Brown, 'The Kings Conundrum: Endowing Queens and Loyal Servants, Ensuring Salvation, and Protecting the Patrimony in Fourteenth-Century France', in J. A. Burrow and I. P. Wei (eds), *Medieval Futures: Attitudes to the Future in the Middle Ages* (Woodbridge: Boydell Press, 2000): 115–63.
39 L. Benz St. John, *Three Medieval Queens: Queenship and Crown in Fourteenth-Century England* (Basingstoke: Palgrave Macmillan, 2012).
40 Parsons, J. C., 'The Pregnant Queen as Counsellor and the Medieval Construction of Motherhood', in J. C. Parsons and B. Wheeler (eds), *Medieval Mothering* (New York: Garland, 1996): 39–61; P. Strohm, 'Queens as Intercessors', in P. Strohm (ed.), *Hochon's Arrow: The Social Imagination of Fourteenth-Century Texts* (Princeton: Princeton University Press, 1992): 95–120.
41 J. Froissart, *Ouevres*, K. de Lettenhove (ed.) (Brussels: Devaux, 1868), vol. 5: 215, trans. in Strom, 'Queens as Intercessors', p. 100.
42 Strohm, 'Queens as Intercessors': 95, 103–5.
43 M. Ormrod, 'The Sexualities of Edward II', in G. Dodd and A. Musson (eds), *The Reign of Edward II: New Perspectives* (York: York Medieval Press, 2006): 22–47.
44 'Letters of Anne of Bohemia, First Wife of Richard II', in *Letters of the Queens of England 1100–1547*, A. Crawford (ed.) (Dover: Alan Sutton, 1994): 102–6.
45 Bell, 'Medieval Women Book Owners': 760.
46 Strohm, 'Queens as Intercessors', quote on p. 105.
47 A. Thomas, *A Blessed Shore: England and Bohemia from Chaucer to Shakespeare* (Ithaca, NY: Cornell University Press, 2007); Bell, 'Medieval Women Book Owners': 765.
48 A. R. Myers, 'The Captivity of a Royal Witch: The Household Accounts of Queen Joan of Navarre, 1419–1421', *Bulletin of the John Rylands Library* 24 (1940): 263–84.
49 K. M. Finn, *The Last Plantagenet Consorts: Gender, Genre, and Historiography, 1440–1627* (Basingstoke: Palgrave Macmillan, 2012); P.-A. Lee, 'Reflections

of Power: Margaret of Anjou and the Dark Side of Queenship', *Renaissance Quarterly* 39 (1986): 183–217; A. R. Myers, 'The Household Accounts of Queen Margaret of Anjou, 1452–3', *Bulletin of the John Rylands Library* 40 (1957–58): 79–113; C. Monro (ed.), *Letters of Queen Margaret of Anjou, Bishop Beckington and Others Written in the Reigns of Henry V and Henry VI* (London: Camden, 1863).

50 J. L. Laynesmith, *The Last Medieval Queens: English Queenship, 1445–1503* (Oxford: Oxford University Press, 2004).

51 T. Earenfight, 'Without the Persona of the Prince: Kings, Queens and the Idea of Monarchy in Late Medieval Europe', *Gender & History* 19 (1) (2007): 1–21.

52 J. L. Chamberlayne, 'Crowns and Virgins: Queenmaking During the Wars of the Roses', in K. J. Lewis, N. J. Menuge, and K. M. Phillips (eds), *Young Medieval Women* (New York: St. Martin's Press, 1999): 47–68; A. Crawford, 'The King's Burden? The Consequences of Royal Marriage in Fifteenth-Century England', in R. A. Griffiths (ed.), *Patronage, the Crown, and the Provinces in Later Medieval England* (Stroud: Sutton, 1981): 33–56.

53 A. R. Myers, The Household of Queen Elizabeth Woodville, 1466–7', *Bulletin of the John Rylands Library* 50 (1959–60): 207–46.

54 S. J. Davies (ed.), *English Chronicle of the Reigns of Richard II, Henry IV, Henry V, and Henry VI Written before the Year 1470* (London: Camden, 1856); J. Gairdner (ed.), *Paston Letters*, 6 vols (London: Chatto, 1904).

55 M. K. Jonas and M. G. Underwood, *The King's Mother: Lady Margaret Beaufort, Countess of Richmond and Derby* (Cambridge: Cambridge University Press, 1993); C. T. Wood, *Joan of Arc and Richard III: Sex, Saints, and Government in the Middle Ages* (Oxford: Oxford University Press, 1988).

56 A. N. Okerlund, *Elizabeth of York* (Basingstoke: Palgrave Macmillan, 2009).

57 C. T. Wood, 'The First Two Queens Elizabeth, 1464–1503', in L. O. Fradenburg, (ed.), *Women and Sovereignty* (Edinburgh: University of Edinburgh Press, 1991): 121–31

58 F. Downie, 'And They Lived Happily Ever After? Medieval Queenship and Marriage in Scotland, 1424–1449', in T. Brotherstone, D. Simonton, and O. Walsh (eds), *Gendering Scottish History: An International Approach* (Glasgow: Cruithne Press, 1999): 129–41; F. Downie, *She Is But a Woman: Queenship in Scotland, 1424–1463* (Edinburgh: John Donald, 2006); and F. Downie, 'Queenship in Late Medieval Scotland', in M. Brown and R. Tanner (eds), *Scottish Kingship, 1306–1488* (Edinburgh: John Donald, 2008).

59 A. P. Hutchinson, 'Leonor Teles: Representations of a Portuguese Queen', *Historical Reflections/Réflexions historiques* 30(1) (2004): 73–87.

60 J. R. Goodman, 'The Lady with the Sword: Philippa of Lancaster and the Chivalry of the Infante Dom Henrique (Prince Henry the Navigator)', in Vann (ed.), *Queens, Regents, and Potentates*: 149–65; M. Santos Silva, 'Philippa of Lancaster, Queen of Portugal: Educator and Reformer', in L. Oakley-Brown and L. J. Wilkinson (eds), *The Rituals and Rhetoric of*

Queenship: Medieval to Early Modern (Dublin: Four Courts Press, 2009): 37–46.
61 A. M. Rodrigues and M. Santos Silva, 'Private Properties, Seigniorial Tributes, and Jurisdictional Rents: The Income of the Queens of Portugal in the Late Middle Ages', in T. Earenfight (ed.), *Women and Wealth in Late Medieval Europe* (Basingstoke: Palgrave Macmillan, 2010): 209–28.
62 Bell, 'Medieval Women Book Owners': 757.
63 I. McCleery, 'Isabel of Aragon (d. 1336): Model Queen or Model Saint?', *Journal of Ecclesiastical History* 57(4) (2006): 668–92.
64 A. Echevarria, 'Catalina of Lancaster, the Castilian Monarchy, and Coexistence', in R. Collins and A. Goodman (eds), *Medieval Spain: Culture, Conflict, and Coexistence: Studies in Honour of Angus McKay* (Basingstoke: Palgrave Macmillan, 2002): 79–122; A. Echevarria, 'The Queen and the Master: Catalina of Lancaster and the Military Orders', in Earenfight (ed.), *Queenship and Political Power*: 91–105.
65 T. Earenfight, 'Royal Women in Late Medieval Spain: Catalina of Lancaster, Leonor of Albuquerque, and María of Castile', in C. Goldy and A. Livingstone (eds), *Writing Medieval Women's Lives* (Basingstoke: Palgrave Macmillan, 2012): 209–25.
66 M. Meyerson, 'Defending Their Jewish Subjects: Elionor of Sicily, Maria de Luna, and the Jews of Morvedre', in Earenfight (ed.), *Queenship and Political Power*: 55–77.
67 D. Bratsch-Prince, 'Pawn or Player? Violant of Bar and the Game of Matrimonial Politics in the Crown of Aragon (1380–1396)', in E. Lacarra Lanz (ed.), *Marriage and Sexuality in Medieval and Early Modern Iberia* (Oxford: Routledge, 2002): 59–89; D. Bratsch-Prince, 'A Reappraisal of the Correspondence of Violant de Bar (1365–1431)', *Catalan Review* 8 (1994): 295–312; and D. Bratsch-Prince, 'A Queen's Task: Violant de Bar and the Experience of Royal Motherhood in Fourteenth-Century Aragon', *La Corónica* 27(1) (1998): 21–34.
68 N. Silleras-Fernández, *Power, Piety, and Patronage in Late Medieval Queenship: Maria de Luna* (Basingstoke: Palgrave Macmillan, 2008).
69 'Queen Violant, E-z ieu am tal que es bo e bell', J. J. Wilhelm (trans.), in Constable (ed.), *Medieval Iberia*: 292–93.
70 T. Earenfight, *The King's Other Body: María of Castile and the Crown of Aragon* (Philadelphia: University of Pennsylvania Press, 2010).
71 T. Earenfight, 'Absent Kings: Queens as Political Partners in the Medieval Crown of Aragon', in Earenfight (ed.), *Queenship and Political Power*: 33–51; T. Earenfight, 'Two Bodies, One Spirit: Isabel and Fernando's Construction of Monarchical Partnership', in B. Weissberger (ed.), *Queen Isabel I of Castile: Power, Patronage, Persona* (Woodbridge: Boydell Press, 2008): 3–18; and T. Earenfight, 'Royal Finances in the Reign of María of Castile, Queen-Lieutenant of the Crown of Aragon, 1432–53,' in Earenfight (ed.), *Women and Wealth in Late Medieval Europe*: 229–44.

72 P. Liss, *Isabel the Queen*, 2nd edn (Philadelphia: University of Pennsylvania Press, 2004; 1st edn, 1992); P. Liss, 'Isabel of Castile (1451–1504), Her Self-Representation and Its Context', in *Earenfight* (ed.), *Queenship and Political Power*: 120–44; N. Rubin, *Isabella of Castile: The First Renaissance Queen* (New York: St. Martin's Press, 1991); Weissberger (ed.), *Queen Isabel I of Castile: Power, Patronage, Persona*; and D. Boruchoff (ed.), *Isabel la Católica, Queen of Castile: Critical Essays* (Basingstoke: Palgrave Macmillan, 2003).

73 B. Weissberger, *Isabel Rules: Constructing Queenship, Wielding Power* (Minneapolis: University of Minnesota Press, 2004).

74 E. Lehfeldt, 'Ruling Sexuality: The Political Legitimacy of Isabel of Castile', *Renaissance Quarterly* 53 (2000): 31–56; E. Lehfeldt, 'The Gender Shared Sovereignty: Texts and the Royal Marriage of Isabella and Ferdinand', in M. V. Vicente and L. R. Corteguera (eds), *Women, Texts, and Authority in the Early Modern Spanish World* (Aldershot: Ashgate, 2003): 37–55.

75 J. Bérenger, *A History of the Habsburg Empire: 1273–1700* (London: Longman, 1994).

76 J. M. Klassen, *Warring Maidens, Captive Wives, and Hussite Queens: Women and Men at War and at Peace in Fifteenth Century Bohemia* (New York: Columbia University Press, 2000); G. Klaniczay, *Holy Rulers and Blessed Princesses: Dynastic Cults in Medieval Central Europe* (Cambridge: Cambridge University Press, 2002).

77 M. Sághy, 'Aspects of Female Rulership in Late Medieval Literature: The Queens' Reign in Angevin Hungary', *East Central Europe* 1(21–3) (1991): 69–86.

78 O. Halecky and T. Gromada, *Jadwiga of Anjou and the Rise of East Central Europe* (Boulder: Social Science Monographs, 1991).

79 V. Etting, *Queen Margrethe I, 1353–1412, and the Founding of the Nordic Union* (Leiden: Brill, 2004); S. Imsen, 'Late Medieval Scandinavian Queenship', in A. J. Duggan (ed.), *Queens and Queenship in Medieval Europe* (Woodbridge: Boydell Press, 1997): 53–73.

80 A. Boureau, 'A Royal Funeral of 1498', in M. Rubin (ed.), *Medieval Christianity in Practice* (Princeton: Princeton University Press, 2009): 59–63.

81 J. Gower, *Confessio Amantis*, R. A. Peck (ed.), A. Galloway (trans.), 3 vols (Kalamazoo: University of Rochester and Medieval Institute Publications, 2000–2006).

82 W. Bower, *Scotichronicon*, D. E. R. Watt (ed.), 9 vols (Aberdeen: Aberdeen University Press, 1987–98); M. S. Byrne, (ed.), *The Lisle Letters*, 6 vols (Chicago: University of Chicago Press, 1981); Davies (ed.), *English Chronicle of the Reigns of Richard II, Henry IV, Henry V, and Henry VI*; R. Fabyan, *The New Chronicles of England and France*, H. Ellis (ed.) (London: Rivington, 1811); E. Hall, *Hall's Chronicle*, H. Ellis (ed.) (London: Johnson, 1809); F. Hingeston (ed.), *Chronicle of England* (London: Longmans, 1858).

83 Monro (ed.), *Letters of Queen Margaret of Anjou, Bishop Beckington and Others Written in the Reigns of Henry V and Henry VI* .

5 The Transformation of Queenship from Medieval to Early Modern Europe

1. C. Beem, *The Foreign Relations of Elizabeth I* (Basingstoke: Palgrave Macmillan, 2011); I. Bell, *Elizabeth I: The Voice of a Monarch* (Basingstoke: Palgrave Macmillan, 2010); A. Hunt and A. Whitelock (eds), *Tudor Queenship: The Reigns of Mary and Elizabeth* (Basingstoke: Palgrave Macmillan, 2010); C. Levin, *The Heart and Stomach of a King: Elizabeth I and the Politics of Sex and Power* (Philadephia: University of Pennsylvania Press, 1994); C. Levin, *The Reign of Elizabeth I* (Basingstoke: Palgrave Macmillan, 2002); C. Levin (ed.), *Elizabeth I: Always Her Own Free Woman* (Aldershot: Ashgate, 2003); D. M. Loades, *Mary Tudor: A Life* (Oxford: Basil Blackwell, 1989); C. Loomis, *The Death of Elizabeth I* (Basingstoke: Palgrave Macmillan, 2010); A. N. McLaren, *Political Culture in the Reign of Elizabeth I: Queen and Commonwealth, 1558–1585* (Cambridge: Cambridge University Press, 1999).
2. T. G. Elston, 'Widow Princess or Neglected Queen? Catherine of Aragon, Henry VIII, and English Public Opinion, 1533–1536', in C. Levin and R. Bucholz (eds), *Queens & Power in Medieval and Early Modern England* (Lincoln: University of Nebraska Press, 2009): 16–30; G. Mattingly, *Catherine of Aragon* (Boston: Little, Brown, 1941).
3. J. Sebastián Lozano, 'Choices and Consequences: The Construction of Isabel de Portugal's Image', in T. Earenfight (ed.), *Queenship and Political Power in Medieval and Early Modern Spain* (Aldershot: Ashgate, 2005): 145–63.
4. K. Crawford, *Perilous Performances: Gender and Regency in Early Modern France* (Cambridge, MA: Harvard University Press, 2005); E. McCartney, *Queens in the Cult of the French Renaissance Monarchy: Public Law, Royal Ceremonial, and Political Discourse in the History of Regency Government, 1484–1610* (London: Routledge, 2007).
5. J. de Longh, *Margaret of Austria, Regent of the Netherlands*, M. D. Herter (trans.) (New York: Norton, 1953); N. M. Sutherland, 'Catherine de' Medici: The Legend of the Wicked Italian Queen', *Sixteenth Century Journal* 9 (1978): 45–56.
6. S. L. Jansen (ed.), *Anne of France: Lessons for My Daughter* (Cambridge: Brewer, 2004).
7. M. K. Hoffman, *Raised To Rule: Educating Royalty at the Court of the Spanish Habsburgs, 1601–1634* (Baton Rouge: Louisiana State University Press, 2011); and J. Patrouch, *Queen's Apprentice: Archduchess Elizabeth, Empress María, the Habsburgs, and the Holy Roman Empire, 1554–1569* (Leiden: Brill, 2010).
8. A. Riehl, *The Face of Queenship: Representations of Elizabeth I* (Basingstoke: Palgrave Macmillan, 2010); L. Shenk, *Learned Queen: The Imperial Images of Elizabeth I* (Basingstoke: Palgrave Macmillan, 2009).

9 M. Sánchez, *The Empress, the Queen, and the Nun: Women and Power at the Court of Philip III of Spain* (Baltimore: Johns Hopkins University Press, 1998).
10 See two essays in B. F. Weissberger (ed.), *Queen Isabel I of Castile: Power, Patronage, Persona* (Woodbridge: Tamesis, 2008): C. Ishikawa, 'Hernando de Talavera and Isabelline Imagery': 71–82 and R. Domínguez Casas, 'The Artistic Patronage of Isabel the Catholic: Medieval or Modern?': 123–48; G. Scillia, 'Gerard David's *St. Elizabeth of Hungary* in the *Hours of Isabella the Catholic*', *Cleveland Studies in the History of Art* 7 (2002): 50–67.
11 S. G. Bell, *The Lost Tapestries of* The City of Ladies: *Christine de Pizan's Renaissance Legacy* (Berkeley and Los Angeles: University of California Press, 2004).
12 S. L. Jansen, *The Monstrous Regiment of Women: Female Rulers in Early Modern Europe* (Basingstoke: Palgrave Macmillan, 2009); C. Jordan, 'Woman's Rule in Sixteenth-Century British Political Thought', *Renaissance Quarterly* 40(3) (1987): 421–51.
13 B. Aram, *Juana the Mad: Sovereignty and Dynasty in Renaissance Europe* (Baltimore: Johns Hopkins University Press, 2005).
14 D. R. Doyle, 'The Body of a Woman but the Heart and Stomach of a King: Mary of Hungary and the Exercise of Political Power in Early Modern Europe', doctoral dissertation (University of Minnesota, 1996); and de Longh, *Margaret of Austria*.

For Further Reading

Queenship studies is a rapidly changing field and a bibliography in print cannot keep pace with the articles and books published. The works listed below focus on the material in English or, if in another language, by authors who routinely publish in English. For an up-to-date bibliography, see theresaearenfight.com

Introduction: Not Partial, Prejudiced or Ignorant: The Study of Queens and Queenship in Medieval Europe

Essay collections

Boruchoff, D. (ed.), *Isabel la Católica, Queen of Castile: Critical Essays* (Basingstoke: Palgrave Macmillan, 2003).

Brown, C. J. (ed.), *The Cultural and Political Legacy of Anne de Bretagne: Negotiating Convention in Books and Documents* (Woodbridge: D. S. Brewer, 2010).

Carpenter, J. and S. B. MacLean (eds), *The Power of the Weak: Studies on Medieval Women* (Urbana: University of Illinois Press, 1995).

Cruz, A. and M. Suzuki (eds), *The Rule of Women in Early Modern Europe* (Urbana: University of Illinois Press, 2009).

Davids, A. (ed.), *The Empress Theophano: Byzantium and the West at the Turn of the First Millennium* (Cambridge: Cambridge University Press, 2002).

Duggan, A. J. (ed.), *Queens and Queenship in Medieval Europe* (Woodbridge: Boydell Press, 1997).

Earenfight, T. (ed.), *Queenship and Political Power in Medieval and Early Modern Spain* (Aldershot: Ashgate, 2005).

Erler, M. and M. Kowaleski (eds), *Women and Power in the Middle Ages* (Athens: University of Georgia Press, 1988).

Erler, M. and M. Kowaleski, *Gendering the Master Narrative: Women and Power in the Middle Ages* (Ithaca: Cornell University Press, 2003).

Fradenburg, L. O. (ed.), *Women and Sovereignty* (Edinburgh: University of Edinburgh Press, 1991).

Kibler, W. W. (ed.), *Eleanor of Aquitaine: Patron and Politician* (Austin: University of Texas Press, 1976).
Levin, C. and R. Bucholz (eds), *Queens & Power in Medieval and Early Modern England* (Lincoln: University of Nebraska Press, 2009).
Nolan, K. (ed.), *Capetian Women* (Basingstoke: Palgrave Macmillan, 2003).
Oakley-Brown, L. and L. J. Wilkinson (eds), *The Rituals and Rhetoric of Queenship: Medieval to Early Modern* (Dublin: Four Courts Press, 2009).
Parsons, J. C. (ed.), *Medieval Queenship* (New York: St. Martin's Press, 1993).
Vann, T. M., (ed.), *Queens, Regents, and Potentates* (Denton, TX: Academia Press, 1993).
Weissberger, B. (ed.), *Queen Isabel I of Castile: Power, Patronage, Persona* (Woodbridge: Tamesis, 2008).
Wheeler, B. and J. C. Parsons (eds), *Eleanor of Aquitaine: Lord and Lady* (Basingstoke: Palgrave Macmillan, 2003).

Regional and comparative studies

Bak, J., *Coronations: Medieval and Early Modern Monarchic Ritual* (Berkeley: University of California Press, 1990).
Beem, C., *The Lioness Roared: The Problems of Female Rule in English History* (Basingstoke: Palgrave Macmillan, 2006).
Beem, C., *The Royal Minorities of Medieval and Early Modern England* (Basingstoke: Palgrave Macmillan, 2008).
Garland, L., *Byzantine Empresses: Women and Power in Byzantium, AD 527–1204* (London: Routledge, 1999).
Herrin, J., *Women in Purple: Rulers of Medieval Byzantium* (London: Weidenfeld & Nicolson, 2001).
Hill, B., *Imperial Women in Byzantium, 1025–1204: Power, Patronage, and Ideology* (New York: Longman, 1999).
Hilton, L., *Queens Consort: England's Medieval Queens* (London: Weidenfeld & Nicolson, 2008).
Hunneycutt, L., 'Medieval Queenship', *History Today* 39(6) (1989): 16–22.
Monter, W., *The Rise of Female Kings in Europe, 1300–1800* (New Haven: Yale University Press, 2012).
Nelson, J. L., 'Medieval Queenship', in L. E. Mitchell (ed.), *Women in Medieval Western European Culture* (New York: Garland Publishing, 1999): 179–207.
Stafford, P., 'Queens and Queenship', in P. Stafford (ed.), *A Companion to the Early Middle Ages: Britain and Ireland, c.500–c.1100* (Oxford: Wiley-Blackwell, 2009): 459–76.
Wood, C. T., 'Queens, Queans, and Kingship: An Inquiry into Theories of Royal Legitimacy in Late Medieval England and France', in W. C. Jordan, B. McNab, T. F. Ruiz (eds), *Order and Innovation in the Middle Ages* (Princeton: Princeton University Press, 1976): 385–400.

Theoretical approaches

Earenfight, T., 'Without the Persona of the Prince: Kings, Queens and the Idea of Monarchy in Late Medieval Europe', *Gender & History* 19(1) (April 2007): 1–21.
McNamara, J., 'Women and Power through the Family Revisited', in M. C. Erler and M. Kowaleski (eds), *Gendering the Master Narrative: Women and Power in the Middle Ages* (Ithaca, NY: Cornell University Press, 2003): 17–30.
McNamara, J. and S. Wemple, 'The Power of Women through the Family in Medieval Europe, 500–1100', *Feminist Studies* 1 (1973): 126–41.
Scott, J. W., 'Gender: A Useful Category of Historical Analysis', *American Historical Review* 91(5) (1986): 1053–75.
Scott, J. W., 'Gender: Still a Useful Category of Analysis?', *Diogenes* 57(225) (2010): 7–14.

1 Theme and Variations: Roman, Barbarian and Christian Societies in the Fashioning of Medieval Queenship, c. 300–700

Browning, R., *Justinian and Theodora* (New York: Praeger, 1971).
Brubaker, L., 'Sex, Lies, and Textuality: The *Secret History* of Prokopios and the Rhetoric of Gender in Sixth-Century Byzantium', in L. Brubaker and J. M. H. Smith (eds), *Gender in the Early Medieval World: East and West, 300–900* (Cambridge: Cambridge University Press, 2004): 83–101.
Cannon, J. and A. Hargreaves, *The Kings and Queens of Britain* (Oxford: Oxford University Press, 2009).
Clover, C., 'Regardless of Sex: Men, Women, and Power in Early Northern Europe', *Speculum* 68(2) (1993): 363–88.
Cooper, K., *The Virgin and the Bride: Idealized Womanhood in Late Antiquity* (Cambridge: Harvard University Press, 1996).
Edel, D., 'Early Irish Queens and Royal Power: A First Reconnaissance', in M. Richter and J.-M. Picard (eds), *Ogma: Essays in Celtic Studies in Honour of Próinséas Ní Chatháin* (Dublin: Four Courts Press, 2002): 1–19.
Enright, M. J., *Lady with a Mead Cup: Ritual, Prophecy and Lordship in the European Warband from La Tène to the Viking Age* (Dublin: Four Courts Press, 1995).
Garland, L., *Byzantine Empresses: Women and Power in Byzantium, AD 527–1204* (London: Routledge, 1999).
Harrison, D., *The Age of Abbesses and Queens: Gender and Political Culture in Early Medieval Europe* (Lund: Nordic Academic Press, 1998).
Herrin, J., *Women in Purple: Rulers of Medieval Byzantium* (Princeton: Princeton University Press, 2001).
Holum, K. G., *Theodosian Empresses: Women and Imperial Dominion in Late Antiquity* (Berkeley and Los Angeles: University of California Press, 1982).

McClanan, A. L., *Representations of Early Byzantine Empresses: Image and Empire* (New York: Palgrave Macmillan, 2002).
McKitterick, R., *The Frankish Kings and Culture in the Early Middle Ages* (Aldershot: Variorum, 1995).
McNamara, J., 'Imitatio Helenae: Sainthood as an Attribute of Queenship in the Early Middle Ages', in S. Sticca (ed.), *Saints: Studies in Hagiography* (Binghamton, NY: Medieval & Renaissance Texts & Studies, 1996): 51–80.
McNamara, J. and S. Wemple, 'The Power of Women Through the Family in Medieval Europe, 500–1100', *Feminist Studies* 1 (1973): 126–41.
Nelson, J. L., 'Early Medieval Rites of Queen-Making and the Shaping of Medieval Queenship', in A. Duggan (ed.), *Queens and Queenship in Medieval Europe* (Woodbridge: Boydell Press, 1997): 301–15.
Nelson, J. L., 'Gendering Courts in the Early Medieval West', in L. Brubaker and J. M. H. Smith (eds), *Gender in the Early Medieval World* (Cambridge: Cambridge University Press, 2004): 185–97.
Smith, J. A., 'The Earliest Queen-Making Rites', *Church History* 66(1) (March 1997): 18–35.
Stafford, P., 'Queens and Queenship', in P. Stafford (ed.), *A Companion to the Early Middle Ages: Britain and Ireland, c.500–c.1100* (Oxford: Wiley-Blackwell, 2009): 459–76.
Stafford, P., *Queens, Concubines, and Dowagers: The King's Wife in the Early Middle Ages* (Athens: University of Georgia Press, 1983).
Wemple, S. F., *Women in Frankish Society: Marriage and the Cloister, 500–900* (Philadelphia: University of Pennsylvania Press, 1981).

2 Legitimizing the King's Wife and Bed-Companion, c. 700–1100

Essay collections

Davids, A. (ed.), *The Empress Theophano: Byzantium and the West at the Turn of the First Millennium* (Cambridge: Cambridge University Press, 2002).
Nolan, K. (ed.), *Capetian Women* (Basingstoke: Palgrave Macmillan, 2003).
Parsons, J. C. (ed.), *Medieval Queenship* (New York: St. Martin's Press, 1993).

Monographs and essays

Chodor, J., 'Queens in Early Medieval Chronicles of East Central Europe', *East Central Europe* 1: 21–23 (1991): 9–50.
D'Amico, H., 'Beowulf's Foreign Queen and the Politics of Eleventh-Century England,' in V. Blanton and H. Scheck (eds), *Intertexts: Studies in Anglo-Saxon Culture Presented to Paul E. Szarmarch* (Tempe: Arizona Center for Medieval and Renaissance Studies, 2008): 209–40.

Herrin, J., *Women in Purple: Rulers of Medieval Byzantium* (Princeton: Princeton University Press, 2001).

Hill, B., *Imperial Women in Byzantium, 1025–1204: Power, Patronage, and Ideology* (New York: Longman, 1999).

James, L., 'Goddess, Whore, Wife or Slave: Will the Real Byzantine Empress Please Stand Up?', in A. J. Duggan (ed.), *Queens and Queenship in Medieval Europe* (Woodbridge: Boydell Press, 1997): 123–39.

James, L. and B. Hill, 'Women and Politics in the Byzantine Empire: Imperial Women', in L. E. Mitchell (ed.), *Women in Medieval Western European Culture* (New York: Garland, 1999): 157–78.

Karkov, C. E., *The Ruler Portraits of Anglo-Saxon England* (Woodbridge: Boydell Press, 2004).

Klein, S. S., *Ruling Women: Queenship and Gender in Anglo-Saxon Literature* (Notre Dame, IN: University of Notre Dame Press, 2006).

MacLean, S., 'Queenship, Nunneries, and Royal Widowhood in Carolingian Europe', *Past and Present* 178 (2003): 3–38.

McNamara, J. and S. Wemple, 'The Power of Women Through the Family in Medieval Europe, 500–1100', *Feminist Studies* 1 (1973): 126–41.

Nelson, J. L., 'The Lord's Anointed and the People's Choice: Carolingian Royal Ritual', in D. Cannadine and S. Price (eds), *Rituals of Royalty: Power and Ceremonial in Traditional Societies* (Cambridge: Cambridge University Press, 1987): 137–80.

Nelson, J. L., 'Women at the Court of Charlemagne: A Case of Monstrous Regiment?', in J. C. Parsons (ed.), *Medieval Queenship* (New York: St. Martin's Press, 1993): 43–61.

Nolan, K., *Queens in Stone and Silver: The Creation of a Visual Imagery of Queenship in Capetian France* (New York: Palgrave Macmillan, 2009).

Runcimann, S., 'The Empress Irene the Athenian', in D. Baker (ed.), *Medieval Women* (Oxford: Blackwell, 1978): 101–18.

Searle, E., 'Women and the Legitimisation of Succession at the Norman Conquest.' *Anglo-Norman Studies* 3 (1980): 159–70.

Stafford, P., *Queen Emma and Queen Edith: Queenship and Women's Power in Eleventh-Century England* (Oxford: Blackwell, 1997).

Stafford, P., 'Queens and Queenship', in P. Stafford (ed.), *A Companion to the Early Middle Ages: Britain and Ireland, c.500–c.1100* (Oxford: Wiley-Blackwell, 2009): 459–76.

Vann, T. M., 'The Theory and Practice of Medieval Castilian Queenship', in T. M. Vann (ed.), *Queens, Regents, and Potentates* (Dallas, TX: Academia, 1993): 125–47.

Wilson, A. J., *St. Margaret, Queen of Scotland* (Edinburgh: Donald, 1993).

3 'The Link of Conjugal Troth': Queenship as Family Practice, c. 1100–1350

Essay collections

Bull, M. and C. Léglu (eds), *The World of Eleanor of Aquitaine: Literature and Society in Southern France between the Eleventh and Thirteenth Centuries* (Woodbridge: Boydell Press, 2005).

Kibler, W. W. (ed.), *Eleanor of Aquitaine: Patron and Politician* (Austin: University of Texas Press, 1976).

Nolan, K. (ed.), *Capetian Women* (Basingstoke: Palgrave Macmillan, 2003).

Wheeler, B. and J. C. Parsons (eds), *Eleanor of Aquitaine: Lord and Lady* (Basingstoke: Palgrave Macmillan, 2003).

Monographs and essays

Benz St. John, L., *Three Medieval Queens: Queenship and Crown in Fourteenth-Century England* (Basingstoke: Palgrave Macmillan, 2012).

Bianchini, J., *The Queen's Hand: Power and Authority in the Reign of Berenguela of Castile* (Philadelphia: University of Pennsylvania Press, 2012).

Chibnall, M., *The Empress Matilda: Queen Consort, Queen Mother, and Lady of the English* (Oxford: Blackwell, 1991).

Earenfight, T., 'Absent Kings: Queens as Political Partners in the Medieval Crown of Aragon', in T. Earenfight (ed.), *Queenship and Political Power in Medieval and Early Modern Spain* (Aldershot: Ashgate, 2005): 33–51.

Facinger, M., 'A Study of Medieval Queenship: Capetian France, 987–1237', *Studies in Medieval and Renaissance History* 5 (1968): 3–47.

Hamilton, B., 'Women in the Crusader States: The Queens of Jerusalem (1100–1190)', in D. Baker (ed.), *Medieval Women* (Oxford: Blackwell, 1978): 143–73.

Herrin, J., *Women in Purple: Rulers of Medieval Byzantium* (Princeton: Princeton University Press, 2001).

Hill, B., *Imperial Women in Byzantium, 1025–1204: Power, Patronage, and Ideology* (New York: Longman, 1999).

Hilton, L., *Queens Consort: England's Medieval Queens* (London: Weidenfeld & Nicolson, 2008).

Howell, M., *Eleanor of Provence: Queenship in Thirteenth-Century England* (Oxford: Blackwell, 1998).

Huneycutt, L., *Matilda of Scotland: A Study in Medieval Queenship* (Woodbridge: Boydell Press, 2003).

Klaniczay, G., *Holy Rulers and Blessed Princesses: Dynastic Cults in Medieval Central Europe* (Cambridge: Cambridge University Press, 2002).

Klassen, J. M., *Warring Maidens, Captive Wives, and Hussite Queens: Women and Men at War and at Peace in Fifteenth Century Bohemia* (New York: Columbia University Press, 2000).

Layher, W., *Queenship and Voice in Medieval Northern Europe* (Basingstoke: Palgrave Macmillan, 2010).

Martin, T., *Queen as King: Politics and Architectural Propaganda in Twelfth-Century Spain* (Leiden: Brill, 2006).

Martindale, J., 'Succession and Politics in the Romance-Speaking World', in M. Jones and M. Vale (eds), *England and Her Neighbours 1066–1453* (London: Hambledon Press, 1989): 19–41.

Mayer, H. E., 'Studies in the History of Queen Melisende of Jerusalem', *Dumbarton Oaks Papers* 26 (1972): 93–182.

McCracken, P., *The Romance of Adultery: Queenship and Sexual Transgression in Old French Literature* (Philadelphia: University of Pennsylvania Press, 1998).

Nolan, K., *Queens in Stone and Silver: The Creation of a Visual Imagery of Queenship in Capetian France* (New York: Palgrave Macmillan, 2009).

Parsons, J. C., *Eleanor of Castile: Queen and Society in Thirteenth-Century England* (NewYork: St. Martin's Press, 1995).

Reilly, B., *The Kingdom of León-Castilla Under Queen Urraca, 1109–1126* (Princeton: Princeton University Press, 1982).

Shadis, M., *Berenguela of Castile (1180–1246) and Political Women in the High Middle Ages* (Basingstoke: Palgrave Macmillan, 2009).

Skovgaard-Peterson, I. and N. Damsholt, 'Queenship in Medieval Denmark', in J. C. Parsons (ed.), *Medieval Queenship* (New York: St. Martin's Press, 1993): 25–42.

Trindade, A., *Berengaria: In Search of Richard the Lionheart's Queen* (Dublin: Four Courts Press, 1999).

Turner, R. V., *Eleanor of Aquitaine: Queen of France, Queen of England* (New Haven: Yale University Press, 2009).

4 Queenship in a Crisis of Monarchy, c. 1350–1500

Essay collections

Boruchoff, D. (ed.), *Isabel la Católica, Queen of Castile: Critical Essays* (Basingstoke: Palgrave Macmillan, 2003).

Brown C. J. (ed.), *The Cultural and Political Legacy of Anne de Bretagne: Negotiating Convention in Books and Documents* (Woodbridge: D. S. Brewer, 2010).

Earenfight, T. (ed.), *Queenship and Political Power in Medieval and Early Modern Spain* (Aldershot: Ashgate, 2005).

Weissberger, B. (ed.), *Queen Isabel I of Castile: Power, Patronage, Persona* (Woodbridge: Boydell & Brewer, 2008).

Wolff, M. (ed.), *Kings, Queens, and Courtiers: Art in Early Renaissance France* (New Haven: Yale University Press, 2011).

Monographs and essays

Adams, T., *The Life and Afterlife of Isabeau of Bavaria* (Baltimore: Johns Hopkins University Press, 2010).
Benz St. John, L., *Three Medieval Queens: Queenship and Crown in Fourteenth-Century England* (Basingstoke: Palgrave Macmillan, 2012).
Brown. C. J., *The Queen's Library: Image-Making at the Court of Anne of Brittany* (Philadelphia: University of Pennsylvania Press, 2010).
Downie, F., *She is But a Woman: Queenship in Scotland, 1424–1463* (Edinburgh: John Donald, 2006).
Earenfight, T., *The King's Other Body: María of Castile and the Crown of Aragon* (Philadelphia: University of Pennsylvania Press, 2010).
Etting, V., *Queen Margrethe I, 1353–1412, and the Founding of the Nordic Union* (Leiden: Brill, 2004).
Finn, K. M., *The Last Plantagenet Consorts: Gender, Genre, and Historiography, 1440–1627* (Basingstoke: Palgrave Macmillan, 2012).
Halecky, O. and T. Gromada, *Jadwiga of Anjou and the Rise of East Central Europe* (Boulder: Social Science Monographs, 1991).
Hunt, D. and I. Hunt (eds), *Caterina Cornaro: Queen of Cyprus* (London: Trigraph, 1989).
Jonas, M. K. and M. G. Underwood, *The King's Mother: Lady Margaret Beaufort, Countess of Richmond and Derby* (Cambridge: Cambridge University Press, 1993).
Klaniczay, G., *Holy Rulers and Blessed Princesses: Dynastic Cults in Medieval Central Europe* (Cambridge: Cambridge University Press, 2002).
Klassen, J. M., *Warring Maidens, Captive Wives, and Hussite Queens: Women and Men at War and at Peace in Fifteenth Century Bohemia* (New York: Columbia University Press, 2000).
Laynesmith, J. L., *The Last Medieval Queens: English Queenship, 1445–1503* (Oxford: Oxford University Press, 2004).
Lehfeldt, E. A., 'Ruling Sexuality: The Political Legitimacy of Isabel of Castile', *Renaissance Quarterly* 53 (2000): 31–56.
L'Estrange, E., *Holy Motherhood: Gender, Dynasty, and Visual Culture in the Later Middle Ages* (Manchester: Manchester University Press, 2008).
Maurer, H. E., *Margaret of Anjou: Queenship and Power in Late Medieval England* (Woodbridge: Boydell Press, 2003).
Okerlund, A. N., *Elizabeth of York* (Basingstoke: Palgrave Macmillan, 2009).
Rodrigues, A. M., 'The Queen-Consort in Late-Medieval Portugal', in B. Bolton and C. Meek (eds), *Aspects of Power and Authority in the Middle Ages* (Turnhout: Brepols, 2007): 131–46.
Silleras-Fernández, N., *Power, Piety, and Patronage in Late Medieval Queenship: Maria de Luna* (Basingstoke: Palgrave Macmillan, 2008).
Weissberger, B., *Isabel Rules: Constructing Queenship, Wielding Power* (Minneapolis: University of Minnesota Press, 2004).
Wood, C. T., *Joan of Arc and Richard III: Sex, Saints, and Government in the Middle Ages* (Oxford: Oxford University Press, 1988).

5 The Transformation of Queenship from Medieval to Early Modern Europe

Aram, B., *Juana the Mad: Sovereignty and Dynasty in Renaissance Europe* (Baltimore: Johns Hopkins University Press, 2005).
Beem, C., *The Foreign Relations of Elizabeth I* (Basingstoke: Palgrave Macmillan, 2011).
Beem, C., *The Royal Minorities of Medieval and Early Modern England* (Basingstoke: Palgrave Macmillan, 2008).
Beem, C., *The Lioness Roared: The Problems of Female Rule in English History* (Basingstoke: Palgrave Macmillan, 2006).
Bell, I., *Elizabeth I: The Voice of a Monarch* (Basingstoke: Palgrave Macmillan, 2010).
Bell, S. G., *The Lost Tapestries of the City of Ladies: Christine de Pizan's Renaissance Legacy* (Berkeley and Los Angeles: University of California Press, 2004).
Crawford, K., *Perilous Performances: Gender and Regency in Early Modern France* (Cambridge, MA: Harvard University Press, 2005).
De Longh, J., *Margaret of Austria, Regent of the Netherlands*, M. D. Herter (trans.) (New York: Norton, 1953).
Eichberger, D. (ed.), *Women of Distinction: Margaret of York and Margaret of Austria* (Turnhout: Brepols, 2005).
Elston, T. G., 'Widow Princess or Neglected Queen? Catherine of Aragon, Henry VIII, and English Public Opinion, 1533–1536', in C. Levin and R. Bucholz (eds), *Queens & Power in Medieval and Early Modern England* (Lincoln: University of Nebraska Press, 2009): 16–30.
Hanley, S., 'The Politics of Identity and Monarchic Governance in France: The Debate over Female Exclusion', in H. L. Smith (ed.), *Women Writers and the Early Modern British Political Tradition* (Cambridge: Cambridge University Press, 1997): 289–304.
Hoffman, M. K., *Raised To Rule: Educating Royalty at the Court of the Spanish Habsburgs, 1601–1634* (Baton Rouge: Louisiana State University Press, 2011).
Hunt, A. and A. Whitelock (eds), *Tudor Queenship: The Reigns of Mary and Elizabeth* (Basingstoke: Palgrave Macmillan, 2010).
Jansen, S. L., *The Monstrous Regiment of Women: Female Rulers in Early Modern Europe* (Basingstoke: Palgrave Macmillan, 2009).
Jansen, S. L., (ed.), *Anne of France: Lessons for My Daughter* (Cambridge: Brewer, 2004).
Jordan, C., 'Woman's Rule in Sixteenth-Century British Political Thought', *Renaissance Quarterly* 40(3) (1987): 421–51.
Kleinman, R., *Anne of Austria: Queen of France* (Columbus: Ohio State University, 1985).
Lehfeldt, E. A., 'The Queen at War: Shared Sovereignty and Gender in Representations of the Granada Campaign', in B. F. Weissberger (ed.), *Queen*

Isabel I of Castile: Power, Patronage, Persona (Woodbridge: Tamesis, 2008): 108–119.

Levin, C., *The Heart and Stomach of a King: Elizabeth I and the Politics of Sex and Power* (Philadephia: University of Pennsylvania Press, 1994).

Levin, C. (ed.), *Elizabeth I: Always Her Own Free Woman* (Aldershot: Ashgate, 2003).

Levin, C., *The Reign of Elizabeth I* (Basingstoke: Palgrave Macmillan, 2002).

Levin, C., D. B. Graves, J. E. Carney, (eds), *High and Mighty Queens of Early Modern England: Realities and Representations* (Basingstoke: Palgrave Macmillan, 2003).

Liss, P., *Isabel the Queen*, 2nd edn (Philadelphia: University of Pennsylvania Press, 2004; 1st edn, 1992).

Loades, D. M., *Mary Tudor: A Life* (Oxford: Basil Blackwell, 1989).

Loomis, C., *The Death of Elizabeth I* (Basingstoke: Palgrave Macmillan, 2010).

Matarasso, P., *Queen's Mate: Three Women of Power in France on the Eve of the Renaissance* (Aldershot: Ashgate, 2001).

Mattingly, G., *Catherine of Aragon* (Boston: Little, Brown, 1941).

McCartney, E., *Queens in the Cult of the French Renaissance Monarchy: Public Law, Royal Ceremonial, and Political Discourse in the History of Regency Government, 1484–1610* (London: Routledge, 2007).

McLaren, A. N., *Political Culture in the Reign of Elizabeth I: Queen and Commonwealth, 1558–1585* (Cambridge: Cambridge University Press, 1999).

Monter, W., *The Rise of Female Kings in Europe, 1300–1800* (New Haven: Yale University Press, 2012).

Patrouch, J., *Queen's Apprentice: Archduchess Elizabeth, Empress María, the Habsburgs, and the Holy Roman Empire, 1554–1569* (Leiden: Brill, 2010).

Redworth, G., *The Prince and the Infanta: The Cultural Politics of the Spanish Match* (New Haven: Yale University Press, 2003).

Riehl, A., *The Face of Queenship: Representations of Elizabeth I* (Basingstoke: Palgrave Macmillan, 2010).

Sadlack, S., *The French Queen's Letters: Mary Tudor Brandon and the Politics of Marriage in Sixteenth Century Europe* (Basingstoke: Palgrave Macmillan, 2011).

Sánchez, M., *The Empress, the Queen, and the Nun: Women and Power at the Court of Philip III of Spain* (Baltimore: Johns Hopkins University Press, 1998).

Shenk, L., *Learned Queen: The Imperial Images of Elizabeth I* (Basingstoke: Palgrave Macmillan, 2009).

Suzuki, M. and A. J. Cruz (eds), *The Rule of Women in Early Modern Europe* (Champaign: University of Illinois Press, 2009).

Weissberger, B. (ed.), *Queen Isabel I of Castile: Power, Patronage, Persona* (Woodbridge: Boydell & Brewer, 2008).

Weissberger, B., *Isabel Rules: Constructing Queenship, Wielding Power* (Minneapolis: University of Minnesota Press, 2004).

Wolff, M. (ed.), *Kings, Queens, and Courtiers: Art in Early Renaissance France* (New Haven: Yale University Press, 2011).

Wormald, J., *Mary Queen of Scots: A Study in Failure* (London: George Philip, 1988).

Bibliography

Queenship studies is a rapidly changing field and a bibliography in print cannot keep pace with the articles and books published. The works listed below focus on the material in English or, if in another language, by authors who routinely publish in English. For an up-to-date bibliography, see *Queens in the Middle Ages* at theresaearenfight.com.

Queens and queenship, women and power: essay collections cited in the bibliography

Boruchoff, D. (ed.), *Isabel la Católica, Queen of Castile: Critical Essays* (Basingstoke: Palgrave Macmillan, 2003).
Brown, C. J. (ed.), *The Cultural and Political Legacy of Anne de Bretagne: Negotiating Convention in Books and Documents* (Woodbridge: D. S. Brewer, 2010).
Carpenter, J. and S. B. MacLean (eds), *The Power of the Weak: Studies on Medieval Women* (Urbana: University of Illinois Press, 1995).
Cruz, A. and M. Suzuki (eds), *The Rule of Women in Early Modern Europe* (Urbana: University of Illinois Press, 2009).
Davids, A. (ed.), *The Empress Theophano: Byzantium and the West at the Turn of the First Millennium* (Cambridge: Cambridge University Press, 2002).
Duggan, A. J. (ed.), *Queens and Queenship in Medieval Europe* (Woodbridge: Boydell Press, 1997).
Earenfight, T. (ed.), *Queenship and Political Power in Medieval and Early Modern Spain* (Aldershot: Ashgate, 2005).
Erler, M. and M. Kowaleski (eds), *Women and Power in the Middle Ages* (Athens: University of Georgia Press, 1988).
Fradenburg, L. O. (ed.), *Women and Sovereignty* (Edinburgh: University of Edinburgh Press, 1991).
Kibler, W. W. (ed.), *Eleanor of Aquitaine: Patron and Politician* (Austin: University of Texas Press, 1976).

Levin, C. and R. Bucholz (eds), *Queens & Power in Medieval and Early Modern England* (Lincoln: University of Nebraska Press, 2009).

Nolan, K. (ed.), *Capetian Women* (Basingstoke: Palgrave Macmillan, 2003).

Oakley-Brown, L. and L. J. Wilkinson (eds), *The Rituals and Rhetoric of Queenship: Medieval to Early Modern* (Dublin: Four Courts Press, 2009).

Parsons, J. C. (ed.), *Medieval Queenship* (New York: St. Martin's Press, 1993).

Vann, T. M., (ed.), *Queens, Regents, and Potentates* (Denton, TX: Academia Press, 1993).

Weissberger, B. (ed.), *Queen Isabel I of Castile: Power, Patronage, Persona* (Woodbridge: Tamesis, 2008).

Wheeler, B. and J. C. Parsons (eds), *Eleanor of Aquitaine: Lord and Lady* (Basingstoke: Palgrave Macmillan, 2003).

Monographs, journal articles, and essays in edited volumes

Adair, P. A., 'Constance of Arles: A Study in Duty and Frustration', in Nolan (ed.), *Capetian Women*: 9–26.

Adams, T., 'Christine de Pizan, Isabeau of Bavaria, and Female Regency', *French Historical Studies* 32(1) (2009): 1–32.

Adams, T., *The Life and Afterlife of Isabeau of Bavaria* (Baltimore: Johns Hopkins University Press, 2010).

Adams, T., 'Notions of Late Medieval Queenship: Christine de Pizan's Isabeau of Bavaria', in Cruz and Suzuki (eds), *The Rule of Women in Early Modern Europe*: 13–29.

Adams, T., 'Recovering Queen Isabeau of France (c.1370–1435): A Re-reading of Christine de Pizan's Letters to the Queen', *Fifteenth Century Studies* 33 (2008): 35–54.

Ainsworth, P., 'Representing Royalty: Kings, Queens, and Captains in Some Early Fifteenth-Century Manuscripts of Froissart's "Chroniques"', *The Medieval Chronicle* 4 (2006): 1–37.

Airlie, S., 'Private Bodies and the Body Politic in the Divorce Case of Lothar II', *Past and Present* 161 (1998): 3–38.

Aram, B., 'Authority and Maternity in Late-Medieval Castile: Four Queens Regnant', in B. Bolton and C. Meek (eds), *Aspects of Power and Authority in the Middle Ages* (Turnhout: Brepols, 2007): 121–9.

Aram, B., *Juana the Mad: Sovereignty and Dynasty in Renaissance Europe* (Baltimore: Johns Hopkins University Press, 2005).

Arewill-Nordbladh, E., 'A Reigning Queen or the Wife of a King – Only? Gender Politics in the Scandinavian Viking Age', in S. Milledge Nelson (ed.), *Ancient Queens: Archeological Explorations* (Walnut Creek: Altamira Press, 2003): 19–40.

Armstrong, D., 'Holy Queens as Agents of Christianization in Bede's 'Ecclesiastical History': A Reconsideration', *Old English Newsletter* 29 (Spring 1996): A–28.

Averkorn, R., 'Women and Power in the Middle Age: Political Aspects of Medieval Queenship', in A. K. Isaacs (ed.), *Political Systems and Definitions of Gender Roles* (Pisa: Edizioni Plus-Università di Pisa, 2001): 11–30.
Avril, F., *Manuscript Painting at the Court of France: The Fourteenth Century, 1310–1380*, U. Molinaro and B. Benderson (trans) (New York: Braziller, 1978).
Azcona, T. de, *Isabel la Católica: Estudio critico de su vida y su reinado* (Madrid: BAC, 1993).
Azevedo, P. de, 'Inquirição de 1336 sobre os milagres da Rainha D. Isabel', *Boletim da Segunda Classe da Academia das Scíencias de Lisboa* 3 (1910): 294–303.
Bak, J., *Coronations: Medieval and Early Modern Monarchic Ritual* (Berkeley and Los Angeles: University of California Press, 1990).
Bak, J., 'Queens as Scapegoats in Medieval Hungary', in Duggan (ed.), *Queens and Queenship in Medieval Europe*: 223–33.
Bak, J., 'Roles and Functions of Queens in Árpádian and Angevin Hungary', in Parsons (ed.), *Medieval Queenship*: 13–23.
Baker, D., ' "A Nursery of Saints": St. Margaret of Scotland Reconsidered', in D. Baker (ed.), *Medieval Women* (Oxford: Blackwell, 1978): 119–41.
Baldwin, J. W., 'The Many Loves of Philip Augustus', in S. Roush and C. L. Baskins (eds), *The Medieval Marriage Scene: Prudence, Passion, Policy* (Tempe: Arizona Center for Medieval and Renaissance Studies, 2005): 67–80.
Balzaretti, R., 'Theodelinda, "Most Glorious Queen": Gender and Power in Lombard Italy', *Medieval History Journal* 2(2) (1999): 183–207.
Bange, P. 'The Image of Women of the Nobility in the German Chronicles of the Tenth and Eleventh Centuries', in Davids (ed.), *The Empress Theophano*: 150–68.
Barber, R., 'Eleanor of Aquitaine and the Media', in M. Bull and C. Léglu (eds), *The World of Eleanor of Aquitaine: Literature and Society in Southern France between the Eleventh and Thirteenth Centuries* (Woodbridge: Boydell Press, 2005): 13–27.
Barrett, E., *Art and the Construction of Medieval Queenship: Dynastic Legitimacy and Family Piety* (Poole: Cassell, 1998).
Barrow, G. W. S., 'A Kingdom in Crisis: Scotland and the Maid of Norway', *Scottish Historical Review* 69(2) (1990): 120–41.
Bates, D., 'The Representation of Queens and Queenship in Anglo-Norman Royal Charters', in P. Fouracre and D. Ganz (eds), *Frankland: The Franks and the World of the Early Middle Ages* (Manchester: Manchester University Press, 2008): 285–303.
Beaune, C., *The Birth of an Ideology: Myths and Symbols of Nation in Late-Medieval France*, S. R. Huston (trans.) (Berkeley and Los Angeles: University of California Press, 1991; 1st French edn, 1985).
Beauvoir, S. de, *The Second Sex*, C. Borde and S. Malovany-Chevallier (trans) (London: Jonathan Cape, 2009; 1st French edn, 1949).
Bedos Rezak, B., 'Women, Seals, and Power in Medieval France', in Erler and Kowaleski (eds), *Women and Power in the Middle Ages*: 61–82.
Beech, G., 'The Eleanor of Aquitaine Vase', in Wheeler and Parsons (eds), *Eleanor of Aquitaine: Lord and Lady*: 369–76.

Beech, G., 'Queen Mathilda of England (1066–1083) and the Abbey of La Chaise-Dieu in the Auvergne', *Frühmittelalterliche Studien* 27 (1993): 350–74.
Beem, C., *The Foreign Relations of Elizabeth I* (Basingstoke: Palgrave Macmillan, 2011).
Beem, C., '"Greater by Marriage": The Matrimonial Career of the Empress Matilda', in Levin and Bucholz (eds), *Queens & Power in Medieval and Early Modern England*: 1–15.
Beem, C., *The Lioness Roared: The Problems of Female Rule in English History* (Basingstoke: Palgrave Macmillan, 2006).
Beem, C., *The Royal Minorities of Medieval and Early Modern England* (Basingstoke: Palgrave Macmillan, 2008).
Bell, I., *Elizabeth I: The Voice of a Monarch* (Basingstoke: Palgrave Macmillan, 2010).
Bell, L. M., '"Hel our queen": An Old Norse Analogue to an Old English Female Hell', *Harvard Theological Review* 76(2) (1983): 263–68.
Bell, S. G., *The Lost Tapestries of the City of Ladies: Christine de Pizan's Renaissance Legacy* (Berkeley and Los Angeles: University of California Press, 2004).
Bell, S. G., 'Medieval Women Book Owners: Arbiters of Piety and Ambassadors of Culture', *Signs* 7 (1982): 742–68.
Benevides, F. da F., *Rainhas de Portugal; estudos historicos com muitos documentos* (Lisbon: Castro Irmão, 1878–79; repr. edn: Lisbon: Livros Horizonte, 2007).
Bennett, J. M., *History Matters: Patriarchy and the Challenge of Feminism* (Philadelphia: University of Pennsylvania Press, 2006).
Bennett, M., 'Virile Latins, Effeminate Greeks, and Strong Women: Gender Definitions on Crusade?', in S. B. Edgington and S. Lambert (eds), *Gendering the Crusades* (Cardiff: University of Wales Press, 2001): 16–30.
Benz St. John, L., *Three Medieval Queens: Queenship and Crown in Fourteenth-century England* (Basingstoke: Palgrave Macmillan, 2012).
Bérenger, J. *A History of the Habsburg Empire: 1273–1700* (London: Longman, 1994).
Bethlehem, U., *Guinevere: A Medieval Puzzle: Images of Arthur's Queen in the Medieval Literature of Britain and France* (Heidelberg: Anglistische Forschungen: 2005).
Bianchini, J., *The Queen's Hand: Power and Authority in the Reign of Berenguela of Castile* (Philadelphia: University of Pennsylvania Press, 2012).
Biebel-Stanley, E. M., 'Sovereignty through the Lady: "The Wife of Bath's Tale" and the Queenship of Anne of Bohemia', in S. E. Passmore and S. Carter (eds), *The English 'Loathly Lady' Tales: Boundaries, Traditions, Motifs* (Kalamazoo: Medieval Institute Publications, 2007): 73–82.
Biles, M., 'The Indomitable Belle: Eleanor of Provence, Queen of England', in H. Sinclair (ed.), *Seven Studies in Medieval English History and Other Historical Essays* (Jackson: University Press of Mississippi, 1983): 113–32.
Bitel, L., *Land of Women: Tales of Sex and Gender from Early Ireland* (Ithaca, NY: Cornell University Press, 1996).
Black, N. B., *Medieval Narratives of Accused Queens* (Gainesville: University Press of Florida, 2003).

Blackley, F. D., 'Isabella of France, Queen of England 1308–1358, and the Late Medieval Cult of the Dead', *Canadian Journal of History* 15(1) (1980): 23–47.

Blanton, V., 'King Anna's Daughters: Genealogical Narrative and Cult Formation in the "Liber Eliensis"', *Historical Reflections/Reflexions historiques* 30(1) (Spring 2004): 127–49.

Blanton, V., *Signs of Devotion: The Cult of St. Æthelthryth in Medieval England, 695–1615* (University Park: Penn State University Press, 2007).

Bloem, H. M., 'The Processions and Decorations at the Royal Funeral of Anne of Brittany', *Bibliothèque d'Humanisme et Renaissance* 54(1) (1992): 131–60.

Blumenfeld-Kosinski, R., 'Christine de Pizan and the Political Life in Late Medieval France', in B. Altmann and D. McGrady (eds), *Christine de Pizan: A Casebook* (London: Routledge, 2003): 9–24.

Bogomoletz, W. V., 'Anna of Kiev: An Enigmatic Capetian Queen of the Eleventh Century: A Reassessment of Biographical Sources', *French History* 19(3) (2005): 299–323.

Bolton, T., 'Ælfgifu of Northampton: Cnut the Great's Other Woman', *Nottingham Medieval Studies* 51 (2007): 247–68.

Bossy, M.-A., 'Arms and the Bride: Christine de Pisan's Military Treaties as a Wedding Gift for Margaret of Anjou', in M. Desmond (ed.), *Christine de Pisan and the Categories of Difference* (Minneapolis: University of Minnesota Press, 1998): 236–56.

Bouchard, C. B., 'Eleanor's Divorce from Louis VII: The Uses of Consanguinity', in Wheeler and Parsons (eds), *Eleanor of Aquitaine: Lord and Lady*: 223–35.

Boyd, M., *Rulers in Petticoats* (New York: Criterion, 1966).

Brabant, M., *Politics, Gender and Genre: The Political Thought of Christine de Pizan* (Boulder: Westview Press, 1992).

Bradbury, J., *Stephen and Matilda: The Civil War, 1139–1154* (Stroud: Sutton, 1996).

Bratsch-Prince, D., 'Pawn or Player? Violant of Bar and the Game of Matrimonial Politics in the Crown of Aragon (1380–1396)', in E. Lacarra Lanz (ed.), *Marriage and Sexuality in Medieval and Early Modern Iberia* (Oxford: Routledge, 2002): 59–89.

Bratsch-Prince, D., 'A Queen's Task: Violant de Bar and the Experience of Royal Motherhood in Fourteenth-Century Aragon', *La corónica* 27(1) (1998): 21–34.

Bratsch-Prince, D., 'A Reappraisal of the Correspondence of Violant de Bar (1365–1431)', *Catalan Review* 8 (1994): 295–312.

Bratsch-Prince, D., *Violante de Bar (1365–1431)*, María Morrás (trans.) (Madrid: Ediclás, 2002).

Bremmer, R. H., Jr., 'Widows in Anglo-Saxon England', in J. Bremmer and L. van den Bosch (eds), *Between Poverty and the Pyre: Moments in the History of Widowhood* (New York: Routledge, 1995): 58–88.

Broadhurst, K. M., 'Henry II of England and Eleanor of Aquitaine: Patrons of Literature in French?', *Viator* 27 (1996): 53–84.

Brown. C. J., *The Queen's Library: Image-Making at the Court of Anne of Brittany* (Philadelphia: University of Pennsylvania Press, 2010).

Brown, E. A. R., 'Eleanor of Aquitaine Reconsidered: The Woman and Her Seasons', in Wheeler and Parsons (eds), *Eleanor of Aquitaine: Lord and Lady*: 1–54.
Brown, E. A. R., 'The Kings Conundrum: Endowing Queens and Loyal Servants, Ensuring Salvation, and Protecting the Patrimony in Fourteenth-Century France', in J. A. Burrow and I. P. Wei (eds), *Medieval Futures: Attitudes to the Future in the Middle Ages* (Woodbridge: Boydell Press, 2000): 115–63.
Brown, E. A. R., 'Order and Disorder in the Life and Death of Anne de Bretagne', in Brown (ed.), *The Cultural and Political Legacy of Anne de Bretagne*: 177–92.
Brown, E. A. R., 'The Political Repercussions of Family Ties in the Early Fourteenth Century: The Marriage of Edward II of England and Isabelle of France', *Speculum* 63 (1988): 573–95.
Brown-Grant, R., *Christine de Pizan and the Moral Defense of Women: Reading Beyond Gender* (Cambridge: Cambridge University Press, 1999).
Browning, R., *Justinian and Theodora* (New York: Praeger, 1971).
Brubaker, L., 'Memories of Helena: Patterns of Imperial Matronage in the Fourth and Fifth Centuries', in L. James (ed.), *Women, Men, and Eunuchs: Gender in Byzantium* (New York: Routledge, 1997): 52–75.
Brubaker, L., 'Sex, Lies, and Textuality: The *Secret History* of Prokopios and the Rhetoric of Gender in Sixth-Century Byzantium', in L. Brubaker and J. M. H. Smith (eds), *Gender in the Early Medieval World: East and West, 300–900* (Cambridge: Cambridge University Press, 2004): 83–101.
Brundage, J. A., 'The Canon Law of Divorce in the Mid-Twelfth Century: Louis VII c. Eleanor of Aquitaine', in Wheeler and Parsons (eds), *Eleanor of Aquitaine: Lord and Lady*: 213–21.
Brundage, J. A., *Law, Sex, and Christian Society in Medieval Europe* (Chicago: University of Chicago Press, 1987).
Brzezińska, A., 'Female Control of Dynastic Politics in Sixteenth-century Poland', in B. Nagy and M. Sebök (eds), *The Man of Many Devices Who Wandered Full Many Ways ... Festschrift in Honor of János M. Bak* (Budapest: CEU Press, 1999): 187–94.
Buc, P., 'Italian Hussies and German Matrons: Luitprand of Cremona on Dynastic Legitimacy', *Frühmittelalterliche Studien* 29 (1995): 207–25.
Burman, J., 'The Christian Empress Eudocia', in J. Perreault (ed.), *Les Femmes et le Monochisme Byzantine* (Athens: Canadian Archaeological Institute, 1991): 51–9.
Cahn, W., 'The Psalter of Queen Emma', *Cahiers archéologiques* 33 (1985): 72–85.
Cameron, A., 'The Empress and the Poet: Paganism and Politics at the Court of Theodosius II', *Yale Classical Studies* 27 (1982): 126–45.
Cannon, J. and A. Hargreaves, *The Kings and Queens of Britain* (Oxford: Oxford University Press, 2009).
Carrasco, M. E., 'Spirituality in Context: The Romanesque Illustrated Life of Saint Radegund of Poitiers (Poitiers, Bibliotheque Municipale, MS 250)', *Art Bulletin* 72(3) (1990): 414–35.
Castro Lingl, V., 'Juan de Flores and Lustful Women: The "Crónica Incompleta de los Reyes Católicos"', *La corónica* 24(1) (1995): 74–89.

Caviness, M. H., 'Anchoress, Abbess, and Queen: Donors and Patrons or Intercessors and Matrons?' in J. H. McCash (ed.), *The Cultural Patronage of Medieval Women* (Athens: University of Georgia Press, 1996): 105–54.

Casteen, E., 'The Making of a Neapolitan She-Wolf: Gender, Sexuality, and Sovereignty and the Reputation of Johanna I of Naples', doctoral dissertation (Northwestern University, 2009).

Chamberlain, C., 'The "Sainted Queen" and the "Sin of Berenguela": Teresa Gil de Viduare and Berenguela Alfonso in the Documents of the Crown of Aragon, 1255–1272', in L. J. Simon (ed.), *Iberia and the Mediterranean World of the Middle Ages* (Leiden: Brill, 1995), vol. 1: 303–21.

Chamberlayne, J. L., 'Crowns and Virgins: Queenmaking during the Wars of the Roses', in K. J. Lewis, N. J. Menuge, and K. M. Phillips (eds), *Young Medieval Women* (New York: St. Martin's Press, 1999): 47–68.

Cherewatuk, K., 'Radegund and the Epistolary Tradition', in K. Cherwatuk and U. Wiethaus (eds), *Dear Sister: Medieval Women and the Epistolary Genre* (Philadelphia: University of Pennsylvania Press, 1993): 20–45.

Chibnall, M., 'The Empress Matilda and Her Sons', in J. C. Parsons and B. Wheeler (eds), *Medieval Mothering* (New York: Garland, 1996): 279–94.

Chibnall, M., 'The Empress Matilda as a Subject for Biography', in D. Bates, J. Crick, and S. Hamilton (eds), *Writing Medieval Biography, 750–1250* (Woodbridge: Boydell Press, 2006): 185–94.

Chibnall, M., *The Empress Matilda: Queen Consort, Queen Mother, and Lady of the English* (Oxford: Blackwell, 1991).

Chodor, J., 'Queens in Early Medieval Chronicles of East Central Europe', *East Central Europe* 1(21–23) (1991): 9–50.

Christys, A., 'The Queen of the Franks Offers Gifts to the Caliph al-Muktafi'', in W. Davies and P. Fouracre (eds), *The Languages of Gift in the Early Middle Ages* (Cambridge University Press, 2010): 149–70.

Ciggar, K., 'Theophano: An Empress Reconsidered', in Davids (ed.), *The Empress Theophano*: 49–63.

Clear, M. J., 'Maria of Hungary as Queen, Patron, and Exemplar', in J. Elliott and C. Warr (eds), *The Church of Santa Maria Donna Regina: Art, Iconography, and Patronage in Fourteenth-Century Naples* (Aldershot: Ashgate, 2004): 45–60.

Clear, M. J., 'Piety and Patronage in the Mediterranean: Sancia of Majorca (1286–1345) Queen of Sicily, Provence and Jerusalem', doctoral dissertation (University of Sussex, 2000).

Clover, C., 'Regardless of Sex: Men, Women, and Power in Early Northern Europe', *Speculum* 68(2) (1993): 363–88.

Coates, S., 'Regendering Radegund? Fortunatus, Baudonivia, and the Problem of Female Sanctity in Merovingian Gaul', *Studies in Church History* 34 (1998): 37–50.

Conklin, G., 'Ingeborg of Denmark, Queen of France, 1193–1223', in Duggan (ed.), *Queens and Queenship in Medieval Europe*: 39–52.

Coldstream, N., 'The Roles of Women in Late Medieval Civic Pageantry in

England', in T. Martin (ed.), *Reassessing the Roles of Women as 'Makers' of Medieval Art and Architecture*, 2 vols (Leiden: Brill, 2012), vol. 1: 175–94.

Coleman, J., 'Philippa of Lancaster, Queen of Portugal—and Patron of the Gower Translations?' in M. Bullón-Fernández (ed.), *England and Iberia in the Middle Ages, 12th–15th Century: Cultural, Literary and Political Exchanges* (Basingstoke: Palgrave Macmillan, 2007): 135–65.

Collins, R., 'Queens-Dowager and Queens-Regent in Tenth-Century León and Navarre', in Parsons (ed.), *Medieval Queenship*: 79–92.

Connon, A., 'The Banshenchas and the Uí Néill Queens of Tara', in A. P. Smyth (ed.), *Seanchas: Studies in Early Medieval Irish Archaeology, History and Literature in Honour of Francis J. Byrne* (Dublin: Four Courts Press, 1999): 98–108.

Consolino, F. E., 'Christianising Barbarian Kingdoms: Queens and Conversion to Catholicism (476–604)', in K. E. Børresen (ed.), *Christian and Islamic Gender Models in Formative Traditions* (Freiburg: Herder, 2004): 103–33.

Cooke, J., 'Scottish Queenship in the Thirteenth Century', *Thirteenth Century England* 11 (2007): 61–80.

Cooper, K., *The Virgin and the Bride: Idealized Womanhood in Late Antiquity* (Cambridge: Harvard University Press, 1996).

Costa Gomes, R., *The Making of Court Society: Kings and Nobles in Late Medieval Portugal*, A. Aiken (trans.) (Cambridge: Cambridge University Press, 2003).

Crawford, A., 'The King's Burden? The Consequences of Royal Marriage in Fifteenth-century England', in R. A. Griffiths (ed.), *Patronage, the Crown, and the Provinces in Later Medieval England* (Stroud: Sutton, 1981): 33–56.

Crawford, A., 'The Queen's Council in the Middle Ages', *English Historical Review* 116(469) (2001): 1193–1211.

Crawford, K., *Perilous Performances: Gender and Regency in Early Modern France* (Cambridge: Harvard University Press, 2004).

Cron, B. M., 'The Duke of Suffolk, the Angevin Marriage, and the Ceding of Maine, 1445', *Journal of Medieval History* 20(1) (1994): 77–99.

Crossley, P., 'The Architecture of Queenship: Royal Saints, Female Dynasties and the Spread of Gothic Architecture in Central Europe', in Duggan (ed.), *Queens and Queenship in Medieval Europe*: 263–300.

Cruz, A. J., 'The Female Figure as Political Propaganda in the "Pedro el Cruel" Romancero', in M. S. Sánchez and A. Saint-Saens (eds), *Spanish Women in the Golden Age: Images and Realities* (Westport, CT: Greenwood, 1996): 69–89.

Curta, F., 'Merovingian and Carolingian Gift Giving', *Speculum* 81(3) (2006): 671–99.

Cutler, A., 'Significant Gifts: Patterns of Exchange in Late Antique, Byzantine, and Early Islamic Diplomacy', *Journal of Medieval & Early Modern Studies* 38(1) (2008): 79–101.

Dahmus, J. H., *Seven Medieval Queens* (Garden City, NY: Doubleday, 1972).

D'Amico, H., 'Beowulf's Foreign Queen and the Politics of Eleventh-Century England,' in V. Blanton and H. Scheck (eds), *Intertexts: Studies in Anglo-Saxon Culture Presented to Paul E. Szarmarch* (Tempe: Arizona Center for Medieval and Renaissance Studies, 2008): 209–40.

D'Amico, H., 'Queens and Female Warriors in Old English Literature and Society', *Old English Newsletter* 16 (1983): 55–6.

Danbury, E., 'Images of English Queens in the Later Middle Ages', *Historian* 46 (1995): 3–9.

Danbury, E., 'Queens and Powerful Women: Image and Authority', in N. Adams, J. Cherry, and J. Robinson (eds), *Good Impressions: Image and Authority in Medieval Seals* (London: British Museum, 2008): 17–24.

Dark, P. A., 'The Career of Matilda of Boulogne as Countess and Queen in England, 1135–1152', doctoral dissertation (University of Oxford, 2005).

Dark, P. A., ' "A Woman of Subtlety and a Man's Resolution": Matilda of Boulogne in the Power Struggles of the Anarchy', in B. Bolton and C. Meek (eds), *Aspects of Power and Authority in the Middle Ages* (Turnhout: Brepols, 2007): 147–64.

Davis-Kimball, J. and M. Behan, *Warrior Women: An Archaeologist's Search for History's Hidden Heroines* (New York: Warner, 2002).

d'Avray, D., *Medieval Marriage: Symbolism and Society* (Oxford: Oxford University Press, 2003).

DeAragon, R. C., 'Do We Know What We Think We Know? Making Assumptions About Eleanor of Aquitaine', *Medieval Feminist Forum* 37 (Spring 2004): 14–20.

DeAragon, R. C., 'Wife, Widow, and Mother: Some Comparisons between Eleanor of Aquitaine and Noblewomen of the Anglo-Norman and Angevin World', in Wheeler and Parsons (eds), *Eleanor of Aquitaine: Lord and Lady*: 97–113.

de Jong, M., 'Bride Shows Revisited: Praise, Slander, and Exegesis in the Reign of the Empress Judith', L. Brubaker and J. M. H. Smith (eds), *Gender in the Early Medieval World: East and West, 300–900* (Cambridge: Cambridge University Press, 2004): 257–77.

de Jong, M., *The Penitential State: Authority and Atonement in the Age of Louis the Pious, 814–840* (Cambridge: Cambridge University Press, 2009).

de Jong, M., 'Queens and Beauty in the Early Medieval West: Balthild, Theodelinda, Judith', in C. La Rocca (ed.), *Agire da Donna. Modelli e pratiche di rappresentazione (Secoli VI–X)* (Turnhout: Brepols, 2007): 235–48.

de Longh, J., *Margaret of Austria, Regent of the Netherlands*, M. D. Herter (trans.) (New York: Norton, 1953).

de Longh, J., *Mary of Hungary: Second Regent of the Netherlands* (New York: Norton, 1958).

Diehl, C., *Theodora, Empress of Byzantium*, S. R. Rosenbaum (trans.) (New York: Frederick Ungar Publishing Company, 1972).

Díez Jorge, M. E., 'Elizabeth of York: Mother of the Tudor Dynasty', in Oakley-Brown and Wilkinson (eds), *The Rituals and Rhetoric of Queenship*: 47–58.

Diller, G. T., 'Froissart, Historiography, the University Curriculum, and Isabeau of Bavière', *Romance Quarterly* 41(3) (1994): 148–55.

Downie, F., 'And They Lived Happily Ever After? Medieval Queenship and Marriage in Scotland, 1424–1449', in T. Brotherstone, D. Simonton, and O. Walsh (eds), *Gendering Scottish History: An International Approach* (Glasgow: Cruithne Press, 1999): 129–41.

Downie, F., 'Queenship in Late Medieval Scotland', in M. Brown and R. Tanner (eds), *Scottish Kingship, 1306–1488* (Edinburgh: John Donald, 2008): 232–54.

Downie, F., *She Is But a Woman: Queenship in Scotland, 1424–1463* (Edinburgh: John Donald, 2006).

Downie, F., '"La voie quelle menace tenir": Annabella Stewart, Scotland, and the European Marriage Market, 1444–56', *Scottish Historical Review* 78 (1999): 170–91.

Doyle, D. R., 'The Body of a Woman but the Heart and Stomach of a King: Mary of Hungary and the Exercise of Political Power in Early Modern Europe', doctoral dissertation (University of Minnesota, 1996).

Duby, G., *The Knight, the Lady, and the Priest: The Making of Modern Marriage in Medieval France* (New York: Pantheon, 1983).

Dumville, D. N., 'The West Saxon Genealogical Regnal List and the Chronology of Early Wessex', *Peritia*, 4 (1985): 21–66.

Earenfight, T., 'Absent Kings: Queens as Political Partners in the Medieval Crown of Aragon', in Earenfight (ed.), *Queenship and Political Power*: 33–51.

Earenfight, T., 'Highly Visible, Often Obscured: The Difficulty of Seeing Queens and Noble Women', *Medieval Feminist Forum* 44(1) (2008): 86–90.

Earenfight, T., *The King's Other Body: María of Castile and the Crown of Aragon* (Philadelphia: University of Pennsylvania Press, 2010).

Earenfight, T., 'María of Castile, Ruler or Figurehead? A Preliminary Study in Aragonese Queenship', *Mediterranean Studies* 4 (1994): 45–61.

Earenfight, T., 'Partners in Politics', in Earenfight, *Queenship and Political Power*: xiii–xxviii.

Earenfight, T., 'Political Culture and Political Discourse in the Letters of Queen María of Castile', *La Corónica* 32(1) (2003): 135–52.

Earenfight, T., 'Royal Finances in the Reign of María of Castile, Queen-Lieutenant of the Crown of Aragon, 1432–53,' in T. Earenfight (ed.), *Women and Wealth in Late Medieval Europe* (Basingstoke: Palgrave Macmillan, 2010): 229–44.

Earenfight, T., 'Royal Women in Late Medieval Spain: Catalina of Lancaster, Leonor of Albuquerque, and María of Castile', in C. N. Goldy and A. Livingstone (eds), *Writing Medieval Women's Lives* (Basingstoke: Palgrave Macmillan, 2012): 209–25.

Earenfight, T., 'Two Bodies, One Spirit: Isabel and Fernando's Construction of Monarchical Partnership', in Weissberger (ed.), *Queen Isabel I of Castile: Power, Patronage, and Persona*: 3–18.

Earenfight, T., 'Without the Persona of the Prince: Kings, Queens and the Idea of Monarchy in Late Medieval Europe', *Gender & History* 19(1) (April 2007): 1–21.

Eastmond, A., *Royal Imagery in Medieval Georgia* (University Park: Pennsylvania State University Press, 1998).

Echevarria, A., *Catalina de Lancaster: reina regente de Castilla, 1372–1418* (Hondarribia: Nerea, 2002).

Echevarria, A., 'Catalina of Lancaster, the Castilian Monarchy, and Coexistence', in R. Collins and A. Goodman (eds), *Medieval Spain: Culture, Conflict, and Coexistence: Studies in Honour of Angus McKay* (Basingstoke: Palgrave Macmillan, 2002): 79–122.

Echevarria, A., 'The Queen and the Master: Catalina of Lancaster and the Military Orders', in Earenfight (ed.), *Queenship and Political Power*: 91–105.
Edel, D., 'Early Irish Queens and Royal Power: A First Reconnaissance', in M. Richter and J.-M. Picard (eds), *Ogma: Essays in Celtic Studies in Honour of Próinséas Ní Chatháin* (Dublin: Four Courts Press, 2002): 1–19.
Edwards, C., 'Dynastic Sanctity in Two Early Medieval Women's "Lives"', in C. J. Itnyre (ed.), *Medieval Family Roles* (New York: Garland, 1996): 3–19.
Edwards, J., ' "The Sweetness of Suffering": Community, Conflict, and the Cult of Saint Radegund in Medieval Poitiers', doctoral dissertation (University of Illinois at Urbana-Champaign, 2008).
Effros, B., 'Dressing Conservatively: Women's Brooches as Markers of Ethnic Identity', in L. Brubaker and J. M. H. Smith (eds), *Gender in the Early Medieval World: East and West, 300–900* (Cambridge: Cambridge University Press, 2004): 165–84.
Eichberger, D. (ed.), *Women of Distinction: Margaret of York and Margaret of Austria* (Turnhout: Brepols, 2005).
Elston, T. G., 'Widow Princess or Neglected Queen? Catherine of Aragon, Henry VIII, and English Public Opinion, 1533–1536', in Levin and Bucholz (eds), *Queens & Power in Medieval and Early Modern England*: 16–30.
Enright, M. J., *Lady with a Mead Cup: Ritual, Prophecy and Lordship in the European Warband from La Tène to the Viking Age* (Dublin: Four Courts Press, 1995).
Etting, V., *Queen Margrethe I, 1353–1412, and the Founding of the Nordic Union* (Leiden: Brill, 2004).
Evans, J., 'The "Nika" Rebellion and the empress Theodora', *Byzantion* 54 (1984): 380–2.
Evans, M., 'Penthesilea on the Second Crusade: Is Eleanor of Aquitaine the Amazon Queen of Niketas Choniates?', *Crusades* 8 (2009): 23–30.
Facinger, M., 'A Study of Medieval Queenship: Capetian France, 987–1237', *Studies in Medieval and Renaissance History* 5 (1968): 3–47.
Famiglietti, R. C., *Royal Intrigue: Crisis at the Court of Charles VI (1392–1420)* (New York: AMS Press, 1986).
Famiglietti, R. C., *Tales of the Marriage Bed from Medieval France (1300–1500)* (Providence, RI: Picardy Press, 1992).
Fawtier, R. W., *The Capetian Kings of France: Monarchy and Nation, 987–1328*, L. Butler and R. J. Adam (trans) (London: Macmillan, 1960).
ffolliott, S., 'Catherine de' Medici as Artemesia: Figuring the Powerful Widow', in M. Ferguson, M. Quilligan, and N. Vickers (eds), *Rewriting the Renaissance: The Discourses of Sexual Difference in Early Modern Europe* (Chicago: University of Chicago Press, 1986): 227–41.
ffolliott, S., 'Women in the Garden of Allegory: Catherine de' Medici and the Locus of Female Rule', in M. Benes and D. Harris (eds), *Villas and Gardens in Early Modern Italy and France* (Cambridge: Cambridge University Press, 2001): 201–24.
Fichtner, P. S., *The Habsburg Monarchy, 1490–1848: Attributes of Empire* (Basingstoke: Palgrave Macmillan, 2003).

Field, S. L., 'Reflecting the Royal Soul: The Speculum Anime Composed for Blanche of Castile', *Mediaeval Studies* 68 (2006): 1–42.

Finn, K. M., *The Last Plantagenet Consorts: Gender, Genre, and Historiography, 1440–1627* (Basingstoke: Palgrave Macmillan, 2012).

Firestone, R. H., 'Queen Helche the Good: Model for Noblewomen', in A. Classen (ed.), *Women as Protagonists and Poets in the German Middle Ages: An Anthology of Feminist Approaches to Middle High German Literature* (Göppingen: Kümmerle Verlag, 1991): 117–45.

Fitch, A., 'Maternal Mediators: Saintly Ideals and Secular Realities in Late Medieval Scotland', *Innes Review: Scottish Catholic Historical Studies* 57(1) (2006): 1–34.

Flint, V. I. J., 'Susanna and the Lothar Crystal: A Liturgical Perspective', *Early Medieval Europe* 4(1) (1995): 61–86.

Flori, J., *Eleanor of Aquitaine: Queen and Rebel*, O. Classe (trans.) (Edinburgh: Edinburgh University Press, 2007; French edn, 2004).

Folda, J., 'Images of Queen Melisende in William of Tyre's 'History of Outremer: 1250–1300', *Gesta* 32 (1993): 97–112.

Folda, J., 'Melisende of Jerusalem: Queen and Patron of Art and Architecture in the Crusader Kingdom', in T. Martin (ed.), *Reassessing the Roles of Women as 'Makers' of Medieval Art and Architecture*, 2 vols (Leiden: Brill, 2012), vol. 1: 429–77.

Folda, J., 'A Twelfth-Century Prayerbook for the Queen of Jerusalem', *Medieval Perspectives* 8 (1993): 1–14.

Forhan, K. L., *The Political Theory of Christine de Pizan* (Aldershot: Ashgate, 2002).

Fradenburg, L. O., *City, Marriage, Tournament: Arts of Rule in Late Medieval Scotland* (Madison: University of Wisconsin Press, 1991).

Fradenburg, L. O., 'Rethinking Queenship', in Fradenburg (ed.), *Women and Sovereignty*: 1–13.

Frankforter, A. D., 'Amalsuntha, Procopius, and a Woman's Place', *Journal of Women's History* 8(2) (1996): 41–57.

Fraser, A., *Mary Queen of Scots* (New York: Delacorte, 1969).

Fraser, A., *The Warrior Queens* (New York: Knopf, 1989).

Fraser, A., *The Wives of Henry VIII* (New York: Knopf, 1999).

Freccero, C., 'Marguerite de Navarre and the Politics of Maternal Sovereignty', in Frandeburg (ed.), *Women and Sovereignty*: 133–49.

Fröhlich, W., 'The Marriage of Henry VI and Constance of Sicily: Prelude and Consequences', *Anglo-Norman Studies* 15 (1992): 99–115.

Gajewski, A., 'The Patronage Question under Review: Queen Blanche of Castile (1188–1252) and the Architecture of the Cistercian Abbeys at Royaumont, Maubuisson, and Le Lys', in T. Martin (ed.), *Reassessing the Roles of Women as 'Makers' of Medieval Art and Architecture*, 2 vols (Leiden: Brill, 2012), vol. 1: 197–244.

Gameson, R., 'The Gospels of Margaret of Scotland and the Literacy of an Eleventh-Century Queen', in L. M. Smith and J. H. M. Taylor (eds), *Women and the Book: Assessing the Visual Evidence* (London: British Library and University of Toronto Press, 1997): 148–71.

Gardner, J., 'Santa Maria Donna Regina in its European Context', in J. Elliott and C. Warr (eds), *The Church of Santa Maria Donna Regina: Art, Iconography, and Patronage in Fourteenth-Century Naples* (Aldershot: Ashgate, 2004): 195–201.

Garland, L., *Byzantine Empresses: Women and Power in Byzantium, AD 527–1204* (London: Routledge, 1999).

Garland, L., 'Conformity and License at the Byzantine Court in the Tenth and Eleventh Centuries: The Case of Imperial Women', *Byzantinische Forschungen* 21 (1995): 101–15.

Garland, L., ' "The Eye of the Beholder": Byzantine Imperial Women and their Public Image from Zoe Porphyrogenita to Euphrosyne Kamaterissa Doukaina (1028–1203)', *Byzantion* 64 (1994): 19–39.

Garver, V. L., 'Weaving Words in Silk: Women and Inscribed Bands in the Carolingian World,' *Medieval Clothing and Textiles* 6 (2010): 33–56.

Gathagan, L., 'Embodying Power: Gender and Authority in the Queenship of Mathilda of Flanders', doctoral dissertation (City University of New York, 2002).

Gaudette, H. A., 'The Piety, Power, and Patronage of the Latin Kingdom of Jerusalem's Queen Melisende', doctoral dissertation (City University of New York, 2005).

Gaudette, H. A., 'The Spending Power of a Crusader Queen: Melisende of Jerusalem', in T. Earenfight (ed.), *Women and Wealth in Late Medieval Europe* (Basingstoke: Palgrave Macmillan, 2010): 135–48.

Geaman, K., 'Queen's Gold and Intercession: The Case of Eleanor of Aquitaine', *Medieval Feminist Forum* 46(2) (2010): 10–33.

Geertz, C., 'Centers, Kings, and Charisma: Reflections on the Symbolics of Power', in C. Geertz, *Local Knowledge* (New York: Basic Books, 1983): 121–46.

Gibbons, R., 'Isabeau of Bavaria, Queen of France (1385–1422): The Creation of an Historical Villainess', *Transactions of the Royal Historical Society*, 6th Series, vol. 6 (1996): 51–73.

Gibbons, R., 'The Piety of Isabeau of Bavaria, Queen of France, 1385–1422', in D. E. S. Dunn (ed.), *Courts, Counties and the Capital in the Later Middle Ages* (Stroud: Sutton, 1996): 205–24.

Gibbons, R., 'The Queen as "Social Mannequin": Consumerism and Expenditure at the Court of Isabeau of Bavaria, 1393–1422', *Journal of Medieval History* 26(4) (2000): 371–95.

Giesey, R., 'The Juridic Basis of Dynastic Right to the French Throne', *Transactions of the American Philosophical Society* 51 (1961): 3–41.

Gillingham, J., 'Love, Marriage, and Politics in the Twelfth Century,' *Forum for Modern Language Studies* 25 (1989): 292–303.

Goldberg, H., 'Queen of Almost All She Surveys: The Sexual Dynamics of Female Sovereignty', *La corónica* 23(2) (1995): 51–63.

Goldy, C. N. and A. Livingstone, 'Introduction: Setting the Stage', in C. N. Goldy and A. Livingstone (eds), *Writing Medieval Women's Lives* (Basingstoke: Palgrave Macmillan, 2012): 1–10.

Goodman, E., 'Conspicuous in Her Absence: Mariana of Austria, Juan José of Austria, and the Representation of Her Power', in Earenfight (ed.), *Queenship and Political Power*: 163–84.

Goodman, J. R., 'The Lady with the Sword: Philippa of Lancaster and the Chivalry of the Infante Dom Henrique (Prince Henry the Navigator)', in Vann (ed.), *Queens, Regents, and Potentates*: 149–65.

Gradowicz-Pancer, N., 'De-gendering Female Violence: Merovingian Female Honour as an "Exchange of Violence"', *Early Medieval Europe* 11(1) (2002): 1–18.

Green, K., 'Isabeau de Bavière and the Political Philosophy of Christine de Pizan', *Historical Reflections* 32 (2006); 247–72.

Griffiths, R. A., 'Queen Katherine of Valois and a Missing Statute of the Realm', *Law Quarterly Review* 93 (1977): 248–58.

Habas, E., 'A Poem by the Empress Eudocia: A Note on the Patriarch', *Israel Exploration Journal* 46 (1996): 108–19.

Hadley, D., 'Negotiating Gender, Family, and Status in Anglo-Saxon Burial Practices, c. 600–950', in L. Brubaker and J. M. H. Smith (eds), *Gender in the Early Medieval World: East and West, 300–900* (Cambridge: Cambridge University Press, 2004): 301–23.

Hahn, C., 'Collector and Saint: Queen Radegund and Devotion to the Relic of the True Cross', *Word and Image* 22 (2006): 268–74.

Halecky, O. and T. Gromada, *Jadwiga of Anjou and the Rise of East Central Europe* (Boulder: Social Science Monographs, 1991).

Haluska-Rausch, E., 'Unwilling Partners: Conflict and Ambition in the Marriage of Peter II of Aragon and Marie de Montpellier', in Earenfight (ed.), *Queenship and Political Power*: 3–20.

Hamilton, B., 'Eleanor of Castile and the Crusading Movement', *Mediterranean Historical Review* 10 (1995): 92–103.

Hamilton, B., 'Women in the Crusader States: The Queens of Jerusalem (1100–1190)', in D. Baker (ed.), *Medieval Women* (Oxford: Blackwell, 1978): 143–73.

Hamilton, D. L., 'The Household of Queen Katherine Parr', doctoral dissertation (University of Oxford, 1992).

Hamilton, T. C., 'Queenship and Kinship in the French "Bible moralisée": The Example of Blanche of Castile and Vienna ÖNB 2554', in Nolan (ed.), *Capetian Women*: 177–208.

Hammond, M. H., 'Queen Ermengarde and the Abbey of St Edward, Balmerino', *Cîteaux: Revue d'histoire cistercienne* 59(1–2) (2008): 11–35.

Hanley, S., 'Identity Politics and Rulership in France: Female Political Place and the Fraudulent Salic Law in Christine de Pizan and Jean de Montreuil', in M. Wolfe (ed.), *Changing Identities in Early Modern France* (Durham: Duke University Press, 1997): 78–94.

Hanley, S., 'The Politics of Identity and Monarchic Governance in France: The Debate over Female Exclusion', in H. L. Smith (ed.), *Women Writers and the*

Early Modern British Political Tradition (Cambridge: Cambridge University Press, 1997): 289–304.

Hardie, P., *Rumour and Renown: Representations of Fama in Western Literature* (Cambridge: Cambridge University Press, 2012).

Harrison, D., *The Age of Abbesses and Queens: Gender and Political Culture in Early Medieval Europe* (Lund: Nordic Academic Press, 1998).

Harvey, C. J., 'Challenging the Court: Kings and Queens in "Les miracles de Nostre Dame par personnages"', in K. Busby and C. Kleinhenz (eds), *Courtly Arts and the Art of Courtliness* (Woodbridge: D. S. Brewer, 2006): 431–42.

Harvey, R., 'Eleanor of Aquitaine and the Troubadours,' in M. Bull and C. Léglu (eds), *The World of Eleanor of Aquitaine: Literature and Society in Southern France between the Eleventh and Thirteenth Centuries* (Woodbridge: Boydell Press, 2005): 101–14.

Hedeman, A. D., *The Royal Image: Illustrations of the Grandes chroniques de France, 1274–1422* (Berkeley and Los Angeles: University of California Press, 1991).

Heidecker, K., 'Why Should Bishops Be Involved in Marital Affairs? Hincmar of Rheims on the Divorce of King Lothar II (855–869)', in J. Hill and M. Swan, (eds), *The Community, the Family, and the Saint: Patterns of Power in Early Medieval Europe* (Turnhout: Brepols, 1998): 225–35.

Hen, Y., 'Gender and the patronage of culture in Merovingian Gaul', in L. Brubaker and J. M. H. Smith (eds), *Gender in the Early Medieval World: East and West, 300–900* (Cambridge: Cambridge University Press, 2004): 217–33.

Herman, E., *Sex with the Queen: 900 Years of Vile Kings, Virile Lovers, and Passionate Politics* (New York: Morrow, 2006).

Herrin, J., 'The Imperial Feminine in Byzantium', *Past and Present* 169 (2000): 3–35.

Herrin, J., 'In Search of Byzantine Women: Three Avenues of Approach', in A. Cameron and A. Kuhrt (eds), *Images of Women in Antiquity*, 2nd edn (London: Routledge, 1993): 167–89.

Herrin, J., 'Theophano: Considerations on the Education of a Byzantine Princess', in Davids (ed.), *The Empress Theophano*: 64–85.

Herrin, J., *Women in Purple: Rulers of Medieval Byzantium* (Princeton: Princeton University Press, 2001).

Heslop, Thomas Alexander. 'The Production of Deluxe Manuscripts and the Patronage of King Cnut and Queen Emma', *Anglo-Saxon England* 19 (1990): 151–95.

Hicks, C., 'The Patronage of Queen Edith', in M. J. Lewis, G. R. Owen-Crocker, and D. Terkla (eds), *The Bayeux Tapestry: New Approaches* (Oxford: Oxbow, 2011): 5–9.

Hill, B., *Imperial Women in Byzantium, 1025–1204: Power, Patronage, and Ideology* (New York: Longman, 1999).

Hill, B., 'Imperial Women and the Ideology of Womanhood in the Eleventh and Twelfth Centuries', in L. James (ed.), *Women, Men, and Eunuchs: Gender in Byzantium* (New York: Routledge, 1997): 76–99.

Hill, B., 'The Vindication of the Rights of Women to Power by Anna Komnene', *Byzantinische Forschungen* 23 (1996): 45–53.
Hill, B., L. James, and D. Smythe, 'Zoe: The Rhythm Method of Imperial Renewal', in P. Magdalino (ed.), *New Constantines: The Rhythm of Imperial Renewal in Byzantium, 4th–13th Centuries* (Aldershot: Variorum, 1994): 215–29.
Hill, T. D., '"Wealhtheow" as a Foreign Slave: Some Continental Analogues', *Philological Quarterly* 69 (1990): 107–12.
Hilton, L., *Queens Consort: England's Medieval Queens* (London: Weidenfeld & Nicolson, 2008).
Hindman, S., *Christine de Pizan's 'Epistre Othéa': Painting and Politics at the Court of Charles VI* (Toronto: Pontifical Institute of Mediaeval Studies, 1986).
Hindman, S., 'The Iconography of Queen Isabeau de Bavière (1410–1415): An Essay in Method', *Gazette des Beaux-Arts* 102 (6th series, 1983): 102–10.
Hochner, N., 'Revisiting Anne De Bretagne's Queenship: On Love and Bridles', in Brown (ed.), *The Cultural and Political Legacy of Anne de Bretagne*: 147–62.
Hodgson, N. R., *Women, Crusading and the Holy Land in Historical Narrative* (Woodbridge: Boydell Press, 2007).
Hoffman, M. K., *Raised To Rule: Educating Royalty at the Court of the Spanish Habsburgs, 1601–1634* (Baton Rouge: Louisiana State University Press, 2011).
Honemann, V., 'A Medieval Queen and Her Stepdaughter: Agnes and Elizabeth of Hungary', in Duggan (ed.), *Queens and Queenship in Medieval Europe*: 109–19.
Hornaday, A. G., 'A Capetian Queen as Street Demonstrator: Isabelle of Hainaut', in Nolan (ed.), *Capetian Women*: 77–97.
Horvat, M. T., 'Queen Sancha of Aragón and the Royal Monastery of Sigena', doctoral dissertation (University of Kansas, 1994).
Howarth, D., *Images of Rule: Art and Politics in the English Renaissance, 1485–1649* (Berkeley and Los Angeles: University of California Press, 1997).
Howell, M., *Eleanor of Provence: Queenship in Thirteenth-Century England* (Oxford: Blackwell, 1998).
Howell, M., 'Royal Women of England and France in the Mid-Thirteenth Century: A Gendered Perspective', in B. K. U. Weiler and I. W. Rowlands (eds), *England and Europe in the Reign of Henry III (1216–1272)* (Aldershot: Ashgate, 2002): 163–81.
Humphrey, P., 'Ermessenda of Barcelona: The Status of her Authority', in Vann (ed.), *Queens, Regents, and Potentates*: 15–35.
Huneycutt, L., '*Alianora Regina Anglorum*: Eleanor of Aquitaine and Her Anglo-Norman Predecessors as Queens of England', in Wheeler and Parsons (eds), *Eleanor of Aquitaine: Lord and Lady*: 115–32.
Huneycutt, L., 'The Creation of a Crone: The Historical Reputation of Adelaide of Maurienne', in Nolan (ed.), *Capetian Women*: 27–43.
Huneycutt, L., 'Female Succession and the Language of Power in the Writings of Twelfth-century Churchmen', in Parsons (ed.), *Medieval Queenship*: 189–201.
Huneycutt, L., 'The Idea of the Perfect Princess: The Life of St. Margaret in the Reign of Mathilda II, 1100–1118', *Anglo-Norman Studies* 12 (1990): 81–97.

Huneycutt, L., 'Images of Queenship in the High Middle Ages', *Haskins Society Journal* (1989): 61–73.

Huneycutt, L., 'Intercession and the High-Medieval Queen: The Esther Topos', in Carpenter and MacLean (eds), *Power of the Weak*: 126–46.

Huneycutt, L., *Matilda of Scotland: A Study in Medieval Queenship* (Woodbridge: Boydell Press, 2003).

Huneycutt, L., 'Medieval Queenship', *History Today* 39(6) (1989): 16–22.

Huneycutt, L., 'Public Lives, Private Lives: Royal Mothers in England and Scotland, 1070–1204', in J. C. Parsons and B. Wheeler (eds), *Medieval Mothering* (New York: Garland, 1996): 295–312.

Hunt, A. and A. Whitelock (eds), *Tudor Queenship: The Reigns of Mary and Elizabeth* (Basingstoke: Palgrave Macmillan, 2010).

Hunt, D. and I. Hunt (eds), *Caterina Cornaro: Queen of Cyprus* (London: Trigraph, 1989).

Husband, T., *The Art of Illumination: The Limbourg Brothers and the Belles Heures of Jean de France, Duc de Berry* (New Haven: Yale University Press, 2008).

Hutchinson, A. P., 'Leonor Teles: Representations of a Portuguese Queen', *Historical Reflections/Réflexions historiques* 30(1) (Spring 2004): 73–87.

Hyam, J., 'Ermentrude and Richildis', in M. Gibson and J. L. Nelson (eds), *Charles the Bald: Court and Kingdom* (Oxford: Oxford University Press, 1981): 133–56.

Imsen, S., 'Late Medieval Scandinavian Queenship', in Duggan (ed.), *Queens and Queenship in Medieval Europe*: 53–73.

Ingham, P. C., 'From Kinship to Kingship: Mourning, Gender, and Anglo-Saxon Community', in J. C. Vaught and L. D. Bruckner (eds), *Grief and Gender: 700–1700* (Basingstoke: Palgrave Macmillan, 2003): 17–31.

Ishikawa, C., *The 'Retablo de Isabel la Católica' by Juan de Flandes and Michael Sittow* (Turnhout: Brepols, 2004).

James, L., *Empresses and Power in Early Byzantium* (London: Leicester University Press, 2001).

James, L., 'Goddess, Whore, Wife or Slave: Will the Real Byzantine Empress Please Stand Up?', in Duggan (ed.), *Queens and Queenship in Medieval Europe*: 123–39.

James, L. and B. Hill, 'Women and Politics in the Byzantine Empire: Imperial Women', in L. E. Mitchell (ed.), *Women in Medieval Western European Culture* (New York: Garland, 1999): 157–78.

Jansen, S. L. (ed.), *Anne of France: Lessons for My Daughter* (Cambridge: D. S. Brewer, 2004).

Jansen, S. L., *The Monstrous Regiment of Women: Female Rulers in Early Modern Europe* (Basingstoke: Palgrave Macmillan, 2002).

Jäschke, K., 'From Famous Empresses to Unspectacular Queens: The Romano-German Empire of Margaret of Brabant, Countess of Luxemburg and Queen of the Romans, d. 1311', in Duggan (ed.), *Queens and Queenship in Medieval Europe*: 75–108.

Jeffrey, J. E., 'Radegund and the Letter of Foundation', in L. J. Churchill, P. R.

Brown, and J. E. Jeffrey (eds), *Women Writing Latin from Roman Antiquity to Early Modern Europe*, 2 vols (Oxford: Routledge, 2002), vol. 2: 11–23.

Jesch, J., 'In Praise of Astridr Olafsdottir', *Saga Book* 24(1) (1994): 1–18.

Jochens, J., 'The Politics of Reproduction: Medieval Norwegian Kingship', *American Historical Review* 92 (1987): 337–49.

Jochens, J., *Women in Old Norse Society* (Ithaca, NY: Cornell University Press, 1995).

Johns, S. M., 'Poetry and Prayer: Women and Politics of Spiritual Relationships in the Early Twelfth Century', *European Review of History* 8(1) (2001): 7–22.

Johnston, E., 'Transforming Women in Irish Hagiography', *Peritia* 9 (1995): 197–220.

Johnstone, H., 'Isabella, the She-Wolf of France', *History. The Journal of the Historical Association* 21 (1936): 208–18.

Johnstone, H., 'The Queen's Household', in J. P. Willard and W. A. Morris (eds), *The English Government at Work, 1327–1336* (Cambridge: Harvard University Press, 1940).

Jonas, M. K. and M. G. Underwood, *The King's Mother: Lady Margaret Beaufort, Countess of Richmond and Derby* (Cambridge: Cambridge University Press, 1993).

Jordan, A. A., 'Material Girls: Judith, Esther, Narrative Modes and Models of Queenship in the Windows of the Ste-Chapelle in Paris', *Word and Image* 15(4) (October–December 1999): 337–50.

Jordan, C., 'Woman's Rule in Sixteenth-Century British Political Thought', *Renaissance Quarterly* 40(3) (1987): 421–51.

Jordan, W. C., 'Isabelle d'Angoulême, By the Grace of God, Queen', *Revue Belge de Philologie et d'Historie* 69 (1991): 821–52.

Kagay, D., 'Countess Almodis of Barcelona: "Illustrious and Distinguished Queen" or "Woman of Sad, Unbridled Lewdness"', in Vann (ed.), *Queens, Regents, and Potentates*: 37–47.

Kamerick, K., 'Patronage and Devotion in the Prayer Book of Anne of Brittany, Newberry Library MS 83', *Manuscripta* 39(1) (1995): 40–50.

Kantorowicz, E., *The King's Two Bodies: A Study in Mediaeval Political Theology* (Princeton: Princeton University Press, 1957).

Karkov, C., 'Pictured in the Heart: The Ediths at Wilton', in V. Blanton and H. Scheck (eds), *Intertexts: Studies in Anglo-Saxon Culture Presented to Paul E. Szarmarch* (Tempe: Arizona Center for Medieval and Renaissance Studies, 2008): 273–85.

Karkov, C., *The Ruler Portraits of Anglo-Saxon England* (Woodbridge: Boydell Press, 2004).

Katz, M. R., 'The Non-Gendered Appeal of *Vierge Ouvrante* Sculpture: Audience, Patronage, and Purpose in Medieval Iberia", in T. Martin (ed.), *Reassessing the Roles of Women as 'Makers' of Medieval Art and Architecture*, 2 vols (Leiden: Brill, 2012), vol. 1: 37–91.

Kay, S., 'Proclaiming Her Dignity Abroad: The Literary and Artistic Network of Matilda of Scotland, Queen of England 1100–1118', in J. H. McCash (ed.), *The Cultural Patronage of Medieval Women* (Athens: University of Georgia Press, 1996): 155–74.

Keane, M., 'Most Beautiful and Next Best: Value in the Collection of a Medieval Queen', *Journal of Medieval History* 34(4) (2008): 360–73.

Kelly, A., *Eleanor of Aquitaine and the Four Kings* (Cambridge: Harvard University Press, 1950).

Kelly, S., *The New Solomon: Robert of Naples (1309–43) and Fourteenth-Century Kingship* (Leiden: Brill, 2003).

Kelly, S. ' "Ubi unus clericus et Aelfgyva": Aelfgyva and the Bayeux Tapestry', *Old English Newsletter* 28(3) (1995): A–15.

Kennedy, G., 'Reform or Rebellion? The Limits of Female Authority in Elizabeth Cary's "The History of the Life, Reign, and Death of Edward II" ', in C. Levin and P. A. Sullivan (eds), *Political Rhetoric, Power, and Renaissance Women* (Binghamton: State University of New York Press, 1995): 204–22.

Kern, F., *Kingship and Law in the Middle Ages* (Oxford: Oxford University Press, 1956).

King, C., 'Women as Patrons: Nuns, Widows, and Rulers', in D. Norman (ed.), *Siena, Florence, and Padua: Art, Society, and Religion, 1280–1400*, 2 vols (New Haven: Yale University Press, 1995), vol. 2: 242–66.

Klaniczay, G., *Holy Rulers and Blessed Princesses: Dynastic Cults in Medieval Central Europe* (Cambridge: Cambridge University Press, 2002).

Klassen, J. M., 'Queenship in Late Medieval Bohemia', *East Central Europe* 1(21–23) (1991): 101–16.

Klassen, J. M., *Warring Maidens, Captive Wives, and Hussite Queens: Women and Men at War and at Peace in Fifteenth Century Bohemia* (New York: Columbia University Press, 2000).

Klein, S. S., 'Beauty and the Banquet: Queenship and Social Reform in Ælfric's "Esther" ', *Journal of English and Germanic Philology* 103(1) (January 2004): 77–105.

Klein, S. S., 'Reading Queenship in Cynewulf's "Elene" ', *Journal of Medieval and Early Modern Studies* 33(1) (Winter 2003): 47–89.

Klein, S. S., *Ruling Women: Queenship and Gender in Anglo-Saxon Literature* (Notre Dame, IN: University of Notre Dame Press, 2006).

Kleinman, R., *Anne of Austria: Queen of France* (Columbus: Ohio State University Press, 1985).

Knecht, R. J., *Catherine de' Medici* (London: Longman, 1997).

Kühnel, B., 'The Kingly Statement of the Bookcovers of Queen Melisende's Psalter', in E. Dassman and K. Thraede, (eds), *Tesserae: Festschrift für Josef Engemann* (Munster: Aschendorff, 1991): 340–57.

Lackner, B., 'A Cistercian of Royal Blood: Blessed Teresa of Portugal', *Vox Benedictina: A Journal of Translations from Monastic Sources* 6(2) (1989): 100–19.

Lambert, S., 'Queen or Consort: Rulership and Politics in the Latin East, 1118–1228', in Duggan (ed.), *Queens and Queenship in Medieval Europe*: 153–69.

Lares, J., 'The Duchess of Malfi and Catherine of Valois', *Notes and Queries* 238 (1993): 208–11.

Larrington, C., 'Queens and Bodies: The Norwegian Translated "Laïs" and Hákon

IV's Kinswomen', *Journal of English and Germanic Philology* 108(4) (2009): 506–27.
Layher, W., *Queenship and Voice in Medieval Northern Europe* (Basingstoke: Palgrave Macmillan, 2010).
Laynesmith, J. L., 'Constructing Queenship at Coventry: Pageantry and Politics at Margaret of Anjou's "Secret Harbor"', *Fifteenth Century* 3 (2003): 137–47.
Laynesmith, J. L., *The Last Medieval Queens: English Queenship, 1445–1503* (Oxford: Oxford University Press, 2004).
Lawrance, H., *Historical Memoirs of the Queens of England, from the Commencement of the Twelfth Century* (London: Edward Moxon, 1838).
Lee, P.-A., 'Reflections of Power: Margaret of Anjou and the Dark Side of Queenship', *Renaissance Quarterly* 39 (1986): 183–217.
Leese, T. A., *Blood Royal: Issue of the Kings and Queens of Medieval England, 1066–1399: The Normans and Plantagenets* (Bowie, MD: Heritage Books, 1996).
Legaré, A., 'Charlotte de Savoie's Library and Illuminators', *Journal of the Early Book Society for the Study of Manuscripts and Printing History* 4 (2001): 32–67.
Legaré, A., 'Reassessing Women's Libraries in Late Medieval France: The Case of Jeanne de Laval', *Renaissance Studies* 10(2) (1996): 209–36.
Lehfeldt, E. A., 'The Gender Shared Sovereignty: Texts and the Royal Marriage of Isabella and Ferdinand', in M. V. Vicente and L. R. Corteguera (eds), *Women, Texts, and Authority in the Early Modern Spanish World* (Aldershot: Ashgate, 2003): 37–55.
Lehfeldt, E. A., 'Ruling Sexuality: The Political Legitimacy of Isabel of Castile', *Renaissance Quarterly* 53 (2000): 31–56.
L'Estrange, E., *Holy Motherhood: Gender, Dynasty, and Visual Culture in the Later Middle Ages* (Manchester: Manchester University Press, 2008).
L'Estrange, E., 'Penitence, Motherhood, and Passion Devotion: Contextualizing Anne de Bretagne's Prayer Book, Chicago, Newberry Library, MS 83', in Brown (ed.), *The Cultural and Political Legacy of Anne de Bretagne*: 81–98.
Levin, C., *The Heart and Stomach of a King: Elizabeth I and the Politics of Sex and Power* (Philadephia: University of Pennsylvania Press, 1994).
Levin, C., 'John Foxe and the Responsibilities of Queenship', in M. B. Rose (ed.), *Women in the Middle Ages and Renaissance* (Syracuse: Syracuse University Press, 1986): 113–33.
Levin, C., *The Reign of Elizabeth I* (Basingstoke: Palgrave Macmillan, 2002).
Levin, C. (ed.), *Elizabeth I: Always Her Own Free Woman* (Aldershot: Ashgate, 2003).
Levin, C., D. B. Graves, J. E. Carney, (eds), *High and Mighty Queens of Early Modern England: Realities and Representations* (Basingstoke: Palgrave Macmillan, 2003).
Lewis, A. W., 'The Birth and Childhood of King John: Some Revisions', in Wheeler and Parsons (eds), *Eleanor of Aquitaine: Lord and Lady*: 159–75.
Lewis, A. W., *Royal Succession in Capetian France* (Cambridge, MA: Harvard University Press, 1981).
Lewis-Simpson, S., 'Viking-Age Queens and the Formation of Identity', in J. Sheehan and D. Ó Corráin (eds), *The Viking Age: Ireland and the West* (Dublin: Four Courts Press, 2010): 217–26.

Lightman, H., 'Political Power and the Queen of France: Pierre DuPuy's Treatise on Regency Government', *Canadian Journal of History* 21 (1986): 299–312.

Lightman, H., 'Sons and Mothers: Queens and Minor Kings in French Constitutional Law', doctoral dissertation (Bryn Mawr College, 1981).

Lindley, P., 'The Sculptural Memorials of Queen Eleanor and their Context', in D. Parsons (ed.), *Eleanor of Castile 1290–1990* (Stamford: Paul Watkins, 1991): 69–92.

Liss, P., 'Isabel of Castile (1451–1504), Her Self-Representation and Its Context', in Earenfight (ed.), *Queenship and Political Power*: 120–44.

Liss, P., *Isabel the Queen*, 2nd edn (Philadelphia: University of Pennsylvania Press, 2004; 1st edn, 1992).

Livingstone, A., 'Piecing Together the Fragments: Telling the Lives of the Ladies of Lavardin through Image and Text', in C. N. Goldy and A. Livingstone (eds), *Writing Medieval Women's Lives* (Basingstoke: Palgrave Macmillan, 2012): 131–51.

Loades, D. M., *Mary Tudor: A Life* (Oxford: Basil Blackwell, 1989).

Loconte, A., 'Royal Women's Patronage of Art and Architecture in the Kingdom of Naples 1300 1450: From Maria of Hungary to Maria D'Enghien', doctoral dissertation (University of Oxford, 2003).

Loomis, C., *The Death of Elizabeth I* (Basingstoke: Palgrave Macmillan, 2010).

LoPrete, K., 'Historical Ironies in the Study of Capetian Women', in Nolan (ed.), *Capetian Women*: 271–86.

Lord, C., 'Queen Isabella at the Court of France', *Fourteenth Century England* 2 (2002): 45–52.

Lyon, J. R., 'The Letters of Princess Sophia of Hungary, a Nun at Admont', in C. N. Goldy and A. Livingstone (eds), *Writing Medieval Women's Lives* (Basingstoke: Palgrave Macmillan, 2012): 51–68.

MacDonald, A., 'Prosopography II: A Prosopography of the Early Queens of Tara', in Edel Bhreathnach (ed.), *The Kingship and Landscape of Tara* (Dublin: Four Courts Press, 2005): 225–357.

MacLean, S., 'Making a Difference in Tenth-century Politics: King Athelstan's Sisters and Frankish Queenship', in P. Fouracre and D. Ganz (eds), *Frankland: The Franks and the World of the Early Middle Ages* (Manchester: Manchester University Press, 2008): 167–90.

MacLean, S., 'Queenship, Nunneries, and Royal Widowhood in Carolingian Europe', *Past and Present* 178 (2003): 3–38.

Manion, M. M., 'Women, Art, and Devotion: Three French Fourteenth-Century Royal Prayer Books', in M. M. Manion and B. J. Muir (eds), *The Art of the Book: Its Place in Medieval Worship* (Exeter: University of Exeter Press, 1998): 21–66.

Marshall, R. K., *Scottish Queens, 1073–1714* (East Linton: Tuckwell, 2003).

Martin, R. E., 'Gifts for the Bride: Dowries, Diplomacy, and Marriage Politics in Muscovy', *Journal of Medieval and Early Modern Studies* 38(1) (2008): 119–45.

Martin, T., 'The Art of a Reigning Queen as Dynastic Propaganda in Twelfth-century Spain', *Speculum* 80(4) (2005): 1134–71.

Martin, T., 'Exceptions and Assumptions: Women in Medieval Art History', in T. Martin (ed.), *Reassessing the Roles of Women as 'Makers' of Medieval Art and Architecture*, 2 vols (Leiden: Brill, 2012), vol. 1: 1–33.

Martin, T., 'Mujeres, hermanas e hijas: el mecenazgo femenino en la familia de Alfonso VI', *Anales de Historia del Arte*, vol. extr. 2 (2011): 147–79.

Martin, T., *Queen as King: Politics and Architectural Propaganda in Twelfth-century Spain* (Leiden: Brill, 2006).

Martin, T., 'Sacred in Secular: Sculpture at the Romanesque Palaces of Estella and Huesca', in C. Hourihane (ed.), *Spanish Medieval Art, Recent Studies* (Tempe: Arizona Center for Medieval and Renaissance Studies, 2007): 89–117.

Martindale, A., 'Theodolinda: The Fifteenth-century Recollections of a Lombard Queen', *Studies in Church History* 33 (1995): 195–225.

Martindale, J., 'Eleanor of Aquitaine', in J. L. Nelson (ed.), *Richard Coeur de Lion in History and Myth* (London: King's College London Centre for Late Antique and Medieval Studies, 1992): 17–50.

Martindale, J., 'Epilogue: Eleanor of Aquitaine and a "Queenly Court?"', in Wheeler and Parsons (eds), *Eleanor of Aquitaine: Lord and Lady*: 423–39.

Martindale, J., 'Succession and Politics in the Romance-Speaking World', in M. Jones and M. Vale (eds), *England and Her Neighbors 1066–1453* (London: Hambledon Press, 1989): 19–41.

Marvin, J., 'Albine and Isabelle: Regicidal Queens and the Historical Imagination of the Anglo-Norman Prose "Brut" Chronicles', *Arthurian Literature* 18 (2001): 143–91.

Matarasso, P., *Queen's Mate: Three Women of Power in France on the Eve of the Renaissance* (Aldershot: Ashgate, 2001).

Mattingly, G., *Catherine of Aragon* (Boston: Little, Brown, 1941).

Maurer, H. E., *Margaret of Anjou: Queenship and Power in Late Medieval England* (Woodbridge: Boydell Press, 2003).

Mayer, H. E., 'Studies in the History of Queen Melisende of Jerusalem', *Dumbarton Oaks Papers* 26 (1972): 93–182.

Mayeski, M. A. and J. Crawford, 'Reclaiming an Ancient Story: Baudonivia's "Life of St. Radegunde" (circa 525–587)', in A. Sharma (ed), *Women Saints in World Religions* (Albany: State University of New York Press, 2000): 71–88.

McCannon, A. E., 'Two Capetian Queens as the Foreground for an Aristocrat's Anxiety in the "Vie de Saint Louis"', in Nolan (ed.), *Capetian Women*: 163–76.

McCartney, E., 'Ceremonies and Privileges of Office: Queenship in Late Medieval France', in Carpenter and MacLean (eds), *Power of the Weak*: 178–219.

McCartney, E., 'The King's Mother and Royal Prerogative in Early Sixteenth-Century France', in Parsons (ed.), *Medieval Queenship*: 117–41.

McCartney, E., *Queens in the Cult of the French Renaissance Monarchy: Public Law, Royal Ceremonial, and Political Discourse in the History of Regency Government, 1484–1610* (London: Routledge, 2007).

McClanan, A. L., 'The Empress Theodora and the Tradition of Women's Patronage in the Early Byzantine Empire', in J. H. McCash (ed.), *The Cultural Patronage of Medieval Women* (Athens: University of Georgia Press, 1996): 50–72.

McClanan, A. L., *Representations of Early Byzantine Empresses: Image and Empire* (Basingstoke: Palgrave Macmillan, 2002).

McCleery, I., 'Isabel of Aragon (d. 1336): Model Queen or Model Saint?', *Journal of Ecclesiastical History* 57(4) (2006): 668–92.

McCracken, P., 'The Queen's Secret: Adultery and Political Structure in the Feudal Courts of Old French Romance', *Romanic Review* 86(2) (1995): 289–306.

McCracken, P., *The Romance of Adultery: Queenship and Sexual Transgression in Old French Literature* (Philadelphia: University of Pennsylvania Press, 1998).

McCracken, P., 'Scandalizing Desire: Eleanor of Aquitaine and the Chroniclers', in Wheeler and Parsons (eds), *Eleanor of Aquitaine: Lord and Lady*: 247–63.

McKiernan-González, E., 'Reception, Gender, and Memory: Elisenda de Montcada and Her Dual-Effigy Tomb at Santa Maria de Pedralbes', in T. Martin (ed.), *Reassessing the Roles of Women as 'Makers' of Medieval Art and Architecture*, 2 vols (Leiden: Brill, 2012), vol. 1: 309–52.

McKitterick, R., 'Les Femmes, les arts et la culture en occident dans le haut moyen âge', in S. Lebecq, A. Dierkens, R. Le Jan, and J.-M. Sansterre (eds), *Femmes et pouvoirs des femmes à Byzance et en Occident (Vie–XIe siècles)* (Centre de Recherche sur l'Histoire de l'Europe du Nord-Ouest, Université Charles de Gaulle-Lille 3, 1999): 149–61.

McKitterick, R., *The Frankish Kings and Culture in the Early Middle Ages* (Aldershot: Variorum, 1995).

McLaren, A. N., *Political Culture in the Reign of Elizabeth I: Queen and Commonwealth, 1558–1585* (Cambridge: Cambridge University Press, 1999).

McNamara, J., '*Imitatio Helenae*: Sainthood as an Attribute of Queenship in the Early Middle Ages', in S. Sticca (ed.), *Saints: Studies in Hagiography* (Binghamton, NY: Medieval & Renaissance Texts & Studies, 1996): 51–80.

McNamara, J., 'Women and Power through the Family Revisited', in M. C. Erler and M. Kowaleski (eds), *Gendering the Master Narrative: Women and Power in the Middle Ages* (Ithaca, NY: Cornell University Press, 2003): 17–30.

McNamara, J. and S. Wemple, 'The Power of Women through the Family in Medieval Europe, 500–1100', *Feminist Studies* 1 (1973): 126–41.

McNulty, J. B., 'The Lady Aelfgyva in the Bayeux Tapestry', *Speculum* 55 (1980): 659–68.

McVaugh, M., *Medicine before the Plague: Practitioners and Their Patients in the Crown of Aragon, 1285–1345* (Cambridge: Cambridge University Press, 1993).

Menache, S., 'Isabelle of France, Queen of England: A Reconsideration', *Journal of Medieval History* 10 (1984): 107–24.

Meyer, M. A., 'Queens, Convents, and Conversion in Early Anglo-Saxon England', *Revue Bénédictine* 109(40180) (1999): 90–116.

Meyer, M. A., 'The Queen's "Demesne" in Later Anglo-Saxon England', in M. A. Meyer (ed.), *The Culture of Christendom* (London: Hambledon Press, 1993): 75–113.

Meyerson, M., 'Defending Their Jewish Subjects: Elionor of Sicily, Maria de Luna, and the Jews of Morvedre', in Earenfight (ed.), *Queenship and Political Power*: 55–77.

Michael, M. A., 'A Manuscript Wedding Gift from Philippa of Hainault to Edward III', *Burlington Magazine* 127 (1985): 582–98.

Miller, D. A., 'Byzantine Sovereignty and Feminine Potencies', in Frandenburg (ed.), *Women and Sovereignty*: 250–63.

Minois, G., *Anne de Bretagne* (Paris: Fayard, 1999).

Mitchell, L. E., 'Joan de Valence: A Lady of Substance', in C. N. Goldy and A. Livingstone (eds), *Writing Medieval Women's Lives* (Basingstoke: Palgrave Macmillan, 2012): 193–208.

Mooney, C. L., 'Queenship in Fifteenth-Century France', doctoral dissertation (Ohio State University, 1977).

Moorhead, J., *Justinian* (London: Longman, 1994).

Monter, W., 'Gendered Sovereignty: Numismatics and Female Rule in Europe, 1300–1800', *Journal of Interdisciplinary History* 41 (2011): 533–64.

Monter, W., *The Rise of Female Kings in Europe, 1300–1800* (New Haven: Yale University Press, 2012).

Morrison, E., A. D. Hedeman, and E. Antoine, *Imagining the Past in France: History in Manuscript Painting, 1250–1500* (Los Angeles: J. Paul Getty Museum, 2010).

Mouillebouche, H., '"So mutable is that sexe": Queen Elizabeth Woodville in Polydore Vergil's "Anglica historia" and Sir Thomas More's "History of King Richard III"', in Oakley-Brown and Wilkinson (eds), *The Rituals and Rhetoric of Queenship*: 104–17.

Mulder-Bakker, A. B., 'Jeanne of Valois: The Power of a Consort', in Nolan (ed.), *Capetian Women*: 253–69.

Mullally, E., 'The Reciprocal Loyalty of Eleanor of Aquitaine and William Marshal', in Wheeler and Parsons (eds), *Eleanor of Aquitaine: Lord and Lady*: 237–45.

Musson, A., 'Queenship, Lordship and Petitioning in Late Medieval England', in W. M. Ormrod, G. Dodd, and A. Musson (eds), *Medieval Petitions: Grace and Grievance* (York: York Medieval Press, 2009): 156–72.

Myers, A. R., 'The Captivity of a Royal Witch: The Household Accounts of Queen Joan of Navarre, 1419–1421', *Bulletin of the John Rylands Library* 24 (1940): 263–84.

Myers, A. R., 'The Household Accounts of Queen Margaret of Anjou, 1452–3', *Bulletin of the John Rylands Library* 40 (1957–58): 79–113.

Myers, A. R., 'The Household of Queen Elizabeth Woodville, 1466–7', *Bulletin of the John Rylands Library* 50(1) (1967): 207–35.

Narbona-Cárceles, M., 'Woman at Court: A Prosopographic Study of the Court of Carlos III of Navarre (1387–1425)', *Medieval Prosopography* 22 (2001): 31–64.

Nassiet, M., 'Anne de Bretagne, A Woman of State', in Brown (ed.), *The Cultural and Political Legacy of Anne de Bretagne*: 163–75.

Nederman, C. J. and N. E. Lawson, 'The Frivolities of Courtiers Follow the Footprints of Women: Public Women and the Crisis of Virility in John of Salisbury', in C. Levin and J. Watson (eds), *Ambiguous Realities: Women in the Middle Ages and Renaissance* (Detroit: Wayne State University Press, 1987): 82–98.

Nelson, J., 'Scottish Queenship in the Thirteenth Century', *Thirteenth Century England* (2007): 61–81.
Nelson, J. L., 'Early Medieval Rites of Queen-Making and the Shaping of Medieval Queenship', in Duggan (ed.), *Queens and Queenship in Medieval Europe*: 301–15.
Nelson, J. L., 'Les Femmes et l'évangelisation au IXe siècle', *Revue du Nord* 269 (1986): 471–85.
Nelson, J. L., 'Gendering Courts in the Early Medieval West', in L. Brubaker and J. M. H. Smith (eds), *Gender in the Early Medieval World: East and West, 300–900* (Cambridge: Cambridge University Press, 2004): 185–97.
Nelson, J. L., 'The Lord's Anointed and the People's Choice: Carolingian Royal Ritual', in D. Cannadine and S. Price (eds), *Rituals of Royalty: Power and Ceremonial in Traditional Societies* (Cambridge: Cambridge University Press, 1987): 137–80.
Nelson, J. L., 'Making a Difference in Eighth-century Politics: The Daughters of Desiderius', in A. C. Murray (ed.), *After Rome's Fall: Narrators and Sources of Early Medieval History* (Toronto: University of Toronto Press, 1998): 171–90.
Nelson, J. L., 'Medieval Queenship', in L. E. Mitchell (ed.), *Women in Medieval Western European Culture* (New York: Garland Publishing, 1999): 179–207.
Nelson, J. L., 'Queens as Converters of Kings in the Earlier Middle Ages', in C. La Rocca (ed.), *Agire da Donna. Modelli e pratiche di rappresentazione (Secoli VI–X)* (Turnhout: Brepols, 2007): 95–107.
Nelson, J. L., 'Queens as Jezebels: The Careers of Brunhild and Balthild in Merovingian History', in D. Baker (ed.), *Medieval Women* (Oxford: Blackwell, 1978): 31–77.
Nelson, J. L., 'Les Reines Carolingiennes', in S. Lebecq, A. Dierkens, R. Le Jan, and J.-M. Sansterre (eds), *Femmes et pouvoirs des femmes à Byzance et en Occident (Vie–XIe siècles)* (Centre de Recherche sur l'Histoire de l'Europe du Nord-Ouest, Université Charles de Gaulle-Lille 3, 1999): 121–32.
Nelson, J. L., 'Women at the Court of Charlemagne: A Case of Monstrous Regiment?', in Parsons (ed.), *Medieval Queenship*: 43–61.
Nie, G. de, 'Consciousness Fecund Through God: From Male Fighter to Spiritual Bride-Mother in Late Antique Female Sanctity', in A. B. Mulder-Bakker (ed.), *Sanctity and Motherhood: Essays on Holy Mothers in the Middle Ages* (New York: Garland, 1995): 100–61.
Ní Ghrádaigh, J., 'Mere Embroiderers? Women and Art in Early Medieval Ireland', in T. Martin (ed.), *Reassessing the Roles of Women as 'Makers' of Medieval Art and Architecture*, 2 vols (Leiden: Brill, 2012), vol. 1: 93–128.
Nitzche, J. C., 'The Anglo-Saxon Woman as Hero: the Chaste Queen and the Masculine Woman Saint', *Old English Newsletter* 14(2) (1981): 28–9.
Nolan, K., *Queens in Stone and Silver: The Creation of a Visual Imagery of Queenship in Capetian France* (New York: Palgrave Macmillan, 2009).
Nolan, K., 'The Queen's Choice: Eleanor of Aquitaine and the Tombs at Fontevraud', in Wheeler and Parsons (eds), *Eleanor of Aquitaine: Lord and Lady*: 377–405.

Nolan, K., 'The Tomb of Adelaide of Maurienne and the Visual Imagery of Capetian Queenship', in Nolan (ed.), *Capetian Women*: 45–76.

Nolte, C., 'Gendering Princely Dynasties: Some Notes on Family Structure, Social Networks, and Communication at the Courts of the Margraves of Brandenburg-Ansbach around 1500', *Gender & History* 12(3) (2000): 704–21.

Oakley, F., *Kingship: The Politics of Enchantment* (Malden, MA: Blackwell, 2006).

O'Callaghan, J. F., 'The Many Roles of the Medieval Queen: Some Examples from Castile', in Earenfight (ed.), *Queenship and Political Power*: 21–32.

O'Callaghan, T. F., 'Tempering Scandal: Eleanor of Aquitaine and Benoit de Sainte-Maure's "Roman de Troie"', in Wheeler and Parsons (eds), *Eleanor of Aquitaine: Lord and Lady*: 301–17.

Odegaard, C. E., 'The Empress Engelberge', *Speculum* 26(1) (1951): 77–103.

Okerlund, A. N., *Elizabeth of York* (Basingstoke: Palgrave Macmillan, 2009).

Olson, K., 'The Cuckold's Revenge: Reconstructing Six Irish "Roscada" in "Táin Bó Cúailnge"', *Cambrian Medieval Celtic Studies* 28 (1994): 51–69.

Olson, K., 'Gwendolyn and Estrildis: Invading Queens in British Historiography', *Medieval Feminist Forum* 44(1) (2008): 36–52.

O'Meara, C. F., *Monarchy and Consent: The Coronation Book of Charles V of France* (Turnhout: Harvey Miller, 2001).

Óriain-Raedel, D., 'Edith, Judith, Matilda: the Role of Royal Ladies in the Propagation of the Continental Cult', in C. Stancliffe and E. Cambridge (eds), *Oswald: Northumbrian King to European Saint* (Stamford: Paul Watkins, 1995): 210–29.

Ormrod, W. M., 'Knights of Venus', *Medium Aevum* 73(2) (2004): 290–305.

Ormrod, W. M., 'Monarchy, Martyrdom, and Masculinity: England in the Later Middle Ages', in P. H. Cullum and K. J. Lewis (eds), *Holiness and Masculinity in the Middle Ages* (Toronto: University of Toronto Press, 2005): 174–91.

Ormrod, W. M., 'The Royal Nursery: A Household for the Children of Edward III', *English Historical Review* 120 (2005): 398–415.

Ormrod, W. M., 'The Sexualities of Edward II', in G. Dodd and A. Musson (eds), *The Reign of Edward II: New Perspectives* (York: York Medieval Press, 2006): 22–47.

Ortenberg, V., 'Virgin Queens: Abbesses and Power in Early Anglo-Saxon England', in R. Gameson and H. Leyser (eds), *Belief and Culture in the Middle Ages* (Oxford: Oxford University Press, 2001): 59–68.

Otter, M., 'Closed Doors: An Epithalamium for Queen Edith, Widow and Virgin', in C. L. Carlson and A. J. Weisl (eds), *Constructions of Widowhood and Virginity in the Middle Ages* (New York: St. Martin's Press, 1999): 63–92.

Owen, D. D. R., *Eleanor of Aquitaine, Queen and Legend* (Oxford: Blackwell, 1993).

Owen-Crocker, G. R., 'Pomp, Piety, and Keeping the Woman in Her Place: The Dress of Cnut and Emma in BL MS Stowe 944', *Old English Newsletter* 29(3) (1996): A–27.

Pappano, M. A., 'Marie de France, Aliénor d'Aquitaine, and the Alien Queen', in Wheeler and Parsons (eds), *Eleanor of Aquitaine: Lord and Lady*: 337–67.

Parsons, D. (ed.), *Eleanor of Castile 1290–1990* (Stamford: Paul Watkins, 1991).

Parsons, J. C., 'Damned If She Didn't and Damned When She Did: Bodies, Babies, and Bastards in the Lives of Two Queens of France', in Wheeler and Parsons (eds), *Eleanor of Aquitaine: Lord and Lady*: 265–99.

Parsons, J. C., *Eleanor of Castile: Queen and Society in Thirteenth-Century England* (New York: St. Martin's Press, 1995).

Parsons, J. C., 'Family, Sex, and Power: The Rhythms of Medieval Queenship', in Parsons (ed.), *Medieval Queenship*: 1–11.

Parsons, J. C., 'The Intercessionary Patronage of Queens Margaret and Isabella of France', *Thirteenth-Century England* 6 (1995): 145–56.

Parsons, J. C., 'Loved Him – Hated Her: Honor and Shame at the Medieval Court', in J. Murrray (ed.), *Conflicted Identities and Multiple Masculinities: Men in the Medieval West* (New York: Garland, 1999): 279–98.

Parsons, J. C., 'Mothers, Daughters, Marriage, Power: Some Plantagenet Evidence, 1150–1500', in Parsons (ed.), *Medieval Queenship*: 63–78.

Parsons, J. C., '"Never was a body buried in England with such solemnity and honour": The Burials and Posthumous Commemorations of English Queens to 1500', in Duggan (ed.), *Queens and Queenship in Medieval Europe*: 317–37.

Parsons, J. C., 'Piety, Power, and the Reputations of Two Thirteenth-Century English Queens', in Vann (ed.), *Queens, Regents, and Potentates*: 107–23.

Parsons, J. C., 'The Pregnant Queen as Counsellor and the Medieval Construction of Motherhood', in J. C. Parsons and B. Wheeler (eds), *Medieval Mothering* (New York: Garland, 1996): 39–61.

Parsons, J. C., 'Of Queens, Courts, and Books: Reflections on the Literary Patronage of Thirteenth-Century Plantagenet Queens', in J. H. McCash (ed.), *The Cultural Patronage of Medieval Women* (Athens: University of Georgia Press, 1996): 175–201.

Parsons, J. C., 'The Queen's Intercession in Thirteenth-Century England', in Carpenter and MacLean (eds), *Power of the Weak*: 147–77.

Parsons, J. C., '"Que Nos in Infancia Lactauit": The Impact of Childhood Care-Givers on Plantagenet Family Relationships in the Thirteenth and Early Fourteenth Centuries', in C. M. Rousseau and J. T. Rosenthal (eds), *Women, Marriage, and Family in Medieval Christendom: Essays in Memory of Michael M. Sheehan, C.S.B.* (Kalamazoo: Western Michigan University, 1998): 289–324.

Parsons, J. C., 'Ritual and Symbol in English Medieval Queenship to 1500', in Fradenburg (ed.), *Women and Sovereignty*: 60–77.

Parsons, J. C., 'Violence, the Queen's Body, and the Medieval Body Politic', in M. Meyerson, D. Thiery, and O. Falk (eds), *'A Great Effusion of Blood'? Interpreting Medieval Violence* (Toronto: University of Toronto Press, 2004): 241–67.

Patrouch, J. *Queen's Apprentice: Archduchess Elizabeth, Empress María, the Habsburgs, and the Holy Roman Empire, 1554–1569* (Leiden: Brill, 2010).

Pernoud, R., *Blanche of Castile*, Henry Noel (trans.) (New York: Coward, McCann & Geoghegan, 1975; 1st French edn, 1972).

Phillips, P., *The Medieval Queen's Daybook: les Très Beaux Jours* (New York: Clarkson Potter, 1990).
Phillippy, P., 'Establishing Authority: Boccaccio's "De Mulieribus claris" and Christine de Pizan's "Le Livre de la cité des dames"', *Romanic Review* 77 (1986): 167–93.
Pick, L. K., '*Dominissima, prudentissime*: Elvira, First Queen-Regent of León', in T. E. Burman, M. D. Meyerson, and L. Shopkow (eds), *Religion, Text, and Society in Medieval Spain and Northern Europe: Essays in Honor of J. N. Hillgarth* (Toronto: Pontifical Institute of Medieval Studies, 2002): 38–69.
Pick, L. K., 'Sacred Queens and Warrior Kings in the Royal Portraits of the *Liber Testamentorum* of Oviedo', *Viator* 42(2) (2011): 49–81.
Poulet, A., 'Capetian Women and the Regency: The Genesis of a Vocation', in Parsons (ed.), *Medieval Queenship*: 93–116.
Power, D., 'The Stripping of a Queen: Eleanor of Aquitaine in Thirteenth-century Norman Tradition', in M. Bull and C. Léglu (eds), *The World of Eleanor of Aquitaine: Literature and Society in Southern France between the Eleventh and Thirteenth Centuries* (Woodbridge: Boydell Press, 2005): 115–35.
Pratt, K., 'The Image of the Queen in Old French Literature', in Duggan (ed.), *Queens and Queenship in Medieval Europe*: 235–59.
Prestwich, M., 'Edward I and the Maid of Norway', *Scottish Historical Review* 69 (1990): 157–74.
Princeses de terres llunyanes: Catalunya i Hongria a l'edat mitjana (Barcelona: Generalitat de Catalunya, 2009).
Proctor-Tiffany, M., 'Portrait of a Medieval Patron: The Inventory and Gift Giving of Clémence of Hungary', doctoral dissertation (Brown University, 2007).
Pryds, D., 'Sancia, Queen of Naples (d. 1345): Protector of the Orders', in D. Pryds (ed.), *Women of the Streets: Early Franciscan Women and their Mendicant Vocation* (St. Bonaventure, NY: Franciscan Institute, 2010): 63–75.
Quilligan, M., *The Allegory of Female Authority: Christine de Pizan's 'Cité des dames'* (Ithaca, NY: Cornell University Press, 1991).
Rabin, A., 'Female Advocacy and Royal Protection in Tenth-Century England: The Legal Career of Queen Ælfthryth', *Speculum* 84(2) (2009): 261–88.
Redworth, G., *The Prince and the Infanta: The Cultural Politics of the Spanish Match* (New Haven: Yale University Press, 2003).
Regalado, N., 'Allegories of Power: The Tournament of Vices and Virtues in the *Roman de Fauvel* (BN MS Fr. 146)', *Gesta* 32(2) (1993): 135–46.
Reid, N. H., 'Margaret Maid of Norway and Scottish Queenship', *Reading Medieval Studies* 8 (1982): 75–96.
Reilly, B., *The Kingdom of León-Castilla Under Queen Urraca, 1109–1126* (Princeton: Princeton University Press, 1982).
Remensnyder, A., 'Marian Monarchy in Thirteenth-Century Castile', in R. Berkhofer, A. Cooper, and A. Kosto (eds), *The Experience of Power in Medieval Europe, 950–1350* (Aldershot: Ashgate, 2005): 247–64.
Renoux, A., 'Elite Women, Palaces, and Castles in Northern France (ca.

850–1100)', in T. Martin (ed.), *Reassessing the Roles of Women as 'Makers' of Medieval Art and Architecture*, 2 vols (Leiden: Brill, 2012), vol. 2: 739–82.

Réthelyi, O., *Mary of Hungary: the Queen and Her Court, 1521–1531* (Budapest: Budapest History Museum, 2005).

Richardson, H. G., 'The Marriage of Isabelle of Angoulême: A Problem of Canon Law', in G. Forchielli and A. M. Stickler (eds), *Collectanea Stephan Kuttner II* (Bologna: Institutum Gratianum, 1967): 397–423.

Ridyard, S., *The Royal Saints of Anglo-Saxon England: A Study of West Saxon and East Anglian Cults* (Cambridge: Cambridge University Press, 1988).

Riehl, A., *The Face of Queenship: Representations of Elizabeth I* (Basingstoke: Palgrave Macmillan, 2010).

Rodrigues, A. M., 'Aliénor, une infante entre la Castille, l'Aragon et le Portugal', *e-Spania* 5 (2008): http://e-spania.revues.org/document11833.html.

Rodrigues, A. M., 'Between Husband and Father: Queen Isabel of Lancaster's Crossed Loyalties', *Imago Temporis: Medium Aevum* 3 (2009): 205–18.

Rodrigues, A. M., 'La casa de Doña Leonor de Aragón, reina de Portugal (1433–1445): Formación y desintegración de un instrumento de poder femenino', in M. I. del Val Valdivieso and C. Segura Graiño (eds), *La participación de las mujeres en lo político: Mediación, representación y toma de decisiones* (Madrid: Almudayna, 2011): 241–79.

Rodrigues, A. M., '"For the Honor of her Lineage and Body": The Dowers and Dowries of Some Late Medieval Queens of Portugal", *e-Journal of Portuguese History* 5(1) (2007): 1–13; http://www.brown.edu/Department/Portuguese_Brazilian_Studies/ejph/html/issue9/pdf/arodrigues.pdf.

Rodrigues, A. M., 'A mesa, o leito, a arca, a mula: Como se provia ao sustento e itinerância das rainhas de Portugal na Idade Média', in A. I. Buescu and D. Felismino (eds), *A Mesa dos Reis de Portugal. Ofícios, consumos, cerimónias e representações (Sécs. XIII–XVIII)* (Lisbon: Círculo de Leitores, 2011): 44–63.

Rodrigues, A. M., 'The Queen-Consort in Late-Medieval Portugal', in B. Bolton and C. Meek (eds), *Aspects of Power and Authority in the Middle Ages* (Turnhout: Brepols, 2007): 131–46.

Rodrigues, A. M., 'Rainhas Medievais de Portugal: Funções, patrimónios, poderes', *Clio* (new series) 16/17 (2007): 139–53.

Rodrigues, A. M., 'The Treasures and Foundations of Isabel, Beatriz, Elisenda, and Leonor: The Art Patronage of Four Iberian Queens in the Fourteenth Century', in T. Martin (ed.), *Reassessing the Roles of Women as 'Makers' of Medieval Art and Architecture*, 2 vols (Leiden: Brill, 2012), vol. 2: 903–35.

Rodrigues, A. M. and M. Santos Silva, 'Private Properties, Seigniorial Tributes, and Jurisdictional Rents: The Income of the Queens of Portugal in the Late Middle Ages', in T. Earenfight (ed.), *Women and Wealth in Late Medieval Europe* (Basingstoke: Palgrave Macmillan, 2010): 209–28.

Roncière, C. M. B. de La, 'Queen Eleanor and Aquitaine, 1137–1189', in Wheeler and Parsons (eds), *Eleanor of Aquitaine: Lord and Lady*: 55–76.

Rosenwein, B., 'Family Politics of Berengar I, King of Italy (888–924)', *Speculum* 71(2) (1996): 247–89.

Rosser, S., 'Aethelthryth: A Conventional Saint?', *Bulletin of the John Rylands University Library of Manchester* 79(3) (1997): 15–24.

Rubin, N., *Isabella of Castile: The First Renaissance Queen* (New York: St. Martin's Press, 1991).

Runcimann, S., 'The Empress Irene the Athenian', in D. Baker (ed.), *Medieval Women* (Oxford: Blackwell, 1978): 101–18.

Runcimann, S., 'Some Notes on the Role of the Empress', *Eastern Churches Review* 4 (1972): 119–24.

Rushforth, R., *St. Margaret's Gospel-book: The Favourite Book of an Eleventh-Century Queen of Scots* (Oxford: Bodleian Library Publishing, 2003).

Sablonier, R., 'The Aragonese Royal Family Around 1300', in H. Medick and D. W. Sabean (eds), *Interest and Emotion: Essays on the Study of Family and Kinship* (Cambridge: Cambridge University Press, 1984): 210–39.

Sadlack, S., *The French Queen's Letters: Mary Tudor Brandon and the Politics of Marriage in Sixteenth Century Europe* (Basingstoke: Palgrave Macmillan, 2011).

Sághy, M., 'Aspects of Female Rulership in Late Medieval Literature: The Queens' Reign in Angevin Hungary', *East Central Europe* 1(21–23) (1991): 69–86.

Sánchez, M., *The Empress, the Queen, and the Nun: Women and Power at the Court of Philip III of Spain* (Baltimore: Johns Hopkins University Press, 1998).

Santos Silva, M., 'A Casa e o Património da Rainha de Portugal, D. Filipa de Lencastre: um Ponto de Partida para o Conhecimento da Casa das Rainhas na Idade Média', *Revista Signum* 11(2) (2010): 207–27.

Santos Silva, M., 'Philippa of Lancaster, Queen of Portugal: Educator and Reformer', in Oakley-Brown and Wilkinson (eds), *The Rituals and Rhetoric of Queenship*: 37–46.

Santos Silva, M., *A região de Óbidos na Epoca medieval: Estudos* (Óbidos: 1994).

Sayles, G. O., 'The Royal Marriages Act, 1428', *Law Quarterly Review* 94 (1978): 188–92.

Scalingi, P. L., 'The Sceptre or the Distaff: The Question of Female Sovereignty, 1516–1607', *The Historian* 41 (1978): 59–75.

Scheck, H., 'Queen Mathilda of Saxony and the Founding of Quedlinburg: Women, Memory, and Power', *Historical Reflections/Reflexions historiques* 35(3) (2009): 21–36.

Schowalter, K. S., 'The Ingeborg Psalter: Queenship, Legitimacy, and the Appropriation of Byzantine Art in the West', in Nolan (ed.), *Capetian Women*: 99–136.

Schulenburg, J. T., 'Female Piety and the Building and Decorating of Churches, ca. 500–1150', in T. Martin (ed.), *Reassessing the Roles of Women as 'Makers' of Medieval Art and Architecture*, 2 vols (Leiden: Brill, 2012), vol. 1: 245–73.

Schulenburg, J. T., 'Female Sanctity: Public and Private Roles, ca. 500–1100', in Erler and Kowaleski (eds), *Women and Power in the Middle Ages*: 102–25.

Schulenburg, J. T., 'Holy Women and the Needle Arts: Piety, Devotion, and Stitching the Sacred, ca. 500–1150', in K. A. Smith and S. Wells (eds), *Negotiating Community and Difference in Medieval Europe* (Leiden: Brill, 2009): 83–110.

Scillia, D. G., 'Gerard David's *St. Elizabeth of Hungary* in the *Hours of Isabella the Catholic*', *Cleveland Studies in the History of Art* 7 (2002): 50–67.
Scott, J. W., 'Gender: A Useful Category of Historical Analysis', *American Historical Review* 91(5) (1986): 1053–75.
Scott, J. W., 'Gender: Still a Useful Category of Analysis?', *Diogenes* 57(225) (2010): 7–14.
Searle, E., 'Emma the Conqueror', in C. Harper-Bill, C. J. Holdsworth, and J. L. Nelson (eds) *Studies in Medieval History Presented to R. Allen Brown*, (Woodbridge: Boydell & Brewer, 1989): 281–8.
Searle, E., 'Women and the Legitimisation of Succession at the Norman Conquest', *Anglo-Norman Studies* 3 (1980): 159–70.
Seaver, K. A., 'Thralls and Queens: Female Slavery in the Medieval Norse Atlantic', in G. Campbell, S. Miers and J. C. Miller (eds), *Women and Slavery: Volume One Africa, the Indian Ocean World, and the Medieval North Atlantic* (Athens: Ohio University Press, 2007): 146–67.
Sebastián Lozano, J., 'Choices and Consequences: The Construction of Isabel de Portugal's Image', in Earenfight (ed.), *Queenship and Political Power*: 145–63.
Shadis, M. T., *Berenguela of Castile (1180–1246) and Political Women in the High Middle Ages* (Basingstoke: Palgrave Macmillan, 2009).
Shadis, M. T., 'Berenguela of Castile's Political Motherhood: The Management of Sexuality, Marriage, and Succession', in J. C. Parsons and B. Wheeler (eds), *Medieval Mothering* (New York: Garland, 1996): 335–58.
Shadis, M. T., 'Blanche of Castile and Facinger's "Medieval Queenship": Reassessing the Argument', in Nolan (ed.), *Capetian Women*: 137–61.
Shadis, M. T., 'The First Queens of Portugal and the Building of the Realm', in T. Martin (ed.), *Reassessing the Roles of Women as 'Makers' of Medieval Art and Architecture*, 2 vols (Leiden: Brill, 2012), vol. 2: 671–702.
Shadis, M. T., 'Piety, Politics and Power: The Patronage of Leonor of England and Her Daughters, Blanche of Castile and Berenguela of León', in J. H. McCash (ed.), *The Cultural Patronage of Medieval Women* (Athens: University of Georgia Press, 1996): 202–27.
Shadis, M. T., 'Women, Gender and Rulership in Romance Europe: The Iberian Case', *History Compass* 4 (2006), 481–87.
Shadis, M. T. and C. H. Berman, 'A Taste of the Feast: Reconsidering Eleanor of Aquitaine's Female Descendants', in Wheeler and Parsons (eds), *Eleanor of Aquitaine: Lord and Lady*: 177–211.
Shenk, L., *Learned Queen: The Imperial Images of Elizabeth I* (Basingstoke: Palgrave Macmillan, 2009).
Shenton, C., 'Philippa of Hainault's Churchings: The Politics of Motherhood at the Court of Edward III', in R. Eales and S. Tyas (eds), *Family and Dynasty in Late Medieval England* (Donington: Shaun Tyas, 2003): 105–21.
Sheridan, M., 'Mothers and Sons: Emma of Normandy's Role in the English Succession Crisis, 1035–42', in C. Meek and C. Lawless (eds), *Victims or Viragos?* (Dublin: Four Courts Press, 2005): 39–48.

Sherman, C. R., *The Portraits of Charles V of France (1338–1380)* (New York: New York University Press for the College Art Association of America, 1969).
Sherman, C. R., 'The Queen in Charles V's "Coronation Book": Jeanne de Bourbon and the "Ordo ad reginam benedicendam"', *Viator* 8 (1977): 255–98.
Sherman, M., '"Pomp and Circumstance": Pageantry, Politics, and Propaganda in France during the Reign of Louis XII, 1498–1515', *Sixteenth Century Journal* 9(4) (1978): 13–32.
Shippey, T., 'Wicked Queens and Cousin Strategies in "Beowulf" and Elsewhere', *The Heroic Age: A Journal of Early Medieval Northwestern Europe* 5 (2001): www.heroicage.org/issues/5/Shippey1.
Silleras-Fernández, N., 'Money Isn't Everything: Concubinage, Class, and the Rise and Fall of Sibil·la de Fortià, Queen of Aragon (1377–87)', in T. Earenfight (ed.), *Women and Wealth in Late Medieval Europe* (Basingstoke: Palgrave Macmillan, 2010): 67–88.
Silleras-Fernández, N., *Power, Piety, and Patronage in Late Medieval Queenship: Maria de Luna* (Basingstoke: Palgrave Macmillan, 2008).
Silleras-Fernández, N., '"Queenship" en la Corona de Aragón en la Baja Edad Media: estudio y propuesta terminological', *La corónica* 32(1) (Fall 2003): 119–33.
Silleras-Fernández, N., 'Spirit and Force: Politics, Public and Private, in the Reign of Maria de Luna (1396–1406)', in Earenfight (ed.), *Queenship and Political Power*: 78–90.
Silleras-Fernández, N., 'Widowhood and Deception: Ambiguities of Queenship in Late Medieval Crown of Aragon', in M. Crane, M. Reeves, and R. Raiswell (eds), *Shell Games: Scams, Frauds, and Deceits (1300–1650)* (Toronto: Centre for Renaissance and Reformation Studies, 2004): 187–205.
Skovgaard-Petersen, I. and N. Damsholt, 'Queenship in Medieval Denmark', in Parsons (ed.), *Medieval Queenship*: 25–42.
Slater, C., '"So Hard was it to Release Princes whom Fortuna had put in her Chains": Queens and Female Rulers as Hostage- and Captive-Takers and Holders', *Medieval Feminist Forum* 45(2) (2009): 12–40.
Smith, J. A., 'The Earliest Queen-Making Rites', *Church History* 66(1) (March 1997): 18–35.
Smith, S. L., *The Power of Women: A Topos in Medieval Art and Literature* (Philadelphia: University of Pennsylvania Press, 1995).
Smythe, D. C., 'Behind the Mask: Empresses and Empire in Middle Byzantium', in Duggan (ed.), *Queens and Queenship in Medieval Europe*: 141–52.
Stafford, P., 'Cherchez la femme. Queens, Queens' Lands, and Nunneries: Missing Links in the Foundation of Reading Abbey', *History: The Journal of the Historical Association* 85(277) (2000): 4–27.
Stafford, P., 'Emma: The Powers of the Queen in the Eleventh Century', in Duggan (ed.), *Queens and Queenship in Medieval Europe*: 3–26.
Stafford, P., 'The King's Wife in Wessex, 800–1066', *Past and Present* 91 (1981): 3–27.

Stafford, P., 'Kinship and Women in the World of Maldon: Byrhtnoth and his Family', in J. Cooper (ed.), *The Battle of Maldon: Fiction and Fact* (London: Hambledon Press, 1993): 225–35.

Stafford, P., 'The Laws of Cnut and the History of Anglo-Saxon Royal Promises', *Anglo-Saxon England* 10 (1981): 173–90.

Stafford, P., 'The Portrayal of Royal Women in England, Mid-Tenth to Mid-Twelfth Centuries', in Parsons (ed.), *Medieval Queenship*: 143–67.

Stafford, P., 'Powerful Women in the Early Middle Ages: Queens and Abbesses', in P. Linehan and J. L. Nelson (eds), *The Medieval World* (Oxford: Routledge, 2001): 398–415.

Stafford, P., *Queen Emma and Queen Edith: Queenship and Women's Power in Eleventh-Century England* (Oxford: Blackwell, 1997).

Stafford, P., *Queens, Concubines, and Dowagers: The King's Wife in the Early Middle Ages* (Athens: University of Georgia Press, 1983).

Stafford, P., 'Queens and Queenship', in P. Stafford (ed.), *A Companion to the Early Middle Ages: Britain and Ireland, c.500–c.1100* (Oxford: Wiley-Blackwell, 2009): 459–76.

Stafford, P., 'Queens, Nunneries, and Reforming Churchmen: Gender, Religious Status, and Reform in Tenth- and Eleventh-Century England', *Past and Present* 163 (1999): 3–35.

Stafford, P., 'Queens and Treasure in the Middle Ages', in E. M. Tyler (ed.), *Treasure in the Medieval West* (York: York Medieval Press, 2000): 61–82.

Stafford, P., 'Sons and Mothers: Family Politics in the Early Middle Ages', in D. Baker (ed.), *Medieval Women* (Oxford: Blackwell, 1978): 79–100.

Stafford, P., 'Women and the Norman Conquest', *Transactions of the Royal Historical Society* 6 (1994): 221–49.

Stafford, P., 'Writing the Biography of Eleventh-Century Queens', in D. Bates, J. Crick, and S. Hamilton (eds), *Writing Medieval Biography, 750–1250* (Woodbridge: Boydell Press, 2006): 99–109.

Stahl, A. M., 'Coinage in the Name of Medieval Women', in J. T. Rosenthal (ed.), *Medieval Women and the Sources of Medieval History* (Athens: University of Georgia Press, 1990): 321–41.

Stalls, W. C., 'Queenship and the Royal Patrimony in Twelfth-Century Iberia: The Example of Petronilla of Aragón', in Vann (ed.), *Queens, Regents, and Potentates*: 49–61.

Stanton, A. R., 'Isabelle of France and Her Manuscripts, 1308–58', in Nolan (ed.), *Capetian Women*: 225–52.

Stoertz, F. H., 'Young Women in France and England, 1050–1300', *Journal of Women's History* 12(4) (2001): 22–46.

Strohm, P., 'Queens as Intercessors', in P. Strohm (ed.), *Hochon's Arrow: The Social Imagination of Fourteenth-Century Texts* (Princeton: Princeton University Press, 1992): 95–120.

Stroll, M., 'Marie "Regina": Papal Symbol', in Duggan (ed.), *Queens and Queenship*: 173–203.

Strong, R., *Art and Power: Renaissance Festivals, 1450–1650* (Berkeley and Los Angeles: University of California Press, 1984).
Strong, R., *Splendor at Court: Renaissance Spectacle and the Theater of Power* (Boston: Houghton Mifflin, 1973).
Strong, R., *The Tudor and Stuart Monarchy: Pageantry, Painting, Iconography* (Woodbridge: Boydell Press, 1995–1998).
Sutherland, N. M., 'Catherine de' Medici: The Legend of the Wicked Italian Queen', *Sixteenth Century Journal* 9 (1978): 45–56.
Sutton, A. F. and L. Visser-Fuchs, 'The Cult of Angels in Late Fifteenth-Century England: An Hours of the Guardian Angel Presented to Queen Elizabeth Woodville', in L. Smith and J. H. M. Taylor (eds), *Women and the Book: Assessing the Visual Evidence* (London: British Library and University of Toronto Press, 1997): 230–65.
Sutton, A. F. and L. Visser-Fuchs, '"A Most Benevolent Queen": Queen Elizabeth Woodville's Reputation, Her Piety, and Her Books', *The Ricardian* 10(129) (1995): 214–45.
Suzuki, M., 'Gender, Power, and the Female Reader: Boccaccio's "Decameron" and Marguerite de Navarre's "Heptameron"', *Comparative Literature Studies* 30(3) (1993): 231–52.
Swabey, F., *Eleanor of Aquitaine, Courtly Love, and the Troubadours* (Westport, CT: Greenwood, 2004).
Sweeney, J. R., 'The Tricky Queen and Her Clever Lady-in-Waiting: Stealing the Crown to Secure Succession, Visegrad 1440', *East Central Europe* 1(21–23) (1991): 87–100.
Tanner, H. J. 'Queenship: Office, Custom, or Ad Hoc? The Case of Queen Matilda III', in Wheeler and Parsons (eds), *Eleanor of Aquitaine, Lord and Lady*: 133–58.
Tatum, S., '*Auctoritas* as *sanctitas*: Balthild's depiction as "queen-saint" in the "Vita Balthildis"', *European Review of History – Revue européenne d'histoire* 16(6) (2009): 809–34.
Taylor, A., 'Anne of Bohemia and the Making of Chaucer', *Studies in the Age of Chaucer* 19 (1997): 95–119.
Taylor, C., 'The Salic Law, French Queenship, and the Defense of Women in the Late Middle Ages', *French Historical Studies* 29(4) (2006): 543–64.
Taylor, C., 'The Salic Law and the Valois Succession to the French Crown', *French History* 15(4) (2001): 358–77.
Thompson, G. G., 'Mary of Hungary and Music Patronage', *Sixteenth Century Journal* 15 (1984): 401–18.
Teixeira, M. B., 'Portuguese Art Treasures, Medieval Women, and Early Museum Collections', in F. E. S. Kaplan (ed.), *Museums and the Making of 'Ourselves': The Role of Objects in National Identity* (Leicester: Leicester University Press, 1994): 291–313.
Thompson, K., 'Reconsidering the Empress Matilda's Act for Andwell', *Historical Research* 84(224) (2011): 74–8.
Thyrêt, I., 'Blessed is the Tsaritsa's Womb: The Myth of Miraculous Birth and Royal Motherhood in Muscovite Russia', *Russian Review* 53(4) (1994): 479–96.

Tolhurst, F., 'The Outlandish Lioness: Eleanor of Aquitaine in Literature', *Medieval Feminist Forum* 37 (Spring 2004): 9–13.

Tolley, T., 'Eleanor of Castile and the "Spanish" Style in England', in M. W. Ormrod (ed.), *England in the Thirteenth Century* (Stamford: Paul Watkins, 1991): 167–92.

Tolley, T., 'States of Independence: Women Regents as Patrons of the Visual Arts in Renaissance France', *Renaissance Studies* 10(2) (1996): 237–58.

Treadgold, W., 'The Bride-Shows of the Byzantine Emperors', *Byzantion* 49 (1979): 395–413.

Trindade, A., *Berengaria: In Search of Richard the Lionheart's Queen* (Dublin: Four Courts Press, 1999).

Truax, J. A., 'Winning Over the Londoners: King Stephen, the Empress Matilda, and the Politics of Personality', *Haskins Society Journal* 8 (1996): 43–61.

Turner, R. V., 'Eleanor of Aquitaine in the Governments of Her Sons Richard and John', in Wheeler and Parsons (eds), *Eleanor of Aquitaine: Lord and Lady*: 77–95.

Turner, R. V., *Eleanor of Aquitaine: Queen of France, Queen of England* (New Haven: Yale University Press, 2009).

Tyler, E. M., 'Fictions of Family: The "Encomium Emmae Reginae" and Virgil's "Aeneid"', *Viator* 36 (2005): 149–79.

Tyler, E. M., 'Queenly Patronage and Clerical Authorship: The "Vita Ædwardi Regis"', *Mediaevistik* 8 (1995): 27–53.

Tyler, E. M., 'Talking about History in Eleventh-century England: The "Encomium Emmae Reginae" and the Court of Harthacnut', *Early Medieval Europe* 13(4) (2005): 359–83.

Ullmann, W., *A History of Political Thought: The Middle Ages* (Harmondsworth: Penguin, 1975).

Valdez Del Alamo, E., 'Lament for a Lost Queen: The Sarcophagus of Doña Blanca in Nájera', *Art Bulletin* 78(2) (1996): 311–33.

Van Landingham, M., 'The Hohenstaufen Heritage of Costanza of Sicily and the Mediterranean Expansion of the Crown of Aragon in the Later Thirteenth Century', in D. Agius and I. R. Netton (eds), *Across the Mediterranean Frontiers* (Turnhout: Brepols, 1997): 87–104.

Van Landingham, M., 'Royal Portraits: Representations of Queenship in the Thirteenth-Century Catalan Chronicles', in Earenfight (ed.), *Queenship and Political Power*: 109–19.

Vann, T. M., 'The Theory and Practice of Medieval Castilian Queenship', in Vann (ed.), *Queens, Regents, and Potentates*: 125–47.

Vidas, M., 'Elizabeth of Bosnia, Queen of Hungary, and the Tomb-Shrine of St. Simeon in Zadar. Power and Relics in Fourteenth-Century Dalmatia', *Studies in Iconography* 29 (2008): 136–75.

Vinson, M., 'The Life of Theodora and the Rhetoric of the Byzantine Brideshow', *Jarhbuch der Österreichischen Byzantinistik* 49 (1999): 31–60.

Vinson, M., 'Romance and Reality in the Byzantine Bride Shows', in L. Brubaker and J. M. H. Smith (eds), *Gender in the Early Medieval World, East and West, 300–900* (Cambridge: Cambridge University Press, 2004): 102–20.

Walker, R., 'Images of Royal and Aristocratic Burial in Northern Spain, c. 950–c. 1250', in E. van Houts (ed.), *Medieval Memories: Men, Women, and the Past, 700–1300* (London: Longman, 2001): 150–72.

Walker, R., 'Leonor of England and Eleanor of Castile: Anglo-Iberian Marriage and Cultural Exchange in the Twelfth and Thirteenth Centuries', in M. Bullón-Fernández (ed.), *England and Iberia in the Middle Ages, 12th–15th Century: Cultural, Literary and Political Exchanges* (Basingstoke: Palgrave Macmillan, 2007): 67–87.

Walker, R., 'Leonor of England, Plantagenet Queen of King Alfonso VIII of Castile, and Her Foundation of the Cistercian Abbey of Las Huelgas. In Imitation of Fontevraud?', *Journal of Medieval History* 31(4) (2005): 346–68.

Walker, R., 'Sancha, Urraca, and Elvira: The Virtues and Vices of Spanish Royal Women "Dedicated to God"', *Reading Medieval Studies* 24 (1998): 113–38.

Walker, R., 'Sisters and Suburbs: Some Reflections on Berengaria of Navarre and her Cistercian Foundation outside Le Mans', in Z. Opacic and A. Timmermann (eds), *Image, Memory and Devotion: 'Liber Amicorum' Paul Crossley* (Turnhout: Brepols, 2011): 229–37.

Wall, V., 'Queen Margaret of Scotland, 1070–93: Burying the Past, Enshrining the Future', in Duggan (ed.), *Queens and Queenship in Medieval Europe*: 27–38.

Wallace, P., 'Queenship and Knowledge in the Second English "Ordo" and the Old English "Christ I"', *Old English Newsletter* 28(3) (1995): A–17.

Wallace-Hadrill, J. M., *The Long-Haired Kings* (London: Metheun, 1962).

Ward, E., 'Caesar's Wife, The Career of the Empress Judith, 819–29', in P. Godman and R. Collins (eds), *Charlemagne's Heir, New Perspectives on the Reign of Louis the Pious* (Oxford: Clarendon, 1990): 205–27.

Wathey, A., 'The Marriage of Edward III and the Transmission of French Motets to England', *Journal of the American Musicological Society* 45(1) (1992): 1–29.

Webb, D., 'Queen and Patron', in Duggan (ed.), *Queens and Queenship in Medieval Europe*: 205–21.

Webster, G., *Boudica and the British Revolt against Rome AD 48–58* (Totowa: Rowman & Littlefield, 1978).

Weissberger, B., *Isabel Rules: Constructing Queenship, Wielding Power* (Minneapolis: University of Minnesota Press, 2004).

Weissberger, B., ' "Me atrevo a escribir así": Confessional Politics in the Letters of Isabel I and Hernando de Talavera', in M. Stone and C. Benito-Vessels (eds), *Women at Work in Spain: From the Middle Ages to Early Modern Times* (New York: Peter Lang, 1998): 147–73.

Wemple, S. F., *Women in Frankish Society: Marriage and the Cloister, 500–900* (Philadelphia: University of Pennsylvania Press, 1981).

Wertheimer, L., 'Adeliza of Louvain and Anglo-Norman Queenship', *Haskins Society Journal* 7 (1995): 101–15.

White, S. D., 'Clotild's Revenge: Politics, Kinship, and Ideology in the Merovingian Blood Feud', in S. K. Cohn and S. A. Epstein (eds), *Portraits of Medieval and Renaissance Living: Essays in Honor of David Herlihy* (Ann Arbor: University of Michigan Press, 1996): 107–30.

Wilkinson, L. J., 'The Imperial Marriage of Isabella of England, Henry III's Sister', in Oakley-Brown and Wilkinson (eds), *The Rituals and Rhetoric of Queenship*: 20–36.
Willard, C. C., 'Anne de France, Reader of Christine de Pizan', in G. McLeod (ed.), *The Reception of Christine de Pizan from the Fifteenth through the Nineteenth Centuries: Visitors to the City* (Lewiston, NY: Edwin Mellen Press, 1991): 59–70.
Willard, C. C., 'Isabel of Portugal, Patroness of Humanism?', in *Miscellanea di studi e ricerche sul quattrocento Francese* (Turin: Giappichelli Editore, 1967).
Wilson, A. J., *St. Margaret, Queen of Scotland* (Edinburgh: Donald, 1993).
Wogan-Browne, J., 'Queens, Virgins, and Mothers: Hagiographic Representations of the Abbess and Her Powers in Twelfth- and Thirteenth-century Britain', in Fradenburg (ed.), *Women and Sovereignty*: 14–35.
Wolf, A., 'Reigning Queens in Medieval Europe: When, Where, and Why?' in Parsons (ed.), *Medieval Queenship*: 169–88.
Wolff, M. (ed.), *Kings, Queens, and Courtiers: Art in Early Renaissance France* (New Haven: Yale University Press, 2011).
Wood, C. T., 'The First Two Queens Elizabeth, 1464–1503', in Fradenburg (ed.), *Women and Sovereignty*: 121–31.
Wood, C. T., *Joan of Arc and Richard III: Sex, Saints, and Government in the Middle Ages* (Oxford: Oxford University Press, 1988).
Wood, C. T., 'Queens, Queans, and Kingship: An Inquiry into Theories of Royal Legitimacy in Late Medieval England and France', in W. C. Jordan, B. McNab, T. F. Ruiz (eds), *Order and Innovation in the Middle Ages* (Princeton: Princeton University Press, 1976): 385–400.
Wood, I., 'Genealogy Defined by Women: The Case of the Pippinids', in L. Brubaker and J. M. H. Smith (eds), *Gender in the Early Medieval World: East and West, 300–900* (Cambridge: Cambridge University Press, 2004): 234–56.
Woodacre, E., 'The Queen and Her Consort in the Kingdom of Navarre 1274–1512: Succession, Politics and Partnership', doctoral dissertation (Bath Spa University, 2012).
Woodacre, E., 'The Queen's Marriage; Matrimonial Politics in Pre-Modern Europe', in J. Murray (ed.), *Marriage in Pre-Modern Europe: Italy and Beyond* (Toronto: CRRS Publications, 2012): 29–46.
Woodacre, E., 'The She-Wolves of Navarre', *History Today* 62(6) (2012): 47–51.
Wormald, J., *Mary Queen of Scots: A Study in Failure* (London: George Philip, 1988).
Zsoldos, A., 'The Problems of Dating the Queens' Charters of the Árpádian Age (Eleventh–Thirteenth Century)', in M. Gervers (ed.), *Dating Undated Medieval Charters* (Woodbridge: Boydell Press, 2000): 151–60.

Index

Notes: name of spouse(s), lover(s), mistress(es) and concubine(s) of a queen or king enclosed in square brackets; **bold face** indicates an item is cross-referenced.

Adair, Penelope, 102
Adams, Tracy, 196–7, 199–200
Adélaide (d. 1004), Queen of France [**Hugh Capet**], 101, 156
Adélaide of Maurienne (d. 1154), Queen of France [**Louis VI**], 151
Adéle of Champagne (d. 1206), Queen of France [**Louis VII**], 130, 152–3, 155
 see also Eleanor of Aquitaine, Constance of Castile
Adelheid of Burgundy (d. 999), Queen of Italy [Lothar II] and Holy Roman Empress [**Otto I**], 79, 99–100, 122
 see also Edith of England
Adelheid of Vohburg (d. 1190), Holy Roman Empress [**Frederick I Barbarossa**], 173, 178
 see also Beatrice of Burgundy
Adeliza of Louvain (d. 1151), Queen of England [**Henry I**], 131, 133–5
 see also Matilda of Scotland
adultery, 22, 50, 66, 72, 82, 94, 96, 101, 103, 106, 113, 137–38, 151, 159, 189, 213–14, 247
Ælfthryth (d. 999–1001), Queen of England [**Edgar**], 106–7, 146
Ælfgifu of Northhampton (d. after 1040), first wife of **Cnut of England**, 110–11
Ælfgifu of York (d. 1002), Queen of England [**Æthelred II**], 107
 see also Emma of Normandy

Æthelflæd (d. 918), 'Lady of the Mercians', 105-6
 see also Alfred 'the Great'
Æthelred II, 'the Unready' (d. 1016), King of England [**Ælfgifu of York, Emma of Normandy**], 104, 106-8, 110, 112, 114, 120
Æthelthryth (d. 679), Queen in Northumbria [Tondberct, Ecgfrith], 67–9
 see also Benedictional of St. Æthelwold
Afonso I (d. 1185), King of Portugal [Mafalda of Savoy], 163
 see also Teresa of León, Urraca of León-Castile
Afonso II (d. 1223), King of Portugal [**Urraca of Castile**], 125
Afonso V (d. 1481), King of Portugal [**Isabel of Coimbra**], 234
Agnes of Antioch (d. c. 1184), Queen of Hungary [**Béla III**], 174
 see also Constance of Hungary, Margaret of France (d. 1197)
Agnes of Brandenburg (d. 1304), Queen of Denmark [Eric V], 176
Agnes of Habsburg (d. 1364), Queen of Hungary [**Andrew III**], 174, 236
Agnes of Meran (d. 1201), Queen of France [**Philip II Augustus**], 152
 see also Ingeborg of Denmark; Isabelle of Hainault

Index

Airlie, Stuart, 96
Albrecht I (d. 1308), King of the Romans [**Elisabeth of Carinthia**], 174
Albrecht II (d. 1439), 'the Great', King of Hungary [**Elisabeth of Luxembourg**], 236
Alexander II (d. 1249), King of Scotland [**Joan of England, Marie de Coucy**], 144
Alexander III (d. 1286), King of Scotland [**Margaret of England, Yolande de Dreux**], 124, 143–4
Alexios I Komnenos (d. 1118), Byzantine Emperor [**Irene Doukaina**], 169–70
 see also Anna Dalassene
Alfonso I (d. 1134), King of Aragon [**Urraca, Queen-regnant of León-Castile**], 163–4
Alfonso II (d. 1196), King of the Crown of Aragon [**Sancha of Castile**], 167, 175
Alfonso IV (d. 1336), King of the Crown of Aragon [**Teresa d'Entença**, Leonor of Castile], 129, 168
Alfonso V (d. 1458), King of the Crown of Aragon [**María of Castile**], 190, 229–32, 241
Alfonso VI (d. 1109), King of León-Castile [Agnes of Aquitaine, **Constance of Burgundy**, Bertha, Zaida of Seville, Beatrice], 161, 163
 see also Teresa of León; Urraca, Queen-regnant of León-Castile
Alfonso VII (d. 1157), King of León-Castile [Berenguela of Barcelona, Richeza of Poland], 162, 166
 see also Alfonso VI of León-Castile; Urraca,Queen-regnant of León-Castile
Alfonso VIII (d. 1214), King of Castile [**Leanor of England**], 125–6, 154, 164
Alfonso IX (d. 1230), King of León [**Teresa of Portugal, Berenguela of Castile**], 127, 164–6, 225
Alfonso X (d. 1284), King of Castile [**Violant of Aragon**], 166–7, 169, 176
Alfonso XI (d. 1350), King of Castile [Constance of Peñafiel, **María of Portugal, Leonor de Guzmán**], 167, 186, 189, 225
Alfred 'the Great' (d. 899), King of England [Ealswith], 104–5, 122
 see also Æthelflæd, 'Lady of the Mercians'
Amalasuintha (d. c. 535), Queen of the Ostrogoths, 51, 73
Anabella Drummond (d. 1401), Queen of Scotland [**Robert III**], 221–2
Anastasia of Kiev (d. c. 1096), Queen of Hungary [Andrew I], 117
Andrew II (d. 1235), King of Hungary [**Gertrude of Meran**, Yolande of Courtenay, Beatrice d'Este], 172, 175
 see also Elizabeth of Hungary, saint
Andrew III (d. 1301), King of Hungary [**Agnes of Habsburg, Fenenna of Kuyavia**], 174
Andronikos II Palaiologos (d. 1328), Byzantine Emperor [Anna of Hungary, **Yolande-Irene of Montferrat**], 191
Andronikos III Palaiologos (d. 1341), Byzantine Emperor [Irene of Brunswick, **Anne of Savoy**], 191
Anna Dalassene (d. c. 1100), Byzantine Empress [John Komnenos], 169
 see also Alexios I Komnenos, Byzantine Emperor
Anna of Kiev (d. 1075), Queen of France [**Henri I**], 103
Anne of Austria (d. 1666), Queen of France [Louix XIII], 251, 256
Anne of Beaujeau [Anne of France] (d. 1522), Duchess of Bourbon, regent of France, 201–3, 242, 251
 see also Charles VIII, King of France; Charlotte of Savoy; *Lessons for My Daughter*; Louis XI, King of France; Margaret of Scotland (d. 1445)
Anne of Bohemia (d. 1394), Queen of England [**Richard II**], 11, 207–10
 see also Isabelle of France (d. 1409); Shrewsbury Charter

Index 341

Anne of Brittany (d. 1514), Queen of France [**Maximilian I, Holy Roman Emperor; Charles VIII, Louis XII**], 203, 242, 251
 see also Jean Pichore, 'Des remedes contre l'une et l'autre fortune'
Anne of Savoy (d. c. 1365), Byzantine Empress [**Andronikos III Palaiologos**], 191
Anne Neville (d. 1485), Queen of England [**Richard III**], 217
annulment, 164, 179, 241
Antependium of Basel Cathedral, 83–4
 see also Cunigunde of Luxembourg; Henry II, Holy Roman Emperor
archaeology, 64, 78
 see also bioarchaeology
Ariadne (d. 515), Byzantine Empress [Zeno], 41, 46
 see also Byzantine ivory panel
Árpád dynasty, 126, 173–6, 236
Arthur, legendary King of Britain [**Guenevere**], 21, 118–19, 138–9
Arthur (d. 1502), Prince of Wales [**Catherine of Aragon**], 219
Augusta, 43–5, 52–3
Austen, Jane, 1–2, 20–1

Baldwin III (d. 1163), King of Jerusalem [Theodora Komnene], 171
 see also Melisende, Queen of Jerusalem
Balthild (d. 680), Merovingian Queen [**Clovis II**], 53, 59–63, 67, 74–5
Balthild's chasuble, 63
Balthild seal matrix, 63
Barbara of Celje (d. 1451), Holy Roman Empress [**Sigismund**], 235
 see also Mary of Hungary
Basil I (d. 886), Byzantine Emperor [Eudoxia Ingerina], 88
Basil II (d. 1025), Byzantine Emperor, 89
basilissa, basileus, 87
Baudonivia, 60
 see also Radegund; Venantius Fortunatus
Bayeux tapestry (embroidery), 114

Beátrice of Burgundy (d. 1184), Holy Roman Empress [**Frederick I Barbarossa**], 173
 see also Adelheid of Vohburg
Beátrice of Provence (d. 1267), queen of Sicily [**Charles I of Anjou**], 123–4, 144
Beatrix, Queen of the Netherlands (b. 1938), 9
Beatriz of Naples (d. 1508), Queen of Hungary [**Matthias Corvinus**] and Queen of Hungary and Bohemia [**Vladislaus II**], 237, 242, 251
Beatriz of Portugal (d. c. 1420), Queen of Castile [**Juan I**], 189–90, 226
Bede, 37, 67, 72, 76
 see also Ecclesiastical History of the English People
Beem, Charles, 136
Béla III (d. 1196), King of Hungary [**Agnes of Antioch**, Margaret of France], 174–5
 see also Constance of Hungary
Béla IV (d. 1270), King of Hungary [**Maria Laskarina**], 174
Benz St. John, Lisa, 125–6
Beowulf, 39, 112
Benedictional of St. Æthelwold, 68–9
 see also Æthelthryth
Berengaria of Navarre (d. 1230), Queen of England [**Richard I**], 131, 140
 see also Eleanor of Aquitaine
Berenguela of Castile (d. 1246), Queen-regnant of Castile, Queen of León [**Alfonso IX of León**], 3, 125, 127, 154, 164–6, 178, 230, 235, 238, 250
 see also Teresa of Portugal; Fernando III, King of Castile; Dulce, *infanta* of Castile; Sancha, *infanta* of Castile
Bertha of Burgundy (d. 1016 or 1035), Queen of France [**Robert II**], 102
 see also Constance of Arles, Rozala of Italy
Bertha of Holland (d. 1093), Queen of France [**Philip I**], 103
Bertha (d. c. 612), Queen of Kent [Æthelbert], 11, 67

Bertrada (d. 783), Queen of the Franks [Pippin], 91–2
Bianchini, Jana, 165–6, 181
bigamy, 82, 103
Blanca of Anjou (d. 1310), Queen of the Crown of Aragon [**Jaume II**], 129, 168, 180
Blanca I of Navarre (d. 1441), Queen-regnant of Navarre, Queen of the Crown of Aragon [Martí I of Sicily, **Juan II, King of Aragon**], 190, 232
 see also Juana Enríquez
Blanca II of Navarre (d. 1464), Queen of Castile [**Enrique IV**], 183–6, 188, 233, 242
 see also Juana of Portugal
Blanche of Artois (d. 1302), Queen of Navarre [Enrique I, King of Navarre; Edmund of Lancaster], 158
Blanche of Bourbon (d. 1361), Queen of Castile [**Pedro I**], 225
 see also María de Padilla
Blanche of Burgundy (d. 1326), Queen of France [**Charles IV**], 159
 see also Marie of Luxembourg, Jeanne d'Evreux
Blanche of Castile (d. 1252), Queen of France [**Louis VIII**], 3, 10, 29, 60, 123, 125, 140, 154–7, 164, 176, 199
 see also Marguerite of Provence
Blanche d'Évreux (d. 1398), Queen of France [**Philip VI**], 160
 see also Jeanne of Burgundy
Boccaccio, Giovanni, 22
 see also On Famous Women (*De mulieribus claris*)
Bohemia, kingdom of, 13, 81, 173–6, 188, 207, 235, 237
Bohun, Mary de (d. 1394), first wife of **Henry IV** of England, 2, 210, 212
 see also Joan of Navarre
Book of Hours of Fernando I, 116
 see also Sancha, Queen of León
Book of the Queen, The, 197–8
 see also Christine de Pizan, Isabeau of Bavaria
Boudicca (d. c. 60), Queen of the Iceni, 64–5, 76
bride-show, 87, 93

Brown, Cynthia, 203
Brubaker, Leslie, 46, 51
Brunhild (d. c. 613), Queen of Austrasia and Burgundy [Sigibert I of Austrasia, Merovech], 10–11, 57–8, 61, 70
Byzantine Empire, 13, 15, 32, 39–54, 58, 72, 74, 80–1, 86–90, 126, 169–70, 191–2, 242
Byzantine ivory panel, 41–2
 see also Ariadne, Byzantine Empress

Capetian dynasty, 2, 60, 80, 85, 100–3, 126–9, 150–9, 188, 190, 249
Cartimandua (d. 69), Queen of the Brigantes, 64–5, 76
Carolingian Empire, 2, 21, 38, 80–1, 86, 91–8, 104–5, 120, 122, 151, 172
Castile, kingdom of, 13, 20, 115–17, 127, 160–7, 183–5, 187–90, 225–7, 232–4, 236, 239, 250, 254
 see also León-Castile
Catalina of Foix (d. 1517), Queen-regnant of Navarre [Juan III of Navarre], 190
Catalina of Lancaster (d. 1418), Queen of Castile [**Enrique III**], 190, 226–7, 229, 242
Caterina Cornaro (d. 1510), Queen-regnant of Cyprus [James II], 191
Catherine of Aragon (d. 1536), Queen of England [**Henry VIII**], 185, 223, 234, 251–2, 257
 see also Arthur, Prince of Wales; Isabel, Queen of Castile
Catherine de' Medicis (d. 1589), Queen of France [Henri II], 251, 256
Catherine of Valois (d. 1437), Queen of England [**Henry V**], 200, 211–12, 240, 250
 see also Owen Tudor
Charibert I (d. 567), King of the Franks [**Ingeborg**], 67
Charlemagne (d. 814), Holy Roman Emperor [**Hildegard, Fastrada, Himiltrude, Liutgard**], 10, 87, 91–3, 100
Charles the Bald (d. 877), King of

West Saxons and Holy Roman Emperor [**Ermentrude**, Richilde of Provence], 18, 91, 93–5, 97, 104
Charles I of Anjou (d. 1285), king of Sicily [**Beátrice of Provence**], 123–4
Charles IV (d. 1328), King of France [**Blanche of Burgundy, Marie of Luxembourg, Jeanne d'Evreux**], 150, 159–60, 188, 195
Charles V (d. 1380), King of France [Jeanne of Bourbon], 185, 192, 196
Charles VI (d. 1422), King of France [**Isabeau of Bavaria**], 189, 193–4, 196–7, 200, 211, 214
Charles VII (d. 1461), King of France [**Marie of Anjou**], 200–1
Charles VIII (d. 1498), King of France [**Anne of Brittany**], 201–2, 242
see also Anne of Beaujeau
Charles II (d. 1387), King of Navarre [Jeanne of France], 2, 195
see also Jeanne II, Queen of Navarre
Charles V (d. 1558), Holy Roman Emperor [**Isabel of Portugal**], 234, 236, 251–2, 254–5
Charlotte (d. 1487), Queen-regnant of Cyprus [João of Portugal, Louis of Savoy], 191
Charlotte of Savoy (d. 1483), Queen of France [**Louis XI**], 201
see also Anne of Beaujeau, Margaret of Scotland (d. 1445)
chastity, 8, 19, 39–40, 50, 60, 67–8, 74, 82–4, 94, 98, 113, 120, 130, 132–3, 178, 184, 210, 237
childless queen, 8, 48, 52, 67–8, 83–4, 92, 95–6, 101, 105, 113–14, 120, 130, 132, 135, 140, 173, 178, 180, 184, 190–1, 201, 209–10, 213, 220–1, 226, 233, 235, 237, 241, 243, 248, 252, 256
Chilperic I (d. 584), King of Neustria [Audovera, **Galsuintha, Fredegund**], 57–8, 70, 72
Clothar I (d. 561), King of the Franks [Guntheuc, **Radegund**, Ingund], 59, 74
Chrétien de Troyes, 21, 139, 180

Christine de Pizan, 22, 192–4, 197, 203, 226, 244, 251
The Book of the Queen, 198
see also Isabeau of Bavaria
Clémence of Hungary (d. 1328), Queen of France [**Louis X**], 128, 158
see also Margaret of Burgundy
Clotilde (d. 545), Queen of the Franks [**Clovis I**], 56–7
Clovis I (d. 511), King of the Franks [**Clotilde**], 53, 56–7
Clovis II (d. c. 657), King of the Franks [**Balthild**], 61–2
Cnut (d. 1035), King of England [**Ælfgifu of Northampton, Emma of Normandy**], 11, 104, 107–12, 114, 120
see also Encomium Emmae Regina; *Liber Vitae* of the New Minster
coinage, 43–5, 52, 78, 87, 89, 97, 104, 121, 134, 136
Comentarios a los Usatges de Barcelona, 231
see also María of Castile
concubine, 11, 16–8, 21, 34–5, 38, 54–5, 57–8, 69, 72, 75, 82, 85, 92–3, 118, 132
consanguinity, 82, 86, 95, 102, 117, 127, 132, 138–9, 141, 152, 163–4, 175, 178, 248
consort, *see* queen-consort
Constance of Aragon (d. 1222), Queen of Hungary [**Emeric**] and Holy Roman Empress [**Frederick II**], 174–5
Constance of Arles (d. 1034), Queen of France [**Robert II**], 102–3, 138
see also Bertha of Burgundy, Rozala of Italy
Constance of Burgundy (d. 1093), Queen of León-Castile [**Alfonso VI**], 161
Constance of Castile (d. 1160), Queen of France [**Louis VII**], 130, 152
see also Eleanor of Aquitaine, Adéle of Champagne
Constance of Hohenstaufen (d. 1302), Queen of the Crown of Aragon [**Pere III**], 167, 169
Constance of Hungary (d. 1240), Queen of Bohemia [Premysl Otakar], 175

Constance of Sicily (d. 1198), Queen-regnant of Sicily, Holy Roman Empress [**Henry VI**], 173
Constantine I (d. 337), Roman Emperor, 32, 40, 42–3, 56, 72
 see also Helena, saint and Roman Empress
Constantine V (d. 775), Byzantine Emperor [Maria, Eudokia], 87
Constantine VIII (d. 1028), Byzantine Emperor, 89
 see also Zoë, Theodora (d. 1056)
Constantine IX Monomachos (d. 1055), Byzantine Emperor [Helena Skleraina; **Empress Zoë**; Maria Skleraina, Guarandukht of Georgia], 89–90, 191–2
 see also Empress Theodora (d. 1056)
Cooper, Kate, 40
coronation
 of emperor or king, 18, 91, 119–20, 122, 136, 145, 148, 155–6, 159, 161, 163, 218, 222
 of empress or queen, 7, 10, 18–9, 21–2, 35, 45, 84, 87, 89, 91, 119–20, 122, 130, 134, 145, 148, 151, 155–6, 161, 178, 180, 187, 195, 211, 220, 222, 234, 239–40, 242, 245, 247, 249, 251
Crown of Aragon, 7–9, 11, 13, 19–20, 122, 125–7, 129, 167–9, 184, 186, 189–91, 195, 225, 227–34, 236, 240, 252, 254–5
Crusader kingdoms, 169–71, 174
 see also Jerusalem, kingdom of
Cunigunde of Luxembourg (d. 1040), Holy Roman Empress [**Henry II**], 83–4, 120
 see also Antependium of Basel Cathedral
Cutler, Anthony, 39
Cynethryth (d. after 798), Queen of Mercia [Offa], 104

D'Amico, Helen, 112
David II (d. 1371), King of Scotland [**Joan of England 'of the Tower'**, **Margaret Drummond**], 220–1
Denmark, kingdom of, 117–19, 188, 191, 237–8
depoina, 90
Dido, Queen of Carthage, 22–3
Dinis (d. 1325), King of Portugal [**Isabel of Aragon**], 130, 164, 167
divorce, 9, 16, 18, 48, 55, 58, 68, 82, 84, 94–6, 98, 102, 120–1, 131, 137–9, 152, 178, 219, 225, 237, 249, 257
Downie, Fiona, 12, 114, 224
Dowager, *see* queen-dowager
dower, 18, 77, 86, 102–3, 107, 141–2, 144, 146–8, 210–2, 217, 223, 243
dowry, 18, 26, 76, 85, 98–9, 130, 135, 147, 149, 152, 180, 187, 207, 216, 243
Dulce, *infanta* of Castile (d. after 1230), 127, 166
 see also Berenguela of Castile; Fernando III, King of Castile; Sancha, *infanta* of Castile
dynasty
 see individual dynasties Árpád, Capetian, Habsburg, Hohenstaufen, Komnenos, Merovingian, Palaiologos, Plantagenet, Saxon

Eadgifu (d. after 955), Queen of the West Franks [Charles III], 104
Ealhswith of Mercia (d. 905), Queen of England [**Alfred 'the Great'**], 105
Eanflæd (d. after 685), Anglo-Saxon Queen of Northumbria [Oswiu], 36
Eastern Roman Empire, *see* Byzantine Empire
Ecclesiastical History of the English People, *see* Bede
Edgar (d. 975), King of England [Æthelflaed, Wulthruth, **Ælfthryth**], 106–7
Edith of England (d. 946), Holy Roman Empress [**Otto I**], 99, 104
 see also Adelheid of Burgundy
Edith of Wessex (d. 1075), Queen of England [**Edward the Confessor**], 8, 83, 112–14, 121
 see also Vita Ædwardi regis

Index

Edward the Confessor (d. 1066), King of England [**Edith of Wessex**], 8, 83, 108, 110–4, 130, 210
 see also Vita Ædwardi regis
Edward I (d. 1307), King of England [**Eleanor of Castile, Margaret of France**], 14, 123, 125, 145–7, 158, 204, 212
 see also Eleanor of Provence
Edward II (d. 1327), King of England [**Isabelle of France**], 13, 125, 144, 147–50, 159, 204, 206, 214, 220
Edward III (d. 1377), King of England [**Philippa of Hainault**], 7, 11, 20, 125, 127, 143–4, 148–50, 159, 186–8, 195, 204–8, 214, 218
 see also Isabelle of France (d. 1358)
Edward IV (d. 1483), King of England [**Elizabeth Woodville**], 186, 203, 216–8, 223, 240
Eleanor of Aquitaine (d. 1204), Queen of France [**Louis VII**] and Queen of England [**Henry II**], 7, 29, 126–7, 130–1, 137–42, 152, 164, 176, 179, 182, 188, 214, 230
 see also Adéle of Champagne; Constance of Castile
Eleanor of Castile (d. 1290), Queen of England [**Edward I**], 14, 145–7, 158, 181, 203, 224
Eleanor of Provence (d. 1291), Queen of England [**Henry III**], 123–4, 143–5
Elionor of Sicily (d. 1375), Queen of the Crown of Aragon [**Pere IV**], 227
Elisabeth (d. c. 1067), Queen of Norway [Harald III], 117, 236
Elisabeth of Carinthia (d. 1312), Holy Roman Empress [**Albrecht I**], 174, 236
Elisabeth of Luxembourg (d. 1442), Queen of Hungary [**Albrecht II**], 235, 238
Elizabeth I Tudor (d. 1603), Queen-regnant of England, 2–3, 20, 219, 240, 251, 256
Elizabeth II (b. 1926), Queen-regnant of England [Philip of Edinburgh], 9
Elizabeth of Anjou (d. 1303), Queen of Hungary [**Ladislaus IV**], 174
Elizabeth de Burgh (d. 1327), Queen of Scotland [**Robert I Bruce**], 145, 219–20
 see also Isabella of Mar
Elizabeth de Mure (d. 1355), first wife of **Robert II**, King of Scotland, 221
 see also Euphemia Ross
Elizabeth of Habsburg (d. 1505), Queen of Poland-Lithuania [Casimir IV Jagiellon], 237
Elizabeth of Hungary (d. 1231), saint, 19, 131, 167, 172, 175, 184, 196
 see also Andrew II, King of Hungary
Elizabeth of York (d. 1503), Queen of England [**Henry VII**], 217–9, 240
 see also Margaret Beaufort
Elizabeth Woodville (d. 1492), Queen of England [**Edward IV**], 186, 216–9
Elvira Ramírez (d. after 982 or 986), Queen-regent of León, 117
 see also Ramiro III, King of León
Emeric (d. 1204), King of Hungary [**Constance of Aragon**], 174–5
Emma of Altdorf (d. 876), Holy Roman Empress [Louis 'the German'], 97–8
Emma of France (d. 934), Queen of West Franks [Rudolph], 99
Emma of Italy (d. after 987), Queen of the West Franks [**Lothar**], 79
Emma of Normandy (d. 1052), Queen of England [**Æthelred II, Cnut**], 104, 107–13, 120, 122
 see also Ælfgifu of Northampton; Ælfgifu of York; *Encomium Emmae Regina*; *Liber Vitae* of the New Minster
empress, 6, 21, 34, 36–7, 39, 66, 74–5, 78, 115, 180, 247–9, 253
 Byzantine, 13, 15, 32, 39–53, 55–7, 61–2, 73–4, 85, 87–90, 138, 163, 169–70, 191–2, 247
 Carolingian, 11, 91–3, 97–8, 128
 Habsburg, 255–6
 Holy Roman, 3, 27, 131, 133–4, 136, 139, 142, 144, 165, 172–7, 226, 235–6, 242
 Ottonian, 18, 79, 98–101, 122, 128

Encomium Emmae Regina, 109–10, 112, 122
 see also Emma of Normandy; Cnut, King of England
Engelberga (d. after 896), Holy Roman Empress [**Louis II**], 4, 97
England
 Anglo-Norman, 107, 131, 133, 177
 Anglo-Saxon, 17, 33, 35–6, 61, 66–70
 Lancastrian, 10, 189, 210–17
 Plantagenet, 136–50, 203–10
 Roman, 64–6
 Tudor, 218–9, 251–2, 256
 York, 217–8
Enright, Michael, 86
Enrique II (d. 1379), King of Castile [Juana Manuel], 225–6
Enrique III (d. 1406), King of Castile [**Catalina of Lancaster**], 190
Enrique IV (d. 1474), King of Castile [**Blanca II of Navarre, Juana of Portugal**], 183–4, 188, 233–4
 see also Isabel of Castile
Erler, Mary, 5
Ermentrude (d. 869), Holy Roman Empress [**Charles the Bald**], 91, 104
Eudoxia (d. 404), Roman Empress [Arcadius], 44–5
Eudoxia (d. 460), Byzantine Empress [**Theodosius II**], 46
Eudoxia Makrembolitissa (d. after 1078), Byzantine Empress [Constantine X Doukas, Romanos IV Diogenes], 90
Euphemia (d. c. 524), Byzantine Empress [Justin], 48
Euphemia (d. 1312), Queen of Norway [Håkon V], 176
Euphemia Ross (d. 1386), Queen of Scotland [**Robert II**], 221, 224
 see also Elizabeth Mure
Euphrosyne (d. after 836), Byzantine Empress [Michael II], 88
Euphrosyne Doukaina Kamatera (d. 1211), Byzantine Empress [Alexios III Angelos], 170

Facinger, Marion, 5, 101, 129, 151–3
fama, 17, 22
 see also reputation
Fastrada (d. 794), wife of **Charlemagne**, 10, 92

femininity, 7, 12, 14, 22, 24, 39, 44, 56, 62, 66, 68, 149–50, 165, 194, 199, 206, 234
Fenenna of Kuyavia (d. 1295), Queen of Hungary [**Andrew III**], 174
 see also Agnes of Habsburg
Fernando I (d. 1416), King of the Crown of Aragon [**Leonor of Albuquerque**], 189, 227
Fernando II (d. 1516), King of the Crown of Aragon [**Isabel of Castile**], 190–1, 234, 250, 252, 254
Fernando I (d. 1065), King of Castile [**Sancha of León**], 116
Fernando III (d. 1252), King of Castile [Beatrice of Swabia, **Jeanne de Dammartin**], 3, 19, 127, 130, 145, 165–6, 230, 236, 239–40
 see also Berenguela of Castile, Dulce, *infanta* of Castile; Sancha, *infanta* of Castile
Fernando IV (d. 1312), King of Castile [Constance of Portugal], 167
Fernão I (d. 1383), King of Portugal [Leonor Teles], 226
finances of the queen
 see dower, dowry, household accounts, *infantazgo*, Queen's Gold, *Terras da Rainha*
Flaccilla (d. c. 385), Roman Empress [**Theodosius I**], 44–5
Fradenburg, Louise Olga, 5, 153
France
 Capetian, 2, 60, 80, 85, 100–3, 117, 126–9, 150–60, 177, 188, 190, 249
 Frankish, 17, 21, 38, 53–63, 67, 70, 72–3, 79–80, 84, 91–3, 95, 98, 101, 104–5, 121
 Valois, 2, 101, 155, 159–60, 188, 190, 195–203, 211, 235, 242
Frank, Roberta, 112
Fredegund (d. 597), Queen of Neustria [Chilperic I], 58–9, 72, 75
 see also Galsuintha
Frederick I Barbarossa (d. 1190), Holy Roman Emperor [**Adelheid of Vohburg, Beatrice of Burgundy**], 164, 173, 178
Frederick II (d. 1250), Holy Roman Emperor [**Constance of Aragon**], 173, 175

Frederick III (d. 1493), Holy Roman Emperor [**Leonor of Portugal**], 226, 236, 252

Galsuintha (d. 568), Queen of Neustria [**Chilperic I**], 58, 72
see also Fredegund
Geaman, Kristen, 147, 177, 182
Geoffrey Plantegenet (d. 1151), Duke of Anjou [**Empress Matilda**], 133, 135–6
see also Henry II, King of England; Eleanor of Aquitaine
Germany
 Carolingian, 2, 21, 38, 80–1, 86, 91–8, 104–5, 120, 122, 128, 151, 172
 Habsburg, 128, 172–4, 235–7, 242, 249, 252–3, 255–6
 Ottonian, 2, 79–80, 85, 98–100, 104, 117, 122, 128, 172
 Saxon, 98–100
Gerberga (d. 984), Queen of the Franks [Louis IV], 98
Gertrude of Hohenberg (d. 1281), Queen of Germany [**Rudolf I**], 173
Gertrude of Meran (d. 1213), Queen of Hungary [**Andrew II**], 172, 175
Gibbons, Rachel, 196
gifts, gift exchange, 23, 37–9, 59, 74, 86, 96, 98, 109, 113, 128, 132, 145, 148–9, 157, 175, 180–1, 199, 208, 218, 243–4
Giovanna I (d. 1382), Queen-regnant of Naples [Andrew of Calabria, Louis of Taranto, Jaume IV of Mallorca, Otto of Brunswick], 20, 190
Giovanna II (d. 1435), Queen-regnant of Naples [Williams of Austria, James II of Bourbon], 8, 20, 190
Goldberg, Eric, 98
Goldy, Charlottte Newman, 174
Gold solidus of Empress Irene, 87–8
see Irene of Athens
Gosuintha (d. 598), Visigothic Queen of Spain [Athanagild, Leovigild], 70, 72
Grandes Chroniques de France, Les, 155–6
see also Blanche of Castile; Louis VIII of France

Gregory of Tours, 37, 53, 55–6, 58–60, 72, 76, 119
Guenevere, legendary Queen of Britain [**Arthur**], 138
Gunnhildr (d. c. 980), Queen of Norway [Eric Bloodaxe], 118–9

Habsburg dynasty, 128, 172–4, 176, 201, 235–7, 242, 249, 252–3, 255–6
Harrison, Dick, 38
Hedwig of Saxony (d. 965), wife of Hugh the Great, count of Paris, 98
Helena (d. c. 330), saint, Roman Empress [Constantius], 42–7, 52, 55–7, 73–4, 247
Henri I (d. 1060), King of France [Matilda of Franconia, Matilda of Frisia, **Anna of Kiev**], 14, 102–3, 117
Henry II (d. 1024), Holy Roman Emperor [**Cunigunde of Luxembourg**], 8, 83–4
see also Antependium of Basel Cathedral
Henry V (d. 1125), Holy Roman Emperor [**Empress Matilda**], 133–5, 172
Henry VI (d. 1197), Holy Roman Emperor [**Constance of Sicily**], 173
Henry I (d. 1135), King of England [**Matilda of Scotland, Adeliza of Louvain**], 3, 27, 115, 128, 132–6
Henry II (d. 1189), King of England [**Eleanor of Aquitaine**], 3, 104, 127, 133–4, 136–7, 139–42, 145–6, 164, 188, 230
see also Empress Matilda (d. 1167); Geoffrey of Anjou
Henry III (d. 1272), King of England [**Eleanor of Provence**], 123–5, 142–6, 157, 188
Henry IV (d. 1413), King of England [**Mary de Bohun, Joan of Navarre**], 1–2, 189, 210–13, 222
Henry V (d. 1422), King of England [**Catherine of Valois**], 159, 200, 210–11, 213
Henry VI (d. 1471), King of England [**Margaret of Anjou**], 10, 189, 194, 201, 211–16, 245
see also *The Shrewsbury Book*

Henry VII (d. 1509), King of England [**Elizabeth of York**], 202, 217–8, 240, 256
 see also Margaret Beaufort
Henry VIII (d. 1547), King of England [**Catherine of Aragon**], 219, 224, 234, 240, 251, 256–7
Henry of Burgundy (d. 1112), Count of Portugal [**Teresa of León**], 161, 163
 see also Alfonso VI, King of León-Castile; Urraca, Queen-regnant of León-Castile
Hicks, Carola, 114
Hill, Barbara, 87
Hildegard (d. 783), wife of **Charlemagne**, 92
Himiltrude (d. c. 780), concubine of **Charlemagne**, 92
Hincmar, archbishop of Reims, 84, 86, 95–6, 119
Historia Pontificalis, see John of Salisbury
History of the Frankish People, see Gregory of Tours
History of the Wars, see Procopius
Hohenstaufen dynasty, 2, 124, 126, 167, 169, 172–3
Holum, Kenneth, 43, 45
household, 2, 11, 23, 34, 37, 39, 43, 59, 64, 74, 85, 96, 98, 113–14, 120, 129, 134, 153–4, 156, 167, 205, 207, 210, 217, 224, 229, 241, 244, 250
household accounts, 2, 18, 23, 39, 76, 85, 124, 142, 145–6, 156, 178, 181, 186–7, 203, 224, 241, 243–5
 see also finances of the queen
Houts, Elisabeth van, 109
Hugh Capet (d. 996), King of France [**Adelaide**], 79, 98, 101
Hundred Years' War, 20, 126–7, 159, 188, 190, 195, 201–2, 204, 207, 214, 225
Hungary, kingdom of, 13, 81, 114, 117, 126, 172–6, 235–7, 240
Hunneycutt, Lois, 5

Igor of Kiev (d. 945), King of Kievan Rus' [**Olga of Kiev**], 117
infantazgo, 165–6
 see also finances of the queen
infertility, see childless queen

Ingeborg (d. 589), Queen of the Franks [**Charibert**], 11, 67
Ingeborg of Denmark (d. 1236), Queen of France [**Philip II Augustus**], 11, 152–3, 175
 see also Agnes of Meran; Isabelle of Hainault
inheritance
 of a realm 3, 6, 9–10, 13, 18–20, 26–7, 32–4, 36, 46, 66, 69, 85–6, 89, 94–5, 102, 106, 110, 120, 126–7, 129–31, 134, 136, 141–2, 144, 150–1, 155, 158–61, 163–5, 170–2, 174, 177–8, 183, 187–8, 190–2, 200, 219, 221–2, 232–3, 235–7, 239–40, 249–51, 254
 of personal lands, property and lordship, 18–19, 26–7, 53, 85–6, 99, 126, 131, 137, 141–2, 157, 179, 201, 203, 212, 236, 240, 244
intercession, 6–7, 11–12, 27, 37, 55–6, 81, 86, 92, 98–9, 122, 125–6, 133, 135, 147, 149–51, 153, 168–9, 173, 177, 181, 185, 194–5, 197, 199, 204–6, 208, 212, 222, 240, 242, 248, 251
 see also Shrewsbury charter
Ireland, 9, 13, 36, 64–5, 68–70, 76, 104, 114, 122, 142–3, 146, 177–8, 218, 249–50
Irene of Athens (d. 803), Byzantine Empress [**Leo IV**], 87–8
 see also Gold solidus of Empress Irene
Irene Doukaina (d. c. 1123–33), Byzantine Empress [**Alexios I**], 169–70
Irmengard (d. 818), Holy Roman Empress [**Louis I the Pious**], 93
 see also Judith of Bavaria
Isabeau of Bavaria (d. 1435), Queen of France [**Charles VI**], 189, 193–4, 196–201, 205, 211, 214–5, 240, 242, 244–5, 248, 250–1
 see also *The Book of the Queen;* Christine de Pizan
Isabel of Aragon (d. 1271), Queen of France [**Philip III**], 158, 176
 see also Marie de Brabant

Isabel of Aragon (d. 1330), Queen of Germany [**Frederick the Fair**], 174
Isabel of Aragon (d. 1336), saint, Queen of Portugal [**Dinis**], 19, 130, 167, 184
Isabel of Castile (d. 1504), Queen of Castile [**Fernando II of Aragon**], 2–3, 14, 19–20, 161, 179, 185, 189, 191, 233–4, 236, 239–41, 248, 250, 252–4
see also La Virgen de los Reyes Católicos
Isabel of Coimbra (d. 1455), Queen of Portugal [**Afonso V**], 227
Isabel of Portugal (d. 1496), Queen of Castile [**Juan II**], 233
see also Isabel of Castile
Isabel of Portugal (d. 1539), Holy Roman Empress [**Charles V**], 251, 254
Isabella of Gloucester (d. 1217), first wife of King **John** of England, 141
see also Isabelle of Angoulme
Isabella of Jerusalem (d. 1205), Queen-regnant of Jerusalem [Humphrey IV of Toron, Conrad of Montferrat, Henry II of Champagne, Amalric I of Cyprus], 171
Isabella of Mar (d. 1296), first wife of **Robert I Bruce**, King of Scotland, 219, 221
see also Elizabeth de Burgh
Isabelle of Angoulême (d. 1246), Queen of England [**John**], 141–2, 144, 146, 212
see also Isabella of Gloucester
Isabelle of France (d. 1358), Queen of England [**Edward II**, Roger Mortimer], 3, 20, 125, 127, 147–50, 159, 187–8, 204, 206, 214, 220
see also Edward III, King of England
Isabelle of France (d. 1409), Queen of England [**Richard II**], 210
see also Anne of Bohemia
Isabelle of Hainault (d. 1190), Queen of France [**Philip II Augustus**], 152, 154
see also Agnes of Meran, Ingeborg of Denmark

Italy, kingdoms, *see* Lombardy; Ostrogoth

Jadwiga (d. 1399), Queen-regnant of Poland [Wladyslaw Jagiello of Lithuania], 20, 184, 191, 237, 239
James I (d. 1437), King of Scotland [Joan Beaufort], 201, 222
James II (d. 1460), King of Scotland [**Mary of Guelders**], 222
James III (d. 1488), King of Scotland [**Margaret of Denmark**], 223
James IV (d. 1513), King of Scotland [**Margaret Tudor**], 223
Jäschke, Kurt-Ulrich, 172
Jaume I (d. 1276), King of the Crown of Aragon [**Leonor of Castile, Violant of Hungary**, Teresa Gil de Vidaure], 125, 158, 169, 175
Jaume II (d. 1327), King of the Crown of Aragon [Isabel of Castile, **Blanca of Anjou**, Marie of Lusignan, Elisenda of Montcada], 129, 168, 180
Jaume III (d. 1349), King of Mallorca [**Violant of Vilaragut**], 228
Jeanne of Bourbon (d. 1378), Queen of France [**Charles V**], 196
Jeanne of Burgundy (d. 1348), Queen of France [**Philip VI**], 196
see also Blanche d'Évreux
Jeanne of Champagne (d. 1305), Queen-regnant of Navarre and Queen of France [**Philip IV**], 148, 158
Jeanne de Dammartin (d. 1279), Queen of Castile [**Fernando III**], 145
Jeanne d'Evreux (d. 1371), Queen of France [**Charles IV**], 159–60, 195
see also Blanche of Burgundy; Marie of Luxembourg
Jeanne II (d. 1349), Queen-regnant of Navarre [Philip III of Navarre], 158–60, 186, 195
Jerusalem, kingdom of, 3, 127, 170–2, 177, 190, 250
Jimena González (d. c. late tenth century), Queen-dowager and regent of Navarre, 117
Joan Beaufort (d. 1445), Queen of Scotland [**James I**], 201, 222–4

Joan of England (d. 1238), Queen of Scotland [**Alexander II**], 142, 144
see also Marie de Coucy
Joan of England, 'of the Tower' (d. 1362), Queen of Scotland [**David II**], 149, 220
see also Margaret Drummond
Joan of Navarre, (d. 1437), Queen of England [**Henry IV**], 2, 210–12
see also Mary de Bohun
Joan I (d. 1396), King of the Crown of Aragon [Martha of Armagnac, **Violant de Bar**], 227–8
João I (d. 1433), King of Portugal [**Philippa of Lancaster**], 190, 226–7
João II (d. 1495), King of Portugal [**Leonor of Viseu**], 226–7
John (d. 1216), King of England [**Isabella of Gloucester, Isabelle of Angoulême**], 7, 124, 126, 137, 139–44, 178, 212
John of Salisbury, 27, 131, 136, 181, 192–3
Jong, Makye de, 93
Juan I (d. 1390), King of Castile [Leonor of Aragon, **Beatriz of Portugal**], 189, 226
Juan II (d. 1454), King of Castile [**Maria of Aragon, Isabel of Portugal**], 227, 229, 232–3
Juan II (d. 1479), King of the Crown of Aragon [**Blanca of Navarre, Juana Enríquez**], 184, 190, 232
Juana Enríquez (d. 1468), Queen of the Crown of Aragon [**Juan II**], 232, 254
see also Blanca I of Navarre
Juana I (d. 1555), Queen of Castile [Philip IV, archduke of Burgundy], 234, 236, 252
see also Isabel of Castile
Juana of Portugal (d. 1475), Queen of Castile [**Enrique IV**], 184, 233
see also Blanca II of Navarre
Judith of Bavaria (d. 843), Holy Roman Empress [**Louis I the Pious**], 11, 84, 93–4
see also Irmengard
Judith of Flanders (d. 870), Anglo-Saxon Queen [Æthelwulf of Wessex, Æthelbald of Wessex, Baldwin I of Flanders], 104–6, 128

Judith of Habsburg (d. 1297), Queen of Bohemia [Václav II], 173
Judith of Swabia (d. c. 1105), Queen of Hungary [**Solomon**, Wladyslaw of Poland], 117
Justinian I (d. 565), Byzantine Emperor [**Theodora**], 47–52, 73

Kalmar Union, 238
Kievan Rus', 81, 117, 122
Klaniczay, Gábor, 172
Komnenos dynasty, 126, 169–70
Kowaleski, Maryanne, 5

Ladislaus IV (d. 1290), King of Hungary [**Elizabeth of Anjou**], 174
Later Life of Mathilda, 98
see Mathilda of Ringelheim
Layher, William, 176, 179
Laynesmith, Joanna, 213–14
Lehfeldt, Elizabeth, 234
Leo III (d. 741), Byzantine Emperor [Maria], 46, 87
Leo IV (d. 780), Byzantine Emperor [**Irene of Athens**], 87
León, kingdom of, 3, 10, 115–17, 127, 160–64, 177
León-Castile, kingdom of, 3, 164–6, 176, 178
Leonor of Albuquerque (d. 1435), Queen of the Crown of Aragon [**Fernando I**], 227, 229, 232–3, 242
Leonor of Castile (d. 1244), Queen of the Crown of Aragon [**Jaume I**], 125
Leonor of England (d. 1214), Queen of Castile [**Alfonso VIII**], 125, 154
Leonor de Guzmán (d. 1351), mistress of King **Alfonso XI** of Castile, 189, 225
see also María of Portugal
Leonor of Portugal (d. 1348), Queen of the Crown of Aragon [**Pere IV**], 186
Leonor of Portugal (d. 1467), Holy Roman Empress [**Frederick III**], 226, 236
Leonor Teles (d. 1386), Queen of Portugal [**Fernão I**], 226
Leonor of Viseu (d. 1525), Queen of Portugal [**João II**], 226–7

Lessons for My Daughter, 203, 242
 see also Anne of Beaujeau [Anne of France]
Liber Vitae of the New Minster, 110–11
 see also Emma of Normandy; Cnut, King of England
lieutenant, see queen-lieutenant
Liutgard (d. 800), wife of **Charlemagne**, 92
Livingstone, Amy, 174
Lombardy, 11, 33, 57, 72–3, 77
Lothar (d. 986), King of West Franks [**Emma of Italy**], 79, 99
Lothar I (d. 855), Holy Roman Emperor [Ermengarde of Tours], 4, 93–4
Lothar II (d. 869), King of Lotharingia [**Theutberga, Waldrada**], 84, 94–6, 120
Lothar Crystal, 96
 see also Lothar II, King of Lotharingia; Theutberga
Louis I the Pious, (d. 840), Holy Roman Emperor [**Irmengard, Judith of Bavaria**], 11, 84, 93–4, 120
Louis II (d. 875), Holy Roman Emperor [**Engelberga**], 4, 97
Louis VI (d. 1137), King of France [Lucienne de Rochfort, **Adélaide of Maurienne**], 103, 151
Louis VII (d. 1180), King of France [**Eleanor of Aquitaine, Constance of Castile,** Adéle of Champagne], 126, 130, 137–40, 151–2
Louis VIII (d. 1226), King of France [**Blanche of Castile**], 10, 125, 140, 142, 152, 154–6, 164, 199
Louis IX (d. 1270), King of France [**Marguerite of Provence**], 3, 10, 19, 60, 123–4, 130, 143, 154–5, 157–8, 188
 see also Blanche of Castile
Louis X (d. 1316), King of France [**Margaret of Burgundy, Clémence of Hungary**], 128, 158–60, 186
Louis XI (d. 1483), King of France [**Margaret of Scotland, Charlotte of Savoy**], 201, 215–6

Louis XII (d. 1515), King of France [Jeanne de Valois, **Anne of Brittany,** Mary Tudor], 202–3
 see also Anne of Beaujeau
Louis II (d. 1526), King of Hungary [**Mary of Habsburg**], 176
Louise of Savoy (d. 1531), regent of France [Charles of Orléans], 11, 251

Margaret I of Denmark (d. 1412), Queen-regnant of Denmark, Norway, and Sweden [Håkon VI], 10, 20, 189, 191, 237–8
Margaret, Maid of Norway (d. 1290), Queen-presumptive of Scotland, 144–5
Margaret (d. 1093), saint, Queen of Scotland [Malcolm III], 114–15, 133
Margaret of Anjou (d. 1482), Queen of England [**Henry VI**], 10, 186, 189, 194, 201, 212–17, 223, 240, 245
 see also *The Shrewsbury Book*
Margaret Beaufort (d. 1509), countess of Richmond and Derby, 217–18
 see also Henry VII, King of England; Elizabeth of York
Margaret of Burgundy (d. 1315), Queen of France [**Louix X**], 158
 see also Clémence of Hungary
Margaret of Denmark (d. 1486), Queen of Scotland [**James III**], 223
Margaret Drummond (d. 1375), Queen of Scotland [**David II**], 220–1, 224
 see also Joan of England 'of the Tower'
Margaret of England (d. 1275), Queen of Scotland [**Alexander III**], 124, 132, 143–4
 see also Yolande de Dreux
Margaret of France (d. 1318), Queen of England [**Edward I**], 125, 147–8, 158, 204, 212, 221
 see also Eleanor of Castile
Margaret of Scotland (d. 1283), Queen of Norway [Erik II], 144
Margaret of Scotland (d. 1445), Dauphine of France [**Louis XI**], 201

Margaret of Scotland
 see also Anne of Beaujeau; Charlotte of Savoy
Margaret Tudor (d. 1541), Queen of Scotland [**James IV**, Archibald Douglas, Henry Stewart], 219, 223
Margarethe II, Queen of Denmark (b. 1940), 9
Marguerite of Provence (d. 1295), Queen of France [**Louis IX**], 123–4, 128, 143, 155–8
 see also Blanche of Castile
Maria of Alania, (d. 1118), Byzantine Empress [Michael VII Doukas, Nikephoros III Botaneiates], 169–70
Maria of Antioch (d. c. 1182), Byzantine Empress [Manuel I Komnenos], 170
Maria of Aragon (d. 1445), Queen of Castile [**Juan II**], 232–3
María of Castile (d. 1458), Queen of the Crown of Aragon [**Alfonso V**], 9, 229–33, 241–2, 254
Maria of Hungary (d. 1395), Queen-regnant of Hungary [**Sigismund**], 20, 191, 237
Maria Komnene (d. 1190), Queen of Hungary [**Stephen IV**], 174
Maria Laskarina (d. 1270), Queen of Hungary [**Béla IV**], 174
Maria de Luna (d. 1406), Queen of the Crown of Aragon [**Martí I**], 227–8
María de Molina (d. 1321), Queen of Castile [**Sancho IV**], 167
María de Padilla (d. 1361), Queen of Castile [**Pedro I**], 225–6
 see also Blanche of Bourbon
María of Portugal (d. 1357), Queen of Castile [**Alfonso XI**], 189, 225
 see also Leonor de Guzmán
Maria of Sicily (d. 1401), Queen of Sicily [Martí I], 191
Marie of Anjou (d. 1463), Queen of France [**Charles VII**], 201
Marie Antoinette (d. 1793), Queen of France [Louis XVI], 2
Marie de Brabant (d. 1321), Queen of France [**Philip III**], 147, 158
 see also Isabel of Aragon (d. 1271)
Marie de Coucy (d. 1285), Queen of Scotland [**Alexander II**], 144
 see also Joan of England (d. 1238)
Marie of Luxembourg (d. 1324), Queen of France [**Charles IV**], 159
 see also Blanche of Burgundy; Jeanne d'Evreux
Marie de' Medidci (d. 1642), Queen of France [Henri IV], 251, 256
Marie of Montferrat (d. 1212), Queen-regnant of Jerusalem [Jean de Brienne], 171
marriage, aspects of queenship, 6, 8, 14–16, 18–19, 25, 27, 29, 34–7, 40, 42, 48, 55, 66, 73–5, 79–82, 84–6, 94–6, 101, 103, 107–12, 117, 120–1, 123, 126–30, 134, 150–1, 153, 167, 172–8, 180–1, 184–5, 187, 194, 219, 235, 239–40, 242–3, 247–9
 see also bigamy; consanguinity
Martí I (d. 1410), King of the Crown of Aragon [**Maria de Luna**, Margarita de Prades], 191, 228
Mary de Bohun (d. 1394), first wife of **Henry IV**, king of England, 2, 210, 212
 see also Joan of Navarre
Mary of Burgundy (d. 1482), Duchess of Burgundy [**Maximilian I**], 236, 252
Mary of Guelders (d. 1463), Queen of Scotland [**James II**], 222–4, 239
Mary of Habsburg (d. 1558), Queen of Hungary and Bohemia [**Louis II**], 176
Mary of Hungary (d. 1395), Queen-regnant of Hungary [**Sigismund**], 235
 see also Barbara of Celje
Mary Stuart (d. 1587), Queen-regnant of Scotland [François II of France, Henry Stuart, James Hepburn], 20, 251, 256
Mary Tudor (d. 1558), Queen-regnant of England [Philip II of Spain], 20, 240, 251–2, 256
Mathilda of Ringelheim (d. 968), saint, Holy Roman Empress [Henry I], 98–9, 122
Matilda (d. 1167), Holy Roman Empress [**Henry V**], Duchess of Anjou [**Geoffrey Plantagenet**], queen presumptive of England, 3, 27, 131, 133–7, 139, 144, 165, 172, 176–7, 250

see also Henry II, King of England; Matilda of Boulogne; Stephen of Blois
Matilda of Boulogne (d. 1152), Queen of England [**Stephen of Blois**], 10
see also Empress Matilda (d. 1167)
Matilda of Flanders (d. 1083), Queen of England [**William of Normandy**], 10, 131
Matilda of Scotland (d. 1118), Queen of England [**Henry I**], 115, 122, 128, 131–2, 134, 203
see also Adeliza of Louvain
Matthias Corvinus (d. 1490), King of Hungary [Catherine of Poděbrady, **Beatriz of Naples**], 237
Maurer, Helen, 215
Maximilian I (d. 1519), Holy Roman Emperor [**Mary of Burgundy, Anne of Brittany**, Bianca Maria Sforza], 226, 236, 252, 255
McClanan, Anne, 48
McCleery, Iona, 17
McCracken, Peggy, 138
McNamara, Jo Ann, 5, 25, 36, 68
McVaugh, Michael, 180
Medb, legendary Irish queen, 65
Melisende (d. 1161), Queen-regnant of Jerusalem [Fulk of Anjou], 3, 127–8, 171
Merovingian dynasty, 17, 21, 38, 53–63, 67, 70, 72–3
Morte d'Arthur, Le, 21
motherhood, as an aspect of queenship, 7–8, 25, 27, 37, 74, 113, 130, 134, 137, 139, 143, 151, 155, 173, 204, 239, 247–8
Myers, A. R., 210
Muslim Spain, 80–1, 115, 117

Navarre, kingdom of, 13, 28, 115, 117, 140, 148, 158–60, 183–4, 190, 225, 232
Nelson, Janet, 61
Nibelungenlied, 21, 59
Nomisma histamenon of Empresses Zoë and Theodora, 90
Norway, kingdom of, 117–19, 188

Odegaard, Charles, 4
Olga of Kiev (d. 969), saint, Queen of Kievan Rus' [**Igor of Kiev**], 117

On Famous Women (*De mulieribus claris*), 22
see Boccaccio, Giovanni
Ormrod, Mark, 24, 194, 206
Osthryth (d. 697), Queen of the Mercians [Æthelred of Mercia], 74
Ostrogoths, 17, 33, 72
Otto I (d. 973), Holy Roman Emperor [**Edith of England, Adelheid of Burgundy**], 79, 98–9, 104, 117
Otto II (d. 983), Holy Roman Emperor [**Theophanu**], 18, 79, 100

Palaiologos dynasty, 126
Parsons, John Carmi, 5, 7, 11, 146, 181, 205
partners in monarchy, queens as, 6–7, 12, 15, 17, 44, 48, 73, 81–2, 97, 99, 101, 120, 129, 153, 175, 177, 219, 222–3, 229–31, 249, 254–5, 257
patronage, queen's, 26, 32, 46, 55, 79, 86, 91, 98–9, 116, 125, 157, 181, 186, 195, 212, 218, 237, 242, 244, 251, 253
 of architecture, 21, 81, 206, 253, 255
 of art, 2, 4, 21, 23, 81, 152, 226, 236, 253, 255
 ecclesiastical, 2, 6, 27, 36, 41, 62, 71, 110, 124, 133, 143–4, 147, 151, 157, 166
 of literature, 4, 133–4, 152, 173, 176, 190, 203, 209, 226, 241, 245, 250, 255
 see also gift
Pedro I (d. 1369), King of Castile [**María de Padilla, Blanche of Bourbon**, Juana de Castro], 186, 189, 225–6
Pere III (d. 1285), King of the Crown of Aragon [**Constance of Hohenstaufen**], 167, 169
Pere IV (d. 1387), King of the Crown of Aragon [María of Navarre, **Leonor of Portugal, Elionor of Sicily**, Sibilla de Fortià], 186, 227
Petronilla (d. 1173), Queen of Aragon [Ramon Berenguer IV], 127
Philip I (d. 1108), King of France [**Bertha of Holland**, Bertrade of Montfort], 103, 150

Philip II Augustus (d. 1223), King of France [**Isabelle of Hainault, Ingeborg of Denmark, Agnes of Meran**], 11, 124, 126, 140, 142, 151–5, 175, 178

Philip III (d. 1285), King of France [**Isabel of Aragon, Marie de Brabant**], 147, 158, 176

Philip IV (d. 1314), King of France [**Jeanne of Champagne**], 3, 20, 127, 148, 151, 158–9, 188, 195, 214

Philip V (d. 1322), King of France [Jeanne of Burgundy], 159

Philip VI (d. 1350), King of France [**Jeanne of Burgundy, Blanche d'Évreux**], 160, 188, 195–6

Philippa of Hainault (d. 1369), Queen of England [**Edward III**], 7, 11, 125, 149, 240, 248
 see also Isabelle of France (d. 1358)

Philippa of Lancaster (d. 1415), Queen of Portugal [João I], 190, 204–8, 226

Pichore, Jean, 'Des remedes contre l'une et l'autre fortune', 202–3
 see also Anne of Brittany

piety, as an attribute of queenship, 8, 23, 27, 37, 40, 42–5, 56, 60, 72, 74, 83, 86, 120, 130, 172, 181, 184–5, 194, 237, 248–9, 253

Plantagenet dynasty, 2, 125–6, 134–50, 203–10

Poland, 20, 81, 117, 174, 184, 191, 235, 237, 239

porphyrogenitus, porphyrogenita, 87–9

Portugal, kingdom of, 13, 28, 125, 130, 160–3, 167, 189–90, 225–7, 244

Poulet, André, 155

primogeniture, 9, 19, 26, 40, 85, 126, 129–30, 135, 166, 221

Procopius, 37, 47–52

Protector, 187, 214–5, 217, 239
 see also queen-regent; regent

Protor-Tiffany, Mariah, 128

Pulcheria (d. 453), Byzantine Empress [Marcian], 45–6

queen-consort, definition, 6, 8, 14, 17

queen-dowager, definition, 6, 11, 14

queen-lieutenant, definition, 6, 9–11, 14, 26

queen-regent, definition, 6, 10, 14, 21, 24–6
 see also Protector, regent

queen-regnant, definition, 6, 14, 20

queen's gold, 146–7, 166
 see also finances of the queen

Radegund (d. after 586), Queen of the Franks [**Chlothar I**], 59–62, 67, 74, 77, 98–9
 see also Baudonivia; Venantius Fortunatus

Ramiro III (d. 984), King of León [Sancha Gómez], 117
 see also Elvira Ramírez

Reciberga (d. *c.* 649), Visigothic Queen of Spain [Khindaswinth], 71–2

Regent, *see* Protector; queen-regent

Remensnyder, Amy, 24

reputation, 17, 37, 82
 see also fama

Richard I (d. 1199), King of England [**Berengaria of Navarre**], 7, 137, 139–41

Richard II (d. 1400), King of England [**Anne of Bohemia, Isabelle of France**], 1, 11, 160, 189, 194, 207–10, 212–13
 see also Shrewsbury Charter

Richard III (d. 1485), King of England [**Anne Neville**], 202, 207, 214–15, 217–18, 240

Richard of Cornwall (d. 1272), King of the Romans [Isabel Marshal, **Sancia of Provence**, Beatrice of Falkenburg], 123–4, 142

Robert II (d. 1031), King of France [**Rozala of Italy, Bertha of Burgundy, Constance of Arles**], 101–2, 131

Robert I Bruce (d. 1329), King of Scotland [**Isabella of Mar, Elizabeth de Burgh**], 145, 149, 219–21, 223

Robert II (d. 1390), King of Scotland [**Elizabeth Mure, Euphemia Ross**], 221

Robert III (d. 1406), King of Scotland [**Anabella Drummond**], 221–2

Rozala of Italy (d. 1003), Queen of France [**Robert the Pious**], 101
 see also Bertha of Burgundy; Constance of Arles

Rudolf I (d. 1291), King of Germany [**Gertrude of Hohenberg**, Isabelle of Burgundy], 173
Ruiz, Teofilo, 184

Saga literature, 109, 118–19, 122
Salic Law, 151, 160, 181, 190, 195, 222, 244, 250
Sancha, *infanta* of Castile (d. after 1230), 127, 166
 see also Berenguela of Castile; Fernando III, King of Castile; Dulce, *infanta* of Castile
Sancha (d. 1067), Queen of León [**Fernando I of Castile**], 115–16
 see also Book of Hours of Fernando I
Sancha of Castile (d. 1208), Queen of the Crown of Aragon [**Alfonso II**], 175
Sánchez, Magdalena, 253, 256
Sancho IV (d. 1295), King of Castile [**María de Molina**], 166–7
Sancia of Mallorca (d. 1345), Queen of Naples [Robert], 130–1
Sancia of Provence (d. 1261), Queen of the Romans [**Richard of Cornwall**], 123–4, 144
sanctity, as an attribute of queenship, 36–7, 54, 56, 59–62, 68, 74, 82, 99, 122, 130, 151, 247
Saxon dynasty, 81, 83, 98–9, 171, 173
Scandinavia, 176, 188
 see also Denmark; Norway; Sweden
Schuleberg, Jane Tibbets, 17
Scotland, 12, 13, 103, 114–15, 132–3, 144–5, 149, 177, 201, 219–24, 239, 249, 256
Scott, Joan Wallach, 5
Seaxburh (d. c. 674), Anglo-Saxon Queen of Wessex [Cenwalh], 35
sebaste, 90
sexuality, 16, 22–3, 40, 83, 138, 140, 148, 150–1, 214, 221
 see also adultery; chastity
Shadis, Miriam, 125–6, 152–3, 165
Shrewsbury Charter, 208–9
 see also Anne of Bohemia; Richard II
Shrewsbury Book, The, 213
 see also Henry VI of England; Margaret of Anjou
Sibylla (d. 1190), Queen-regnant of Jerusalem [William of Montferrat, Guy of Lusignan], 171

Sigismund (d. 1437), King of Hungary, Holy Roman Emperor [**Mary of Hungary, Barbara of Celje**], 235
Solomon (d. 1087), King of Hungary [**Judith of Swabia**], 117
Sophia (d. c. 601), Byzantine Empress [Justin II], 52–3, 62
Spain, *see* Castile; Crown of Aragon; León; León-Castile; Navarre; Portugal; Visigothic Spain
Stafford, Pauline, 38, 94, 99
Stephen of Blois (d. 1154), King of England [**Matilda of Boulogne**], 134, 136, 144
 see also Matilda, Holy Roman Empress
Stephen IV (d. 1165), King of Hungary [**Maria Komnene**], 174
Strohm, Paul, 11, 205
Sweden, kingdom of, 117–19, 188

Terras da Rainha, 226
 see also finances of the queen
Teresa d'Entença (d. 1327), Queen of the Crown of Aragon [**Alfonso III**], 129, 168
Teresa of León (d. 1130), Countess of Portugal [**Henry of Burgundy**], 161, 163–4
 see also Alfonso VI of León-Castile; Urraca, Queen-regnant of León-Castile
Teresa of Portugal (d. 1250), Queen of León [**Alfonso IX**], 161, 163–4
 see also Berenguela of Castile; Dulce, *infanta* of Castile; Sancha, *infanta* of Castile
Thekla (d. 823), Byzantine Empress [Michael II], 88
Theodelinda (d. 628), Queen of the Lombards [Agilulf], 57, 73
Theodora (d. 548), Byzantine Empress [**Justinian I**], 47–52, 61, 87
Theodora (d. 1056), Byzantine Empress, 85, 87, 89–90;
 see also Constantine VIII; Constantine IX Monomachos; Empress Zoë; *Nomisma histamenon* of Empresses Zoë and Theodora
Theodosius I (d. 395), Roman Emperor [**Flaccilla**], 43–4

Theodosius II (d. 450), Byzantine Emperor [**Eudoxia**], 45–6
Theophanu (d. 991), Holy Roman Empress [**Otto II**], 79, 100, 101
theoretical approaches, 24–7
Theutberga (d. c. 9th century), Holy Roman Empress [**Lothar II**], 84, 94–7
see also Waldrada
Thyra, legendary Viking queen, 119
Toda Asnúrez (d. after 970), Queen of Navarre [García I Sánchez], 117
Tombs of the Plantagenet Kings, 141
see also Eleanor of Aquitaine; Henry II of England; Isabelle of Angoulême
Treaty of Troyes (1420), 200, 211
Tudor, Owen (d. 1461) [**Catherine of Valois**], 212, 240
Tumbo A, 162
see also Urraca, Queen-regnant of León-Castile

Urraca (d. 1126), Queen-regnant of León-Castile [Raymond of Burgundy, **Alfonso I of Aragon**], 161–4, 166, 176–8
Urraca of Castile (d. 1220), Queen of Portugal [**Afonso II**], 125
Urraca Fernández (d. 1007), Queen of León [Ordoño III, Ordoño IV] and Navarre [Sancho II], 117

Valois France, 2, 128, 155, 159–60, 188, 190, 195–203, 242
Vann, Theresa M., 5
Venantius Fortunatus, 59–60
see also Baudonivia; Radegund
Verina (d. 484), Byzantine Empress [Leo I], 46
Victoria (d. 1901), Queen-regnant of England, 2–3
Violant of Aragon (d. 1301), Queen of Castile [**Alfonso X**], 11, 166, 176
Violant de Bar (d. 1431), Queen of the Crown of Aragon [**Joan I**], 7, 227–8
Violant of Hungary (d. 1251), Queen of the Crown of Aragon [**Jaume I**], 158, 169, 175

Violant of Vilaragut (d. 1372), Queen of Mallorca [**Jaume III of Mallorca**, Otto of Brunswick], 228–9
Virgen de los Reyes Católicos, La, 241
see also Isabel of Castile
Virgin Mary, as a model of queenship, 8, 11, 39, 42, 47, 54–5, 74, 96–8, 110, 130, 151, 195, 197, 240, 247–8
Visigothic Spain, 33, 70–2
Vita Ædwardi regis, 113
see also Edith of Wessex; Edward the Confessor

Waldrada (d. 868), Queen of Lotharingia [**Lothar II**], 84, 94–6
see also Theutberga
Wealhtheow, 112
see also Beowulf
Weissberger, Barbara, 234
Wemple, Suzanne Fonay, 5, 21, 25, 38
William of Normandy 'the Conqueror' (d. 1087), King of England [**Matilda of Flanders**], 112, 114, 126, 131–2
Wood, Charles T., 219
Wulfthryth (d. late 9th century), Queen of Wessex [Æthelred of Wessex], 105

Yolande of Aragon (d. 1442), Queen of Naples [Louis II of Anjou], 201, 242
Yolande de Dreux (d. 1322), Queen of Scotland [**Alexander III**, Arthur of Brittany], 144
see also Margaret of England
Yolande-Irene of Montferrat (d. 1317), Byzantine empress [**Andronikos II**], 191

Zoë (d. 1050), Byzantine Empress, 85, 87, 89–90, 163
see also Constantine VIII; Constantine IX Monomachos; *Nomisma histamenon* of Empresses Zoë and Theodora; Empress Theodora (d. 1056)